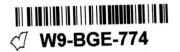
AMERICAN ART
at the VIRGINIA MUSEUM OF FINE ARTS

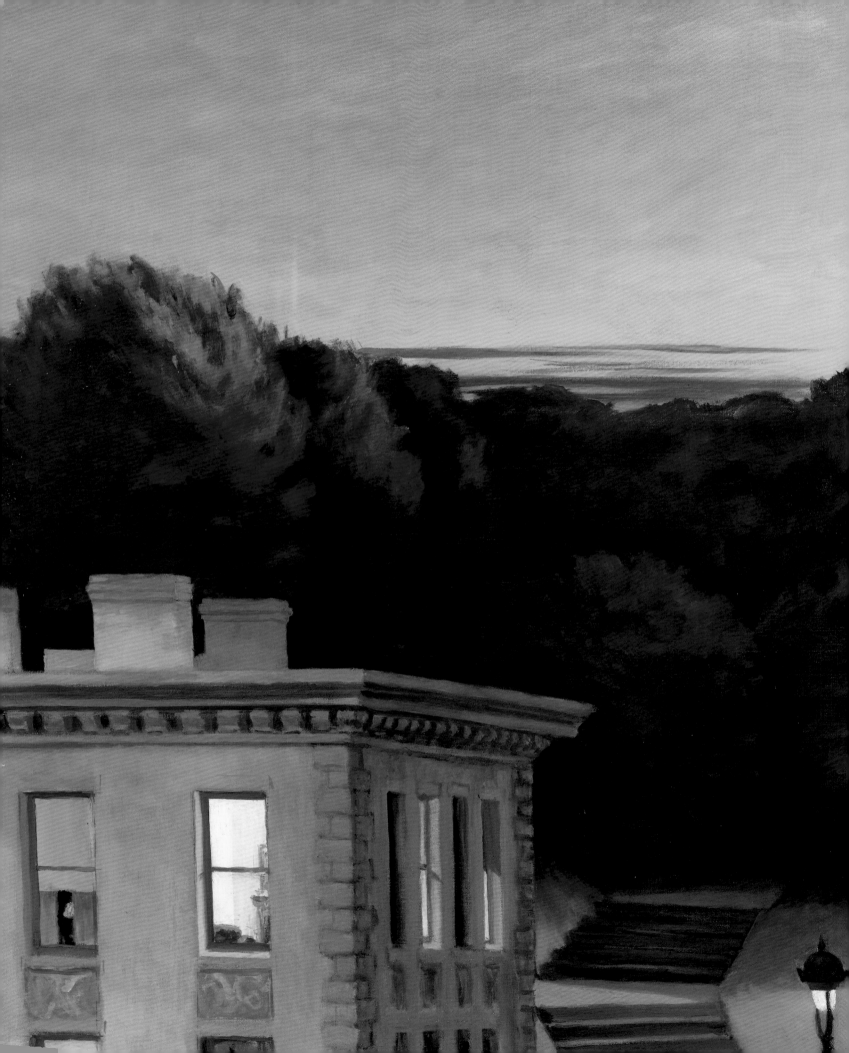

AMERICAN ART
at the VIRGINIA MUSEUM OF FINE ARTS

Elizabeth L. O'Leary

Sylvia Yount

Susan Jensen Rawles

David Park Curry

VMFA

Virginia Museum of Fine Arts, Richmond, in association with

University of Virginia Press, Charlottesville and London

This book was made possible through the generous support of the Julia Louise Reynolds Fund and the Elisabeth Shelton Gottwald Fund.

Library of Congress Cataloging-in-Publication Data
Virginia Museum of Fine Arts.
 American art at the Virginia Museum of Fine Arts / Elizabeth O'Leary ... [et al.].—1st ed.
 p. cm.
 Includes index.
 ISBN 978-0-917046-94-0 (hardcover : alk. paper).—
 ISBN 978-0-917046-93-3 (softcover : alk. paper)
 1. Art, American--Catalogs. 2. Art.—Virginia.—Richmond.—Catalogs. 3. Virginia Museum of Fine Arts.—Catalogs. I. O'Leary, Elizabeth L. II. Title.
 N6505.V55 2010
 709.73'074755451—dc22 2010003419

Produced by the Department of Publications
Virginia Museum of Fine Arts
200 N. Boulevard, Richmond, Virginia 23220-4007 USA
Rosalie West, editor in chief
Stacy Moore, project editor
Sarah Lavicka, book designer
Lauren Kitts, production assistant
Katherine Wetzel, photographer except as noted on page 422
Composed in Adobe InDesign using Garamond 3 and Futura fonts
Printed on acid-free 150 gsm Lumisilk text by Artegraphica, Verona, Italy

Image details: FRONT COVER: Thomas Hart Benton, **Brideship (Colonial Brides)** (cat. no. 118); BACK COVER: William Wetmore Story, **Cleopatra** (cat. no. 58); FRONTISPIECE: Edward Hopper, **House at Dusk** (cat. no. 124); PAGE vi: Julius Brutus Stearns, **The Marriage of Washington and Martha Custis** (cat. no. 50); PAGE x: Charles Caryl Coleman, **Quince Blossoms** (cat. no. 77); PAGE 15: John Singleton Copley, **Mrs. Isaac Royall (Elizabeth Mackintosh)** (cat. no. 5); PAGE 61: Unknown artisan, **Grecian Couch** (cat. no. 24); PAGE 107: Severin Roesen, **The Abundance of Nature** (cat. no. 44); PAGE 163: Pottier and Stymus Manufacturing, **Slipper Chair** (cat. no. 70); PAGE 207: John Singer Sargent, **The Sketchers** (cat. no. 91); PAGE 288: Paul Manship, **Flight of Europa** (cat. no. 117); PAGE 361: Stuart Davis, **Little Giant Still Life (The Champion)** (cat. no. 136); PAGE 413: John William Orr, **Still Life with Newspapers** (cat. no. 43)

Contents

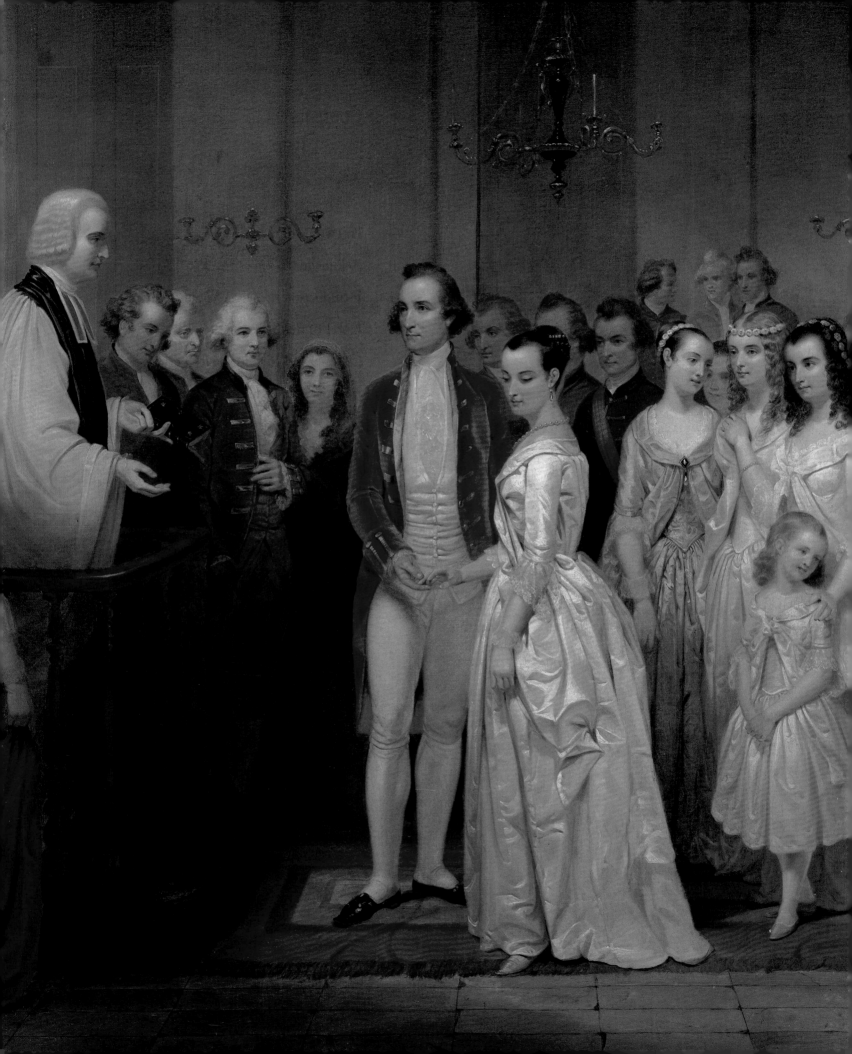

Foreword

For nearly seventy-five years American art has been the corner-stone of the collection at the Virginia Museum of Fine Arts. The bulk of the original collection came from Judge John Barton Payne, who in 1919 gave the Commonwealth fifty-one works of art, of which twenty were American. Since that time, the history of the museum's American holdings is a record of generations of magnanimous donors who have followed the example of Judge Payne in giving works of art or funds to purchase them: Adolph D. and Wilkins C. Williams, Arthur and Margaret Glasgow, Mrs. Preston Davie, Ivor and Anne Massey, the Charles Thalhimer family, Harry H. and Alma Coon, the Gottwald family, Harwood and Louise Cochrane, Jim and Fran McGlothlin, and many others.

The Cochranes' gift in 1988 created a significant endow-ment dedicated to the acquisition of American art. During the past twenty years, the museum has purchased more than thirty important paintings, sculptures, works on paper, and decorative arts by American artists. Works by Severin Roesen, William Wetmore Story, Edwin Lord Weeks, and Thomas Hart Benton are among those featured in this volume. The Cochranes have also endowed the curatorial chair for the American department.

In 2005, Jim and Fran McGlothlin announced their intention to bequeath to the Virginia Museum of Fine Arts their collection of American art, which could modestly be described as one of the finest in the country. They also pledged financial support for the museum's new wing and the new American galleries that bear their name. The McGlothlin Galleries, like this book, bring together a broad range of objects that tell the story of American art since the seventeenth century. VMFA's American art collection, part of our country's great artistic tradition, is a legacy we continue to build.

This book would not have been possible without the support of the Julia Louise Reynolds Fund and the Elisabeth Shelton Gottwald Fund, as well as the incredible hard work and dedication of a curatorial department that richly deserves praise and admiration. In her introduction to this book, Dr. Sylvia Yount, the Louise B. and J. Harwood Cochrane Curator of American Art and department head, relates for us the fascinating history of American art at the Virginia Museum of Fine Arts. With enthusiasm and insight she and her colleagues—Dr. Elizabeth L. O'Leary, Associate Curator of American Art; Dr. Susan Jensen Rawles, Assistant Curator of American Decorative Art; and Dr. David Park Curry, former VMFA American Arts Curator, now at the Baltimore Museum of Art—situate the museum's choice holdings in the greater sweep of American art. We owe them and the many others involved in this project a debt of gratitude for producing a book that both celebrates the past and points toward the future.

Alex Nyerges
Director

Acknowledgments

The publication of this first critical consideration of key artworks in the American collection at the Virginia Museum of Fine Arts unfolded over the course of seven years. It would not have been possible without the encouragement and efforts of many people. For more than nine decades, major patrons have donated objects or endowed funds for museum acquisitions, and it has been our pleasure in this volume to explore stellar examples of their munificence. A handful of these generous individuals are discussed in the introduction, and their names—Cochrane, Davie, Glasgow, Gottwald, McGlothlin, Payne, Thalhimer, Williams, among others—are proudly acknowledged in object credit lines. We also gratefully recognize the Reynolds family and Floyd D. Gottwald Jr. who, through the Julia Louise Reynolds Fund and the Elisabeth Shelton Gottwald Fund, have provided important sources of support for American art scholarship and programming. Pamela Reynolds, who serves as president of VMFA's board of trustees, remains a constant source of inspiration and friendship.

We are indebted to the active support of two VMFA administrations. Former director Michael Brand enthusiastically endorsed the book's publication and witnessed its inception; and present director, Alex Nyerges, has provided crucial, ongoing encouragement during the past three years. We owe thanks to the chief operating officer, Carol Amato, and former vice president for development Peter Wagner for their essential help with fiscal matters; Joan Murphy, the museum's liaison with the Commonwealth's Attorney General's office, provided guidance with contractual issues; and Joseph Dye, VMFA chief curator, granted us much-needed writing sabbaticals away from the office. Other colleagues in the museum's collections division have been especially helpful in providing information and occasionally reading entry drafts related to their collections: Mitchell Merling, Paul Mellon Curator and curator of European art; Corey Piper, curatorial assistant for the Mellon collection; John Ravenal, Sydney and Frances Lewis Family Curator of Modern and Contemporary Art; Emily Smith,

modern and contemporary fellow; and Barry Shifman, Sydney and Frances Lewis Family Curator of Decorative Arts from 1890 to the Present. We owe particular thanks to former American art research associate Jonathan Stuhlman, who helped lay the groundwork for this endeavor, and the late Frederick Brandt, former head of the Department of Twentieth-Century Art, whose wisdom and guidance are deeply missed. Caryl Burtner, the division's intrepid administrative coordinator, has deftly managed object files and provenance organization; and we thank Penny Arvin-Arrighi for her dependable administrative support.

The extraordinary staff of VMFA's Publications Department managed the production of this book with meticulous care and professionalism. We extend heartfelt appreciation to successive department managers Suzanne Freeman and Sarah Lavicka for overseeing the project's complicated logistics. Editor-in-chief Rosalie West, project editor Stacy Moore, and editor Sally Curran adeptly combed and refined myriad versions of the large manuscript, no small feat when working with the varied approaches and voices of four authors. Sarah Lavicka, who also serves as VMFA's chief graphic designer, produced the book's handsome format with production assistance from graphic designer Lauren Kitts. Additional thanks go to marketing representative Elizabeth Causey-Hicks, and indexer Carolyn Sherayko.

The museum's conservation departments, headed by objects conservator Kathy Gillis and paintings conservator Carol Sawyer, worked tirelessly to treat and prepare artworks for photography. The book's stunning images were made by VMFA's chief photographer Katherine Wetzel and assistant photographer Travis Fullerton, an assignment that grew even more complex with the shift to digital photography midway through the multiyear project. Photography office manager Susie Rock organized and tracked hundreds of shoots and coordinated efforts with Susan Turbeville, project registrar, and the museum's exceptional Registration Department and

art handlers. We also thank photographic resources manager Howell Perkins, who not only organized and archived in-house images, but adroitly tackled the difficulties associated with securing reproduction rights, verifying caption text, and acquiring photographs from both outside institutions and private collectors.

We are enormously grateful to VMFA's head fine arts librarian Suzanne Freeman and librarians Courtney Yevich and Lee Viverette for their invaluable assistance with our continuing research needs. For two years, special project researcher Dennis Halloran aided us in numerous investigations. We are also indebted to a series of dedicated volunteers: Ann Hunter McLean, Caroline Nichols, Rebecca Shields, and Sara Desvernine Reed. Special thanks go to Meghan Holder who, for the past year and a half, has provided steady research and logistical assistance. Over time, interns from area universities and colleges have also lent a hand; they include: Anne Lauinger Fechtel, Nan Goss, Felicia Herzog, Corinne Jeltes, Lindsay Kurlak, Christopher Oliver, Lauren Piccolo, and Lauren Teague.

In exploring myriad artworks in some depth, we frequently turned to the broader intellectual community of national and international American art scholars who proved wonderfully forthcoming with insights and information. Their names appear, with our appreciation, in specific entries. It is also a privilege for the museum to copublish this book with the esteemed University of Virginia Press, and we extend special thanks to director Penelope Kaiserlian and her staff for facilitating this collaborative venture.

We close by offering deepest gratitude to our spouses—John Martin, Tom Genetta, Ben Rawles, and Becky Morter—whose steadfast love and support have sustained us through this and related endeavors.

The authors

Introduction

"Most Intimately Connected"
American Art and the Virginia Museum of Fine Arts

Sylvia Yount

One might assume that American art has always been a flag-ship collection of the Virginia Museum of Fine Arts (VMFA) given our location in one of this nation's most historic commonwealths. Its prominence, however, is a more recent development. Long considered a stepchild of art history because of its so-called immaturity and lack of a deeply rooted tradition, American art did not equally come of age in the academy, the museum, and the marketplace until the 1980s.[1] The same can be said of American art at VMFA, which despite its early exhibition and aquisition, was not formalized as a separate curatorial department until 1987; in contrast, the encyclopedic museum's other collecting areas were first organized by culture in 1954.[2] Yet the history of American art at VMFA is inextricably linked to the history of the museum itself—from its beginnings in the Great Depression to its fifth and largest expansion debuting in 2010—and both accounts are grounded in civic philanthropy and cultural nationalism. This introduction to the museum's first published catalogue of its American art collection explores this evolutionary arc, providing a broader context for the individual, object-based essays that follow.

"A True Emblem of Virginia," Early Years

The Commonwealth of Virginia's collecting of American art actually predates the official 1935 founding of its art museum. The nucleus of its holdings was created with the 1919 donation of fifty-one works from the collection of the Virginia-born Judge John Barton Payne (fig. 1), then living in Washington, D.C. First installed in 1921 in Richmond's newly dedicated Confederate Memorial Institute (popularly known as Battle Abbey), the collection was permanently transferred to the fledgling VMFA in 1936 when it opened the doors of its new Georgian Revival building (fig. 2) on the grounds of the neighboring Confederate veterans' camp. The museum had been formally created by an act of the Commonwealth's General Assembly two years earlier, the result of fund-raising efforts initiated by a $100,000 challenge grant from Payne to

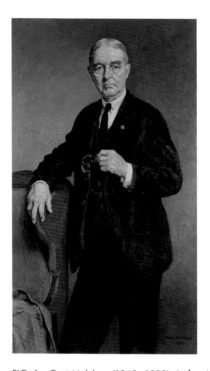

FIG. 1 Gari Melchers (1860–1932), **Judge John Barton Payne,** 1930, oil on canvas, 55 x 33 in. (139.79 x 83.8 cm). Gift of John Barton Payne, 30.1.1.

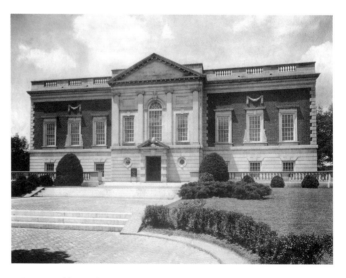

FIG. 2 Peebles and Ferguson Architects, **Virginia Museum of Fine Arts Boulevard facade,** 1936.

FIG. 3 George P. A. Healey (1813–1894), **Jennie Byrd Bryan,** 1874, oil on canvas, 54½ x 40 in. (138.4 x 101.6 cm). Gift of John Barton Payne, 19.1.25.

FIG. 4 Paul Manship (1885–1966), **John Barton Payne,** 1935, plaster bas-relief model for John Barton Payne medal, 8 ½ in. (21.6 cm) dia. Museum Purchase, 37.23.1.

construct a public museum for Virginia's art collections. Governor John Garland Pollard, assisted by the Richmond Academy of the Arts, enthusiastically spearheaded additional campaigns, including one for a gallery in memory of the late Virginia artist Gari Melchers. As a New Deal project, critical federal assistance was also secured—the Federal Public Works Administration donated 30 percent of labor and construction costs as well as additional funds for installation expenses—transforming Payne's dream of a public-private partnership into a tangible reality. The General Assembly bill that officially established VMFA also named Payne as its first president.[3]

Payne was born in 1855 in Pruntytown, Virginia (now West Virginia). He trained as a lawyer and practiced in Chicago before obtaining a judgeship on the Cook County Superior Court in Illinois. From 1920 to 1921, he served as secretary of the interior under President Woodrow Wilson, concluding his professional career as the president of the American Red Cross. As this illustrious résumé suggests, Payne's cultural sophistication and myriad talents included a deep and abiding appreciation for art. His wife, Jennie Byrd Bryan, studied painting in Chicago with midcentury portraitist George Healy; the painter's 1874 depiction of her portraying him (fig. 3) is one of nine Healys included in the original Payne gift to the Commonwealth.[4] Along with his wife, Payne considered the fine arts to be a critical component of democratic society—a belief that underlined his 1919 stipulation to the state that the building that housed his collection should be free to the public on Saturday afternoons, Sundays, and holidays, presumably to make it accessible to members of the working classes.[5] Sadly, Payne died within a year of the museum's January 16, 1936, opening, leaving a bequest of seventy-five more works of American art, including twenty-three etchings by late-nineteenth-century expatriate James McNeill Whistler. Governor Pollard, who followed Payne as VMFA president, issued a three-part resolution to honor him by establishing: the museum's first art purchase fund, the John Barton Payne Fund, using interest from the $50,000 bequeathed by the donor to acquire "Paintings of Real Merit by American Artists"; a biennial exhibition of contemporary painting; and an artist's medal graced with the founder's portrait, designed by the leading American sculptor Paul Manship (fig. 4). All of these efforts were intended exclusively for the benefit of American art.[6]

The association of the Payne name with the acquisition of contemporary American art is somewhat curious, as only twenty of the fifty-one works in his original gift were by American artists, historical or otherwise. These include a marble bust of Benjamin Franklin by Hiram Powers (fig. 5)—believed to have been selected from the sculptor's Florence, Italy, studio in 1866 by Payne's father-in-law[7]—and Richard Norris Brooke's depiction of Virginia's first native aristocrat, Pocahontas (fig. 6), begun in 1889 and completed in 1907 for the three-hundredth anniversary of the Jamestown Colony. Both objects suggest the primarily antiquarian interests of the donor. Yet the museum's first curator-cum-director, Thomas Colt Jr., found a way to honor Payne's taste for historical American art while using the museum's biennials to develop its contemporary holdings.[8]

Befitting the country's first state-owned museum, VMFA's inaugural exhibition, *The Main Currents in the Development of American Paintings*, curated by Colt, featured approximately 150 significant paintings produced "prior to the modern revolt"—in effect, a "complete survey of American painting from the Colonial times until the first years of the Twentieth Century." Colt explained his choice of "the most appropriate subject of American art" as "the art that is most intimately connected with the life that we are living," a popular and timely sentiment that also informed the prominence of contemporary exhibitions at the museum, echoing the broader nationalist call for a vital cultural scene in Depression-era America.[9]

This theme of intimacy surfaced again in a 1936 VMFA circular, its "plan of membership" crediting Judge Payne with an institutional vision—to forge "an intimate personal contact with the people of Virginia"—and calling on the support of "those Virginians who appreciate the high value of culture, design, and inspiration in life" to help make the museum a "true emblem of Virginia." An emphasis on the building's "homelike" qualities was first articulated by Gari Melchers in the early planning stages—"let us design a home for pictures and sculpture, living Art—not a Mausoleum." This advice was later echoed by his widow, museum board member Corinne L. Melchers, in her wish for VMFA to be "regarded less as a temple of art, where one speaks in hushed tones, and real emotions are not set free, and rather more as a dwelling or *home* of art, where one enters simply and intimately, and with a friendly

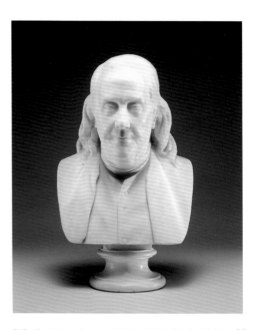

FIG. 5 Hiram Powers (1805–1873), **Benjamin Franklin,** modeled 1848–51, carved 1851–66, marble, 24½ x 15⅜ x 12⅞ in. (62.2 x 39.1 x 32.7 cm). Gift of John Barton Payne, 19.1.50.

FIG. 6 Richard Norris Brooke (1847–1920), **Pocahontas,** 1889 and 1907, oil on canvas, 84 x 52 in. (213.36 x 132.08 cm). Gift of John Barton Payne, 19.1.51.

feeling of sympathy and relaxation."[10]

Colt's *Main Currents* exhibition was predicated on the notion that Virginia, the first of the original thirteen colonies, was also the "first state to organize an art institution." The accompanying catalogue traced this "chronological progression," beginning with the leadership efforts of the Chevalier Alexandre Marie Quesnay de Beaurepaire, a young French officer of the colonial armies who in 1786 had the "ambitious audacity" to found in Richmond the short-lived Academy of Sciences and Fine Arts of the United States of America. The historical timeline moved next to the 1796 installation of Houdon's famous marbles of George Washington and the Marquis de Lafayette in the Thomas Jefferson–designed state capitol and on to the 1817 establishment of the Museum of Art and Natural Science on Capitol Square (also short lived). The catalogue's chronology then jumped a century to the 1919 presentation of Payne's gift to the Commonwealth and concluded with the 1936 opening of VMFA and its inaugural exhibition, "conceived by the Museum in response to its desire for the people of the State to gain a clear perspective of the best art that our country had produced." In a burst of regional pride, this resurgence of state-supported art appreciation, though shown to be lacking in the past, was linked to "the inherent love of Virginians for tradition."[11]

The appropriateness of the exhibition's American theme may also be understood in broader cultural terms. During a time of economic hardship and political isolationism, the 1936 exhibition resonated with the country's inward-looking populist spirit that vigorously celebrated both regional and national character in a variety of art forms. It also coincided with the initial stirrings of a more serious study of the history of American art, launched by a generation of academics as well as museum curators and directors. Unsurprisingly, Colt sought the assistance of an advisory board made up of respected directors of the Carnegie Institute, Corcoran Gallery of Art, Pennsylvania (now Philadelphia) Museum of Art, Phillips Memorial Gallery (now Phillips Collection), and Whitney Museum of American Art, presumably in order to negotiate an impressive group of loans from public and private collections. These advisors, and their respective institutions, may also have offered potential models for the new museum, particularly in terms of collecting strategies.[12]

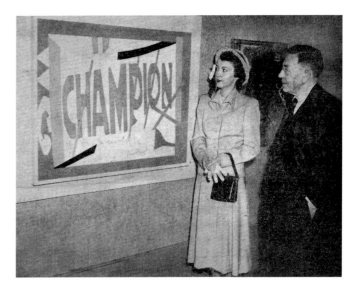

FIG. 7 Visitors at the *American Painting 1950* exhibition. "'Not Even Good Sign Painting,' says Thomas P. Ayer, of **Little Giant Still Life,** by Stuart Davis. But Mrs. J. B. Jackson, Jr., likes its 'carnival spirit'" (*Richmond News Leader,* May 3, 1950).

Yet with the celebratory subject of the opening exhibition came a wariness of provincialism, a note sounded in the popular press. Perhaps in an attempt to underplay the Commonwealth's and Richmond's legacy—that is, its colonial and Confederate pasts (reflected in the museum's Georgian-Revival facade situated on the grounds of a Civil War soldiers' home)—VMFA's management took pains to describe the inaugural exhibition as "a true national interpretation of life and of nature" that told the "story of American art, rather than the story of art in America." At the same time, they argued for the museum's "positive value in restoring Richmond to its rightful position as a noted art center."[13]

By debuting with such an ambitious survey show on the second floor, and the Payne collection on the first, the museum asserted its commitment to historical American art at its foundation. One year later, the *First Biennial Exhibition of Contemporary American Paintings* staked a claim for the post-"modern revolt." The museum's biennial shows, which ran until 1950, were largely conservative affairs where representational art predominated. Despite this profile, the juried exhibitions proved to be the source for many of the museum's most significant mid-twentieth-century acquisitions—for example, Stuart Davis's *Little Giant Still Life* (see cat. no. 136), which caused no end of controversy (fig. 7) when it was

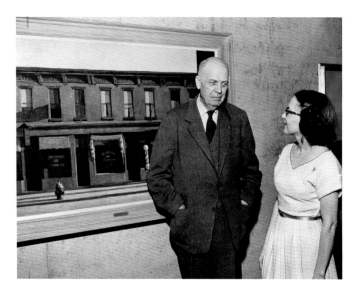

FIG. 8 At the *Judge the Jury* exhibition, "Edward Hopper, artist, discusses his famous painting **Early Sunday Morning** with a local artist, Miss Belle Worsham, one of the hostesses of the evening at the Museum" (*Richmond Times-Dispatch,* March 21, 1953).

awarded the Payne medal and purchased for the collection in 1950 as one of the museum's first near abstractions, and Edward Hopper's *House at Dusk* (see cat. no. 124), a more universally popular choice acquired three years later (fig. 8). Both paintings have since achieved international fame as anchors of VMFA's permanent collection.

Directors' Choice, 1940s – 1970s

During the 1940s, the number of VMFA's American art exhibitions—mostly focused on Virginia artists—nearly tripled from the previous decade. And, perhaps more surprising for a relatively young museum in the Jim Crow South, three significant works by contemporary African American artists entered the collection in the mid-1940s: gifts of a gouache on paper by Jacob Lawrence (see cat. no. 128) and a wood sculpture by Leslie Bolling (see cat. nos. 129 and 130) and the purchase of an oil by George H. Ben Johnson (see cat. no. 131) from the Virginia Artists exhibition series. These were acquired during the remarkable World War II – period tenure of Beatrice von Keller, a professor of art at Virginia's Randolph Macon Woman's College, who served as coacting director—along with former First Lady of Virginia Violet McDougall Pollard, wife of Governor John Garland Pollard—while Colt was fighting with the U.S. Marines in the Pacific.[14]

Von Keller was also responsible for the first purchase of works by historical American artists—specifically, the haunting Italian scene by American Old Master George Inness (see cat. no. 68), who in 1884 had painted a series of works in Virginia's Goochland County, and a still life by the Richmond-born Robert Loftin Newman. A credit to the museum's creative wartime leadership, these pictures were acquired with surplus operating funds and a one-time approval of the governor's office. According to VMFA board minutes, von Keller secured from various New York galleries pictures by such artists as George Bellows, Ralph Blakelock, Frank Duveneck, Inness, George Luks, Newman, Maurice Prendergast, and Albert Pinkham Ryder—all acclaimed figures at the time. The accessions committee selected the Inness, offered for $3,000 by the Macbeth Galleries—an important purveyor of American art—and Duveneck's *Head of an Old Man* for $1,800, noting that if funds for the latter could not be located, Newman's *Chrysanthemums* would be acquired for $750. Both the Inness and Newman carry the credit line "Gift of the Commonwealth of Virginia."[15]

Generally, in the realm of historical American art, gifts continued to outweigh purchases during these years. One of the first was John Singleton Copley's *Mrs. Isaac Royall* (see cat. no. 5), an important eighteenth-century Anglo-American portrait by an acknowledged early "master." The work was donated in 1949 by Mrs. Adolph Williams; three years later, she and her husband gave a larger collection (some forty-two paintings, mostly European Old Masters) and established the museum's first endowed fund for acquisitions—at the time, the largest art gift of its kind in the South.[16]

Much of VMFA's early director-led collecting of American art was haphazard and episodic. Under Leslie Cheek Jr.'s (fig. 9) inspired twenty-year leadership (1948 – 68), the acquisition emphasis was largely on contemporary work. Nevertheless, in the 1950s the Williams Fund made possible purchases of eighteenth-century American silver as well as early- and late-nineteenth-century genre pictures (in oil and pastel), by Samuel Morse (see cat. no. 36) and Mary Cassatt (see cat. no. 99).

Scion of a wealthy Nashville, Tennessee, family, Cheek studied fine arts at Harvard and architecture at Yale. In 1937 he began a teaching career at William and Mary (during which he served on the Virginia Art Commission) and a directorship

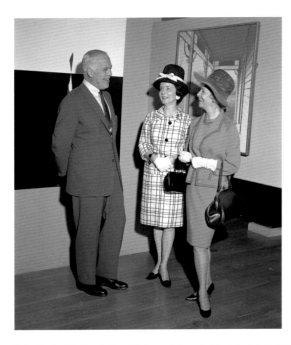

FIG. 9 **Leslie Cheek Jr. with two visitors** to *Virginia Artists 1967* exhibition. William Bevilaqua's *The Brink* and Richard Porter's *The Front Porch* are in the background.

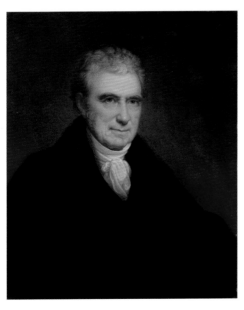

FIG. 10 Rembrandt Peale (1778–1860), **John Marshall,** 1834, oil on canvas, 30 x 25 in. (76.2 x 63.5 cm). Museum Purchase, The Arthur and Margaret Glasgow Fund, 56.10.

of the Baltimore Museum of Art two years later. His "experiential," or holistic, approach to museum programming—bringing together the various visual and performing arts for public benefit—underlined his devotion to "correlate the fine arts with the art of living." Moreover, Cheek's then-novel focus on audiences and multilayered learning opportunities that were both educational and entertaining—not to mention his preference for mixing media and artworks in dramatic gallery installations (no doubt derived from his experience with architecture and stage design)—proved to be pioneering for the museum field at large and made a lasting impact at VMFA, in particular.[17]

Cheek's interest in American history and material culture, likely also inspired by his privileged background, led to a series of acquisitions and exhibitions in the area of decorative arts, including the major *Furniture of the Old South* effort of 1952. In keeping with such antiquarian taste, a significant event of this period was Edgar William and Bernice Chrysler Garbisch's 1950 donation of Junius Stearn's historicist life of Washington cycle (see cat. nos. 50–53), a group of paintings that remain important Colonial Revival icons and textbook illustrations familiar to countless schoolchildren, especially in Virginia.

In 1956, Arthur and Margaret Glasgow established the museum's second major purchase fund; its first acquisition was Rembrandt Peale's portrait of another native son, *John Marshall* (fig. 10). This was followed two years later by the purchase of John Singer Sargent's more experimental plein-air portrait of artist-friends, *The Sketchers* (see cat. no. 91), a perennial favorite in VMFA's collection.

Important works by two other acclaimed expatriates, Mary Cassatt and Elihu Vedder, entered the museum in the mid-1970s by gift and purchase—Cassatt's *Child Picking a Fruit* (see cat. no. 98) was donated by Richmonders Ivor and Anne Massey, while Vedder's *The Cup of Death* (see cat. no. 87) came in through the Williams Fund. The intervening decades also witnessed additional gifts of early-nineteenth-century American paintings (from Mrs. Preston Davie) along with a large collection of nineteenth-century American glass from Mr. and Mrs. William B. Thalhimer Sr.[18]

The advent of the 1976 American Bicentennial catalyzed a renewed national interest in historical American art, and the

museum (then under the direction of Peter Mooz) responded accordingly by placing a greater emphasis on eighteenth- and nineteenth-century decorative arts, particularly furniture, as well as early- to mid-nineteenth century painting. That year, a large gift of primarily Anglo-American colonial-era decorative arts from Richmonders John C. and Florence S. Goddin joined what would become the museum's core American furniture collection of Dr. and Mrs. Brooks H. Marsh of New York, purchased with proceeds from the Williams Fund.[19]

Sculpture, frequently neglected in public collections, was soon identified as a critical need and answered with the generous establishment, in 1980, of the Thalhimer Family Fund, which brought to the museum such significant and diverse bronzes as Augustus Saint-Gaudens's *The Puritan* (see cat. no. 92) and Paul Manship's *Head of a Girl* (see fig. 196).

Watershed Years, Mid-1980s–1990s

In spite of these judicious acquisitions, which adhered to the museum's early dictum to build the collection slowly, with an emphasis on quality, VMFA's American holdings were not widely promoted outside of Richmond. For example, in December 1985, the British art magazine *Apollo* devoted a special issue to the Virginia Museum and its collections—with the notable exception of American art. English editor Denys Sutton, citing the Commonwealth's classical traditions and the influence of European culture on Richmond in particular—for example, Jefferson's Capitol building and Houdon's *Washington* marble—selected VMFA's Roman marble *Caligula* for the magazine's cover.[20]

The emphasis on the museum's significant world-cultures collection over its founding Anglo-American character (this despite Sutton's note of Richmond's "special relationship" with England) suggests the lurking fear of provincialism that to this point had largely shaped VMFA's acquisition and exhibition programs—perhaps stemming from Virginia's "embarrassment of riches" status in the realm of American cultural history, or the lingering academic bias against American art.[21] This position would become increasingly untenable for an American museum at a time when a flourishing cultural nationalism spurred an explosive growth in the American art market (during the mid-1980s), a development that resonated at VMFA.

Five years after the *Apollo* article was published, the American art periodical *The Magazine Antiques* featured on its cover the detail of a new acquisition, *Quince Blossoms* by expatriate American painter Charles Caryl Coleman (see cat. no. 77). In the introduction to that special issue, VMFA director Paul Perrot observed that whereas a strong collection of "world art" had been created at the museum, "the American collections were somewhat neglected," asserting that "they are going to be among the museum's highest priorities in the years ahead."[22]

Between 1985 and 1990 VMFA's growing commitment to American art was in ample evidence, beginning with the 1987 appointment of William M. S. Rasmussen as the museum's first full-time assistant curator of American art to 1900. Like his curatorial colleague Frederick R. Brandt, who in 1983 became VMFA's curator of twentieth-century art (both European and American), Rasmussen began his career at the museum in the Education Department. Until Rasmussen's appointment as the resident Americanist, chief curator Pinkney Near—a Harvard Ph.D. who had been hired in 1954 by Leslie Cheek Jr. as the museum's first curatorial assistant—oversaw the historical American holdings.[23]

Also during the 1980s, a sequence of some ten exhibitions—including the seminal VMFA-organized *Painting in the South, 1564–1980* (1983)—revealed the heightened profile of American art at the museum.[24] But the most demonstrable proof of this new prominence occurred in the area of collection development. Under the board leadership of Bruce C. Gottwald, shifting acquisition priorities increasingly favored historical American painting and sculpture. (Significantly, in 1985 Gottwald and his wife, Nancy, donated to VMFA a major canvas by Georgia O'Keeffe, *White Iris* [see cat. no. 120].) Both Rasmussen and Brandt would add numerous American works to the collection during their respective tenures, despite the skyrocketing market costs and lack of museum funds dedicated for that purpose.[25]

In response to VMFA's ongoing drive to strengthen these holdings, Richmond-area residents Louise B. and J. Harwood Cochrane made a generous contribution of $1 million in 1988, establishing the museum's first dedicated fund for the purchase of historical American painting, sculpture, works on paper, and decorative art. The civic-minded couple had first become

FIG. 11 Before and after conservation and reupholstery, 2000. Unknown artisan, **Easy Chair**, ca. 1740–50, Massachusetts (probably Boston), mahogany, maple and white pine, reproduction wool moreen upholstery, 47 x 36 x 30 in. (119.4 x 91.4 x 76.2 cm). Museum Purchase, The Adolph D. and Wilkins C. Williams Fund, 76.42.24.

FIG. 12 Before and after rehousing in period frame. George Inness (1825–1894), **Stone Pines (Pine Grove, Barberini Villa, Albano Italy)**, 1874, oil on canvas, 30¼ x 45⅜ in. (76.8 x 115.2 cm). Gift of the Commonwealth of Virginia, 44.16.1. Period frame, American, ca. 1875, wood; cast, applied, and incised composition ornament, gilded. Gift of The Council of the Virginia Museum of Fine Arts.

involved at VMFA in the 1970s, when Louise Cochrane volunteered with the museum's Artmobile, an educational enterprise that brought original art to different parts of the state. By 1977 she had joined the VMFA Council and trained to become a museum docent. Harwood Cochrane also joined the museum that year and was appointed to a ten-year term on the VMFA Board of Trustees, which was subsequently served by his wife, Louise. By the time of their landmark 1988 gift, they had already donated $3 million to the museum's general endowment.[26]

With the 1990 appointment of David Park Curry as senior curator of American art (a position he held until 2005), a more systematic approach to growing the collection gained an institutional foothold. Often buying boldly against market fashion—Coleman's *Quince Blossoms*, the first work to be acquired through the Cochrane Fund, in 1990, is a prime example—Curry oversaw the most productive period of development to date for VMFA's American art department. Throughout his fifteen-year tenure, Curry's keen eye and taste for artful design shaped the museum's inventive presentation of American art, echoing Leslie Cheek's emphasis on thoughtful and sometimes playful juxtapositions of fine and decorative objects—areas in which Curry held equal expertise.[27]

The increased activity in the American art department during the 1990s, including a reinstallation of the collection and a dozen special exhibitions, resulted from ongoing and new sources of targeted financial support, especially for acquisitions (in addition to the Cochrane Fund, the 1985 establishment of the Floyd D. and Anne C. Gottwald Fund proved critical to continued growth) and educational programming (three consecutive symposia on American decorative arts were funded by the Julia Louise Reynolds Fund), as well as necessary staff development (namely, the arrival of invaluable research associates Susan Jensen Rawles, Elizabeth O'Leary, and Jonathan Stuhlman). In addition to expanding the quantity and quality of American objects, Curry and his colleagues placed a strategic emphasis on refining the collection—through deaccessioning initiatives in furniture, silver, and glass as well as major reupholstery (fig. 11) and reframing (fig. 12) efforts that were made possible through the generous support of the VMFA Council, various museum patrons, and local foundations.[28]

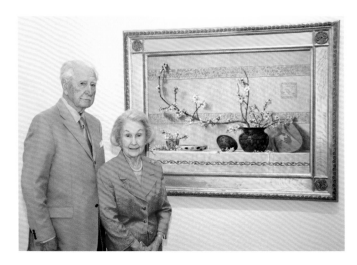

FIG. 13 **J. Harwood and Louise B. Cochrane** with Charles Caryl Coleman's *Quince Blossoms*, 2007.

Today and Tomorrow

The momentum behind VMFA's well-endowed program in American art, first launched in the late 1980s, shows no signs of slowing. With acquisition funds that rank among the top in the country, a healthy future of departmental collecting based on a solid foundation is ensured. Since 1990, the ground-breaking support of the Cochranes (fig. 13) has underwritten the acquisition of some twenty oils, four works on paper, and three sculptures by leading American artists, including Cecilia Beaux, Thomas Hart Benton, William Merritt Chase, Jasper Francis Cropsey, Robert Henri, Paul Manship, William Wetmore Story, Henry Ossawa Tanner, John Trumbull, Benjamin West, and James McNeill Whistler. This wide-ranging collection of objects dates from the colonial era to the late 1920s and encompasses the major genres of American art—from

FIG. 14 **Installation view,** *An Enduring Legacy: The J. Harwood and Louise B. Cochrane Fund for American Art Acquisitions,* 2007.

the founding tradition of portraiture and the first "national" style of landscape painting to a diversity of still-life and figure painting as well as choice sculpture (fig. 14). In American decorative arts, the department has focused its acquisition dollars on individual works that represent momentous historical and stylistic trends. For example, the Cochrane Fund has enabled the purchase of six decorative objects, including an important eighteenth-century rococo tassel-back side chair, a rare late-nineteenth-century Louis Comfort Tiffany trifold screen, and an early-nineteenth-century monumental porcelain urn by the Tucker Factories. Richmond's Gottwald family also continues to support a diversity of purchases through their endowed fund, while underwriting publications (such as this one) and making gifts of singular importance, for example, the eighteenth-century kneehole bureau table by the Goddard-Townsend Group (see cat. no. 8).

In the broader realm of gifts, a variety of significant works have been donated in the past decade by such established museum organizations and patrons as the VMFA Council (Robert Duncanson's *The Quarry*; see cat. no. 42); Harry H. and Alma Coon (an extensive collection of Audubon prints; see cat. no. 26); Charles G. Thalhimer (a Robert Henri child portrait, *Her Sunday Shawl*; see cat. no. 111); Jane Joel Knox (the museum's first American Renaissance canvas, *Lotus and Laurel* by Henry Prellwitz; see cat. no. 101); and James W. and Frances G. McGlothlin (a Munich-style figure painting, *The Wounded Poacher* by William Merritt Chase; see cat. no. 72).

In 2005, the McGlothlins (fig. 15), native Virginians and among the country's leading American art collectors, promised to bequeath to VMFA their outstanding late-nineteenth- and early-twentieth-century paintings, sculptures, and works on paper—a selection of which was featured in a Curry-organized commemorative exhibition, *Capturing Beauty: American Impressionist and Realist Paintings from the McGlothlin Collection*. This remarkable promised gift, with its particularly strong representation of art by George Bellows, Robert Blum, Childe Hassam, Martin Johnson Heade, Winslow Homer, and John Singer Sargent—coupled with a substantial contribution toward the museum's latest expansion project—resulted in the naming of the McGlothlin Wing (fig. 16), designed by Rick Mather and opening in spring 2010. With approximately eleven thousand square feet of new gallery space—more than

double the previous footprint and the largest allotment for any curatorial area—American art at VMFA has truly come of age.[29]

Dating from the late-seventeenth to the mid-twentieth centuries, the collection currently numbers approximately 1,900 objects—from paintings, sculptures, and works on paper to the decorative arts of furniture, silver, glass, and ceramics. With an eye to its 2010 reinstallation, the museum is growing the American holdings with strategic acquisitions of major works as well as objects that add necessary texture and

FIG. 15 **James W. and Frances G. McGlothlin** at the 2005 opening of *Capturing Beauty: American Impressionist and Realist Paintings from the McGlothlin Collection.*

dimension to the planned displays and interpretive approaches. Along with filling critical gaps, we continue to build on collection strengths—for example, the recent gift of the fully furnished Worsham-Rockefeller Aesthetic-movement interior (see cat. no. 74) positions VMFA as a major destination for the study and enjoyment of this important late-nineteenth-century cultural phenomenon. Following the thoughtful course set by our predecessors and echoing the current shape of academic and museum scholarship and practice, we have most recently acquired work that situates American art in

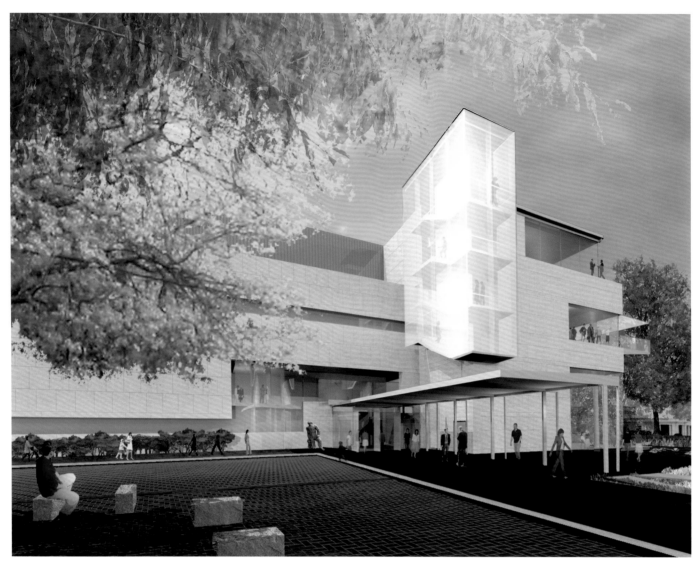

FIG. 16 Rick Mather Architects, **Rendering of James W. and Frances G. McGlothlin Wing North Entrance facade,** Virginia Museum of Fine Arts, 2006.

regional, national, and international contexts, while expanding our representation of women artists and artists of color as befitting the museum's increasingly diverse audiences.[30]

Commemorating the latest iteration of VMFA's American art collection in our newly expanded galleries, this inaugural publication's organizational format roughly corresponds to the installation framework—chronological with a narrative flow that encompasses stylistic and sociohistorical themes. A selection of the museum's most compelling American paintings, sculptures, works on paper, and decorative arts traces a history of our nation's artistic production and reception, but rather than presenting a prescriptive text-book survey, the resulting stories and conversations begin with the objects themselves. From colonial Anglo-American worldly goods to midtwentieth-century expressions of private and public identity, the following essays (and forthcoming galleries) offer fresh perspectives on cherished icons and little-known treasures, marking the transformation of a collection that has grown in quantity and quality, character and profile, over the past seventy-four years.

In addition to the tireless efforts of my predecessors who laid the groundwork for the expanded repositioning of American art at VMFA, I want to recognize the indispensible assistance of Dr. Elizabeth O'Leary, Associate Curator of American Art, and Dr. Suzanne Freeman, Head Fine Arts Librarian, in the preparation of this essay.

NOTES

1. For an overview of American art's rising twentieth-century reputation, see Wanda Corn, "Coming of Age: Historical Scholarship in American Art," *Art Bulletin* 70 (1988): 188–207. See also John Davis, "The End of the American Century: Current Scholarship on the Art of the United States," *Art Bulletin* 85 (September 2003): 544–80.

2. See unpublished lecture by former VMFA associate director for exhibitions and collections management, Kathleen Morris Schrader, "How We Got Here: Chapters from the History of the VMFA," September 18, 2002, VMFA history vertical files. All vertical files cited hereafter are in the VMFA Library and Archives.

3. See John Garland Pollard, "The Origin and Development of the Virginia Museum of Fine Arts," *The Four Arts* 2 (April 1935): 4–5. See also VMFA circular, 1936, VMFA history vertical files. Thanks to William J. Martin, director of the Valentine Richmond History Center, for initially bringing this document to our attention. For more on the Robert E. Lee Camp, No. 1, Confederate Veterans, which opened at Boulevard and Grove Avenue in 1885, see Douglas Southall Freeman, "Little Remains of 'Perpetual Memory'," *Richmond Times-Dispatch*, February 18, 1984. See also, Herbert A. Claiborne, Jr., "Virginia Museum is Cultural Jewel," *Richmond Times-Dispatch*, June 22, 2003, E-1.

4. See *Catalogue of the Paintings in the John Barton Payne Collection Given in Memory of his Wife and Mother to the Commonwealth of Virginia* (Richmond: Virginia Museum of Fine Arts, 1921).

5. See John Barton Payne to Governor Westmoreland Davis, December 15, 1919, VMFA John Barton Payne vertical file.

6. See VMFA circular, 1936; VMFA Payne vertical file; and announcement of first biennial (March 12–April 23, 1938), VMFA history vertical files.

7. According to Judge Payne, his esteemed father-in-law, the Honorable T. Barbour Bryan "was one of the leading men of Chicago, Commissioner-at-Large to the European Court at the [1893 Columbian] World Exposition, Vice-Chairman of the Exposition, and in 1877–80 served as Commissioner of the District of Columbia under appointment from President Hayes." See *Catalogue of the Paintings in the John Barton Payne Collection*, 18.

8. Although generally described as "curator," Colt was appointed VMFA "director" by Governor Pollard on April 13, 1935. A native of New Jersey, he had previously worked at New York's Rehn Galleries, developed the art department at Dartmouth College (his alma mater), and served as a consultant to Abby Aldrich Rockefeller. After a brief stint as a navy pilot, he was stationed at Quantico, thereafter choosing to remain in Virginia. In 1932, he moved to Richmond, where he became affiliated with the Virginia Art Alliance and the Richmond Academy of Fine Arts. For his controversial selection as the first head of VMFA, a position he held until 1948, see "Arts Academy Group Drafts Colt Protest," *Richmond Times-Dispatch*, April 30, 1935, 10, and for the debacle's resolution, "Arts Academy Votes to Back State Museum," *Richmond Times-Dispatch*, May 8, 1935, 18. For a later overview of the consequences of this divisive episode for the city's art community, see Robert Merritt, "Museum Role Sought by Academy of Arts," *Richmond Times-Dispatch*, March 25, 1984, G-1. See also, "Thomas C. Colt Jr., 80, Dies; Led Art Museums in 3 States," *New York Times*, March 9, 1985, 16.

9. See *The Main Currents in the Development of American Painting: Inaugural Exhibition of the Virginia Museum of Fine Arts*, (January 16–March 1, 1936); VMFA history vertical files. Colt's comments are recorded in the VMFA Board minutes, 1:58. For an analysis of this New Deal spirit and the "use" value of art during the 1930s, see Emily Genauer, "New Horizons in American Art," *Parnassus* 8 (October 1936): 3–7.

10. See VMFA 1936 circular; Finley F. Ferguson, "Some Notes on the Planning and Design of the Museum," *The Four Arts* 2 (April 1935): 8; and Corinne L. Melchers, "Your Museum," *The Four Arts* 2 (April 1935): 11.

11. Foreword in *The Main Currents* in the Development of American Painting, 13–15. The Academy's 1786 building, which predated Jefferson's capitol, stood on the current site of the equally historic Monumental Church. See Thomas C. Parker, "The New Museum and the Academy," *The Four Arts* 2 (April 1935): 12–13.

12. See 1936 VMFA circular. Significantly, Fiske Kimball, before directing the Philadelphia museum, vetted the Payne collection for the Commonwealth while chairing the University of Virginia's new McIntire School of Fine Arts. See his January 15, 1920, letter to the Honorable Westmoreland Davis, Governor of Virginia, VMFA Payne vertical file. For a discussion of the inaugural exhibition's unusual formalist framework for the installation of pictures—by color and tone rather than chronology—as well as a list of the rather diverse selection of artists (the American Renaissance painter George de Forest Brush was identified as the only "living" participant) and galleries organized by stylistic themes, or "major trends"—from the "English Influence" to "The Impressionists"—see Julia Sully, "Era of Art Appreciation is Opened in Virginia: New Museum Here Has Fine Loan Collection on Public Display," *Richmond News Leader*, January 18, 1936, 9 and "State Museum Art Exhibit to Show Trend in America," *Richmond News Leader*, June 24, 1935, 10.

13. Sully; J. Winston Johns, "Relation of the Art Museum to Virginia's Material Prosperity," *The Four Arts* 2 (April 1935): 7.

14. Schrader, 4.

15. See VMFA Board Minutes, 1:255, 259, 264.

16. Pinkney Near, "European Paintings and Drawings: The Williams Collection and Fund," *Apollo* 122 (December 1985): 440–51.

17. See "Our New Director," *VMFA Bulletin* 9 (October 1948); and "New Director Selected for Art Museum," *Baltimore Sun*, January 17, 1939, 20. For a fascinating analysis of Cheek's groundbreaking initiatives at VMFA (many later adopted) by a famous future director of the National Gallery of Art, produced for a graduate "museum" seminar while still a student at New York University's Institute of Fine Arts, see J. Carter Brown, "The Virginia Museum of Fine Arts: An Essay," April 26, 1960, VMFA history vertical files. In his paper, Brown notes the overall "provincial" quality of VMFA's collections, while declaring the American section "relatively strong both in furniture and paintings, with a Gilbert Stuart *Washington* [since downgraded to a copy] and a good Sully, Eakins, Inness, rounded out with purchases of Sargent, Mary Cassatt, Stuart Davis, and Hopper" (5). Applauding Cheek's public-spirited mission, he finds the museum to have a "distinct and intriguing personality. But it is a personality not of what it *is*, but what it *does*" (2). Brown concludes his text by declaring that the "imagination and sheer vitality" with which VMFA pursues its many activities invests it with a "supra-provincial significance" (49).

18. The most important acquisition event of the decade for the museum overall was the 1970 establishment of a purchase fund for contemporary (post-1960s) American art by Richmond collectors Sydney and Frances Lewis, founders of Best Products Company. One year later, they donated additional funds for the specific purchase of a collection of European Art Nouveau decorative objects. See Frederick R. Brandt, *Late 19th and Early 20th Century Decorative Arts: The Sydney and Frances Lewis Collection in the Virginia Museum of Fine Arts*, exh. cat. (Richmond: Virginia Museum of Fine Arts, 1985).

19. The Goddin gift also included two later objects—the late-nineteenth-century Aesthetic movement–period Lejambre *Occasional Table* (see cat. no. 79) and the Colonial Revival *Fan-Back Armchair* by Wallace Nutting (see fig. 106). Whereas VMFA's founding director Colt initiated a series of "Furniture of the Week" didactic exhibitions as early as 1936, subsequent directors Cheek and Mooz developed the museum's decorative arts collection with a greater emphasis on aesthetic quality as well as historical significance. See Jay-Bee, "Queen Anne Museum Antiques," *Richmond Times-Dispatch*, November 8, 1936, Sunday Magazine Section, 7; and R. Peter Mooz and Carolyn J. Weekley, "American Furniture at the Virginia Museum of Fine Arts," *The Magazine Antiques* 113 (May 1978): 1052–63. In 1975 VMFA marked its own distinctive bicentennial effort with the acceptance

of The Oaks, an eighteenth-century Virginia plantation house. Dismantled and transported to Richmond from Amelia County, in 1927, by Lizzie Edmunds Boyd, The Oaks was bequeathed to the museum for use as the director's residence, a practice that continues today; see William M. S. Rasmussen, "Living with Antiques: The Oaks, Richmond, Virginia," *The Magazine Antiques* 113 (May 1978): 1064–69.

20. Reflecting the general European bias that the only consequential, nonderivative American art production dated from the post–World War II years, the special issue featured an essay on the Lewis Collection but made no mention of historical American work. See Frederick R. Brandt, "Building a Collection for the Twentieth Century: The Sydney and Frances Lewis Collection of Late Twentieth-Century American Art," *Apollo* 122 (December 1985): 82–85.

21. Denys Sutton, "A Centre of Civilization," *Apollo* 122 (December 1985): 7.

22. Paul N. Perrot, "Introduction," *The Magazine Antiques* 138 (August 1990): 251. In the same issue, see also William M. S. Rasmussen, "American Art to 1900," 278–93.

23. Rasmussen, now the Lora M. Robins Curator of Art at the neighboring Virginia Historical Society, oversaw a reinstallation of VMFA's American holdings in 1988. Brandt's enduring relationship with Sydney and Frances Lewis (he served as their private curator from 1980 to 1986) encouraged the couple's 1979 decision to donate to VMFA their world-renowned decorative art holdings—with special concentration in the work of Louis Comfort Tiffany, among other American and European designers—as well as selections of important postwar art. Joining forces with Paul Mellon, of Upperville, Virginia, these exceptional collectors and philanthropists funded the construction of the museum's West Wing (its fourth addition), which debuted in 1985, more than doubling the institution's size. In anticipation of the wing's opening, Mellon donated to VMFA a sizeable collection of European impressionist and modernist painting and sculpture, followed by a focused group of "sporting art," the latter which included significant American works by George Catlin, Thomas Eakins, Winslow Homer, Eastman Johnson, and Herbert Haseltine. Both the Lewis and Mellon holdings, while still housed in the West Wing for which they were intended—thus, freestanding from the broader American art collection—continue to add strength and texture to its representation at VMFA.

 Although a specialist in Old Master painting, Pinkney Near, as a "Sachs fellow"—that is, a student of Paul Sach's famous museum course at Harvard University that included an unapologetic consideration of American art—would at the time of his 1964 promotion to chief curator have been considered well prepared to oversee VMFA's small American art collection. In these years, it was not unusual for scholars to "minor" in the study of historical American art. For example, the leading Asian art specialist and esteemed museum director Sherman Lee (father of future VMFA director Katharine Lee) produced the first dissertation in American art—a 1941 study of American watercolor painting for Case Western University. Similarly, Benjamin Rowland Jr. of Harvard's Fogg Museum encouraged many young graduate students—among them Barbara Novak, Jules Prown, Theodore Stebbins, and Roger Stein—to pursue American art and cultural history, producing the first generation of serious scholars in the burgeoning field. For a discussion of Harvard's respected American civilization and museum study programs in the 1950s and 1960s, see Corn, "Coming of Age," 194. Near was also responsible for the 1974 hiring of Franklin Kelly as curatorial assistant, a position he held for roughly five years before pursuing graduate study. Kelly, currently Deputy Director and Chief Curator (formerly Senior Curator of American and British Painting) of the National Gallery of Art, credits VMFA for inspiring his future American specialization. See VMFA personnel vertical file.

24. See Ella-Prince Knox et al., *Painting in the South, 1564–1980*, exh. cat. (Richmond: Virginia Museum of Fine Arts, 1983). Exhibitions of historical American sculpture, photography, quilts, and watercolors—as well as a focused look at Winslow Homer's African American imagery and broader surveys of nineteenth- and twentieth-century African American artists—also traveled to VMFA in the 1980s. For full citations, see VMFA exhibition records.

25. For the board's increasing preference for American art, which was sometimes at odds with the museum staff's "encyclopedic" priorities—a debate that was openly and avidly covered in the local press—see Robert Merritt, "Museum Accessions Group Can't Agree on What to Buy," *Richmond Times-Dispatch*, September 19, 1985, C-6; Robert Merritt, "Group Changes Purchase Policy," *Richmond Times-Dispatch*, October 27, 1985, K-4; and Robert Merritt, "Rarity, High Prices Create Acquisition Problems," *Richmond Times-Dispatch*, October 4, 1987, J-4.

26. The Cochranes' munificence toward VMFA has also included the donation of residential and commercial real estate, the sale revenue from which continues to benefit the institution. In 2007 I was named the Louise B. and J. Harwood Cochrane Curator of American Art, an endowed position that reinforces for perpetuity a commitment to their favored collection area. Now in their mid-nineties, the couple has established a critical legacy at VMFA—from the acquisition endowment that continues to grow the American holdings to the Cochrane Atrium, a centerpiece of the museum's 2010 expansion.

27. Curry held two different positions during his long VMFA tenure—deputy director of collections (1990–93) and curator of American arts (1990–2005). For discussion of his first two bravura (in terms of beauty and price) acquisitions—both associated with the late nineteenth-century Anglo-American Aesthetic movement (Coleman's *Quince Blossoms* and a Herter Brothers ornate table [see cat. nos. 77 and 75])—see Robert Merritt, "'Time to Be Bold': Museum Clears Big Purchases," *Richmond Times-Dispatch*, March 18, 1990, C-6. See also Curry's 1993 "Collections Report: American Art to 1950," and his illustrated brochure for a novel reinstallation marketed as a special exhibition, *At Home: American Art in the Virginia Museum of Fine Arts, 1700–1950*, Summer 1991–Summer 1992, VMFA curatorial files.

28. Between 1990 and 2001, some thirty-five American pictures were rehoused in sympathetic period frames or contemporary replicas, while other original frames were conserved, thanks to the financial support of VMFA's Council, an anonymous Richmond foundation, individual patrons, and the leading American art collectors, donors, and board members James W. and Frances G. McGlothlin. See Curry, "What's in a Frame?" in *The Gilded Age: The Art of the Frame*, ed. Eli Wilner (San Francisco: Chronicle Books, 2000), 134–55. Similarly, the reupholstery of sixteen pieces of American furniture—from a mid-eighteenth-century Boston easy chair (see cat. no. 4) to early-twentieth-century side chairs by the Arts and Crafts designers Greene and Greene (see cat. no. 109)—was overseen by VMFA's Objects Conservation department working with Anne Battram, upholstery conservator at Biltmore Estate. This major undertaking was funded by the Roller-Bottimore Foundation, the Richard and Caroline T. Gwathmey Memorial Trust, and the Museum Fellows.

29. Discussing the significance of the McGlothlins' gift in relation to other leading public collections of American art located along the northeastern seaboard— from Boston to Williamsburg—VMFA director Michael Brand observed that the museum would join these institutions "at the southern end of this cultural corridor, deepening the story of American art for those wanting to experience the finest works produced by American hands and minds." See "Virginia Museum of Fine Arts Announces Landmark Gift: Major Private Collection of American Art Coming to Virginia's Flagship Fine Arts Museum," May 16, 2005, VMFA press release. See also, David Park Curry, *Capturing Beauty: American Impressionist and Realist Paintings from the McGlothlin Collection*, exh. cat. (Richmond: Virginia Museum of Fine Arts, 2005).

30. For a discussion of the increasingly global shape and profile of American art, see Veerle Thielemans, "Looking at American Art from the Outside In," *American Art* 22 (Fall 2008): 2–10. VMFA is indebted to the Henry Luce Foundation for its generous support of the 2010 reinstallation and reinterpretation project, in effect, validating the museum's efforts to make its American art collection more visible and accessible both within and beyond its campus.

Notes to the Reader

Titles of works of art are those used by the current owner and are given in English.

Secondary titles appear in parentheses.

Dates of works of art have been corroborated by inscriptions or other forms of documentation whenever possible.

All dimensions are height x width x depth.

Each essay's author is noted by initials.

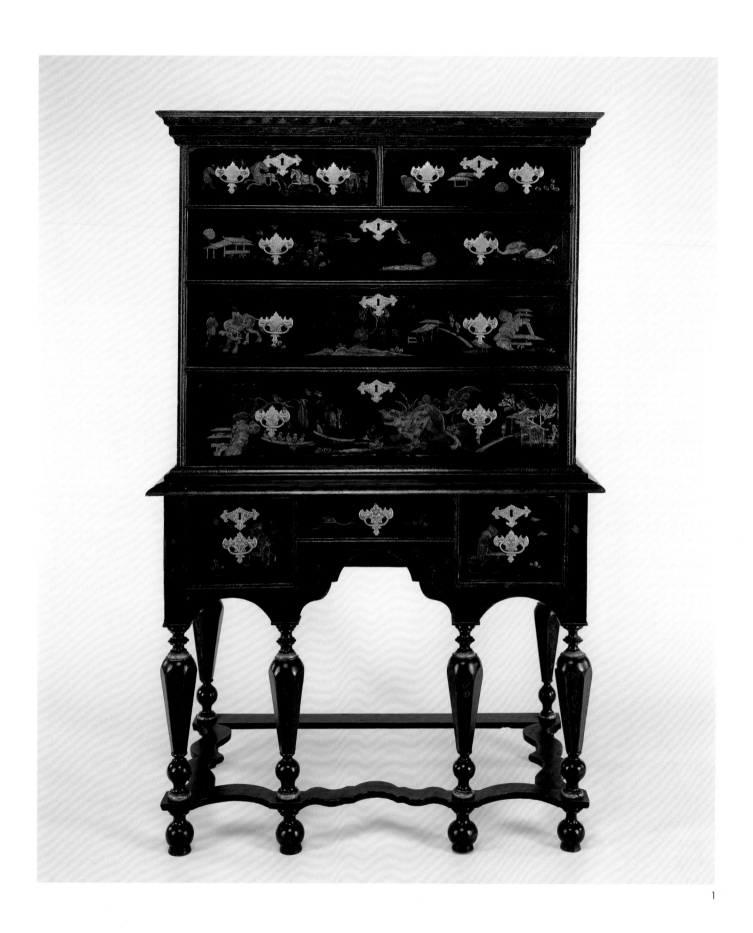

1

1. John Scottow (1701–1790), cabinetmaker
Attributed to Randle-Davis Group
(active 1720–ca. 1735), japanner

High Chest, 1720–30
Boston, Massachusetts

Maple, white pine; paint, gesso, gilt; brass pulls

Signed in black chalk on each drawer back: "Scottow"

64 1/4 x 40 1/2 x 22 1/2 in. (163.2 x 102.9 x 57.2 cm)

Museum Purchase, The Adolph D. and Wilkins C. Williams Fund,

 91.8 a–b

PROVENANCE: Cogswell Family, Mass.; Cogswell-Dixon Family, Conn.; Elizabeth Lord Cogswell Dixon; to niece Clementine Dixon Welling (ca. 1852); to daughter Elizabeth "Elsa" Dixon Welling; Nathan Liverant and Sons Antiques, Colchester, Conn.; Israel Sack, Inc., New York, N.Y.; George and Linda Kaufman Collection, Norfolk, Va. (1975–90); Israel Sack, Inc., New York, N.Y.

With its powerful stance and fanciful ornamentation, VMFA's high chest is a remarkable survivor in the well-harrowed field of early American art. Case pieces were the most delicate and perishable high-style furniture produced in America during the eighteenth century, and japanned versions were particularly vulnerable. First popular in Holland and England during the reign of Charles II (1660–85), "japanning" refers to the process by which thin sheets of gold are applied over layers of flat or modeled gesso—powdered calcium or chalk mixed with glue—atop a highly varnished, typically black-painted surface. The result is a brilliant and decorative play of contrasting tones and materials imitative of Asian lacquers.

Of the approximately forty known examples of colonial-made japanned case pieces, this is one of six high chests in the early baroque style.[1] Although uniformly treated with a dark solid or tortoiseshell ground, each chest presents a distinct combination of cornice and legs.[2] The museum's example has a standard flat top with a restrained, stepped cornice, but is distinguished by faceted legs based on imported English prototypes.[3] Two features helped contribute to its longevity. Though constructed almost entirely of pine, its drawer fronts and skirt are maple, a hard, close-grained wood particularly suited to japanning. Regional techniques also played a role.[4] Boston, where this chest was made, was colonial America's leading center for japanned work,[5] and while English artisans and their New York counterparts added a thin layer of whiting

beneath the painted, gessoed, and gilded surface, Boston japanners applied their base paints directly over the wood. Although less smooth in effect, the practice made for a more stable decoration.[6]

While underscoring England's influence on American decorative art, the VMFA chest also records the ongoing exchange between East and West. As demand for Chinese and Japanese imports exceeded supply, Western craftsmen on both sides of the Atlantic adopted imitation as a sincere—and profitable—form of flattery. Many of the gold images scattered over the chest are typical elements of chinoiserie—pavilions, willow trees, robed figures, flying birds.[7] Of particular note are the two figures tending an anemic tusked creature (fig. 17). The scene recalls an ancient Buddhist theme frequently rendered on Chinese ceramics, "Washing the Elephant," which signified

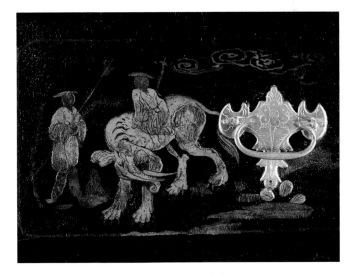

FIG. 17 "Washing the Elephant" motif. Detail of cat. no. 1.

mental disengagement (cleansing) from the material world (symbolized by the elephant). Paradoxically, among early-eighteenth-century Bostonians, no form so exuded material luxury as this intricate and costly high chest.

Like japanned case pieces, other highly accomplished objects of the colonial period obscured the distinction between "fine" and "decorative" art, as many skills that were employed in surface ornamentation were alternately applied to painting and sculpture. Colonists like Nehemiah Partridge actively engaged in both of these disciplines.[8] Two cabinets painted

FIG. 18 Attributed to Nehemiah Partridge (1683–1730), **Edward Jaquelin Jr.,** ca. 1722–1723, oil on canvas, 30 x 25 in. (76.2 x 63.5 cm). Virginia Museum of Fine Arts, Lent by the Ambler family with the permission of William F. Brodnax III, L.1.39.6.

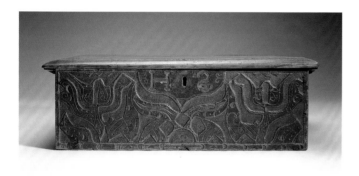

FIG. 19 Unknown artisan, **Document Box,** ca. 1685–1720, New England, oak and pine, 8 ⅛ x 26 x 15 in. (20.6 x 66 x 38.1 cm). Virginia Museum of Fine Arts, The Mary Morton Parsons Fund for American Decorative Arts, 79.145.

by Partridge display images similar to the one on the VMFA drawer front, while his virtually contemporary portrait, *Edward Jaquelin Jr.* (fig. 18), is fittingly housed in a japanned frame. Other objects in the museum's collection further highlight the interplay between art and craft. For instance, an oak and pine document box of the period, which retains traces

of original reddish brown paint on its weathered surface, boasts hand-carved tulips, a popular motif in Elizabethan England (fig. 19).[9]

In addition to representing the global influence on colonial artisans and the contemporary link between art and craft, the VMFA chest underscores the collaborative nature of early American cabinetmaking. Only five Boston japanners are known to have been active before 1730; thirty years later, there were just fourteen.[10] English-born Robert Davis arrived in Boston sometime after completing his apprenticeship about 1717 and joined in partnership with local japanner William Randle.[11] The possibility that these specialists collaborated with John Scottow, who signed the VMFA high chest, is suggested by the evidence of a late-baroque dressing table: though stripped of all japanning, its backboard is marked "Scottow W. Randle" in black paint, recording the working relationship between them.[12] DPC

NOTES

1. The colonial American early baroque style, ca. 1700–30, is also called the William and Mary style because objects produced in the colonies during this period, while dating primarily from the reign of George I (1714–27), are stylistically derived from works produced in England during the reign of William II (1689–1702) and Mary II (1689–94). Prior to the nineteenth century, western European modes tended to travel from Italy through Europe to England and, finally, to the colonies. Since master craftsmen generally practiced the styles and techniques of their apprenticeship, adopting new styles under the influence younger masters, more rural and peripheral regions like Boston were slower to transition from one trend to the next, resulting in a confusing disparity between stylistic and historical—based on monarchs or patrons—terminology.

2. The Winterthur Museum, Historic Deerfield, the Metropolitan Museum of Art, the Adams Historic National Site, and the Chipstone Foundation also have examples. Other japanned forms include dressing tables, tall clocks, and looking glasses.

3. The Warner House Association in Portsmouth, New Hampshire, owns an English gaming table with similar faceted legs, dated ca. 1700.

4. The chest still retains its original brasses; cotter pins securing the brasses to the maple drawer fronts give no sign of ever having been disturbed.

5. New York japanners have also been identified. As yet, no Philadelphia-made japanned furniture is known.

6. Nonetheless, minor repair and retouching (in-painting) have been necessary during the chest's 250-year history, most recently in 1976. Fortunately, these treatment campaigns have been sensitive. A varnish, probably applied in the nineteenth century, has helped protect the original ornament.

7. For a compendium of commonly used patterns, see John Stalker and George Parker, *A Treatise of Japanning and Varnishing* (1688; repr., London: Alec Tirani, 1971).

8. Partridge was active in Boston from 1712 until his relocation to Portsmouth, New Hampshire, in the 1720s. His painted dogs appear on japanned high chests now at the Metropolitan Museum of Art and the Chipstone Foundation.

9. Flanking initials may record the box's maker or owner. The tulips are popularly described as a "Hadley" motif. See Clair Franklin Luther, *The Hadley Chest*

2

(Hartford, Conn.: Case, Lockwood and Brainard, 1935); Dean A. Fales Jr., *The Furniture of Historic Deerfield* (New York: Dutton, 1976), 168–72.

10. Discussed by Deborah Anne Federhen, "The Adams and Cranch Family Important William and Mary Japanned High Chest of Drawers," *Important Americana: Furniture, Folk Art, and Decorations, the Case by 'Park', the Japanning Probably by Nehemiah Partridge, Boston, Massachusetts, 1712–25*, Sotheby's, New York, sale, October 15, 1999, lot 107, 97–98.

11. Randle was active from 1714 to 1735, after which Davis took over the concern following his marriage to Randle's daughter Elizabeth.

12. Bernard Levy and Dean S. Levy, "Levy and Levy," company catalogue, no. 15 (1986). The drawers may have been marked to prevent confusion. Japanners often had furniture from several different cabinetmakers on their premises simultaneously. Moveable parts like drawers could be mixed up if not identified. Federhen, 100.

2. Henrietta Dering Johnston (ca. 1674–1729)

Thomas Moore as a Child, 1725

Pastel on paper

11 5/16 x 8 5/8 in. (28.7 x 21.9 cm)

Signed in ink on original wooden backing panel: "No. 2 [1?] / Henrietta Johnston Fecit / New York, ano 1725"

Gift of The Honorable and Mrs. Alexander W. Weddell, 39.1.1

PROVENANCE: Miss M. A. Moore, New York, N.Y.; Sarah Hall, Richmond, Va. (ca. 1904); Mr. and Mrs. Alexander W. Weddell, Richmond, Va.

Aesthetic expression beyond architecture and the decorative arts came slowly to colonial America. According to William Dunlap, author of the first history of American art, European settlers needed to "grasp the axe and the plough, instead of the crayon and pencil." By 1700, however, the population of the colonies had grown to 250,000, and for some, individual prosperity allowed the acquisition of luxury goods—including paintings, drawings, and prints. Portraiture was favored above all; people of means desired images of themselves and their loved ones. And a small but growing number of artists—both native born and émigré, trained and self-taught—supplied them.[1]

Among the earliest artists was Henrietta Johnston, an Irish immigrant of French Huguenot descent who settled in South Carolina. Johnston's first husband, Robert Dering, who died young, had been a member of the British gentry. At his estate in Ireland and neighboring residences, Henrietta had the opportunity to study ancestral portraits. She began to create images of family and friends using what would remain her favorite medium—pastel, also called crayon. Later, when negotiating hardships in the New World, this pleasant hobby became a necessary livelihood.[2]

When Johnston first arrived in colonial America in 1708, she faced grim challenges. Her second husband, an Anglican clergyman, was gravely ill. And their new community of Charleston (then Charles Towne), South Carolina, was plagued by economic hardship, political discord, and Indian uprisings. To help support her husband and four children, Johnston began making portraits of the settlement's prominent citizens. Soon, local aristocrats, merchants, planters, and their families sought out the resourceful painter—destined as the first European American woman to become a professional artist. Over the next two decades, Johnston produced compelling depictions of gentlemen in cascading wigs and ladies with lace-trimmed gowns and soft eyes. In a letter to friends abroad, the Reverend Gideon Johnston confided: "Were it not for the Assistance my wife gives me by drawing . . . Pictures . . . I should not have been able to live."[3]

By the early 1720s Johnston was widowed once more. With dwindling resources, she journeyed to New York City, where she found comfort among others of French Huguenot descent and earned a livelihood producing likenesses of

FIG. 20 Attributed to Nehemiah Partridge (1683–1730), **Mary Jaquelin,** ca. 1721–23, oil on canvas, 29 x 24 3/16 in. (73.7 x 61.4 cm). Virginia Museum of Fine Arts, Gift of Alice Holliday Miller, Lucy Holliday O'Neal, and William Jaquelin Holliday, 60.40.

John Moore; his wife, Frances; and at least two of their many children. Three-year-old Thomas Moore II was the seventh of their eighteen children, five of whom, including Thomas's twin brother, did not survive infancy.[4] Johnston's 1725 pastel image of the youngster is delicate in line, color, and substance. He stands in an indefinable woodland setting, wearing a shift accented with a cloak draped over one shoulder. His large head and plump cheeks are appropriate to his age, but his bow and arrow—unlikely playthings for a toddler—were probably included to signify class and gender.[5] The child's large, liquid eyes—his true features, perhaps—are a prominent characteristic of Johnston's portraits.

Johnston renders young Thomas in a stiff, three-quarter-length pose. This conventional presentation—head and shoulders turned in different directions—appears in other contemporary portraits, including *Mary Jaquelin* by Nehemiah Partridge (fig. 20). Like other provincial limners on both sides of the Atlantic, Johnston and Partridge found a rich repertoire of poses, costumes, props, and backgrounds in British mezzotints. Book and print shops throughout the colonies sold these

engravings, which reproduced baroque portraits by such painters as Peter Lely and Godfrey Kneller.[6] As Johnston journeyed north, Partridge, a Massachusetts-born portraitist who worked primarily in the upper Hudson region, traveled south.[7] Between 1721 and 1723, he resided in the households of Edward Jaquelin and William Brodnax, leading citizens of Jamestown, Virginia. His images of young Mary Jaquelin and Edward Jaquelin (see fig. 18) are among a dozen surviving portraits from his southern sojourn.[8]

It would be another two to three decades before painting developed further in America. After 1750, a wave of European-trained artists—including John Smibert, Jeremiah Theus, and John Wollaston—arrived willing to satisfy a growing demand for portraits. By that time, they would join a generation of native-born painters—among them Benjamin West, John Singleton Copley, and Charles Willson Peale—whose careers would bridge the formation of a new nation. ELO

NOTES

1. William Dunlap, *History of the Rise and Progress of the Arts of Design in the United States* (1834; repr., New York: Dover, 1969), 1:17. For thorough considerations of colonial portraiture, see Wayne Craven, *Colonial American Portraiture* (Cambridge: Cambridge University Press, 1986) and Richard H. Saunders and Ellen G. Miles, *American Colonial Portraits, 1700–1776*, exh. cat. (Washington, D.C.: Smithsonian Institution Press for the National Portrait Gallery, 1987).

2. Whaley Batson, "Henrietta Johnston (ca. 1674–1729)," in *Henrietta Johnston, "Who greatly helped . . . by drawing pictures,"* exh. cat., ed. Forsyth Alexander (Charlotte, N.C.: Old Salem for the Museum of Early Southern Decorative Arts and the Gibbes Museum of Art, 1991), 1–7, 16; Margaret Simons Middleton, *Henrietta Johnston of Charles Town, South Carolina, America's First Pastellist* (Columbia: University of South Carolina Press, 1966), 47, 64–65. Beginning with the first scholarly consideration of Johnston by Middleton in the 1960s, art historians have credited various British painters with instructing the young artist. In her 1995 article, Martha Severens explores and then discounts the possibility of several, arriving at the convincing conclusion that Johnston taught herself by studying portraits—primarily by Kneller—at the Derings' Irish estate. See Martha R. Severens, "Who was Henrietta Johnston?," *The Magazine Antiques* 147 (November 1995): 707–8.

3. Batson, 10; Severens, 704–9.

4. Colonel John Moore, born in South Carolina, was a New York City alderman and commander of a royal militia. His wife, Frances Lambert, emigrated from France as a Huguenot refugee. The couple maintained two residences: White Hall in the city and Moore's Folly in the Hudson River Valley—later site of the U.S. Military Academy, West Point. David Moore Hall, *Six Centuries of the Moores of Fawley, Berkshire, England, and Their Descendants amid the Titled and Untitled Aristocracy of Great Britain and America* (Richmond, Va.: privately printed, 1904), 34.

5. For a discussion of children's costumes and poses in early American art, see Karen Calvert, "Children in American Family Portraiture, 1670–1810," *William and Mary Quarterly* 39 (January 1982): 87–113. Other colonial paintings depicting children with bows and arrows include John Smibert, *James Bowdoin II*, 1736 (Bowdoin College Museum of Art) and Justus Engelhardt Kühn, *Henry Darnall III,*

1710 (Maryland Historical Society). The convention is also seen in a seventeenth-century portrait by an unknown English painter, purported to depict *William Byrd I as a Young Boy* (VMFA, acc. no. 56.30). The sitter Thomas Moore II would in fact attain adulthood. An aged but "uncompromising Tory" during the American Revolution, he lived to see one son serve as a captain in the Royal Navy and a son-in-law as a captain in the Continental army. Another son, Richard Channing Moore, would serve as bishop of the Episcopal Diocese of Virginia and rector of Richmond's Monumental Church, 1814–41.

6. The reliance of colonial artists on English mezzotints is examined in Waldron Phoenix Belknap Jr., *American Colonial Painting: Materials for a History* (Cambridge, Mass.: Belknap Press of Harvard University, 1959).

7. For decades, art scholars referred to Partridge as the "Aetatis Suae Limner" from his use of these Latin words to indicate the age of subjects on the backs of his canvases. His identity—revealed in a 1718 day book entry by one of his sitters—was discovered and published by Mary Black in "Contributions Toward a History of Early Eighteenth-Century New York Portraiture: Identification of the Aetatis Suae and Wendell Limners," *American Art Journal* 12 (Autumn 1980): 4–31.

8. Eleven additional portraits of Brodnax and Jaquelin family members have been lent by descendants to VMFA since 1939. See also Black, "The Case of the Red and Green Birds," *Arts in Virginia* 3 (Winter 1963): 2–9.

3. Benjamin West (1738–1820)

Caesar Reading the History of Alexander's Exploits, 1769

Oil on canvas

37 x 39 ¼ in. (94 x 99.7 cm)

Signed lower left: "B West / pinxit / 1769"

Museum Purchase, The Adolph D. and Wilkins C. Williams Fund, 64.23

PROVENANCE: Painted for General Giles Stibbert, London; returned to the artist (by 1811); sold by artist's sons to Robins, London (May 22–25, 1829, lot no. 1), bought by Hopkinson; Mortimer Brandt, New York, N.Y.

Highly classical in form and content, Benjamin West's painting *Caesar Reading the History of Alexander's Exploits* perfectly suited the cultural ambitions and tastes of the artist's era. West depicted a scene described by the first-century historian Plutarch in which Julius Caesar is moved to tears after reading an account of Alexander the Great. "Do you think," he asks his friends, "I have not just cause to weep, when I consider that Alexander at my age had conquered so many nations, and I have all this time done nothing that is memorable?" The Roman general then redoubled his political and military efforts, setting himself on the path to ultimate power as dictator.[1]

Just as his subject looked to the past for instruction and inspiration, Benjamin West, and other late-eighteenth-century

3

painters in the Anglo-American art world, sought models in earlier artistic traditions. In his *Discourses on Art,* West's English contemporary and friend Sir Joshua Reynolds urged fellow artists to turn to mythological and historical events of antiquity for subject matter. Reynolds also praised the beauty and simplicity of ancient Greek and Roman styles—an appreciation clearly shared by West.[2] For *Caesar Reading,* West created a friezelike composition in which muted colors help to emphasize the sculptural quality of the figures. The shallow space is anchored at center with a hefty filleted column.[3]

British general Giles Stibbert commissioned West to paint this historical vignette in 1769.[4] Three years later, he requested a second painting, *Alexander's Confidence in His Physician Philip*—a scene also taken from Plutarch.[5] Whether West or his patron suggested the themes for the pair of canvases, Stibbert likely admired these tenacious and ambitious generals. In the following decade, he served as commander-in-chief of the East India Company in Bengal and was subsequently appointed British governor of that region.[6]

Benjamin West's career was no less meteoric. By the time he portrayed the regretful Caesar, he had already gained favor with England's King George III for similar depictions of ancient history. The achievement was especially remarkable for a colonial painter who began his career as a self-taught artist in rural Pennsylvania. Wealthy Philadelphia patrons funded the young artist's travel to Italy, where he honed his skills by sketching and painting antiquities. Among the ruins of Rome, West studied with German painter Anton Raphael Mengs. Italy's newly excavated treasures of ancient Herculaneum and Pompeii further stimulated his interests, positioning him at the forefront of a nascent neoclassical movement in Europe.

Relocating to London in 1763, where he would remain for the rest of his life, West found his way into the circle of England's foremost artists and scholars. In short time, he was a founding member of the Royal Academy alongside Reynolds and succeeded him as the institution's second president. While West continued to paint portraits, his fame and fortune rested upon his grand-manner depictions of biblical, literary, mythological, and historical subjects. The latter brought him the most notoriety; George III named him "History Painter to the King" in 1772.[7]

FIG. 21 Benjamin West (1738–1820), **Three Ladies Making Music,** 1798, oil on canvas, 14 ½ x 18 ⅝ in. (36.83 x 47.3 cm). Virginia Museum of Fine Arts, The J. Harwood and Louise B. Cochrane Fund for American Art, 2007.18.

On rare occasions the artist also produced genre scenes, including the elegant *Three Ladies Making Music* of 1798 (fig. 21). Intimate in scale, it pictures three idealized female musicians gathered in a fashionable neoclassical interior. Their simplified linear forms suggest the artist's interest in the recently published illustrations of John Flaxman, whose attenuated figures were further popularized as motifs on the ceramic jasperware of Josiah Wedgwood (see fig. 35).[8]

The first American artist to gain international attention, West still made time for his young countrymen even as he was building his enviable reputation. Extending hospitality of his home and studio, he served as a teacher, mentor, and father figure to three generations of protégés, including many future luminaries of the budding republic such as John Singleton Copley, Samuel F. B. Morse, Charles Willson Peale, Rembrandt Peale, Thomas Sully, John Trumbull, and Gilbert Stuart. Stuart, who was generally known for his irascibility, lovingly described his teacher as "the wisest man" he had ever known.[9] ELO

NOTES

1. Plutarch, "The Life of Caesar," in *The Lives of the Noble Grecians and Romans,* Dryden Translation (Franklin Center, Pa.: Franklin Library, 1981), 3:231.

2. Sir Joshua Reynolds, "Discourse III" and "Discourse IV" in *Discourses on Art,* ed. Robert R. Wark (San Marino, Calif.: Huntington Library, 1959), 49, 58.

3. The painting was reduced in size sometime after 1811. In that year, Henry Moses

produced an outline engraving included in *The Gallery of Pictures Painted by Benjamin West* (plate 8), which shows that the image extended on either side. See Helmut von Erffa and Allen Staley, *The Paintings of Benjamin West* (New Haven and London: Yale University Press, 1986), 177.

4. Close to the same time, West was painting what would become his most famous work, *The Death of General Wolfe*, 1771 (National Gallery of Canada), controversial because of its nontraditional depiction of a general in modern military costume. See Barbara J. Mitnick, "The History of History Painting," in *Picturing History: American Painting, 1770–1930*, exh. cat., ed. William Ayers (New York: Rizzoli and Fraunces Tavern Museum, 1993), 29–30.

5. Painted ca. 1771, this second canvas is presently in the collection of the Wellcome Institute for the History of Medicine, London. Following Stibbert's death in 1809, West managed to gain possession of the pair of paintings once again and exhibited them at the 1819 Royal Academy exhibit. See von Erffa and Staley, 166–67, 176–77.

6. Ibid., 167. In the late nineteenth century, Stibbert's grandson, Frederick, founded a museum of military armor and weaponry. Museo Stibbert, located in Florence, Italy, at the Villa di Montughi, is still open today.

7. For surveys of the artist's life and milieu, see von Erffa and Staley and Richard Hirsch, *The World of Benjamin West* (Allentown, Pa.: Allentown Art Museum, 1962).

8. In their 1986 catalogue raisonné, von Erffa and Staley, record eighteen genre paintings, of which only eight had been located, 414–23, cat. nos. 440–57. West turned to genre subjects in earnest beginning in 1793, the same year that Flaxman published his extremely linear engraved illustrations for Homer's *Odyssey*. Von Erffa and Staley, 113; Albert Boime, *Art in an Age of Revolution, 1750–1800* (Chicago and London: University of Chicago Press, 1987), 370–82.

9. For an examination of West's influence, see Dorinda Evans, *Benjamin West and His American Students*, exh. cat. (Washington, D.C.: Smithsonian Institution Press for the National Portrait Gallery, 1980); Stuart quote cited, 21.

4. Unknown Artisan

Easy Chair, ca. 1740–50

Massachusetts, probably Boston

Mahogany; maple, white pine (secondary wood); reproduction wool
 moreen upholstery (stamped "Aberton" pattern)

47 x 36 x 30 in. (119.4 x 91.4 x 76.2 cm)

Museum Purchase, The Adolph D. and Wilkins C. Williams Fund,
 76.42.24

PROVENANCE: Brooks Marsh, New York, N.Y.

Easy chairs—often described today as wing chairs—were initially designed for the aged and infirm. The chair's high, sloping back, enclosed sides, and distinctive serpentine wings shielded the sitter from cold drafts; ample padding, including a down-filled cushion, offered more comfort than the straight backs and hard seats of traditional chairs. Sometimes outfitted with a "close stool" for the feet or a hidden chamber pot,

easy chairs were often positioned near the fireplace in the bedchamber—the "sitting room" in European and colonial American households. Not surprisingly, they became one of the most popular seating forms. Because of the heavy investment in upholstery, however, they would also remain among the most costly.[1]

Function and utility did not necessarily preclude beauty—as exhibited by the Massachusetts-made Queen Anne easy chair in the VMFA collection. Its frame displays the characteristic lines and proportions favored by Boston craftsmen in the mid-eighteenth century. The crest rail arches gently, the seat frame has rounded front corners, and the cone-shaped arm supports open outward to accommodate a capacious seat. The exposed wood is mahogany: cabriole front legs ending in pad feet, a block-and-spindle stretcher, and chamfered square rear legs.[2]

The making of such a substantial chair fell to various craftsmen. Cabinetmakers produced wood frames in only a handful of shops in the Boston area; upholsterers, on the other hand, numbered over forty in that colonial city. These specialists, who also made draperies for beds and windows, would acquire a chair frame and then cover it to suit a client's wishes. Expensive imported fabric—typically English worsteds such as cheney, harrateen, and moreen—made up the largest part of the price of an easy chair. Although owners usually protected the upholstery with slipcovers, it was not unusual for a chair to be recovered two to three times.[3]

The original covering for the museum's easy chair has long disappeared; nail-hole patterns in the frame give evidence that previous owners had reupholstered it more than once. A new show cover was produced in 2000 based upon study of a related chair at the Brooklyn Museum of Art—the only known eighteenth-century Boston easy chair with original upholstery. The current fabric is a wool moreen reproduced from surviving bed hangings dated 1770, now preserved in the Peabody Essex Museum, in Salem, Massachusetts. Wool moreen, watered and embossed with a pattern, produced a sheen that is enhanced by firelight and candlelight—a valued effect in the eighteenth century.[4] To replicate the distinctive "Aberton" design, the present fabric was hand woven in Scotland, moreened in Ireland, and stamped with a floral pattern in France. The cording tape outlining the chair was woven

and dyed separately—silk diamonds upon a wool ground—replicating the Brooklyn chair's original trim. The VMFA Objects Conservation Department attached the new upholstery using current, noninvasive techniques to protect the now-fragile original frame.[5] ELO

NOTES

1. Elisabeth Donaghy Garrett, *At Home: The American Family, 1750–1870* (New York: Abrams, 1990), 124; Patricia E. Kane, *300 Years of American Seating Furniture* (Boston: New York Graphic Society, 1976), 227. For an examination of this seating form, see Morrison H. Heckscher, *In Quest of Comfort: The Easy Chair in America*, exh. cat. (New York: Metropolitan Museum of Art, 1971).

2. Benno M. Forman, *American Seating Furniture, 1630–1730: An Interpretive*

4

Catalogue (New York and London: Norton and Winterthur Museum, 1988), 358; Brock W. Jobe, "The Boston Upholstery Trade, 1700–1775," in *Upholstery in America and Europe,* ed. Edward S. Cooke (New York: Norton, 1987), 65.

3. Jobe, 65; Garrett, 124.

4. Garret, 112. The Peabody Essex bed hangings were woven on the occasion of the marriage of Daniel and Sarah Peele Saunders of Salem, Massachusetts. A portion is pictured in color, plate 5, in Anne Farnam, "Household Textiles in the Essex Institute, Salem, Massachusetts," *The Magazine Antiques* 127 (April 1985): 889.

5. Treatment file, VMFA Objects Conservation Department.

5. John Singleton Copley (1738–1815)

Mrs. Isaac Royall (Elizabeth Mackintosh),

ca. 1767–69 and ca. 1777–78

Oil on canvas

50 x 40 in. (127 x 101.6 cm)

Gift of Mrs. Adolph D. Williams, 49.11.2

PROVENANCE: Isaac Royall; to grandson William Pepperell; to sister Harriet Pepperell Hudson, later Palmer (Lady Charles Palmer), Wanlip Hall, Leicestershire, England; to son George Joseph Palmer, 3rd Bart.; to son Sir Archdale Robert Palmer, 4th Bart.; to wife Lady Augusta Shirley Palmer; Booth Tarkington, Kennebunkport, Maine (1937); Newhouse Gallery, New York, N.Y.; Mrs. A.D. Williams, Richmond, Va. (1949)

John Singleton Copley's ability to capture a realistic likeness raised American portraiture to new heights, but commissioned portraits have always involved a negotiated compromise between artist and patron. This image of a prominent colonial American wife and mother is unusual in combining the artist's elaborate English and simpler American styles on a single canvas. The face and forearms of the portrait, *Mrs. Isaac Royall,* were done in Boston about 1769. However, the subject died the following year, and Copley painted much of the picture after both he and Isaac Royall had departed Massachusetts by 1775 at the outbreak of the Revolutionary War.[1]

Isaac Royall's patronage of Copley was enabled by an inheritance from his father, Isaac Royall Sr., a West Indies trader who had made a fortune in Antigua. Until he relocated to England, the younger Royall and his family lived regally in Medford, Massachusetts, on an estate overlooking the Mystic River. His imposing mansion, which his father had purchased in 1732, was deemed "one of the grandest in North America."[2] Royall made improvements to the property and staffed it with an unusually large number of slaves for New England. The establishment flourished.[3]

Mrs. Royall, born Elizabeth Mackintosh, also held properties abroad. Eventually she bequeathed to her husband and children a plantation called Fairfield in Surinam, Dutch Guiana (now Suriname, South America).[4] She had inherited the land from her grandfather, Colonel Henry Mackintosh, who was a dealer in mahogany, a prime wood much desired for fine furniture.[5]

In an ambitious group portrait painted by Robert Feke in 1741, nineteen-year-old Elizabeth Royall is seated next to her husband. She holds the first of their four daughters (fig. 22).[6]

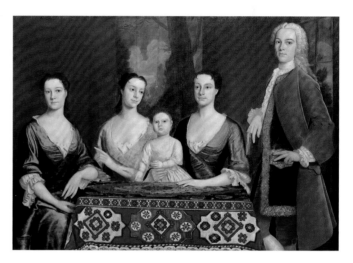

FIG. 22 Robert Feke (1707–1752), **Isaac Royall and Family,** 1741, oil on canvas, 56 3/16 x 77 3/4 in. (142.7 x 197.5 cm). Gift of Dr. George Stevens Jones, March 31, 1879. Courtesy of Special Collections Department, Harvard Law School Library.

A quarter of a century later, about 1769, she and her husband sat to Copley, who by then had supplanted Feke as the most accomplished portraitist working in New England and had pretensions to the life of a gentleman along the lines enjoyed by the Royall family, among others. The younger Isaac Royall was noted for lavish entertainments, a taste for fine wines, and a flamboyant chariot he liked to ride down Massachusetts country lanes.[7] Yet Copley presented his patron as a sober man of affairs, holding a packet of letters and gesturing toward scattered documents (fig. 23).

Details of the original image of Elizabeth Royall, including her cap, white cuffs, pearl bracelet, and a bit of her hair, were painted over at her widower's request.[8] While the jewelry was suppressed, an updated, more elaborate cap was added.

5

FIG. 23　John Singleton Copley (1738–1815), **Isaac Royall**, 1769, oil on canvas, 50 x 40 in. (127 x 101.6 cm). Museum of Fine Arts, Boston, The M. and M. Karolik Collection of Eighteenth-Century American Arts, 39.247.

FIG. 24　John Singleton Copley (1738–1815), **Portrait of a Lady (Mrs. Seymour Fort),** ca. 1780, oil on canvas, 49 ½ x 39 ⅝ in. (125.7 x 151.6 cm). Wadsworth Atheneum, Hartford, Connecticut, Gallery Fund, 1901.34.

Elizabeth Royall's refurbished costume comes close to another Copley portrait, once thought to be of Mrs. Seymour Fort, painted in England about 1778 (fig. 24).

In altering the picture, Copley partially filled the previously empty space above the subject's head. The loss of this "head room," characteristic of Copley's portraits, left Elizabeth Royall looking somewhat cramped, an impression intensified by a solid, straight-edged frame. Added later to the picture, the neoclassical frame further compressed the image, making it seem trapped and heavy. The present reproduction frame replicates a light, rococo style frequently used on Copley's colonial American portraits.[9] Pierced carving allows the image to "breathe," echoing the lacy details of the sitter's clothes and bonnet. More somber than what was first envisioned, the twice-painted, reframed portrait of Elizabeth Royall lets viewers ponder the meanings of "realistic" and "original."

DPC

NOTES

1. Carrie Rebora et al., "Chronology," in *John Singleton Copley in America* (New York: Metropolitan Museum of Art, 1995), 326. Copley left Boston in June 1774; his family joined him in England the following year. While sympathetic to the American patriots, Royall had family and business ties that kept him loyal to the British king. In 1775, only three days before the battle of Lexington, he fled to England via Halifax, Nova Scotia.

2. "Journal of Captain Francis Goelet (1747–1754)," *New England Historical and Genealogical Register,* 24 (1870): 58.

3. The elder Isaac asked that his twenty-seven slaves be tax exempt since they would not be resold but were to remain with the Royall family. James H. Stark, *The Loyalists of Massachusetts and the Other Side of the American Revolution* (Clifton, N.J.: Augustus M. Kelly, 1972), 290.

4. The will was drawn in 1754 when Elizabeth was in her thirties. Born September 22, 1722, to Laughlan and Elizabeth Mackintosh of Bristol, Rhode Island, she married in 1737. She died July 14, 1770, and is buried in the Royall family vault at Upham's Corner, Dorchester, Massachusetts.

5. Will of Mary Mackintosh Royall Erving, Mrs. Royall's daughter, proved 1785, in Barbara Neville Parker and Anne Bolling Wheeler, *John Singleton Copley: American Portraits in Oil, Pastel, and Miniature, with Biographical Sketches* (Boston: Museum of Fine Arts, Boston, 1938), 168. See also Miriam A. Barclay, "Elizabeth McIntosh Royall, Wife of Isaac Royall, Jr.," *Royall House Reporter* 4 (July 1964): n.p.

6. This child, Elizabeth, died in infancy. The Royalls named their third daughter Elizabeth after the earlier baby. She married Sir William Pepperell, but she too died before Copley included her posthumously in the group portrait, *Sir William Pepperell and His Family,* 1778 (North Carolina Museum of Art).

7. After Royall left the country, his Medford estate was seized by the Continental government. In 1805 it was returned to family descendants in recognition of the Royall family's generous public bequests. Stark, 292–93.

8. These changes are evident from X-ray examinations. The English portion of the picture dates stylistically from the early years of Copley's English career, perhaps from 1778, according to Copley scholar Jules Prown. See Prown, *John Singleton Copley* (Cambridge, Mass.: Harvard University Press, 1966), 2:266–67, and

letter, VMFA curatorial files. The VMFA Painting Conservation Department has made subsequent examinations.

9. The replica frame, a gift of James and Frances McGlothlin, was carved by Felix Teran and gilded by Jose Perez at Eli Wilner and Company in New York. It is modeled on a frame carved by John Welch, original to Copley's *Mrs. Isaac Smith* (1769, Yale University Art Gallery).

6. Unknown Artisan

Compass-Seat Side Chair, ca. 1750

Philadelphia, Pennsylvania

Walnut; pine (secondary wood); original horse hair, natural fiber
 webbing, muslin under-upholstery; documented wool and silk
 reproduction needlework seat cover

Marks: "II" (frame); "VI" (seat)

42 ½ x 20 ½ x 22 ½ in. (107.9 x 52.1 x 57.2 cm)

Museum Purchase, The Floyd D. and Anne C. Gottwald Fund, 1998.21

PROVENANCE: Thomas Graeme (d. 1772); to daughter Elizabeth Graeme Ferguson (until 1797); to nephew Dr. William Smith (until 1801); to Samuel Penrose; to Hannah Penrose and Isaac Worstall Hicks (1857); to daughter Sarah Hicks; to granddaughter Hannah Hicks Lee; to great-granddaughter Eleanor Lee Schwartz; Leigh Keno, New York, N.Y. (1998)

When English painter and engraver William Hogarth declared that a flowing S curve—the "line of beauty"—was the essence of aesthetic perfection, he identified a design principle that influenced all branches of British and American decorative art during the mid-eighteenth century.[1] This Philadelphia Queen Anne side chair is a supreme expression of Hogarth's ideal line. Beautiful proportions, a sculptural use of positive and negative space, and elegant simplicity result in a harmonious unity founded upon graceful curves. Much of this success turns on its masterful construction.

Elaborately rounded shapes like the compass seat—also called a "balloon" or "horseshoe" seat—required complex joinery between seat and legs, notably in the form of integrated tenons. For example, to reinforce the seat, the straight inner edges of the front legs continue as dowels through the front rail. The curves in the stiles as well as the backward thrust of the chamfered rear legs depend upon these and other techniques for their dramatic sculptural appearance.[2]

In addition to its sophisticated joinery, the chair boasts accomplished carving. Sometimes called a "crook back" or "spoon back" (or, in England, a "bent back"), the chair's

6

serpentine back splat is one of its most seductive features.[3] The splat is framed by dramatically curved stiles and a scrolled crest rail. Like a delicate ribbon, a beaded molding unfurls from the volutes flanking the crest rail and follows the stiles all the way down to the rear seat rail to emphasize further this graceful set of curves. Using an unusually thick piece of figured wood, the craftsman was able to shape the splat in multiple dimensions and embellish it with additional volutes that correspond to those on the crest rail. A handsome shell on the crest is carved from the solid block, as are slightly simpler corresponding shells on the knees below. Like the trifid (three-toed) feet, these details were expensive trimmings on the

standard issue. As Hogarth put it, the serpentine "leads the eye on a wanton kind of chase, and from the pleasure that gives to the mind, entitles it to the name of beautiful."[4]

Ultimately, the dramatic sculptural appearance of this chair reflects the rare skills of Philadelphia craftsmen, who according to scholars and collectors produced the most integrated and sculptural expression of the Queen Anne aesthetic. Once part of a set that furnished Graeme Park, a house erected about 1722 in Horsham, Pennsylvania, the VMFA chair is one of four known to have survived: the other three are at Colonial Williamsburg; Greenfield Village, Michigan; and in a New York private collection.[5] Set against a mellow old finish and covering original stuffing, the exuberant needlework, copied from an original example on the Williamsburg chair, demonstrates eighteenth-century householders' appreciation of bold colors as well as elegant form. DPC

NOTES

1. See William Hogarth, *Analysis of Beauty* (London: J. Reeves, 1753).
2. For a Chippendale-style chair with a similar construction, see Sotheby's, New York, sale, June 17–18, 1997, lot 771.
3. The design owes something to Asia, where gracefully curved chair backs were popular during the Ming dynasty (1368–1644). Woodblock prints and decorative painting likely carried the design to the West. This is suggested by seventeenth-century blue-and-white K'ang-Tsi porcelains, which were popular with Western collectors by the late 1600s. Nicholas Grindley, *The Bended Back Chair*, exh. cat. (London: Barling, 1990).
4. Hogarth, 25.
5. Originally known as Fountain Low, Graeme Park was built for Sir William Keith, governor of Pennsylvania from 1717 to 1726, and later purchased by Mrs. Keith's son-in-law, Dr. Thomas Graeme. Having totally transformed the interior with richly paneled partitions and large fireplaces, Graeme renamed the house after his own family. This chair was made shortly thereafter. Marks on the slip seats and frames indicate that the original set numbered at least eight. As the VMFA chair suggests, such elements are often mixed up over time when a set goes out for new show covers. A related chair is in the collection of the Metropolitan Museum. See G. E. Kidder Smith, *The Architecture of the United States*, vol. 1, *New England and the Mid-Atlantic States* (Garden City, N.Y.: Anchor Press, 1981), no. 13, and Morrison Heckscher, *American Furniture in the Metropolitan Museum of Art*, vol. 2, *Late Colonial Period* (New York: Metropolitan Museum of Art, 1985), no. 38, 82–84.

7. Unknown Artisan

High Chest of Drawers, ca. 1745–50

Philadelphia, Pennsylvania
Mahogany, yellow pine, poplar; brass pulls
95 x 43 x 24 in. (241.3 x 109.2 x 61 cm)
Museum Purchase, The Adolph D. and Wilkins C. Williams Fund,
 2000.2a–b

PROVENANCE: Henry Ford; Henry Ford Museum, Dearborn, Mich. (by the early 1940s); sold at auction by Sotheby's, New York, N.Y. (October 15, 1999, sale no. 7350, lot no. 19); Leigh Keno, New York, N.Y.

By the time automobile tycoon Henry Ford collected this bonnet-top high chest of drawers in the early twentieth century, it had become the form most readily associated with American furniture of the colonial period. Originally used in bedchambers, such monumental storage pieces often grace living rooms today. The sculptural power of this example makes it suitable for a fine arts gallery as well.

First seen in England, the high chest of drawers (also known as chest on frame or chest on stand) was introduced by the 1690s to America, where it remained popular long after the roomier chest on chest supplanted it in the British market. The high chest of drawers reached its fullest development in mid-eighteenth-century Philadelphia, the city that was most influential in shaping the artistic culture of the colonies surrounding the upper Chesapeake Bay and the southern backcountry.[1] Offering an authoritative statement of Philadelphia's early rococo aesthetics, VMFA's high chest belongs to a recognized group of furniture made by a small circle of important cabinetmakers and carvers.[2] Their work, while not yet fully sorted out, reveals a remarkable degree of continuity, both in stylistic relationships and construction details.[3]

Because of its artistic ornamentation, this beautifully proportioned chest was the most expensive of its type available during the colonial period. It is easy to forget that a cabinetmaker designed it to provide functional storage space. The pediment top, tall cabriole legs, and scalloped skirt all offer grounds for elaborate shaping and carving. The patron would have paid for each added decorative element. Unlike most bespoke (custom-made) chests, this one features carving on both the front and rear legs, an extravagant design option.

FIG. 25 Detail of cat. no. 7.

The client also chose figured mahogany, a costly imported wood, rather than a cheaper local material such as walnut.[4]

The provenance of this piece is an eloquent testament to the history of twentieth-century patronage. The American industrialist Ford, who established the Henry Ford Museum and Greenfield Village at Dearborn, Michigan, in 1929, probably acquired the chest himself—perhaps in the late 1920s or early 1930s.[5] Ford's determination to take "Americana in quantity to the Middle West" put him in direct competition with a few other well-heeled, public-spirited collectors, notably John D. Rockefeller Jr., who founded Colonial Williamsburg in 1926, and Henry Francis du Pont, who launched the Winterthur Museum in Delaware in 1930. Additional competitors whose collections eventually enriched museums include Francis and Mabel Brady Garvan (Yale University Art Gallery) and Ima Hogg (Bayou Bend, Museum of Fine Arts, Houston).[6]

When the Henry Ford Museum decided to deaccession this chest to avoid redundancy in its collections, its facade was marred by the later addition of overly elaborate foliage crowding the original shell carvings. Such "improvements" to an early piece of furniture during the peak of the Colonial Revival (1876–1930) were not unusual. Unsuitable elaboration ordinarily represents an attempt to make the piece more desirable—the Colonial Revival was marked by efforts to aggrandize American heritage.[7] In Ford's day, the added leaves still looked appropriate, but they could not withstand scrutiny after a half century of developing scholarship.

Fortunately, this problem was reversible; old finish surviving beneath the added carvings bore marks that allowed a conservator to replace the later additions with appropriate decoration (fig. 25).

The cabinet's various design elements combine into a unified vertical thrust, so prized that cabinetmakers charged extra for creating works over a certain height. The gracefully curved legs—each with a knuckled webbed foot and bold acanthus leaf–carved knee—lift the massive body of the chest upward. Fluted chamfered edges bracketing the drawers further emphasize upward motion, as does placement of the brass drawer handles, which are close together at the center and more widely spaced to flare out again on the upper drawers. Deeply carved shells, with distinctive convex and concave lobes, ornament the chest's skirt and top drawer. A splendid bonnet with a strong swan-neck pediment embellished with flower heads maintains the vertical emphasis, while three vigorously carved urn finials suggest infinite movement carried ever higher in graceful swirls of smoke. DPC

NOTES

1. Luke Beckerdite, "Identity Crisis: Philadelphia and Baltimore Furniture Styles of the Mid-Eighteenth Century," in Catherine Hutchins, *Shaping a National Culture: The Philadelphia Experience, 1750–1800* (Winterthur, Del.: Winterthur Museum, 1994), 243–81.

2. Beckerdite, "A Problem of Identification: Philadelphia and Baltimore Furniture Styles in the Eighteenth Century," *Journal of Early Southern Decorative Arts 7* (May 1986): 21–65. These pieces were attributed to Maryland cabinetmakers until the 1980s, when their regional characteristics were conclusively linked to Philadelphia.

3. Fourteen interrelated case pieces have been identified so far. They include the Henry Clifton high chest, now in the Colonial Williamsburg collection. It is the only known instance of a rococo-style high chest inscribed and dated (1753) by a cabinetmaker. See Morrison H. Heckscher and Leslie Greene Bowman, *American Rococo, 1750–1775: Elegance in Ornament* (New York: Metropolitan Museum of Art, 1992), fig. 47. A very closely related high chest and dressing table are owned by the Winterthur Museum. Other related pieces are in the Maryland Historical Society, the Kaufman Americana Foundation, and private collections.

4. William MacPherson Horner Jr., *Blue Book of Philadelphia Furniture, William Penn to George Washington* (1935; repr., Washington, D.C.: Highland House, 1977), 110.

5. While records from the early days of the Henry Ford Museum are sadly sparse, the high chest is known to have been in the collection by the early 1940s. Author's conversations with Judith Endelman, director of curatorial resources, and Henry Prebis, decorative arts curator, Henry Ford Museum, Greenfield Village, January 21, 2000.

6. See Marian S. Carson, Preface in Horner, xviii–xix.

7. Recent studies include Alan Axelrod, ed., *The Colonial Revival in America* (New York: Norton, 1985) and William H. Truettner and Roger B. Stein, eds., *Picturing Old New England: Image and Memory* (New Haven: Yale University Press, 1999).

8. Goddard and Townsend Group

(active late 1730s–late 1770s)

Bureau Table, ca. 1765–70

Newport, Rhode Island

Mahogany, white pine, birch, chestnut; original brass pulls

33 x 36 x 20 ¾ in. (83.8 x 91.4 x 52.7 cm)

Gift of Floyd D. and Anne C. Gottwald, 2002.559

PROVENANCE: George Munson Curtis, Meridan, Conn. (until 1915); Curtis descendants (1915–48); Parke-Bernet, New York, N.Y. (1948); Israel Sack, Inc., New York, N.Y.; Mrs. Thomas Wilson (1953); Robert Crawford, Richmond, Va.; Mr. and Mrs. Floyd D. Gottwald Sr., Richmond, Va.

Newport bureau tables—with their distinctive shell-carved block-front design—have long been celebrated as exceptional achievements in colonial American furniture.[1] This elegant bureau table in the VMFA collection is one of approximately fifty examples that have survived the past two and a half centuries. While unsigned, the Chippendale-style case piece exhibits the highly sculptural characteristics of the Goddard and Townsend group of Newport, Rhode Island.

A specialty form developed in England after 1700, the bureau table became fashionable on both sides of the Atlantic as a bedchamber furnishing. A chest of drawers with a double-pedestal base, two stacked columns of small drawers, a long top drawer, and a central niche, it functioned variously as writing surface, dressing table, and safe. The many drawers, each fitted with its own lock, held valuable papers, articles of clothing, jewelry, and toiletries. The distinctive "kneehole"—a recessed cupboard at center—could be tall enough to house a wig and wig stand or be fitted with shelves. After 1730, New England cabinetmakers introduced block-front ornamentation to case pieces, dividing the facade into three vertical panels, the central one concave and the flanking outside panels convex.[2] Such rounded blocking on a fine Boston-made bureau table from midcentury (fig. 26) softens its compact and otherwise rigid composition. The bureau's molded top edges conform to the serpentine contours. The elegantly executed form of a fall-front desk—made about 1793 and attributed to William Seay of Bertie County, North Carolina (fig. 27)—gives evidence of the skillful adaptation of the block-front mode in the southern American colonies.[3]

It was in Newport that block-front ornamentation took on its most elaborate form. A large extended family of entrepreneurial cabinetmakers—headed up by brothers Job and Christopher Townsend, their respective sons Job Jr. and John, and Job's son-in-law, John Goddard—introduced deeply carved shells, either applied or hewn, to the top of the projecting or receding blocking. The resulting effect is architectural: projecting panels rise columnlike, topped with carved ornamental "capitals" to support tops with precise moldings. The Goddard and Townsend aesthetic is manifest in the VMFA bureau table. Symmetrically proportioned and crafted primarily of dense figured mahogany, it features a wonderfully undulant block-and-shell surface that extends down into ogee-bracket feet. Projecting panels are crowned on the upper drawer with wide, fanlike shells made up of alternating lobes and fillets. At center, a relief-carved concave shell echoes its neighbors. Eight original brass pulls punctuate the surface. The deeply recessed central niche conceals a compartment with two shelves.

The Goddards and Townsends—and their many artisan associates linked by birth or marriage—refined their style in the 1740s. Successfully dominating Newport's cabinet trade in a competitive marketplace, they found little need to alter their characteristic designs over the next forty years. Beyond commissioned work in the immediate Newport region, they

8

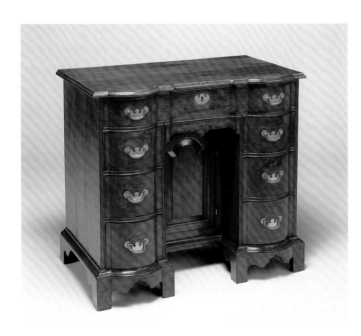

FIG. 26 Unknown artisan, **Bureau Table,** Massachusetts, ca. 1740–65, mahogany, pine, 30 x 33 ¾ x 19 ¾ in. (76.2 x 85.7 x 50.2 cm). Virginia Museum of Fine Arts, The Adolph D. and Wilkins C. Williams Fund, 76.42.8.

FIG. 27 Attributed to William Seay (ca. 1750–ca. 1815), **Block-Front Desk,** North Carolina, ca. 1793, black walnut; yellow pine, black walnut (secondary woods), 47 ⅞ x 46 ¹⁄₁₆ x 22 ⅞ in. (121.6 x 117 x 58.1 cm). Virginia Museum of Fine Arts, Gift of Mrs. A. D. Williams, 49.11.17.

also produced case pieces for the broader New England market and for export trade to ports throughout colonial America, the Caribbean, and Great Britain. As art historian Margaretta Lovell elaborates: "Newport cabinetmakers were not trading on S curves alone. Their wares were extremely functional and appealed to pragmatists who valued solidity, painstaking craftsmanship, and compartmentalized, specialized surfaces and containers to equip their physical world with the separation of functions and spaces and codified order that they valued at least as highly as they valued Beauty."[4]

The VMFA bureau table gives visual testimony to the high level of craftsmanship and attention to detail associated with the Goddard-Townsend group. Further contextual study of this cabinetmaking dynasty also provides a glimpse of colonial Newport as a center of intercolonial and international trade and of the notable role the Goddards and Townsends played in the development of early America's venture cargo market. After supporting three generations and close to sixty artisans, their endeavors came to an end in the late 1770s, unable to survive the economic isolation imposed by a three-year occupation of Newport by British forces during the Revolutionary War.[5] ELO

NOTES

1. The examination and authentication of a similar bureau table—described as "quite simply, an icon of American furniture"—figures prominently in Leigh Keno and Leslie Keno, *Hidden Treasures: Searching for Masterpieces of American Furniture* (New York: Warner Books, 2000), 71–80.

2. Morrison H. Heckscher discusses the bureau table form in *American Furniture in the Metropolitan Museum of Art,* vol. 2, *Late Colonial Period: The Queen Anne and Chippendale Styles* (New York: Metropolitan Museum of Art and Random House, 1985), 209–16. See also Charles F. Montgomery and Patricia E. Kane, eds., *American Art, 1750–1800: Towards Independence* (New Haven: Yale University Art Gallery; London: Victoria and Albert Museum, 1976), 149–50.

3. The desk was attributed earlier to a North Carolina cabinetmaker known only by the initials of his patron "WH" in John Bivins Jr., *The Furniture of Coastal North Carolina, 1700–1820* (Winston-Salem, N.C.: Museum of Early Southern Decorative Arts; Chapel Hill: University of North Carolina Press, 1988), 291–322. We are indebted to conservator F. C. Howlett, who researched and restored the desk in 2007 and bolstered the attribution first posited by Bivins. Recent research identifies the "WH" cabinetmaker as William Seay. See Thomas R. J. Newbern and James R. Melchor, *WH Cabinetmaker: A Southern Mystery Solved* (Paducah, Ky.: Legacy Ink, 2009).

4. Margaretta M. Lovell, "'Such Furniture as Will Be Most Profitable,' The Business of Cabinetmaking in Eighteenth-Century Newport," *Winterthur Portfolio* 26 (Spring 1991): 50. For additional studies of the Goddard and Townsend craftsmen, their milieu and work, see Morrison H. Heckscher, *John Townsend: Newport Cabinetmaker* (New York: Metropolitan Museum of Art, 2005); Luke Beckerdite, "The Early Furniture of Christopher and Job Townsend," *American Furniture (2000),* ed. Beckerdite, 1–30; Mabel M. Swan, "The Goddard and Townsend

9

Joiners, Part I" and "The Goddard and Townsend Joiners, Part II," *The Magazine Antiques* 49 (April 1946): 228–31 and (May 1946): 292–95. Genealogical listings and charts appear in Lovell, 54–55, and Wendell Garrett, "The Goddard and Townsend Joiners of Newport: Random Biographical and Bibliographical Notes," *The Magazine Antiques* 121 (May 1982): 1153–55.

5. Lovell, 61. At VMFA, other objects attributed to the Goddard-Townsend group include a card table (acc. no. 76.42.4) and a high chest (acc. no. 76.42.6).

9. Unknown Artisan

Sofa, ca. 1765–80

Philadelphia, Pennsylvania

Mahogany, tulip poplar, yellow poplar, red oak, yellow pine, American black walnut; reproduction wool damask upholstery ("Braintree Basket" pattern)

40 ½ x 85 x 29 in. (102.9 x 215.9 x 73.66 cm)

Museum Purchase, The Mary Morton Parsons Fund for American Decorative Arts, 76.42.14

PROVENANCE: Brooks Marsh, New York, N.Y.

10. Unknown Artisan

Side Chair, ca. 1765–70

Philadelphia, Pennsylvania

Mahogany, pine; replacement slip-seat cover of 19th-century textile

41 ¼ x 23 ½ x 21 ½ in. (104.8 x 59.7 x 54.6 cm)

Museum Purchase, The J. Harwood and Louise B. Cochrane Fund for American Art, 97.106

PROVENANCE: John Walton, Inc., New York, N.Y. (early 1950s); William S. Serri, Woodbury, N.J. (until 1989); sold at auction by Sotheby's, New York, N.Y. (January 31, 1993, sale no. 6392, lot no. 1277); Hirschl and Adler Galleries, New York, N.Y.

Thomas Chippendale's *The Gentleman and Cabinet-Maker's Director*, published in 1754, surely numbers among the most influential of all pattern books used on both sides of the Atlantic during the eighteenth century. Before giving the reader a series of plates for furniture design ideas, Chippendale includes some rules for drawing various architectural orders—at once communicating proportions he considered appropriate and emphasizing the close relationship between architecture and the decorative arts. An imposing sofa and an elegant side chair now in the VMFA collection attest to the particular impact of Chippendale's rococo design on craftsmen serving Philadelphia as it burgeoned into a mid-Atlantic economic center. The city's inhabitants avidly subscribed to the luscious curves and intricate detailing that distinguish their exuberant rococo style from more restrained interpretations created in New England.

Chippendale encouraged the use of his pattern book—in its third edition by 1762—for inspiration rather than imitation by providing multiple options. He included notes such as "[in] various Designs of Chairs for Patterns, the front Feet are mostly different, for the greater Choice."[1] American variations on Chippendale's themes are astonishingly numerous.

FIG. 28 Thomas Chippendale (1718–1779), plate 30, from **The Gentleman and Cabinet-Maker's Director,** 3rd ed., 1762, detail.

In commentary accompanying his four sofa designs, Chippendale explained, "the sizes differ greatly; but commonly they are from six to nine, or ten feet long," adding, "part of the Carving may be left out, if required."[2] With its straight legs, gracefully arched back, and generously scrolled arms, VMFA's classic Philadelphia sofa most closely resembles one shown in plate 30 of the *Director* (fig. 28). Devoid of carved ornament, aside from modest detailing on its rather severe front legs, the museum's sofa relies on form rather than ornament for its visual impact—again eloquently expressing the S curve or "line of beauty" so admired during the mid-eighteenth century. The sofa frame served quite

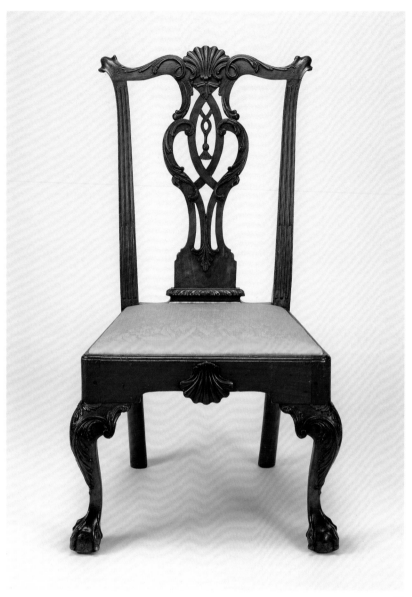

10

literally as a vehicle for the display of fine, expensive fabric. Chippendale instructed his readers that, "when made large," a sofa should have "a Bolster and Pillow at each End, and Cushions at the Back, which may be laid down occasionally, and form a Mattrass."[3]

The original upholstery, a commodity as fragile as it was costly, was long gone by the time VMFA acquired the sofa as part of an institutional emphasis on Americana during the bicentennial of the United States. The sofa was completely reupholstered in 2000. After removing layers of inappropriate padding, conservators re-created the original lean and

vigorous shape with Ethafoam, a modern conservation material. Sofas of this period often had a row of nails outlining the edges of the arms and apron, but this example had no nail holes in its frame. The absence of decorative nails, like the minimal carving, was likely an economic choice made by the patron. The sofa is now covered in wool damask woven on period looms, which produce narrower bolts of cloth than their modern counterparts.[4] Necessary seaming is evident on some of the cushions.

The museum's handsomely carved Philadelphia side chair has also lost its original show cover and now exhibits

FIG. 29 Thomas Chippendale (1718–1779), plate 15, from **The Gentleman and Cabinet-Maker's Director,** 3rd ed., 1762, detail.

a nineteenth-century faille on its replaced slip seat.[5] This piece combines well-orchestrated elements from all three chairs included in plate 14 of the *Director,* while the tassel that distinguishes the back splat recalls a similar element from a chair in plate 15 (fig. 29) Moreover, the American designer modified the rules propounded by his English source. "The Height of the Back seldom exceeds twenty-two Inches above the Seat," advised Chippendale, but the Philadelphia cabinetmaker gave this chair back a full twenty-five-inch height. By doing so, he invested it with magnificent sweep and balanced poise.

The VMFA side chair and the others related to it represent "at its refined best" the type of Philadelphia chair featuring a scrolled strapwork "tasel back" splat.[6] Survivors from at least three sets of chairs incorporate this beautiful element. All known examples seem to have been based upon the same template, but cabinetmakers could elect to lengthen the bottom of the splat for a taller stance, the characteristic that separates one set from another.[7]

The talented craftsman achieved a grace and lightness in the fine rococo ornament of this superbly balanced union of form and design. Long since separated from the original set,[8] which could have included any number from six to twelve or more, this chair retains its power as an individual work of art. Carefully orchestrated decoration creates a smooth visual flow from carved crest rail to claw-and-ball foot. An idealized scallop shell of delicate beauty centers the crest rail; a corresponding heavier shell on the apron balances it. Twisting

and twining acanthus leaves unite crest rail with splat, leading into sinuous curves that enclose the hanging tassel. Below the ears, reeded stiles curve gently down to the apron, which encloses a flat seat calculated to emphasize further the sweeping height of the back. Stop fluting on the stiles provides strong verticals to frame the wonderfully active curves of the splat. As the tassel opens out, it leads the eye down to the seat rail with its bold shell that fans out and down to counter the richly carved knees. These curve down to well-cut ball-and-claw feet that conjure Asian dragons grasping pearls.

For rarity, condition, and sheer visual power, this lovely example of the eighteenth-century cabinetmaker's art would be difficult to beat. Chippendale himself noted of his chair designs, "Several Sets have been made, which have given entire Satisfaction." As surviving sets are scattered in public collections, this single, stellar example, with its mellow old finish, gives satisfaction still. DPC

1. Thomas Chippendale, *The Gentleman and Cabinet-Maker's Director,* 3rd ed. (1762; repr., New York: Dover, 1966). See plates 9–15.

2. Chippendale, 4.

3. Ibid.

4. The documented pattern of the reproduction cover is called "Braintree Basket."

5. Faille is a middle-weight, flat-ribbed textile with slight luster; the ribs are not as rounded or heavy as grosgrain.

6. Morrison Heckscher, *American Furniture in the Metropolitan Museum of Art,* vol. 2, *Late Colonial Period: The Queen Anne and Chippendale Styles* (New York: Random House, 1985), 95, no. 50.

7. It has been established that the splats were cut from a single template and that differences in height were achieved by modifying the proportions of the straight-sided base of each splat. See ibid. At least two different people carved examples of these chairs, for specialists working for the trade in general did carving for individual chair makers. To compare chairs from different sets by different hands, see J. Michael Flanigan, *American Furniture from the Kaufman Collection* (Washington, D.C.: National Gallery of Art, 1986), 28–31, nos. 7, 8. See also Helen Comstock, *American Furniture: Seventeenth, Eighteenth, and Nineteenth Century Styles* (Exton, Pa: Schiffer, 1962), 144, no. 263. Construction on the VMFA chair closely parallels that of examples in the George and Linda Kaufman collection, Norfolk, Virginia. See Flanigan, 28.

8. Besides the VMFA chair, two pairs in private collections and one each in the diplomatic reception rooms of the Department of State, the Henry Ford Museum, and the Museum of Fine Arts, Boston, survive from the tallest group or set. Each features a seven-lobed scallop on the apron front. A pair of chairs at the Metropolitan Museum of Art, one chair at Winterthur, and another from the Karolik Collection at the Museum of Fine Arts, Boston, are not as tall as the VMFA example and related chairs.

11. Myer Myers (1723–1795)

Coffeepot, ca. 1765–70
New York, New York
Silver; wood handle
12 ¼ x 9 ½ x 5 ½ in. (31.1 x 24.1 x 14 cm)
Marked: "Myers" in script, in conforming surround, struck twice under
 the foot; "K" over "L C" in block letters under the foot
Monogrammed: "RCC"
Weight: 39 oz., 8 ½ dwts. Troy
Museum Purchase, The Floyd D. and Anne C. Gottwald Fund, 97.104

PROVENANCE: Probably unidentified members of the Koecks (a.k.a. Cocks/Cox)
family with initials "K/LC," New York, N.Y.; to Robert Cocks ("RCC"), who in 1764
married Catherine Ogden; to son Robert; to great-great-granddaughter Julia
Whitridge Bergland; to Bergland descendant; consigned to Phyllis Tucker Antiques,
Houston, Tex. (1996)

12. Myer Myers (1723–1795)

Teapot, 1765–76
New York, New York
Silver; wood handle
6 ⅝ x 9 ¾ x 5 ¹¹⁄₁₆ in. (15.8 x 24.8 x 29.7 cm)
Marked: "Myers" on underside
Weight: 21 ozs.
Gift of Mrs. Rita R. Gans, 2006.592

PROVENANCE: S. J. Shrubsole, New York, N.Y.; Mrs. Jerome T. Gans, New York,
N.Y.

13. Paul Revere (1735–1818)

Teapot and Stand, ca. 1790–95
Boston, Massachusetts
Silver; wood handle
Teapot: 6 ¼ x 11 ¾ x 3 ⅝ in. (15.9 x 29.8 x 9.2 cm)
Stand: 1 x 7 ⅜ x 5 ¼ in. (2.54 x 18.7 x 13.3 cm)
Marked: "Revere" struck on bottom of teapot and stand
Monogrammed: "JH"
Weight: 27 oz., 19 dwts. Troy
Gift of Daniel D. Talley III, Lilburn T. Talley, and Edmund M. Talley in
 memory of their mother, Anne Myers Talley, and Museum Purchase,
 The Arthur and Margaret Glasgow Fund, 91.392a–b

11

12

13

PROVENANCE: Mr. and Mrs. Moses Michael Hays; to daughter Judith Hays upon her marriage to cousin Samuel Myers (1796); to son Samuel Hays Myers; to son Edmund Trowbridge Dana Myers; to son Edmund Trowbridge Dana Myers Jr.; to daughter Ann Hays Myers Talley; to sons Daniel III, Lilburn, and Edmund Talley, Richmond and Millwood, Va.

Silver was one of the first materials with which American artists reached an international standard of excellence, creating visually compelling hollowware. Coffee, tea, and chocolate— expensive beverages served with great ceremony in polite society— deserved special forms to ensure a lavish presentation. Made by Myer Myers of New York and Paul Revere of Boston, three majestic silver vessels in the VMFA collection underscore important artistic, social, and commercial relations between Virginia and colonies to the north. Together, the three pots also record stylistic and technological change.

In 1774, a guest at Colonel Robert Carter's Virginia plantation, Nomini Hall in Westmoreland County, commented in his journal, "After dinner we had a Grand and agreeable Walk in & through the Gardens—There is a great plenty of Strawberries, some Cherries, Goose berries &c.—Drank Coffee at four, they are now too patriotic to use tea."[1] Tea was a popular beverage in the colonies, but its taxation and the consequent drive for American independence seem to have stimulated a demand for coffee. However, the size, weight, and cost of silver serving pots made such vessels rarities in the work of America's early silversmiths.[2] Hidden in a private collection for decades, the museum's coffeepot (cat. no. 11) is one of fourteen recorded from the workshop of leading New York craftsman Myer Myers.[3] It is the first rediscovery of an important coffeepot by Myers since the late 1930s[4] and the first to enter a southern museum.

A coffeepot, like a high chest, is among the most imposing forms of eighteenth-century decorative art. This one embodies simplified baroque elegance. The baluster-shaped body was hammered from a single and unusually heavy sheet

of silver, itself a craftsman's tour de force. The domed lid and spreading foot were also raised from single sheets before being soldered to the body. The surface of the pot is remarkably fine, showing little wear. Indeed, traces of Myers's hammer can still be seen on the interior of both body and lid.

Cast in two pieces, the spout is a graceful S scroll detailed with curvaceous leaf forms sweeping from base and top. The lid, edged with a cast gadrooned rim, has a well-formed bud finial. The hinge that links lid to body—often a clumsy or neglected design passage in the hands of a less-skilled silversmith—is here particularly well conceived. The pinned hardwood handle, certainly an old one if not the original, is mounted at the top with a shell and at the bottom with a scroll. One pin—the lower one—has been replaced. Overall, with its gracefully modulated series of curves and carefully balanced, harmonious proportions, this coffeepot once again embodies Hogarth's serpentine "line of beauty," a dominant eighteenth-century design principle also expressed in furniture (see cat. nos. 9 and 10).

Dating from the same period, the Myer Myers teapot also has a rounded form (specifically an inverted pear shape), S-scroll spout, and C-scroll handle. Yet the chased ornamentation, extraordinary for the period on a piece of this size, suggests the move from a baroque toward a rococo taste. This is resonant in the asymmetrical and "broken" C-scroll cartouche, the free-flowing tumble of flowers and vines, and the rings of acanthus leaves from which foot and finial emerge.[5] In a rare example of eighteenth-century silver en suite, a companion "slop bowl" with identical decoration was engraved by the same unknown hand.[6]

Myer Myers was born in New York, and the coffee- and teapots in the VMFA collection were likely produced for local clients. Yet in a serendipitous twist of fate, the New York silversmith came to be connected with Richmond and an important silver teapot created by Paul Revere.[7] In 1795, Myers's son Samuel, a successful international merchant, settled in Richmond and the following year married Judith Hays of Boston.[8] To mark the event, Judith's father, merchant Moses Michael Hays, gave her a pair of richly decorated Revere teapots and stands, each piece engraved with her monogram, "JH."[9] From Judith Hays Myers the teapots descended through four generations to the sons of Anne Hays Myers Talley, in whose

memory one of them now resides at VMFA.[10] The other is in the U.S. State Department collection.

Like his legendary feats as a patriot, Paul Revere's silver teapot (cat. no. 13) exhibits both democratic fervor and refined sensibilities. Its fluted oval form recalls classical columns of early American portraits, reminding citizens of the New Republic of their philosophical roots in ancient Greece and Rome. At the same time, the teapot stands as a textbook example of Boston high-style design during the federal period. At the end of the eighteenth century, neoclassicism flourished internationally. The style was to be found not only in grand houses decorated by the brothers Adam in Great Britain, but also in the decorative arts made for important American patrons like Hays.

Unlike the Myers vessels, Revere's teapot and stand are made of rolled sheet silver, an innovative time-saving material that spared craftsmen from hand raising their hollowwares from ingots. The crisply fluted, straight-sided body is set off by a strong, tapering, cylindrical spout balanced by a vigorous carved-wood handle. The handle may be original, as the pins affixing wood to metal appear undisturbed. The hinged oval cover is surmounted with a cast finial, variously interpreted as a bud, a pinecone, or a pineapple. The sides are engraved with especially elegant "bright cut" floral swags, at that time the height of fashion. Such dainty patterns were also inlaid in federal furniture (see cat. no. 22). The pot rests on a similarly engraved conforming stand, its monogram contained within a tied-ribbon escutcheon. The stand has a molded rim and four fluted bracket feet.

Both the handle and footed stand had practical implications beyond their significant visual impact. Like the poised foot of the coffeepot, the stand raised the flat-bottomed metal teapot, full of hot liquid, off the wooden surface of tea table or sideboard that heat might easily damage. The nonconductive wood handle prevented Judith Hays Myers and her descendants from burning themselves when pouring the tea.

DPC

NOTES

1. Cited in Morrison H. Heckscher and Leslie Greene Bowman, *American Rococo, 1750–1775: Elegance in Ornament* (New York: Metropolitan Museum of Art; Los Angeles: Los Angeles County Museum of Art, 1992), 95.

2. The precious commodity was priced by pennyweights, abbreviated "dwts"; there are 20 dwts in an ounce of silver.

3. David L. Barquist, *Myer Myers: Jewish Silversmith in Colonial New York* (New Haven and London: Yale University Press, 2001), 134, no. 47. See also Henry Miller, *The Cox Family in America* (New York: Unionist Gazette Association, 1912), 130, and *Baltimore: Its History and Its People* (New York and Chicago: Lewis Historical Publishing Company, 1912), 2:275–80. Julia Whitridge Bergland, who owned the coffeepot in the early twentieth century, was a direct descendant of Susan Ellen Savage and Henry Parke Custis Wilson of the Virginia Custises. She mistakenly believed that the coffeepot had been passed down through the Custis family.

4. Barquist, 134.

5. The dot-and-diaper pattern on the cartouche interior is not original and likely served to replace an earlier monogram or coat of arms. Barquist, 164, no. 68.

6. The bowl is in the collection of the Detroit Institute of Arts. Barquist, 164, no. 69.

7. Myer Myers is further linked to the history of Virginia families through his second wife, Joyce Mears. Their second daughter, Richea, had many descendants including some of the Mayos of Richmond, the Bartons of Winchester, the Baldwins of Staunton, and the Myerses of Norfolk. See genealogical report and letter from John Frederick Dorman, C.G.,F.A.S.G., Fredericksburg, Virginia, February 15, 1997, VMFA curatorial file.

8. Samuel Myers had offices in New York, Amsterdam, and Saint Eustatia.

9. Jane Bortman, "Moses Hays and his Revere Silver," *The Magazine Antiques* 66 (October, 1954): 304ff. Hays was born in New York on May 9, 1739, and died on the same day sixty-six years later. By 1769 Moses had been made a freeman of New York, an indication of his rising economic stature and a designation that entitled him to elect public officials and hold public office. Sometime later the family moved to Newport and eventually, about 1777, to Boston. Moses Hays was an influential religious rights activist.

10. VMFA curatorial file.

14. Christian Forrer (1737–1783), clockmaker

Unknown artisan, cabinetmaker

Tall Clock, ca. 1754–77

Lampeter, Lancaster County, Pennsylvania

Walnut with mahogany stain; brass, iron, pewter, glass; clockworks

99 x 23 ⅝ x 13 ¾ in. (251.5 x 60 x 34.9 cm)

Gift of Dr. Samuel H. Forrer, 55.27

PROVENANCE: Samuel H. Forrer, Strasburg, Va.

15. David Rittenhouse (1732–1796), clockmaker

Unknown artisan, cabinetmaker

Tall Clock, ca. 1765–70

Norriton, Pennsylvania (clockworks)

Norriton or Philadelphia, Pennsylvania (case)

Mahogany; glass, brass; clockworks

91 ½ x 21 ¼ x 12 ⅛ in. (232.4 x 54 x 30.8 cm)

Gift of Anne Rowland, 2003.177

14

PROVENANCE: Thomas Rowland, Cheltenham, Montgomery Co., Pa.; to son Harvey Rowland; to wife Emily B. Kingsbury Rowland (later Rittenhouse); to niece Mary Rowland Hansell (ca. 1918); to niece Katherine Hansell Biddle; to cousins William O. and Margaretta Gersed Rowland; to granddaughter Anne Rowland, Williamsburg, Va.

16. Jacob Danner (1763–1850), clockmaker

Unknown artisan, cabinetmaker

Tall Clock, ca. 1820

Middletown, Virginia

Cherry, maple; painted metal dial; wooden clockworks

100 x 19 ½ x 13 ¼ in. (254 x 49.5 x 33.6 cm)

Museum Purchase, The Kathleen Boone Samuels Memorial Fund, 95.18

PROVENANCE: Mr. and Mrs. Henry P. Deyerle, Harrisonburg, Va.; sold at auction by Sotheby's, Charlottesville, Va. (May 26–27, 1995, sale no. 6716, lot no. 616)

By the second quarter of the eighteenth century, the tall clock had emerged as an architecturally inspired response to the instrument's technical evolution from an open-weight to a pendulum movement. As immigrant mechanics arrived in the colonies from Germany, Switzerland, England, and elsewhere, they introduced the techniques and master-apprentice structure of European clockmaking to American artisans. Over time, innovative local entrepreneurs manipulated such practices to suit native economies and materials, ultimately transforming the rarefied world of hand-engraved faces and bespoke (custom-made) cabinets into one of industrial time cards and alarms.[1] Subsequently, the tall clock was recast in a romantic narrative of grandfatherly nostalgia and colonialism.[2] But until that moment, this architectonic timepiece remained one of the most prestigious effects of the mechanic and cabinetmaker, available to only the wealthiest eighteenth-century consumers.[3]

Prior to the nineteenth century, most brass works housed in American cabinets were made in England by specialists. However, as skilled clockmakers immigrated to the colonies, a growing number of such works were made by domestic entrepreneurs. VMFA is fortunate to own three works by known artisans whose cases represent a stylistic continuum in early American cabinetmaking: a rococo tall clock with works by Christian Forrer of Lancaster County, Pennsylvania; a transitional rococo-neoclassical tall clock with works by

David Rittenhouse of Norriton and Philadelphia, Pennsylvania;[4] and a classical tall clock with works by Jacob Danner of Middletown, Virginia.

Between 1750 and 1850, Lancaster County was home to over one hundred clockmakers.[5] Settled by Swiss Mennonite farmers in 1710, the region became known for its mechanical arts as early as the French and Indian War years (1754–63), when it supplied arms, wagons, and household goods to the mid-Atlantic region.[6] After the war, those mechanical and artisan skills were translated into a clock industry fueled by contemporary philosophical and scientific interest in rationalizing planetary movements for the "ordering" of the natural world.[7] Having apprenticed with Swiss clockmaker Jan François Guillerat, Christian and Daniel Forrer arrived in the colonies in the early 1750s.[8] By 1756, the Mennonite brothers had established a clockmaking shop in Lampeter. Upon Daniel's departure about 1760, Christian continued as sole proprietor of the concern. In 1774 he retired and moved to York County.[9]

In the VMFA example (cat. no. 14), Forrer's brass, iron, and pewter eight-day movement is housed in a cabinet indicative of Lancaster County's vigorous rococo sensibilities.[10] The hood, its three flame-and-acorn finials crowning a swan-neck pediment that ends in boldly carved rosettes, bears an arabesque-relief frieze above an arched and glazed front panel. Four free-standing columns frame glazed sidelights behind arched doors. The waist, topped by a cove molding, is centered by an arched door flanked by quarter columns. And the base, likewise topped by a cove molding, bears an applied serpentine panel above ogee-bracket feet. The case illustrates the high quality of Lancaster cabinetmaking and the combined influence of Philadelphia and English precedents on local production, most notably in the boldness of its carving and the architectural relationship of its parts.

In addition to master Swiss and German clockmakers, Forrer's contemporaries included a small group of colonial American-born makers, among them David Rittenhouse. Scientist, mathematician, astronomer, professor, politician, and patriot, Rittenhouse was celebrated for his clocks, which number among the most important examples of early American horology. Born near Germantown, Pennsylvania, the self-taught mechanic had established a studio on the family farm

15

in Norriton by the 1750s. Using tools and books bequeathed by his uncle, cabinetmaker David Williams, he constructed a variety of scientific and mechanical devices.[11] In the VMFA tall clock (cat. no. 15), a small, circular upper plate tops a larger circular face inscribed in black with Roman hours and Latin minutes. This is centered by a brass punch-work panel, the upper center of which hosts a third circular face marked with black Latin seconds. Against the silvered dial, brass filigree spandrels effect a particularly strong rococo statement.

Although the works by Forrer and Rittenhouse may be contemporaneous, their respective cases suggest a stylistic gap between them. Both invoke the weight, balance, and symmetry of baroque design, manifestations of their ideological link with classical values of stability and control particularly suited to the housing of time. The clocks also display comparable (and characteristically Philadelphian) aesthetic features— freestanding colonettes, quarter-turned fluted columns at waist and base, arched doors, raised base panels, and ogee-bracket feet. Yet their details expose subtle differences. Consider the bonnets: whereas the Forrer hood is a dialogue of motion—strained swan necks arch into crunched and folded petals, aggressively carved flames crack from the tension of twisting finials, asymmetrical bowers of acanthus leaves move freely across the surface of the tympanum (the triangular space between the finials and the clock face)—the Rittenhouse case is restrained, its tympanum undecorated, its finials oddly spired, and its swan-neck pediment ending in linear rosettes. Even at waist and base, the dentil-and-leaf detailing and scalloped appliqué of the earlier work give way to simple, narrow columns and a centralized, five-point, "bear-skin" panel.[12] Despite the similar architectural structures, the greater movement and variety of the Forrer example challenges the integrity of baroque classicism—symmetrical and balanced—as is typical of American rococo design. Together, the two cabinets underscore the stylistic shift from a bold and external rococo aesthetic toward a more attenuated and reserved neoclassicism.

Although a center of science and philosophy, Philadelphia was not the only venue for clockmaking. The Boston Willards—Benjamin, Simon, and Aaron—were important innovators in clock construction and design, propelling the trade into a factoried industry. In the VMFA clock by Aaron

FIG. 30 Aaron Willard (1757–1844), clockmaker; unknown cabinetmaker, **Tall Clock,** ca.1790–1810, Boston, mahogany, satinwood, brass, enameled metal, glass, clockworks, 101 ½ x 22 ⅝ x 11 ¹/₁₆ in. (257.8 x 57.5 x 28.1 cm). Virginia Museum of Fine Arts, Gift of the Estate of Mrs. Gordon C. Raab, Richmond, Va., 2003.195.

Willard (fig. 30), an unidentified cabinetmaker incorporated prefabricated parts into a mahogany Roxbury case.[13] A virtually identical English-made dial on a Simon Willard clock suggests a family-wide practice of integrating imported works into Willard-brand objects.[14] While challenging received ideals about craftsman practices, the clock is no less successful for being "assembled." Such cost-efficient methods satisfied economic and aesthetic demands by masking standardized parts with decorative details.[15] Ultimately, the integration of specialty interior and exterior components permitted the Willards to supply a broader market. With a history of ownership in Nottoway County, Virginia, the Willard clock suggests the firm's likely engagement in the venture cargo trade, either directly, through dockside sales to would-be owners, or indirectly through retail venders. This possibility is

supported by another Roxbury case, its dial marked "William McCabe/RICHMOND."[16]

Produced in the Shenandoah Valley of Virginia during the first quarter of the nineteenth century, Jacob Danner's tall clock (cat. no. 16) represents the extension of clockmaking practices beyond the eastern seaboard and the coincident synthesis of diverse cultural influences into a local, vernacular style.[17] Born in 1763 in Frederick County, Maryland, Danner departed for Middletown in the northern Shenandoah Valley of Frederick County, Virginia, at some point prior to 1795.[18] There he wed Hannah Senseney a year after her father, Dr. Peter Senseney, settled the town in 1794.[19] Once in the Virginia backcountry, Jacob served as a "bleeder," bone setter, silversmith, lawyer, postmaster, and poet among a community of Mennonites, Lutherans, Presbyterians, Quakers, German, Swiss, Scots-Irish, and English. He also served as a clockmaker. Southern furniture historians Ronald Hurst and Jonathan Prown have observed an unusual demand for tall clocks in the Germanic communities of the South's backcountry; in addition to their practical function, the clocks likely served a religious purpose—chiming the hours of the daily twelve petitions.[20]

In the museum's example, a wooden movement constructed of local materials is faced with a white-painted metal dial (fig. 31). The manufacturing of these white dials occupied dozens of Birmingham, England, manufacturers in the late eighteenth and early nineteenth centuries. With painted or transfer-print details, and blank spaces for inserting the maker's name and location, their versatility and affordability made them popular alternatives to the conventional brass dial.[21] While it is tempting to read the bird and floral motifs on the Danner dial as evidence of his known talents as a watercolorist, a dial with virtually identical floral painting—its movement attributed to nearby Winchester, Virginia—cautions against easy assumptions.[22] Still, the overall simplicity of the Danner dial and the absence of any secondary mechanics— for example, there is no arch to house a lunar work—suggests a rural origin. It may be one of the few white dials made in early America.[23]

The dynamic culture in which Danner worked is suggested by the clock's case. The Forrer-to-Rittenhouse stylistic transition toward greater restraint culminates in Danner's

orderly geometric design, which is based on a balanced and repetitive dialogue between vertical and horizontal components. Waist and base are framed, top and bottom, with vertical bands, each flanked by carved (waist) or applied (base) columns. This compartmentalization is echoed in the recessed panels (one below and two above), each of which is anchored by a single roundel—a stylized sunflower. Although the hood retains a traditional, if highly attenuated, swan-neck pediment surmounted by spires, its moldings, colonettes, and paterae motifs reiterate the structure's regulated nature. Even the feet boast horizontal turnings.

The result is a robust and rhythmic symmetry born of an imposed relationship between solid and void, projection and recession. Divided, measured, and controlled, it is reminiscent of seventeenth-century mannerism and an Anglo-Germanic appreciation for stylized forms: a classical reining in of rococo exuberance. It likewise coincides with a German American worldview in which the spiritual, intellectual, and physical realms are understood as complementary primary, secondary, and tertiary manifestations of a single, unified Creation.[24] Finally, it suggests the conditions under which rural cabinetmakers labored: without ready access to specialists or suppliers of inlaid panels and other decorative elements, one made do with lathe and chisel, turning and carving decorative components.[25] It is this combination of aesthetic sensibility and economic circumstance, more than the isolated transfer of any single influence, that best expresses the culture of the developing backcountry. The compelling link between the VMFA clocks is their common participation in the physical and intellectual motion of early America. SJR

NOTES

1. One innovation was the use of wood to construct movements, as found in the example by Jacob Danner. This proved particularly astute in the face of Jefferson's Embargo Act (1807), the Non-Intercourse Act (1809), and the War of 1812, which limited access to imported materials and goods. Edwin A. Battison, "The Development of American Clocks and Clockmaking," in Battison and Patricia E. Kane, *American Clock, 1725–1865* (Greenwich: New York Graphic Society, 1973), 16–19; Derek de Solla Price, "A Cultural History of Clocks," in Battison and Kane, 13.

2. Henry Clay Work's 1876 hit song "My Grandfather's Clock" is often credited with popular usage of the term "grandfather clock." It is the tale of an English long-case clock that slowly loses time following the death of one brother, stopping altogether after the death of the other. Price, 12.

3. Prior to the arrival of skilled artisans, colonists had difficulty keeping their clocks in working order. By the early nineteenth century, clocks were popular retail

FIG. 31 Detail of cat. no. 16.

objects. Oscar P. Fitzgerald, *Four Centuries of American Furniture* (Radnor, Pa.: Wallace-Homestead, 1995), 69; Ronald L. Hurst and Jonathan Prown, *Southern Furniture 1680–1830: The Colonial Williamsburg Collection* (Williamsburg, Va.: Colonial Williamsburg Foundation, 1997), 568.

4. Rittenhouse moved to Philadelphia in 1770, and the cabinet was probably made after this date. Rittenhouse is thought to have maintained a clockmaking enterprise on the Norriton farm even after his relocation to the city. The rococo dial may have been among his holdings there. Beatrice B. Garvan, "David Rittenhouse (1732–1796)," in *Philadelphia: Three Centuries of American Art* (Philadelphia: Philadelphia Museum of Art, 1976), 162.

5. Stacy B. C. Wood Jr. and Stephen E. Kramer III, *Clockmakers of Lancaster County and their Clocks 1750–1850* (New York: Van Nostrand Reinhold, 1977), 7.

6. Wood and Kramer, 9–10.

7. Price, 10–13.

8. The brothers arrived together with their sister, Christina. Wood and Kramer, 19.

9. Price, 13. By 1757, the family had received the remaining payment on their estate in Switzerland. Shortly thereafter, between 1759 and 1760, Daniel seems to have left Lancaster County, perhaps for Virginia. Wood and Kramer, 19.

10. The cabinet was once attributed to Swiss-born cabinetmaker John Bachman II. For further information about Bachman, see "Bachman Family Papers, 1769–1864," Winterthur Museum Library, col. 285.

11. See George H. Eckhardt, "David Rittenhouse—His Clocks," *The Magazine Antiques* 21 (May 1932): 228–29; Garvan, 162.

12. This panel is virtually identical to that found on the Griffith Owen clock in the Mabel Brady Garvan Collection at Yale University. Although the maker of the Owen case is unidentified, Owen did not work independently until about 1780, acquiring his master's shop in 1782. The clock is dated ca. 1785–95 and was probably made after the Rittenhouse cabinet, the dating of which has been complicated by the rococo dial and Norriton inscription. For an illustration of the Owen clock, see Battison and Kane, 130.

13. The case is similar to examples in the Garvan Collection of Yale University and the Kaufman Collection of Norfolk, Virginia. The reference to nearby "Roxbury" reflects the brothers' likely employment of skilled artisans there. The case may have been made on the factory's premises or contracted to a smaller shop for reassembly. John Ware Willard, *Simon Willard and his Clocks* (1911; repr., New York: Dover, 1968), 85–86; Battison and Kane, 66, 70; J. Michael Flanigan, *American Furniture from the Kaufman Collection* (Washington, D.C.: National Gallery of Art, 1986), 240, ill. 241.

14. The Simon Willard clock is in the collection of Old Sturbridge Village. Philip Zea and Robert C. Cheney, *Clock Making in New England, 1725–1825* (Sturbridge Village, Ma.: Old Sturbridge Village, 1992), 41, fig. 2.28.

15. Battison, 19; Zea and Cheney, 41.

16. Colonial Williamsburg Collection. Hurst and Prown, 567–71.

17. The trafficking of mechanical and aesthetic innovations was facilitated by the Great Wagon Road, the principal route for backcountry settlement in Virginia, the Carolinas, Tennessee, and Georgia. Immigrants lured by plentiful land at affordable prices joined diverse communities; their close proximity invited technical and aesthetic interaction. Philadelphia, Lancaster, and Middleton were three of the road's key junctions. Even Willard's clock may have taken this route, its interior and exterior parts traveling separately until final assembly in Virginia. See Parke Rouse, *The Great Wagon Road: From Philadelphia to the South* (1992; repr., Richmond: Dietz Press, 2004), vii–viii, 4–5, 7, 11–7; 21–30; Hurst and Prown, 337–38; Philip Zea, "A Revolution in Taste: Furniture Design in the American Backcountry," *The Magazine Antiques* 159 (Jan. 2001): 186–95.

18. Jacob was the son of Jacob Danner Sr., who, along with his brother and father, the Swiss Mennonite Michael Danner, surveyed the Monocacy Trail from their home county of Lancaster, Pennsylvania, to Frederick County, Maryland, where Jacob Sr. relocated in 1760. See Family File (land records) and Pre-1800 Tax Cards, York County Heritage Trust Library Archives; "Minutes of the Provincial Council," *Colonial Records*, vol. 3, 284, cited in Ralph B. Strassburger and

William J. Hinke, eds., *Pennsylvania German Pioneers* (Norristown, Pa.: Pennsylvania German Society, 1934), 1:10–12; Jerry Maurice Henry, "Michael Danner," *History of the Church of the Brethren in Maryland* (Elgin, Ill.: Brethren Publishing House, 1936), 34–44; Zelma D. Barrow, *Danner* (Saint Petersburg, Fla.: Z. D. Barrow, 1986), 5; John Gibson, ed., *History of York County Pennsylvania, From the Earliest Period to the Present Time, Divided into General, Special, Township and Borough Histories, with a Biographical Department Appended* (Chicago: F. A. Battey, 1886), 322, 388, 485, 691, 694–95; www.ancestry.com, *1850 United States Federal Census, Middletown, Frederick County, Virginia* (Provo, Utah: Generations Network, 2005): roll M432-945, p. 328.

19. Hannah and Jacob were married October 5, 1795. Following her death, he married again before 1840. Jacob and Hannah Danner are buried at Middletown Cemetery, Frederick County, Virginia. John Vogt and T. William Kethley Jr., *Virginia Historic Marriage Register. Frederick County Marriages, 1738–1850* (Athens, Ga.: Iberian Press, 1984), 88; Nancy Delaney-Painter and Susan L. McCabe, eds., *Index to Burials in Frederick County Virginia* (2001; repr., Athens, Ga.: Iberian Press, 2004), 82; www.ancestry.com, *1820 United States Federal Census, Frederick County, Virginia,* roll M33-138, p. 11, and *1840 United States Federal Census, Frederick County, Virginia,* roll 555, p. 93.

20. Hurst and Prown, 341.

21. Ibid., 564–65.

22. The Keller family tall clock is in the Colonial Williamsburg Collection. See Hurst and Prown, 562–65, ill. 564.

23. David Todd has suggested that a small number of white dials were made in America. See Hurst and Prown, 568.

24. An eight-day clock by Johannes Spitler, produced in Shenandoah (now Page) County, Virginia, is decorated with a dead bird above which a flower blossoms in reference to the Resurrection. Zea, 192, plate 11; Herbert Leventhal, *In the Shadow of the Enlightenment: Occultism and Renaissance Science in Eighteenth-Century America* (New York: New York University Press, 1976), 192, cited in Hurst and Prown, 343n7.

25. Zea, 190.

17. Unknown Artisan

Drop-Front Secretary, ca. 1780

Vizagapatam (Vishakhapatnam), India

Sandalwood, veneered with incised ivory panels filled with black lac; silver and brass pulls, brass hinges

53 x 30 ⅝ x 13 ⅝ in. (134.6 x 77.8 x 34.6 cm)

Museum Purchase, The Adolph D. and Wilkins C. Williams Fund, 2001.231a–b

PROVENANCE: Vizagapatam to Pondicherry, India (by 1784); to Philadelphia, Pa., aboard the *United States* with "an English gentleman from Calcutta named Campbell" (by 1785); to Anne Willing Bingham, daughter of ship owner Thomas Willing (ca. 1786); descended through six generations of Willing family, intermarried with Bingham, Brown, and Francis families; to Henry A. L. Brown, Warwick, R.I. (1954); Israel Sack, Inc., New York, N.Y.

Clad in sheets of pale ivory inscribed with vivid black patterns, this diminutive yet dramatic drop-front secretary, with its impeccable provenance, argues for a closer look at the

17

trade patterns supporting the rise of the United States as an international power. It also suggests the disjunction between republican politics and royalist aesthetics, adding tension to the study of early American art and culture.

Although American revenues from exports to India exceeded those of the China trade by the mid-1780s, studies of the latter have long overshadowed the history of America's Indian trade. In fact, shortly after the *Empress of China* sailed from New York for Canton (now Gouangzhou) initiating the China trade, the first American ship bound for India left the port of Philadelphia.[1] The *United States*, owned by the merchant and civic leader Thomas Willing, dropped anchor at the French port of Pondicherry on the southeast coast of India in 1784.[2] Among the objects included in the return cargo was the elaborate ivory-clad secretary subsequently given to the shipowner's daughter, Anne Willing Bingham. As is evident in a portrait by Gilbert Stuart (fig. 32), Anne Bingham was one of the most fashionable socialites in federal America. She counted Thomas Jefferson and George Washington among her illustrious friends.[3] At age sixteen, she married William Bingham, an extremely wealthy merchant and banker who, under the direction of her father, played an active role in the Bank of North America—the nation's first private commercial bank[4]—and later served as U.S. senator from Pennsylvania.[5]

With its severe classical pediment and crisp architectural proportions, the Indian secretary would have been quite at home in the Binghams' grand neo-Palladian establishment in Philadelphia. Built about 1788 on Third Street above Spruce Street, Mansion House was certainly the finest dwelling in the city, becoming a social and political nexus for powerful citizens.[6] After a gala there in late 1787, James Brown described his formidably dressed hostess in a manner suggestive of her

FIG. 32 Gilbert Stuart (1755–1828), **Portrait of Anne Willing Bingham,** 1797, oil on canvas, 28 ¾ x 24 ¼ in. (73.03 x 61.6 cm). Philadelphia Museum of Art, Gift of Mr. and Mrs. Robert L. McNeil Jr., in memory of Anne d'Harnoncourt, 2008.

recently acquired cabinet:

> light [and] airy [Anne Bingham wore] a black velvet gown . . . with white gause and a false trail of the same, her hair dressed uncommonly broad and high, [in] a profusion of curls. A monstrous hat 6 inches in the brim with a high crown, a white fox and lined with black . . . [included] a diamond pin and rose that cost 300 Guineas on the top. Had an uncommonly elegant effect, the brilliance of the diamond contrasted with the black part of the hat, [and] shone with great splendor.[7]

FIG. 33 Detail of cat. no. 17.

As Anne Bingham's sister Dorothy Francis later recalled, the ivory-clad secretary inspired similar "curiosity."[8] There was probably no other cabinet like it in federal America.

The Bingham secretary was made in Vizagapatam, a textile center in southeastern India that provided the only natural harbor between Madras and Calcutta. In the early 1700s, craftsmen from this region began producing elaborately inlaid furniture for the Western market, combining Indian materials with patterns drawn from chintz textiles, Western architectural prints, and eighteenth-century English furniture forms (fig. 33). By midcentury, they had devised the technique of pegging ivory sheets to wooden carcasses (fragrant, insect-resistant sandalwood in the case of the VMFA secretary). Once applied, the ivory was incised with patterns and filled with black lac.[9]

While elaborate inlays of precious materials were not unknown in European furniture, ivory-clad pieces were rare in the United States.[10] In the 1780s, as the English East India Company became the de facto ruler of Bengal, such works remained closely associated with grand households in colonial India and Regency England.[11] At the time of the secretary's construction, guests of the governor of Madras would have encountered an entire suite of ivory furniture from Vizagapatam—presently in the collection of Buckingham Palace.[12]

After the Revolutionary War, Americans like Thomas Willing, wishing to establish themselves in international commerce, were greatly facilitated by Westward-looking Calcuttans such as Ramdoolal Dey, who helped to advance commercial relations between the two countries. In 1801, Dey received a copy of Gilbert Stuart's *Lansdowne* portrait of George Washington, originally commissioned by William Bingham (National Portrait Gallery).[13] Presented as "a mark of esteem and affection" by an influential group of American merchants and ship captains, it likely inspired VMFA's unique Indian ivory statuette of George Washington (fig. 34).[14]

Apart from intriguing political and social links, the ivory-clad secretary stands in its own right as a powerful and engaging work of art. Like the museum's important japanned Boston high chest (see cat. no. 1), the ivory-clad cabinet raises stylistic issues that involve other important collections at VMFA. With its ornamental links to textiles and pattern books, grand furniture, and humble "scrimshaw" pieces—executed in ivory

FIG. 34 Unknown artisan, **George Washington,** ca. 1800–1810, India, carved ivory, 9 7/8 x 4 7/8 x 2 1/2 in. (25.1 x 12.4 x 6.4 cm). Virginia Museum of Fine Arts, The Arthur and Margaret Glasgow Fund, 97.103.

by American sailors—the drop-front secretary invites fresh thinking in the field of eighteenth-century decorative arts.

DPC

NOTES

1. See G. Bhagat, *Americans in India, 1784–1860* (New York: New York University Press, 1970).

2. Thomas Willing was a Philadelphia-born merchant and banker who joined with Robert Morris to form Philadelphia's major mercantile firm, Willing and Morris. He served as a delegate to the Continental Congress of 1775–76. *Dictionary of American Biography,* ed. Dumas Malone (New York: Scribner's, 1936), 10:302–4. Willing's company ship, the two-hundred-ton *United States,* cleared Philadelphia on March 24, 1784, carrying ginseng, naval stores, copper, miscellaneous hardware, and a "considerable sum in dollars." The voyage took nine months and one day. It returned to Philadelphia on September 13, 1785. Baghat, 4–7.

3. Ellen G. Miles, "Anne Willing Bingham," in Carrie Rebora Barratt and Miles, *Gilbert Stuart* (New Haven and London: Yale University Press, 2004), 195–98, no. 51; Earl E. Lewis, "Anne Willing Bingham," in *Notable American Women, 1607–1950: A Biographical Dictionary,* ed. Edward T. James et al. (Cambridge, Mass.: Belknap Press of Harvard University Press, 1971), 1:146–47; *Philadelphia: A 300-Year History,* ed. Russell F. Weigley (New York: W. W. Norton, 1982), 177–78; *Dictionary of American Biography,* ed. Allen Johnson (New York: Charles Scribner's Sons, 1936), 1:273, 278–79.

4. The Continental Congress chartered the Bank of North America in 1781. The bank was designed by Captain Samuel Blodget (see cat. no. 19), who likewise built a fortune through the India trade.

5. *Dictionary of American Biography*, 1:273, 278–79. Anne married the Philadelphia-born Bingham in 1780. Having served four years as Continental agent in the West Indies and as British consul in Martinique, Bingham made a fortune in trade and privateering. In 1781, he became a founder and director of the Bank of North America under the supervision of his father-in-law, Thomas Willing, who served as bank president. Bingham served as a United States senator from 1795 until 1801. He was the founder of Binghamton, New York.

6. See Wendy Nicholson, "Making the Public Private: Anne Willing Bingham's Role as a Leader of the Philadelphia Social Elite in the Late Eighteenth Century" (M.A. thesis, University of Delaware, 1988). See also Susan Branson's chapter on the Binghams' political salon in *These Fiery Frenchified Dames: Women and Political Culture in Early National Philadelphia* (Philadelphia: University of Pennsylvania Press, 2001), 133–40.

7. Letter from James Brown to Abby Brown (sister), December 3, 1787, "Log and Journal of the *United States*, 1784–1785," HPS 1115, Historical Society of Pennsylvania.

8. Testamentary letter from Dorothy Willing Francis to her children, June 14, 1846, in ibid.

9. The technique of engraving ivory on furniture for royal consumption existed earlier in coastal Orissa, to the north of Vizagapatam. See Amin Jaffer, "Ivory-Inlaid and Veneered Furniture of Vizagapatam, India, 1700–1825," *The Magazine Antiques* 159 (Feb. 2001): 343. In making pieces for indigenous patrons, Vizagapatam artisans often colored the lac patterns. Scholars at the Victoria and Albert Museum suggest that the monochrome black decorations on objects made for Europeans reflect the use of Western engravings as patterns for the workmen to copy. See *Arts of India: 1550–1900*, ed. John Guy and Deborah Swallow (London: Victoria and Albert Museum, 1990), 202. The recipe for lac used in eighteenth-century Vizagapatam is not known, but present-day artisans mix eight parts wax to one part black soot. For further discussion, see Jaffer, *Furniture from British India and Ceylon: A Catalogue of the Collections in the Victoria and Albert Museum and the Peabody Essex Museum* (Salem, Mass.: Peabody Essex Museum, 2001), 175.

10. Elaborate cabinets decorated in precious materials were first made in Augsburg; after the middle of the sixteenth century they took Europe by storm. While the earliest collector's cabinets were as significant for their curious contents as their decorative embellishments, by the next century the taste was for outward show. The visually stunning black-and-white cabinets of Vizagapatam carried this international luxury trade into the eighteenth century. See Reinier Baarsen, *17th-Century Cabinets*, trans. John Rudge (Amsterdam: Rijksmuseum, 2000), 3.

11. The Peace of 1783 restricted the French to commercial activities in India. By 1784, England had gained control over Bengal, Bihar, and Orissa. During the 1790s, the East India Company encouraged American ships to trade with India because they imported much-needed silver. See Bhagat, xxi, xxii. For examples of works in colonial and British residences, see Jaffer, *Furniture From British India and Ceylon*, and *The Raj: India and the British 1600–1947*, ed. C. A. Bayly (London: National Portrait Gallery, 1990), 156.

12. The suite once belonged to Alexander Wynch, governor of Madras from 1773 to 1775. It included two settees, fourteen side chairs, two armchairs, and two miniature cabinets, all related to mid-eighteenth-century English design. Bought by George III and given to Queen Charlotte, it was purchased on her death in 1818 by the prince regent (crowned George IV, 1820), who installed it at the Royal Pavilion in Brighton. See Jaffer, "Ivory-Inlaid and Veneered Furniture of Vizagapatam," 345–46. Such noble provenances are common with important Indian ivory furniture.

13. The Binghams leased a summer estate, Lansdowne, from John Penn in 1790. See George B. Tatum, *Penn's Great Town: 250 Years of Philadelphia Architecture Illustrated in Prints and Drawings* (Philadelphia: University of Pennsylvania Press, 1961), 42.

14. That painting is now at Washington and Lee University, Lexington, Virginia.

18. John Trumbull (1756–1843)

Priam Returning to His Family with the Dead Body of Hector, 1785

Oil on canvas

24 ¾ x 36 ¾ in. (62.9 x 93.3 cm)

Museum Purchase, The Williams Fund, 78.8

PROVENANCE: Christopher Gore, Waltham, Mass.; Mrs. Christopher Gore; bequeathed to Boston Athenaeum, Boston, Mass. (1834); Museum of Fine Arts, Boston, Mass. (1879–1976); Hirschl and Adler Galleries, New York, N.Y. (1976)

19. John Trumbull (1756–1843)

Portrait of Captain Samuel Blodget in Rifle Dress, ca. 1786

Oil on canvas

21 ³⁄₁₆ x 17 ⅛ in. (53.8 x 43.5 cm)

Museum Purchase, The J. Harwood and Louise B. Cochrane Fund for American Art, 2001.2

PROVENANCE: Mr. Boogher, Mass.; private collection; by family descent to an English private collection; through Phillips, London, December 17, 1996, lot 32, to Adelson Galleries, New York, N.Y.

These two pictures, painted within a short time span by John Trumbull in London, intertwine the aspirations of an ambitious, outspoken artist with those of the profession he espoused and the clients he served in federal America.[1] *Priam Returning to His Family with the Dead Body of Hector* is a history painting, representing the loftiest aims of eighteenth-century easel painters.[2] *Portrait of Captain Blodget in Rifle Dress*, on the other hand, is an example of commissioned private portraiture, the bread-and-butter of many an artistic livelihood. While the history painting, once owned by Trumbull's closest college friend, Christopher Gore,[3] remained prominent in the literature, the portrait disappeared (unaccounted for during a comprehensive Trumbull retrospective exhibition in 1982) and finally resurfaced in the 1990s.

Hostilities between England and America had only recently concluded when Trumbull based *Priam Returning* on a scene in the final book of *The Iliad*, Homer's classical account of the Greek and Trojan wars.[4] After vanquishing Hector in combat, Achilles ties the body to his chariot and drags it

18

around the walls of Troy, dishonoring both the warrior and the city he defended. But "under the golden aegis" of Apollo, Hector's body remains intact.[5] Priam, king of Troy, visits Achilles's tent and ransoms the body of his dead son.[6] In Trumbull's picture, Priam brings the body back to the grieving Trojans, including Hector's mother, Queen Hecuba, shrouded in dark blue, and his wife, Andromache. At right stands Helen, the Spartan beauty whose flight to Troy with Priam's second son, Paris, was the pretext on which the Greeks sailed across the Aegean Sea to launch a war against the wealthy Trojans.[7] One would not be amiss in sensing a parallel with British efforts to control the wayward but lucrative American colonies.

While the American painter followed the Greek poet's text, he exercised judicious license to arrive at the present image. The scene takes place not at the city gates but on the

steps of Priam's stately palace, giving Trumbull the opportunity to focus upon the dead hero by bracketing him with classical columns. He composed the central group rather like a Christian deposition from the cross, the sort of Old Master image familiar to his audience from engravings if not actual paintings.[8] Trumbull would later win fame for works that memorialized events in the American Revolution, but an historian writing shortly after the 1876 centennial said of *Priam Returning*, "Trumbull touched a chord here which was vastly deeper and more genuine than any that he struck in his huge historical canvases and reached a higher level of expression."[9]

Theatrically lit, the dead Hector's glowing white draperies take center stage in *Priam Returning*. Trumbull used white again for his dashing portrait *Captain Samuel Blodget in Rifle Dress*. The lithe figure of this New Hampshire militia officer, armed with rifle, powder horn, and sheathed sword, stands out

19

against a dark forest backdrop.[10] Blodget's fine form reveals Trumbull's skills as a draftsman—all the more astonishing considering that the artist had been blind in one eye since childhood. Many years later, Trumbull recalled the canvas, fondly referring to it as a "beautiful little picture probably now in Boston."[11]

Blodget's costume is based on rugged fringed leather garments worn by America's soldiers. Hunting shirts, also called hunting smocks, were actually adapted from the Native American "wamus," or tunic. They usually had broad attached capes or collars like the one floating out behind Blodget. Instead of leather fringe, designed to conduct raindrops away from the body, elegant lace trims Blodget's "rifle dress."

Revolutionary War soldiers, at every level and from every colony, wore widely differing attire, but by the time uniformity was sought, hunting shirts were among the garments issued. Apparently General George Washington had scant confidence in the ability of either Congress or individual colonies to clothe his armies. The concerned commander issued this order:

> The General, being sensible of the difficulty and expense of providing clothes of almost any kind for the troops, feels an unwillingness to recommend, much more to order, any kind of uniforms, but as it is absolutely necessary that men should have clothes and appear decent and tight, he earnestly encourages the use of hunting shirts, with long breeches made of the same cloth, gaiter-fashion about the legs, to all those yet unprovided. No dress can be cheaper or more convenient. Besides it is a dress justly supposed to carry no small terror to the enemy, who think every such person a complete marksman.[12]

Trumbull here celebrates an American patriot who was already devoting his attention to building up a considerable fortune when the artist painted him. Resigning from the militia in December 1777, Blodget moved to Boston, where he amassed riches in the East India trade. During that period, he traveled abroad, taking time out from his business dealings to have a portrait painted in England. By 1790 Blodget had relocated to Philadelphia, married well, and engaged

FIG. 35 Wedgwood Factory (est. 1759), **Snake-handled Vase,** ca. 1786, Staffordshire, England, blue-and-white jasperware, 15 ¾ x 6 ¼ in. (40 x 41.3 cm) dia. Virginia Museum of Fine Arts, The Arthur and Margaret Glasgow Fund, 98.22.

in the gentlemanly pursuit of architecture, an interest that he shared with Trumbull himself. By 1792 he had begun acquiring real estate in Washington, D.C., and in 1795 he designed the Bank of the United States. Located in Philadelphia, it was America's first marble-fronted bank. Eventually he served as superintendent of buildings in the nation's new capital city.[13]

Trumbull regularly incorporated references to familiar poses from antiquity in his work. Some of the best known of his historical pictures signal his knowledge of standard sources like *The Antiquities of Athens* (1762–94), published serially in London by James Stuart and Nicholas Revett. Trumbull was also aware of Sir Joshua Reynolds's advice that portraitists should render full-length figures with verve while endowing them with the dignity of classical allusion. *Captain Blodget's* pose recalls the *Apollo Belvedere.* This Roman marble after a lost Greek bronze was among the most beloved of all antiquities

during the age of neoclassicism. Such references to ancient art were intended to add weight and resonance to a picture.[14] Produced at the same time as Trumbull's paintings, imposing ceramics like the *Snake-handled Vase* by Wedgwood (fig. 35) furthered neoclassical taste in America following the Revolutionary War.[15] Similar examples were ordered for royal collections, suggesting that republican politics by no means eradicated patrician tastes.[16] Indeed, in Blodget's case, speculations ultimately led him into bankruptcy and imprisonment.

Trumbull's undeniably dramatic portrait may also reflect recent changes on the British stage. Particularly after the Italo-French performer Gaetan Vestris and his son Marie-Auguste won acclaim for their unconventional dancing at London's King's Theatre in 1781, exaggerated dance posture began to invade British sensibilities.[17] Poised on thin leather boots that seem more suited to the dance floor than the forest, Blodget's light-footed liveliness conveys a "stage presence" that helps to emphasize the fresh energies of the New Republic as seen in one of its leading movers and shakers.

Each of Trumbull's paintings in the VMFA collection emphasizes civic duty. By cultivating awareness of shared interests, history paintings sought to encourage viewers to promote the good of all.[18] In *Priam Returning*, three royal women step forward to receive a hero's body. The scene is indeed a sad one, but the mourners' decorum illustrates the virtue of personal sacrifice. The gods kept Hector beautiful in death. Trumbull himself kept Captain Blodget beautiful in life. While Blodget's inspiring pose derives in part from classical antiquity, his portrait offers a direct message that more literal adaptations from the classics tend to mute. It is not coincidental that touches of red and blue embellish his white costume, repeating the colors of the national flag. Looking back at the past while striding boldly into the future, Blodget wanted to be seen as more than just a patriotic soldier. Trumbull intended him to be viewed as an intrepid player on history's stage. DPC

NOTES

1. Trumbull recorded his works: see John Trumbull, "Account of Paintings by Jno. Trumbull. Copied from an Early Book which was Ruined by Damp," reprinted in *Yale University Library Gazette* 22 (April 1948): 116–23. For *Priam Returning*, begun with preliminary drawings in 1784, see ibid., sec. 2, no. 26. For *Blodget*, begun in 1786, see ibid., sec. 2, no. 29.

2. By the seventeenth century, French theoretician André Félibien had placed history painting at the top of a hierarchy of subject matter. See *Conferences de l'Academie Royale de peinture et de sculpture*, in *The Printed Sources of Western Art*, ed. Theodore Besterman (Portland, Ore.: Collegium Graphicum, 1972). Sir Joshua Reynolds confirmed the status of history painting in the fourth of his *Discourses on Art*. For general discussion of American history painters' contribution to creating a pantheon of heroes, see William S. Ayres and Barbara J. Mitnick, "Picturing History," *The Magazine Antiques* 144 (November 1993): 662–71.

3. Gore served as governor of Massachusetts in 1809 and as U.S. senator from 1813 to 1816. Helen Pinkney, *Christopher Gore, Federalist of Massachusetts, 1758–1827* (Waltham, Mass.: Gore Place Society, 1969). Trumbull called Gore his "only one, intimate acquaintance." John Trumbull, *Autobiography, Reminiscences and Letters by John Trumbull from 1756 to 1841* (New York and London: Wiley and Putnam; New Haven: B. L. Hamlen, 1841), 13.

4. Trumbull chose scene 24, 708. For general discussion, see Dora Wiebenson, "Subjects from Homer's *Iliad* in Neoclassical Art," *Art Bulletin* 46 (1964), 23–38.

5. *Iliad*. 24.20.

6. Trumbull's drawing of an earlier scene, "Priam in the Tent of Achilles," has also been recorded. Irma B. Jaffe, *John Trumbull: Patriot-Artist of the American Revolution* (Boston: New York Graphic Society, 1975), fig. 52.

7. At the end of the tale, Paris mortally wounds the Spartan hero Achilles in the heel.

8. David Steinberg, "Priam Returning to His Family, with the Dead Body of Hector," in *John Trumbull: The Hand and Spirit of a Painter*, ed. Helen A. Cooper (New Haven: Yale University Art Gallery, 1982), 247–48. Benjamin West's *Devout Men Taking the Body of St. Stephen*, 1776, London, Saint Stephen, Walbrook, is suggested as a possible source. Trumbull's *Priam Returning* was painted in West's London studio.

9. William Howe Downes, "Boston Painters and Paintings, I," *Atlantic Monthly*, July 1888, 96.

10. *Dictionary of American Biography*, ed. Dumas Malone (New York: Scribner's, 1936), 2:180–81. Samuel Blodget, a merchant, economist, and architect, was born in Goffstown, New Hampshire. After service in the Revolutionary War, he resigned from the militia on December 22, 1777.

11. Trumbull, quoted in Theodore Sizer, *The Works of Colonel John Trumbull: Artist of the American Revolution*, rev. ed. (New Haven: Yale University Press, 1967), 21.

12. Gene Gurney, *A Pictorial History of the United States Army in War and Peace, from Colonial Times to Vietnam* (New York: Crown, 1966), 14.

13. www.philadelphiabuildings.org.

14. Sir Joshua Reynolds, "Discourse IV" and "Discourse V" in *Discourses on Art*, ed. Robert R. Wark (New Haven and London: Yale University Press for the Paul Mellon Centre for Studies in British Art, 1997), 71–73, 82–84.

15. Wedgwood issued a trade catalogue illustrating this vase as a frontispiece in 1786. Snake-handled vases number among those ordered from the Wedgwood factory by Philadelphia merchant John Bringhurst in 1793. His customers included Thomas Jefferson and George Washington. See Harwood A. Johnson and Diana Edwards, "Ornamental Wedgwood Wares in Philadelphia in 1793," *The Magazine Antiques* 145 (January, 1994), 166–73.

16. Earl Cowper, King Ferdinand IV of Naples, Lord Auckland, the Duchess of Brunswick, and the Duke of York all had examples of this popular vase, among the most elaborate and expensive in production at the time.

17. Paul Sandby also caricatured the dancers by comparing a static male Greek statue ("out of fashion") to the Vestrises' exaggerated dance postures ("in fashion"). See etching with mezzotint (1781, Theatre Museum London, Harry R. Beard Collection, F.64-13).

18. David Solkin calls history painting "the only truly civic form of two-dimensional art" during the eighteenth century. See Solkin, *Painting for Money: The Visual Arts and the Public Sphere in Eighteenth-Century England* (New Haven and London: Yale University Press, 1993), 13.

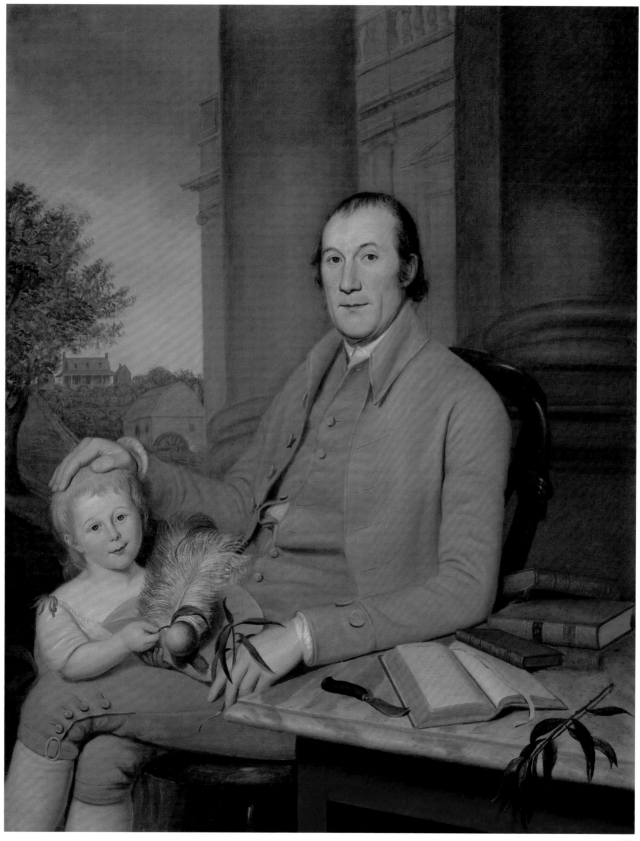

20

20. Charles Willson Peale (1741–1827)

William Smith and His Grandson, 1788

Oil on canvas

51 ¼ x 40 ⅜ in. (130.2 x 102.6 cm)

Signed and dated lower right: "C W Peale / paintd / 1788"

Museum Purchase, The Robert G. Cabell III and Maude Morgan Cabell
 Foundation and The Arthur and Margaret Glasgow Fund, 75.11

PROVENANCE: By descent through the family of the artist; to artist's great-granddaughter Anne von Kapff; Mrs. William D. Poultney, Garrison, Md.; Hirschl and Adler Galleries, New York, N.Y. (1975)

"Mr. Smith satt this mornig and he desires me to paint his grand son in the same piece," Charles Willson Peale noted in a diary entry of October 11, 1788.[1] Initially, the artist had agreed to depict only William Smith, a prominent Baltimore merchant and statesman soon to be elected to the first United States Congress.[2] The portrait was commissioned by Smith's son-in-law, General Otho Holland Williams, whose two-year-old son, Robert Smith Williams, was the suggested second figure. Peale completed the double portrait three weeks later. While it records pleasant likenesses of Smith and his young grandson, Robert, it also pictures candidate Smith as a worthy contender for political office in the New Republic: an educated citizen, a prosperous landholder, and a devoted family man.[3] Furthermore, the portrait offers an idealized vision of familial and societal blessings in post-Revolutionary America.

With his characteristic linear contours, clear lighting, and broad passages of muted color, Peale produced an image of confidence and solidity. He positioned William Smith firmly at center looking out with a gentle but commanding gaze. Smith lays one arm across a marble-top table; the other he extends to his grandson, resting his hand on the child's head with a gesture that is both affectionate and benedictory. The boy leans on his grandfather's lap, holding a ripe peach and his ostrich-plumed hat. Around them, artfully arranged views and objects communicate Smith's interests, both public and private. Imaginary columns and a classical facade frame his shoulders and head, denoting stability and civic virtue. At left is a glimpse of Eutaw, Smith's actual country estate, named for the Battle of Eutaw Springs, in which his son-in-law led a successful charge against the British seven years earlier. The tidy view includes a farmhouse, outbuildings, a mill, and an orchard.[4] At this rural retreat, four miles from the merchant's Baltimore residence, Smith assumed the role of gentleman farmer. The peach branch in his hand, the nearby pruning knife, and an open text titled *Gardening* underscore the sitter's avid interest in horticulture.[5] But peaches are not the only "fruit" of Smith's efforts. Having long cultivated wealth, property, knowledge, and a new democratic system in which to enjoy them, he also nurtures his progeny.

While it was Smith who requested to have his grandson pictured at his side, Charles Willson Peale likely proposed the painting's symbolic background and array of details. A product of the Enlightenment, Peale was keenly interested in the arts and sciences, as well as political, social, and human relationships. His neoclassical artistic training in London with Benjamin West (see cat. no. 3) also fostered a conviction that narrative portraiture could both commemorate and persuade. During the Revolutionary War, in which Peale served as a captain in a Pennsylvania militia, and the early years of a new nation, Peale's instructive imagery often evoked republican ideals and opportunity.[6]

The entrepreneurial artist saw himself as beneficiary of such opportunities. From his humble beginnings as a saddle maker and clock mender, Peale rose through the ranks to become a renowned painter of and friend to many of the country's leading military and political figures. In the mid-1780s, he opened a gallery in his Philadelphia residence featuring close to forty portraits of war heroes. Soon after, a growing interest in natural history led to his establishment of the Peale Museum, which intermingled images of great men with such objects as fossils and preserved specimens of birds and animals. While this endeavor occupied most of his energies for the remainder of his career, Peale encouraged many of his seventeen children—some with such ambitious names as Raphaelle, Angelica Kauffman, Rembrandt, and Titian—to become artists and naturalists as well.[7] Alongside that new generation, he also trained his youngest brother, James, as shop assistant, frame maker, and artist. The period frame on the Smith double portrait, in fact, may well have been made by James.[8]

Compared to his mentor-brother, James Peale was more versatile in subject matter, producing landscapes and still

FIG. 36 James Peale (1749–1831), **John Parke Custis,** ca. 1772, watercolor on ivory, 2½ x 2 in. (6.4 x 5.1 cm). Virginia Museum of Fine Arts, Gift of Mrs. A. Smith Bowman and her brother Robert E. Lee IV, 76.21.2.

lifes as well as oil portraits. He became most proficient in rendering portrait miniatures—the exacting practice of laying down a diminutive likeness in watercolor on ivory. For these, James built a significant clientele, but he also assisted Charles by making an occasional replica of his brother's earlier work—including an elegant miniature of John Parke (Jacky) Custis (fig. 36), stepson of George Washington.[9] When James created this replica in the early 1790s for the Washington-Custis family, Jacky was deceased, having succumbed to "camp fever," or typhus, during the siege of Yorktown. From Charles's miniature, James faithfully replicated the young man's features, but by enlarging his version an inch in each direction, he was able to add his own details to the sitter's cravat and embroidered waistcoat.[10]

Charles Willson Peale, like William Smith whom he so carefully delineated on canvas, consciously nurtured both nation and family. Enormously influential as painter, naturalist, and founder of the country's first museum, Peale and his creative dynasty of brothers, children, and grandchildren would help shape and enliven the early republic's cultural endeavors.

ELO

NOTES

1. An almost daily account of the painting's progress can be followed in Peale's diary notations between October 10 and November 4, 1788. *The Selected Papers of Charles Willson Peale and His Family,* vol. 1, *The Autobiography of Charles Willson Peale,* ed. Lillian B. Miller (New Haven: Yale University Press in association with the National Portrait Gallery, Smithsonian Institution, 2000), 538–45, 571, 636.

2. Congressional elections were held the following January. Pennsylvania-born William Smith settled in Baltimore in the 1760s. He actively supported the War of Independence, serving in the Second Continental Congress in 1777–78. In the postwar years, he participated in the successful campaign for Maryland's ratification of the new U.S. Constitution. A Federalist, Smith served one term in the First U.S. Congress, 1789–91. He was also first auditor of the Treasury in 1791, an elector in 1792, and Maryland state senator from 1801 to 1806. *The Documentary History of the First Federal Elections 1788–1790,* ed. Gordon DenBoer (Madison: University of Wisconsin Press, 1984), 2:104, 243.

3. For a consideration of the portrait in the context of Smith's heated 1788–89 election campaign, see Amy Speckart, "The Changing Landscape of Post-Revolutionary Politics: A Critical Examination of the Portrait of a Baltimore Merchant, *William Smith and His Grandson,* 1788" (unpublished seminar paper, College of William and Mary, 1997). I thank David Steinberg for bringing this study to my attention and Amy Speckart for allowing a copy to be deposited in the VMFA curatorial files.

4. In the first week of sittings, Peale took a day trip to Eutaw with General Williams to make field sketches. He notes in his diary that these were made with "the machine"—likely a camera obscura. *Selected Papers of Charles Willson Peale and His Family,* 494n2, 540. An extant drawing is pictured in Edgar Richardson, Brooke Hindle, and Lillian B. Miller, *Charles Willson Peale and His World* (New York: Abrams, 1982), 91, fig. 56.

5. The other books pictured are a volume of John Milton's poetry, James Beattie's *Essays on Trust,* and James Thomson's *Seasons.* For considerations of the painting's iconographical program, see Charles Coleman Sellers, "Monumentality with Love: Charles Willson Peale's Portrait of William Smith and His Grandson," *Arts in Virginia* 16 (Winter–Spring 1976): 14–21, and Brandon Brame Fortune, "From the World Escaped: Peale's Portrait of William Smith and His Grandson," *Eighteenth-Century Studies* 25 (Summer 1992): 587–615.

6. Lillian B. Miller, "The Peales and Their Legacy," in *The Peale Family, Creation of a Legacy, 1770–1870,* exh. cat., ed. Lillian B. Miller (New York: Abbeville in association with the Trust for Museum Exhibitions and the National Portrait Gallery, Smithsonian Institution, 1996), 19, 42–49. See also chapters 30 and 31 in Wayne Craven, *Colonial American Portraiture* (Cambridge: Cambridge University Press, 1986) and David Steinberg, "The Characters of Charles Willson Peale: Portraiture and Social Identity, 1769–1776" (Ph.D. dissertation, University of Pennsylvania, 1993), 131–32, 280.

7. On Peale's life and career, see Richardson et al., *Charles Willson Peale and His World* and Charles Coleman Sellers, *Portraits and Miniatures by Charles Willson Peale* (Philadelphia: American Philosophical Society, 1952).

8. Sellers, 197; William Adair, *The Frame in America, 1700–1900,* exh. cat. (Washington, D.C.: Octagon and American Institute of Architects Foundation, 1983), 46.

9. The miniature, which came into the VMFA collection as a work by Charles Willson Peale, was reattributed to James Peale in 1996 by Elle Shusan. While no documentation of its commission has been located, the replica was likely produced at the request of Martha Washington. It descended through her grandson, George Washington Parke Custis, to Mrs. A. Smith Bowman and her brother, Robert E. Lee IV, who donated it to the museum in 1976.

10. Sellers, 59–60. For a discussion of James Peale's life and career see Linda Crocker Simmons, "James Peale: Out of the Shadows," in *The Peale Family, Creation of a Legacy, 1770–1870,* 202–19.

Early Republic and Jacksonian Eras

21

21. Unknown Artist, called the Payne Limner (active ca. 1780–1803)

Alexander Spotswood Payne and His Brother John Robert Dandridge Payne, with Their Nurse, ca. 1790–91

Oil on canvas
56 x 69 in. (142.2 x 175.3 cm)
Gift of Miss Dorothy Payne, 53.24

PROVENANCE: Alexander Spotswood Payne (sitter); to William M. Payne; to Alexander Spotswood Payne; to Dorothy V. Payne, Roanoke, Va.

An unidentified artist produced this group portrait of two brothers and their nursemaid in rural Virginia at the end of the eighteenth century. Against a sky streaked with the fading light of day, eleven-year-old Alexander Spotswood Payne stands beneath an apple tree and proudly displays a woodpecker brought down by his bow and arrow.[1] Pristine in a tawny suit, rose waistcoat, and ruffled shirt adorned with a monogrammed pin, the boy is greeted by his brother, John Robert Dandridge Payne, and the family dog. The barefoot youngster toddles forward dressed in a linen infant shift. At right, a mindful African American girl, barefoot as well, reaches out to steady him. She wears the typical jacket-and-petticoat ensemble of a plantation house servant and a necklace of blue beads.[2]

The painting is one of ten canvases created for the Payne family of New Market, a large plantation in Goochland County, west of Richmond. Taking residence with the family for several months, the artist dutifully rendered images of third-generation planter Archer Payne; his wife, Martha Dandridge Payne; and their nine living children.[3] Almost nothing is known about the so-called Payne Limner, whose sobriquet stems from this substantial commission. While these and a handful of his other surviving portraits bear no mark or signature, they share stylistic similarities rendered in a thin, flat application of paint and linear contours. The artist took care to capture specific facial features of his subjects. However, a lack of formal training is apparent in his obvious struggle with anatomy, foreshortening, and modeling—resulting in his idiosyncratic presentation of shoulders, arms, and hands. Having some understanding of European pictorial conventions,

likely from prints, he crafted an ambitious conversation piece in his depiction of the Payne brothers and their attendant; nevertheless, he encountered challenges with the multifigure composition.[4] Close examination of the canvas reveals a repositioning of the older boy's bow, as well as the nurse's skirt and right foot. There may have been another impediment to the limner's abilities. Passing along family lore, a grandson of Alexander Spotswood Payne noted that the unnamed portraitist "was said to have considerable talent as a painter, but it was hard to keep him sober enough to do his work."[5]

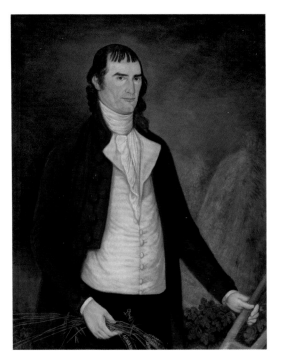

FIG. 37 Payne Limner (active ca. 1780–1803), **Archer Payne**, ca. 1790–91, oil on canvas, 40 ⅝ x 32 ¼ in. (103.2 x 81.9 cm). Virginia Museum of Fine Arts, Gift of Dorothy Payne, 69.34.

Whatever the circumstances of the commission, the artist readily captured the privileged world of an affluent Virginia planter. Archer Payne, master of New Market, was a man of significant property.[6] At the time his family members sat for their portraits, he owned a two-story manor house, 1,172 acres of productive land, and about two dozen enslaved laborers to maintain both.[7] For his own portrait (fig. 37), Archer is pictured as a gentleman farmer, wearing a tailored suit and standing before newly harvested haystacks. One hand holds a sheaf of wheat, the other the handle of a plow—proprietary

gestures that communicate the abundance of his property as well as his eligibility as a white male landowner to cast a vote in the newly formed republic.[8]

Abundance is also a theme in the portrait of Archer's sons. The landscape opens behind them, stretching through thick woods to a distant mountain.[9] Young Alexander, the eventual heir of New Market, is permitted to help himself to the land's fruit and game. His baby brother emerges from an imposing masonry edifice—apparently an imaginary one, as insurance documents indicate that the Payne residence was a five-bay frame building.[10] Nevertheless, on canvas, the masonry structure reiterates the family's stability and substance.

The edge of the wall visually separates the boys from the African American nursemaid, who serves as an additional symbol of the family's financial holdings.[11] The figure may represent a specific individual; detailed attention to the face indicates some study from a model. The girl's height suggests that she is close in age to Alexander—a nurse of children who is no more than a child herself.[12] On reaching age twelve she would qualify, alongside horses and carriages, as taxable property in Goochland County.[13]

The inclusion of this watchful but deferential figure underscores a long-entrenched racial hierarchy. For a century and a half, the order and prosperity of the South's agrarian economic system depended upon slave labor. Despite the era's revolutionary rhetoric about liberty and freedom—including the famous speech by Archer Payne's distant relation, Patrick Henry—the new United States ratified a constitution that extended the slave trade for another twenty years. Moreover, in determining congressional representation, the U.S. Constitution proclaimed that each enslaved man, woman, and child would be counted only as three-fifths of a human being.[14] In crowding the figure of the young nurse to the canvas edge, the limner inadvertently presents a likeness that represents three-fifths of a person.

For nearly a century, the Payne family owned slaves and systematically bequeathed them to their descendants.[15] Archer Payne's nephew John Payne, however, rejected the practice. As a converted member of the Society of Friends, informally known as Quakers, he became a staunch abolitionist. In 1783, Payne freed his slaves and relocated with his wife and teenage daughter, Dolley, to Philadelphia. Within a few years, the

Quaker-led Society for Effecting the Abolition of the Slave Trade in London approved a powerful antislavery emblem: a kneeling black man in chains surrounded by the words "AM I NOT A MAN AND A BROTHER?" English ceramic manufacturer Josiah Wedgwood produced the image as a jasperware cameo at his pottery factory. In 1788, he sent a shipment of medallions to Benjamin Franklin in Philadelphia. Throughout the following decades, the medallions became popular and persuasive political ornaments (fig. 38). In abolitionist circles, the John Payne family would have seen them worn as bracelets, pendants, and even inlaid on snuff boxes. In 1794, Dolley Payne married prominent Virginia planter, slave owner, and congressman James Madison. A key member of the 1787 Constitutional Convention, Madison, despite personal misgivings, drafted the compromise language that allowed the continuation of slavery as a legal institution in America. Upon marriage, Dolley Payne Madison, former Quaker and future first lady, assumed a new role as the mistress of slaves.[16] ELO

FIG. 38 Wedgwood Factory (est. 1759); William Hackwood (ca. 1757–1839), modeler; Henry Webber (1754–1826), designer, **Anti-Slavery Trade Medallion,** modeled 1787, manufactured early 19th century, blue-and-white jasperware. Museum Purchase, The Virginia Museum Art Purchase Fund, 2001.13.

NOTES

1. Employed as a visual indication of gender, a bow and arrow also signified a sitter's gentility in Anglo-American portraiture. See the discussion of Gilbert Stuart's portrait *Master Clarke* (1783–84, private collection) in Carrie Rebora Barratt and Ellen G. Miles, *Gilbert Stuart* (New York: Metropolitan Museum of Art, 2004), 44.

2. Enslaved children rarely received shoes. Clothing for house servants, including garments made of distinctive striped "Virginia cloth," was finer than the plain shifts typically issued to field workers, male and female alike. Linda Baumgarten, "'Clothes for the People,' Slave Clothing in Early Virginia," *Journal of Early Southern Decorative Arts* 14 (November 1988): 63–64, 68; Phillip S. Foner, *History of Black Americans: From the Emergence of the Cotton Kingdom to the Eve of the Compromise of 1850* (Westport, Conn.: Greenwood Press, 1983), 2:87, 118.

3. John, the toddler in the picture, was the last of Martha and Archer Payne's eleven children. Martha died in 1791, shortly after the portrait series was completed. Remarrying in 1797, Archer would father an additional four children. Of his fifteen offspring, nine would live to adulthood. "Register of Ages for Archer Payne Family, Goochland County, Virginia," transcribed by Robert W. Vernon, *Magazine of Virginia Geneaology* 41 (February 2003): back cover.

4. To date the most extensive consideration of this unidentified artist—primarily through formal analysis—is Elizabeth Thompson Lyon's "The Payne Limner" (M.A. thesis, Virginia Commonwealth University, 1981). Along with the canvases made for the Archer Payne family, she attributes three additional portraits to his hand: *Theodosia Cowley* and *Mary White* (both in private collections) and the *Ege-Galt Family Portrait* (Colonial Williamsburg), 46–61. Lyon also examines the work of a few contemporary limners and argues that "Joseph Badger deserves further study as a previously unidentified artist who worked in Petersburg and might have been the author of the paintings attributed to the Payne limner," 45.

5. John M. Payne, "Payne Portraits," *Virginia Magazine of History and Biography* 24 (April 1916): 200.

6. Archer Payne descended from a colonial governor on his mother's side and one of the first settlers and early justices of Goochland County on his father's side. Both he and his father were officers in the Goochland militia during the French and Indian War. For information about the Payne family, see Elie Weeks, "Hickory Hill," *Goochland County Historical Society Magazine* 9 (Autumn 1977): 2–11.

7. Weeks, "A List of the 1790 Land Tax of Goochland County," *Goochland County Historical Society Magazine* 3 (Autumn 1971): 8; "Goochland County Virginia 1800 Tax List," *Virginia Genealogist* 25 (April–June 1981): 109. This listing indicates that Archer Payne owned twenty-two slaves above the age of twelve. There is no record of the number of younger enslaved children.

8. The middle-sized plantation produced some tobacco, though the limestone soil of the Piedmont was better suited for grain. In 1778 Archer bartered 250 pounds of tobacco for an acre of land. Lyon, "Payne Limner," 64; Clifford Dowdey, *The Great Plantation: A Profile of Berkeley Hundred and Plantation Virginia from Jamestown to Appomattox* (New York: Rinehart, 1957), 276.

9. The hill or mountain—its indiscernible distance obscures scale—may be an imaginary feature added for picturesque effect. Phyllis Silber, director of the Goochland County Historical Society, notes that New Market (no longer extant) was located where such a vista is nonexistent. Telephone interview with author, December 10, 2004.

10. Mutual Assurance Society Policy, Goochland County, Virginia, November 19, 1801, no. 545, Library of Virginia, Richmond. I thank Christopher Oliver for his assistance in locating these and other documents related to the Payne family and this portrait.

11. For an examination of the controlled placement of doorways and edges of walls in images as demarcations of race and class separateness, see Elizabeth L. O'Leary, *At Beck and Call: The Representation of Domestic Servants in Nineteenth-Century American Painting* (Washington, D.C.: Smithsonian Institution Press, 1996), 59–65.

12. Depending on their aptitude for baby minding, such attendants could remain in the "big house" as nurses for successive children or be returned to the fields to work alongside other enslaved laborers. Elizabeth Fox-Genovese, *Within the Plantation Household, Black and White Women of the Old South* (Chapel Hill: University of North Carolina Press, 1988), 158.

13. "1800 Tax List," 109. Archer Payne was conscious of the monetary value of his human capital. In 1778 he petitioned the Virginia House of Delegates to be reimbursed for the cost of his slave, Sambo, who was shot and killed by county officials after a jail break. Petition of Archer Payne to the Virginia House of Delegates, November 13, 1778, Legislative Petitions, Goochland County, Virginia, PAR #11677805, cited in Loren Schweninger, ed., *The Southern Debate over Slavery* (Urbana: University of Illinois Press, 2001), 1:3.

14. Charles Johnson et al., *Africans in America: America's Journey through Slavery* (New York: Harcourt Brace, 1998), 41–42, 48, 201–2. In 1790, enslaved Africans and African Americans outnumbered the white population in Goochland County. "A List of the 1790 Land Tax," 2–3.

15. In 1775 Archer Payne inherited New Market, two tracts of land, and twenty-one enslaved African Americans from his father. "The Payne Family of Goochland," *Virginia Magazine of History and Biography* 6 (June 1899): 314; Lyon, "Payne Limner," 65. See also Weeks, "Hickory Hill," 2–11.

16. David B. Mattern and Holly C. Shulman, *The Selected Letters of Dolley Payne Madison* (Charlottesville and London: University of Virginia Press, 2003), 11–12, 17, 306; Hugh Honour, *The Image of the Black in Western Art* (Houston: Menil Foundation, 1989), 4:62–64. James Madison's 5,000-acre plantation in Orange County, thirty miles north of Archer Payne's New Market, was maintained by over one hundred enslaved laborers. Mattern and Shulman, 217–18.

22. Unknown Artisan

Armchair, ca. 1790–1800

Probably Northern Virginia

Mahogany inlaid with holly; yellow pine (secondary wood); reproduction wool-taffeta moreen upholstery

36½ x 24 x 20 in. (92.7 x 61 x 50.8 cm)

Museum Purchase, The Floyd D. and Anne C. Gottwald Fund, 95.81

PROVENANCE: H. Marshall Goodman Jr., Richmond, Va.

A testament to the rapid and pervasive influence of English design manuals during the late eighteenth century, this elegant shield-back armchair was produced in the American South only a few years after an image of its prototype was published in London. Following an almost decade-long hiatus imposed during the Revolutionary War and its aftermath, affluent citizens of the early republic were quite ready to reestablish cultural ties across the Atlantic. By 1800, a fervor for the dramatically fresh designs published in George Hepplewhite's *The Cabinet-Maker and Upholsterer's Guide* (1788) and Thomas Sheraton's *The Cabinet-Maker and Upholsterer's*

22

Drawing-Book (1791) had swept through the ranks of American cabinetmakers from New England to South Carolina.[1]

Furnishings reflecting the new fashion were markedly different from those of previous modes. Gone were the cabriole legs, undulating surfaces, and naturalistic carvings popularized by Chippendale's pattern book (see cat. no. 10). Instead, a cleaner, more austere style featuring delicate proportions and straight tapering legs predominated. Ornament was sparsely carved or—more typically—inlaid with contrasting woods in classically derived motifs such as swags, bellflowers, and

urns. The reform movement, inspired by archeological discoveries at the ancient Roman cities of Herculaneum and Pompeii, was introduced to wealthy English patrons by enterprising architects and interior designers Robert Adam and his brother, James. In turn, the attenuated neoclassical aesthetic was neatly incorporated into the furniture design of Hepplewhite and Sheraton.

The most striking element of the powerfully composed armchair in the VMFA collection is its bold shield-shaped back.[2] A variation of plate 9 in Hepplewhite's *Guide*, the

back has a rounded rather than pointed base. Supporting the serpentine crest rail, five ribs with flared tops radiate from a semicircle lunette. The chair's front legs are tapered, square in section, with modified spade feet—again from Hepplewhite, adapted from plate 1.[3] These extend above the seat and are tenoned into the arm supports. Imaginative inlays of blonde holly wood ornament the chair's back and front legs. A generous saddle seat—rare in southern furniture—completes the design. The present over-the-rail upholstery, a reproduction cover of wool-taffeta moreen, was attached by noninvasive application by the VMFA Objects Conservation Department. The brass nail–head trim conforms to evidence of tack patterns in the frame.

In the 1790s, the acquisition of such shield-back chairs helped signal a new standard of taste in the homes of America's elite. In furnishing Mount Vernon, George Washington ordered a pair of armchairs from Philadelphia; for Monticello, Thomas Jefferson turned to a New York cabinetmaker for a similar pair.[4] These Virginians did not have to look so far to find such sophisticated craftsmanship. This armchair—and its identical mate in the collection of Atlanta's High Museum of Art—is among the few surviving examples of early republic chairs crafted in Northern Virginia.[5] Further research may help substantiate an Alexandria or Georgetown provenance.[6]

The shield-back armchair complements VMFA's small but strong selection of early federal period furniture from the Old Dominion. A graceful mahogany and satinwood sideboard (fig. 39) exemplifies the wide reach of high-style Hepplewhite design into Virginia's Shenandoah Valley at the turn of the nineteenth century. Moreover, a pair of side chairs likely produced in Winchester at about the same time features a bold square-back Sheraton design (fig. 40).[7] ELO

FIG. 39 Unknown artisan, **Sideboard,** ca. 1790–1800, Virginia, mahogany with satinwood inlay. Virginia Museum of Fine Arts, Gift of Virginia Sargeant Reynolds, in memory of her son, J. Sargeant Reynolds, 82.13.

FIG. 40 Unknown artisan, **Pair of Side Chairs,** ca. 1810, possibly Winchester, Virginia, mahogany, yellow pine (secondary wood), 36 x 19 ¾ x 18 in. (91.4 x 50.2 x 45.7 cm) each. Museum Purchase, The Kathleen Boone Samuels Memorial Fund, 95.19.1–2.

NOTES

1. For an examination of furnishing styles in the early national period, see Charles F. Montgomery, *American Furniture: The Federal Period, in the Henry Francis du Pont Winterthur Museum* (New York: Viking, 1966).

2. Patricia Kane notes that the form described today as "shield-back" was called "vase" or "urn" in the late eighteenth and early nineteenth centuries. Patricia E. Kane, *300 Years of American Seating Furniture* (Boston: New York Graphic Society, 1976), 162.

3. George Hepplewhite, *The Cabinet-Maker and Upholsterer's Guide,* 3rd ed. (1794; repr., New York: Dover, 1969), plates 1 and 9.

4. Susan R. Stein, *The Worlds of Thomas Jefferson at Monticello* (New York: Abrams in association with the Thomas Jefferson Memorial Foundation, 1993), 270–71.

5. Following conversations in September 1995 with Ronald L. Hurst and Jonathan Prown of the Colonial Williamsburg Foundation, and John Bivins Jr., advisor to the Museum of Early Southern Decorative Arts, VMFA curator of American arts David Park Curry ruled out a Norfolk attribution in favor of Northern Virginia origins. For a consideration of regional influences and designs, see Ronald L. Hurst and Jonathan Prown, *Southern Furniture, 1680–1830: The Colonial Williamsburg Collection* (New York and Williamsburg: Abrams in association with the Colonial Williamsburg Foundation, 1997). Other significant studies include Wallace B. Gusler, *Furniture of Williamsburg and Eastern Virginia, 1710–1790* (Richmond: Virginia Museum of Fine Arts, 1979) and Ronald L. Hurst and Sumpter Priddy III, "The Neoclassical Furniture of Norfolk, Virginia, 1770–1820," *The Magazine Antiques* 137 (May 1990): 1139–52.

6. The difficulty of attribution stems from the era's expanding influence of transient mid-Atlantic cabinetmakers—those from New York, Philadelphia, and Baltimore, for example—on artisans practicing in Virginia cities like Georgetown, Alexandria, Winchester, and Norfolk.

7. The side chairs show a variation of plate 33 in Thomas Sheraton's *The Cabinet-Maker and Upholsterer's Drawing-Book* (1973; repr., New York: Dover, 1972).

23. Charles B. J. Févret de Saint-Mémin

(1770–1852)

Robert Greenhow Jr., ca. 1808

Pastel and crayon on toned paper

18 ⅜ x 14 in. (47.9 x 35.6 cm)

Gift of Mrs. William R. Scott, 98.3.3/3

PROVENANCE: Robert Greenhow, Sr.; to Mary Greenhow Lee, Baltimore, Md.; Hall Park McCullough, New York, N.Y.; to Ethel McCullough Scott (Mrs. William R. Scott), North Bennington, Vt.

When Charles B. J. Févret de Saint-Mémin arrived in Richmond in the summer of 1807, the itinerant artist encountered a bustling population of five thousand people.[1] He likely timed his extended stay to coincide with the sensational trial of Aaron Burr, who had been indicted for taking part in a treasonous conspiracy to create a Mississippi River empire. The trial attracted scores of visitors to the state capital, boosting the number of Saint-Mémin's potential clients. Upon opening his studio, he placed a newspaper ad "to inform the ladies and gentlemen . . . that he takes and engraves LIKENESSES in a style never introduced before, in this country." Offering directions to his rented rooms, he urged readers to make haste in securing an appointment, as "his stay in this place will be short."[2] During a residency that would last just over a year, 120 individuals sat for him—including merchants, planters, lawyers, and doctors. Among them were Williamsburg mayor Robert Greenhow; his wife, Mary Ann; and their eight-year-old son, Robert Jr.

Saint-Mémin's reputation preceded him. An aristocrat who found haven in the United States during the French Revolution, he trained himself as an artist—first mastering engraving techniques and then producing the occasional landscape (fig. 43). It was for his highly detailed and lifelike portraits, however,

FIG. 41 Charles B. J. Févret de Saint-Mémin (1770–1852), **Mrs. Robert Greenhow Sr. (Mary Ann Willis)**, ca. 1808, pastel and crayon on toned paper, 19 ⅝ x 13 ⅞ in. (49.8 x 35.3 cm) sight. Virginia Museum of Fine Arts, Gift of Mrs. William R. Scott, 98.3.1/3.

FIG. 42 Charles B. J. Févret de Saint-Mémin (1770–1852), **Robert Greenhow Sr.**, ca. 1808, pastel and crayon on toned paper, 19 ⅝ x 14 ⅛ in. (48.8 x 35.9 cm) sight. Virginia Museum of Fine Arts, Gift of Mrs. William R. Scott, 98.3.2/3.

23

FIG. 43 Charles B. J. Févret de Saint-Mémin (1770–1852), **View of Richmond**, ca. 1805, etching with wash, 13 ¼ x 21 ¾ in. (33.7 x 55.2 cm). New York Public Library.

that the Frenchman gained renown in the New Republic. After successful years in New York and Philadelphia, he traveled south to secure patrons in Baltimore, Washington, D.C., Richmond, and Charleston. By the time of Napoleon's abdication in 1814, when Saint-Mémin returned permanently to France, he had produced nearly a thousand images of America's elite, including many of the luminaries of his day.[3]

To achieve the immediacy and naturalism so highly prized by his sitters, Saint-Mémin employed an unusual but efficient approach. Aided by descriptions published by French inventors, he built a physiognotrace—a mechanical apparatus that aided the artist in replicating an exact profile.[4] Once he laid down his subject's contour, Saint-Mémin then sketched in the features and costume. Using a pantograph, he could also reduce the original drawing within a two-inch circle on a engraving plate to create prints. For a cost of $25 to $45, the sitter would receive the large crayon portrait, the copperplate, and one dozen proofs. For an additional fee, the artist also provided a simple gilded frame outfitted with his distinctive reverse-painted glass mat.[5]

Young Robert's charming portrait—like those of his mother and father (figs. 41 and 42)—was finely rendered with black crayon on pink-tinted paper. The youngster's plump cheeks, shell-like ear, and soft ruffled collar are shaped with delicate hatchings and given additional volume with white highlights. While the artist's practiced style is unmistakable, the Greenhow portraits and several other of Saint-Mémin's

Richmond images exhibit a broader, looser chalk stroke than that seen in his earlier works—the result, perhaps, of pressure to complete numerous portraits quickly.[6]

Saint-Mémin was able to take full advantage of a growing American appetite for profile imagery, ranging from simple silhouettes cut from black paper to fully realized drawings and paintings. This fashion followed European neoclassical taste. Intense interest in the ancient world produced artistic re-creations of Greek-figured vases and Roman-profile coins and cameos—notable among the latter is Josiah Wedgwood's porcelain jasperware (see fig. 35). The enthusiasm for classicized profiles gained further impetus when Swiss pastor Johann Casper Lavater published his three-volume *Essays on Physiognomy for the Promotion of the Knowledge and Love of Mankind* in 1775–78 (English edition, 1778–79). The study, which promoted the analysis of a person's character from the shape of his or her face, gave "scientific" justification to the rendering and examination of profiles—another appeal to reason in this Age of Enlightenment.[7]

The trio of Greenhow portraits takes on a note of poignancy when one considers the family's subsequent story. Robert Greenhow Sr. relocated his household in 1810 to Richmond, where he eventually served as mayor. The following year, Mary Ann became one the many victims of the tragic Richmond Theatre fire, from which father and son barely escaped. Robert Jr. grew to be a man of many interests and talents. Trained as both a physician and attorney, he also edited a newspaper, worked as a translator for the U.S. State Department, and served as a federal land commissioner. Before his death in San Francisco in 1854, he wrote histories of Oregon, California, and Tripoli.[8]

ELO

NOTES
1. The artist's full name was Charles Balthazar Julien Févret de Saint-Mémin.
2. The most comprehensive survey of the artist's life and work is found in Ellen G. Miles, *Saint-Mémin and the Neoclassical Profile Portrait in America* (Washington, D.C.: Smithsonian Institution, 1994). For an examination of his Richmond interlude, see Fillmore Norfleet, *Saint-Mémin in Virginia: Portraits and Biographies* (Richmond, Va.: Dietz Press, 1942). Saint-Mémin's 1807 Richmond ad, reprinted in Miles, 165, appeared in the *Virginia Argus*, July 15, and the *Enquirer*, July 17 (thereafter appearing in the latter twice a week until August 14).
3. President Thomas Jefferson was arguably the artist's most prominent subject. In 1804, the president's daughters wrote to him from Monticello, urging: "We had both thought you had promised us your picture if ever St. Mémin went to Washington. If you did not know what a source of pleasure it would be to us while so much separated from you to have so excellent a likeness . . . you would not I think

refuse us," quoted in Miles, 131–32. Jefferson complied; his portrait drawing and print are pictured as figs. 65 and 66 in Susan R. Stein, *The Worlds of Thomas Jefferson at Monticello* (New York: Abrams in association with the Thomas Jefferson Memorial Foundation, 1993), 198–99.

4. The device included a metal rod that traced the length of the sitter's profile. Saint-Mémin likely re-created the mechanism and method developed in France by Gille-Louis Chrétien and his partner, Edme Quenedy. Quenedy's sketch of a physiognotrace is reproduced in Miles, 42. Saint-Mémin was not the first artist to use such an apparatus in America. In the 1790s, other French émigrés were producing machine-assisted portraits. American competitors emerged after 1800—notably Charles Willson Peale and his sons, who used a similar device designed by Englishman John Hawkins. Ibid., 61–66, 99–112.

5. Norfleet, 11–56.

6. Miles, 171. VMFA is fortunate to have additional examples of Saint-Mémin's Richmond portraits in its holdings, including crayon profiles of Creed Taylor, Sara de Graffenreid Woodson Taylor, and Jacob Kinney and engraved images of William H. Cabell and Nicholas Cabell Jr.

7. Ibid., 27–38.

8. The seventy-two victims of the disastrous theater fire—including the Commonwealth's governor—were buried in a mass grave. The site, marked by a neoclassical urn, was transformed into the portico of Monumental Episcopal Church, designed by Robert Mills and dedicated in 1814. Robert Greenhow Sr. became a vestryman and lifelong communicant of the new parish. Norfleet, 168–69. [Monumental's first rector was the Reverend Richard Channing Moore—son of Thomas Moore, pictured as a child by Henrietta Johnston (see cat. no. 2.)] For more information about the fire, see Virginius Dabney, *Richmond: The Story of a City,* rev. ed. (Charlottesville: University Press of Virginia, 1990), 90–92.

24. Unknown Artisan

Grecian Couch, 1815–25

Probably Philadelphia, Pennsylvania

Maple; original blue-green paint, yellow paint, gilt decoration; original
 English gilt brass mounts by Messenger and Sons, Birmingham,
 England; reproduction rush seat

32 ¼ x 66 ¼ x 19 in. (81.9 x 168.3 x 48.3 cm)

Museum Purchase, The Floyd D. and Anne C. Gottwald Fund, 2002.523

PROVENANCE: Private collection, New England; Carswell Rush Berlin, Inc.,
New York, N.Y. (by 1999)

24

Like the ancient Greeks and Romans, who were fond of reclining on couches to dine, the nineteenth-century owners of "fancy furniture"—lightweight hardwood pieces enlivened with color and pattern—embraced refined leisure. These festive seating pieces were occasionally used outdoors, but more often, suites of this delicately painted and stenciled furniture graced elegantly appointed neoclassical interiors.[1]

Couches—typically higher at one end to facilitate reclining—were the most elaborate form in a suite of fancy furniture. Alternately called a "chaise longue" or "recamier," after Jacques-Louis David's famous 1800 portrait of Madame Recamier stretched out on a similar piece (Musée du Louvre), the couch assumed the practical function of the eighteenth-century daybed.[2] Couches were made either as singles or in pairs or, more typically, en suite with several armchairs and a large number of side chairs. Surviving examples are scarce; rarer still are grained and painted ones.[3]

As early as 1811, Rudolph Ackerman's *Repository* published a design for an upholstered version of the couch. The British designer called the piece a "very elegant Grecian sofa, adapted for the library, boudoir, or any fashionable apartment; the frame either in mahogany, ornamented with or-molu, or rosewood, &c."[4] Ackerman's attribution of a Greek source was deliberate. In the early nineteenth century, European designers embraced *le goût grec* (the Greek taste). This particular wave of neoclassicism swept England, the Continent, and then America, celebrating ancient Greece for its purity of design.[5]

The scrolling arm, curved sides, and swept-back saber legs of the VMFA couch recall the simple, elegant lines appreciated in Greek forms—particularly the *klismos* chairs pictured on ancient vases (fig. 44). The painted surface, however, is an American treatment favored in Boston, New York, Philadelphia, and Baltimore.[6] The overall blue-green coating, applied directly to the maple frame, is detailed with stenciling, painted outlines, and gilding.[7] Substantial gilded spheres appear beneath the rear armrest and under each foot. Smaller spheres punctuate the ball-and-bar stay rails at either end. The ormolu mounts on the seat rail—cast brass palmettes and cornucopias derived from published images of an ancient frieze fragment at Albani near Rome—are identical to the applied ornaments on a pair of Argand lamps made by Messenger and Sons of Birmingham, England. The mounts exemplify the

FIG. 44 Attributed to the Felton Painter, **Red-figured Squat Lekythos** (detail), 4th century BC, Greek, South Italian (Apulian), glazed terra-cotta, 12½ x 6½ in. (31.8 x 16.5 cm) dia. Virginia Museum of Fine Arts, Gift of the Lipman Foundation, 91.24.

FIG. 45 Unknown artisan, **Pair of Side Chairs,** ca. 1830–40, possibly Baltimore, painted wood, original resist-dye cotton upholstery, 33 ⅜ x 17 ¾ x 19 ¼ in. (84.8 x 45.1 x 48.9 cm) each. Museum Purchase, The Adolph D. and Wilkins C. Williams Fund, 76.40.3–4.

widespread adaptation and mixing of neoclassical elements by artisans on both sides of the Atlantic.[8]

As the demand for fancy furniture continued into the nineteenth century, American cabinetmakers produced imaginative high-style painted pieces. A pair of side chairs in the VMFA collection (fig. 45) retain a faint echo of the Greek Revival in their saber-shaped rear legs. The painted crest rails, however, feature charming trompe-l'oeil images that emulate the carved curvilinear details favored in newly fashionable Rococo Revival furnishings of the 1840s. The chairs have also kept their original slip seats and resist-dye upholstery.

DPC

NOTES

1. For more on "fancy furniture," see Sumpter Priddy, "Early Fancy Furnishings," in *American Fancy: Exuberance in the Arts, 1790–1840* (Milwaukee, Wis.: Chipstone Foundation, 2004), 37–80; Wendy A. Cooper, "American Painted Furniture: A New Perspective on Its Decoration and Use," *The Magazine Antiques* 161 (January 2002): 212–17.

2. When arms of even height bracket the seat, the piece is called a sofa. French examples of the Grecian couch may date from as early as 1788, with English examples following close behind by 1795. Dated 1815–25, VMFA's couch is early for an American example.

3. No related blue-green pieces from this suite have as yet come to light. The only other painted Grecian couch in a public collection is a bright red example at the Brooklyn Museum, part of a suite divided among the collections of Brooklyn, the Metropolitan Museum of Art, and Winterthur Museum. That couch is pictured in Dean A. Fales Jr. et al., *American Painted Furniture, 1660–1880* (New York: E. P. Dutton, 1972), 144–45, fig. 236. Other related couches, either faux grained or left in natural wood (usually maple), are in the collections of the Carnegie Museum of Art, New York; Philadelphia Museum of Art; Lemon Hill, Philadelphia; and the Telfair Museum, Savannah, Georgia.

4. Rudolph Ackermann, "A Library Couch," *Repository of Arts* (March 1811): 161, plate 25.

5. Hugh Honour, *Neo-classicism* (1968; repr., London: Penguin Books, 1977), 58–62; Roger Kennedy, *Greek Revival America* (New York: Stewart, Tabori and Chang, 1989), 269–75.

6. After examining period side chairs with ball-and-bar stay rails of similar construction, early republic furniture scholar and vendor Carswell Rush Berlin suggests that this couch—as well as the red Grecian couch at the Brooklyn Museum—was likely produced in Philadelphia. VMFA curatorial files.

7. The original finish, revealed during restoration, was long hidden under a black overpaint—an "ebonized" coating that, along with the replaced rush seat, was likely an 1880s addition prompted by the later Aesthetic movement taste. The original seat may have been rush as well. See Cynthia V. A. Schaffner and Susan Klein, *American Painted Furniture, 1790–1880* (New York: Clarkson Potter, 1997), 13.

8. A line drawing of the fragment is published in Charles Heathcote Tatham, *Examples of Ancient Ornamental Architecture* (London, 1799), plate 13. Similar mounts ornament the grained couches made for Picnic House in Pittsburgh—now, with other pieces of the suite, in the collection of the Cathedral of Learning at the University of Pittsburgh. One of the couches is pictured in Cooper, *Classical Taste in America*, exh. cat. (Baltimore: Baltimore Museum of Art and New York: Abbeville, 1993), 140. The Argand lamps are in the collection of Carswell Rush Berlin, New York.

25. Unknown Artisan

Fall-Front Secretary, ca. 1820–25

Probably New York, New York

Rosewood, mahogany, pine, tulip poplar; gold leaf, brass, marble, glass, baize, leather, lead, steel

63 ⅞ x 36 x 18 ½ in. (160 x 91.4 x 47 cm)

Museum Purchase, The Adolph D. and Wilkins C. Williams Fund, 99.43

PROVENANCE: Hirschl and Adler, New York, N.Y.

Architectural proportions and a careful selection of luxurious materials—book-matched rosewood veneers, cut-brass bandings, sculptural gilded mounts, and pure white marble—transform this drop-front secretary, or *secrétaire à abattant*, from what is fundamentally a large, rectangular box into a visually striking desk (fig. 46). As chic and costly as the high chest and tall clock had been during the eighteenth century, it ranks among the most imposing of all furniture forms. The desk also signals the growing importance of French design in American furniture and underscores the complexities of the cabinet-making trade in federal America.

VMFA's desk is one of nine similar case pieces currently attributed to a still-unnamed New York cabinetmaking shop.[1] They all share certain construction details, such as tiny, refined dovetailing of interior drawers. Their general aesthetic subordination of parts to the whole—with controlled distribution of ormolu mounts and string banding on vertically oriented cases bracketed by base-to-cornice columns—argues for predominately French influence. Yet each of the nine differs in the orchestration of materials. While some are veneered with highly figured mahogany—a typical French choice—five, including the VMFA example, are covered in costly rosewood more characteristic of English Regency furniture.[2]

French ideas, like British ones, reached American shores through the usual print sources, particularly, as in this case, Pierre de la Mésangère's *Collections des Meubles et Objets de Goût*, a periodical published between 1796 and 1830.[3] Moreover, during the French Revolution and the subsequent consulat period from 1799 to 1804, émigré craftsmen in search of political and economic stability relocated to America, bringing with them fresh ideas as well as direct links to sophisticated French artistic circles. Prominent among them were

Jean-Charles Cochois and his first cousin Charles-Honoré Lannuier, who came from a family of well-established Parisian cabinetmakers. Work by émigrés challenged the British-inspired designs of such established New York cabinetmakers as Duncan Phyfe.[4]

The American vogue for cabinets in the French style was nurtured by the personal tastes of leading political figures—Benjamin Franklin, Thomas Jefferson, and James Monroe among others.[5] Monroe, for example, while minister to France

FIG. 46 View of cat. no. 25, desk open.

from 1794 to 1797, acquired a suite of French furniture in the rather tailored *gôut moderne* (now called *directoire* style). It included a *secrétaire à abattant*, placing the form at the forefront of high-style taste in federal America.[6] After being elected president in 1817, he ordered a suite of French furniture for the White House to ameliorate ravages suffered during the War of 1812. Despite the whiff of republicanism that *directoire* pieces carried on their polished mahogany surfaces,

his choice was controversial. Some Americans felt Monroe should have patronized craftsmen in his own country.[7] Certainly, as the VMFA desk makes clear, fine American furniture in the French taste was available during his years in office, and these cabinets are comparable in quality of execution to the best French production.[8]

Touched by *le goût moderne*, the VMFA drop-front desk also reflects the French movement toward a richer, more ornamental style called *le goût antique.* Massive and monumental, the *antique* style recognized and drew upon ancient architectural forms during an age of increasing interest in archeology. Even though the desk retains the simple elegance of the *moderne* style, it partakes of classical architectural principles of symmetry and balance. Its gilt-brass Corinthian capitals topping engaged plinths with square bases signal the designer's awareness of *le goût antique.*

Although the piece recalls the classical past, the cabinetmaker relied on recent technologies to achieve its beauty. Machinery for cutting large thin sheets of veneer woods had reached sophisticated heights, as had the equipment for producing cut-brass banding. The latter was hailed as one of the great advances in decoration, achieved by the French late in the eighteenth century. Influential collector and designer Thomas Hope praised this development so extensively that it was soon imitated in Britain. Both French and English brass work was available to cabinetmakers in New York.

The waters of historical design are further muddied on consideration that print sources influencing American cabinetmakers reached Europeans as well. Germans, including Jean-François Oeben, a cabinetmaker practicing in Paris, helped popularize the fall-front secretary on the Continent. Not wholly "French" or "English" in influence, the VMFA cabinet bears the strong impression of Germanic Biedermeier design, and it was made after German cabinetmakers had begun migrating to America.[9]

In the end, VMFA's beautiful fall-front desk and its cousins may be most revealing of the material, philosophical, and aesthetic complexities of the nineteenth-century American cabinetmaking trade. The lack of a precise attribution for these highly important secretaries suggests that furniture making of the period was more accomplished and less concentrated than previously thought—as would befit a nation

informed by dramatically changing demographic trends and internationally mobile makers and tastes.　　　　DPC

NOTES

1. Scholars have discussed coeval fall-front cabinets made in Philadelphia, where they were called "French secretaries," in the *Philadelphia Book of Prices* of 1828. See Robert C. Smith, "The Furniture of Anthony G. Quervelle, Part IV: Some Case Pieces," *The Magazine Antiques* 105 (January 1974): 180–93; Charles L. Venable, "Germanic Craftsmen in Philadelphia," in *American Furniture* (1998), ed. Luke Beckerdite, 41–80. Colonial Williamsburg owns a William and Mary style fall-front desk made in Philadelphia and branded "Edward Evans 1707."

2. Among French cabinetmakers of the period, including Charles-Honoré Lannuier, mahogany was the wood of choice, and it seems to dominate the French-inspired work produced in other American cities. The fall-front desk made in Boston, ca. 1820–1825, for the Beacon Hill mansion of David Sears, now in the Art Institute of Chicago, is closely aligned to the French in its use of highly patterned mahogany veneers. Wendy Cooper, *Classical Taste in America, 1800–1840*, exh. cat. (Baltimore: Baltimore Museum of Art, 1993), 163. See also Peter M. Kenny, *Honoré Lannuier, Cabinetmaker from Paris: The Life and Work of a French Ebéniste in Federal New York*, exh. cat. (New York: Metropolitan Museum of Art, 1998), 91.

3. Examples of fall-front desks were illustrated in 1803, 1804, and 1823, plates 57, 101, 563.

4. Peter Kenny compares the group of drop-front desks with rosewood veneer, including the VMFA example, favorably with Lannuier's work in his definitive study of the French émigré cabinetmaker, but notes that "Lannuier's large and splendidly documented legacy of surviving work . . . allows us to affirm with a high degree of certainty that none of these other rosewood examples is by him. This knowledge, however, only raises more questions as to whether other makers were following Lannuier's lead, or whether he was borrowing from them. The very existence of this other extremely ornate furniture reminds us to be careful about casting Lannuier as a monolithic presence in New York" (91). Among those who attribute the secretaries to Phyfe, Lannuier is sometimes discussed as a source of inspiration. VMFA curatorial files.

5. For Jefferson's interest in French decorative arts, see Susan R. Stein, *The Worlds of Thomas Jefferson at Monticello* (New York: Abrams in association with the Thomas Jefferson Memorial Foundation, 1993), 300ff.

6. For illustration, see Lee Langston-Harrison, *A Presidential Legacy: The Monroe Collection* (Fredericksburg, Va.: James Monroe Museum, 1997), 83. See also Clement E. Conger and Betty C. Monkman, "President Monroe's Acquisitions," *Connoisseur* (May 1976): 56–63.

7. See Lucius Wilmerding Jr., "James Monroe and the Furniture Fund," *New-York Historical Society Quarterly* 45 (April 1960): 133–49. Although *le goût moderne* was understood by contemporaries to be a republican antidote to the florid court style of the ancien régime, Peter Kenny speculates that some Americans considered the style "too risky a choice" because it carried with it "connotations of the excesses of the French Revolution" 91.

8. Cooper, 265.

9. Venable, 60–68. The author discusses the fall-front secretary as "A Case Study in European Influences." He notes that a "Biedermeier aesthetic" marked by a "strange geometric core and French and English undercurrents" has thrown a wrench into American decorative arts scholarship (56). Many Germans migrated to the United States after 1820. Nearly 125,000 came in the 1830s, followed by nearly half a million between 1840 and 1850. See *Art and the Empire City: New York, 1825–1861*, exh. cat., ed. Catherine Hoover Voorsanger and John K. Howat (New York: Metropolitan Museum of Art, 2000), 289. As cutting-edge designs, the VMFA desk and its fellows were made at the outset of massive German immigration.

26. John James Audubon (1785–1851)

Carolina Parrot, ca. 1828
From The Birds of America, 1827–38

Hand-colored engraving, etching, and aquatint on rag paper

38 ⅝ x 25 ¾ in. (98.1 x 65.4 cm)

Inscribed: "No. 6. [. . .] Plate, 26 / Carolina Parrot, Males 1. F. 2. Young. 3. / sitacus Carolinensis / Plant Vulgo. Cuckle Burr. / Drawn from Nature & Published by John J. Audubon, F. R. S. E. M. W. S. / Engraved, Printed, & Coloured by R. Havell & Son, London."

Watermark: J. Whatman, Turkey Mill, 1828

Gift of Alma and Harry H. Coon, 2000.108

PROVENANCE: Sold at auction by Sotheby's, New York, N.Y. (January 28, 1988, lot no. 631); sold at auction by Christie's, New York, N.Y. (January 26, 1995, lot no. 225); Alma and Harry H. Coon, Manquin, Va.

The name Audubon is easily associated today with conservation advocacy, particularly the study and preservation of birds. It also brings to mind such tour-de-force ornithological imagery as *Carolina Parrot*, an intricate composition laid down with meticulous detail and sure lines.[1] That the commanding influence of John James Audubon lingers a century and a half after the artist's death is not surprising. Emerging as America's foremost artist-naturalist after the publication of his *Birds of America* in the 1830s, Audubon captured the public's imagination. Some believed that the émigré artist was the dauphin, heir to the French throne who had been spirited to the United States at the time of the Revolution—he was not. Others thought that the self-described "American Woodsman" was the protégé of the renowned painter Jacques-Louis David in the Old World and companion to Kentucky pioneer Daniel Boone in the New—tall tales put forward by the painter himself.[2] In truth, the details of Audubon's life and accomplishments prove extraordinary in their own right, with no need for romantic embellishment.

Born in Haiti as the illegitimate son of a French sea captain, Audubon was raised and educated as a gentleman by his father and stepmother in Nantes. Sent to America in 1803 to avoid conscription into Napoleon's army, he found little success in business but gained "an innate desire to acquire a thorough knowledge of the birds of this happy country."[3] Through the 1810s and 1820s, he supported himself and his young

PLATE 26.

Carolina Parrot

PSITTACUS CAROLINENSIS.

Plant Vulgo Cockle Burr

26

family first by operating a store and flour mill in Kentucky and then by teaching art, dancing, and fencing, as well as painting portraits and signboards in Louisiana. During these years Audubon envisioned and began his "Great Work"—the study and delineation of every bird species then known in America.[4]

By the mid-1820s, the determined artist had traversed much of the American terrain in order to observe, capture, mount, and draw hundreds of varieties of birds. Traveling and working incessantly, Audubon made as many field sketches from life as possible, but for the most part he created his studies from specimens that he shot and mounted. In an era when the discipline of ornithology was still in its infancy, he resolved to picture each bird in its actual size and coloring. But he also ventured beyond visual accuracy and strove to present the figures in aesthetically pleasing compositions. Following positive response to early exhibitions of his watercolors, Audubon went abroad to find a publisher for his images.[5] In 1827, he commissioned the London firm of R. Havell and Son to print his series using a complicated process of engraving, etching, and aquatint, followed by hand coloring.[6] An extremely ambitious endeavor that took eleven years to complete, *Birds of America* eventually comprised 435 plates that were released serially in eighty-seven groupings of five prints each. Audubon also decided to maximize the visual impact of the engravings by having them produced in double-elephant folio size—just over three by two feet—"and finished in such superb style as to eclipse all the kind in existence."[7]

To fund the long-term project, the artist traveled extensively through England, France, and America to sell subscriptions for the series. He wrote to his wife of his successes, which included securing patronage from the kings of both France and England as well as an order from the U.S. Congress. Abroad, he gained admission into the company of other naturalists and was named a fellow of the Royal Society of London. But it was encouragement from prominent French painter François Gérard that warmed him especially. "You are the king of ornithological painters," this "Brother in Arts" told him, "Who would have expected such things from the woods of America!" In his letter home, Audubon noted that Gérard uttered the compliment after examining his study of the Carolina parrot.[8]

FIG. 47 John James Audubon (1785–1851), **Grey Fox,** 1843, from *The Viviparous Quadrupeds of North America,* hand-colored lithograph on rag paper, 21 x 27 in. (53.3 x 68.6 cm). Virginia Museum of Fine Arts, Gift of Alma and Harry H. Coon, 2002.577.

In *Carolina Parrot*—or "Carolina Parakeet," as Audubon annotated the watercolor on which this large engraving was based—the artist presents seven birds amid the brambles of a cocklebur bush. The multiple poses permit the viewer to examine the bright green plumage from many angles. The bird positioned at top left was a female, captured and sketched by the artist near Bayou Sarah, Louisiana, about 1825. As the penciled inscription on his original study indicates, Audubon was intrigued with his subject, noting that it "appeared so uncommon having 14 Tailfeathers all 7 sizes distinct and firmly affixed in 14 different recepticals [sic] that I drew it more to verify one of those astonishing fits of nature than anything else."[9] In his 1831 *Ornithological Biography,* the five-volume narrative text that he published separately from his engraved plates, Audubon expounds on parakeet behavior. Describing the species' habit of flocking together in trees, he records the birds' manner of "moving sidewise, climbing or hanging in every imaginable posture, assisting themselves very dexterously in all their motions with their bills."[10] In less than a century after Audubon committed their images to paper, these engaging birds—once plentiful across the southeastern and Ohio Valley regions—were extinct. The last captive Carolina parrot died in the Cincinnati Zoo in 1918,

and the final sighting of the vibrant bird in the wild came two years later.[11]

The completion of *Birds of America* in 1838 coincided with the closing of the era of grand aquatint color folios in both Europe and America.[12] Audubon turned to the new and less expensive process of lithography to replicate his portfolio in a smaller octavo edition (1840–44), which was published by J. T. Bowen, in Philadelphia. At the same time, the aging artist, assisted by his sons, Victor and John Woodhouse Audubon, and naturalist John Bachman, began studies of the nation's mammals. His far-ranging search for specimens included an expedition to western territories along the Missouri and Yellowstone Rivers. The resulting *Viviparous Quadrupeds of North America* imperial portfolio (1845–48, also published by J. T. Bowen) featured 150 hand-colored lithographs, including the superb *Grey Fox* (fig. 47). Sadly, Audubon suffered a stroke in 1847, and its effects prevented him from comprehending his final great accomplishment by the time the last volume was published.[13] ELO

NOTES

1. The print is one of twenty-seven double-folio engravings from *Birds of America* (Havell, London, 1827–39) and eighteen folio lithographs from *The Viviparous Quadrupeds of North America* (Bowen, Philadelphia, 1845–48) that comprise the generous donation given to VMFA by Alma and Harry H. Coon between 2000 and 2003.

2. Theodore E. Stebbins Jr., "Audubon's Drawings of American Birds, 1805–38" in *John James Audubon: The Watercolors for Birds of America*, ed. Annette Blaugrund and Theodore E. Stebbins Jr. (New York: Villard, Random House in association with the New-York Historical Society, 1993), 18.

3. John James Audubon, "Account of the Method of Drawing Birds," *Edinburgh Journal of Science* 8 (1828): 48, quoted in Stebbins, 7.

4. Stebbins, 3–13. For a detailed biography of Audubon, see Richard Rhodes, *John James Audubon: The Making of an American* (New York: Vintage, 2006).

5. Stebbins, 11–16; Rhodes, 148–59.

6. Joseph Goddu, "The Making of Audubon's *Birds of America*," *The Magazine Antiques* 162 (Nov. 2002): 112–21.

7. Quoted in Rhodes, 273. In 2002, it was determined there were 120 complete editions of *Birds of America* extant worldwide. Susanne Low, *A Guide to Audubon's "Birds of America"* (New Haven: William Reese Company; New York: Donald A. Heald, 2002), 3, 10.

8. Rhodes, 302, 315–16, 339; Maria R. Audubon, *Audubon and His Journals* (1897; repr., New York: Dover, 1994), 1:330.

9. Carole Anne Slatkin, "Carolina Parakeet," in Rhodes, 154. The figure with a solid green head is an adolescent bird. Low, 45.

10. John James Audubon, *Ornithological Biography, or an account of the habits of the birds of the United States of America* (Edinburgh, Scotland: Adam Black, 1831–39), 1:137.

11. Slatkin, 154.

12. Goddu, 120.

13. Rhodes, 430–32.

27. Robert Salmon (1775–ca. 1848/51)

Dismal Swamp Canal, 1830

Oil on wood panel

11 x 15 in. (27.9 x 38.1 cm)

Signed lower right: "R. S."

Inscribed on back: "No. 650 / Painted by R. Salmon / 1830"

Gift of Eugene B. Sydnor, Jr., 88.161

PROVENANCE: Hirschl and Adler Galleries, New York, N.Y. (1973); Eugene B. Sydnor Jr., Richmond, Va.

English-born Robert Salmon had been in the United States for less than two years when he painted this small but lively view of the Dismal Swamp Canal, a channel constructed to traverse the Virginia–North Carolina border. The fifty-five-year-old artist had already built a reputation on both sides of the Atlantic for his beautifully executed and highly detailed marine scenes. In previous decades—during which he lived in Liverpool, London, and Greenock, Scotland—Salmon had become one of Britain's most prolific painters of ships and harbor life. After settling in a wharf-side studio in Boston, he easily gained exhibition opportunities, favorable newspaper reviews, and steady American patronage.[1]

While seascapes and harbor views had been part of the American painting tradition since colonial times, Salmon found an especially warm reception in a young country where domestic and international maritime trade was expanding at a brisk pace. In his imagery, he employed the low horizon, clear light, and spatial recession that he learned from studying seventeenth-century Dutch and eighteenth-century English seascapes. Salmon, however, was less concerned with portraying the sea itself than providing crisp portraits of specific vessels or recognizable features of particular ports.[2] His large-scale panoramic *Boston Harbor from Castle Island (Ship Charlotte)* (fig. 48) of 1839 does both. Like many of his other paintings, it records the appearances and activities of the sailors, fishermen, and stevedores who populated the waterfront.[3]

Although more intimate in scale, *Dismal Swamp Canal* fully captures the Jacksonian era's bright optimism and confidence in technology and commerce. Beneath sunny skies and a fluttering oversize flag, the steam-powered *Lady of the Lake* makes its way up the narrow channel, its stacks emitting

27

clouds of smoke over a canopied hull filled to capacity with sightseers. A strong wind propels sailboats on either side and generates whitecaps on the water's surface—these set down in a scalloped-wave pattern characteristic of Salmon's paintings. From the canal-side Lake Drummond Hotel, fashionably attired figures interrupt promenades and conversations or lean out from upstairs windows to observe the spectacle.[4]

In 1829, the year before Salmon created his painting, the canal had made national headlines. President Andrew Jackson journeyed to the site to help mark completion of the twenty-two-mile commercial waterway that skirts the eastern boundary of the Great Dismal Swamp. After three decades of fund-raising, legal challenges, and intermittent construction, the engineering feat successfully linked Albemarle Sound to the Elizabeth River and the Chesapeake Bay. At the time, the funding of such "internal improvements"—this one supported jointly by private shareholders, two states, and the federal government—prompted heated debate between Democrats and the nascent Whig coalition.[5]

Long before such political considerations, the site had already entered the popular imagination—not as a locus of cheerful, bustling commerce, but as a place of mystery, danger, and intrigue. The Great Dismal Swamp, a vast bog that then comprised close to seven hundred square miles, had been described in the eighteenth century by William Byrd II and George Washington, each having negotiated its murky terrain during boundary surveys. Irish poet Thomas Moore immortalized the area with his romantic 1803 ballad describing dead lovers whose spirits could be seen paddling a white canoe on Lake Drummond "at the hour of midnight damp." That eerie narrative inspired popular prints as well as a large oil painting—also in the VMFA collection—entitled *Dismal Swamp* (fig. 49), created in 1840 by self-taught Connecticut painter George Washington Mark.[6] The site also earned notoriety through its unusual boundary-straddling location that attracted eloping lovers and dueling foes looking to sidestep the law by simply walking across the state line. The Lake Drummond Hotel, so prominently featured in Salmon's painting, was known for facilitating such nefarious activities. Also called "The Half-way House," this "large and commodious" inn offered guests rooms that were situated in either Virginia or North Carolina.[7]

FIG. 48 Robert Salmon (ca. 1775–ca. 1848/51), **Boston Harbor from Castle Island (Ship Charlotte)**, 1839, oil on canvas, 40 x 60 in. (101.6 x 152.4 cm). Museum Purchase, The Adolph D. and Wilkins C. Williams Fund, 73.14.

FIG. 49 George Washington Mark (1795–1879), **Dismal Swamp,** 1840, oil on canvas, 38 x 48 in. (96.5 x 121.9 cm). Virginia Museum of Fine Arts, Gift of Edgar William and Bernice Chrysler Garbisch, 70.1.

Salmon's *Dismal Swamp Canal* presents a surprising choice of subject considering the artist's usual American imagery set in and around Boston. As his own account book suggests, the painter did not travel south to capture the scene in person but relied on newspaper descriptions and an on-site sketch by Norfolk, Virginia, artist Thomas Williamson.[8] Salmon's catalogue listing, penned in his idiosyncratic spelling, documents completion of the painting as well as his desire to have it rendered into a print: "No. 650, 8 ½ day the Dismall swamp Canell, to lend to Pendelton for lithegrap. 5." The print was

indeed produced by William Pendleton, the owner of Boston's leading lithography shop for whom Salmon occasionally worked.[9] However, the print—only slightly different from the painting—carried Williamson's name, not Salmon's. In November 1830, the *Norfolk and Portsmouth Herald* announced the new lithograph's availability through subscription from a local publisher and praised it for conveying the canal's "importance as an avenue of commercial enterprise and agricultural prosperity."[10] (In short time, the image became an icon of progress, appearing in miniature form on the paper currency of several states—typically paired with a depiction of a steam locomotive.[11]) Whether Salmon agreed in advance that Williamson would be credited for the printed image or felt the sting of disappointment afterward, he was pleased enough with his painting to send it to the 1832 annual exhibition at the Boston Athenaeum.[12] ELO

NOTES

1. Born in Whitehaven, county of Cumberland, the artist developed his reputation under his given name Salomon, which he changed to Salmon just before his relocation to Boston. John Wilmerding, *Robert Salmon, Painter of Ship and Shore* (Salem, Mass.: Peabody Museum of Salem and Boston Public Library, 1971), 14–36.

2. For a consideration of American marine imagery, see Roger B. Stein, *Seascape and the American Imagination* (New York: Clarkson N. Potter in association with the Whitney Museum of American Art, 1975). Stein locates Salmon within a highly commercial era that valued empiricism, 54–63.

3. John Wilmerding, "Robert Salmon's 'Boston Harbor from Castle Island,'" *Arts in Virginia* 14 (Winter 1974): 14–27.

4. Fred Brandt and John Wilmerding, *American Marine Painting,* exh. cat. (Richmond: Virginia Museum of Fine Arts, 1976), 14, 37, no. 9; Wilmerding, *Robert Salmon,* 75.

5. Bland Simpson, *The Great Dismal: A Swamp Memoir* (New York: Henry Holt, 1993), 102–7; Arthur Charles Cole, *The Whig Party in the South* (Washington, D.C.: American Historical Association; London: Oxford University Press, 1913), 8–9, 88–89.

6. Mark based his painting on a late 1820s engraving by Henry Inman. James C. Kelly and William M. S. Rasmussen, *The Virginia Landscape: A Cultural History* (Charlottesville, Va.: Howell Press in association with the Virginia Historical Society, 2000), 80–85.

7. Simpson, 110–15.

8. R. Lewis Wright, *Artists in Virginia before 1900: An Annotated Checklist* (Charlottesville: University Press of Virginia for the Virginia Historical Society, 1983), 180.

9. Wilmerding, *Robert Salmon,* 40, 91.

10. An April notice in the Norfolk paper indicated that Pendleton had possession of the Williamson sketch, along with a commission by local publisher C. Hall, to transform it into a lithographic image "in the best style of the celebrated artists who have it in hand." As the notice coincides in time with Salmon's account book entry, it is likely that he is the unnamed artist who was contracted to compose the image. "Canal Views," *Norfolk and Portsmouth Herald,* April 30, 1830, 2; "View on the Canal," *Norfolk and Portsmouth Herald,* November 22, 1830, 2. A rare copy of the lithograph is in the collection of the Mariners' Museum, Newport News, Virginia. I thank Jeanne Willoz-Egnor, director of collections management, for sharing information from that museum's curatorial records.

11. In following decades, the canal image appeared on paper currency issued in Virginia, Delaware, Maryland, Indiana, New York, New Jersey, and Alabama. John A. Muscalus, *The Dismal Swamp Canal and Lake Drummond Hotel on Paper Money, 1838–1865,* (Bridgeport, Pa.: Historical Paper Money Research Institute, 1965), n.p.

12. Wilmerding, *Robert Salmon,* 104.

28. Thomas Jefferson Wright (1798–1846)

Elizabeth Thatcher Corbin Major of "Fairview" Plantation, Culpeper County, Virginia, 1831

Oil on canvas

28 ⅛ x 24 in. (71.1 x 61 cm)

Signed lower right in white rectangle: "Jeff: Wright / Painter 1831"

Museum Purchase, The Adolph D. and Wilkins C. Williams Fund, 88.61.2/2

29. Thomas Jefferson Wright (1798–1846)

William Major of "Fairview" Plantation, Culpeper County, Virginia, 1831

Oil on canvas

28 ⅛ x 24 in. (71.1 x 61 cm)

Signed lower right in white rectangle: "Jeff: Wright / Painter 1831"

Museum Purchase, The Adolph D. and Wilkins C. Williams Fund, 88.61.1/2

PROVENANCE (both paintings): By descent to the LaRue family, Rippon, W. Va.; Frank Horton, Winston-Salem, N.C.; Museum of Early Southern Decorative Arts, Winston-Salem, N.C.; Sumpter Priddy III, Richmond, Va.

In both style and subject, solidity distinguishes these 1831 portraits of William and Elizabeth Major, master and mistress of Fairview plantation in Culpeper County, Virginia. Their creator, Thomas Jefferson Wright, captured his sitters' solemn likenesses with unbroken lines and opaque passages of pigment. In three-quarter seated poses, the figures are presented against flat gray backgrounds. Their jet-black garments are relieved with white accents that define William's spotless shirt, tie, and waistcoat as well as Elizabeth's intricate lace collar and cap. Touches of color ease the otherwise somber palette: the bright red of his upholstered chair and the intense blue of her cap ribbons and embroidered scarf. A flash of gold

28

29

buttons and jewelry suggest that the couple's financial circumstances are as firm as their steadfast gazes.[1]

In the tradition of earlier itinerant portraitists—including the Payne Limner (see cat. no. 21)—Wright resided at the home of his sitters during the commission of multiple family portraits. He remained at Fairview for approximately two years.[2] How the Kentucky-born artist came to be recommended to the Majors in central Virginia is unknown. In the previous decade, Jeff Wright—as he often signed his canvases—was active in his native state as a portraitist, sign painter, and carpenter. Evidently self-taught, he did come to know Lexington portraitist Matthew Jouett, from whom he

gained a letter of introduction to renowned painter Thomas Sully in Philadelphia. "You will find Mr. W. amiable, modest," Jouett described the young artist, "although entirely devoid of the graces of early learning."[3] While the anticipated meeting with Sully is undocumented, Wright did make his way to the mid-Atlantic region by 1828. Following his extended stay with the Majors a few years later, the artist relocated to Houston, where he gained the influential patronage of Sam Houston, president of the Republic of Texas. Wright became a leading portraitist to the new, independent nation's prominent citizens, whose images he presented in a similarly forthright, simple manner.[4]

While the portraits of William and Elizabeth Major reveal the artist's lack of training (shoulders and hands, for example, are anatomically awkward), they nevertheless convey much about the sitters. In presentation and detail, Wright not only positioned his subjects well within the prosperous ranks of Virginia's landed gentry, he also communicates a dutiful adherence to prescribed middle- and upper-class gender roles. In William's portrait, the artist inserts a glimpse of what is likely the couple's original residence on Fairview plantation.[5] This story-and-a-half frame dwelling establishes the sitter's status as a landowner, which, in the commonwealth of Virginia, also denotes his eligibility to vote in this era before universal white male suffrage. Pictured in a domestic setting, William is also symbolically located outside the home where he—and the viewer—may regard the residence from a distance. Elizabeth, however, is firmly situated within. The vista over her shoulder reveals a walkway leading toward a white-picket perimeter fence and gate. Her love of cultivated nature, suggested by the tidy ornamental plantings outside, is echoed in the floral patterns of her collar and scarf. Despite prevailing social and pictorial conventions that consigned the Majors to separate spheres—the male world of public discourse and business and the private female realm of home and family—each wielded considerable power.[6]

From historical accounts, William Major was as commanding in person as he appears on canvas. The seventh-generation Virginia planter stood six and one-half feet tall and weighed close to 250 pounds. By the time he sat for his portrait at age fifty-seven, he had increased his landholdings to two thousand acres. His three farms yielded crops of tobacco, wheat, oats, flax, and corn—all maintained and harvested by a workforce of seventy-one enslaved laborers. In addition to managing his properties and supporting a large, ever-growing family, William served as justice of the peace, an appointment that he held for over forty years. Meeting each month, he and fellow justices performed as the legislators, judges, and administrators of Culpeper County. Wright pictures him holding a newspaper, folded back to the "From Europe" column, underscoring William's interest in regional, national, and even international affairs.[7] The inclusion of the paper also hints at the Virginian's political leanings. Published in Washington, D.C., the *National Intelligencer* was the central

mouthpiece for a growing anti-Jackson coalition that officially formed itself into the Whig Party in 1834.[8]

As her portrait suggests, Elizabeth Major was an equally authoritative figure. Wright captures her as a seasoned fifty-two-year-old matron who had successfully endured two decades of bearing and raising nine children—all of whom reached adulthood. Elizabeth's matriarchal responsibilities were great, extending also to the medical care, food, clothing, and shelter of the plantation's large slave community.[9] When provisions were not before a mistress's watchful eye, they

FIG. 50 Unknown artisan, **Key Basket,** ca. 1830–60, probably Virginia, embossed, appliquéd, and stitched leather, 9 x 9 x 6 in. (22.9 x 22.9 x 15.2 cm). Virginia Museum of Fine Arts, Gift of Franklin P. Watkins and Miriam Hill by exchange, 95.80.

fell under her lock and key. The region's custom of providing new wives with leather key baskets—including a beautifully tooled example in the VMFA collection (fig. 50)—grew from the very prosaic need to organize and transport heavy bunches of household keys. Wright, however, indicates his sitter's interest in concerns more spiritual than practical. The mistress of Fairview rests her hand on the family Bible, with reading glasses ready for scriptural study. A staunch Baptist, Elizabeth may have experienced the intense wave of religious fervor that swept the United States during the early decades of the nineteenth century—a phenomenon often referred to as the

Second Great Awakening. Assuming the role of moral guardian of the family would have also been in keeping with conventional expectations concerning the duties of wife and mother.[10]

Elizabeth Major defied the doctrine of separate gender spheres—specifically the idealized notion that women were to be protected from the taint of commerce—in her management of the estate's financial affairs after the death of her husband. For twenty-two years, and to the consternation of her grown sons, she kept the account books of the plantation farms and mills.[11] "She was a very capable woman, very stern and feared by all her nine sons and daughters. Yet she seemed to have been very kind to her grandchildren, for my father . . . lived with her at Fairview as a boy," wrote Julian Neville Major. This great-grandson also noted that after her death at age eighty-nine in 1869, the Fairview residence remained unoccupied until it collapsed from neglect in 1915. It housed beautiful furniture, china, and even silk dresses and small satin shoes, yet no one "entered the house to disturb them for fear of 'Old Miss.'"[12] In Elizabeth's steely blue-eyed gaze, one might comprehend a strength of personality that could persist a half century beyond the grave. ELO

NOTES

1. During his time at Fairview between 1831 and 1833, Wright produced at least three sets of the portraits of William and Elizabeth—the other two pairs are still owned by descendants. Each painting has slight differences in detail. In what are likely the original images taken from life, William holds a snuffbox and wears a dark waistcoat; Elizabeth sports a full-circle lace fichu on her shoulders and a square scarf pinned at her throat. Her cap is drawn lower over her forehead, and the family Bible sits on a table behind her. The VMFA portraits, which appear to be the second set from the September 7, 1831, date on the newspaper, are described above. The third set, bearing a date of October 7, 1831, pictures William in a dark waistcoat again. A table in the scene holds a quill pen and inkwell sitting atop a volume of *The Virginia Justice*. The view behind him shows what must be the more substantial Fairview house, built ca. 1810; the garden behind Elizabeth features deciduous trees rather than the pointed cypresses shown in the other versions. This last set of portraits is illustrated in James Russell Richards Major, *A Major Family of Virginia* (Fernandina, Fla.: Wolfe, 1998), frontispiece and 183. I extend thanks to Mrs. Blair Rogers Major for sharing her insights about the portraits and for the gift of this book, written by her husband, a great-great-grandson of the sitters. Mrs. Major also imparted the traditional family belief that there are additional copies of the portraits, whereabouts presently unknown.

2. At Fairview, Wright also painted portraits of the couple's daughter Frances; sons William II, Wingfield, and Langdon; and two grandsons (canvases presently in family collections). There may be others, at this time undocumented and unlocated. Major, 220–21; Patty Willis and Edward Phillips, "Jefferson County Portraits and Portrait Painters," *Magazine of the Jefferson County Historical Society* 6 (1940): 34.

3. Letter from Matthew H. Jouett to Thomas Sully, November 12, 1822, Pennsylvania Historical Society, cited in Pauline Pinckney, *Painting in Texas: The Nineteenth Century* (Austin and London: University of Texas Press for the Amon Carter Museum of Western Art, 1967), 17.

4. During his twelve years in Texas, where Wright also served variously as an Indian agent and a major in the republic's militia, his reputation as a painter grew. His efforts culminated in an 1837 exhibition of a *Gallery of National Portraits*—the focal point of which was his full-length image of George Washington. Sam Houston repeatedly displayed that canvas during political speeches. Ibid., 12–15. Pinkney's *Painting in Texas* offers the most thorough consideration of Wright's life and career to date.

5. This is a rather modest dwelling compared to the substantial two-story stone manor house that William had built at Fairview ca. 1810. The choice to picture the frame structure in this canvas may represent a sentimental homage to the cabin in which he and Elizabeth resided in their early years of marriage. Major, 182, 208–9. For a 1915 photo of the later Fairview, see Major, 212. That grand five-bay, four-chimney residence is also shown in the third version of William's portrait, pictured in the frontispiece of the same book.

6. As social historian Carl Degler has argued, American marriages became more companionate in the first three decades of the nineteenth century. As before, men still enjoyed political, social, legal, and economic rights denied their wives, mothers, daughters, and sisters, but women played an increasingly influential role as moral leaders in the home. Degler points out, however, that the "cult of true womanhood" was an idealized middle-class construct put forward in novels, essays, and articles—and oftentimes not grounded in the diverse circumstances of actual home life. Carl N. Degler, *At Odds: Women and the Family in America from the Revolution to the Present* (New York and Oxford: Oxford University Press, 1980), 8, 27–28, 378. For an overview of recent scholarship concerning nineteenth-century American gender roles, see Linda K. Kerber, "Separate Spheres, Female Worlds, Woman's Place: The Rhetoric of Women's History" in *No More Separate Spheres!*, ed. Cathy N. Davidson and Jessamyn Hatcher (Durham, N.C., and London: Duke University Press, 2002), 29–65.

7. The pictured newspaper matches the masthead, date, and issue number (4663) of the *National Intelligencer* issue printed September 7, 1831, with a notable exception: the "From Europe" column of the actual newspaper was moved to the top right corner—artistic license on the part of Wright to underscore his sitter's broad interests.

8. Major and his sons were supporters of the Whig Party, whose states' rights stance garnered substantial support from southern planters. Major, 189–90; Arthur Charles Cole, *The Whig Party in the South* (Washington, D.C.: American Historical Association and London: Oxford University Press, 1913), 8–9, 88–89.

9. At the time of his death in 1847, William's estate was valued at $53,000—of which $24,300 represented capital tied up in slaves. Major, 200–201.

10. Degler, 300.

11. Major, 199; Julian Neville Major, "The Majors of Virginia and Their Connections" (unpublished manuscript, 1937, Library of Virginia), 19.

12. Portrait history, unpublished document written by Julian Neville Major, November 15, 1949, private collection, VMFA curatorial files. For an additional description of the house's demise, see Major, 272.

30. Attributed to **Joseph Meeks and Sons**
(active 1829–35)

Pier Table, ca. 1829–35

New York, New York

Pine; gold leaf, white marble, mirrored glass

37 x 66 ¾ x 23 ½ in. (94 x 169.5 x 59.7 cm)

Museum Purchase, The Adolph D. and Wilkins C. Williams Fund, 77.9

PROVENANCE: Peter Hill, East Lempster, N.H.

The grand scale and gilded surface of this high-style classical pier table exude upper-class American taste during the second quarter of the nineteenth century. Priced at $90, the table is one of forty-four items advertised in the Joseph Meeks and Sons 1833 broadside (fig. 51).[1] The firm's diverse offerings reveal the period's evolution in technology and trade as well as the burgeoning expectations of fashionable consumers. The company claimed to serve clients "from Boston to New Orleans," far beyond the immediate reach of its "wholesale and retail furniture trade" on New York's Broad Street.[2]

30

FIG. 51 **Broadside,** 1833, New York, Joseph Meeks and Sons, designer; Endicott and Swett, publisher, hand-colored lithograph, 21 ½ x 17 in. (54.6 x 43.2 cm). The Metropolitan Museum of Art, Gift of Mrs. R. W. Hyde, 1943 (43.15.8).

Much more elaborate than its engraved counterpart (fig. 52), the pier table features lyre-form supports flanked by sweeping acanthus-carved scrolls before a mirrored back (fig. 53). The reflective surface augmented the natural light that filtered through the pier's flanking windows. The box shape of the stretcher, which rests above acanthus-scrolled feet, is reiterated in the apron, where raised molding and ornamental appliqués signal the influence of French Empire pattern books.[3] With its overall gilding and white marble top, the table displays the fashionable splendor recommended in 1821 by Rudolph Ackerman in his monthly periodical *Repository of Arts, Literature, Commerce, Manufactures, Fashions and Politics* (1809 – 29).[4] Informed by the work of Charles Percier and Pierre-François-Leonard Fontaine (see cat. no. 33), whose designs were widely disseminated through serial printings from 1801 to 1812, Ackerman's *Repository* was the cornerstone of English Regency taste. It included plates by cabinetmakers such as Thomas Hope and George Smith and inspired related pattern books like Smith's *The Cabinet-maker and Upholsterer's Guide.*[5] The Meeks firm adopted a number of designs from

FIG. 53 Detail of cat. no. 30.

Smith's sourcebook, including plate 98, *Occasional Table II* (fig. 54), on which this impressive pier table is based.

The bold language of the classical style complemented the stately residences of nineteenth-century America's urban neighborhoods. Although oral tradition places this pier table in a Fifth Avenue town house, it might just as easily have graced the townhome of a southern planter. The increased

FIG. 54 George Smith (ca. 1786–1826), **Occasional Table II,** plate 98, from *The Cabinet-Maker and Upholsterer's Guide,* 1827. Smithsonian Institution, Cooper-Hewitt, National Design Museum Library.

marketing of northern goods in the South was fueled by a number of sociopolitical policies that curtailed the importation of European manufactures.[6] The subsequent emphasis on domestic trade meant that well-heeled southerners "too much prejudiced in favour of British manners, customs, and knowledge" were compelled to look north for their luxury furnishings.[7] New York, the largest exporter of southern agricultural goods, was a ready resource for southern planters already in business with local merchants and bankers. In 1811, Margaret Manigault of Charleston, South Carolina, having received shipment of a set of gold-and-white painted chairs from New York, exclaimed: "When I want chairs again, I shall certainly send to New York for them!"[8]

In response to such demand, Joseph Meeks was quick to offer large numbers of mid- and high-end goods through venture cargo or commission.[9] By 1799, he and his brother Edward were working in Savannah with "Mr. Clay," to whom the firm's speculative goods were likely consigned for local sale.[10] By 1820, Meeks had expanded operations into New Orleans, the center of the burgeoning Mississippi River trade.[11] The success of northern retailers in southern markets had much to do with the highly erratic but economically influential cotton market, which supported the appetite for luxury goods. As the South Carolinian Robert Gage described

the prosperity of the period, "everybody is as rich as Rothschild and can buy what he pleases."[12] Nonetheless, southerners dressed their homes according to an aesthetic distinction between "town" and "country."[13] In 1819, Charleston upholsterers Barelli, Torre and Company were forced to advertise "ELEGANT WINDOW CURTAINS . . . with gilt cornices and an Eagle in the center" that were refused by a local gentleman because they were "too rich a Furniture for his Country Seat."[14] Grander, Empire-inspired objects with inlay, gilding, and bronze mounts—largely imported—were decidedly "urban" effects.[15] More modest solid-wood or veneered objects in the Grecian "plain style" were the accepted mode for rural residences, including Greek Revival plantation homes.[16] Works like VMFA's classical center table by North Carolina cabinetmaker Thomas Day (see cat. no. 49), a contemporary of J. and J. W. Meeks, although suitable for less formal town rooms, were uniquely appropriate for the country. In answer to these differences, Meeks offered both options.[17]

By 1840, the influence of ornate French Empire design on American classicism had begun to wane in favor of a simplicity inspired by the French Restoration.[18] The accompanying demand for specialized materials and labor—and, by extension, foreign and northern imports—likewise subsided.[19] As John Hall's 1840 *Cabinet-Maker's Assistant* suggests, the "pillar and scroll" style of late "Grecian" classicism—with its simple single and double scrolls, bold supports, little or no carving, and band-sawed, thick-cut curves—was financially and technically accessible to even the most modest households and cabinetmaking concerns. For these reasons, the style persisted well into the 1850s, side by side with the emerging fashion for Gothic and rococo designs.[20] SJR

NOTES

1. The same table with an "Egyptian marble top" was advertised for $110.

2. For more information on the Meeks family and an outline of the firm's listings in New York City directories, see John N. Pearce, Lorraine W. Pearce, and Robert C. Smith, "The Meeks Family of Cabinetmakers," *The Magazine Antiques* 85 (April 1964): 417. See also Jodi Pollack, "The Meeks Cabinetmaking Firm in New York City: Part 1, 1787–1835," *The Magazine Antiques* 161 (May 2002): 102–4, and Elizabeth Feld and Stuart Feld, *In Pointed Style: The Gothic Revival in America, 1800–1860* (New York: Hirschl and Adler Galleries, 2006), 55. Meeks sold goods in Boston, Baltimore, Alexandria, Charleston, Savannah, and New Orleans. He may also have had distributors in South America. See John Pearce and Lorraine W. Pearce, "More on the Meeks Cabinetmakers," *The Magazine Antiques* 90 (July 1966): 70. Obituary of Joseph Meeks, *New York Herald*, July 24, 1868, quoted in Pearce, Pearce, and Smith, 417.

3. For example, "Recueil des dessins d'ornements d'architecture," published by Joseph Beunat about 1813 and reprinted as *Empire Style Designs and Ornaments* (New York: Dover, 1974). See plates 17 and 18 for tables of this type. A similar gilded pier table with white marble top was commissioned by President James Monroe from important Parisian cabinetmaker Pierre-Antoine Bellangé for the White House Oval Room. See Betty C. Monkman, *The White House: Its Historical Furnishings and First Families* (New York and London: Abbeville Press for the White House Historical Association, 2000), 59–62, fig. 63.

4. Robert C. Smith, "Late Classical Furniture in the United States, 1820–1850," *The Magazine Antiques* 74 (December 1958): 521.

5. First published in London by Jones and Company, 1826.

6. Maurie D. McInnis and Robert A. Leath, "Beautiful Specimens, Elegant Patterns: New York Furniture for the Charleston Market, 1810–1840," *American Furniture* (1996), ed. Luke Beckerdite, 141.

7. John Drayton, *A View of South-Carolina* (Charleston, S.C.: W. P. Young, 1802), 217, quoted in McInnis and Leath, 137.

8. Margaret Izard Manigault of Charleston to Alice Delancey Izard of New York, December 22, 1811, quoted in McInnis and Leath, 141.

9. An announcement in the *Columbian Museum and Savannah Advertiser*, March 6, 1798, suggests as much. Later in the decade, retail venues and special commissions largely supplanted the venture cargo trade. See Forsyth M. Alexander, "Cabinet Warehousing in the Southern Atlantic Ports, 1783–1820," *Journal of Early Southern Decorative Arts* 15 (November 1989): 30, cited in Pollack, 109n13; McInnis and Leath refer specifically to the Charleston venture cargo trade, 144.

10. According to Alexander, from the turn of the century until 1820, about thirty firms had warehouse operations in Savannah, the majority with New York origins. Alexander, cited in Pollack, 109n16. See also Pollack, 105.

11. Between November 22, 1820, and February 22, 1821, the *Louisiana Gazette* advertised: "J MEEKS respectfully informs the inhabitants of New-Orleans and its vicinity, that he has just opened a warehouse, at No. 23 Charter [sic] street, where he offers for sale an elegant assortment of New-York Cabinet Furniture, Received per Ship Bellona, and warranted New-York manufacture." According to Pollack, the firm likely maintained its warehouse on Chartres Street until 1839. Pollack, 109nn19–20.

12. Robert I. Gage to James M. Gage, April 3, 1836, cited in Lacy K. Ford Jr., *Origins of Southern Radicalism: The South Carolina Upcountry, 1800–1860* (1988; repr., New York: Oxford University Press, 1991), 37.

13. Alicia Hopton Russell Middleton to Euretta Barnewall Middleton, July 31, 1834, Cheves-Middleton Papers, South Carolina Historical Society, Charleston, cited in McInnis and Leath, 146n20.

14. McInnis and Leath, 142.

15. By 1830, the new classical fashions of Europe were almost immediately available in America by way of imports and pattern books. These informed the innovative Meeks circular and the *New York Price Book* of 1834, the first of its kind to include complete images of furniture designs. Smith, 522.

16. The French Restoration period (1814–48) included the reigns of Louis XVIII (1814–24), Charles X (1824–30), and Louise-Philippe (1830–48). The "Grecian plain style" in America was largely coincident with the reign of Louis-Phillipe. The erratic cotton market caused alternate prosperity and depression during the first half of the nineteenth century. It also motivated a steady migration of cotton farmers farther south into Georgia, Alabama, and Mississippi. See Ford, 7, 12–14, 37–39, 216.

17. An 1835 center table with a Deming and Bulkley label derives from the same model as Day's, reproduced in McInnis and Leath, 166.

18. In America, a lighter, neoclassical style (ca. 1785–1815) gave way to a more ornate, archeologically based classicism akin to English Regency and French Empire designs, ca. 1815–40. This style in turn evolved and gave way to a simplified and weighty "Grecian" taste (ca. 1835–50) similar to that produced in England and France during the reigns of William IV and Louis-Phillipe, respectively.

19. The staple-crop foundation of the late-eighteenth- and early-nineteenth-century southern economy began diversifying in the 1850s with improvements in transportation, banking, and commerce. Ford, 216. See also McInnis and Leath, 145.

20. Two years after John Hall's *Cabinet Maker's Assistant* was published in Baltimore in 1840, the New York cabinetmaker Robert Conner published his own *The Cabinet Maker's Assistant* including Gothic and rococo references. By the time of New York's 1853 Crystal Palace Exhibition, the Gothic and Rococo Revivals had largely displaced the "pillar and scroll" style. Celia Jackson Otto, "Pillar and Scroll: Greek Revival Furniture of the 1830s," *The Magazine Antiques* 81 (May 1962): 505–7; Smith, 522–23.

31. Charles Koones (1791–1857)

Table, ca. 1830

Alexandria, Virginia

Carved and veneered mahogany; amboyna and rosewood veneers; oak, pine, mahogany (secondary woods); stenciled gold leaf, red paint; brass casters

29 ½ x 44 in. (74.9 x 111.8 cm)

Inscribed in white chalk script on underside of table above latch: "MRM" or "WRM"

Labeled: "Charles Koone's Cabinet, Chair & Sofa Manufactory / King next door to the corner of Alfred St. Alexandria / Mahogany Chairs and every article in the Cabinet line at moderate prices"

Museum Purchase, Bequest of John C. and Florence S. Goddin, Bequest of Lillian Thomas Pratt, Gift of Mr. and Mrs. Henry S. Raab, and the Mary Morton Parsons Fund for American Decorative Arts, by exchange, and The Floyd D. and Anne C. Gottwald Fund, 2000.1

PROVENANCE: Benjamin and Martha L. Miller; possibly to Mr. and Mrs. Maddox, Georgetown, Md.; to Benjamin Miller Jr. and Frances Moughan Maddox Miller; to daughter Frances Miller, Virginia Beach, Va.; to son Maddox Nelson Pieter HinKamp; to daughter Margriet F. Caswell, Washington, D.C.

This tilt-top occasional, or "loo," table represents one of the most elegant bespoke (custom-made) pieces labeled by the southern furniture firm of Charles Koones.[1] Its grand and gleaming surface is orchestrated from crotch-mahogany veneers banded, centered, and aproned in amboyna and framed by cross-grained rosewood with naturalistic gilt stenciling. Loosely based on English "pillar and claw" prototypes, it is composed of three sections: the octagonal top, a cylindrical "pillar" support wreathed with naturalized carving, and a triangular-shaped base with swelling convex sides supported by boldly carved lion-paw feet.[2] With sweeping acanthus leaves that arch back over the attenuated forelegs and foliate

scrolls that extend beneath the boxed platform, the table's base expresses a stylistic combination common to Philadelphia furniture of the period, as demonstrated in works by Anthony Gabriel Quervelle, (fig. 55) Michael Bouvier, and brothers Charles H. and John F. White.[3] In combination with its ornamental top, it records the particular influence of the French-

By that time, Alexandria, Virginia, had emerged as a vital commercial center for the region's developing agrarian economy.[6] Raw materials like grain were exchanged at the Potomac River locale for imported goods—Philadelphia furniture included—purchased by locals or resold by agents farther south and west. At the same time, expanding commercial

born Quervelle, who in 1829 was commissioned by President Andrew Jackson to produce three similar center tables for the formal East Room of the White House (fig. 56).[4]

Indeed, the artisans who detailed the VMFA table were probably trained or active under Philadephia's broad influence, which increased with the introduction of annual craft exhibitions.[5]

interests and access to direct roadways fueled migration from both foreign and domestic ports—particularly from Philadelphia.[7] Carpenters, cabinetmakers, turners, carvers, and others relocated in response to the housing and furnishing needs of a growing population.[8] Specialists like ornamental painter and gilder John Creighton, upholsterers Stephen Sanger and

FIG. 55 Anthony Quervelle (1789–1856), **Center Table,** ca. 1829, Philadelphia. White House Historical Association.

FIG. 56 **East Room, White House,** engraving, ca. 1850, detail. White House Historical Association.

William Muir, and ornamental carvers W. D. Minton and William Demontor arrived in Alexandria in the 1830s.[9] They joined a group of local artisans and builders, a few of whom may have worked in multiple media.[10] Unsurprisingly, the form, material, and detail of the Koones table reflect the merging influence of migrating individuals and objects commissioned by local patrons or sold port side by coastal merchants.[11]

The successful integration of high-style urban design practices demanded both "exotic" woods—amboyna was imported from the Dutch East Indies—and modern technologies, and their convergence in this table marks Koones's place at the top of the Alexandria cabinetmaking industry. In 1822, Charles and John S. Koones notified the public that they had "purchased the establishment of the late Mr. Robert Abercrombie, King Street" where "they intend carrying on the Cabinet making and Turning Business, in all their various branches" using "the best Hands and Materials . . . to merit a share of public patronage." Thereafter, John S. Koones and Company produced "Splendid Furniture" until 1824 when the partnership was dissolved and Charles took over. By 1828, Koones's "FASHIONABLE CABINET FURNITURE" was promoted as "def[ying] competition . . . for elegance and durability" in Alexandria or Washington, D.C. Included in the firm's 1831 inventory were "Pillar and block dining, card and breakfast tables . . . Plain[,] Centric or loo" with "Turning & Carving executed in the best manner," as this table illustrates.[12]

Koones's reliance on bold advertising suggests the competitive environment in which he worked. He vied for patronage among available imported wares, factory-made furniture transported via railroads and canals, and merchandise from more than a dozen independent cabinetmaking concerns lining the King Street "furniture district." In order to contend with the more modern and prolific Green family furniture manufactory, his advertisements stressed the quality of his carriage-trade goods.[13] Although Koones likewise produced utilitarian wares, this emphasis distinguished his furniture from the simplified, midgrade objects suited to less formal urban and "country" residences produced by the larger factory.[14] As a final marketing gesture, Koones offered his clients free delivery to Washington, D.C.

In addition to imparting superior goods, Koones was one of only three Alexandria cabinetmakers to subscribe to the *District of Columbia Cabinetmakers Book of Prices.*[15] Intended to ensure "best practices," the price book provided a structure of fair wages that helped Koones attract the most skilled journeymen while casting aspersions on nonmembers like Green.[16] Moreover, it assisted him in pricing optional details like inlay, gilding, veneering, and carving, the costs for which depended upon materials and labor. The same held true for modifications to standard dimensions.[17] In the case of the VMFA table, once the form was crafted in-house by a seasoned apprentice,

additional details were likely executed by local specialists at prearranged prices.[18] The chalk inscription on the table's underside—if not the owner's initials—may reference the name of one such specialist.[19]

If the center table was an "emblem of the family circle," as Andrew Jackson Downing claimed in 1850, this eight-sided version was also a symbol of social engagement—each niche defining a player's space.[20] Loo (*lanterloo*) was a French card game of trumps in which five or more persons played independently for tricks that won—or "looed"—them a portion of the ante. Such modish entertainments helped fuel the demand for new styles and forms of cabinetmaking. Ultimately, however, for all Koones's innovative efforts to meet the needs of fashionable society, business declined. In 1857, an erratic economy and increased competition forced the firm into foreclosure.[21] Koones died later the same year.[22]

SJR

NOTES

1. Koones probably began using the label found on the VMFA table in the late 1820s. It depicts an elaborately carved classical sofa and Gothic Revival sideboard.

2. See George Smith, *Collection of Designs for Household Furniture* (1808; repr., New York: Praeger, 1970), plate 69. The designs of Thomas Hope and the serial publications of Rudolph Ackerman were also important sources for American cabinetmakers. Ackerman's *Repository of Arts, Literature, Commerce, Manufactures, Fashions and Politics* appeared monthly from 1809 until 1829 and included plates by Hope, Smith, and others. For more information, see Donald L. Fennimore, "American Neoclassical Furniture and its European Antecedents," *American Art Journal* 13 (Autumn 1981): 49–65.

3. For discussion of a similar center table attributed to Quervelle, see William Voss Elder III and Jayne E. Stokes et al., *American Furniture 1680–1860 from the Baltimore Museum of Art* (Baltimore: Baltimore Museum of Art, 1987), 174–75. For a discussion of Philadelphia's particular blending of bold specialist skills with imported designs, and a work table with similar base by Charles H. White, see Alexandra A. Kirtley, "Philadelphia Furniture in the Empire Style," *The Magazine Antiques* 171 (April 2007): 99, 101. See also Charles L. Venable, "Germanic Craftsmen and Furniture Design in Philadelphia, 1820–1850," *American Furniture* (1998), ed. Luke Beckerdite, 41–80, illus. 61. For an example of Michael Bouvier's use of a similar paw-and-scroll table base, see John William Boor and Allison Christina Boor, "Philadelphia Furniture: Bold, Brash, and Beautiful," *Philadelphia Antique Show*, exh. cat. (Philadelphia: Philadelphia Antiques Show, 2007), 129, fig. 8.

4. Allison Boor et al., *Philadelphia Empire Furniture* (West Chester, Pa.: Boor Management: 2007), 67–68; Robert C. Smith, "The Furniture of Anthony G. Quervelle, Part II: The Pedestal Tables," *The Magazine Antiques* 104 (July 1973): 90–99.

5. Approximately one thousand cabinetmakers worked in Philadelphia between 1815 and 1830, and the lions-paw foot was a particularly popular motif of the period. See Boor and Boor, 123–24.

6. The Koones family moved from Maryland to Alexandria in 1801. Elaine Hawes, "Charles Koones and the Alexandria Furniture Trade, 1820–1860," *Alexandria History* 9 (1992): 5.

7. Kirtley, 101; Oscar P. Fitzgerald, *The Green Family of Cabinetmakers: An Alexandria Institution, 1817–1887* (Alexandria, Va.: Alexandria Association, 1986), 6–7.

8. Between 1790 and 1820, the population of Alexandria increased from 2,700 to 8,000. See Fitzgerald, 9.

9. Hawes, 10.

10. According to Kirtley, William Thomas LeGrand, for example, advertised both stone- and wood-carving skills in Richmond in 1814 and Baltimore in 1810 and 1816, noting that "he was 'well versed with the mode of ornamenting [furniture and small details], in the neatest and most elegant style.'" See Kirtley, 95–96.

11. For more information on Quervelle's pedestal tables, see Smith, 90–99.

12. *Alexandria Gazette*, October 10, 1882; January 8, 1824; June 24, 1824; July 10, 1828; and May 20, 1831, cited in Hawes, 53–56.

13. The Green family factory was established in 1817 by the English-born William Green. For a history of the factory, see Fitzgerald, 5–17.

14. *Alexandria Gazette*, May 1830, cited in Hawes, 8–9; Andrew Jackson Downing, *The Architecture of Country Houses* (1850; repr., New York: Dover, 1969), 409–12.

15. Hawes, 9.

16. Ibid.; Fitzgerald, 6–7.

17. Hawes, 15–16.

18. Josiah Satterwhite was probably one of the apprentices listed in the 1830 census as a member of Koones's household. He left Koones to open his own business in 1834. See Hawes, 10, 16, 18–19.

19. As is the case with the VMFA's japanned high chest (see cat. no. 1.)

20. Figure 223 in Downing's publication shows a sketch for a center table with similar base, which compares in design to the Baltimore center table cited above. Downing, 428–29; Voss and Elder, 174–75.

21. Hawes, 26–27; Fitzgerald, 9.

22. Remaining items were sold at public auction following Koones's death on June 17, 1857. *Alexandria Gazette*, June 9, 1857, cited in Hawes, *57*.

32. George Catlin (1796–1872)

Tuch-ee, A Celebrated War Chief of the Cherokees, 1834

Oil on canvas

28 ¼ x 23 ⅛ in. (71.7 x 58.7 cm)

Label on back of stretcher: "AMNH 490 / Catlin 118. / CHEROKEE / TUCH-EE [——] (a celebrated war / chief of the Cherokees."

The Paul Mellon Collection, 85.628

PROVENANCE: Bequest from the artist to his daughters Clara Gregory Catlin, Elizabeth Wing Catlin, and Louise Catlin Kinney (1872); American Museum of Natural History, New York, N.Y. (1912); Kennedy Galleries, New York, N.Y.; Paul Mellon, Upperville, Va. (1959)

George Catlin described the Cherokee leader Tuch-ee as "one of the most extraordinary men that lives on the frontiers . . . both for his remarkable history, and for his fine and manly figure, and character of face."[1] Indeed, among the myriad portraits and genre scenes that the artist produced from his

32

travels to the western frontier, his image of Tuch-ee is particularly striking in its immediacy. The sensitive rendering suggests both Catlin's familiarity with and his admiration for the sitter. Having carefully delineated his subject's distinctive features and intense gaze, the artist then captured with bold, sure brushstrokes the intricate folds and quivering feathers of Tuch-ee's head wrap as well as the angular glints of light that articulate his claw necklace.[2]

Catlin met Tuch-ee at Fort Gibson, situated on the Arkansas River in what is now Oklahoma. Accompanying a military expedition at his own expense, the self-taught painter and ethnologist was on his second of five major trips into Indian country, this one taking him to the farthest southwestern outpost of the territory dominated by the United States. Catlin's broader mission, as stated in his memoirs, was to depict representatives and activities of various American Indian cultures, "to fly to their rescue, not of their lives or their race (for they are doomed and must perish) but to the rescue of their looks and their modes."[3] He painted individuals from neighboring tribes—Cherokee, Choctow, Creek, and Osage—and traveled with army dragoons several hundred miles west to visit and sketch images of the Comanche. Tuch-ee—his name is variously recorded as "Tahchee," "Tatsi," or "Dutch," the latter a nickname consigned to him by white settlers and soldiers—worked as a government-employed guide. He became Catlin's "constant companion for several months" and the model for this handsome portrait.[4]

Raised in Pennsylvania and trained as an attorney, Catlin became a professional artist in the 1820s. During a trip to Philadelphia, he observed a visiting delegation of western Indians, which solidified his budding interest in becoming "the historian and limner of the aborigines of the vast continent of North America." Catlin was aware that native peoples were at ever-increasing risk from war, disease, and forced relocation, and he set out to record their appearances and customs. In 1830, after bidding wife, home, and studio goodbye in Albany, New York, he traveled to Saint Louis, Missouri, a base from which he launched his exploratory journeys over the next seven years.[5]

Ultimately, Catlin's personal and entrepreneurial venture resulted in nearly five hundred oil portraits and scenes, which he assembled into a traveling exhibition. Between 1837 and

FIG. 57 George Catlin (1796–1872), **The Bear Dance,** plate 18, from *Catlin's North American Indian Portfolio,* ca. 1844, hand-colored lithograph, 16 x 23 in. (40.6 x 58.4 cm) sheet, 12 ½ x 18 in. (31.8 x 45.7 cm) image. Collection of Dr. Herbert A. Claiborne, Jr., Richmond, Virginia.

FIG. 58 George Catlin (1796–1872), **Shooting Flamingoes, Grand Saline, Buenos Aires,** 1856, oil on canvas, 18 ½ x 25 ¾ in. (46.9 x 65.3 cm). Virginia Museum of Fine Arts, The Paul Mellon Collection, 85.618.

1839, his "Indian Gallery" went on tour to New York, Philadelphia, Baltimore, and Washington, D.C. In the following decade, it also traveled to Holland, England, and France—supplemented with a Crow teepee, several thousand Indian artifacts and costumes, and a live bear. The 1840s were productive for the artist, who became a lecturer and author as well. During his residency in London, he turned to the recently developed process of lithography to reproduce several of his paintings in the large-folio *Catlin's North American*

Portfolio (1844). It was an effective medium for showcasing such dramatic imagery as *The Bear Dance* (fig. 57), which documents the rhythmic hunting ceremony of the Teton Dakota (Western Sioux). Catlin also published his two-volume *Letters and Notes on the Manners, Customs, and Condition of the North American Indians* (1841), which includes the warm tribute to Tuch-ee.[6]

Despite the Romantic fatalism that informs much of Catlin's writings about native peoples and their precarious fate, *Tuch-ee* appears as the epitome of resilience and survival. The artist contended that the details of his guide's story were as "curious and surprising" as any of the popular tales emerging from the frontier. Tuch-ee, Catlin explained, had relocated with several hundred other Cherokee from their land in Georgia some twenty years earlier. Initially they settled "beyond the reach and contamination of civilized innovations" on land that was situated just west of the Mississippi River. However, "the appearance of white faces, which began to peep through the forests at them, [prompted] another move of miles to the banks of the Canadian [River], where they now reside." In his memoirs, Catlin positions the narrative of Tuch-ee's life within the broader and more turbulent context of mounting governmental pressure to remove all remaining Indians from the East.[7] While Tuch-ee migrated voluntarily, the Cherokee who chose to hold onto their traditional lands were ultimately forced to leave at gunpoint, their exodus culminating in the tragic 1838 overland march known as the Trail of Tears.[8]

Catlin continued his efforts to create "a literal and graphic delineation of the living manners, customs, and character of an interesting race of people . . . for the benefit of posterity" throughout the rest of his long career. His travels included expeditions to South America to produce similar images of indigenous people, flora, and fauna (fig. 58).[9] At his death in 1872, the artist left behind an impressive and invaluable body of work that documents native cultures and segments of America's unspoiled landscape and wildlife. By the late nineteenth century, however, both eastern and western tribes were displaced and isolated on reservations, white settlements and industry developed and spread from coast to coast, and the federal government concluded three decades of Indian Wars with the massacre at Wounded Knee.

FIG. 59 Richard Norris Brooke (1847–1920), **Pocahontas**, 1889 and 1907, oil on canvas, 84 x 52 in. (213.4 x 132.1 cm). Virginia Museum of Fine Arts, Gift of John Barton Payne, 19.1.51.

In 1889, the year that the famous land rush catapulted homesteaders into Oklahoma's panhandle, Virginia-born artist Richard Norris Brooke began a life-size image of one of America's most famous Native Americans—Pocahontas (fig. 59). He chose as his source an adaptation of a 1616 life portrait of the Powhatan woman, but quickly abandoned his work claiming that "the court costume on an Indian type was not pleasing and made it exceedingly difficult" to complete.[10] Eighteen years later, the nostalgic fervor surrounding the three-hundredth anniversary of the English landfall at Jamestown prompted him to return to the painting and finish it in time for the celebratory exposition in Norfolk. His final *Pocahontas* is a fair-skinned beauty who presents herself, hand on hip, in elaborate European costume. Above a white-lace ruff, her face turns to meet the viewer with a confident gaze. Long after George Catlin's valiant attempt to depict

and celebrate the distinctive appearance of America's native peoples, Brooke ultimately surmounted his discomfort in picturing "an Indian type" by anglicizing his imaginary Virginia princess. ELO

NOTES

1. George Catlin, *Letters and Notes on the Manners, Customs, and Conditions of the North American Indians* (London, 1841; repr., Minneapolis: Ross and Haines, 1965), 2:121.
2. When a bankrupt Catlin sold his collection in 1852, this painting was held back and eventually sold by his heirs to the American Museum of Natural History with the so-called Cartoon Collection. A watercolor version is in the collection of the Gilcrease Institute, Tulsa, Oklahoma. William H. Truettner, *The Natural Man Observed: A Study of Catlin's Indian Gallery* (Washington, D.C.: Smithsonian Institution Press, 1979), 222, no. 284.
3. Catlin, 1:16.
4. Truettner, 26–31; Catlin, 2:36–39, 121. A brief biography and an earlier image of the same individual, labeled "Tahchee," appears in Thomas L. McKenney and James Hall, *History of the Indian Tribes of North America* (Philadelphia: Edward C. Biddle, 1836), 1:341–42. That hand-colored lithograph was made after an 1825 portrait by Charles Bird King (now destroyed). Tuch-ee sat for King in Washington, D.C., during a visit east as a delegate for treaty negotiations. James D. Horan, *The McKenney-Hall Portrait Gallery of American Indians* (New York: Crown, 1972), 270–72.
5. Truettner, 11–16. For discussions about this painting and twenty-three other Catlin works given to VMFA by Paul Mellon, see William M. S. Rasmussen, "'Wild Gentlemen in the Simplicity of Nature': George Catlin's Indian Paintings," *Arts in Virginia* 26 (1986): 14–39, and Malcolm Cormack and Francis Domingue, *George Catlin's "Indian Gallery": Views of the American West*, exh. cat. (Richmond: Virginia Museum of Fine Arts, 1993).
6. Christopher Mulvey, "George Catlin in Europe," in *George Catlin and His Indian Gallery,* ed. George Gurney and Therese Thau Heyman (Washington, D.C.: Smithsonian American Art Museum; New York: Norton, 2003), 63–91. Catlin's *Letters and Notes* also includes engraved outline illustrations of his portraits; Tuch-ee's image appears in vol. 2, plate 218.
7. Catlin, 2:119–21. While Catlin suggests that Tuch-ee migrated west as an adult, the McKenney and Hall biography notes that he moved as a child during the earliest wave of Cherokee relocation in the 1820s. Horan, 270.
8. Francis Paul Prucha, "United States Indian Polices, 1815–1860," in *History of Indian-White Relations*, ed. Wilcomb E. Washburn (Washington, D.C.: Smithsonian Institution, 1988), 4:43–47.
9. Catlin, 1:2.
10. Richard Norris Brooke, *Record of Work* (1918), no. 217, 76, Collection of the Smithsonian American Art Museum–National Portrait Gallery Library, Washington, D.C. In this hand-written account book, Brooke noted that he was working "from photo obtained from Mrs. Herbert Jones Sculthorpe Rectory, Fakenham Norfolk England," which likely pictured the eighteenth-century Booton Hall painting after Simon van de Passe's original engraved portrait of 1616. Rasmussen and Robert S. Tilton, *Pocahontas, Her Life and Legend,* exh. cat. (Richmond: Virginia Historical Society, 1994), 11, 32–34.

33. Tucker and Hemphill Factory or Joseph Hemphill Factory / American Porcelain Company (active 1826–38)

Urn, ca. 1833–38

Philadelphia, Pennsylvania

Glazed porcelain, enamel-painted and gilded; brass mounts

22 x 12 ⅛ x 8 ½ in. (55.9 x 30.8 x 21.6 cm)

Museum Purchase, The J. Harwood and Louise B. Cochrane Fund for American Art, 2007.19a–c

PROVENANCE: Hirschl and Adler Galleries, New York, N.Y.

Standing almost two feet tall and flanked by brass eagle-shaped handles evocative of French ormolu (gilded bronze), this grand urn is one of six known examples produced by the first commercially successful American porcelain factory of the early nineteenth century.[1] It signals both the contemporary influence of French Empire taste and the aspirations of a Philadelphia firm to compete with the established porcelain manufactories of Europe.[2] At the same time, its boldly rendered, gilt-rimmed paintings hint at the emerging fancy for Gothic narratives set in Romantic landscapes.

Although William Ellis Tucker was not the first Philadelphian to take up the challenge of porcelain making, he appears to have been the first to realize a consistent production.[3] In part, Tucker's achievement was the natural outcome of interests inspired by his father, Benjamin Tucker—a teacher, writer on chemistry, successful purveyor of chinaware, and charter member of the Franklin Institute. William Tucker's success also represented an American entrepreneur's optimistic response to contemporary demands for domestic manufactures manifest in the establishment of the Franklin Institute in 1825 and the Philadelphia Society for the Promotion of National Industry in 1819. Unfortunately, Tucker's domestic manufactures were impeded by the high cost of research and development in a market of fiscally minded consumers; growing numbers of imported ceramics from large-scale, cost-efficient European concerns undermined the triumph of American start-ups.[4] Even so, extant works suggest that the firm produced a respectable range of domestic, commercial, and exhibition pieces, among them this monumental polychrome urn.

33

(side 2) 33

Likely made after the 1832 death of William Ellis Tucker for the factory's subsequent owner, Joseph Hemphill, this urn—and its five counterparts—derives from a type produced at the Sèvres factory during the Napoleonic era of the First Empire (1804–14).[5] Under the directorship of Alexandre-Théodore Brongniart, the French firm improved its hard-paste production and polychrome decoration, developing an enhanced vocabulary of forms and colors accompanied by extensive gilding. A rich archive of amphora-form designs and an influx of accomplished artisans united to create signature Grecian-style works commonly detailed with historical and literary subjects.[6]

The decorative elements of the Philadelphia urn, like that of the Sèvres wares, derive from the influence of Charles Percier and Pierre-François-Leonard Fontaine, Napoleon's official architect-designers. Through their highly influential serial prints of 1801 to 1812 and best-seller *Recueil de décorations intérieures* (Collection of Interior Decorations), published in 1812 and 1827, the semantics of imperial France—a blend of Greco-Roman, Egyptian, and French-Gothic motifs meant to inspire a free, virtuous, and rational people—were appropriated by a republican America intent upon similar ideals.[7] Urn-shaped vases, the most popular ceramic form of the First Empire, thus became desirable among the American elite.[8] Symmetrical winged figures, like the eagles on the VMFA vase, were ubiquitous in Percier and Fontaine engravings. With torsos emerging from acanthus-banded cornucopias, they also recall the symbolic eagle of imperial France, a bird of virtually identical profile bearing similar horns of plenty in its talons.[9]

Turned and molded in separate parts prior to assembly, the various bisque components of the Philadelphia urn were fired and then dipped into a feldspathic glaze. Once refired, details were rendered in lead-based enamel paint. Gilding and burnishing occurred after a third firing. Each process involved different craftsmen whose earnings were calculated according to the job performed. Of the approximately forty workers employed by the factory in 1830, a handful special-ized in painting.[10] To their credit, the VMFA vase boasts a unique and impressive pair of narrative landscapes. On one side, a leather-breeched man flees on a galloping white horse, one arm grasping a perilously seated woman, the other raised

postfire at spear-bearing Native Americans. On the reverse, a rocky, storm-ravaged coastline hosts figures tensely poised to assist victims of a shipwreck. While the backgrounds vary, the consistent treatment of the horses suggests that the two images were painted by the same hand—perhaps that of William's brother, Thomas Tucker, who became the firm's chief decorator in 1829.

Although no visual source has been identified for these images, they recall the works of James Fenimore Cooper, whose renowned eighteenth-century novel *The Last of the Mohicans* relates the massacre at Fort William Henry in upstate New York. They also reflect the growing alliance between artists and writers manifest in associations like the Bread and Cheese Club, founded by Cooper in 1824, and the burgeoning taste for literary references in American fine and decorative art.[11] In 1825, the leader of the Hudson River school, Thomas Cole, left Philadelphia and moved to New York City, taking up residence adjacent Cooper, who later described him as "one of the very first geniuses of the age."[12] In their shared appreciation for narratives of universal mean-ing and relevance, Cooper and Cole created literary and artis-tic passages using particular details to general effect. In the same year that Cooper's novel was published, Cole began his visits to Lake George and the ruins of Fort Ticonderoga. There he made sketches later selectively orchestrated—perhaps with Cooper's help—into images expressive of the Mohican tale.[13] By these means, text void of illustration was transformed into a Romantic visual experience, complete with craggy granite ridges, large boulders, broken tree limbs, and distant mountains.

Engravings after Cole's sketches were published in 1830 and may inform the effects similarly rendered on the Phila-delphia urn.[14] A jagged tree branch arches over a stream, bridging spectator and stage. Beyond the verdant valley that hosts the fleeing figures, steep stone outcroppings with scored, barren ridges rise into a dome of undulating treetops. A single grayed mountain anchors the distant vista. The whole recalls Cole's 1846 painting *The Mountain Ford* (fig. 60). Within this setting, Cooper's novel invokes the trope of the captivity narrative, turning on the plight of two kidnapped sisters—"dark-hair" Cora and "she of the yellow locks and blue eyes," Alice—to redress the contest between "noble Savage" and

FIG. 60 Thomas Cole (1801–1848), **The Mountain Ford,** 1846, oil on canvas, 28 ¼ x 40 ¹/₁₆ in. (71.8 x 101.8 cm). The Metropolitan Museum of Art, Bequest of Maria DeWitt Jesup, from the collection of her husband, Morris K. Jesup, 1914 (15.30.63).

FIG. 61 Thomas Birch (1779–1851), **Shipwreck,** 1829, oil on canvas, 27 ³/₁₆ x 39 ¹/₁₆ in. (69.1 x 99.2 cm). Brooklyn Museum, Dick S. Ramsay Fund, 45.166.

"civilized" white man. In general, the urn displays all the descriptive details presented by Cooper: the wild landscape; a figure (per Major Duncan Heyward) in "hunting shirt of forest green" and "buckskin leggings" bearing a "short military rifle" atop an impressive "war horse"; and the "barbed Spears" and "council fires" of Magua and the Hurons. On first glance, the scene appears to recount Heyward's rescue of his fair fiancée, Alice, from the confines of the Huron camp—except that the rescued figure appears to have dark hair and, therefore, to be Cora.[15] This difficulty suggests a second possibility: the painter of the urn's landscape created a pastiche of narrative parts that together allude to the novel's larger and more general themes of captivity and rescue, savagery and civilization.

Similar challenges impede interpretation of the reverse image. While it is possible that the two reserves derive from the same tale, the reverse painting appears to illustrate the other Romantic genre for which Cooper was famous—the sea novel. The swelling popularity of the shipwreck theme reflected contemporary taste for Romantic tales with Gothic overtones. Set in eighteenth-century America and Britain, Cooper's narratives—*The Pilot* (1824), *The Red Rover* (1828), and *The Water-Witch* (1830)—bore particular resonance in port cities like Philadelphia where the threat of shipwreck was a daily reality. In satisfying this sensibility, the porcelain painter likely drew on a known artist of the genre, Thomas

Birch.[16] Influenced by French marine painter Joseph Vernet, whose works were on regular local display, Birch was famed for the kind of rocky coastlines, storm-tossed ships, and splitting waves evident in *Shipwreck,* dated 1829 (fig. 61).[17]

For all its unsolved mysteries, this monumental urn stands as one of the most accomplished pieces of early American porcelain. Its scale and sophistication suggest it may have been produced for a special commission or exhibition—perhaps in 1833 when Tucker's successor, Joseph Hemphill, was awarded an honorable mention from the Franklin Institute and a silver medal from the American Institute of New York for "the great improvement" in the factory's manufactures.[18] That same year, an "astonished" contemporary writer for the *West Chester Republican and Democrat* noted that the "quality of the ware manufactured in this establishment . . . [is] in every respect equal to French china."[19] SJR

NOTES

1. Two pairs of monumental urns are in the collection of the Philadelphia Museum of Art (PMA). The fifth is in a private collection. For an illustration of this fifth example, see Elizabeth Feld and Stuart Feld et al., *In Pointed Style: The Gothic Revival in America, 1800–1860* (New York: Hirschl and Adler Galleries, 2006), 31, fig. 1B.

2. The amphora form nods at a European vogue for Grecian-inspired classicism manifest in the works of the Sèvres Porcelain Manufactory and, more locally, the soft-paste *blanc-de-chine* of Dr. Henry Mead, a New York physician who operated the Mead Factory in New York City, ca. 1816. An example of Mead's prototype is in the collection of the PMA. See Marvin S. Schwartz and Richard

Wolfe, *A History of American Art Porcelain* (New York: Renaissance Editions, 1967), 20–21, 24 (plate 5); Alice Cooney Frelinghuysen, *American Porcelain, 1770–1920* (New York: Abrams for the Metropolitan Museum of Art, 1989), 78–79; PMA Accession File (31.55.1).

3. Although opinions vary, the first American porcelain may have been produced in Cain Hoy, South Carolina, by John Bartlam, ca. 1765–70. In Philadelphia, Gousse Bonnin and George Anthony Morris operated the American China Manufactory from December 1769 until 1772. The short-lived factory of Louis François Decasse and Sèvres-trained Nicolas Louis Edouard Chanou ran in New York ca. 1824–27. See Luke Beckerdite and Robert Hunter, "Earth Transformed: Early Southern Pottery at MESDA and Old Salem," *The Magazine Antiques* 171 (January 2007): 160–69; Robert Hunter, Introduction in *Ceramics in America* (2007), ed. Hunter, xv–xvi; and Frelinghuysen, 12–13, 80–82.

4. For a discussion of these challenges, see Phillip H. Curtis, "Tucker Porcelain, 1826–1838: A Re-Appraisal" (M.A. thesis, University of Delaware, 1972), 12–29.

5. William Ellis Tucker established the factory in 1826 and took on successive partners—John Bird, Thomas Hulme, and Joseph Hemphill—until his death on August 22, 1832. Following Tucker's death, Joseph Hemphill became owner of the factory and store. Thomas Tucker, William's brother, joined the firm in 1828 and became its chief decorator a year later. He remained as manager of the factory through Hemphill's tenure and leased the factory for six months between 1837 and 1838. It was incorporated as the American Porcelain Company in 1835. This urn represents a variation on pattern nos. 62–64 produced in retrospect by William's brother, Thomas Tucker. The pattern book is in the collection of PMA. For more information, see Edwin Atlee Barber, *The Pottery and Porcelain of the United States* and *Marks of American Potters* (combined ed., New York: Feingold and Lewis, 1979), 16–20, 126–53; and Curtis.

6. For more information and illustrations of earlier and contemporary prototypes, see Marie-Noelle Pinot de Villechenon, *Sèvres: Porcelain from the Sèvres Museum 1740 to the Present Day,* trans. John Gilbert (Paris, 1993; London: Lund Humphries Publishers, 1997), 44–47, 55–57, 68–75, fig. 56. See also Tamara Préaud, "Brongniart and Imperial Iconography at the Manufacture de Sèvres," in Odile Nouvel-Kammerer, *Symbols of Power: Napoleon and the Art of the Empire Style, 1800–1815* (New York: Abrams in association with the American Federation of Arts and Les Arts Décoratifs, Paris, 2007), 70–77.

7. For the designs of Percier and Fontaine, see Charles Percier and Pierre Fontaine, *Empire Stylebook of Interior Design: All 72 Plates for the "Recueil de decorations interiors,"* with New English Text (1812; repr., New York: Dover, 1991). See also Odile Nouvel-Kammerer, "Discourse on Ornament Under the Empire," in Kammerer, 26–39; Daniela Gallo, "On the Antique Models of the Empire Style," in Kammerer, 40–51; and Anne Dion-Tenenbaum, "Published Sources of Ornaments," in Kammerer, 62–69.

8. Préaud, 71–74.

9. See Jean-Pierre Samoyault, "The Creation of Napoleonic Symbolism and Its Spread throughout the Decorative Arts in the Imperial Era," in Kammerer, 52–61, figs. 1–4.

10. Curtis, 43–46.

11. James F. Beard Jr., "Cooper and his Artistic Contemporaries," *New York History* 35, no. 4 (Oct. 1954): 480–95.

12. Cooper to the Reverend Louis L. Noble, Cooperstown, January 6, 1849, cited in Beard, 480.

13. Cole was one of the first artists to visit the wilderness areas of New York and New Hampshire. See Caroline M. Welsh, "Paintings of the Adirondack Mountains," *The Magazine Antiques* 155 (July 1997): 78–88.

14. John H. Hinton, ed., *The History and Topography of the United States of North America* (London, 1830; Boston: Samuel Walker, 1834), cited in Caroline M. Welsh, "John Frederick Kensett: *A Showery Day, Lake George* (ca. 1860s)," in *Seeing America: Painting and Sculpture from the Collection of the Memorial Art Gallery of the University of Rochester* (Rochester, N.Y.: Memorial Art Gallery, 2006), 65.

15. James Fenimore Cooper, *The Last of the Mohicans: A Narrative of 1757* (New York: Penguin, 2005), 192–93, 214, 221, 225, 227–28, 298, 309–24.

16. With his father, enamelist and engraver William Russell Birch, Thomas Birch was known for twenty-seven views published as *The City of Philadelphia as It Appeared in the Year 1800* (Philadelphia: W. Birch and Son, 1800).

17. Signed lower left: "Thos Birch / 1829 / Philadelphia." Cole, too, produced shipwreck scenes of similar design. For example, see Thomas Cole, *View Across Frenchman's Bay from Mt. Desert Island [Maine], after a Squall* (1845, Cincinnati Art Museum).

18. Barber, 137.

19. See *West Chester (Pennsylvania) Republican and Democrat,* July 9, 1833, 3, cited in Curtis, 61.

34. Charles Deas (1818–1867)

Turkey Shooting, by 1838

Oil on canvas

24 ¼ x 29 ½ in. (61.6 x 74.9 cm)

Signed and dated lower right (on log): "C. DEAS. 18[—]"

The Paul Mellon Collection, 85.632

PROVENANCE: Peter Gerard Stuyvesant (d. 1847); to nephew Lewis Morris Rutherfurd (d. 1892); to son Rutherfurd Stuyvesant (d. 1909, born Stuyvesant Rutherfurd but reversed his given and surnames as requested in the 1847 testament of Peter Gerard Stuyvesant), Allamuchy, N.J.; to second wife Countess Matilde E. de Wassanaer (née Lowenguth), later Princesse Alexandre de Caraman Chimay (d. 1948); to son Alan R. Stuyvesant (d. 1954), Allamuchy, N.J.; consigned to Wildenstein, New York, N.Y. (1953); Paul Mellon, Upperville, Va. (1953)

After showing *Turkey Shooting* at the 1838 National Academy of Design exhibition, Charles Deas received glowing praise for a "capital performance, giving promise of great things; [the artist] only wanting experience and unwearied perseverance, to rank among the best of American painters."[1] Within weeks, financier and philanthropist Peter G. Stuyvesant purchased the canvas and later that year lent it for exhibit at the newly established Stuyvesant Institute in New York City.[2] Attention swirling around this "much admired" picture led Deas— a self-taught painter barely out of his teenage years—to be elected as an associate in the National Academy of Design the following year.[3]

Many contemporary viewers would have recognized the literary source of Deas's image as a scene from James Fenimore Cooper's 1823 novel *The Pioneers, or the Sources of the Susquehanna; A Descriptive Tale.*[4] The painting pictures several marksmen from all walks of life shown in sharp contrast against a snowy field and pale winter sky. They assemble on

34

the outskirts of a western New York village to compete for a Christmas turkey. The contest, Cooper writes, had been organized by Abraham "Brom" Freeman, a free African American man who raised the bird and solicits wagers from the men. One by one they have taken a turn, only to miss the mark when Brom shouts a warning to the hapless gobbler. In Deas's scene, the next contestant takes aim on bent knee while Brom anxiously leans forward and clutches the fellow's hat. That young marksman, who will miss the shot as well, is Oliver Edwards, the mysterious backwoodsman whose identity as the high-born Edward Effingham will be revealed at the novel's end. Deas provides a clue by inscribing the initials "E. E." beneath the hat's brim.

Like Cooper, who presents Brom as a stock "comic darkey" leaping and shouting nonsensical phrases, Deas resorts to racial caricature in his visual depiction.[5] The black man's flashy costume features a towering hat, striped gloves, and oversize trousers tied at the ankles. With bulging eyes, he gawks over the rifleman's shoulder. A small African American boy positioned at bottom left as yet another element in the rustic still life looks out at the viewer. His distorted minstrel-show grin cues the audience to laugh at the buffoonery. In other respects, Deas has taken some liberties with Cooper's story. He added an unknown participant who reaches forward to restrain Brom from interfering. Also, Deas's turkey appears an easier target than the fictional bird, which shows only its small, bobbing head above a snowdrift. Last, in an odd act of omission, the artist chose not to picture the famous frontiersman who ultimately wins the competition: Natty Bumppo, the protagonist of this and Cooper's other Leatherstocking Tales.[6]

Deas's success with *Turkey Shooting* coincided with a surge of interest in American themes in literature and art. Supported with patronage from urban bankers and merchants nostalgic for simpler times and encouraged by luminaries such as Ralph Waldo Emerson to "embrace the common," writers and painters began to capture the national character through depictions of supposed everyday life. Previously, in the early nineteenth century, a handful of painters including Alvan Fisher (fig. 62) populated the foregrounds of their landscapes with commonplace folk going about their daily activities. With an eye to Dutch and British antecedents, readily

FIG. 62 Alvan Fisher (1792–1863), **A Roadside Meeting: Winter,** 1815, oil on panel, 28 ⅝ x 39 ⅞ in. (72.7 x 101.3 cm). Virginia Museum of Fine Arts, Gift of the Fellows of the Virginia Museum of Fine Arts, 76.2.2.

FIG. 63 Louis-Adolphe Gautier (active 1847–79), after George Caleb Bingham (1811–1879), **Stump Speaking,** 1856, hand-colored engraving, mezzotint, and roulette, 22 ⅛ x 30 ⅛ in. (56.2 x 76.5 cm). Museum Purchase, The Adolph D. and Wilkins C. Williams Fund, 87.456.

available through prints, the next generation of American painters met the growing taste for genre scenes in the 1830s and 1840s.[7] Born and reared in Philadelphia, Deas may have had access to the earlier paintings and prints of the resident German-born painter John Krimmel. On relocating to New York City in 1835, however, he likely found his major inspiration in the work of William Sidney Mount, whose anecdotal scenes had been garnering critical acclaim for close to

a decade. Indeed, Mount's *Raffling for the Goose* (Metropolitan Museum of Art), exhibited at the National Academy in 1837, features a similar diverse gathering of attentive men competing for a prize bird.[8]

If Deas passed up the opportunity to picture an American frontiersman in *Turkey Shooting*, he more than compensated later by devoting much of his brief career to portraying mountain men, trappers, hunters, and guides. Motivated by an exhibition of Indian paintings by George Catlin (see cat. no. 32), Deas traveled west in 1840. After exploring territory along the Upper Mississippi and Upper Missouri Rivers, he settled in Saint Louis, Missouri, where he resided for nearly a decade. From there he sent his western scenes back to New York to be exhibited and reproduced as prints. At the same time that his Saint Louis contemporary George Caleb Bingham came to prominence with lively images of flatboat men engaged in rough leisure activities or bustling crowds convening for a country election (fig. 63), Deas built his reputation by depicting such dramatic frontier dangers as Indian attacks, prairie fires, and lightning storms. Most famous is his bloodcurdling painting *The Death Struggle* (1845, Shelburne Museum), in which a mounted trapper and an Indian are locked in mortal combat as they plunge over a cliff.

Deas's health deteriorated after his return to New York in the late 1840s and he was confined to a mental asylum for the last twenty years of his life. Nevertheless, at his death in 1867, Deas was remembered by Daniel Huntington, president of the National Academy of Design, who lauded him for his "pictures of wild border life."[9] In the intervening years, other eastern painters, including Arthur F. Tait and William Ranney (see cat. no. 48), found similar success in picturing rugged frontiersmen who negotiate the perils of the American West.[10]

ELO

NOTES

1. *New York Mirror,* July 7, 1838, 15, quoted in Ellwood Parry, *The Image of the Indian and the Black Man in American Art, 1590–1900* (New York: George Braziller, 1974), 78.

2. *Dunlap Benefit Exhibition,* November 19, 1838, Stuyvesant Institute, New York, no. 110, listed in James L. Yarnall and William Gerdts, *The National Museum of American Art's Index to American Art Exhibition Catalogues: From the Beginning Through the 1876 Centennial Year* (Boston: G. K. Hall, 1986), 2:948. The Stuyvesant Institute, a literary association that flourished in New York between 1834 and 1859, sponsored lectures, concerts, exhibitions, and political rallies in its assembly hall at 659 Broadway.

3. Carol Clark, "Charles Deas," in *American Frontier Life: Early Western Painting and Prints* (New York: Abbeville in association with the Amon Carter Museum and Buffalo Bill Historical Center, 1987), 51. See also Carol Clark et al., *Charles Deas and 1840s America,* exh. cat. (Norman: University of Oklahoma Press in cooperation with Denver Art Museum, 2009), 71–74, 172.

4. The painting would have had special appeal for its first owner, Peter Stuyvesant, a descendant of the formidable Dutch colonial governor of the same name. An enthusiast of Knickerbocker history, he gave his newly purchased painting the clarifying title *Shooting on the Ice, From Fenimore Cooper's Pioneers.* Yarnall and Gerdts, 948. For more information about Stuyvesant, one of the nation's first millionaires, see Edward Pessen, *Riches, Class, and Power: America Before the Civil War* (New Brunswick, N.J., and London: Transaction Publishers, 1990), 93, 226, 276.

5. For further discussion about black stereotypes in American theater, art, and this painting in particular, see Guy C. McElroy, *Facing History: The Black Image in American Art, 1710–1940,* exh. cat. (San Francisco: Bedford Arts Publishers in association with Corcoran Gallery of Art, 1990), xiii, 25.

6. Parry, 77–81; Malcolm Cormack, *Country Pursuits: British, American, and French Sporting Art from the Mellon Collections in the Virginia Museum of Fine Arts* (Richmond: Virginia Museum of Fine Arts; Charlottesville: University of Virginia Press, 2007), 339. In his 1857 *The Turkey Shoot* (New York State Historical Society), painter Thompkins Matteson presents the unmistakable figure of Natty Bumppo front and center, illustrated in Parry, 79, fig. 61.

7. Ralph Waldo Emerson, "The American Scholar" (1836) in *The Complete Works of Ralph Waldo Emerson Nature: Addresses and Lectures* (Boston: Houghton Mifflin; Cambridge, Mass.: Riverside Press, 1903), 1:111–12; Elizabeth Johns, *American Genre Painting: The Politics of Everyday Life* (New Haven and London: Yale University Press, 1991), 3; Catherine Hoover, "The Influence of David Wilkie's Prints on the Genre Paintings of William Sidney Mount," *American Art Journal* (Summer 1981): 6–8.

8. Elizabeth Johns sets Mount's "gambling" painting within the context of intense land speculation that swept the United States in the mid-1830s. When the market collapsed in 1837, the ensuing panic closed all banks and triggered a major economic depression. Despite its obvious literary reference, Deas's *Turkey Shooting,* exhibited in the immediate wake of the crash, may have also prompted viewers to contemplate the risks of speculation. Johns, 38–41.

9. Cited in Clark, "Charles Deas," 74.

10. For an examination of the ways in which genre scenes by Deas and Ranney helped to shape and perpetuate the mythology of the American West, see Johns, 66–84.

35

35. Wheeling Flint Glass Works (active 1829–37); John Ritchie and Craig Ritchie, proprietors (1833–34)

Window Pane, 1833–37
Wheeling, [West] Virginia
Pressed glass
5 ¹⁄₁₆ x 7 in. (12.9 x 17.8 cm)
Museum Purchase, The Arthur and Margaret Glasgow Fund, 2006.8

PROVENANCE: Private collection; Collectors' Sales and Service, Middletown, R.I. (1997); Robert E. Crawford, Richmond, Va. (1997–2006)

This sparkling pane of colorless pressed glass embodies the exuberance and industry of America's Midwest during the Jacksonian Age.[1] Produced in the early 1830s in Wheeling, Virginia (now West Virginia), it depicts two urns supporting arrangements that feature fully opened roses and curling vines. A robust thistle—suggestive of the region's Scots-Irish heritage—sprouts from a stylized anthemion below.[2] Most significant is the central panel that pictures a side-wheel steamboat. A symbol of advanced technology, commerce, and westward expansion, the vessel sports an oversize American flag on its deck. Above it, the inscription "J. & C. Ritchie," manufacturers of the glass, appears beneath the festoons. The background is filled with hundreds of minute, raised stipples, a design motif that enhances the reflection of light and results in an overall pattern popularly described as "lacy."[3]

The discovery of this and seven other identical pressed-glass panes in 1955 was published almost immediately in *The Magazine Antiques* and heralded as the first firm evidence of fine-quality glass production in western Virginia in the early nineteenth century.[4] In the subsequent sixty years, the panes have remained exceptionally rare examples because of their distinctive markings, regional origin, lively visual appeal, and unusual form.[5] In size, they approximate the standard dimensions of other extant pressed-glass panes that were produced with a variety of geometric and naturalistic patterns for use in windows. These were sometimes set into doors or alongside entryways as sidelights or, on occasion, placed into furnishings like corner cupboards and hanging lanterns. While there is no conclusive documentation of the intended use for this particular set—found carefully stored in a secretary drawer—

an interesting application is suggested in an 1836 Pittsburgh advertisement for Bakewell, Page and Bakewell's "Pressed panes for steamboats." And, indeed, the packet boat sparkles with small windows.[6]

While other nations had already developed free-blown and mold-blown methods of glass production—processes readily adopted in the United States—mechanically pressed glass was a fully American product. Less than a decade before this fanciful pane was created, a handful of Boston-area glass manufacturers devised and patented a system in which molten glass was dropped into a heated metal mold and compressed with a handle into the desired shape and pattern. "Flint glass"— a misnomer that came to refer to glass manufactured with a certain amount of lead for weight, clarity, and resonance— was the preferred medium. Although mechanical pressing was first used to create glass knobs for doors and furniture, the

FIG. 64 Attributed to the Boston and Sandwich Glass Company (active 1826–88), manufacturers, **Shell-shaped Peacock Eye Tray,** ca. 1830–45, Sandwich, Massachusetts, colorless pressed glass, 1 ½ x 9 ½ x 7 ½ in. (3.8 x 24.1 x 1.91 cm). Virginia Museum of Fine Arts, Gift of Mr. and Mrs. William B. Thalhimer Sr., 70.11.

revolutionary process was quickly adapted for more elegant products such as tableware and decorative dishes as well as panels. Northeastern glass firms—including the New England Glass Company, the Boston and Sandwich Glass Company, and the Union Glass Company of Philadelphia—soon excelled in pressed-glass production. Each mastered the shimmering lacy stippling, as beautifully articulated in the peacock-feather

design of a tray attributed to the Boston and Sandwich Glass Company (fig. 64). With amazing speed, glasshouses west of the Alleghenies embraced the new technology. As early as the late 1820s, glass manufactories were established in the river cities of Pittsburgh and Wheeling.[7]

The Wheeling Flint Glass Works, maker of the steam boat pane, was in operation by December 1, 1829, advertising the fine quality of its cut, pressed, and plain glassware.[8] Three years later, founding owners John Ritchie and Jesse Wheat parted ways, leaving only Ritchie to run the growing business. In 1833 he sold half interest in the property to his brother, Craig Ritchie, and a year later brought in a third partner, George Wilson, whose name was added to the firm. The rare inscription, "J. &. C. Ritchie," helps identify the pane's manufacturer, city of origin, and period of production.[9]

ELO

NOTES

1. In describing regional manufacture of pressed glass in the late 1820s through 1870, the terms *Midwest* and *midwestern* traditionally indicate products of western Pennsylvania, western (later West) Virginia, and Ohio. Lowell Innes, *Pittsburgh Glass, 1796–1891* (Boston: Houghton Mifflin, 1976), 7.

2. Natural motifs were favored among early glassmakers west of the Alleghenies. Innes, 277.

3. George S. and Helen McKearin, *American Glass* (New York: Crown, 1941), 337.

4. James H. Rose, "Wheeling Lacy Glass," *The Magazine Antiques* 69 (June 1956): 526–27. Six other panes from the set have also entered museum collections: two in the Corning Museum of Glass and one each in the Metropolitan Museum of Art, Toledo Museum of Art, Chrysler Museum, and the Oglenay Mansion (Wheeling). One remains in private hands. I thank Jane S. Spillman, curator Corning Museum of Glass, for sharing her insights about this group.

5. The whimsical design prompted the inclusion of one of these panes in the 2004 *American Fancy* exhibition, organized by the Milwaukee Museum of Art. Sumpter Priddy, *American Fancy: Exuberance in the Arts, 1790–1840*, exh. cat. (Milwaukee, Wis.: Chipstone Foundation in association with the Milwaukee Art Museum, 2004), illus. 193.

6. Innes, 283–86; Jane Shadel Spillman, *American and European Pressed Glass in the Corning Museum of Glass* (Corning, N.Y.: Corning Museum of Glass, 1981), 106; James H. Rose, "Lacy Glass Window Panes: Their Use, Process, and Origin," *The Magazine Antiques* 51 (February 1947): 120–21. The side-wheel paddleboat motif also appears in lacy pressed-glass plates made in Pittsburgh, just up the Ohio River from Wheeling. See examples in Innes, 267, 290, and Rose, "Wheeling Lacy Glass," 527.

7. Ruth Webb Lee, *Early American Pressed Glass*, rev. ed. (Wellesley Hills, Mass.: Lee, 1958), 4–6; McKearin, 8; Innes, 41–43, 232.

8. To date, this is the earliest known advertisement in the United States to mention the production of pressed glass. Josephine Jefferson, *Wheeling Glass* (Mount Vernon, Ohio: Guide, 1947), 18, 32.

9. The two Ritchies and Wilson continued their operation until bankruptcy forced them to sell to new owners in 1837. Having fabricated the mold for this design in 1833, the company could have pressed panes from it as late as 1837. Jefferson, 32–45; Rose, "Wheeling Lacy Glass," 526; Innes, 254.

Antebellum Years

36

36. Samuel F. B. Morse (1791–1872)

Contadina at the Shrine of the Madonna, ca. 1830

Oil on canvas

21 ½ x 17 ¼ in. (54.6 x 43.7 cm)

Museum Purchase, The Adolph D. and Wilkins C. Williams Fund, 58.12

PROVENANCE: Charles Carvill, New York, N.Y.; T. R. Walker, Utica, N.Y. (ca. 1867); M. Knoedler and Company, New York, N.Y.

37. Thomas Cole (1801–1848)

View of Mt. Etna, ca. 1842

Oil on canvas

15 ½ x 23 in. (39.4 x 58.4 cm)

Signed on rock, lower right center: "T. Cole."

Museum Purchase, The Adolph D. and Wilkins C. Williams Fund, 76.39

PROVENANCE: Doll and Richards gallery, Boston, Mass.; Crowninshield family, Boston, Mass.; Boyden family, Boston, Mass.; James H. Stevenson III, Philadelphia, Pa.

These Italian subjects by two leading American painters reveal different early-nineteenth-century approaches to the European landscape. Encompassing more than the formal language of the picturesque and sublime, the paintings also suggest contemporary dialogues about the classical past and American exceptionalism, internationalism and nativism, as well as political and theological differences.

Although best known for his invention of the electromagnetic telegraph and its signaling code, Samuel F. B. Morse began his wide-ranging career in the art world. After graduating from Yale College in 1810, he traveled to England and studied under Benjamin West (see cat. no. 3) at the Royal Academy. He quickly established himself as a successful portrait painter and, later, arts administrator, serving from 1826 to 1845 as founding president of the National Academy of Design, New York's leading artist-run organization. Morse first visited Italy in 1830 during a European trip financed by patrons. Arriving in Rome with numerous commissions for copies of Old Master as well as original compositions, the artist began his most extensive exploration of landscape and genre imagery.[1]

From his studio base in the Eternal City, Morse made frequent sketching excursions into the neighboring countryside.

In May, he traveled with Virginia artist John Gadsby Chapman to the region around Tivoli and the Sabine Hills—arriving by donkey in Subiaco, approximately forty miles east of Rome. Morse and Chapman were among the earliest Americans to paint the picturesque hill town, long popular with European artists. In addition, Morse may have been the first to focus on a common scene of everyday village life—a worshipper at a roadside shrine. Interestingly, the subject became a popular one with American artists, who were largely Protestant, in subsequent decades.[2]

After his first day of sketching near the convent of San Benedetto, a landmark for artists, Morse described the experience in his travel journal. Amid the "scenery of Salvator Rosa and the Poussins," he discovered "a Madonna, very picturesque at the side of the road near the village; three artists were painting it and two shepherds had their flocks around it." Over the next several days, Morse revisited the rustic shrine, producing a vibrant oil sketch that became the model for what he called "the best landscape I ever painted," *Chapel of the Virgin at Subiaco* (fig. 65).[3]

While hewing closely to the plein-air study, Morse enlarged the scene on all four sides, situating the shrine within a more expansive and atmospheric *campagna* setting and dramatically using it to block the sun. Working in his Rome studio, the

FIG. 65 Samuel F. B. Morse (1791–1872), **Chapel of the Virgin at Subiaco,** 1830, oil on canvas, 29 ¹⁵/₁₆ x 37 in. (76 x 94 cm). Worcester Art Museum, Worcester, Massachusetts, Bequest of Stephen Salisbury, 1907.35.

artist also drew from a composition he had produced during a spring excursion to nearby Nettuno—*Contadina at the Shrine of the Madonna.* This earlier image gave the young woman in traditional dress a more central and, for American audiences, "exotic" role. Whereas the viewer is distanced from the small-scaled figural scene in the Subiaco landscape—rendering the ritual action more mysterious—the young worshipper in *Contadina* appears close-up. Morse depicts her tenderly, rapt in tranquil devotion with eyes raised to the beckoning figure of the Madonna and Christ child at the top right edge of the composition. For an image of reverence, however staged, the picture is coolly static and unemotional, the overall composition rendered in a muted palette of ocher, brown, and blue green, which serves to heighten the rich saturated colors of the woman's distinctive headdress and picturesque costume.[4]

The subject was a curious one for Morse, who, as the son of a Calvinist minister, was critical of Roman Catholic rituals. After bitterly discarding his painting career in 1836, Morse ran unsuccessfully for mayor of New York City as a radical Nativist Party candidate on an anti-Papist platform. One year earlier, he had put his extremist ideas on paper, and the resulting diatribe, *Foreign Conspiracy Against the Liberties of the United States,* has since been credited with "shaping anti-Catholicism in America well into the twentieth century."[5] Undoubtedly, Morse's xenophobic campaign against immigrants (and abolitionists) harmed his artistic career, likely costing him a mural commission for the Rotunda of the United States Capitol. That devastating loss led him to shift his focus to science and invention.[6]

And yet, despite this deeply held bigotry, during his time in Italy Morse was clearly fascinated, if not wholly seduced, by the cultural differences of its people. That Morse's particular aversion to what he called "the idolatry of the Virgin Mary" did not preclude an artistic attraction to the shrine subject may explain this image's more convincing picturesque versus pious qualities, its tentativeness and ambivalence.[7]

Thomas Cole's love affair with Italy was markedly different from that of his older friend and colleague Morse. After the two returned from their first visits to Europe within a few weeks of each other, American art historian William Dunlap was prompted to pen a chauvinistic essay, published by William Cullen Bryant in the *New York Evening Post,* proclaiming the artists' rediscovered devotion to the New World. While this may have been truer for Morse, given his conflicted relationship to European, especially Catholic, culture, Cole's deep reverence for Italian painting and scenery was indisputable and shaped all of his subsequent work as America's most notable landscapist.[8]

The English-born Cole, based primarily in Florence during his first Italian sojourn of 1831–32, ventured farther south on his second trip ten years later. While finding Rome a "city of the soul . . . the Mecca of the artist," his time on the ancient island of Sicily had the greatest long-term impact. The highlight of Cole's monthlong tour of the region was his ascent of the iconic Mount Etna, which became the artist's favorite Italian subject. VMFA's southern view of the volcano looming over a fertile valley is one of his approximately six versions of the site. Cole detailed the arduous journey up the mountain in an 1844 essay for *Knickerbocker* magazine, employing the aesthetic conventions of the sublime to describe the "glorious . . . and fearful sight" that greeted the hikers as they "gazed in wonder and astonishment" at the "gloomy crater."[9]

Cole was drawn to Sicily for its combination of spectacular scenery and tangible vestiges of history. In the VMFA picture, the artist's focus on classical ruins (a Roman aqueduct) and a diminutive pipe-playing goatherd in the pastoral foreground

FIG. 66 Thomas Cole (1801–1848), **The Cascatelli, Tivoli, Looking towards Rome,** ca. 1832, oil on canvas, 32 ¾ x 44 ½ in. (83.1 x 112.9 cm). Columbus Museum of Art, Ohio, Gift of Mr. and Mrs. Walter Knight Sturges and Family, 1991.013.001.

37

invokes the ancient past far more than the everyday present, albeit with its "exotic" rituals that attracted Morse. (Cole's earlier *The Cascatelli, Tivoli, Looking towards Rome* [fig. 66] is more suggestive of Morse's approach to the Italian *campagna* with its diminutive grouping of nineteenth-century *contadini* at right.) The snow-topped mountain itself, with a small plume of smoke signaling the crater's destructive potential, floats like a mirage in the background of the scene, timeless and indomitable. Cole considered the view of Etna "one of the grandest scenes in the world."[10]

This juxtaposition of past and present, nature and civilization, runs throughout Cole's famous allegorical epics— *The Course of Empire* and *The Voyage of Life*. The second version of the latter he completed in Rome in 1842 while also painting his Etna canvases. Franklin Kelly has argued that Cole's Sicilian imagery may be read as a visual convergence of myth, allegory, and science given the artist's deeply held ideas about the cycles of nature and time. There is no question that he viewed the volcano, evocative in its ancient might, as a manifestation of God. As Cole once wrote of the value of foreign

experiences, "he is unworthy of the privilege of travelling who gleans not from the fields he visits some moral lesson or religious truth." Unlike Morse, who found Italy's religious truths" distasteful and utterly foreign to an American (and Protestant) way of life, which he held to be superior, Cole celebrated the country's many natural and historic wonders, rendering them with an aesthetic grandeur and rich symbolism in his pursuit of a more elevated form of landscape painting.[11]

SY

NOTES

1. For an overview of Morse's life and art, see Paul J. Staiti, *Samuel F. B. Morse* (Cambridge: Cambridge University Press, 1989).

2. Susan Ricci, *The Lure of Italy: American Artists and the Italian Experience, 1760–1914*, exh. cat. (Boston: Museum of Fine Arts Boston, 1992), 282. For a thoughtful analysis of the wide-ranging Protestant fascination with images of Catholic faith in antebellum America, see John Davis, "Catholic Envy: The Visual Culture of Protestant Desire," in *The Visual Culture of American Religions,* ed. David Morgan and Sally M. Promey (Berkeley, Los Angeles, and London: University of California Press, 2001), 105–28.

3. Ricci, 282.

4. The initial owner of the VMFA painting was Charles Carvill, one of Morse's patrons who had requested a small work for his $100 contribution to the artist's Italian sojourn. See William Kloss, *Samuel F. B. Morse* (New York: Abrams, 1988), 122. For a comparison of Morse's Subiaco scene with Thomas Cole's more empathetic image of Catholic devotion, *Il Penseroso,* see Davis, 119–22.

5. See S. Matthew White, "Ambivalence in Bigotry: Catholicism in the Art and Ideology of Samuel Finley Breese Morse" (undergraduate seminar paper, University of Richmond, April 2000), VMFA curatorial files.

6. Staiti, 207–12.

7. See Staiti, "Compliance and Resistance: Samuel F. B. Morse, Puritan in Arcadia," in *The Italian Presence in American Art, 1760–1860* (New York: Fordham University Press, 1989), 95–105. As John Davis has argued, antebellum paintings of Catholic ritual and prayer were "situated between the competing realms of enticement and revulsion." See Davis, 114.

8. Ellwood C. Parry III, "On Return from Arcadia in 1832," in *The Italian Presence in American Art,* 196–231. For a discussion of Cole's Episcopalianism and its influence on his Italian imagery of the 1840s, see Davis, 119.

9. Louis Legrand Noble, *The Life and Works of Thomas Cole* (1853), ed. Elliot S. Vesell (Cambridge, Mass.: Belknap Press of Harvard University Press, 1964), 234, 242–46. Cole's breathless accounts of Sicily were first delivered as a lecture at the Catskill Lyceum, New York, in 1843; one year later they were published as "Sicilian Scenery and Antiquities," *Knickerbocker* 13 (February and March, 1844): 103–13, 236–44. The article also contained a poem to Etna's sublimity.

10. Quoted in Elizabeth Mankin Kornhauser, *New World: Creating an American Art,* exh. cat. (München: Hirmer Verlag and Bucerius Kunst Forum, 2007), 136.

11. For an overview of the artist's ideological approach to landscape, see *Thomas Cole: Landscape into History,* exh. cat., ed. William H. Truettner and Alan Wallach (New Haven, Conn.: Yale University Press; Washington, D.C.: National Museum of American Art, Smithsonian Institution, 1994). For a focused look at VMFA's painting, see Franklin W. Kelly, "Myth, Allegory, and Science: Thomas Cole's Paintings of Mount Etna," *Arts in Virginia* 23 (1983): 2–17. See also Cole, "Sicilian Scenery," 242, 244.

38. Attributed to Alexander Jackson Davis
(1803–1892), designer

William Burns and Peter Trainque
(active 1842–56), manufacturers

Side Chair, 1848
New York, New York

Rosewood, walnut, pine, ash, with rosewood veneer; reproduction
upholstery

42 ¾ x 18 ¼ x 20 in. (108.6 x 46.4 x 50.8 cm)

Museum Purchase, The Mary Morton Parsons Fund for American
Decorative Arts, 79.3

PROVENANCE: Philip St. George Cocke, Belmead, Powhatan County, Va.; to John Bowdoin Cocke, Belmead, Powhatan County, Va.; to Betty and Louise Cocke, Charlottesville, Va.; to Lucy Hamilton Cocke Elliott, Washington, D.C.; to John Page Elliott, Alexandria, Va.; Ramon G. Osuna, Jr., Pyramid Gallery, Washington, D.C.; David A. Hanks, Washington, D.C.

39. Attributed to Alexander Jackson Davis
(1803–1892), designer

Attributed to Alexander Roux (1813–1886), manufacturer

Center Table, ca. 1845–50
New York, New York

Rosewood, oak, walnut; white marble

30 ¾ x 42 x 36 ¾ in. (78.1 x 106.7 x 93.3 cm)

Museum Purchase, The J. Harwood and Louise B. Cochrane Fund for
American Art and Partial Gift of Juliana Terian Gilbert in memory
of Peter G. Terian, 2009.3

PROVENANCE: Julian Hastings Granbery, Richmond, Va. and Machias, Maine; Virginia Historical Society, Richmond, Va. (1944–91); J. Michael Flanigan, Baltimore, Md. (1991–98); sold at auction by Christie's, New York, N.Y. (January 15, 1998, sale no. 8840, lot no. 530); Peter and Juliana Terian, New York, N.Y. (1998)

In April 1848, Philip St. George Cocke traveled to New York City to order furniture for Belmead, his newly completed residence in Powhatan County, Virginia (fig. 67). His chief consultant for the task happened to be his architect as well—the renowned Alexander Jackson Davis. The two paid a call on cabinetmaker William Burns, who, with his partner, Peter Trainque, had previously manufactured furniture to Davis's specifications. The visit resulted in a substantial order to fabricate a ten-piece drawing-room suite, to which this attractive

side chair belonged. Davis provided professional guidance—if not actual sketches—to ensure that Belmead's furnishings would complement the scale and style of the mansion itself, a service for which he charged Cocke a $5 fee.[1]

Three years earlier, with the confidence that a prominent family name and wealth can bestow, Cocke made the bold decision to commission Davis to design a Gothic Revival manor house for his plantation. In the 1830s and 1840s castellated villas had sprung up along the Hudson River Valley and Long Island Sound in the North—most of them Alexander J. Davis projects—but this picturesque style was rarely chosen for domestic architecture in the conservative

FIG. 67 Alexander Jackson Davis (1803–1892), architect, **Belmead,** constructed 1845–48, Powhatan County, Virginia. The Valentine Richmond History Center, Richmond, Virginia.

South.[2] Nevertheless, Cocke, who had progressive notions about agricultural reform as well as architecture, believed that the "irregular or Gothic style" was "better adapted to Country houses than the more regular & formal Roman and Grecian styles."[3] The Virginian's choice in architects was obvious; Davis was the nation's leading proponent and designer of Romantic, medieval-inspired residences, interiors, and furnishings.[4] On a hill overlooking the James River, Belmead rose castlelike, complete with sixty-foot tower, steep gables, spires, and stained-glass bay windows. As the end of construction drew near, Cocke informed Davis, "The house is

attracting a good deal of attention in our state as it is the first that has been erected here of any size in the pointed style."[5]

The rosewood drawing-room suite must have been a great source of pride for the Cocke family at Belmead.[6] Certain features of the individual pieces nicely echo architectural motifs in the house: tall vertical profile, flattened Tudor arch that defines the crest rail, crenellated pendants suspended beneath the chair back, and pierced leg braces that resemble window tracery.[7] To create imaginative designs for both buildings and

furnishings, Davis learned the vocabulary of Gothic ornament through available prints, magazine illustrations, and books; publications by English designer A. W. N. Pugin were highly influential.[8] Still, the eclecticism of midcentury American taste allowed Gothic elements to be unashamedly wed to alternative stylistic sensibilities. The lofty carved floral ornament that crowns the crest rail of the Belmead side chair owes much to the dominating influence of the Rococo Revival that prevailed in the work of contemporary furniture designers such as John Henry Belter (see cat. nos. 45 and 46).

While a mature Gothic Revival style did not materialize in the United States until the 1830s, the movement had developed several decades earlier in Europe—with England at the forefront. Interest in the Middle Ages emerged from the Romantic era's fascination with the societies, mysteries, and esoteric religions of the past. By the turn of the nineteenth century, medieval themes began appearing in literature, music, art, architecture, and the decorative arts. In America the Gothic style was initially introduced through ecclesiastical architecture. But by the 1830s, the Romantic

39

FIG. 68 Attributed to Alexander Jackson Davis (1803–1892), illustrator; Albert Bobbett and Charles Edmonds, engravers, **Drawing Room at Kenwood, Gothic Style,** wood engraving, from A[ndrew] J[ackson] Downing, *The Architecture of Country Houses,* 1850.

FIG. 69 Attributed to Boston and Sandwich Glass Company (active 1826–88), manufacturers, **Sugar Bowl,** ca. 1840–60, pressed glass, 5 3/8 x 5 in. (13.7 x 12.7 cm) dia. Virginia Museum of Fine Arts, Gift of Mr. and Mrs. William B. Thalhimer Sr., 69.75.33a–b.

impulse was also manifesting in residential and decorative arts design—and with Davis as its leading advocate.[9]

When Andrew Jackson Downing, landscape architect and cultural tastemaker, published *The Architecture of Country Houses* in 1850, he turned to his friend Davis for guidance, images of elevations, and plans for villas constructed in the "pointed style."[10] Davis, a skilled draftsman, also provided drawings of a few interiors—including a view of the drawing room at Kenwood, the 1842 mansion he designed near Albany, New York. As he would with Philip St. George Cocke a few years later, Davis assisted Kenwood's owner with plans for Gothic Revival furnishings—which likely included the hexagonal center table featured prominently in the illustration (fig. 68). It became a favorite form; Davis apparently urged Cocke to acquire a similar table to grace Belmead as well (Art Institute of Chicago).[11]

With proportions and details strikingly similar to the Kenwood and Belmead tables, the design of the hexagonal center table in VMFA's collection is also attributed to Davis.[12] Exhibiting "the signature form of American furniture in the Gothic taste," this elegant piece features a white marble top supported by a bracketed apron with drops and turrets, a suspended pierced tracery cage, three clustered columns, and a tripod base. The table's fine craftsmanship has led scholars to suggest that it was produced in the New York shop of

Alexander Roux, an émigré cabinetmaker whose knowledge of French styles and techniques attracted elite customers eager to display a taste for the latest in progressive design.[13]

Davis was not alone in his interest in the Gothic mode. As the movement's popularity reached its height at midcentury, other American designers applied pointed arches, crockets, lancets, quatrefoils, and trefoils to furniture, metalwork, glass, textiles, and ceramics. VMFA's American art holdings feature additional fine examples, including a delicate folding side table, also attributed to Roux, and several glass objects ranging from a deep-blue covered sugar bowl (fig. 69), likely manufactured by the Boston and Sandwich Glass Company of Massachusetts, to that company's tour-de-force monumental triple-overlay lamp (see cat. no. 62). ELO

NOTES
1. Alexander Jackson Davis, "Day Book," Alexander Jackson Davis Papers, New York Public Library, 1:361, cited in Lynn E. Springer, "American Furniture," *Saint Louis Art Museum Bulletin* (Summer 1980): 32. In 1850 Andrew Jackson Downing praised Burns and Trainque for producing "[t]he most correct Gothic furniture that we have yet seen executed in this country." A[ndrew] J[ackson] Downing, *The Architecture of Country Houses* (New York: D. Appleton, 1850), 440n.
2. For an examination of Davis's career in domestic architectural design, see Patrick Alexander Snadon, "A. J. Davis and the Gothic Revival Castle in America, 1832–1865" (Ph.D. dissertation, Cornell University, 1988). In chapter four, Snadon focuses on the limited patronage for Gothic Revival residences in the South.
3. Letter from Cocke to William Maxwell, May 1, 1845, University of Virginia Library, Special Collections Department, cited in Charles E. Brownell et al., *The*

Making of Virginia Architecture (Richmond: Virginia Museum of Fine Arts, 1992), 73, 272; Snadon, 195–97.

4. Davis also gained substantial academic commissions, including six Gothic Revival buildings for Virginia Military Institute, Lexington, Virginia (1848–61), which came about through Cocke's recommendation. Brownell et al., 274–75.

5. Snadon, 197. From 1895 to 1972, Belmead estate was the site of Saint Emma's Industrial and Agricultural School, a Roman Catholic academy for black male youth (the mansion housing the school library and dorms for the priests on faculty). Today the property—now a conference center, retreat, and nature conservancy—remains in the hands of the Philadelphia-based Sisters of the Blessed Sacrament.

6. The other matching pieces in the Belmead suite are in various museum collections: a settee each at Baltimore Museum of Art and the Museum of Fine Arts, Boston; an armchair each at the Saint Louis Art Museum and New York State Museum; two side chairs at the Art Institute of Chicago; and a side chair each at the Metropolitan Museum of Art, New York, and the Indianapolis Museum of Art.

7. The suite's armchairs and settees also feature arm supports comprised of pierced, repeating pointed arches. Illustrated in William Voss Elder III and Jayne E. Stokes, *American Furniture 1680–1880, from the Collection of the Baltimore Museum of Art* (Baltimore: Baltimore Museum of Art, 1987), 70–71. For similar chairs attributed to Davies, see entries 53a and 53b in Elizabeth Feld, Stuart P. Feld, and David B. Warren, *In Pointed Style: The Gothic Revival in America, 1800–1860*, exh. cat. (New York: Hirschl and Adler Galleries, 2006), 104–5.

8. Jane B. Davies, "Gothic Revival Furniture Designs of Alexander J. Davis," *The Magazine Antiques* 111 (May 1977): 1014–16, 1020. Lynn Springer suggests that the initial inspiration for the Belmead suite may have come from a Gothic Revival chair pictured in Richard Bridgens, *Furniture with Candelabra and Interior Decoration* (London, 1838), which features a similar low arch back, carved foliated corbels at the sides, and turned legs with discs. Springer, 33.

9. Davies, Introduction in Katherine S. Howe and David B. Warren, *The Gothic Revival Style in America, 1830–1870*, exh. cat. (Houston: Museum of Fine Arts, Houston, 1976), 1–9; Feld et al., 11–20.

10. J. Steward Johnson, Introduction in Downing, xvii; Davies, 1024.

11. Notations in Davis's day book and journal, as well as correspondence between the architect and Kenwood's owner, Joel Rathbone, refer to Davis's drawings for various furnishings for that residence. Davies, 1020–21, 1027nn36–39. The Belmead hexagonal center table was acquired by James Biddle for his Gothic cottage in Andalusia, Pennsylvania. The Art Institute of Chicago subsequently purchased it in 2000. That table is not part of the multipiece suite to which the VMFA side chair belongs; it appears to have been crafted by a different cabinet-making shop. Feld et al., 82; "Highly Important American Furniture, Silver, Paintings, Prints, Folk Art, and Decorative Arts," Christie's, New York, sale 8840, January 16, 1998, lot 530.

12. Other examples of related hexagonal tables are in the collections of the High Museum of Art, Atlanta; the Museum of Fine Arts, Boston; the Pollock-Krasner House, Long Island; University of Utah Museum, Salt Lake City; Westervelt Warner Museum of American Art (on loan to the President's House, University of Alabama); and one private holding. I thank J. Michael Flanigan for his insights on this and related tables.

13. Born and trained as a cabinetmaker in France, Roux first appeared in New York City directories in 1838. By 1850 his company (active until 1880) employed over one hundred workmen and produced high-end furniture in several revival styles. Feld et al., 82, 105; Catherine Hoover Vorsanger and John K. Howat, *Art and the Empire City, New York 1825–1861*, exh. cat. (New York: Metropolitan Museum of Art, 2000), 317. In *The Architecture of Country Houses*, Downing wrote that Roux's shop offered "the rarest and most elaborate designs" and that it produced "some excellent specimens" in the Gothic mode. Downing, 412, 440n. Another possible manufacturer for a table of this caliber is Charles Baudouine (shop active 1829–54), the other prominent French émigré cabinetmaker in New York City. Feld et al., 82; Vorsanger and Howat, 312–14.

40. Worthington Whittredge (1820–1910)

View from the Hawk's Nest, Western Virginia, Morning, 1846

Oil on canvas

17 x 24 in. (43.2 x 61 cm)

Signed and dated lower right on tree: "Whitridge [sic] / 1846"

Inscribed verso: "View from the 'Hawk's Nest' / West'rn Va. / Morning."

Museum Purchase, Anonymous Donor Fund, 73.45

PROVENANCE: Bernard Danenberg Galleries, New York, N.Y. (before 1973)

This picturesque vista is among the earliest landscapes painted by Worthington Whittredge. The Ohio native began his career as a portraitist in Cincinnati. In 1843, he journeyed to western Virginia (now West Virginia) and settled in Charleston in search of sitters. While traveling around the region's forested mountains, Whittredge was inspired by the surrounding natural beauty, particularly the views near Hawk's Nest, a promontory that overlooks New River Gorge. Over the next five years, he produced at least five paintings of the site. Those canvases—including *View from the Hawk's Nest, Western Virginia, Morning*—launched his lifelong career as a landscape artist.[1]

In this 1846 depiction, Whittredge presents the prospect from Marshall's Pillar, a cliff at Hawk's Nest.[2] Gentle mountains flank a long valley view where wisps of low clouds drift among peaks and coves. From the rocky platform in the foreground, a tree stands sentinel, its S-shaped trunk echoing the meandering ribbon of water far below. The painting's natural features closely match those laid down in the artist's field sketch made the year before (fig. 70).[3] For the larger, more detailed canvas, Whittredge inserted narrative elements: a hunter and his dog at center, a decaying tree across the foreground, and a distant column of smoke suggesting inhabitants at the river's edge.

Although delineating the characteristics of a specific locale, Whittredge's carefully arranged composition also reveals his understanding of the conventions of seventeenth- and eighteenth-century European picturesque landscape painting, gleaned through prints and book illustrations available in the United States. His canvas further suggests knowledge of the work of contemporary artists associated with the Hudson

40

River school, including that of Thomas Doughty and Thomas Cole (see fig. 105 and cat. no. 37).[4]

Whittredge's image of the western Virginia promontory added to the era's growing compendium of national views by American artists. He was influenced by the same impulses that prompted Cole to picture New York's *Falls of Kaaterskill* (1826, Westervelt Warner Museum) and, later, Frederic Church to paint *Niagara* (1857, Corcoran Gallery of Art) and Virginia's *Natural Bridge* (1852, University of Virginia Art Museum). The fad for picturesque tourism had grown steadily over the previous half century in Europe and the United States. Essays, travelogues, and books such as William Gilpin's *An Essay on Picturesque Travel* (American edition, 1783) sent cultivated tourists near and far in search of the scenic and sublime. Those who could not venture forth sought satisfaction in paintings, prints, and picture books.[5]

By the early 1840s, the breathtaking view from Hawk's Nest, accessible by stagecoach, had already become a popular tourist destination. Located on a turnpike that connected Charleston with the fashionable White Sulphur Springs resort, the overlook rated mention by prominent travel writers—including Englishwoman Harriet Martineau, who described Hawk's Nest as:

> a platform of rock, springing from the mountain side, without any visible support, and looking sheer down upon an angle of the roaring, river between eleven and twelve hundred feet below. Nothing whatever intervenes. Spread out beneath, shooting up around, are blue mountain peaks, extending in boundless expanse. . . . With each arm clasping a pine-stem, I looked over, and saw more, I cannot but think, than the world has in reserve to show me.[6]

While Whittredge pictured a solitary, red-shirted hunter standing at the dramatic precipice, printmaker Edward Beyer produced a glimpse of the regular day-trippers who took in the view. Well-dressed tourists promenade at Hawk's Nest in Beyer's 1858 lithograph, created for his *Album of Virginia* portfolio (fig. 71).

Following Whittredge's return to Cincinnati and successful exhibitions there of his work, the painter gained patronage and support that allowed him to travel to Europe in 1848.

FIG. 70 Worthington Whittredge (1820–1910), **A View from Hawk's Nest, Western Virginia,** ca. 1845, oil on board, 9 1/16 x 11 1/4 in. (23 x 25.6 cm). Virginia Museum of Fine Arts, Gift of CSX Corporation, 2003.196.

FIG. 71 Edward Beyer (ca. 1820–1865), **View from the Hawk's Nest, Fayette County, Va.,** from *Album of Virginia*, 1858, lithograph, 16 3/4 x 24 3/4 in. (42.5 x 62.9 cm) sheet, 8 1/2 x 17 1/4 in. (21.6 x 43.8 cm) image. Museum Purchase, The Virginiana Fund, 71.13.24/37.

Over the next ten years, he trained in Düsseldorf with Emmanuel Leutze and studied in Rome in the company of American landscape painters Sanford Gifford and Albert Bierstadt. Whittredge then returned to New York City, where he fully mastered the Hudson River school aesthetic. A prolific artist, his approach to landscape varied over time, ranging from intimate woodland interiors to vast panoramas of the western frontier. At age seventy-five, the venerable painter wrote an autobiography, leaving significant record of his

experiences and colleagues as well as a first-hand account of the flourishing of the national landscape movement.[7] ELO

NOTES

1. Anthony F. Janson, "Worthington Whittredge: Two Early Landscapes," *Bulletin of the Detroit Institute of Arts* (1977): 199–203; Janson, *Worthington Whittredge* (Cambridge: Cambridge University Press, 1989), 17–18, 21–24.

2. The oil-on-board preliminary study for this painting (fig. 70) is inscribed by the artist on verso: "A view from Hawk's Nest on Marshall's Pill[ar?] / looking up New River, Western Virginia / Morning / painted in 1840 / by Whittredge." The overlook was named for Chief Justice John Marshall, who surveyed the region in the early 1800s.

3. By extraordinary coincidence, the study was given to VMFA in 2003, independently of the later, larger canvas that had entered the collection twenty years earlier. Although the artist inscribed the date of 1840 on the back of the study, it was probably painted in 1845. Scholars have determined that Whittredge added dates to the backs of some paintings for a 1905 exhibition, relying on a sometimes inaccurate memory. Anthony Janson, "The Paintings of Worthington Whittredge" (Ph.D. dissertation, Harvard University, 1975), 217; Edward H. Dwight, *Worthington Whittredge (1820–1910): A Retrospective Exhibition of an American Artist* (Utica, N.Y.: Munson-Williams-Proctor Arts Institute, 1969), 24. Janson suggests that the artist first painted outdoors in 1846. However, the immediacy of the study and the inscription "morning" on the back suggest otherwise. Janson, *Worthington Whittredge*, 28. For discussion of Whittredge's on-site sketching, see Eleanor Jones Harvey, *The Painted Sketch: American Impressions from Nature, 1830–1880*, exh. cat. (Dallas: Dallas Museum of Art, 1998), 270–71.

4. Janson, *Worthington Whittredge*, 20–21.

5. The growing taste for travel imagery flourished throughout the nineteenth century, ranging from the success of Joshua Shaw's 1820–21 portfolio of aquatints, "Picturesque Views of American Scenery," to the highly accessible woodcut images in "Picturesque America," serialized in *Appleton's Journal* through the 1870s. Bruce Robertson, "The Picturesque Traveler in America" in *Views and Visions: American Landscape before 1830* (Washington, D.C.: Corcoran Gallery of Art, 1986), 187–211; Sue Rainey, *Creating Picturesque America: Monument to the Natural and Cultural Landscape* (Nashville and London: Vanderbilt University Press, 1994), 29–31.

6. Harriet Martineau, *Society in America* (London: Saunders and Otley, 1837), 1:243. See also James C. Kelly and William M. S. Rasmussen, *The Virginia Landscape: A Cultural History* (Charlottesville, Va.: Howell Press, 2000), 66–67. Today the region has been set aside as Hawks Nest State Park. The area features an attraction unimagined in Whittredge's day: the lofty New River Gorge Bridge is a well-known launching place for bungee-jumping aficionados.

7. *Autobiography of Worthington Whittredge, 1820–1910*, ed. John I. H. Baur (1942; repr., New York: Arno Press, 1969).

41. Fitz Henry Lane (1804–1865)

View of Gloucester Harbor, 1848

Oil on canvas mounted on panel

27 x 41 in. (68.6 x 104.1 cm)

Signed and dated lower right: "F. H. Lane / Jan: 1848"

Museum Purchase, The Adolph D. and Wilkins C. Williams Fund, 62.32

PROVENANCE: William Saville, Waban, Mass.; Vose Galleries, Boston, Mass.

In creating his panoramic *View of Gloucester Harbor* in 1848, Fitz Henry Lane delineated a scene that he knew intimately. A favorite vista that he would picture in several sketches and paintings, this view became especially significant the following year when Lane established his home and studio near the painting's vantage point. The artist directs the eye from Duncan's Point in the inner harbor of Gloucester, Massachusetts, toward the open sea. The late afternoon sky holds a wisp of a cloud; in the far distance more clouds announce an incoming front. Lane frames the scene with prominent Cape Ann landmarks: at center right, a peninsula topped by the ruins of the Revolutionary War–era stronghold Fort Defiance, and at left, Ten Pound Island.[1]

Lane's fairly accurate rendering offers more than a topographical record, however. With an eye to compositional balance and pictorial effect, he positions watercraft, buildings, and figures with measured discipline across the horizontal scene. A variety of ships' masts break the low horizon, stitching earth to water to air. The artist also provides a narrative of Gloucester's harbor-side activities. In the foreground, a double-ended schooner has come to rest on land at low tide. Its tall parallel masts draw the eye to a gathering of fishermen onshore. One cleans fish at a makeshift table while his mates carry them to two waiting townsmen. The quantity suggests that the day's catch may not be destined for their dinner tables alone, but for stalls in a village market.

Lane's Gloucester neighbors and patrons, well familiar with such scenes of local commerce, would have noted the square-rigged merchant ship pictured in the harbor at distant left. Such vessels were ubiquitous in Gloucester, which, as a terminus for inland canals and railroads, was one of New England's primary seaports for national and international trade. In the 1840s, newer icing processes boosted Gloucester's commercial export of fish to points along the nation's eastern seaboard as well as to Surinam in the West Indies. Lane goes further, hinting in his visual account of yet another source of local revenue. With the region's new railways, hotels were springing up around the cape to accommodate a growing tourism industry. At left, a small excursion boat draws near a rocky spit, providing several visitors the opportunity to take in the salty air and picturesque views.[2]

Fitz Henry Lane had relocated permanently to his home-

41

town of Gloucester only months before he completed *View of Gloucester Harbor*.[3] Sixteen years earlier, this son of a sailmaker had left the seaport for formal art instruction in Boston, where for over a decade he worked as an artist and printmaker in William Pendleton's lithography firm. In the early 1830s Lane solidified his lifelong commitment to seascapes and harbor views, probably influenced by an acquaintance with Robert Salmon, the British émigré and prominent maritime painter, who took on occasional lithography projects at Pendleton's as well (see cat. no. 27). Upon Salmon's return to England in 1842, Lane and a handful of other painters vied for the role of leading marine artist in the United States. Among them was another Englishman, James E. Buttersworth, best known for his portraits of racing vessels set against dramatic skies and seas—such as the sleek sandbagger pictured in *A Racing Yacht on the Great South Bay* (fig. 72), made after 1850. But it was Lane, America's first native-born seascapist of note, who captured attention through exhibitions and prints of his Gloucester paintings—as well as images set in Boston, New York, Baltimore, and along the coast of Maine.[4]

The narrative qualities, solid draftsmanship, and studied tonality of *View of Gloucester Harbor* give evidence of Lane's formative years as a graphic artist in Pendleton's lithography firm. At the same time, the warm, atmospheric glow that permeates this late afternoon scene signals the artist's developing interest in depicting the quality of light at specific moments of the day. His 1864–65 painting *Sunset off Ten-Pound Island* (fig. 73), in which he again pictures Gloucester Harbor, presents a more dramatic sunset that casts the port in rosy hues. At midcentury, as Lane sought to capture the changing effects of weather and time in his water views, his paintings became ever more spacious, still, and luminous.[5] ELO

FIG. 72 James E. Buttersworth (1817–1894), **A Racing Yacht on the Great South Bay,** after 1850, oil on canvas, 10 x 12 in. (25.3 x 30.4 cm). Virginia Museum of Fine Arts, Gift of Eugene B. Sydnor, Jr., 71.35.

FIG. 73 Fitz Henry Lane (1804–1865), **Sunset off Ten-Pound Island,** ca. 1860, oil on canvas, 12 x 20 in. (30.5 x 50.8 cm). Collection of James W. and Frances G. McGlothlin, Promised Gift to Virginia Museum of Fine Arts.

NOTES

1. James A. Craig, *Fitz H. Lane: An Artist's Voyage through Nineteenth-Century America* (Charleston, S.C., and London: History Press, 2006), 88–89, 93–94.

2. Erik A. R. Ronnberg Jr., "Imagery and Types of Vessels," in John Wilmerding et al., *Paintings by Fitz Hugh Lane*, exh. cat. (New York: Abrams in association with the National Gallery of Art, 1988), 80, 83; Craig, 82–85.

3. In 2005, Cape Ann historians and archivists Sarah Dunlap and Stephanie Buck determined that Lane's middle name was Henry—not Hugh as asserted by scholars since the 1930s. For undetermined reasons, the young artist petitioned to have his original name, Nathaniel Rogers Lane, legally changed to Fitz Henry Lane on December 26, 1831. "Fitz Who Lane?," *The Magazine Antiques* 167 (June 2005): 48; Craig, 20–21, 181nn39,40.

4. Craig, 56–75; Wilmerding, *American Marine Painting* (New York: Abrams, 1987), 98; 113–15; Wilmerding, *Fitz Hugh Lane* (Westport, Conn.: Praeger, 1971), 19–23, 42–43, 62–63.

5. Wilmerding, *Fitz Hugh Lane*, 75–80. In 1954, art historian John I. H. Baur identified such poetic, light-imbued, atmospheric effects employed by mid-nineteenth-century landscapists, including Lane and Martin Johnson Heade (see cat. no. 66), as "Luminism." Subsequent scholars have since characterized such qualities as being part of individual artistic approaches rather than a specific stylistic movement. For a historiographic consideration of the issue, see Mark D. Mitchell, "First Light: John I. H. Baur, James Suydam, and Luminism," *Archives of American Art Journal* 46 (2006): 24–35.

42. Robert Scott Duncanson (1821–1872)

The Quarry, ca. 1855–63

Oil on canvas

14½ x 22⅝ in. (36.8 x 57.5 cm)

Gift of The Council of the Virginia Museum of Fine Arts, in

 Commemoration of Its Fiftieth Anniversary, 2006.11

PROVENANCE: Private collection; Alexander Gallery, New York, N.Y.; Questroyal Fine Art, New York, N.Y.

Robert Scott Duncanson's *The Quarry* features an indomitable rock formation that seems to defy assaults from both nature and man. Like his subject, Duncanson has his own story of endurance as a free African American who established an international reputation during the tumultuous years surrounding the Civil War.

A self-taught painter whose grandfather and mother were once enslaved in Virginia, Duncanson transcended his era's strict race boundaries. He was born in rural New York and raised in Monroe, Michigan, where he learned carpentry, glazing, and house-painting skills from his father. As a teenager, he opened a house-painting and decorating business but soon pursued artistic interests by copying images from prints. In the early 1840s, Duncanson relocated to the Cincinnati area, where he gained commissions for portraits. He then began to create landscape imagery, attracting the notice of leading Ohio Valley landscapists William Sonntag and Worthington Whittredge (see cat. no. 40), who befriended him and shared current theories and approaches. Through determination and perseverance—and funding for European study from Cincinnati philanthropist and abolitionist Nicholas Longworth—Duncanson became a highly skilled and prolific painter.[1] By 1861, his work had garnered attention in national exhibitions, prompting the *Daily Cincinnati Gazette* to describe him as "the best landscape painter in the West."[2]

The Quarry is an excellent example of Duncanson's mature style and ability at midcentury.[3] The painting's composition reveals his absorption of European landscape conventions—long associated with seventeenth-century French landscapist Claude Lorraine—that encouraged the careful organization of views. The focal point is the rather foreboding precipice that looms above a pool of water. Although the title locates the site as a quarry, the painter inserted a small waterfall to add a lyrical glimpse of untouched nature. The image opens up at center to feature additional rock formations and, in the background, a field dotted with haystacks. Beyond this lies a small village, barely discernible at the foot of distant mountains, all indistinct with atmospheric haze. In what would otherwise be a bucolic setting, a plume of factory smoke speaks of technological and economic development (fig. 74). To balance the scene visually, Duncanson added a gnarled tree in the left foreground. That sentinel feature—pictured well into its decline but still clinging to life—suggests another artistic influence. A single framing tree, a Claudian device, was a favorite motif of Thomas Cole, founder of the Hudson River school movement and a powerful model and theorist for two generations of American landscapists (see cat. no. 37).[4]

FIG. 74 Detail of cat. no. 42.

The exact site of the quarry in Duncanson's scene is undetermined. It may be a faithfully documented view or an imagined composite of pleasing features gathered during the artist's frequent sketching trips in Ohio, Michigan, and North Carolina. Painted in a Romantic era when landscape often carried the metaphoric narrative of literature and art, *The Quarry* may have easily summoned national and religious associations for its viewers. Unlike Cole, who sometimes included in his landscapes connotations of loss and warnings about the destruction of the wilderness, Duncanson presents a harmonious balance between nature and humankind.[5] An abundant

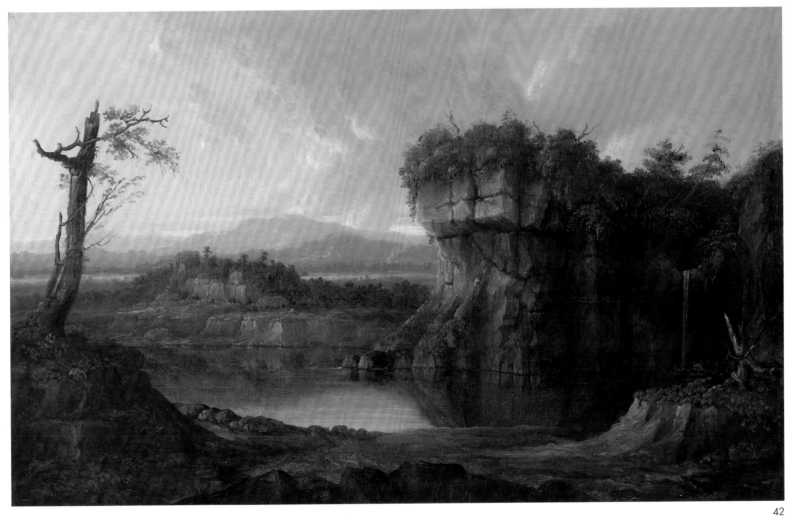

42

land yields its resources with little or no injury: hewn stone builds roads and fences in the distant community, an unseen stream fuels a mill, and cleared fields provide timber for houses and open farmland for crops. Those seeking indication of a divine hand in this otherwise straightforward prospect might find it in the repeating crosslike cleavage that marks the prominent rock face.

After the Civil War commenced, Duncanson took temporary exile in Montreal, where he helped launch a Canadian landscape movement. Following a successful postwar tour of his work in England and Scotland, he returned to Cincinnati and a burgeoning career. Celebrated abroad by many admirers—including Alfred, Lord Tennyson, with whom he stayed as a houseguest—the artist still struggled at home in a racially charged atmosphere. Publicly and privately, many commented as freely on the light-skinned Duncanson's mixed heritage as on his canvases. To a family member who suggested that he might benefit by passing as white, the artist sent a terse reply: "Mark what I say here in black and white I have no color on the brain all I have on the brain is paint. . . . I care not for color: 'Love is my principle, order is the basis, progress is the end.'"[6] In 1871 Duncanson suffered a sudden mental breakdown, likely caused by sustained exposure to lead house paint in his early years. He died in 1872 at age fifty-one.[7] Twenty-five years would pass before another African American painter, Henry Ossawa Tanner (see cat. no. 102), would rise to and surpass Duncanson's national and international prominence. ELO

NOTES

1. For a thorough consideration of the artist's life and career, see Joseph D. Ketner, *The Emergence of the African-American Artist: Robert S. Duncanson, 1821–1872* (Columbia and London: University of Missouri Press, 1993). The genealogical facts regarding four generations of the Duncanson family—many documented as "mulatto"—are listed in federal census records. Ketner, 11–13, 208n3. Nevertheless, incorrect accounts claiming that the artist was the son of a Scottish-Canadian white father and a freeborn mother are still perpetuated in art historical literature today.

2. *Daily Cincinnati Gazette,* May 30, 1861, 3, cited in Ketner, 1. For a review of Duncanson's exhibition successes in the 1850s, see chapter 5 in Ketner. For an exploration of Duncanson's career within the context of Cincinnati's political and cultural milieu, see chapter 3 in Wendy Katz, *Regionalism and Reform: Art and Class Formation in Antebellum Cincinnati* (Columbus: Ohio State University Press, 2002).

3. My thanks to Joseph Ketner for helping establish the general dates of the painting's creation.

4. Ketner, 34–35; Alan Wallach, "Thomas Cole, Landscape and the Course of American Empire," in *Thomas Cole, Landscape into History,* ed. William H. Truettner and Alan Wallach (New Haven: Yale University Press; Washington, D.C.: National Museum of American Art, Smithsonian Institution, 1994), 70.

5. Cole, with his associates and followers, often evoked national and religious associations through naturalistic imagery. Wallach, 64; J. Gray Sweeney, "The Advantages of Genius and Virtue, Thomas Cole's Influence, 1848–58," in *Thomas Cole, Landscape into History,* 118–19.

6. R. S. Duncanson to Reuben Graham, June 29, 1871, quoted in Linda Roscoe Hartigan, *Sharing Traditions: Five Black Artists in Nineteenth-Century America* (Washington, D.C.: Smithsonian Institution Press for the National Museum of American Art, 1985), 65. For an alternative reading of Duncanson's career within the context of contemporary American race relations, see chapter 3 in David M. Lubin, *Picturing a Nation: Art and Social Change in Nineteenth-Century America* (New Haven and London: Yale University Press, 1994).

7. Ketner, 137–39, 153–55, 184.

43. John William Orr (1815–1887)

Still Life with Newspapers, ca. 1850

Watercolor and ink on paper

20 ⅞ x 28 ⅝ in. (53 x 72.7 cm)

Watermark: Whatman Turkey Mill, 1847

Museum Purchase, The J. Harwood and Louise B. Cochrane Fund for American Art, 2001.228

PROVENANCE: H. Marshall Goodman Jr., Richmond, Va.

Viewers are inevitably compelled to draw close to examine John William Orr's *Still Life with Newspapers.* Using watercolor and ink, the artist painted an astounding illusionistic display of mid-nineteenth-century newspapers, pamphlets, and broadsheets. The spiraling black-and-white composition is topped with a hand-addressed envelope; franked with red ink, the letter introduces a single touch of color.[1]

Wood engraver, draftsman, illustrator, and publisher, Orr rarely ventured into the field of painting. *Still Life with Newspapers* is exceptional, if not unique, in his oeuvre. Inspection of the trompe-l'oeil painting discloses something of the artist and his world. Meticulous renderings of the *New York Herald,* the *Sun,* and the *Home Journal* reveal his residency in New York City, America's cultural and commercial capital. Other newspapers bear witness to the cosmopolitan nature of this important urban seaport: *Carrier's Shipping & Co., Faro Industrial de la Habana, Wiener Abendzeitung,* and *Courrier des Etats-Unis.* The envelope at center, posted to New York from Paris, extends the theme of global exchange. The prominent cover

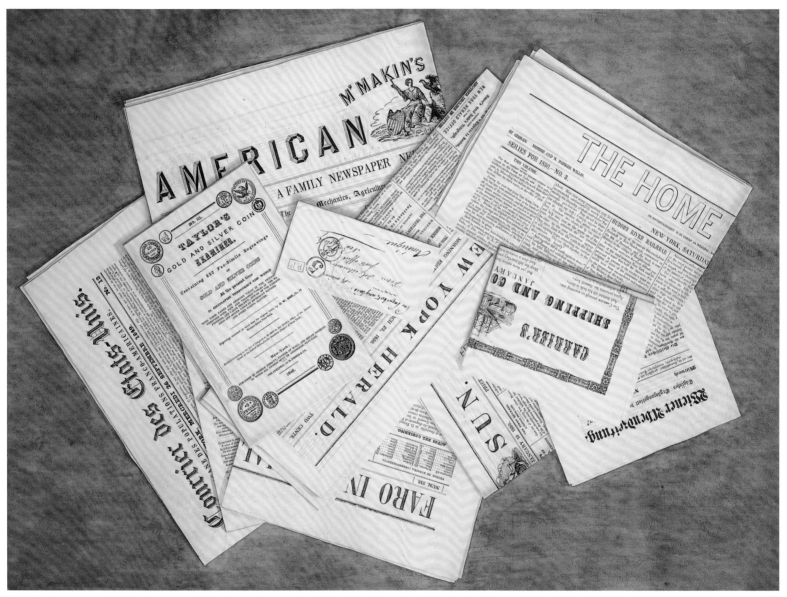

43

for *Taylor's Gold and Silver Coin Examiner* pictures international coinage. More important, it also announces the artist's name and foremost profession: "Engravings executed on wood from the original Coins by J. W. ORR, No. 75 Nassau Street, New York."

FIG. 75 Detail of cat. no. 43.

Beyond introducing international diversity, Orr also seems to have chosen the publications to present a variety of text styles. In this way, the painting suggests the artist's keen appreciation—even love—of typeface, design, and ornamental graphics. In giving the coin brochure pride of place, Orr showcases his own illustrations. He also may have been the anonymous artist-engraver for other mastheads or borders decorating the assembled ephemera.

Born in Ireland, Orr was brought by his parents to Buffalo, New York, as an infant. By the time he was twenty-one, he had garnered recognition for his abilities as a wood engraver. "Mr. Orr," an 1836 exhibition catalogue proclaimed, "evinces talents which are rapidly securing him an extended reputation." After 1844, he was established in New York City, where he and his brother Nathaniel founded one of the largest engraving companies in the region. By the time this watercolor was executed in 1850, Orr's interests were expanding to include book illustration. Between 1862 and 1871, he also served as editor and publisher of the *American Odd Fellow*.[2]

The process of wood engraving was painstaking, requiring enormous patience and an unerring hand. Fully developed in the previous century, the practice was the primary method of printing during most of the 1800s. Text and images were carefully cut by hand into blocks of boxwood. An electrotype cast was made to deliver thousands of impressions, while the original block could be stored as a master for future use.[3] Typically, there was a distinction between the duties of artist and engraver; however, Orr occasionally undertook both.[4]

Orr obviously transferred his engraver's controlled focus to the task of achieving the empirical fidelity of *Still Life with Newspapers*. Using actual newspapers and broadsides—and very likely a magnifying glass—he faithfully rendered the text and graphics by hand.[5] Close examination of the miniscule lettering offers testimony to the labor-intensive endeavor (fig. 75). The visual deception is strengthened by the soft shadows and a hint of the ink on the reverse sides of the pages.

In producing his illusionary still life, Orr participated in a long but sporadic tradition in Western art. Ancient history relates the tale in which birds swooped down to peck at the realistically rendered grapes in a painting by Zeuxis, and in subsequent ages, Renaissance artists left a legacy of deception imagery in their explorations of perspective, space, and volume. Trompe-l'oeil painting flourished in the seventeenth-century Golden Age of Dutch painting.[6]

In American art, Orr's visual trickery follows the memorable efforts by Charles Willson Peale and his progeny (see cat. no. 20) but precedes the better-known practitioners of the 1880s and 1890s: William Harnett, John F. Peto, De Scott Evans, Claude Hirst (see cat. no. 95), and Richard LaBarre Goodwin (the latter four are represented in the VMFA collection as well).[7] Today's visitors may also experience a sense of familiarity when viewing Orr's artfully arranged newspapers; his painting anticipates the synthetic cubist compositions of Pablo Picasso and George Braque of the early 1910s. However, those pioneers of modernism often secured actual newspapers to their papier collé, whereas Orr fools the viewer into thinking that he did. ELO

NOTES

1. The envelope is addressed to "Monsieur Josué Heilmann, New York, Amérique." The recipient may have been Josué [Joshua] Heilmann, son and partner of the famous Frenchman of the same name whose inventions—most notable the

cotton-combing machine—had revolutionized the textile industry. At the time of this painting, Josué Heilmann *fils* was on an extended visit to New York, where he likely met Orr through a close network of editors, publishers, and artists affiliated with editor John Inman—Heilmann's future father-in-law and brother to painter Henry Inman. The prominence of the envelope in the composition suggests a friendship between Orr and the younger Frenchman. Claude Fohlen, *L'Industrie Textile au Temps de Second Empire* (Paris: Librarie Plon, 1956), 53, 80, 227; marriage announcement, *New York Daily Times,* July 24, 1854, 8.

2. Rochester Mechanics' Library Association (October 12, 1839), cited in James L. Yarnall and William H. Gerdts, *Index to American Art Exhibition Catalogues, from the Beginning through the 1876 Centennial Year* (Boston: G. K. Hall, 1968), 4:2634; Peter Hastings Falk, ed., *Who Was Who in American Art,* (Madison, Conn.: Sound View Press, 1999), 2:2477.

3. "Woodengraving," *Dictionary of Art* (New York: Grove, 1996), 33:367–70.

4. John Lewis, *Printed Ephemera* (Ipswich, Suffolk: W. S. Cowell, 1962), 207. Among his book illustrations, Orr produced wood engravings for Lambert A. Wilmer, *The Life, Travels and Adventures of Ferdinand de Soto, Discoverer of the Mississippi* (Philadelphia: J. T. Lloyd, 1858); *Pictorial Guide to the Falls of Niagara* (Buffalo: Salisbury and Clapp, 1845); William Roscoe, *Butterfly's Ball and Grasshopper's Feast, with Other Interesting Stories for Young People* (New York: Wiley and Putnam, 1847); Susan Warner, *Mr. Rutherford's Children* (New York: G. P. Putnam, 1853–55); and some of the illustrations in Andrew J. Downing's *The Architecture of Country Houses* (New York: D. Appleton, 1850).

5. A review of microfilmed copies of antebellum newspapers confirms that Orr produced verbatim replicas of the front pages of the *Home Journal* (January 12 1850) and the *New York Herald* (March 23, 1850).

6. William Kloss, *More Than Meets the Eye: The Art of Trompe l'Oeil* (Columbus, Ohio: Columbus Museum of Art, 1985), 20.

7. For further information on American trompe-l'oeil painting, see William H. Gerdts, *Painters of the Humble Truth: Masterpieces of American Still Life* (Columbia, Mo., and London: Philbrook Art Center with University of Missouri Press, 1981).

44. Severin Roesen (ca. 1815–ca. 1872)

The Abundance of Nature, ca. 1855

Oil on canvas

56⅛ x 40⅛ in. (142.6 x 101.9 cm)

Signed with tendril device lower right: "Roesen"

Museum Purchase, The J. Harwood and Louise B. Cochrane Fund for American Art, 2002.558

PROVENANCE: James Thomas Carter and Catherine Taylor Prescott Carter, Chatham Co., Va.; to son James Prescott Carter, Estouteville, Albemarle Co., Va. (ca. 1944); Estate of James Prescott Carter (1998); Private collection, Bethesda, Md.

Severin Roesen's aptly titled painting *The Abundance of Nature* offers an exuberant cascade of colorful fresh flowers and luscious fruit. Fourteen different types of blossoms, from the humble nasturtium to the resplendent crown imperial, tower above fifteen varieties of fruit scattered over stepped-stone ledges. A tiny bird's nest filled with eggs is perched on the

upper level under the sheltering profusion of blooms. A basket of red berries, a goblet of white wine, and a compote of blue plums enliven the tumbled bunches of grapes that threaten to spill over the second ledge and onto the floor. Careful inspection reveals minute details: ladybugs, droplets of water,

FIG. 76 Detail of cat. no. 44.

and even the reflection of a studio window in the surface of the wine goblet (fig. 76). An important element is Roesen's prominent signature in vine tendrils at the lower right corner of the canvas, for the painter did not always sign his work.

Although scholars are still piecing together the scant bits of information about the artist's work and life, Severin Roesen holds pride of place as the outstanding practitioner of still lifes in the United States during the mid-nineteenth century. A German Rhinelander, Roesen immigrated to New York City following the turbulent European revolutions of 1848. Ten years later, he relocated to rural Williamsport, Pennsylvania, where he found patronage in the town's prosperous German American community until his death in the early 1870s.[1]

Roesen was prolific, creating numerous still lifes that feature flowers or fruit. On rare occasion, as this grand canvas testifies, he combined the two.[2] *The Abundance of Nature* is representative of Roesen's fully mature style and exhibits his synthesis of several artistic currents: emulation of seventeenth-century Dutch still life, the Düsseldorf Academy's fidelity to

44

sharp naturalism, and the era's heightened interest in botany and entomology. The artist created what seems to be an objective representation, yet the image is an idealized studio composite of fruit and flowers that, in nature, ripen or bloom in different seasons. Roesen blended scientific empiricism with aesthetic choice.[3]

The painting's bountiful display captures the optimistic vision of pre–Civil War Americans who saw themselves as beneficiaries of God's blessings in an abundant New World. That sentiment is echoed in the ebullient ornamentation on a pair of sofas produced by New York cabinetmaker John Henry Belter (see cat. nos. 45 and 46). Exhibiting a Victorian *horror vacui* similar to Roesen's, Belter lavished every inch of the rosewood crest rails with cornucopias spilling forth flowers, nuts, and fruit. Roesen's bright, crisply modeled forms hint, as well, at his earlier training as a painter of china, a trade often undertaken by aspiring artists.[4] Colorful hard-edge fruit and flowers decorated many sets of European porcelain acquired by wealthy Americans to embellish their dining rooms. Such motifs adorn a gold-rimmed, multipiece dessert set (fig. 77) produced in the early 1840s by Edouard Honoré in Paris. It was acquired by Sarah Coles Stevenson and her husband, Andrew Stevenson, minister to the Court of Saint James in England (1836–41). After Ambassador Stevenson's retirement and the couple's return to their native Virginia, the service graced the table at their residence near Richmond.[5]

In the second half of the twentieth century, Roesen's *The Abundance of Nature* dominated the dining room at Estouteville, an Anglo-Palladian mansion in Albemarle County, Virginia.[6] This pastoral setting suited the bounteous image. A century earlier, Selina Skipwith Coles and her husband, John Coles III—brother to Sarah Stevenson—developed Estouteville into an agricultural showplace renowned for its ornamental fruit trees and flower gardens.[7] ELO

NOTES

1. William Gerdts, *Painters of the Humble Truth: Masterpieces of American Still Life, 1801–1939* (Columbia, Mo., and London: University of Missouri Press; Tulsa, Okla.: Philbrook Art Center, 1981), 84. The most comprehensive study of the artist's life and work to date is Judith Hansen O'Toole, *Severin Roesen* (Lewisburg, Pa.: Bucknell University Press; London: Associated University Presses, 1992), 29.

2. Beyond its complexity of subject, this canvas is one of only a handful of Roesen's known paintings executed on such a grand scale. It is also possibly the largest. The majority of the artist's other paintings are horizontal in format.

3. O'Toole, 29.

4. Ibid., 23–24.

5. Francis Fry Wayland, *Andrew Stevenson: Democrat and Diplomat, 1785–1857* (Philadelphia: University of Pennsylvania Press; London: Oxford University Press, 1949), 257–58; curatorial records, Valentine Richmond History Center, Richmond, Va. I thank Elise Wright, Meghan Holder, and Suzanne Savery at the Valentine for sharing information about this splendid dessert set.

6. When VMFA purchased *The Abundance of Nature* in 2002, it came with an erroneous provenance indicating unbroken ownership by Coles-Skipwith descendants at Estouteville. Subsequent correspondence with family members has clarified that James Prescott Carter, who had Skipwith family connections, acquired Estouteville in 1944, at which time he placed the canvas in the dining room. The painting had previously belonged to his parents in Chatham County, Virginia, who, in the 1930s, lent it to the Lynchburg [Virginia] Woman's Club. Carter resided at Estouteville between 1944 and 1983 after which he relocated to Esmont, Virginia. The painting remained in his possession there until his death in 1998. Correspondence in VMFA curatorial files.

7. For more about Estouteville (built 1827–30) and the Coles family, see Elizabeth Langhorne, K. Edward Lay, and William D. Rieley, *A Virginia Family and Its Plantation Houses* (Charlottesville: University Press of Virginia, 1987), 29, 97–101.

FIG. 77 Edward Honoré (d. 1855) (company active 1825–78), **Dessert Set,** select pieces, Paris, ca. 1840–45, porcelain. The Valentine Richmond History Center, Richmond, Virginia.

45. Attributed to **John Henry Belter** (1804–1863)

Sofa, ca. 1850

Laminated, carved, and gilded rosewood; reproduction silk damask
 upholstery
43 x 94 x 36 ½ in. (109.2 x 238.8 x 92.7 cm)
Gift of Mrs. Hamilton Farnham Morrison in memory of her parents,
 Robert Letcher Moore and Josephine Landes Moore, 54.15.2/2

46. Attributed to **John Henry Belter** (1804–1863)

Sofa, ca. 1850

Laminated and carved rosewood; reproduction silk damask upholstery
42 ½ x 90 x 36 in. (108 x 228.6 x 91.4 cm)
Gift of Mrs. Hamilton Farnham Morrison in memory of her parents,
 Robert Letcher Moore and Josephine Landes Moore, 54.15.1/2

PROVENANCE: John Roll McLean and Emily Beale McLean, Washington, D.C.;
Edward Beale McLean and Evalyn Walsh McLean, Washington, D.C.; Evalyn Walsh
McLean Estate Sale, Meredith Galleries (May 15, 1948); Mrs. Hamilton Farnham
Morrison (née Bessye "Polly" Moore), Washington, D.C.

These magnificent sofas have a bold presence and an intrigu-
ing history. Although unlabeled, they exhibit the distinctive
design and construction characteristics of the New York City
shop of John Henry Belter.[1] Produced midcentury, when
the ornate Rococo Revival style was at its height in America,
the curvilinear rosewood frames were deeply carved into C and
S scrolls that support naturalistic cornucopias overflowing
with fruit and flowers. Together or separately—or, perhaps,
as part of Belter's popular multipiece parlor suites—the pair
initially graced the residences of now-unknown but certainly
prosperous owners.[2] At the turn of the twentieth century,
decades after the ornate revival style had fallen out of fashion,

(after conservation treatment to restore gilding) 45

the sofas gained surprising new vitality. Their original wood surfaces received a coat of bright gold leaf, allowing them to take their places alongside antique French gilt furnishings that graced the music gallery of a prominent Washington, D.C., newspaper magnate.

Like other eclectic revival movements of the nineteenth century—including Gothic, Egyptian, and Renaissance (see cat. nos. 38, 39, 70, and 30)—the Rococo Revival came from Europe. However, it was this "Modern French" style, as architect and critic Andrew Jackson Downing described it in 1850, that stood "much higher in general estimation in this country than any other."[3] The movement, which employed French seventeenth- and eighteenth-century forms and motifs, flourished in France and England in the 1830s before making its way to the United States the following decade. The exuberant style appealed to prosperous American patrons who

viewed their young nation's expanding physical and economic boundaries with optimism. By the 1850s, architectural woodwork in fashionable residences became emphatic with bold curvaceous ornament. Rooms brimmed with silver, glass, textiles, and bric-a-brac, featuring arabesques, fruit, and flowers. And beneath landscape paintings that extolled the majestic beauty of America's vistas (see cat. no. 57), or still lifes that celebrated the abundance of its natural bounty (see cat. no. 44), elaborately carved furnishings displayed scrolling lines, naturalistic flora, and the requisite cabriole legs (fig. 78).[4]

Since its heyday in the mid-nineteenth century, American Rococo Revival furniture has been closely associated with the name of John Henry Belter. An émigré who honed his cabinetmaking skills in his native Germany, Belter established a shop in New York City about 1844, just as the taste for the rococo aesthetic took hold.[5] Competition for revival furniture was

(before conservation treatment to remove gilding) 46

fierce. Many companies—including those owned by Joseph Meeks and Sons (see cat. no. 30), Alexander Roux, and Charles A. Baudouine—produced fine furnishings in a variety styles. As the pace of the Industrial Revolution quickened, those shops, like Belter's, made the transition from hand-crafted cabinet-making to machine-assisted manufacturing. Only Belter, however, committed himself solely to the complex "Modern French" manner. In the 1850s, he patented processes and equipment that produced more durable furniture by more efficient means.[6] Key to his success was his use of laminated wood—typically six to eight layers of thin rosewood fused together. While Belter did not invent the lamination process, he devised a

FIG. 78 Unknown artisan, **Center Table,** ca. 1850, Philadelphia, Pennsylvania, mahogany and marble, 30 x 48 x 28 in. (76.2 x 121.9 x 71.1 cm). Virginia Museum of Fine Arts, Gift of the Historic Richmond Foundation, 79.79.

FIG. 79 Detail of cat. no. 45, following conservation of surface gilding.

method of alternating layers with grains running perpendicularly, which resulted in intrinsically strong frames able to withstand the elaborate piercing and deep carving that the Rococo Revival mode required.[7] The undulating "line of beauty" so beloved by William Hogarth and his eighteenth-century contemporaries (see cat. no. 6) could be amplified and embellished as never before.

Though it is not known when the sofas in the VMFA collection were paired—whether purchased together from the Belter shop or later matched by an owner with opportunity and an eye for symmetry—they make a striking set. While one is topped with bouquets of roses and the other a flower-filled basket (fig. 79), the sofas share many major features: a richly carved, curving frame; cabriole legs at front with "knees" of applied roses and tapering legs at rear that are rectangular in section; a three-arch back defined by a pierced crest rail of cornucopias sprouting grapes, tendrils, leaves, seedpods, and flowers; elaborate ornamental carvings dominating the crest rail's central apex and flanking shoulders; and smaller carvings at the center of the seat rail below.[8]

Images by prominent Washington, D.C., photographer Frances Benjamin Johnston provide the earliest extant documentation of the sofas, picturing them together about 1907 in the lavish new residence of John R. McLean. Owner of the *Washington Post,* McLean made an immense fortune through his investments in other newspapers, real estate, utilities, and transit companies. Four years after commissioning John Russell Pope to design a Georgian Revival mansion in 1903 for his rolling estate off Wisconsin Avenue, he hired the prominent architect to produce a grand Italian Renaissance–style palazzo at 1500 I Street in the heart of the city. The residence was intended as a showplace for social affairs.[9] Johnston's interior views capture the mansion's vast public spaces, including the "Music Room," where the then-gilded sofas provided seating. With upholstery enhanced by loose, oversize pillows, the pair stood at the center of the room facing opposite directions, a rectangular table between them (fig. 80). When McLean died in 1916, his son Edward inherited the property and its contents. During the Jazz Age, the sofas served, in effect, as gilded frames for the city's political and social elite as the younger McLean and his wife, Evalyn—goldfield heiress and proud owner of the Hope Diamond—

FIG. 80 Frances Benjamin Johnston (1864–1952), **Interior of John R. McLean House, 1500 I Street, N.W., Washington, D.C. – Staircase from Music Room Balcony,** ca. 1907, photograph.

FIG. 81 Detail of cat. no. 46, following conservation treatment to remove gilding.

hosted countless parties at the I Street residence.[10] In 1948, the sofas were sold at a seven-day auction of Evalyn McLean's estate, alongside her extensive collection of jewelry, antique furnishings, and objets d'art.[11]

In subsequent decades, the sofas were celebrated as extremely rare examples of gilded furniture made by the Belter company. Recent microscopic examination of the finish layers, however, convincingly demonstrates that these imposing pieces initially emerged from the shop with only a transparent oil-resin coating on their rosewood surfaces. Following current conservation work, which returns one of the sofas to its original appearance (fig. 81), the museum will be able to represent sequential periods in the pair's long and curious history.[12] ELO

NOTES

1. For discussions of Belter's construction methods, see Clare Vincent, "John Henry
Belter: Manufacturer of All Kinds of Fine Furniture," in *Technological Innovation
and the Decorative Arts,* Winterthur Conference Report, ed. Ian M. G. Quimby
and Polly Anne Earle (Charlottesville: University Press of Virginia for the Winterthur
Museum, 1975), 207–34; Edward J. Staneck and Douglas K. True, "Technical
Observations" in *The Furniture of John Henry Belter and the Rococo Revival*
(New York: E. P. Dutton, 1981), 9–23.

2. Only affluent patrons could afford Belter's furnishings. An extant 1855 invoice
for a Belter suite—produced in an "Arabasket" motif similar to one of the VMFA
sofas—itemizes two sofas, two arm chairs, four parlor chairs, one center table,
and one étagère for a total cost of $1,265, with a single sofa priced at $175.
Prices in today's money, adjusted for inflation, would be approximately $29,500
and $4,000 respectively. Ed Polk Douglas, "The Rococo Revival Furniture of John
Henry Belter," *Art and Antiques* 3 (July–August 1980): 37, 40 (conversion figures
from www.measuringworth.com/calculators/uscompare).

3. A[ndrew] J[ackson] Downing, *The Architecture of Country Houses* (New York:
D. Appleton, 1850), 432.

4. John Morley, *Furniture: The Western Tradition* (London: Thames and Hudson,
1999), 250–52; Catherine Hoover Voorsanger, "'Gorgeous Articles of Garni-
ture': Cabinetmaking in the Empire City," in *Art and the Empire City: New York,
1825–1861,* exh. cat. (New York: Metropolitan Museum of Art; New Haven
and London: Yale University Press, 2000), 308, 320.

5. Voorsanger, 305

6. Marvin D. Schwartz, "The Basic Facts and Some Theories about John Henry
Belter's Origins," in *The Furniture of John Henry Belter,* 24–29.

7. Stanek and True, 9–23. For a discussion of Belter's patents, see David A. Hanks,
Innovative Furniture in America from 1800 to the Present, exh. cat. (New York:
Horizon Press, 1981), 52–55.

8. This second motif Belter labeled "Arabasket," combining the words arabesque
and basket. A nearly identical sofa—ungilded—is in the collection of the Metro-
politan Museum of Art. *Nineteenth Century America: Furniture and Other Decora-
tive Arts* (New York: Metropolitan Museum of Art, 1970), no. 126.

9. The residence was razed in 1940. James B. Garrison, *Mastering Tradition: The
Residential Architecture of John Russell Pope* (New York: Acanthus Press, 2004),
49–56.

10. The notorious couple faced a change of fortune in the 1930s and 1940s, which
brought scandal, mental breakdown, bankruptcy, divorce, and death. Evalyn
Walsh McLean with Boyden Sparkes, *Father Struck It Rich* (1936; repr., Ouray,
Colo.: Western Reflections, 1999); "Mrs. Evalyn W. McLean, Owner of Hope
Diamond, Dies in Capital," *New York Times,* April 27, 1947, sec. 1, 60.

11. Johnston's various photographs of the McLean's music room also depict a match-
ing gilded Belter side chair. In the 1948 estate auction, the chair was likely sold
under the mistaken description, "Louis XV Carved Giltwood Fauteuil." Meredith
Galleries, "At Public Auction: The Estates of Evalyn Walsh McLean and J. R.
McLean" (Washington, D.C., May 8, 10–15, 1948), 223, 238–39, lots 2780,
2781, 2783.

12. I thank Charles Brownell for his keen eye and understanding of Belter that
prompted the investigation of the sofas' gilded surfaces and their history in the
McLean collection. In 2004, under the direction of VMFA objects conservator
Kathy Gillis, F. Carey Howlett undertook cross-sectional, ultraviolet flourescence
microscopy of the surfaces and discovered the presence of an intact oil-resin
coating beneath the gold leaf. Between 2005 and 2009 the museum conserva-
tors restored the gilding on one sofa (cat. no. 45) and undertook the lengthy
process of removing the gilded layer on the other (cat. no. 46). Report and
photos, VMFA curatorial and conservation files. For more detailed information
about the project, see Kathy Z. Gillis, *A Tale of Two Sofas: John Henry Belter
at the Virginia Museum of Fine Arts* (Richmond: Virginia Museum of Fine Arts,
unpublished manuscript).

47. Thomas E. Warren (active 1849–52), designer
American Chair Company (active 1829–58), manufacturer

Centripetal Spring Chair

Troy, New York

Painted cast iron, sheet metal, steel spring, wood

31 ¾ x 24 x 24 in. (80.7 x 61 x 61 cm)

Bears original paper label of American Chair Company

Museum Purchase, The National Endowment for the Arts Fund for
 American Art, 97.111

PROVENANCE: M. W. Schwind Jr., Yarmouth, Maine

In an era obsessed with material abundance, creature comforts, and the power of the machine, Thomas E. Warren's centripetal spring chair was an homage to the industrial age, which transformed nineteenth-century America from a rural to an urban economy. Yet his aesthetic choices—curvaceous, rather flat solids resting upon delicately scrolled open ironwork poised on tiny wheels—suggest that the psychic relationship of man to machine was less stable than the physical comforts offered by the chair itself. Conjuring an open shell amid seaweed on the ocean floor, Warren's design tempers then-new technology with the cultural refinement of eighteenth-century French rococo decoration, now reinforced by replacement silk upholstery in a documented Rococo Revival pattern.[1] Revivalist aesthetics are best understood as a desire to ameliorate the shock of the new—not to deny it.[2]

Working in Troy, New York, an important iron-making center, Warren patented a new method of constructing springs from steel, an iron alloy, to provide a resilient and comfortably supported seat. The springs were first used by the American Chair Company in the production of reclining seats for railway cars, a welcome amenity for weary travelers. The 1849 patent also facilitated the transfer of industrial materials and techniques from the public arena of the railway to the private realm of the parlor.[3]

Warren's design met with quick success; in 1850, the "Spring Iron Chairs" exhibited by the American Chair Company at the Franklin Institute's twentieth annual exhibition in Philadelphia won a "second premium."[4] One critic explained the chair's appeal: this "very handsome" piece of furniture enjoys an "agreeable elasticity in every direction. The freedom with which the chair may be turned on its center, renders it very convenient. . . . The castings are good, and the design neat and pretty; the whole reflecting much credit on the inventor and on American art."[5]

In 1851, at London's Great Exhibition, several variations of the chair, including one quite similar to the VMFA example, were exhibited at the Crystal Palace to general acclaim. While arms, headrests, and fringed upholstery lent variety, all chairs depended upon Thomas Warren's patented design. Still, innovative construction wed to revivalist taste highlights the age's discomfort with industrial progress. Warren's chairs reveal the same uneasiness found in the work of many

mid- and late-nineteenth-century American painters, from Thomas Cole and Jasper Cropsey to James McNeill Whistler and John Singer Sargent. And just as painted celebrations of the machine age were a phenomenon of the twentieth century, it would take a later generation of architects and designers to express modern technology in an equally new, streamlined style (fig. 82). DPC

FIG. 82 Frank Lloyd Wright (1867–1959), **Armchair**, 1904–6, painted steel, leather, 37 ½ x 24 ¹¹⁄₁₆ x 21 ⅛ in. (95.2 x 62.7 x 53.6 cm). Virginia Museum of Fine Arts, Gift of Sydney and Frances Lewis Foundation, 85.75.

NOTES

1. In 2000, VMFA recovered the chair in a documented silk fabric—"Pompadour"— gauffraged (stamped) using period rollers. Additional centripetal spring chairs survive in several institutions, including the Metropolitan Museum of Art, Saint Louis Art Museum, Smithsonian Institution, the Hermitage, Denver Art Museum, Dallas Art Museum, Winterthur Museum, and Museum of Fine Arts, Boston.

2. For a discussion of this point, see Katherine C. Grier, *Culture and Comfort* (Rochester, N.Y.: Strong Museum, 1988), 139.

3. Patent no. 6,740, September 25, 1849, is one of several patents Warren would eventually hold related to the making of metal parlor furniture, railway-car seats, and, eventually, railroad carriage bodies of iron. Warren's patent description is cited in David A. Hanks, *Innovative Furniture from 1800 to the Present* (New York: Horizon Press, 1981), 126.

4. The American Chair Company was one of the few non-Philadelphia firms to exhibit at this fair in its thirty-year history. Hanks, 126.

5. The critic explained: "The framework . . . is made wholly of cast iron, the base consisting of four ornamental bracket feet, mounted on castors, and secured to

a center piece, to which eight elliptical springs are attached. The springs are connected to another center piece, which sustains the seat of the chair on a vertical pin; on this, the chair-seat revolves, while at the same time the springs sustaining the seat from the under-frame give to it an agreeable elasticity in every direction." *The Illustrated Exhibitor,* 1851, quoted in Hanks, 126. Another reviewer added: "America has long been noted for the luxurious easiness of its chairs. . . . [I]nstead of the ordinary legs conjoined to each angle of the seat, they combine to support a stem . . . between which the seat and the spring is inserted. . . . It will allow of the greatest weight and freest motion on all sides." *Art Journal,* catalogue for Crystal Palace exhibition, London, 1851, quoted in Hanks, 129.

48. William Ranney (1813–1857)

The Wounded Hound, 1850

Oil on canvas

29 ¾ x 24 ¾ in. (75.5 x 62.8 cm)

Signed lower center left: "W. Ranney"

Signed and dated on verso: "W. Ranney / 1850"

Museum Purchase, The J. Harwood and Louise B. Cochrane Fund for American Art, 2002.538

PROVENANCE: The artist, Hoboken, N.J.; Ranney Estate Sale, H. H. Leeds and Co., New York, N.Y. (December 20, 1858, lot no. 24); Mr. Wood, New York, N.Y.; Private collection, Hartford, Conn.

A leading painter of hunting and western genre scenes, William Ranney created a tribute to the American frontiersman in his 1850 canvas *The Wounded Hound*.[1] The image features a rocky promontory and two hunters, one of whom kneels to examine a dog that has been injured. The hound sits trustingly under his skillful care, while a younger hunter, resting on his rifle, looks on. Ranney draws the viewer to the older man's intent expression by using intersecting diagonals punctuated by a splash of red shirting at his throat. His gentle smile and the reassuring stability of the composition's monumental forms and steady light source suggest a positive outcome to the day's mishap despite the threatening gray clouds.

Throughout the 1840s, Ranney gained acclaim for his images of hunters, trappers, and mountain men. The artist had earned his knowledge of rigorous outdoor life firsthand. In 1836, prior to undertaking art training in Brooklyn, he enlisted in the Army of the Republic of Texas. His experiences fighting in its war of independence against Mexico remained fresh as he became fully engaged in the mainstream professional art market of New York City.[2] In 1850, the year he produced

The Wounded Hound, he was elected an associate in the prestigious National Academy of Design.[3]

After returning to the East, Ranney pursued authentic western imagery, based not only on his earlier travels but also on his personal collection of artifacts. According to a contemporary account, his "old flint-lock guns, pistols and cutlasses, and trappings characteristic of border life" were "suspended from every corner" of the studio attached to his "picturesque cottage," while "saddles and riding gear of patterns belonging to the early history of our land, besides numerous and well painted oil studies covered the walls making this quiet retreat one of the most novel and interesting in our midst."[4] On occasion, Ranney produced ambitious historical scenes—such as *Boone's First View of Kentucky* (1849, Gilcrease Museum)— or images of settlers, cowboys, and scouts of the far west, including a portrait of Kit Carson (1854, private collection).

America's increasing taste for genre paintings buoyed Ranney's flourishing professional career. Growing up in the Jacksonian "Age of the Common Man," Ranney and other artists—including George Caleb Bingham and William Sidney Mount—heeded the prevailing call for American themes in literature and art. Built upon genre traditions from the Netherlands and Great Britain, their homespun portrayals of "everyday life" celebrated republican democracy and took on overtones of nationalism and nation building.[5] As the United States annexed vast expanses of western territory through treaty and war, romantic frontier imagery became especially alluring to audiences back east. Ranney's choice of subjects also coincided with the rising popularity of leisure-time hunting, hiking, and fishing among the urban elite, for whom new sporting magazines and manuals offered guidance. Young hunters, one such handbook advised, should become proficient in the "art of breaking dogs, of managing them in sickness or in health, in the kennel or in the field."[6]

The hunters pictured in *The Wounded Hound* are not meant as portraits (although the central figure was modeled after Ranney's brother, Richard) or stock characters in an outdoor scene.[7] Rather, they are the archetypal frontiersmen who first captured the American imagination in the press, the theater, and literature during previous decades. The figures are related to the pioneers in the stories of James Fenimore Cooper and Washington Irving; strong, independent, and

48

FIG. 83 Raphael (1483–1520), **The Holy Family with a Lamb,** 1507, oil on canvas, 11 ³⁄₈ x 8 ¼ in. (29 x 21 cm). Prado Museum, Madrid, Spain.

NOTES

1. This is likely Ranney's second version of this image. An unsigned, undated canvas (private collection) remained in the artist's collection and was sold at the 1858 estate sale following his untimely death. A related ink-on-paper sketch, titled *Mountain Men with Dogs,* is in the collection of the Phoenix Art Museum. I am indebted to Mark Thistlethwaite for exploring the sequence of the two canvases with me. See also Linda Bantel and Peter H. Hassrick, *The Art of William Ranney: Forging an American Identity,* exh. cat. (Cody, Wyo.: Buffalo Bill Historical Center, 2006), 67–69, 206–7.

2. Born in Middletown, Connecticut, Ranney moved at age thirteen to Fayetteville, North Carolina, where he lived with an uncle. By 1834 he had settled in Brooklyn to study art. In 1836 he joined the Army of the Republic of Texas. His first painting was accepted by the National Academy of Design two years later. For biographical considerations of Ranney's life, see Bantel and Hassrick; Francis S. Grubar, *William Ranney: Painter of the Early West,* exh. cat. (Washington, D.C.: Corcoran Gallery of Art, 1962); and Mark Thistlethwaite, *William Tylee Ranney: East of the Mississippi,* exh. cat. (Chadds Ford, Pa.: Brandywine River Museum, 1991).

3. Other early genre artists who preceded Ranney in specializing in western imagery are George Catlin (see cat. no. 32) and Arthur Fitzwilliam Tait.

4. Ranney's studio was located in Hackensack, New Jersey, across the Hudson River from New York City. Obituary of William Ranney, *Crayon* 5 (1855): 26.

5. Linda Ayers, "William Ranney," in *American Frontier Life: Early Western Painting and Prints,* exh. cat. (Fort Worth, Tex.: Amon Carter Museum, 1987), 104. For an examination of the rise of genre painting in the antebellum period, see Elizabeth Johns, *American Genre Painting: The Politics of Everyday Life* (New Haven and London: Yale University Press, 1991).

6. Johns, 63–80; Frank Forester [pseud. Henry William Herbert], *Complete Manual for Young Sportsmen* (1856; repr., New York: Westvaco Corporation, 1993), 23–24. I am grateful to Linda Bantel for bringing the hunting manual to our attention.

7. The same figure appears in *Duck Shooting* (1850, Corcoran Gallery of Art). This related canvas—featuring recreational sportsmen in the marshes of Hackensack rather than subsistence hunters in the wild—was also completed in 1850. Ranney's grandson identified the model for the figure as Richard Ranney, the artist's brother. Corcoran Gallery of Art curatorial files. I thank Sarah Cash, Bechhoefer Curator of American Art at the Corcoran, for providing access to the painting's records.

able to survive on their wits, they draw from inner depths of knowledge and ability to carve out subsistence from the vast depths of the wilderness. They are meant to signify the young republic itself.

While paying homage to the pioneering spirit of the New World, Ranney nevertheless employed Old World artistic traditions in *The Wounded Hound.* His Bible-literate audience of the mid-nineteenth century could hardly have missed the allusion to the Good Shepherd, who tenderly watches his flock and heals with a protective touch. The beatific younger hunter appears as an updated John the Baptist, shepherd boy, or angel. The art-literate among Ranney's viewers may have also recognized that the painting's slight aura of sanctity rested upon conventional pyramidal groupings of Holy Family members in Renaissance and baroque painting. Indeed, the composition echoes a well-known and often reproduced Old Master painting, Raphael's *Holy Family of the Lamb* (fig. 83). Ranney's *The Wounded Hound* demonstrates how knowledgeable nineteenth-century American artists selected subjects from their own culture and experiences while building on the bedrock of Western art traditions. ELO

49. Attributed to Thomas Day (1801–1861)

Center Table, 1850s

Milton, North Carolina

Mahogany veneer; tulip poplar (secondary wood); marble top; brass casters

31 (with casters) x 36 in. (78.7 x 91.4 cm) dia.

Museum Purchase, Kathleen Boone Samuels Memorial Fund, 2007.84.

PROVENANCE: Alston family, Aspen Hall, near Pittsboro, N.C.; Private collection; sold at auction by Mebane Antique Auction Gallery, Mebane, N.C. (December 14, 2007)

This handsome octagonal center table is attributed to the shop of Thomas Day, the celebrated African American cabinetmaker who owned and operated one of the most successful furniture

manufactories in the antebellum South.[1] From 1825 to 1860, the talented craftsman and entrepreneur strove to provide his patrons with furniture of "the newest fashion, and executed in the most faithful manner" (fig. 84).[2]

Whether gracing the parlor of an urban townhouse or a country manor, a center table was an essential item in fashionable American residences through much of the nineteenth century. Supporting a lighting device, such as VMFA's superb triple-overlay lamp by the Boston and Sandwich Glass Company (see cat. no. 62), a center table became the locus of family activities when night fell.[3] Beyond mere utilitarian function, however, a well-crafted center table could also signal its owner's taste. In an era known for an abundance of revival

furnishings, stylistic variations abounded—including Egyptian, Renaissance, Gothic (see cat. nos. 38 and 39), and rococo (see fig. 78). This table offers an imaginative late–Classical Revival presentation with Gothic hints. Its octagonal form—reiterated from the marble top through the eight-sided pedestal and stepped base—terminates with a quartet of feet supported by thin circular pads. The black "Egyptian" marble top is especially striking with its unusual pattern of perpendicular cream and gold striations.[4]

In his North Carolina workshop, Thomas Day worked in a number of styles, including an occasional foray into Gothic and Rococo Revival designs. His preferred mode, however, was late classical—a variation of European classicism that swept

49

ANTEBELLUM YEARS 139

THOMAS DAY,
CABINET-MAKER,

RETURNS his thanks to his friends and the public for the patronage he has received, and wishes to inform them that he intends continuing his business at his old stand, and is well prepared to manufacture all kinds of
Mahogany, Walnut, and Stained Furniture.

He has on hand a small stock of Mahogany Furniture, made of the best St. Domingo mahogany, in the newest fashion, and executed in the most faithful manner;—and also some Walnut and Stained Furniture, and high and low post Bedsteads, turned according to the latest patterns; all which he will sell at reduced prices and on the most accommodating terms

FIG. 84 **Advertisement** for Thomas Day's cabinetmaking shop, *Hillsborough Recorder*, April 27, 1825.

America's urban centers in the 1830s and 1840s and continued through later decades in rural regions. It was at times described as the "Grecian plain style" for its simplified elements and broad surfaces.[5] In embracing the aesthetic, Day may have been inspired by illustrated advertisements published and widely circulated by Joseph Meeks and Sons (see cat. no. 30), the New York firm that first popularized the design trend.[6] A more likely influence, however, was John Hall's popular 1840 pattern book, *The Cabinet Makers' Assistant, Embracing the Most Modern Style of Cabinet Furniture,* with designs incorporating broad, straightforward lines that could be easily adapted in developing cabinet shops like Day's, which made use of the latest steam-driven equipment.[7]

Day's professional achievements are extraordinary considering his circumstances as an African American who resided and worked in the slave-holding South. A Virginia native born into a free black family in Dinwiddie County, he first learned carpentry and cabinetmaking skills from his father.[8] As a young adult in the late 1820s, he relocated to the small Dan River market town of Milton, in Caswell County, North Carolina, and opened his own shop.[9] In short time he developed a growing clientele on both sides of the Virginia–North Carolina state line for his solidly built case pieces, tables, sofas, chairs, rockers, and beds—most of them carved walnut or finely veneered mahogany over mahogany, pine, or poplar.

In 1830, Day's stature as a respected citizen prompted his fellow townspeople to successfully petition the state legislature to grant resident status for his new wife, Aquilla, an African American woman from Halifax County, Virginia. Supporting this waiver of a recent ban on the migration of free blacks into North Carolina, lawmaker Romulus Saunders further testified that "Thomas Day is a free man of color of very fair character; an excellent mechanic, industrious, honest and sober in his habits."[10]

By the 1850s, Day's business had grown into the largest cabinet shop in North Carolina, serving several states and operating with the latest technology and the labor of a dozen white, free black, and enslaved workers. Among Day's predominantly white patrons were affluent merchants, businessmen, and politicians—including Governor David Reid.[11] A large percentage of his clients were regional planters; the VMFA center table is purported to have been made for Aspen Hall plantation in Chatham County, North Carolina.

Also renowned as a carpenter, Day designed and built interiors for several churches, the Fayetteville Market House and town hall, and the University of North Carolina. And he created stylish, often imaginative mantelpieces, doorways, stair rails, and newel posts for numerous private residences throughout the Piedmont region. Nevertheless, this high level of productivity and accomplishment could not shield Day from devastating setbacks on the eve of the Civil War. Increased competition from a growing number of furniture companies alongside a nationwide financial panic in 1857 forced him to put his business in receivership the following year. Suffering from poor health, he died in 1861.[12]

In the past twenty years, there has been renewed interest in Thomas Day's life, career, architectural woodwork, and furniture—the latter becoming prized additions in both private and public collections.[13] Ongoing study and research of Day's structural and stylistic approaches enliven discourse about the cabinetmaker. Some scholars, including Derrick J. Beard, argue that Day's idiosyncratic lines and decorative embellishments have their source in West African design traditions. And there is some oral tradition of African laborers in the Day shop as well as speculation about possible but undocumented influence from Day's brother, John, who may have shared ideas during his years in Liberia.[14] Other decorative arts historians,

such as Jonathan Prown, underscore the cabinetmaker's reliance on contemporary pattern books. Still, as Prown notes, Day clearly contributed his own innovative variations, whether evidence of an African aesthetic or the result of the expressive freedom of American vernacular improvisation in general.[15]

ELO

NOTES

1. A generous gift from VMFA's Friends of African and African American Art funded the table's conservation in 2009.

2. "Thomas Day, Cabinet-Maker," advertisement published in the *Hillsborough North Carolina Recorder*, April 27, 1825, reproduced in Patricia Phillips Marshall, "The Legendary Thomas Day: Debunking the Popular Mythology of an African American Craftsman," in *Thomas Day: African American Furniture Maker*, ed. Rodney D. Barfield and Patricia Marshall (Raleigh: North Carolina Office of Archives and History, 2005), 39. The most recent consideration of Day's life and work appears in Patricia Phillips Marshall and Jo Ramsay Leimenstoll, *Thomas Day: Master Craftsman and Free Man of Color*, exh. cat. (Chapel Hill: University of North Carolina Press in association with the North Carolina Museum of History, 2010). We thank Patricia Marshall for sharing her expertise, information, and insights with us.

3. Wendy A. Cooper, *Classical Taste in America, 1800–1840* (New York, London, and Paris: Baltimore Museum of Art and Abbeville Press, 1993), 217; Elisabeth Donaghy Garrett, *At Home: The American Family, 1750–1870* (New York: Abrams, 1990), 149, 151.

4. Black marble—marketed as "Egyptian" in early-nineteenth-century furniture manufacturing—was the more expensive selection in tabletops. Catherine Hoover Voorsanger, "'Gorgeous Articles of Furniture': Cabinetmaking in the Empire City," in *Art and the Empire City, New York, 1825–1861*, ed. Catherine Hoover Voorsanger and John K. Howat (New York: Metropolitan Museum of Art; New Haven and London: Yale University Press, 2000), 291. In its 1833 advertising circular, the New York firm of Joseph Meeks and Sons (see fig. 51) offered a center table for $80, with an additional $20 fee for a black "Egyptian marbletop." Cooper, 215, 217.

5. Some scholars and collectors also refer to the style as Late Empire. Celia Jackson Ott, *American Furniture of the Nineteenth Century* (New York: Viking, 1965), 89, 94, 114–15; Thomas Gordon Smith, "John Hall and The Grecian Domestic Environment," in *John Hall and the Grecian Style in America*, Acanthus Press Reprint Series, *The 19th Century: Landmarks in Design* (New York: Acanthus Press, 1996), 2:5–8. The popular mode owed a debt to English, French, and German trends—the latter transferred by an influx of German immigrants schooled in "Biedermeier" design. Cooper, 210, 212.

6. Cooper, 210–11.

7. Jonathan Prown, "The Furniture of Thomas Day, A Reevaluation," *Winterthur Portfolio* 33 (Winter 1998): 223; John Hall, *The Cabinet Makers' Assistant, Embracing the Most Modern Style of Cabinet Furniture* (Baltimore: John Murphy, 1840), reprinted in Smith. Celia Otto suggests that Hall's simpler "plain style" became popular when adopted by shops using new steam technology to mass-produce less expensive furniture for a middle-class market. Thomas Gordon Smith, however, has reviewed period price books and has determined that production remained costly for these bulky, heavily veneered pieces, which continued to attract an affluent clientele. Otto, 114; Smith, 16.

8. Since the mid-1990s, scholarship sponsored by the North Carolina Museum of History, the North Carolina Humanities Council, and the Thomas Day Education Project (now the Apprend Foundation) has revealed much of the intriguing history of the Day family. Significant details have emerged from the papers of the craftsman's brother, John Day Jr., who became a Southern Baptist missionary and a founding colonist of Liberia in the 1830s. See Laurel C. Sneed and Christine Westfall, "Uncovering the Hidden History of Thomas Day: Findings and Methodology," report to the North Carolina Humanities Council (Durham, N.C.: Thomas Day Education Project, 1995); Laurel C. Sneed and Patricia D. Rogers, *The Hidden History of Thomas Day* (Durham, N.C.; Apprend Foundation, 2009); and Rodney D. Barfield, "Thomas and John Day and the Journey to North Carolina," in *Thomas Day: African American Furniture Maker*, 1–29.

9. After operating his business in Milton for two decades, Day purchased the old federal-period Union Tavern in 1848, converted it to a residence, and added a rear frame building for his shop. Today, the Thomas Day House is a National Historic Landmark open to the public by appointment. Barfield, 13–14, 16, 23.

10. *Journal of the House of Commons of North Carolina, 1830–31*, 238, quoted in Prown, 216.

11. Day's shop laborers included several of his own slaves. Barfield, 25, 27, 29; Marshall, 47–48, 50. His specialty woods—including his well-advertised West Indies mahogany—likely came via river and rail connections from Norfolk, Virginia. Marshall, 38.

12. Barfield, 20–25.

13. The North Carolina Museum of History in Raleigh has the largest holding of Day furniture and documents.

14. In his 1993–98 traveling exhibit, *Sankofa: A Celebration of African-American Arts and Crafts, 1790–1930*, Beard proposed that Day's innovative patterns and carvings have their source in African design, manifest most obviously in the Sankofa-like symbol featured on one of his secretary bookcases (private collection). Marshall, 51; Theodore C. Landsmark, "Comments on African-American Contributions to American Material Life," *Winterthur Portfolio* 33 (Winter 1998): 270.

15. Prown, 223.

50. Junius Brutus Stearns (1810–1885)

The Marriage of Washington to Martha Custis, 1849

Oil on canvas

40 ½ x 55 in. (102.9 x 139.7 cm)

Signed lower left: "J. B. STEARNS 1849"

Gift of Edgar Williams and Bernice Chrysler Garbisch, 50.2.2

PROVENANCE: Harry Shaw Newman Gallery, New York, N.Y. (1945); Edgar Williams and Bernice Chrysler Garbisch, New York, N.Y.

51. Junius Brutus Stearns (1810–1885)

Washington as Captain in the French and Indian War, ca. 1851

Oil on canvas

37 ½ x 54 in. (95.2 x 137.1 cm)

Gift of Edgar Williams and Bernice Chrysler Garbisch, 50.2.3

PROVENANCE: Gorham D. Abbot, Spingler Institute, New York, N.Y. (before 1863); Dr. Benjamin Brandreth, New York, N.Y.; Brandreth descendants (1880s); Harry Shaw Newman Gallery, New York, N.Y. (1946); Edgar Williams and Bernice Chrysler Garbisch, New York, N.Y.

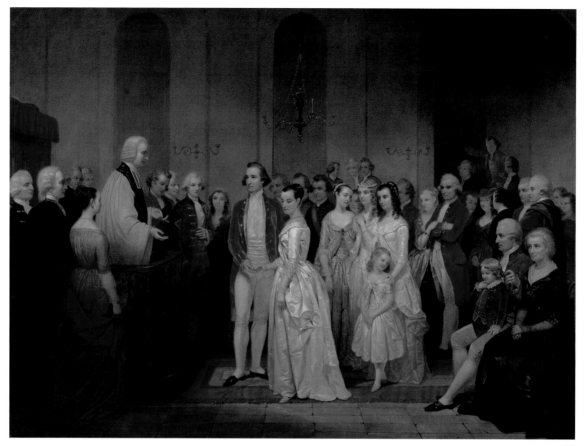

50

51

52

53

52. Junius Brutus Stearns (1810–1885)

Washington as a Farmer at Mount Vernon, 1851

Oil on canvas

37 ½ x 54 in. (95.2 x 137.1 cm)

Signed lower right center: "J. B. Stearns / 1851"

Gift of Edgar Williams and Bernice Chrysler Garbisch, 50.2.4

PROVENANCE: Gorham D. Abbot, Spingler Institute, New York, N.Y. (before 1863); Dr. Benjamin Brandreth, New York, N.Y.; Brandreth descendants (1880s); Harry Shaw Newman Gallery, New York, N.Y. (1946); Edgar Williams and Bernice Chrysler Garbisch, New York, N.Y.

53. Junius Brutus Stearns (1810–1885)

Washington as Statesman at the Constitutional Convention, 1856

Oil on canvas

37 ½ x 54 in. (95.2 x 137.1 cm)

Signed lower right: "STEARNS"

Gift of Edgar William and Bernice Chrysler Garbisch, 50.2.1

PROVENANCE: Gorham D. Abbot, Spingler Institute, New York, N.Y. (before 1863); Dr. Benjamin Brandreth, New York, N.Y.; Brandreth descendants (1880s); Harry Shaw Newman Gallery, New York, N.Y. (1946); Edgar Williams and Bernice Chrysler Garbisch, New York, N.Y.

"The first word of infancy should be mother, the second father, and the third WASHINGTON," proclaimed biographer Horatio Hastings Weld in 1845. In mid-nineteenth-century America, all laudable aspects of Washington's life, not just his central role in the founding of the country, were to be remembered and celebrated. Weld urged, "Through life his glorious example should be constantly before the citizen to animate and encourage him in the performance of duty."[1] The years surrounding 1849, the fiftieth anniversary of Washington's death, brought a heightened interest in the nation's first president, and with reverential fervor equaling that of Weld, a flurry of public and private commemorations ensued.[2] These included the laying of the cornerstone of the massive memorial obelisk in Washington, D.C.; a congressional designation of Washington's birthday as a national holiday; the launch of an intense fund-raising campaign to save Mount Vernon; and this ambitious series of oil paintings by Junius Brutus Stearns.

Stearns, who studied art at New York City's National Academy of Design, had established a reputation for portraiture and genre subjects before turning his attention in the mid-1840s to history painting.[3] After some success with American colonial and Revolutionary scenes, he began a cycle of paintings in 1848 portraying episodes from the life and career of George Washington. By 1856, he had completed five large canvases picturing Washington's marriage; his roles as soldier, farmer, and statesman; and his death.[4] All but the last painting are in VMFA's American art collection.

For the initial image in this series about a very public hero, Stearns chose a private moment. *The Marriage of Washington to Martha Custis* (cat. no. 50) re-creates the exchange of nuptial vows between the handsome Virginia planter and the wealthy widow Martha Dandridge Custis. Within an elegant stagelike setting that represents the interior of Saint Peter's Church in New Kent County, Virginia, Washington places a ring on the hand of his demure bride.[5] At left, the Reverend David Mosson officiates while a bewigged Governor Robert Dinwiddie looks on from his favored position between rector and groom. Around the couple, friends and family draw near, including Martha's two small children, Martha (Patsy) and John (Jacky). Beautifully clad in rich velvets and satins, the gathering represents the upper echelon of the Virginia gentry in 1759. Both the setting and participants, however, were imagined by Stearns, who was unaware that the wedding took place at White House, the Custis residence. Nor did he know the identity of those who attended. The painter did, though, take extraordinary care to create accurate likenesses of a young George and Martha. At the invitation of George Washington Parke Custis, Washington's step-grandson, Stearns visited Arlington House in Virginia to make copies of their eighteenth-century portraits by John Wollaston and Charles Willson Peale.[6]

Stearns looked to a time preceding the wedding for his *Washington as a Captain in the French and Indian War* (cat. no. 51), completed about 1851. To represent Washington's military career, the artist selected an episode from the French and Indian War rather than the more celebrated American Revolution. In the middle of the battle of Monongahela, a twenty-three-year-old Washington is on horseback confronting a chaotic, smoke-filled scene. Among the soldiers—fighting men as well as the dead and dying of both sides—a determined

Washington points his saber forward. There is little in this image to indicate that the British and colonial forces faced defeat near the Monongahela River, or that the young captain was lucky to escape with his life. Nevertheless, biographers including Jared Sparks—whose *The Life of George Washington* (1848) had been published only a few years before Stearns produced this canvas—claimed that the young officer's wisdom, valor, and conduct in this battle did much to establish his reputation.[7]

In 1850 and 1851, Stearns traveled from New York for additional research at Mount Vernon, Washington's estate in Alexandria, Virginia.[8] With the permission of owner John A. Washington, great-great-nephew of the former president, the artist explored the grounds and manor house. Visiting two years before Ann Pamela Cunningham launched her national ladies' campaign to preserve the property as a "sacred spot," Stearns would have found the fields overgrown and the famous residence in disrepair.[9] Nevertheless, his painting *Washington as Farmer at Mount Vernon* (cat. no. 52) depicts the plantation at peak production.[10] On his daily inspection rounds, the retired general—impeccable in the black coat and breeches of a country squire—consults with his overseer. The shining white facade of Mount Vernon appears in the distance. In 1783, following an eight-year absence during the Revolutionary War, Washington did indeed turn his attention to the restoration and management of the eight-thousand-acre, five-farm complex that made up his landholdings. In his own day and for decades to follow, this transformation from soldier to farmer drew laudatory comparisons to Cincinnatus, the ancient Roman consul who, having successfully defended his republic on the battlefield, relinquished military power to return to his farm. French sculptor Jean-Antoine Houdon certainly made the allusion when he included a plow behind his full-size marble figure of the American hero (fig. 85), completed in 1786. On visiting Washington at Mount Vernon the year before, an Englishman noted: "His greatest pride now is, to be thought the first farmer in America. He is quite a Cincinnatus, and often works with his men himself."[11]

Later, during the turbulent years when the question of slavery began to dominate American public and political thought, Stearns took care in crafting an image of Washington as a benevolent master whose enslaved laborers appear healthy,

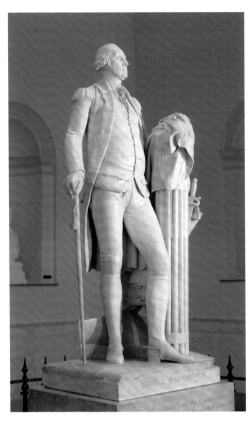

FIG. 85 Jean-Antoine Houdon (1741–1828), **George Washington,** 1786, marble, 74 in. high, state capitol, Richmond, Virginia.

efficient, and humanely treated.[12] With a pose reminiscent of Gilbert Stuart's Washington in the well-known Lansdowne portrait (1796, National Portrait Gallery, Smithsonian Institution), he gestures toward the field hands harvesting wheat. In the central vignette, some of the workers pause to take a drink. Racial hierarchy is unmistakable here; white figures command while black figures toil and serve. At the same time, Stearns inserts suggestions of harmony: under Washington's patriarchal watch, his step-grandchildren play happily in proximity to the workers—also his dependents—while above them, a brown horse stands alongside a white one, both ready to pull the hay wagon.[13]

A dying yet stoic Washington is the subject of Stearns's fourth canvas, *Washington on His Deathbed* (fig. 86), also produced in 1851. Likely consulting firsthand accounts, Stearns re-created the intimate circle that witnessed the president's final hours on December 14, 1799. Within a darkened room, a pale Washington—brought down by a severe throat infection—

FIG. 86 Junius Brutus Stearns (1810–1885), **Washington on His Deathbed,** 1851, oil on canvas, 37 x 54⅛ in. (94.62 x 137.48 cm). The Dayton Art Institute, Gift of Mr. Robert Badenhop, 1954.16.

appears illuminated within an island of white linen bed-clothes. Martha, already gowned in deepest black, keeps vigil, while his secretary and physician stand ready to provide comfort—although the physician's hand-to-chin gesture suggests that his patient is beyond further medical aid. Saddened and distressed, family members gather attentively at the foot of the bed. They are joined by a light-skinned African American manservant who keeps prayerful watch at far right.[14]

A commission from Goupil and Company to publish the Washington series as lithographic prints likely pushed Stearns to complete three canvases in just over a year. The successful French printmaking and art-sales firm had established a New York branch in 1847. At midcentury, the company sought out American artists and themes to attract a broader audience—and the subject of Washington, who had reached iconic status, had guaranteed appeal. In Paris, Stearns's paintings, at the time numbering four, were copied by lithographer Claude Regnier and printed by Lemercier and Company. The resulting hand-colored lithographs, produced in 1853 and 1854, were titled *Life of Washington.* Each bears a subtitle defining the related role that Washington assumes in each scene—*The Citizen* (picturing his marriage), *The Soldier, The Farmer,* and *The Christian* (picturing his death)—as well as a corresponding passage from Jared Sparks's biography or speech by John Marshall.[15]

In 1853, three years after a second version of *The Marriage of Washington* (1849, Butler Institute of Art) was raffled

through the American Art Union, Stearns contacted the painting's owner, John Merrick. In an introductory letter, the artist described his efforts to complete the Washington series and his arrangement with Goupil to reproduce the images. More to the point, he asked Merrick to lend his canvas to be reproduced by the printmaking firm. Subsequent correspondence shows that the owner complied in return for two sets of the completed lithographs. In his initial letter, Stearns had also revealed his plans to produce a fifth painting, one featuring Washington's skill as a statesman.[16]

Stearns painted his final and most complex canvas of the cycle in 1856: *Washington as Statesman at the Constitutional Convention* (cat. no. 53).[17] His tribute to Washington's accomplishments as public servant surprisingly bypasses events from his term as the first president of the United States in favor of an earlier political achievement—his climactic 1787 address to delegates convened in Philadelphia to craft the new nation's constitution. As president of the assembly, the Virginian had maintained a self-imposed silence during the sometimes tense deliberations. The painting shows him, draft in hand, coming forward at long last to urge final approval of the document—a request that his fellow delegates granted unanimously. As with his earlier canvases, Stearns devoted much time to preparatory research. To create likenesses of the thirty-nine participants, all formally positioned as if upon a stage, he studied available portraits in print and oil. At the same time, Stearns inadvertently introduced an anachronism into the setting. The side chair at far left, with its Greek Revival saber legs, is of a design that did not become stylish until the early nineteenth century (see cat. no. 24).[18]

By 1860, four of the five canvases—those picturing Washington as soldier, farmer, and statesman, as well as his death scene—had entered the collection of the Reverend Gorham D. Abbot of New York City. No doubt the paintings' didactic nature and sizable scale appealed to the Presbyterian educator, who exhibited them alongside Thomas Cole's epic *Voyage of Life* series (1839–40, Munson-Williams-Proctor Institute) at the Spingler Institute, the female academy that he founded at Union Square. When the Abbot collection went up for auction in 1863, a notice in the *New York Times* singled out Stearns's "Washington Series," noting that the paintings were "truly a work of national importance."[19] ELO

NOTES

1. [Horatio Hastings Weld], *Life of George Washington* (Philadelphia: Lindsay and Blakiston, 1845), ii–iv, quoted in Mark Thistlethwaite, "Picturing the Past: Junius Brutus Stearns's Paintings of George Washington," *Arts in Virginia* 23 (1985): 13.

2. For an examination of Washington imagery, see *George Washington, American Symbol*, exh. cat., ed. Barbara J. Mitnick (New York: Hudson Hills Press in association with the Museums at Stony Brook and the Museum of Our National Heritage, 1999).

3. Vermont-born Stearns was a student at NAD in the late 1830s. In 1849, the year he was elected academician, he traveled abroad to study in Paris and London. George C. Groce and David H. Wallace, *The New-York Historical Society's Dictionary of Artists in America, 1564–1860* (New Haven and London: Yale University Press, 1957), 600. For a consideration of the development of history painting in the United States, see *Picturing History, American Painting 1770–1930*, exh. cat., ed. William Ayers (New York: Rizzoli in association with Fraunces Tavern Museum, 1993).

4. Mark Thistlethwaite, *The Image of George Washington: Studies in Mid-Nineteenth-Century American History Painting* (New York and London: Garland, 1979), 30–31.

5. William M. S. Rasmussen and Robert S. Tilton, *George Washington: The Man Behind the Myths* (Charlottesville and London: University Press of Virginia, 1999), 79–86, 93–94; Thistlethwaite, *The Image of George Washington*, 41–45.

6. Rasmussen and Tilton, 93–94. The purpose of Stearns's visit of "some days" to Arlington House (today called the Custis-Lee mansion) was noted in "Washington's Marriage in 1759," *Alexandrian Gazette*, September 30, 1848, 2.

7. Rasmussen and Tilton, 57–59; Thistlethwaite, *The Image of George Washington*, 71–75.

8. An article published in the summer of 1851 states that Stearns paid a "professional visit to Mount Vernon" to make "drawings of the interior of the residence of the Father of his Country for future studies." An interior scene was never produced. However, he likely had visited the estate before, as the same notice comments that the artist's painting of "Washington in his harvest field"—no doubt this canvas—"has been sent to Paris to be engraved." "Art and Artists," *New York Home Journal*, August 16, 1851, 3.

9. Cunningham's first appeal in 1853 called for immediate action on the part of the "Ladies of the South." Over the next five years, the endeavor expanded nationwide, resulting in the purchase of the property in 1858 by the Mount Vernon Ladies' Union (now Association). Mitnick, 65.

10. Stearns was drawing upon a long-established tradition in American art and literature that extolled rural labor as virtuous and noble. Sarah Burns, *Pastoral Inventions: Rural Life in Nineteenth-Century American Art and Culture* (Philadelphia: Temple University Press, 1989), 3–39.

11. Rasmussen and Tilton, 155; John Hunter, quoted in ibid., 189.

12. Rasmussen and Tilton, 192–93. Washington struggled with the prospect of emancipating his slaves, ultimately postponing their manumission in his will until after his wife's death. For more about Washington and the enslaved community at Mount Vernon, see Henry Wiencek, *An Imperfect God: George Washington, His Slaves, and the Creation of America* (New York: Farrar, Straus, and Giroux, 2003).

13. For a close contextual reading of the painting see Maurie D. McInnis, "The Most Famous Plantation of All: The Politics of Painting Mount Vernon," in *Landscape of Slavery: The Plantation in American Art*, exh. cat., ed. Angela D. Mack and Stephen G. Hoffius (Columbia, S.C.: University of South Carolina Press in cooperation with the Gibbes Museum of Art/Carolina Art Association, 2008), 86–109.

14. The published recollections of the death scene by Washington's secretary, Tobias Lear, and his physician, James Cruik, documented the presence of four black house servants—Christopher, Caroline, Molly, and Charlotte. Rasmussen and Tilton, 258–60.

15. Stearns first proposed in 1849 that the American Art-Union commission the print series, which it declined. The Art-Union did eventually acquire a second version of *The Marriage of Washington* (1849, Butler Institute of Art) in 1850. Thistlethwaite, *The Image of George Washington*, 33, 66n1.

16. The two versions of *The Marriage of Washington,* obviously painted in quick succession in 1849, are quite similar. The most notable difference is that the far-left figure in VMFA's painting wears a white wig; the Butler Institute canvas shows him with brown hair. I thank Patrick McCormick, Butler Institute of American Art archivist, for sharing copies of Stearns's correspondence with Merrick. In the first of two letters, dated July 2 and August 2, 1853, Stearns outlines "a series of *five* illustrating Scenes and Characteristicks of Washington. . . . They will comprise when complete:

 No. 1 The Soldier. (Braddocks defeat)
 " 2 " Statesman. (First reception of foreign ministers)
 " 3 " Farmer. (at Mt. Vernon)
 " 4 " Christian. (or last hours.
 " 5 " Marriage."

 His listing does not follow the chronology of Washington's life nor the order in which he completed the paintings. Ultimately Stearns changed the venue for the *Statesman* to the Constitutional Convention.

17. Stearns did not complete this fifth painting in time for the Goupil commission. A slightly different version (1856, private collection) was used as the basis of the U.S. three-cent stamp issued in 1937 in commemoration of the 150th anniversary of the signing of the Constitution. Thistlethwaite, "Picturing the Past," 21n35; Thistlethwaite, *The Image of George Washington*, 31–32.

18. The likely catalyst for the subject of the historical group portrait was the designation of the delegates' assembly room as a national shrine in 1855. Thistlethwaite, *The Image of George Washington*, 152–58.

19. *Dictionary of American Biography*, ed. Allen Johnson (New York: Charles Scribner's Sons, 1957), 1:12–13; "A Card," *New York Times*, March 25, 1863, 6. To follow some of the changing circumstances of Abbot and the Spingler Institute, see Paul D. Schweizer, *The Voyage of Life by Thomas Cole: Paintings, Drawings and Prints*, exh. cat. (Utica, N.Y.: Museum of Art, Munson-Williams-Proctor Institute, 1985), 49–52. By the time the paintings were described in the artist's obituary as part of the Brandreth collection in 1885, *Washington as Statesman* had joined the previous four canvases in one collection. "Death of J. B. Stearns," *New York Times*, September 19, 1885, 1.

54. Hiram Powers (1805–1873)

Benjamin Franklin, modeled 1848–51; carved 1851–66
Marble
24 ½ x 15 ⅜ x 12 ⅞ in. (62.2 x 39.1 x 32.7 cm) with base
Signed in intaglio on reverse: "H. POWERS *sculp.*"
Gift of John Barton Payne, 19.1.50

PROVENANCE: Thomas Barbour Bryan, Chicago, Ill.; to daughter Jennie Byrd Bryan Payne (after 1906); to husband John Barton Payne, Washington, D.C.

Hiram Powers, America's most celebrated sculptor of the antebellum period, created this portrait bust of Benjamin Franklin at a time of growing demand for images of the nation's founders. As the United States approached its seventy-fifth anniversary and precarious political compromises kept pro- and antislavery factions in balance, paintings, sculptures, and prints of such Revolutionary luminaries as George Washington (see

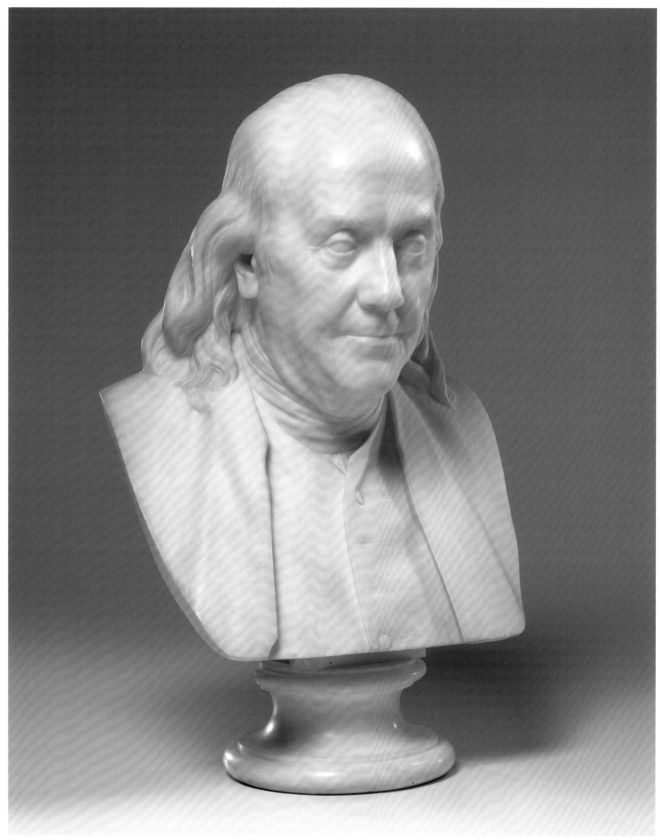

54

cat. nos. 50–53), Thomas Jefferson, and Franklin served to bolster national unity. In this favorable atmosphere and at the zenith of his artistic career, Powers seized the opportunity to depict Franklin, though he found the prospect somewhat daunting. Studying the details of his subject's life, he learned of his international acclaim, not only for accomplishments as a diplomat but also as a scientist, inventor, printer, philosopher, writer, and abolitionist. "He was distinguished for so many excellences," Powers wrote, "it is difficult to illustrate more than one or two in a single statue."[1]

While Powers was developing his image of Franklin at midcentury, he himself was enjoying international recognition. The leader of the first circle of expatriate American artists to establish residency in Italy (the more urbane William Wetmore Story [see cat. no. 58] would head up the next generation), the sculptor had parlayed his talent, perseverance, and business acumen into a successful studio workshop in Florence. Powers had begun his professional career in the 1820s in Cincinnati by making portrait busts of friends and local notables. Attracting the patronage of Nicholas Longworth—the wealthy businessman who also helped fund the budding careers of Ohio artists Worthington Whittredge and Robert Duncanson (see cat. nos. 40 and 42)—Powers traveled to Washington, D.C., and gained commissions from prominent sitters, including President Andrew Jackson. In 1838, the sculptor relocated to Italy, where he studied and embraced neoclassical themes and styles.[2]

In subsequent decades, Powers found his greatest success with mythological, allegorical, and ideal figures. He described his 1841 *Fisher Boy* (fig. 87)—one of the first fully nude male figures created by an American sculptor—as "a kind of Apollino, but . . . modern" youth who holds a conch shell to his ear to listen for the "still small voice" of God.[3] But it was Powers's *Greek Slave,* commenced the same year and conceived with similar religious overtones, that brought the artist fame on both sides of the Atlantic. The marble rendering of a nude Christian girl who calmly awaits her sale into slavery by Turkish captors made a triumphant and lucrative tour through Europe and the United States in the late 1840s and early 1850s. Both sculptures created a popular sensation at London's Crystal Palace in the Great Exhibition of 1851.[4] Powers, adept at marketing and aided by skilled Italian artisans in his Florentine studio, produced replicas of these and many of his other sculptures

FIG. 87 Hiram Powers (1805–1873), **Fisher Boy,** modeled 1841–44; carved ca. 1846–50, marble, 58 x 18 x 16 in. (147.3 x 45.7 x 40.6 cm). Lent to the Virginia Museum of Fine Arts by Carey Thompson Viego and Sarah Alston Thompson, L.29.55.

at full-size, two-thirds, and nineteen-inch scale adaptations, as well as busts.[5]

Even while his reputation as a sculptor of ideal figures flourished, Powers continued to fill orders for portraits. Anticipating a commission from the city of New Orleans for a life-size statue of Benjamin Franklin, he began to craft an image in the late 1840s. To produce a close facial likeness, he acquired earlier portrait engravings and drawings, as well as articles of Franklin's clothing lent to him by descendants. Powers found his primary source, however, in a cast of the 1778 bust of Franklin made by the incomparable French sculptor Jean-Antoine Houdon. When funding for the New Orleans project faltered, Powers used his preliminary study to produce and sell his own version of the Franklin bust.[6]

Like Houdon's earlier portrait, which was made from direct observation of the seventy-two-year-old Franklin, Powers's bust depicts the head and shoulders of the aging statesman, dressed in a plain jacket, waistcoat, and neck cloth with

thinning hair worn long. As the figure's bejowled, kind face tilts downward, the lift of an eyebrow and slight smile convey something of Franklin's intelligence and humor. While lacking the crisp, unrelenting naturalism of the French prototype, Powers's adaptation nevertheless provides a compelling likeness.[7] Early Franklin biographer James Parton could have easily had this sculpture in mind when writing that "[h]is countenance expressed serenity, firmness, benevolence, and easily assumed a certain look of comic shrewdness, as if waiting to see whether his companion had 'taken' a joke."[8]

Powers found eager patrons in both the public and private sectors for his sculptures of Franklin. In 1858, when the United States Congress commissioned him to create a larger-than-life standing figure of Franklin for the newly expanded Capitol, the artist was prepared, having an understanding of his subject as well as a convincing model for the figure's head.[9] In 1863, his full-length Franklin—further outfitted with a double-button suit, knee britches, and tricornered hat—was installed with ceremony in the Senate wing.[10] For domestic display, however, Powers's private clients preferred the smaller bust.[11] Among them was Virginia-born Thomas Barbour Bryan, a Harvard University–trained attorney who established himself as one of Chicago's leading citizens. During a family trip abroad in 1866, Bryan likely visited Powers in Florence and picked out the Franklin portrait bust directly from the studio.[12] Fifty-three years later, the marble sculpture was included among the artworks presented by Bryan's son-in-law, John Barton Payne, that formed the original collection of the Virginia Museum of Fine Arts. ELO

NOTES

1. Hiram Powers to Miner K. Kellogg, May 2, 1849, quoted in Sylvia E. Crane, *White Silence: Greenough, Powers, and Crawford, American Sculptors in Nineteenth-Century Italy* (Coral Gables, Fla.: University of Miami Press, 1972), 243.

2. "'Almost a Buckeye': Hiram Powers and Cincinnati, His Adopted Hometown," in *Hiram Powers: Genius in Marble*, exh. cat., ed. Lynne D. Ambrosini and Rebecca A. G. Reynolds (Cincinnati: Taft Museum of Art, 2007), 29–35.

3. Ibid., 54–55.

4. Richard P. Wunder, *Hiram Powers, Vermont Sculptor, 1805–1873*, (Newark, Del.: University of Delaware Press; London and Toronto: Associated University Presses, 1991), 1:207–74; Linda Hyman, "'The Greek Slave' by Hiram Powers: High Art as Popular Culture," *Art Journal* 35 (Spring 1976): 216–23. Powers produced six full-size versions of *The Greek Slave*; his second, completed in 1846, is now in the collection of the Corcoran Gallery of Art, Washington, D.C.

5. For a discussion of the artist's studio practice, see Rebecca A. G. Reynolds, "Hiram Powers's Sculpture Process," in *Hiram Powers: Genius in Marble*, 43–44.

6. Wunder, 2:149–51.

7. Compared to the Houdon portrait bust, the features of Powers's *Franklin* are softened, likely the result of his studying a cast rather than the Frenchman's original. In fact, Powers worked from an 1844 mold of an 1801–2 cast made by English artist John Flaxman of Houdon's 1778 bust. Wunder, 2:149–51. Other obvious differences in the Powers bust from the Houdon portrait include the lower position of the head, rectangular format to the shoulders and chest, addition of a fourth buttonhole to the waistcoat, and omission of incised irises and pupils in the eyes. For discussions of each sculpture, see Charles Coleman Sellers, *Benjamin Franklin in Portraiture* (New Haven and London: Yale University Press in cooperation with the American Philosophical Society, 1962), 119, 311, 314; illus. 18, 21.

8. James Parton, *Life and Times of Benjamin Franklin* (New York, 1864), quoted in John Clyde Oswald, *Benjamin Franklin in Oil and Bronze* (New York: William Edwin Ruge, 1926), 9.

9. Wunder, 2:149–51; Ambrosini and Reynolds, 58–59. Powers's congressional commission also included a similarly scaled marble figure of Thomas Jefferson, completed and installed in the House wing in 1863. Wayne Craven, *Sculpture in America* (Newark, Del.: University of Delaware Press; New York and London: Cornwall Books, 1984), 121–22.

10. A dozen years later, a version of the standing Franklin was made posthumously by Powers's workshop to satisfy the resurrected New Orleans commission.

11. Approximately seventeen marble copies of the bust are known today. Powers's account records indicate that the Reverend Philip Slaughter of Fredericksburg, Virginia, ordered the first in 1850. Wunder, 2:152.

12. Ibid., 153. Thomas Barbour Bryan maintained an interest in the arts throughout his lifetime. In 1892–93, he served as vice president of the World's Columbian Exposition in Chicago. *Dictionary of American Biography,* ed. Allen Johnson and Dumas Malone (New York: Charles Scribner's Sons, 1958), 2:190–91.

55. Clark Mills (1815–1883)

Andrew Jackson on Horseback, 1855

Zinc

41 ¾ x 31 ⅜ x 21 in. (106 x 79.7 x 53.3 cm)

Inscribed in high relief on base: "PATENTED / MAY 15 1855"

Impressed on base: "CORNELIUS & BAKER / PHILADELPHIA"

Marked on underside of horse's tail: "XXIII"

Marked on base beneath horse's proper left-rear hoof: "XXIII"

Museum Purchase, The J. Harwood and Louise B. Cochrane Fund for American Art, 2006.37

PROVENANCE: Private collection, Hagerstown, Md.; James Graham and Sons, New York, N.Y.

Naturalistic and highly detailed, Clark Mills's two-foot-high sculpture *Andrew Jackson on Horseback* is a replica of the artist's famous life-size monument that stands in Lafayette Square near the White House in Washington, D.C. (fig. 88). The larger statue was unveiled in 1853 as the first equestrian statue and the first major bronze sculpture produced in the United States. Two additional full-size versions of the work

55

FIG. 88 Clark Mills (1815–1883), **Andrew Jackson on Horseback,** bronze monument, Lafayette Square near the White House, Washington, D.C.

were made for Jackson Square in New Orleans (1856) and the statehouse grounds in Nashville (1880).[1]

Mills chose a bold pose for Andrew Jackson—country lawyer, military leader, and America's first populist president. The mounted general raises his hat in salute to his troops just before the Battle of New Orleans, the closing conflict of the War of 1812. "His restive horse," the artist explained, "attempts to dash down the line; the bridle hand of the dauntless hero being turned under, shows that he is restraining the horse, whose mouth and curved neck indicate that the animal is feeling the bit."[2] For his likeness, Mills relied upon portrait prints and sculptural busts of the recently deceased president. He also studied Jackson's uniform and military paraphernalia on view at the Patent Office in Washington, D.C. For all the attention given to the rider, however, the artist's tour de force is the rearing stallion that paws the air—an achievement that Mills engineered by a careful centering of the sculpture's weight over the hind legs.[3]

Such an accomplishment was remarkable for the self-taught sculptor. Without the academic training and privileges of better-known contemporaries like Hiram Powers and William Wetmore Story (see cat. nos. 54 and 58), his career followed a more pragmatic course. A native of Onandaga County, New York, Mills left home as a teenager and made his way as an itinerant laborer and carpenter in various locations in the South. Settling in 1837 in Charleston, South Carolina,

he honed his skills in modeling and casting ornamental plaster. By the early 1840s he had begun earning a reputation for creating portrait busts from plaster life masks. A providential introduction in 1848 to the chair of the Andrew Jackson Memorial Committee in Washington, D.C., encouraged Mills to submit his equestrian design—a daring proposition for an artist who had yet to attempt a full-figure sculpture, not to mention one on a horse. Upon winning the commission, Mills relocated to the nation's capital and labored for five years in a makeshift studio near the White House to create the life-size plaster model. After teaching himself the intricacies of foundry work, he cast the model, with the help of assistants, using bronze from melted British cannons captured during the War of 1812. By the time the ambitious fifteen-ton monument was dedicated amid parades and patriotic speeches, the sculptor had established a permanent foundry on the outskirts of the city, where he would cast subsequent commissions.[4]

In 1855, following the enormous success of the full-size equestrian Jackson, Mills decided to produce approximately twenty-five smaller versions—including the one in VMFA's collection.[5] As his new foundry was engaged with the large New Orleans commission, the artist consigned the manufacture of the series to the eminent Philadelphia firm of Cornelius and Baker (best known for making elaborate cast lamps, girandoles, and chandeliers).[6] Fabricated in zinc, the statuettes include most of the fine details of the larger monument. Each figure was cast in twenty pieces, soldered together, and outfitted with a miniature sword and sheet-metal reins. The surfaces were finished with a bronze-hued coating containing copper flakes.[7]

Mills's *Andrew Jackson on Horseback* perfectly evokes the Jacksonian "Age of Common Man." Like his famous subject, the artist rose from humble beginnings to achieve renown in his day. And his dynamic image—forged from persistence and innovation—foreshadows the astounding western equestrian bronzes that Frederic Remington would create half a century later (see cat. no. 105). ELO

NOTES

1. Tom Armstrong et al., *200 Years of American Sculpture* (New York: David R. Godine in association with the Whitney Museum of American Art, 1976), 292–93. Bronze equestrian monuments to George Washington designed by Henry Kirke Brown (New York, unveiled 1853) and Thomas Crawford (Richmond, unveiled 1857) were a close second and third. Each features a horse standing comfortably on three hooves. For a brief review of the history of equestrian statues in both

Europe and the United States, see Wayne Craven, *Sculpture in America,* rev. ed. (Newark, Del.: University of Delaware Press; New York: Cornwall Books, 1984), 168–70.

2. Mills, quoted in W. O. Hart, "Clark Mills," *Louisiana Historical Quarterly* 3 (1920): 615.

3. "History of the Jackson Statue," *New York Daily News,* January 22, 1853, 3; James G. Barber, *Andrew Jackson, A Portrait Study* (Washington, D.C.: National Portrait Gallery and Nashville: Tennessee State Museum, 1991), 212–16.

4. For detailed discussions of Mills's life and career, see Craven, 166–74, and Lorado Taft, *The History of American Sculpture* (New York and London: Macmillan, 1903), 123–28. The artist's major commissions after 1853—beyond the two replicas of the full-size *Andrew Jackson on Horseback*—include the equestrian *George Washington,* commissioned by Congress and dedicated in Washington, D.C., in 1860, and, in the same year, the casting of Thomas Crawford's colossal figure of *Freedom* for the top of the Capitol dome.

5. The zinc statuettes of Jackson comprise the only known series of small figures by the artist. Other versions in this size are located in the Smithsonian National Portrait Gallery, the White House, New-York Historical Society, Historic New Orleans Collection, Virginia Military Institute, and various private collections.

6. The model for the reductions may have been the plaster miniature submitted to the monument committee mid-1848. Barber, 216.

7. Carol A. Grissom, *Zinc Sculpture in America: 1850 to 1950* (Newark, Del.: University of Delaware Press, 2009), 470–75.

56. Frederic Edwin Church (1826–1900)

In the Tropics, 1856

Oil on canvas

25 ¼ x 36 ¼ in. (64.2 x 92.1 cm)

Museum Purchase, The Arthur and Margaret Glasgow Fund, 65.28

PROVENANCE: Private collection, Rochester, N.Y.; Vose Galleries, Boston, Mass. (1965)

No paintings better represent the culmination of the nineteenth-century landscape movement in America than those of Frederic Church. This inquisitive, erudite, and extraordinarily talented artist synthesized traditional approaches with current aesthetic theories and scientific thought. As a result, canvases like *In the Tropics*—which pictures a rugged South American scene—provided his viewers with much more than picturesque representations of chosen terrains.[1] With technical mastery, Church also sought to convey specifics about a site's natural features as well as intimations of his own philosophical or spiritual response to his subject. As a New York reviewer commented on seeing another of Church's South American views, "The truth of such a picture as this . . . is not the truth of a photograph, but pure, pictorial truth—truth, that is, to the *perceptions of a human being.*"[2]

The only pupil of Thomas Cole (see cat. no. 37), Church rose to the forefront of the so-called Hudson River school at the time of his mentor's death in 1848. Gaining prominence in his early twenties, he was skilled at making detailed pencil sketches during treks into the forested mountains of the Northeast. Once back in his New York City studio, he was equally adept at creating composite views in oil according to established pictorial conventions. Like his older contemporary landscapist Asher B. Durand (see cat. no. 64), Church had absorbed Cole's convictions—sympathetic to the reflections of transcendentalists Ralph Waldo Emerson and Henry David Thoreau—that landscape could convey moral and spiritual lessons. After producing a number of historical and allegorical landscapes, however, Church shifted to more factual renderings of the natural world. This new concern with empirical accuracy was influenced in part by the "truth to nature" aesthetics championed by English art theorist John Ruskin, whose book *Modern Painters* had just become available in the United States.[3] But Church's primary inspiration was a recent English translation of the writings of German naturalist Alexander von Humboldt. The painter's close reading of Humboldt's multivolume *Cosmos: A Sketch of the Physical Description of the Universe* not only bolstered his fascination with geology, botany, and atmospheric phenomena, but also prompted the young American to set out in 1853—and again in 1857—to retrace segments of the scientist's earlier journeys in South America.[4]

Like Humboldt before him, Church was astonished by the scale, drama, and diversity of the regions he traversed during lengthy expeditions through New Granada (now Colombia), Chile, and Ecuador. After returning to New York, he mined scores of his field studies to create a series of paintings that depict the "exotic" and then largely unknown wonders of South America.[5]

In the Tropics, an 1856 composite of Ecuadorian scenes, visually reiterates Humboldt's earlier appreciation of a land where the "different climates ranged the one above the other."[6] Church brings the viewer into a tangle of tropical foliage at lower right, where indigenous plants are articulated in meticulous detail. The lush environment has encouraged a vine to scale the height of a palm tree, the fronds of which shelter a flock of circling birds. Across a darkened ravine, a craggy

56

pinnacle rises to mark the foothills of the Andes. The waterfall at its base appears to be fed by a meandering river that shows itself in the open valley beyond, a light-filled expanse stretching toward distant ranges over which Mount Chimborazo's snow-capped summit towers. The massive peak, as an 1843 travel book noted, could indeed be seen from the Pacific coast, two hundred miles away, "whence it resembles an enormous semitransparent dome defined by the deep azure of the sky; dim, yet too decided in outline to be mistaken for a cloud."[7] In Church's image, morning sunlight illuminates the mountain's crest as well as the sparse, thin clouds that soar even higher overhead.

In this almost Edenic vista, Church offers a study in contrasts, layering dark volcanic formations against sun-filled valleys, verdant undergrowth against the arid savannah, the moist humidity of lowland tropics against the white contours of a frozen peak. Art historian Franklin Kelly points out that such juxtapositions are typical of Church, who was deeply interested in scientific differentiation.[8] He suggests, too, that the artist crafted another significant contrast by creating a second landscape titled *Sunset* (fig. 89), also painted in 1856. Perhaps an unofficial pendant to *In the Tropics,* that canvas shares similar dimensions and compositional scheme— a mountain range, valley, water feature, thick underbrush, and a single prominent tree in the foreground. But with its cool atmosphere, spruce trees, and softer glaciated terrain, *Sunset* serves as a North American counterpart to the tropical South American scene.[9]

Over the course of the 1860s and 1870s, Church enjoyed enormous success with his South American scenes—some so large and remarkably detailed that visitors paid to gaze upon them with opera glasses. While continuing to render breathtaking national imagery, including an unprecedented over-the-water view of Niagara Falls (1857, Corcoran Gallery of Art), the artist traveled in search of other dramatic views in Labrador, Jamaica, Mexico, Europe, and the Near East. At home, Church turned his energies to designing and building Olana, his magnificent "orientalized" mansion and studio overlooking the Hudson River. As the end of the century drew near, Church witnessed a declining interest in the "national school" of landscape in favor of new styles arriving from Europe. When the painter died in 1900, the Metropolitan Museum of

Art honored him with a memorial exhibition and praised him for his efforts in creating "landscape art as an expression of the majesty and beauty of the divine manifestation in nature."[10]

ELO

FIG. 89 Frederic Edwin Church (1826–1900), **Sunset,** 1856, oil on canvas, 37 ¾ x 49 ¾ in. (95.9 x 126.4 cm) framed. Proctor Collection, PC.21, Munson-Williams-Proctor Arts Institute, Utica, New York.

NOTES

1. While evidence is inconclusive, art historians Franklin Kelly and John Howat have suggested that *In the Tropics* might be the same canvas Church submitted to the 1856 National Academy of Design exhibition under the title *A Tropical Morning.* Gerald Carr, however, has identified that work as a painting now known as *Mountains of Ecuador* (1855, Wadsworth Atheneum). Franklin Kelly, "Frederic Church in the Tropics," *Arts in Virginia* 27 (1986): 26n24; John K. Howat, *Frederic Church* (New Haven and London: Yale University Press, 2005), 67; Gerald L. Carr, *In Search of the Promised Land: Paintings by Frederic Edwin Church,* exh. cat. (New York: Berry-Hill Galleries, 2000), 66.

2. The painting was Church's grand-scaled and much-acclaimed *Andes of Ecuador* (1855, Reynolda House Museum of American Art, Winston-Salem, North Carolina). "The National Academy Exhibition," *New York Daily Times,* May 2, 1857, 2, cited in Carr, 30.

3. Franklin Kelly, "A Passion for Landscape: The Paintings of Frederic Edwin Church," in Franklin Kelly et al., *Frederic Edwin Church,* exh. cat. (Washington, D.C.: National Gallery of Art, 1989), 42. While influenced by Ruskin, Church was not a devoted follower like the artists who formed the Association for the Advancement of Truth in Art, popularly known as the American Pre-Raphaelites (active 1863–64). See the entry on one of the group's founding members, Henry Roderick Newman (cat. no. 86).

4. Church owned several editions of Humboldt's *Cosmos: A Sketch of the Physical Description of the Universe,* originally published in 1845–47 and available in English translations by 1849. Kelly, 47–48, 72n69. See also Stephen Jay Gould, "Church, Humboldt, and Darwin: The Tension and Harmony of Art and Science," in Kelly et al., 94–107.

5. Howat, 43–57, 75–81.

6. Alexander von Humboldt, *Cosmos: A Sketch of the Physical Description of the Universe* (New York: Harper and Brothers, 1855), 1:33.

7. Hugh Murray et al., *Encyclopedia of Geography* 3: (Philadelphia, 1843), 247; quoted in Carr, 61 (fig. 42), 63.

8. Kelly, "A Passion for Landscape," 49.

9. Kelly, "Frederic Church in the Tropics," *Arts in Virginia* 27 (1986): 26n24; Kelly, "American Landscape Pairs of the 1850s," *The Magazine Antiques* 146 (November 1994), 654.

10. *Paintings by Frederic E. Church, N. A.,* exh. cat. (New York: Metropolitan Museum of Art, 1900), n.p., quoted in Kelly, "A Passion for Landscape," 68.

57. Jasper Francis Cropsey (1823–1900)

Mt. Jefferson, Pinkham Notch, White Mountains, 1857

Oil on canvas

31 ½ x 49 ½ in. (80 x 125.7 cm)

Signed and dated lower left: "J. F. Cropsey 1857"

Inscribed on rear panel of the stretcher: "Mt. Jefferson, Pinkham Notch, White Mountains, by J. F. Cropsey, London, February 1857"

Museum Purchase, the J. Harwood and Louise Cochrane Fund for American Art, 96.35

PROVENANCE: R. M. [Robert Morrison] Olyphant, New York, N.Y. (1857–77); R. M. Olyphant Sale, Chickering Hall, New York, N.Y. (December 18–19, 1877, lot no. 159, as *Mt. Jefferson, New Hampshire*); Le Grand Bouton Cannon (1877–1906); Cannon Estate Sale through Fifth Avenue Art Galleries, New York, N.Y. (April 3–5, 1907, lot no. 215, as *Mount Jefferson, White Mountains*); Robert Morrison Olyphant, New York, N.Y. (1907–18); consigned by the Olyphant estate to American Art Association (February 15–17, 1919, lot no. 88); W. A. Burnett (1919); Private collection, by descent; Pioneer Auction, Amherst, Mass. (January 1, 1995); Peter G. Terian, New York, N.Y.; David Nisinson Fine Art, New York, N.Y.

"Mr. Cropsey is one of the few among our landscape painters who go directly to Nature for their materials," stated the *Literary World* in 1847, "and it is no disparagement to the abilities of those veterans of landscape art, Cole and Durand, to prophesy, that before many years have elapsed, he will stand with them in the front rank, shoulder to shoulder."[1] Within a few years, Jasper Cropsey went "to Nature" again to observe, explore, and sketch the details of New Hampshire's rugged terrain. He cast his subsequent painting, *Mt. Jefferson, Pinkham Notch, White Mountains,* in a glowing palette of gold and orange. The canvas would help establish the artist's international reputation as America's painter of autumn.[2]

Through Pinkham Notch—a natural gap in the White Mountains—Cropsey pictures a majestic peak rising thousands of feet above a valley floor. Thin ribbons of water course down the jagged cliff faces, while wisps of low clouds drift along the river gorge below. There, the dense forest is ablaze with autumn color. In the foreground, diminutive and nearly imperceptible against the bright hues, a red-clad figure sets off with an axe over his shoulder and a dog at his side.[3] The open shed behind him—a sawmill—and tidy stacks of new lumber signal a central paradox of advancing civilization: with settlement and development comes destruction of primeval wilderness.

Cropsey was among the younger generation of core artists that became known as the Hudson River school—though they were never an organized group. Traveling forth and sketching regional forests and mountains, the artists returned to their New York City studios to produce landscapes for an approving urban audience. The White Mountains, comprising the highest peaks in the Northeast, rated among the favorite subjects for prominent landscapists. Such dramatic scenery suited prevailing sentiment that images of America's vast wilderness and natural resources were ideal vehicles for national and religious expression.[4] By the mid-1840s, the new railroads that gave artists access to unspoiled wilderness had also conveyed developers and tourists.[5] In fact, the location that offers this splendid view through Pinkham Notch was the site of Glen House Hotel, which opened in 1851. During his visit to the White Mountains four years later, Cropsey was likely a guest at the six-hundred-room mountain resort where he could easily sketch the distinctive profile of the Presidential Range.[6] The artist came away with several field sketches that would serve him well in reproducing the scene in oil. From those on-site renderings, he also inadvertently perpetuated the mistaken identity of the prominent peak; it is Mount Adams that commands the view, with Mount Jefferson to the left.[7]

Cropsey did not commit the scene to oil until the winter of 1856–57, after he had relocated to London. There, he was influenced by the work of near-contemporary British landscapists such as John Constable and J. M. W. Turner, as well as by the theories of John Ruskin, the prominent art critic who advocated the scrutiny of nature. Cropsey successfully blended these new stimuli with his evident admiration for the two American pioneers of the Hudson River school movement: Thomas Cole and Asher B. Durand (see cat. nos. 37 and 64).[8] During his seven-year London sojourn, Cropsey completed and exhibited several large American landscapes, garnering serious comment and acclaim. However, when English visitors to the

57

1860 Royal Academy exhibition questioned the vivid color of his *Autumn on the Hudson River* (National Gallery of Art), the artist mounted a makeshift display of preserved New England leaves to testify to the veracity of his fall imagery.[9]

Cropsey's critical success grew at home as well. Almost as the paint dried, *Mt. Jefferson, Pinkham Notch* was purchased by a prominent New York collector in the spring of 1857 and was promptly sent for exhibition at the National Academy of Design.[10] *Crayon,* the most influential American art journal of its day, found passages in the picture "remarkably well painted," while the enthusiastic *Evening Express* found it "beyond praise" and "one of the gems of the exhibition."[11] A decade later, the picture was seen by hundreds of thousands of visitors at the 1867 Universal Exposition in Paris, where it was featured in the special display of American art.[12]

In the late nineteenth century, Cropsey continued to produce his highly naturalistic and detailed landscapes. Many of them, such as *Autumn in the Warwick Valley* (fig. 90), featured his favorite autumn coloration. In 1903, author and critic Henry James singled out Cropsey among American landscape painters from the previous century, praising his "luscious paint" and the "autumnal scarlet, amber, orange which were not the least of the glories of the 'Hudson River school.'" James continued:

> That was an age in which American artists yielded to the natural impulse to paint American scenery . . . and when no subject for landscape art was deemed superior to the admirable native "fall."[13]

FIG. 90 Jasper Francis Cropsey (1823–1900), **Autumn in the Warwick Valley,** 1883, oil on canvas, 12 ⅝ x 22 ⁵⁄₁₆ in. (32 x 57.5 cm). Virginia Museum of Fine Arts, Gift of Mrs. James H. Symington, 98.29.

As new European approaches—including those developed by French Barbizon and impressionist painters—were adopted by young American artists, the works of the once-renowned painter faded from favor. For James they became a symbol of changing taste; put simply: "the Cropseys, generically speaking, wouldn't do."[14] In the late twentieth century, art historians resurrected his reputation as the undisputed colorist of the second generation of the Hudson River school.[15] ELO

NOTES

1. *Literary World,* May 8, 1847, 323, quoted in William S. Talbot, *Jasper F. Cropsey, 1823–1900,* exh. cat. (Washington, D.C.: Smithsonian Institution Press for National Collection of Fine Arts, 1970), 18.

2. Cropsey made sketching trips to the White Mountains in 1849, 1850, and 1855. Talbot, 54; Peter Bermingham, *Jasper F. Cropsey, 1823–1900,* exh. cat. (College Park: University of Maryland Art Gallery, 1968), 46.

3. In Cropsey's *The Backwoods of America,* made the following year, the man and his dog appear again, but in larger scale. Transformed from entrepreneurial logger to homesteading pioneer, he stands before a log cabin instead of a sawmill. *Paintings from the Manoogian Collection,* exh. cat. (Washington, D.C.: National Gallery of Art; Detroit: Detroit Institute of Arts, 1989), 12–13.

4. Oswaldo Rodriguez Roque, "The Exaltation of American Landscape Painting," in *American Paradise: The World of the Hudson River School,* exh. cat. (New York: Metropolitan Museum of Art, 1987), 38–39; Gail S. Davidson, "Landscape Icons, Tourism, and Land Development in the Northeast," in Gail S. Davidson et al., *Frederic Church, Winslow Homer, and Thomas Moran: Tourism and the American Landscape,* exh. cat. (New York: National Design Museum; Boston: Bullfinch Press in association with the Smithsonian Cooper-Hewitt, 2006), 36–41.

5. Talbot, 24; Donald D. Keyes et al., *The White Mountains: Place and Perceptions,* exh. cat. (Durham: University of New Hampshire Art Galleries, 1980), 41–43; Bermingham, 24.

6. The site for this specific view, located by the author in the fall of 1998, features a marker noting the former location of Glen House. The original hotel was destroyed by fire in 1884, the fate of two subsequent inns at the same site. For a history of Glen House, see Randall H. Bennett, *The White Mountains: Alps of New England* (Charleston, S.C.: Arcadia, 2003), 29–30, 92–93, 121.

7. Several related pencil sketches survive in the collection of the Newington-Cropsey Foundation, Hastings-on-Hudson, New York. I am indebted to Kenneth W. Maddox, art historian at the foundation, for sharing significant provenance information for this painting and—with assistance from Roger E. Belson—for sorting out the identity of the pictured mountains.

8. Originally trained as an architect, Cropsey began working in watercolor in 1840. By 1845, he had devoted himself to painting full time. His first trip abroad, in 1847, took him to Italy for two years. The second trip, to England, ended with the outbreak of the American Civil War, when Cropsey returned to his native New York. Talbot, 19–35.

9. Bermingham, 26–27.

10. *National Academy of Design Exhibition Record, 1826–1860* (New York: J. J. Little and Ives for the New-York Historical Society, 1943) 1:102. This vibrant painting has an equally colorful history: R. M. [Robert Morrison] Olyphant purchased this major work on April 16, 1857. After his family's China trade company experienced financial difficulties, Olyphant sold his collection at auction in 1877. *Mt. Jefferson* was purchased by prominent businessman Le Grand B. Cannon, who, seventeen years later, would lead a much-publicized boardroom fight against Olyphant and the Vanderbilt family for control of the Hudson and Delaware Canal Company. Following Cannon's death, Olyphant won the canvas back at auction

in 1907. His estate consigned it for sale in 1919, when it entered the collection of W. A. Burnett. Descending in the family, it remained out of public view until it emerged in a New England auction house in 1995.

11. *Crayon* (July 1857): 221 and *Evening Express* (1857), undated news clipping in the Cropsey papers, Newington-Cropsey Foundation, both cited in Talbot, 133.

12. Clara Erskine Clement Waters and Laurence Hutton, *Artists of the Nineteenth Century and Their Works,* 7th ed., rev. (1884; repr., New York: Arno Press, 1969), 173.

13. Henry James, *William Wetmore Story and His Friends* (Boston: Houghton Mifflin, 1903), 1:124.

14. Ibid.

15. Bermingham, 46–48; Rogue, 200–16; Andrew Wilton and Tim Barringer, *American Sublime: Landscape Painting in the United States, 1820–1880,* exh. cat. (London: Tate Britain, 2002), 24, 80, 137–38.

58. William Wetmore Story (1819–1895)

Cleopatra, modeled 1858; carved 1865

Marble

54 x 45 x 27 in. (137.2 x 114.3 x 68.6 cm)

Inscribed in medallion to left of chair: "WWS / Roma 1865"

Carved in relief on front of base: "Cleopatra"

Museum Purchase, The J. Harwood and Louise B. Cochrane Fund for American Art, 2005.73

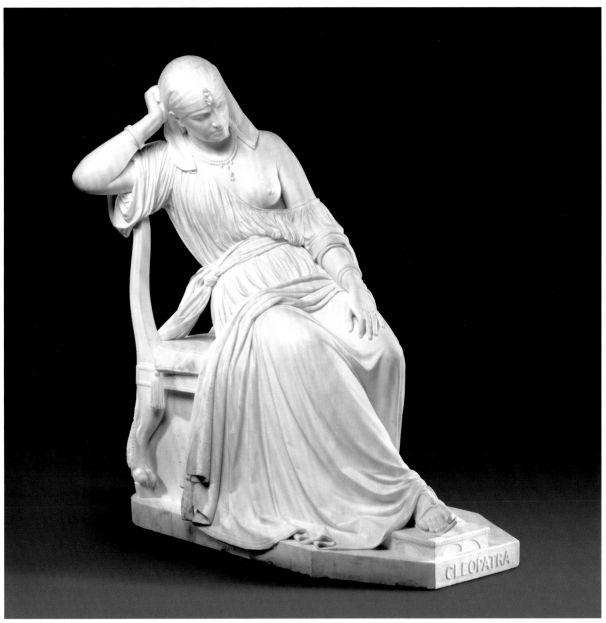

58

PROVENANCE: Possibly Mr. Paran Stevens, New York, N.Y. (1865); Estate sale of Mrs. Paran Stevens, American Art Association, New York, N.Y. (November 2, 1895); Waldorf-Astoria Hotel, New York, N.Y. (1929); sold at auction by Wise Auction Galleries, New York, N.Y. (1929, lot no. 12640); Eugene Leone, New York, N.Y.; Spanierman Gallery, L.L.C., New York, N.Y. (1989)

This striking figure of Cleopatra represents the high point of America's taste for white marble neoclassical sculpture in the mid-nineteenth century. And its maker was, in his own day, one of the nation's most famous and successful artists.[1] William Wetmore Story, leader of the second generation of American expatriate sculptors residing in Italy, created a monumental image. His life-size figure portrays Cleopatra VII, the last Ptolemaic ruler of Egypt and a descendant of Alexander the Great. As chronicled by history and legend, the ambitious queen forged political and romantic liaisons with Rome's most powerful men, Julius Caesar and Mark Antony. When defeated in battle and held captive by the subsequent Roman emperor, Octavian, Cleopatra committed suicide rather than capitulate. Over the course of two millennia—and through dramatic narratives by writers from Plutarch to Shakespeare— she came to symbolize the potent forces of female intelligence, power, and sexuality.[2]

Story conceived the figure without the support of a commission, which was unusual for the time. Working on speculation, he gave free rein to his imagination. While other artists often depicted Cleopatra's unusual method of suicide by snakebite, the sculptor presents her instead in a moment of brooding contemplation. She leans back on her lion-leg throne, head in hand, as if weighing her next move in the high-stakes game of survival. For her costume, Story combined elements of both Greek and Egyptian apparel. Defying the hard medium, he defined the soft folds of her gown in exquisite detail (fig. 91). The gaping neckline exposes one breast, a Greco-Roman convention that recalls the mythological Amazon female warriors. At the same time, Story took care to adorn the queen with Egyptian jewelry and a pharaoh's head-dress—the striped *nemes* embellished with the *uraeus,* the rearing female cobra that protects both ruler and land. In the mid-nineteenth century, viewers steeped in neoclassical imagery would have recognized the trappings of both cultures. At the same time, some sought to determine the figure's race; "You are looking," one contemporary writer reminded his readers, "on an *African* queen."[3]

Even before its public unveiling, Story's *Cleopatra* had gained widespread renown. In 1858, American author Nathaniel Hawthorne became fascinated with the work when visiting the artist's studio in Rome. Having followed the figure's progress from clay to plaster to marble, Hawthorne included both sculptor and sculpture in his 1860 novel *The Marble Faun.* In a lengthy and rather Romantic passage, the character Kenyon (a thinly disguised Story) draws back a cloth to reveal the clay *bozzetto.* Closely examining the figure, his visitor finds:

> The face was a miraculous success. . . . The expression was of profound, gloomy, heavily revolving thought; a glance into her past life and present emergencies, while her spirit gathered itself up for some new struggle, or was getting sternly reconciled to impending doom. . . .
>
> In a word, all Cleopatra—fierce, voluptuous, passionate, tender, wicked, terrible, and full of poisonous and rapturous enchantment—was kneaded into what, only a week or two before, had been a lump of wet clay from the Tiber. Soon, apotheosized in an indestructible material, she would be one of the images that men keep forever, finding a heat in them which does not cool down, throughout the centuries.[4]

Subsequent visitors to Story's studio admired and wrote of *Cleopatra,* fueling popular curiosity on both sides of the Atlantic about the marble figure. The sculpture's critical success was solidified when it made its debut at the 1862 International Exhibition in London—shipped there from Rome courtesy of Pope Pius IX when a money-strapped U.S. government could not cover transport.[5] Papal intervention only bolstered the artwork's mystique and reputation.

This version of Story's *Cleopatra* is the second of four known renderings, all carved from white marble and with similar dimensions. The original sculpture was purchased from the International Exhibition and remained in a British collection until acquired over a century later by the Los Angeles County Museum of Art. According to the artist's checklist, Story reworked the figure in 1864 for Paran Stevens of New York— the likely owner of this sculpture—and completed it in

FIG. 91 Detail of cat. no. 58.

also characterizes the prevailing neoclassical mode. Before long, Story's apartments at the Palazzo Barberini became a gathering place for prominent British and American residents and travelers. Following the critical acclaim of *Cleopatra,* he enjoyed a steady clientele of the rich and aristocratic of two continents. Described by his biographer and friend Henry James as "frankly and forcibly romantic," Story went on to produce several full-scale idealized figures—many of them powerful women from history and mythology. His *Cleopatra,* however, remained one of the best-known American sculptures of the century.[7] ELO

NOTES

1. Wayne Craven, *Sculpture in America* (Newark, Del.: University of Delaware Press, 1984), 281.

2. For an illustrated study of Cleopatra's life in history and legend, see Edith Flamarion, *Cleopatra: The Life and Death of a Pharaoh* (New York: Abrams, 1997).

3. Considerations of race in imagery heightened during the American Civil War; such associations extended to Story's *Cleopatra.* Novelist Nathaniel Hawthorne describes the figure's "full, Nubian lips" in *The Marble Faun, or The Romance of Monte Beni* (1860; repr., London and New York: Standard, 1931), 81. The following year, minister and abolitionist Edward Everett Hale penned a long tribute to the sculpture, adding emphasis that the doomed Cleopatra is "an *African* queen" and a metaphor for "the constant tragedy" of the ongoing enslavement of African Americans in the United States. See Edward E. Hale, *Ninety Days' Worth of Europe* (Boston: Walker, Wise, 1861), 145–48. Present-day historian Mary Hamer explored various racial readings of this sculpture in her presentation, "Black *and* White: Viewing *Cleopatra* in 1862," College Art Association, annual meeting, Seattle, 1993.

4. Hawthorne, 81. In 1865, Story published his own florid homage, a lengthy poem that locates the Egyptian queen in her bed, yearning for Mark Antony's embrace. William Wetmore Story, "Cleopatra," *Dwight's Journal of Music* 25 (September 16, 1865): 1. Twenty years later, the artist produced a new sculpture of a reclining Cleopatra (ca. 1884–85, whereabouts unknown). Mary E. Phillips, *Reminiscences of William Wetmore Story* (Chicago and New York: Rand, McNally, 1897), 229–32, 297.

5. Under the Pope's aegis, Story's *Cleopatra* and *The Libyan Sibyl* were exhibited at the fair as examples of "Roman art." Phillips, 134–35.

6. Ibid., 296. In 1895, the sculpture was sold at auction from the estate of Mrs. Stevens for $1,600. See "Paran Stevens Pictures Sold," *New York Times,* November 26, 1895, 5. Among its subsequent twentieth-century owners was Eugene Leone, who displayed it in his family's famous restaurant, Mamma Leone's, in New York City. William H. Gerdts, "William Wetmore Story," *American Art Journal* 4 (November 1972): 20.

7. Henry James, *William Wetmore Story and His Friends* (Boston: Houghton Mifflin, 1903), 2:77. See biographical summaries in Craven, 274–81, and Gerdts, 16–33. For an exploration of the sculptor's youth, training, and significant influences, see Jan M. Seidler, "A Critical Reappraisal of the Career of William Wetmore Story (1819–1895), American Sculptor and Man of Letters" (Ph.D. dissertation, Boston University, 1985.)

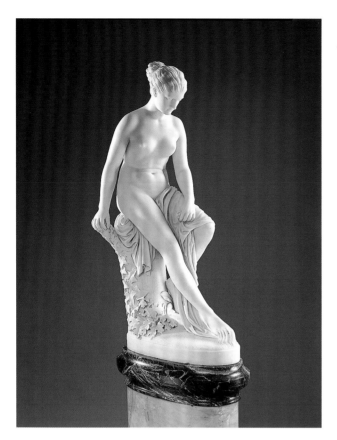

FIG. 92 Chauncey B. Ives (1810–1894), **Egeria,** 1876, marble, 41 ½ x 16 x 20 in. (105.4 x 40.6 x 50.8 cm). Virginia Museum of Fine Arts, Gift of the Commonwealth of Virginia, 48.10.1.

1865.[6] The remodeling included slight variations of the waist sash, sleeve, and necklace, as well as the addition of a small footstool and Cleopatra's name in relief. Two subsequent versions followed in 1869 (Metropolitan Museum of Art) and in 1875 (West Foundation, on loan to the High Museum of Art).

Story, a Harvard University–trained attorney, art critic, writer, poet, and musician, came of age within the elite Brahmin society of Boston. Having taught himself to model sculpture, he began his artistic career after gaining the commission to create a memorial sculpture of his father, U.S. Supreme Court Justice Joseph Story. In 1856 he relocated permanently to Rome, where he took advantage of the city's abundant supply of fine marble and skilled stonecutters as well as its enduring legacy of classicism. In Italy, he found other American sculptors who produced mythological, biblical, and allegorical figures— including the venerable Hiram Powers (see cat. no. 54) and Chauncey Ives, whose lovely water nymph *Egeria* (fig. 92)

Civil War and Centennial Eras

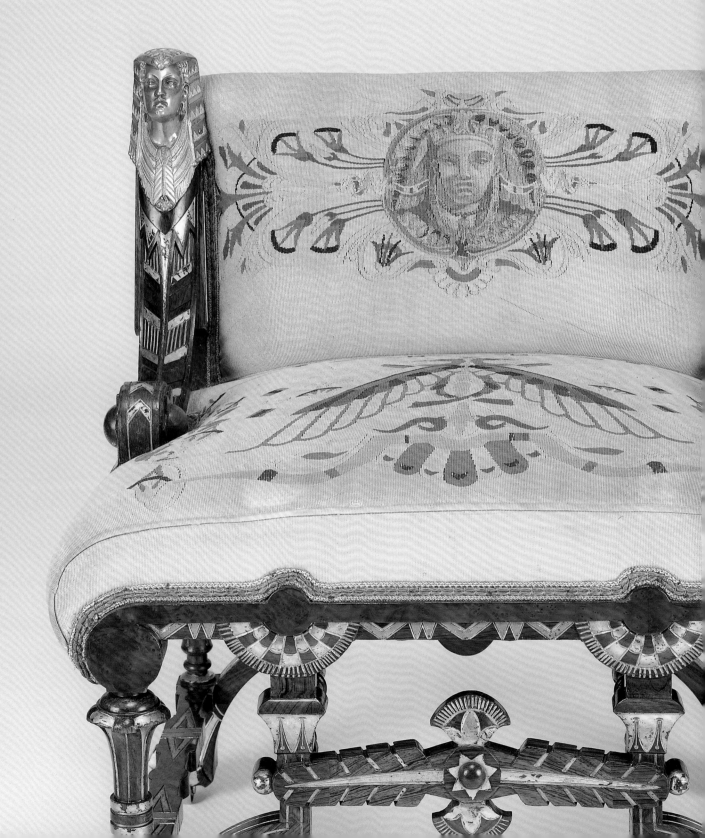

59

59. George Henry Durrie (1820–1863)

Winter in the Country: A Cold Morning, 1861

Oil on canvas

26 x 36 in. (66 x 94 cm)

Signed and dated lower right corner: "G.H. Durrie / 1861."

Museum Purchase, The J. Harwood and Louise B. Cochrane Fund for
 American Art, 92.124

PROVENANCE: Harry Shaw Newman Gallery, New York, N.Y.; Mr. and Mrs. C.K.
Davis, Fairfield, Conn. (until 1976); Bertha Davis; Hirschl and Adler Galleries, New
York, N.Y.; Private collection; Hirschl and Adler Galleries, New York, N.Y.; Corporate
collection, New York, N.Y.; Richard York Gallery, New York, N.Y.

For this luminous, highly finished winter scene, genre painter
George Henry Durrie chose an evocative title, *Winter in the
Country: A Cold Morning.* Durrie's carefully constructed visual
experience invites the viewer in out of the cold, sending a clear
message of hospitality linked to old-fashioned country ways.
Under a frosty pearl sky, two travelers abandon the chilly dis-
comforts of their red and green horse-drawn sleds, which are
pulled up under a rural tavern's welcoming red signboard.
The inn's sunny yellow walls provide a warm contrast with the
snow-filled yard, leading the eye directly to the tavern's front
door. The artist reinforced this movement by placing another
traveler in the midst of a broad sweeping path. He approaches
on foot, carrying a basket and followed by a little dog. Nearby,
farmhands are feeding animals, while a woman in country
dress draws water from the well behind the inn. The kettle, no
doubt, will soon be on the boil. It is no accident that Durrie's
images, which reaffirm basic cultural values of shelter and suste-
nance, achieved their widespread popularity at a time when
the United States was torn by the Civil War and coping with
the challenge of a rapidly industrializing economy.[1]

Durrie painted this enticing, beautifully detailed image in
1861.[2] That same year, the firm of Currier and Ives—"print-
makers to the American people"—secured a national follow-
ing for the gentle genre painter by reproducing another of
his oils as a lithographic print. Between 1861 and 1867,
Currier and Ives would publish ten of Durrie's finest rural
images as large-folio, hand-colored lithographs, including
Winter in the Country: A Cold Morning (fig. 93).[3] This print was
released in 1864, a year after the artist's untimely death at age
forty-three. The series of popular lithographs was enough to

establish Durrie's lasting reputation for recording the old ways
of rural New England. Harry T. Peters, the first historian to
chronicle the activities of Currier and Ives, lamented in 1929
that "it is indeed to be regretted that [Durrie's] contributions
were not more numerous."[4]

But the paintings, especially fully realized images like
Winter in the Country, go far beyond the lithographed prints in
the level of their subtle artistic nuance. Durrie's remarkable
skill as a painter of light and atmosphere can be appreciated
only in his oils.[5] Eventually, the artist's fame rested on pictures
like *Winter in the Country;* his was "the major contribution to
native American winter landscape painting in the nineteenth
century," according to his biographer.[6]

FIG. 93 Currier and Ives (active 1857–1907), publishers, after George H.
Durrie, **Winter in the Country: A Cold Morning,** 1864, two-color lithograph,
hand colored, 18 ⅝ x 27 in. (47.3 x 68.6 cm). Virginia Museum of Fine Arts
Purchase, The J. Harwood and Louise B. Cochrane Fund for American Art,
2007.15.

Durrie spent most of his life in New Haven, Connecticut.
In the early 1840s he painted portraits in Virginia, New
Jersey, and upper New York State before returning to New
Haven. By the next decade, he was producing genre scenes
such as the light-hearted *Sledding* of 1851, in which the prom-
inent figures of laughing boys seem frozen in place despite the
precarious angle of the snowy slope (fig. 94). Having experi-
mented with various approaches and subjects, the artist finally
found his métier in rural winter scenes populated with small
figures.[7] There were certainly precedents for wintry scenes in

FIG. 94 George Henry Durrie (1820–1863), **Sledding**, 1851, oil on panel, 19½ x 23¾ in. (49.5 x 60.3 cm). Virginia Museum of Fine Arts, The Paul Mellon Collection, 85.637.

Dutch and Flemish painting of earlier centuries, and American painters studied prints and paintings of European models available to them. At the same time, Durrie found personal joy in the charming views and activities of the season. On January 21, 1845, he confided to his diary that it had "snowed considerably this afternoon. . . . This evening the moon shone out beautifully on the new fallen snow, the trees sparkling with icy limbs—made the scene almost enchanting." The next day he noted that "the weather has been beautiful and the sleighs have been constantly on the move, making the scene very animated."[8]

Durrie's concentration on people and rural buildings—mills, barns, or, in this case, an inn—as community gathering places ensured that a picture like *Winter in the Country: A Cold Morning* retains its accessibility over time as an archetypal American statement of rural contentment. DPC

NOTES

1. Harry Peters, like other early-twentieth-century historians, especially valued Durrie's "record of the old-time farm and its life, now vanishing." Ongoing research in American art and material culture suggests that Americans were uncomfortable with the speed of change even before the Civil War. Thus Durrie would have found a ready-made audience for his paintings by the time his career was fully launched in the 1840s. See Harry T. Peters, *Currier and Ives: Printmakers to the American People* (Garden City, N.Y.: Doubleday, Doran, 1929), 116.

2. In 1863, Durrie approached the same subject in a similarly scaled canvas. For this *Winter in the Country, A Cold Morning* (Vose Galleries), the setting—buildings and trees—is the same. However the artist made slight changes to the figures, and therefore the narrative. While the farmhand pitching hay at the shed at left remains, the travelers at the inn door and woman at the well have vanished. At the foot of the towering center tree, a farmhand drives a loaded wood sledge pulled by an ox. A small oil on board with the same title is in the Hosek collection, Texas.

3. Currier and Ives published the lithographic reproduction in 1864 along with Durrie's *Winter in the Country: Getting Ice* and *Winter in the Country: The Old Grist Mill.* The important place that Durrie's work occupies in the Currier and Ives canon is the more impressive when one realizes that the lithographic firm published almost 7,500 images by various artists. For a comprehensive catalogue of the lithographs of Nathaniel Currier, James Merritt Ives, and Charles Currier, see *Currier and Ives: A Catalogue Raisonné,* comp. Gale Research Company, 2 vols. (Detroit: Gale Research, 1984). The ten Durrie paintings reproduced as lithographs are listed on 2:984. See also Martha Young Hutson, *George Henry Durrie, American Winter Landscapist,* exh. cat. (Santa Barbara, Calif.: American Art Review Press in association with Santa Barbara Museum of Art, 1977), 166–81, 230–31.

4. Peters, 116.

5. Currier and Ives reproductions were lithographed in black and white, and then hand colored. The prints relied for their impact on narrative details coupled with simplicity of form.

6. Hutson, 175, 181.

7. Hutson offers the most thorough consideration of Durrie's life and career to date. VMFA has a third Durrie canvas, also a winter scene, *The Country Inn* (ca. 1851, oil on panel, 19½ x 23¾ in., The Paul Mellon Collection, 85.636).

8. For an historical survey of American winter landscape painting in the nineteenth century, see Huston, 63–88. Durrie's diary, New Haven Colony Historical Society, quoted in Hutson, 93.

60. Eastman Johnson (1824–1906)

A Ride for Liberty – The Fugitive Slaves, March 2, 1862, 1862

Oil on board

21½ x 26 in. (54.6 x 66 cm)

Signed lower right: "E. Johnson"

Inscribed on paper label verso: "A veritable incident / in the civil war seen by / myself at Centerville / on the morning of / McClellan's advance / towards Manassas. March 2d, 1862 / Eastman Johnson."

Gift of Mr. and Mrs. Paul Mellon, 85.644

PROVENANCE: Estate of the artist, sold at auction by American Art Galleries, New York, N.Y. (February 26–27, 1907, lot no. 123); Louis Ettlinger; Mrs. Giles Whiting, Scarborough, N.Y.; by bequest to the Museum of the City of New York, New York, N.Y.; Bernard Danenberg Galleries, New York, N.Y. (1972); Paul Mellon, Upperville, Va.

With all the drama that its title suggests, *A Ride for Liberty – The Fugitive Slaves* captures the urgency of an African American family in a life-threatening dash for freedom. Silhouetted by the early light of dawn, a man and woman with a baby and

young child huddle together on a single horse. The parents' tense profiles convey both purpose and fear: his face directed ahead as he guides the galloping horse, and hers cast backward in search of pursuers. This daring escape, according to the artist, was an actual event. His carefully written label, still affixed to the back of the painting, describes the scene as "A veritable incident in the civil war seen by myself at Centerville on the morning of McClellan's advance towards Manassas. March 2d, 1862 Eastman Johnson."[1]

A native of Maine, Johnson studied abroad in Düsseldorf and Paris before relocating to Washington, D.C., in 1855. Having gained initial success with portraits, he shifted his focus to genre imagery, which made his reputation. Residing at the home of his father and stepmother on F Street, the painter found models among the urban neighborhood's African American laborers. Johnson caused a sensation at the 1859 National Academy of Design exhibition with his ambitious, multifigure painting titled *Negro Life at the South* (New-York

60

Historical Society). Soon acquiring the alternative title of *Old Kentucky Home,* the canvas pictures a white mistress stepping gingerly into the cramped and ramshackle yard of the slave quarters behind her house. In a pastiche of stereotypical "Negro" activities—music making, dancing, child tending— the several black figures seem oblivious to her entrance. While Johnson's picturesque treatment reinforced the notion of contented slaves, it also details their impoverished circumstances. In this way, his image neatly straddled the political and moral issues of the relationship between slave and owner on the eve of the Civil War.[2]

Johnson was well aware of growing national tensions surrounding the question of slavery. Living in the nation's capital, he would have heard arguments on all sides—perhaps including those between his New England father, a midlevel bureaucrat in the Navy Department, and his Virginia-born stepmother, who, according to census records, owned three slaves.[3] Indeed, the Johnson household might be seen as a microcosm of the nation's rather precariously balanced slavery and antislavery factions throughout the 1850s. In the previous decade, the question of admitting western territories as free states brought secessionist threats from southern lawmakers. In 1850, Senator Henry Clay of Kentucky drafted a compromise permitting the admission of some free states in exchange for the enactment of binding fugitive-slave legislation. "The Great Compromiser," as Clay was called, was heralded as the savior of the nation. His visage appeared in prints, paintings, and sculptures—including Thomas Ball's 1858 bronze portrait (fig. 95). The Fugitive Slave Act, the crucial provision of Clay's plan, permitted southern owners to reclaim their runaway slaves; it also subjected any person aiding, harboring, or obstructing the arrest of a fugitive to a fine or imprisonment.[4] Northern indignation fueled the development of the so-called Underground Railroad, with its system of safe houses for runaways making their way north. It also prompted Harriet Beecher Stowe to write *Uncle Tom's Cabin* (1852). Featuring its own daring escape scene, the book would eventually become the most widely read novel in nineteenth-century America.[5]

In *Ride for Liberty,* which was painted less than a year after the commencement of the war, Johnson's clearly abolitionist sympathies lie with the African American family. Perhaps inspired by letters from his brother Reuben, who had enlisted

FIG. 95 Thomas Ball (1819–1911), **Henry Clay,** 1858, bronze, 30½ x 11⅝ x 10¾ in. (77.5 x 29.5 x 27.3 cm). Virginia Museum of Fine Arts Purchase, Charles G. Thalhimer Family Fund, 88.41.

in the Union army, the painter traveled to Northern Virginia in late February 1862.[6] Under the aegis of the Army of the Potomac, he arrived at the front just as General George McClellan ordered his Federal troops to begin an offensive push toward Confederate lines. Marching to the southwest, they advanced in the direction of Centreville (often misspelled Centerville), where forty thousand Confederate troops had been entrenched since the previous October. Other than troop movement, encampment, and the occasional skirmish, Johnson did not witness much action. On March 9, the Confederate forces withdrew to a position south of the Rappahannock River; a full-blown bloody campaign at nearby Manassas would wait until August.[7]

Johnson would have noted a steady stream of civilians— both white and black—abandoning Centreville as northern soldiers surged forward to claim houses, shelters, and trenches formerly occupied by the Confederates. The advancing Union line brought another significant demarcation: a fluid boundary

of freedom for enslaved African Americans. The desperate family in Johnson's painting needed only to cross the outer Federal picket line to escape bondage. Almost a year earlier, the U.S. government declared that slaves who escaped to the safety of the northern ranks would be designated "contraband of war"—no longer required by law to be returned to their former owners. By 1865, Johnson's family of four would be counted among the approximately one million black refugees who eventually found safe haven, food, and sometimes paid employment as laborers with the Union army.[8]

Even before the end of the war, Johnson turned his focus to the more peaceful subjects that would dominate his imagery throughout the remainder of his career: farm folk in quiet rural pursuits, children playing in haylofts or fields, and wealthy sitters in their beautifully appointed urban interiors.[9] Nevertheless, with *A Ride for Liberty*—crafted from memory and conviction—Johnson produced one of the most poignant images created by an American painter during the Civil War.

ELO

NOTES

1. Johnson painted three versions of *The Ride for Liberty*. One of similar size (22 x 26 ¼ in.) in the Brooklyn Museum differs slightly; in place of the streak of morning light at left, there is a line of glistening Union bayonets on the horizon. The location of the third, smaller painting (16 ½ x 21 in.) is presently unknown; it was sold through Kende Galleries, New York, New York, May 1–2, 1940, lot 283. Teresa A. Carbone, *American Paintings in the Brooklyn Museum* (London: D. Giles in association with the Brooklyn Museum, 2006), 2:707–9. The VMFA version, the only one bearing the artist's inscription, remained in Johnson's possession until his death in 1906.

2. For contextual examinations of this painting, see John Davis, "Eastman Johnson's *Negro Life at the South* and Urban Slavery in Washington, D.C.," *Art Bulletin* 80 (March 1998): 67–92, and Patricia Hills, "Painting Race: Eastman Johnson's Pictures of Slaves, Ex-Slaves, and Freedmen," in Teresa A. Carbone et al., *Eastman Johnson: Painting America*, exh. cat. (New York: Brooklyn Museum of Art in association with Rizzoli, 1999), 126–31.

3. Davis, 68, 75–78.

4. Philip S. Foner, *History of Black Americans*, vol. 3, *From the Compromise of 1850 to the End of the Civil War* (Westport, Conn.: Greenwood Press, 1983), 4, 9–15.

5. Peter Conn, *Literature in America* (New York: Cambridge University Press, 1989), 183–85.

6. Reuben Johnson's description of the first battle of Bull Run (Manassas) is quoted in full in John I. H. Baur, *Eastman Johnson* (New York: Brooklyn Museum, 1940), 18–19. For a discussion of Johnson's Civil War activities and imagery, see Teresa A. Carbone, "The Genius of the Hour: Eastman Johnson in New York, 1860–1880," in *Eastman Johnson Painting America*, 54–65, 114nn30,42.

7. Joseph Mills Hanson, *Bull Run Remembered: History, Traditions, and Landmarks of the Manassas (Bull Run) Campaign Before Washington, 1861-1862* (Manassas, Va.: National Capital Publishers, 1957), 39–41, 55. It appears that in writing "March 2ᵈ" on the label for the painting, Johnson either misremembered the precise date he saw the fugitive family or the specific location of the incident.

The Federal troops with whom he traveled did not enter Centreville until March 9–10. The label's date would be even more erroneous if, as one scholar has suggested, the smudged character following the "2" might be a second numeral instead of a "d." After March 17, McClellan and the Army of the Potomac had relocated 160 miles away to the eastern seaboard, where they embarked on the two-month Peninsula Campaign.

8. The decree, first issued by General Benjamin Butler at Fortress Monroe, Virginia, on May 1861, was codified by the U.S. Congress the following August. Randall M. Miller and John David Smith, *Dictionary of Afro-American Slavery* (New York; Westport, Conn.; and London: Greenwood Press, 1988), 143–44.

9. For an examination of Johnson's career see Patricia Hills, *The Genre Painting of Eastman Johnson: The Sources and Development of His Style and Themes* (New York: Garland, 1977), 55–60.

61. William D. Washington (1833–1870)

The Last Touch, 1866

Oil on canvas

Signed and dated lower right: "W. D. W. 1866"

24 x 21 in. (61 x 53.3 cm)

Museum Purchase, The Dr. William Harrison Higgins Jr. Fund, 2002.525

PROVENANCE: Private collection, Emmitsburg, Md.; Marshall Goodman, Distinctive Consignments, Richmond, Va.

When Virginia-born William Dickinson Washington sent *The Last Touch* to the National Academy of Design for exhibition in 1866, he found himself in an unenviable position as a southern painter trying to establish a foothold in an American art market centered in New York City.[1] In the tentative environment of this early post–Civil War exhibition, Washington submitted a neutral subject that might have appealed to his audience and fellow artists alike.

The image—most likely a self-portrait—depicts a painter in his studio.[2] Casually but artistically dressed in robe and slippers, the man pauses to sit and gauge the effect of the "last touch" of pigment on a canvas. His picture is already mounted in an elaborate gilded frame as if nearly ready for public exhibition. A young woman, who serves as a muse, studies the painting with him. In an interior where reddish brown hues dominate, her white blouse and emerald green skirt draw the eye immediately to the couple.

Amid the clutter of painting props, an international array of objets d'art—large Old Master paintings on the back wall, the plaster cast of a classical cherub, a framed tondo of

61

a Madonna—presents a genteel studio that is neither north-ern nor southern but instead European in its references. The theme of *The Last Touch* is in keeping with a long line of artist-at-work imagery; from Rembrandt and Diego Velázquez to Gustave Courbet, many painters addressed the topic.[3] In America, the narrative of the receptive studio visitor also recalls William Sidney Mount's 1836 canvas *The Painter's Triumph* (fig. 96), which had been reproduced in a popular 1840s gift book. However, unlike Mount, who pictured a humble studio where canvases line the bare floor and face the wall, Washington presents a stylish setting.[4] At midcentury, as the audience for art expanded into the middle classes, the care-fully decorated studio became a prime site for contact between painter and public. In 1858, the influential art journal *Crayon* announced: "It is evidently becoming the fashion for the artist to receive his guest in a style of elegance and taste that should always characterize the man. . . . At a time when men of all professions are cultivating the Arts, and surrounding them-selves with all that taste and money can procure, it behooves the artist not to be left behind."[5]

By the time he painted *The Last Touch*, William Washing-ton was well versed in artistic traditions and the art market. He had trained in the 1850s at the Düsseldorf Art Academy in Germany under Emanuel Leutze, the German-American painter whose *Washington Crossing the Delaware* (1851, Metropoli-tan Museum of Art) eventually found its way into generations of history books.[6] On his return to America, Washington exhibited in Philadelphia and Baltimore as well as Washing-ton, D.C., where he resided and helped found the Washington Art Association.[7]

At the outbreak of the Civil War, the artist relocated to Richmond, Virginia, establishing his reputation in 1864 with a history painting of his own, *The Burial of Latané* (fig. 97). The large canvas depicts the interment of William Latané in Hanover County, Virginia, attended by the women and enslaved laborers of Westwood Plantation. Latané, a captain in the 9th Virginia Cavalry, was the only casualty of J. E. B. Stuart's 1862 defense of Richmond. Washington's sentimen-tal rendering of the funeral scene created a "furor" in the city when it went on view at the Virginia state capitol. The canvas was exhibited with a bucket to collect donations for the war effort.[8]

As Washington ventured northward in the immediate postwar years, he gained important New York connections—including, no doubt, reestablished contact with former Düssel-dorf associates such as Leutze and Worthington Whittredge (see cat. no. 40). After successfully exhibiting *The Last Touch*, he collaborated in 1868 with engraver A. G. Campbell and William Pate, proprietor of one of Manhattan's successful

FIG. 96 William Sidney Mount (1807–1868), **The Painter's Triumph,** 1838, oil on wood, 19 ½ x 23 ⁹/₁₆ (49.5 x 59.8 cm). Courtesy of the Pennsylvania Academy of the Fine Arts, Philadelphia, Bequest of Henry C. Carey (The Carey Collection), 1879.8.18.

FIG. 97 William D. Washington (1833–1870), **The Burial of Latané,** 1864, oil on canvas, 36 ⅛ x 46 ⅛ in. (91.4 x 116.8 cm). The Johnson Collection.

FIG. 98 William D. Washington (1833–1870), **Lady Clara de Clare,** ca. 1869, oil on canvas, 24⅜ x 19⅜ in. (61.9 x 49.2 cm). Museum Purchase, The John Barton Payne Fund, 2007.69.

printmaking firms, to produce a large steel engraving of *The Burial of Latané.* The print, which evokes the sacrifice and faith of southern families on the home front, gained wide distribution and became an icon of Lost Cause imagery.[9]

In the summer of 1869, Washington returned to Virginia to serve as chairman of the fine arts department at the Virginia Military Institute in Lexington. Between his lecturing duties and work on a major commission to paint portraits of all VMI war dead, he produced a handful of literary images, including *Lady Clara de Clare* (fig. 98). Inspired by *Marmion,* an 1808 epic poem by Sir Walter Scott set in the Court of Henry VIII, the richly detailed scene pictures the fair Lady Clara after she has taken refuge in the convent of Saint Hilda on the Island of Lindisfarne.[10] It would be one of Washington's final paintings. He died unexpectedly the following year at age thirty-six.[11]

ELO

NOTES

1. For the 1866 NAD exhibition, the artist gave his address as "N.Y. University." *The National Academy of Design Exhibition Record, 1861–1900,* ed. Maria Naylor (New York: Kennedy Galleries, 1973), 2:994. A stencil on the back of the painting reads "Goupil's 772 Broadway"—indicating the probability that Washington purchased the canvas in New York in the months following the end of the war.

Print publisher and art dealer Goupil and Company sold art supplies at that address between 1859 and 1869. DeCourcy E. McIntosh, "New York's Favorite Pictures in the 1870s," *The Magazine Antiques* 165 (April 2004): 122n2; interview with Decourey McIntosh, November 18, 2005, whom I thank for exploring the Goupil connection with me.

2. The similarity between the figure and an extant photograph of the painter is striking. I thank Keith Gibson, director of museum operations, VMI Museum, Lexington, Virginia, for sharing his insights and images. Correspondence, VMFA curatorial files.

3. For discussions of studio imagery, see Ronnie L. Zakon, *The Artist and the Studio in the Eighteenth and Nineteenth Centuries* (Cleveland: Cleveland Museum of Art, 1978) and Nicolai Cikovsky, *The Artist's Studio in American Painting, 1840–1983* (Allentown, Pa.: Allentown Art Museum, 1983). Washington could have seen the 1865 portrait *Worthington Whittredge in His Tenth Street Studio* (Reynolda House Museum of American Art), produced in New York by his former teacher, Emanuel Leutze. This canvas pictures the landscape artist contributing a "final touch" to a painting mounted on an easel, but already housed in its gilded show frame. The portrait is illustrated in Annette Blaugrund, *The Tenth Street Studio Building: Artist-Entrepreneurs from the Hudson River School to the American Impressionists* (Southampton, N.Y.: Parrish Art Museum, 1997), 61.

4. The simple setting of Mount's *Painter's Triumph*—including a sketch of the head of the *Apollo Belvedere* turning away—is sometimes read as the artist's rejection of European artistic influence during an era of heightened nationalism. See Elizabeth Johns, *American Genre Painting: The Politics of Everyday Life* (New Haven and London: Yale University Press, 1991), 42–43. German-trained Washington, like many of the next generation of painters, did not hesitate to display evidence of cosmopolitan travel, study, and influence.

5. *Crayon* 5 (January 1858): 24, quoted in Blaugrund, 14–15. At this time, *Crayon* was chronicling the opening of New York's Tenth Street Studio Building, the first commercial structure designed specifically for artists. Among its prestigious tenants was Leutze, who established a studio there in 1859. Blaugrund, 26–27.

6. The Düsseldorf Academy played an important role in the history of American painting between 1840 and 1870, having trained such stellar landscape artists as Albert Bierstadt, William Stanley Haseltine, and Worthington Whittridge (see cat. no. 40). Significant American history and genre painters with Düsseldorf training include George Caleb Bingham, Emanuel Leutze, and Eastman Johnson (see cat. no. 60). Donelson F. Hoopes and Wend Von Kalnein, *The Düsseldorf Academy and the Americans* (Atlanta: High Museum of Art, 1972).

7. George C. Groce and David H. Wallace, *The New-York Historical Society's Dictionary of Artists in America, 1564–1860* (New Haven: Yale University Press, 1957), 664. To date, the most thorough consideration of Washington's life and career is Ethelbert Nelson Ott, "William D. Washington (1833–1870), Artist of the South" (M.A. thesis, University of Delaware, 1968). Ott opens by confirming that the artist's middle name was Dickinson, not the erroneous "de Hartburn" that appears with frequency in literature about the painter.

8. Mark Neely Jr., Harold Holzer, and Gabor S. Boritt, *The Confederate Image: Prints of the Lost Cause* (Chapel Hill and London: University of North Carolina Press, 1987), ix–xiv, 101; Ott, 89–96.

9. Estill Curtis Pennington, *Look Away: Reality and Sentiment in Southern Art* (Spartanburg, S.C.: Saraland Press, 1989), 22, 24–26, 104–6; Ella-Prince Knox et al., *Painting in the South: 1564–1980* (Richmond: Virginia Museum of Fine Arts, 1983), 87, 249.

10. The model for the heroine may have been Mary Maury (daughter of Commodore Matthew Fontaine Maury), who also posed at the same time for a Tennysonian subject, *Elaine* (VMI Museum). Ott, 143–44; correspondence with VMI Museum director Keith Gibson, VMFA curatorial files. For an intriguing consideration of the role of Scott's courtly idylls in the development and evolution of southern identity in nineteenth-century America, see Claudia Roth Pierpont, "A Critic at Large (A Study in Scarlett)," *New Yorker*, August 31, 1992, 87–103.

11. Contemporary accounts report that Washington had a congenital disability that resulted in lameness and chronic bouts of poor health. Ott, 67, 153.

62. Boston and Sandwich Glass Company (active 1826–88)

Lamp, ca. 1865–75

Sandwich, Massachusetts

Glass, blown, overlaid, frosted, and wheel cut; marble, gilt-bronze, and brass base

42 ⅛ x 7 ¾ (at base) x 9 dia. (with shade) (107 x 19.7 x 22.9 cm)

Gift of Dr. and Mrs. Henry P. Deyerle in memory of Mary Byrd Warwick Deyerle and Evelyn Byrd Deyerle; Bequest of Mr. and Mrs. Edgar G. Gunn; Gift of Mrs. Peter Knowles; Gift of Helen K. Mackintosh in Honor of her Parents, Reverend and Mrs. D.C. Mackintosh; Gift of William B. O'Neal; Gift of Mrs. A. D. Williams; Gift of Mr. and Mrs. A. D. Williams and The Adolph D. and Wilkins C. Williams Collection, by exchange, 2008.1a–e

PROVENANCE: Private collection, New York, N.Y.

A masterful example of nineteenth-century American glassmaking, this monumental lamp rises above a stepped marble pedestal in an elegant succession of cyma, or C-shaped, curves.[1] Founded in 1825, the Boston and Sandwich Glass Company was known by midcentury for its complicated plate-glass wares; by 1875, it could boast this rare and extraordinary object.[2] The pattern of circles and crosses, described in the firm's catalogue as "Cut Punty-and-Diamond-Flint," was rendered from three layers of glass—clear "flint," "Opal," and "Ruby"—each blown successively, one inside the other, prior to molding and cutting.[3] The systematic patterning revealed by the careful carving away of the overlaying pink and white glass is testimony to the cutter's skill (fig. 99).[4] The company employed as many as fifty cutters, whose work was acknowledged to be among the finest examples of cut and ground glass at the 1876 Centennial International Exhibition in Philadelphia.[5] The rich color of the glass in the VMFA lamp—"Ruby Red 1"—was one of the factory's most prized and costly secrets, in part for its use of gold.[6] Probably assembled off the factory premises, the lamp's two parts—the font for kerosene and the "pillar" support—were joined by an internal rod secured to the base and collar beneath the burner's "frosted and bright" cut globe.[7]

As impressive as the lamp's technical excellence may be, it nonetheless pales in comparison to its visual currency.

FIG. 99 Detail of cut glass, cat. no. 62.

Standing three and one-half feet tall, with its splendid marriage of ruby glass, white marble, and gilded brass, the lamp may have been placed beside an organ or piano, its frosted glass protecting the player from glare, or, to ease reading and writing, atop a pier or center table. The latter was a new furniture form intended to facilitate the period's interest in "polite conversation"—a genteel activity induced by illuminated displays of unusual or decorative objects. When lit, the pattern of translucent glass was reflected on surrounding surfaces, creating a dramatic backdrop to elite entertainments,

as suggested by Henry Sargent's painting *The Tea Party* (fig. 100).[8] Its required maintenance only added to the object's exclusivity; the lamp's stunning aesthetic appeal came at the expense of a well-trained servant capable of transporting, cleaning, refilling, and assembling its fragile twenty-six pounds.[9] Such demands help explain its limited production: fewer than a dozen of such scale are known.[10]

As an art historical artifact, the lamp's technical and aesthetic relationship also suggests the period's tensions with encroaching modernity.[11] Reinforced by a post–Civil War

nostalgia for "olden days," a gendered cult of domesticity emerged to temper the implications of industrial "progress."[12] Just as evidence of the lamp's mechanical innovation is physically mitigated by its neo-Gothic presentation, so the authority of an Anglo-American ideal of home and family is reaffirmed through the language of a Gothic Revival style evocative of reassuring Anglican values.[13] Reiterated in horticultural and architectural pattern books by authors like Andrew Jackson Downing and Alexander Jackson Davis, as well as contemporary prescriptive literature by writers such as Catharine E. Beecher and Harriet Beecher Stowe, the ideal of "old-fashioned" domestic comfort and refinement helped middle- and upper-middle-class Americans navigate the changes occurring in everyday life and assimilate their socioeconomic effects into an acceptable narrative of behavior and meaning.[14] SJR

FIG. 100 Henry Sargent (1770–1845), **The Tea Party,** ca. 1824, oil on canvas, 64 ⅜ x 52 ⅜ in. (163.5 x 133 cm). Museum of Fine Arts, Boston, Gift of Mrs. Horatio Appleton Lamb in memory of Mr. and Mrs. Winthrop Sargent, 19.12.

NOTES

1. The marble base and brass collars were likely produced by specialty firms. See Raymond E. Barlow and Joan E. Kaiser, *The Glass Industry in Sandwich* (Windham, N.H.: Barlow-Kaiser, 1989), 2:154–55, 162.

2. The Boston and Sandwich Glass Company was founded in 1825 by Deming Jarves and incorporated a year later. Its wares were sold in Boston, New York, Philadelphia, Baltimore, Chicago, and elsewhere. Kerosene was first introduced in 1854 and became commonplace by the 1860s in nonrural areas. See Ruth Webb Lee, *Sandwich Glass: The History of the Boston and Sandwich Glass Company* (1939; repr., Wellesley Hills, Mass.: Lee Publications, 1966), 106–44; Frederick L. Irwin, *The Story of Sandwich Glass* (Manchester, N.H.: Granite State Press, 1926), 18, 20–47, 56–65, 85–86; Edgar De N. Mayhew and Minor Myers Jr., *A Documentary History of American Interiors: From the Colonial Era to 1915* (New York: Charles Scribner's Sons, 2002), 191.

3. Plates 76–77, reproduced in Barlow and Kaiser, 159–60. "Double-plated"— in which two layers are adhered to the clear flint glass—is the same as "triple-overlay"—three layers adhered together. See Barlow and Kaiser, 195.

4. Irwin, 86–87; Jane Shadel Spillman, *Glass from World's Fairs, 1851–1904* (Corning, N.Y.: Corning Museum of Glass, 1986), 30.

5. James D. McCabe, *Illustrated History of the Centennial Exhibition* (Philadelphia, 1876), cited in Spillman, 30.

6. The colors were formulated by Theodore Kern, foreman of the cutting shop and later superintendent of the glasshouse. See Irwin, 82, 93.

7. The globe is not original to the lamp, but is of a type that would have been available to the client at the time of production. Barlow and Kaiser, 204–5, 211, figs. 2345–2346, 2348, 2365.

8. Kaiser and Barlow, 211, fig. 2365; Jane C. Nylander, *Our Own Snug Fireside: Images of the New England Home, 1760–1860* (1993; New Haven and London: Yale University Press, 1994), 256.

9. It is possible that the font on a lamp of this size, properly weighted by the three-stepped marble base, could be removed for cleaning and refilling without relocating the entire lamp. Barlow and Kaiser, 195, figs. 2357 (208), 2365 (211). For more information about lighting and its usage, see Nylander, 6–9, 112–13; Barlow and Kaiser, 153–54; Richard L. Bushman, *The Refinement of America: Persons, Houses, Cities* (1992; repr., New York: Vintage Books, 1993), 126; John E. Crowley, *The Invention of Comfort: Sensibilities and Design in Early Modern Britain and Early America* (2000; repr., Baltimore and London: Johns Hopkins University Press, 2001), 194; Judith A. Barter, Kimberly Rhodes, and Seth Thayer, *American Arts at the Art Institute of Chicago: From Colonial Times to World War II* (Chicago: Art Institute of Chicago, 1998), 200.

10. Other examples of this monumental type are in the collections of the Art Institute of Chicago, the Corning Museum of Glass, the Detroit Institute of Arts, the Metropolitan Museum of Art, and the Saint Louis Art Museum. See Lee, 101–2, 137; Barlow and Kaiser, 3:34–36; Spillman, 30; Barter, 200.

11. Crowley, 198.

12. Nylander, 5–6; Bushman, 444.

13. The cult of domesticity addressed the threat of modern industrialization by casting the home as a safe haven from outside influences. It idealized interpretations of past "colonial" homes of real (or imagined) grandparents into a new model of comfortable "cottages." At the same time, the home became a feminine realm. The technology of comfort was assimilated into this culture and its instruments were likewise gendered. See Nylander, 3–7, 15; Bushman, 440–42; Crowley, 198, 203–29, 262–89.

14. See Downing, *The Architecture of Country Houses: Including Designs for Cottages, and Farm-Houses and Villas, with Remarks on Interiors, Furniture, and the Best Modes of Warming and Ventilating* (1850); Downing and Davis, *Cottage Residences: or, A Series of Designs for Rural Cottages and Adapted to North America* (1842); Beecher and Stowe, *The American Woman's Home* (1869).

63. Attributed to **Gustave Herter** (1830–1898), designer

Attributed to **Gustave Herter** (active 1858–64) or **Herter Brothers** (active 1864–1906), manufacturer

Sofa, ca. 1860–65

New York, New York

Rosewood, carved, incised, and gilded

41 x 79 x 42 in. (104.1 x 200.6 x 106.6 cm)

Marked: "Mullhussen" in pencil on frame

Museum Purchase, The Adolph D. and Wilkins C. Williams Fund, 89.79

PROVENANCE: Margot Johnson, Inc., New York, N.Y.

This sofa demonstrates the superb skills of sculptor-cabinet-maker Gustave Herter at the height of the midcentury revivalist period. Delicate foliate scrolls sweep along the feet and frame, rising and falling in reticulated waves at the shoulder and neck of the crest rail, while robustly carved sculptural torsos ascend from tapering legs rendered in their entirety from a single block of wood. At the same time, the sofa evokes Germany's guild system and the corps of highly skilled apprentices who trained under its design legacy. The demi-lyre profile (fig. 101), formed of a continuous seat and back that terminates in a volute scroll, recalls the contours of a neoclassical chair published in 1807 by Englishman Thomas Hope.[1] Similarly, while made modern by the addition of a tufted

back and rounded seat, various components—the gilt-incised néo-Grec anthemia (floral forms) that detail the seat frame, the carved classical heads with extended wings that enliven the armrests, and the carved and partially gilded beaded acanthus leaves that embellish the surface of the posts—reflect designs by Hope and others.[2]

Likely part of a suite of furniture intended for the parlor of a well-heeled patron, this sofa exemplifies the output of Herter Brothers in the years preceding Gustave's retirement. By the 1830s matching sofas, side chairs, armchairs, and other pieces were upholstered en suite for arrangement in a single room.[3] Derived from the eclectic French "Renaissance moderne," the neo-Renaissance style blended Italian, Greek, Egyptian, and baroque forms with a portfolio of Second Empire (1852–70) motifs disseminated through printed and visual sources.[4] The sofa's néo-Grec variation was particularly enduring in America, where its archeologically correct form and more restrained and rectilinear features signified ancient virtues appealing to the young democracy.[5]

This sofa compares closely with a documented suite of furniture produced by Herter Brothers about 1860 for the Ruggles S. Morse house in Portland, Maine. A console table in the Morse collection features boldly carved figures bearing well-modeled facial masks akin to the museum's example. But there are also notable differences; against the detailed carving and foliate-scrolled feet of the VMFA sofa, the applied mounts and hooved feet of the Morse sofa appear more directly inspired by the designs of Alexandre-Georges Fourdinois.[6] Fourdinois and his son Henri-Auguste exhibited "Renaissance chairs carved in rosewood, covered in crimson silk damask" at the 1855 Paris Universal Exposition.[7] The design for these chairs was reproduced in John Braund's *Illustrations of Furniture, Candelabra, Musical Instruments from the Great Exhibitions of London and Paris* (1858), one of forty-nine plates advertised for study, duplication, and improvement.[8] From this example, Gustave Herter likely produced the only known sketch for a Herter design (fig. 102), the probable model for the VMFA sofa.

Gustave Herter relocated to New York City in 1848 from Stuttgart, Württemberg, one of many Germans compelled to emigrate following the economic crises of the 1840s.[9] His arrival coincided with New York's ascension as the center of

FIG. 101 Side view, cat. no. 63.

FIG. 102 Gustave Herter (ca. 1830–1898), **Design for a Sofa and Chair,** 1858–64, watercolor on paper, 8 ½ x 14 in. (21.6 x 35.6 cm). Private collection, location unknown.

the American cabinetmaking industry, much of which was situated below Fourteenth Street in Klein-deutschland ("Little Germany").[10] There, he began work as a *bildhauer,* or sculptor, a trade he learned from German masters who had apprenticed during the preceding era's strict guild system. By 1851, however, he was employed as a cabinetmaker. Following a brief association with Auguste Pottier at 48 Mercer Street, he established a partnership with Erastus Bulkley.[11] At the city's Exhibition of the Industry of All Nations, held in 1853, the

Bulkley and Herter firm displayed works characteristic of conservative French cabinetmaking—monumental, sculptural, and historical. Drawing particularly on the example of the senior Fourdinois, these works appealed to the American taste for carved ornament.[12]

In 1858, after purchasing Bulkley's business share, Herter established his own company, becoming a "Manufacturer of Decorative Furniture Also Fittings of Banks & Offices." Six years later, supporting one hundred men and a substantial inventory of largely imported materials, Gustave partnered with his brother, Christian, to form Herter Brothers.[13] Upon Gustave's return to Germany in 1870, Christian assumed responsibility for the business.[14] Then, in 1882, in a decision that likely influenced the artistic career of his son, Albert Herter (fig. 103), Christian retired to Paris and took up painting. Christian Herter died of tuberculosis a year later. The firm continued in operation until 1906. SJR

FIG. 103 Albert Herter (1871–1950), **The Muse**, 1894, oil on canvas, 48 x 24 ¼ in. (121.8 x 61.6 cm). Virginia Museum of Fine Arts, Gift of Jordan-Volpe Gallery, Inc., 92.9.

NOTES

1. Thomas Hope, *Household Furniture and Interior Decoration* (1807; repr., London: John Tiranti, 1937), plate 40, no. 6, plate 59.

2. Hope, plate 19, no. 7 passim; Charles Percier and Pierre Fontaine, *Empire Style-book of Interior Design: All 72 Plates for the "Recueil de decorations interiors,"* with New English Text* (1812; repr., New York: Dover, 1991), plates 15, 33, 60, 63; Owen Jones, *The Grammar of Ornament* (1856; repr. New York: Dover, 1987), plates 16, 18–20, 22.

3. This was to last until the 1870s. Marilynn Johnson, "The Artful Interior," in Doreen Bolger Burke et al., *In Pursuit of Beauty: Americans and the Aesthetic Movement* (New York: Metropolitan Museum of Art, 1986), 137.

4. The designs incorporated forms and ornaments dating from Francis I to the French Revolution (1494–1789). Marc Bascou, "France," in Katherine S. Howe, Alice Cooney Frelinghuysen, and Catherine Hoover Voorsanger, *Herter Brothers: Furniture and Interiors for a Gilded Age* (New York: Abrams in association with the Museum of Fine Arts, Houston, 1994), 30, 32–3; Katharine S. Howe, "Introduction to Herter Brothers," in Howe et al., 40; Hans Ottomeyer, "Germany," in Howe et al., 23–28.

5. Bascou, 33–34.

6. The Morse objects are illustrated in Howe et al., 128–38.

7. Frelinghuysen, "Sofa and Armchair, ca. 1860," in Howe et al., *Herter Brothers,* 132–33, no. 3.

8. Voorsanger, "'Gorgeous Articles of Furniture': Cabinetmaking in the Empire City," in Voorsanger and John K. Howat, eds., *Art and the Empire City: New York, 1825–1861* (New Haven and London: Yale University Press, 2000), 321.

9. Ottomeyer, 26–28.

10. Voorsanger, "From the Bowery to Broadway: The Herter Brothers and the New York Furniture Trade," in Howe et al., 56–58.

11. See cat. no. 70, *Slipper Chair* and cat. no. 74, *Worsham-Rockefeller Bedroom.* Ottomeyer, 22–25; Howe, 36–39; Voorsanger, "From the Bowery to Broadway," 61–63.

12. Ottomeyer, 25–26, 28; Howe, 39–40; Voorsanger, 64.

13. Howe, 40; Voorsanger, 65–67.

14. See cat. no. 75, *Center Table.*

64. Asher B. Durand (1796–1886)

Study for Summer Afternoon (Summer Afternoon), ca. 1865

Oil on canvas

16 ⅝ x 21 in. (39.7 x 53.3 cm)

Signed lower left corner: "A. B. D."

Museum Purchase, The Adolph D. and Wilkins C. Williams Fund, 77.27

PROVENANCE: Benjamin S. Field; Childs Gallery, Boston, Mass.

In his *Study for Summer Afternoon,* Asher B. Durand offers a pastoral ideal.[1] On a warm, still day, cattle amble along a pond's edge. Across the water, the hazy prospect opens up to reveal a distant mountain ridge. Dominating the scene is a copse of immense trees, venerable survivors of a virgin forest that once stood upon a now-domesticated terrain. An identical stand

64

of "noble trees" caught the eye of critic Henry Tuckerman while examining Durand's larger canvas, *Summer Afternoon* (Metropolitan Museum of Art), for which this painting served as an intermediary study. "All Durand's rare faculty appears in the [trees]," he wrote, "which are full of local character." Tuckerman continued:

> [T]he details of the scene are exquisitely true, but the surpassing charm is that the delicate and deep feeling which revives, as we gaze, the absolute sensation, and above all the *sentiment* of nature. . . . this picture has all [of Durand's] most endeared characteristics."[2]

By the mid-1860s Durand was considered a beloved elder statesman of American painting, universally recognized for his distinguished career as a practitioner, theorist, and leader. Alongside Thomas Cole (see cat. no. 37), he was heralded in particular as a founder of the Hudson River school—the landscape movement based in the Northeast that swept American art between 1840 and 1870.[3] As a young artist, however, Durand was slow to embrace this mode of painting. Trained as a printmaker nearly four decades earlier, he first came to prominence for his fine draftsmanship and engraving skills—in evidence in his superb 1835 rendering of *Ariadne* (fig. 104), after the 1812 oil by John Vanderlyn. About the same time, Durand commenced his painting career; his earliest canvases were portraits and genre studies. His friendship with Cole, however, as well as a yearlong European journey during which he studied the work of past masters such as Claude Lorrain, Aelbert Cuyp, and John Constable, triggered an enduring interest in landscape,[4] which intensified after Cole's untimely death in 1848.[5] Thereafter, he easily took his place as America's chief advocate for landscape painting— a role bolstered by his influential position as longtime president of the National Academy of Design (1845–61).

In picturing native terrain, Durand introduced a new approach that mediated between conventional pictorial effects and empirical observation. Previous American landscapists like Thomas Doughty, who produced the lovely yet formulaic *Solitude* (fig. 105) in 1837, turned to drawing books and prints to learn the controlled compositional approaches codified in previous centuries by Claude Lorrain and William Gilpin.

FIG. 104 Asher B. Durand (1796–1886), **Ariadne Asleep on the Island of Naxos,** after John Vanderlyn, 1835, line engraving and etching printed on wove paper, 16 15/16 x 20 1/4 in. (43 x 51.4 cm). Virginia Museum of Fine Arts Purchase, The Adolph D. and Wilkins C. Williams Fund, 87.455.

FIG. 105 Thomas Doughty (1793–1856), **Solitude,** 1837, oil on canvas, 20 x 24 1/4 in. (50.8 x 61.6 cm). Virginia Museum of Fine Arts, Gift of Miss Roberta Trigg, 45.3.1.

Durand, however, became one of the first American painters to practice and popularize painting *en plein air*—that is, painting directly from nature in the open air.[6] He asserted that through the study and depiction of natural scenery, one could find "lessons of high and holy meaning" as well as an enduring source for national pride.[7]

Further inspired by the truth-to-nature imperative that was espoused at midcentury by English theorist John Ruskin, Durand spent two to four months each year on sketching trips to natural areas in New York and New England. On his return to the studio, he converted his field studies—some fully realized small paintings and others highly naturalistic details of specific trees, rocks, and ground foliage—into larger, idealized scenes, many of them infused with lush atmospheric effects. Durand employed this "improving" process from the very inception of the image. John Durand, the artist's son, explained:

> My father's practice was, while faithfully painting what he saw, not to paint all that he saw. Finding trees in groups, he selected one that seemed to him, in age, colour, or form, to be the most characteristic of its species, or, in other words, the most beautiful. In painting its surroundings, he eliminated all shrubs and other trees which interfered with the impression made by this one. Every outdoor study, as well as every pictorial composition, was regarded as a sort of dramatic scene in which a particular tree or aspect of nature may be called the principal figure.[8]

Other painters followed Durand's lead through the subsequent decades, including such accomplished landscapists as Jasper Cropsey, Worthington Whittredge, and Robert Duncanson (see cat. nos. 57, 40, and 42). However, the long-lived painter, age ninety at the time of his death, witnessed the gradual eclipse of the Hudson River school aesthetic.[9] By 1880, younger landscape artists, perceiving the American school's romantic realism as conservative and old-fashioned, began to turn to the sharp naturalism of the British Pre-Raphaelites, the moody tonalism of the French Barbizon style, or the high color and abbreviated brushstrokes of French Impressionism.

ELO

NOTES

1. The VMFA painting is an intermediate study for *A Summer Afternoon* (1865, 22 ⅛ x 35 in., Metropolitan Museum of Art). Durand drew from his field studies to create the composition and then expanded the vista for the larger canvas. The prominent grouping of trees is identical in both paintings. David B. Lawall, *Asher B. Durand, A Documentary Catalogue of the Narrative and Landscape Paintings* (New York: Garland, 1978), 141–42, figs. 141, 141A.

2. Henry T. Tuckerman, *Book of the Artists* (New York: G. P. Putnam and Son, 1867), 195.

3. As the popularity of the romantic landscape movement was fading, the "Hudson River school" label was coined by an art critic as a pejorative term. Linda Ferber, "Asher B. Durand, American Landscape Painter," in *Kindred Spirits: Asher B. Durand and the American Landscape*, exh. cat., ed. Linda S. Ferber (Brooklyn: Brooklyn Museum in association with D. Giles, London, 2007), 195.

4. Barbara Dayer Gallati, "Asher B. Durand's Early Career: A Portrait of the Artist as an Ambitious Man," in *Kindred Spirits*, 67–70; and, also by Gallati, "'A Year of Toilsome Exile,'" in ibid. 95, 97.

5. Durand paid tribute to his late friend in his well-known painting *Kindred Spirits* (1849, Crystal Bridges Museum of American Art). It pictures Cole conversing with poet William Cullen Bryant surrounded by the perfect natural scenery of the Catskill Mountains. Ferber, 154–58.

6. Eleanor Jones Harvey, *The Painted Sketch: American Impressions from Nature, 1830–1880*, exh. cat. (Dallas: Dallas Museum of Art, 1998), 33–36, 128, 133.

7. Asher B. Durand, Letter II, "Letters on Landscape Painting," *Crayon*, originally published 1855, reprinted in *Kindred Spirits*, 235.

8. Ferber, Introduction in John Durand, *The Life and Times of Asher B. Durand* (1894; repr. Hensonville, N.Y.: Black Dome Press, 2007), 188.

9. Ferber, "Asher B. Durand, American Landscape Painter," 195.

65. Edward L. Henry (1841–1919)

The Meeting of General Washington and Rochambeau, 1873

Oil on panel

10 ¾ x 15 in. (27.3 x 38.1 cm)

Signed and dated lower right: "E. L. Henry 1873"

Gift of Mrs. Preston Davie, 60.52.7

PROVENANCE: W. H. Raynor (1874); Eugénie Ladenburg Davie (Mrs. Preston Davie), New York, N.Y. (1960)

In a 1906 tribute, *American Art News* summed up the long career of Edward Lamson Henry:

> He is really the art historian of American early life and customs, for his pictures have had for their subjects the life of the United States during the late 18th and early 19th centuries. To the depiction of these scenes and times, their quaintness of custom and costume, Mr. Henry has given a life of persevering study and research.[1]

65

The emphasis on his efforts in documenting the past—rather than on his painting style and skill—would not have displeased Henry. Over time, he remained steadfast in his dedication to the production of vignettes of bygone eras. In 1870 Henry wrote to a friend of his recent accomplishments, including his election to associate member in the National Academy of Design.[2] "Oh!" he added, "I never thought to write before that my great reputation, my stock in trade, is that of an Antiquarian."[3]

Henry's fascination with the past began during the Civil War. Serving as a civilian clerk on a quartermaster's transport ship, the young artist traveled in 1864 to the Virginia front, where he sketched captured colonial plantation houses along the James River.[4] In his New York studio the following year, he produced *Westover, Virginia* (Century Association). While the image documents Union encampments and war damage at the historic eighteenth-century estate, it still celebrates the lingering grandeur of the Georgian manor house.[5] The painting marked the beginning of Henry's lifelong passion for picturing period architecture. To this interest he added a love for depicting antique relics—costumes, furnishings, artifacts, and carriages—many from his own growing collection. His life's work would result in hundreds of images of picturesque country cottages, farmhouses, train stations, and town squares.

The years surrounding the celebration of the nation's centennial in 1876 brought mounting public enthusiasm for images of historic events, sites, and figures. Already fully engaged in various architectural preservation efforts and the staging of costumed *tableaux vivants,* Henry was well positioned to ride this first full surge of Colonial Revival fervor. He folded a few scenes from the Revolutionary War into his retrospective imagery, and for this, his thoughts returned to Virginia.[6]

Henry situates *The Meeting of General Washington and Rochambeau* in the broad entryway of a Virginia plantation manor. Washington, unmistakable at center in his blue and buff uniform with epaulets, pauses with another officer outside a drawing room door.[7] Distinctive in their red tunics are a bewigged British officer—his hand extended in greeting—and his saluting aide. The additional American soldiers gathered at left, as well as a blue-coated picket standing guard outside, suggest that this event is set sometime after the surrender of British forces at Yorktown. Despite Henry's title, original to the canvas, the image has less to do with Washington and the Comte de Rochambeau, commander of the French forces at Yorktown, than with the American general's formal call on a newly captured Lord Charles Cornwallis.[8]

Beneath a broad, proscenium-like arch, the figures are staged within an interior that is a pastiche of many of the artist's favorite colonial features and furnishings. The grand setting is imaginary. While historical accounts describe a few postsurrender meetings between opposing commanders, none was set in a location that matches this floor plan or scale.[9] Nor did the artist have an opportunity to explore and sketch

FIG. 106 Frances Benjamin Johnston (1864–1952), **Toddsbury, Interior,** ca. 1930–36, gelatin-silver print photograph, 17 x 19⅞ in. (43.2 x 50.5 cm). Virginia Museum of Fine Arts, Gift of the Carnegie Corporation, 36.10.6.

the interiors of Tidewater manor houses during his brief sojourn to battle-worn Virginia.[10] A preliminary unpopulated study for the painting, simply titled *Doorway* (New York State Museum), reveals Henry's careful sketch of the wide hall, paneled wainscoting, and gracious trilevel stairway.[11] A survey of the artist's other painted interiors indicates that his primary architectural source was the federal-era front hall of a friend's Philadelphia townhome—broadened for this painting by nearly half. Henry had documented the accurate dimensions of that residence six years earlier in *The Old Clock on the Stairs*

(1868, Shelburne Museum). For both paintings, inspiration for the prominent placement of a tall clock on the stair landing—a mid-nineteenth-century fashion rather than a colonial one—was a sentimental poem of the same title by Henry Wadsworth Longfellow about a timepiece "halfway up the stairs" that stands witness to the poignant passages in a family's life.[12]

The Colonial Revival—for which Henry was an enthusiastic proponent—flourished between the 1870s and 1940s. American fine and decorative artists, architects, musicians, writers, playwrights, and photographers (fig. 106) adopted the themes and motifs of early America. Portrayals of George

FIG. 107 Wallace Nutting (1861–1941), **Fan-Back Armchair,** after 1917, hardwoods, pine (secondary wood), 46 ¾ x 26 ½ x 23 in. (118.8 x 67.3 x 58.5 cm). Virginia Museum of Fine Arts, Bequest of John C. and Florence S. Goddin, by exchange, 92.166.

Washington, whose likeness had never fallen out of favor (see cat. nos. 50–53), graced all manner of products, from oil paintings and prints to fabrics and advertisements for insurance policies. The early twentieth century brought the restoration, at times re-creation, of entire colonial villages

across the country—Colonial Williamsburg being among the most ambitious of these projects. Popular nostalgia also launched the mass manufacture of early-style furniture, from the simple oak interpretations of Gustav Stickley (see fig. 178) to the near-faithful reproductions of Wallace Nutting (fig. 107).

The "Quest for the Quaint" had its basis in the celebration of the founding of the nation and its Anglo-Saxon Protestant forebears. It was also fueled, in part, by growing reaction against a rising tide of immigrants, anxiety about the African American population as it sought a place in free society, and a response to urbanization and modernization.[13] By adhering to retrospective subjects, rendered in the tightly detailed style of an earlier generation of genre painters, Henry also resisted such influential waves of artistic change as Aestheticism, impressionism, and modernism. Positioned in the early twentieth century as a dean of the conservative art establishment, his final critics respectfully acknowledged his retrospective approach and role as pictorial historian. "Too full of precision and detail to suit the tastes of the moment," offered a reviewer in 1919. At the same time, she added, his paintings "are the best of their kind."[14] ELO

NOTES
1. Cited in Elizabeth McCausland, "The Life and Work of Edward Lamson Henry, N.A., 1841–1919," *New York State Museum Bulletin,* no. 339 (September 1945), 67.
2. Henry received formal art instruction at the Pennsylvania Academy of the Fine Arts in the late 1850s. From 1861 to 1863, he studied abroad with Paul Weber, Charles Glyre, and Gustav Courbet. McCausland, 26–28.
3. Henry to Edward V. Valentine, September 21, 1870, Valentine Richmond History Center (VRHC) archives, Richmond, Virginia. Valentine was a sculptor living in Richmond.
4. In a letter to Valentine, Henry writes, "I was there Nov. 1864 on U.S. transport just to see what I could see and though I longed to see Richmond, you fellows wouldn't let anyone, you were so selfish, but I made numbers of sketches up and down the River . . . so my trip was very profitable." He adds, "When I go down to Richmond I shall expect you to tell me all the old places worth seeing in the Antique line." September 21, 1870, VRHC archives.
5. Amy Kurtz, *Historical Fictions: Edward Lamson Henry's Paintings of Past and Present* (New Haven: Yale University Art Gallery, 2005), 2–4, fig. 1. Another version, *The Old Westover House,* 1870, is in the collection of the Corcoran Gallery of Art.
6. Others from this period include *Independence Hall* (1871), *Lady Ferguson Sending a Letter to Gen. Joseph Reed* (1871), and *Reception Given to Lafayette* (1874).
7. The model for Washington's colleague (Rochambeau?) may have been Henry himself. Amy Kurtz discusses the artist's collection of tintypes picturing him in various poses and costumes. She illustrates one (New York State Museum) taken close to the time of this painting, which shows Henry in a similar three-quarter pose, back toward camera, and wearing a military coat. Kurtz, 21, fig. 18.

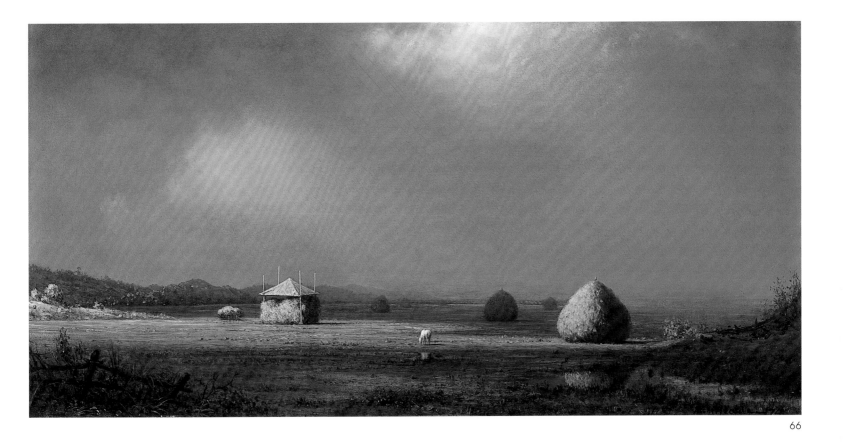

8. Henry used this title when exhibiting the painting at the National Academy of Design in 1874. Maria Naylor, ed., *The National Academy of Design Exhibition Record, 1861–1900* (New York: Kennedy Galleries, 1973), 425. In 1961, while reconciling the image with historical events, VMFA curator Pinkney Near renamed the canvas *George Washington and General Rochambeau Calling on Cornwallis at Nelson House, Yorktown.* The original title has since been restored.

9. "Diary of General David Cobb," *Proceedings of the Massachusetts Historical Society* 19 (1881–82): 69–70; author's correspondence with Diane K. Depew, Supervisory Park Ranger, Colonial National Historical Park, Yorktown, Virginia, February 7–8, 2006. I thank Dennis Halloran for sharing findings of his careful review of floor plans and features of relevant Virginia manor houses.

10. In her biographical accounting of her late husband's career, Frances Henry noted that following an incident in which a Union soldier reprimanded Henry for sketching military sites on land, "he did his drawings on deck afterwards." Frances L. Henry, "A Memorial Sketch: E. L. Henry, N.A., His Life and His Life Work," *New York State Museum Bulletin,* 339 (September 1945), 319.

11. McCausland, 242, no. 1020; illus. 307, fig. 222.

12. Henry Wadsworth Longfellow's "Old Clock on the Stairs" was published in 1845. For an illustration of Henry's painting of the same name and an exploration of possible significance of the poem for the artist, see Kurtz, 34–39, fig. 28.

13. Alan Axelrod, ed., *The Colonial Revival in America* (New York and London: W. W. Norton, 1985), 10–14; Kurtz, 14, 22–29.

14. McCausland, 117.

66. Martin Johnson Heade (1819–1904)

A Cloudy Day, 1874

Oil on canvas

14 ⅛ x 30 in. (35.6 x 76.2 cm)

Signed lower right: "M. J. Heade 1874"

Museum Purchase, The Adolph D. and Wilkins C. Williams Fund, 77.24

PROVENANCE: Doll and Richards gallery, Boston, Mass. (1879); Child's Gallery, Boston, Mass. (1972); Samuel M. Robbins, West Newton, Mass.; Coe Kerr Gallery, New York, N.Y. (1977)

Martin Johnson Heade, a largely self-taught artist from Bucks County, Pennsylvania, found his subject in the flatly expansive salt marsh landscapes of the East Coast. His interest in unspecified locales—the artist painted such images from Massachusetts to Florida—set him apart from his contemporaries' pursuit of inherently marketable, recognizable vistas.

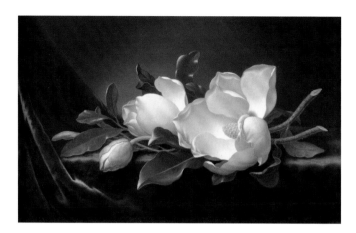

FIG. 108 Martin Johnson Heade (1819–1904), **Two Magnolias and a Bud on Teal Velvet,** ca. 1890, oil on canvas, 15 x 24 in. (38.1 x 61 cm). Collection of James W. and Frances G. McGlothlin, Promised Gift to Virginia Museum of Fine Arts.

Heade was more fascinated with the evocative effects of light and atmosphere, qualities that he emphasized in his distinctly horizontal compositions of striking simplicity and intensity.[1]

The artist produced different pictorial series throughout his career—from marsh scenes, numbering more than 120, to close-up floral still lifes (fig. 108) and naturalist views of tropical orchids and hummingbirds. His attraction to the marsh, as Theodore Stebbins notes, may have stemmed from the subject's relative novelty in American art, even if rendered more familiar through Heade's own repeated variations. While other artists had begun to treat the subject around the same time as he—perhaps following the lead of writers such as James Russell Lowell and Henry David Thoreau who described the marsh as a kind of American paradise—none embraced it as repeatedly, or even obsessively. Heade painted his first marsh scene in 1859, his last in 1904, the year of his death. The practice became one of the few constants for a peripatetic figure who traveled widely throughout his life in search of pictorial subjects.[2]

As Stebbins has observed, Heade celebrated the marsh as the embodiment of both pristine and cultivated land, a place for leisure and labor that resonated for a lifelong hunter and naturalist reared in a rural setting. A mid-nineteenth-century artist poised between the Hudson River school generation and the more progressive Barbizon-inspired

tonalists, Heade learned from both to render his heightened realism with looser brushwork and a quieter sensibility. Similarly, as a quintessentially hybrid subject, the marsh fused the wilderness and pastoral genres of landscape painting, producing an alternative to the Anglo-American picturesque aesthetic. In this context, the artist and subject were well matched.[3]

Painted after Heade's 1866 move from New England to New York, *A Cloudy Day* likely depicts the marshes of Hoboken, New Jersey, across the Hudson River from Manhattan, though it may be a composite view of the artist's memories of Newburyport, Massachusetts, or Newport, Rhode Island. Like most of his later marsh subjects, it features a limited range of pictorial elements—sky, clouds, ground, haystacks—painted in subtle gradations of gray green tinged with silver and arranged in a meticulous planar structure. A single grazing white horse in the center of the composition—highlighted by glints of sunshine—takes the place of any substantial human activity, which is merely implied by the stacked hay. And unlike earlier versions, the watery presence is negligible, with only a hint of the salt marsh indicated at lower right.[4]

Heade's marsh scenes, with their dominating, vaporous skies and fleeting atmospheric effects, have generally been interpreted as placid evocations of the slower rhythms of nature and nineteenth-century agrarian life. Yet their disquieting stillness, polish, and precision, retrospectively labeled "luminist," proved to be more appealing to modernist than to Victorian sensibilities. Indeed, the popularity of Heade's marsh pictures—so domestic in both subject and scale—has yet to cease since the time of their first reemergence in the 1940s.[5]

John Wilmerding has remarked that the marsh, with its tidal rivers, is "the one landscape in constant flux."[6] Perhaps with this understanding, Heade returned to the subject again in the late 1860s and 1870s as a way to capture America's post–Civil War transitional mood. The VMFA version—originally purchased out of an 1879 exhibition at the artist's Boston dealer, Doll and Richards—reveals the currency of Heade's landscape vision in the Reconstruction years, when the healing promise of peace and prosperity loomed large.

SY

NOTES

1. Little detailed information is known of Heade's biography, but the bare outlines include early training in portraiture with his Bucks County neighbor Edward Hicks, the Quaker minister and self-taught artist. Heade began painting landscapes in the mid-1850s, traveled extensively throughout New England, Europe, and South America, and then settled in Saint Augustine, Florida, where he was supported by oil tycoon Henry Morrison Flagler. Having only enjoyed modest success in his lifetime, Heade died in relative obscurity. For a comprehensive examination of the artist, see Theodore E. Stebbins Jr., *The Life and Work of Martin Johnson Heade: A Critical Analysis and Catalogue Raisonné* (New Haven and London: Yale University Press, 2000). See also Stebbins, *Martin Johnson Heade*, exh. cat. (Boston: Museum of Fine Arts and Yale University Press, 1999) and Sarah Cash, *Ominous Hush: The Thunderstorm Paintings of Martin Johnson Heade*, exh. cat. (Fort Worth: Amon Carter Museum, 1994).

2. See Stebbins, *Life and Work of Martin Johson Heade*, 116–17, and Stebbins, *Martin Johnson Heade*, 29–31.

3. Stebbins, *Life and Work of Martin Johson Heade*, 116–17; Stebbins, *Martin Johnson Heade*, 29–31. See also David Cameron Miller, *Dark Eden: The Swamp in Nineteenth-Century American Culture* (Cambridge: Cambridge University Press, 1989).

4. Regarding the work's depicted location, see correspondence, Theodore Stebbins (curator of American painting, Museum of Fine Arts, Boston) to Franklin Kelly (VMFA curatorial assistant), October 6, 1977, VMFA curatorial files.

5. For the arc of Heade's career, see Stebbins, "Picturing Heade: The Painter and His Critics," in *Martin Johnson Heade*, 141–67.

6. Quoted in Stebbins, *Martin Johnson Heade*, 31.

67. Thomas Eakins (1844–1916)

The Artist and His Father Hunting Reed-Birds on the Cohansey Marshes, ca. 1874

Oil on canvas laid on composition board

17⅛ x 26½ in. (43.5 x 67.3 cm)

Gift of Mr. and Mrs. Paul Mellon, 85.638

PROVENANCE: Susan Macdowell Eakins, Philadelphia, Pa.; Roland J. McKinney, Los Angeles, Calif.; Knoedler and Company, New York, N.Y. (1955); Paul Mellon, Upperville, Va. (1961)

The interpretation of Thomas Eakins's sporting pictures has undergone a veritable renaissance since their early reception as straightforward depictions of contemporary leisure in late-nineteenth-century America. Ranging from the formal and technical to the sociohistorical and psychobiographical, different interpretive lenses have yielded new thinking about these exacting genre scenes by the celebrated Philadelphia realist.[1]

Like the rowing pictures that preceded it, VMFA's painting of the artist and his father hunting sora rail (marsh birds once prized as fine game delicacies) belongs to a series of works that derived from Eakins's personal experience with a sport long popular with Philadelphians. The Eakins family had at their disposal a "Fishouse" in Fairton, New Jersey, about forty miles south of their native city, where the Cohansey and Delaware rivers merge. For a few weeks each fall, the family retreated to the rural site for various outdoor activities—fishing, hunting, sailing, swimming—a practice the artist continued until his seventieth year.[2] While Eakins relished the strenuous outdoor life, he also welcomed the opportunity it afforded to study "the color and character of the scene" and to continue his experiments with plein-air painting and perspectival strategies first explored during his European training.[3]

He began the Delaware River series in 1873, producing numerous studies before contracting malaria while hunting in the mosquito-infested marshes. The first fully executed image to result from this period of work and convalescence was a composition now known as *Starting Out After Rail* (Museum of Fine Arts, Boston), which Eakins likely completed in oil in late 1873 and in watercolor in early 1874. As art historian Kathleen Foster has argued, *The Artist and His Father Hunting Reed-Birds on the Cohansey Marshes* may be viewed as a "narrative pendant" to this earlier work in its depiction of the actual hunt underway amid the reddish golden glow of twilight.[4]

It is believed that Eakins sent both paintings—so different in mood and format—to the Paris Salon of 1874 on the advice of his former teacher Jean-Leon Gérôme. Eakins wrote to Gérôme, another avid sportsman, about the pictorial challenges of the scenes, particularly his frustration with maintaining consistent outdoor color and light effects while working in the studio from the memory of earlier "impressions." Eakins's hunting paintings attracted a good deal of attention from French critics, who found them relatively "exotic"—that is, singularly American. One described them as "mighty strange" works of "genuine precision . . . rendered in a way that is photographic." Another pondered whether they were "specimens of a still secret industrial process."[5]

The writers' emphasis on the exactitude of the images must have pleased Eakins, who approached all of his paintings in these years with a premeditated, almost mechanized deliberateness. Eakins's own scientific method—encompassing an emphasis on anatomical accuracy gained from medical study as well as the use of newer tools, like photography—is fully

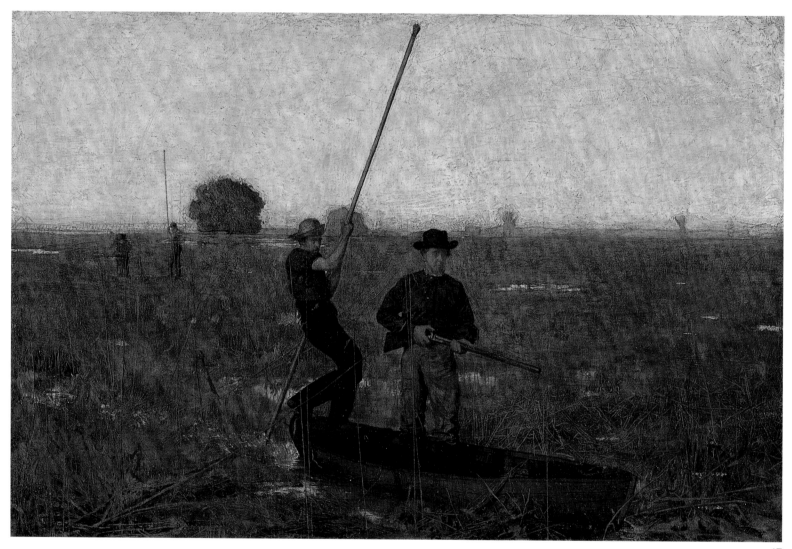

67

apparent in his boating scenes and distinguishes them from popular sporting imagery of the time (fig. 109) in both technique and tone.

As Douglass Paschall has argued, Eakins learned from Gérôme at the École des Beaux Arts to think of paintings as "accretions, as collections of parts to be worked up in succession from sketches, memory, and life study." By 1874 Eakins began to embrace photography as a means to an end in his quest to render a scene as accurately as possible, at times even projecting and tracing images on his canvases with a so-called magic lantern. This approach endows certain of his compositions with a synthetic rather than a naturalistic feel,

FIG. 109 Frances (Fanny) Flora Bond Palmer (1812–1876), **Rail Shooting on the Delaware,** 1852, hand-colored lithograph, published by Nathaniel Currier, 22½ x 28 in. (57.2 x 71.1 cm). Virginia Museum of Fine Arts, Gift of the Honorable David K. E. Bruce, 53.28.1.

as if stitched together from quick graphic sketches, painstaking perspectival drawings, photographs, and tonal oil studies—which, in fact, many were.[6]

This rigorous method may account for the disjointed quality of *The Artist and His Father*—especially evident in the relationship of foreground to background as well as between the two protagonists. Here, Benjamin Eakins and his son, who appear at a distance in *Starting Out After Rail,* are positioned front and center, nestled in the stark planar marsh. While the gun-toting father should represent the more commanding character in the scene, the son, holding an impossibly long pole that nearly bisects the composition, actually draws

greater attention in a more animated and off-balance position at a slightly higher vantage point. The overall stillness of the work, which shares some of the hushed qualities of Martin Johnson Heade's contemporary marsh landscapes (see cat. no. 66), unwittingly emphasizes the awkward disconnection between father and son, one that Henry Adams has interpreted as a menacing sign of oedipal conflict.[7]

Marking the significance of this first portrayal of his father in an outdoor subject, Eakins inscribed in Latin across the boat's bow: *BENJAMINI EAKINS FILIUS PINXIT* (painted by the son of Benjamin Eakins). This self-referential inscription of filial respect, which, as Alan Braddock notes, only indirectly identifies Eakins as the painter, emphasizes his dual role as "participant-observer"—one who is skilled in both painting and poling.[8]

In this work, Eakins paid tribute to his father (with whom he shared lifelong interests) and the lessons of childhood by emphasizing the skillful teamwork required by the poler and shooter in the hunting of rail, a difficult sport that demanded physical and mental agility from both participants. This united purpose of father and son, or teacher and student, foreshadows Eakins's more ambitious *The Gross Clinic,* begun in 1875, a challenging painting that marked an end to his outdoor genre scenes and a new emphasis on the heroic portraiture that would define his controversial career. SY

NOTES

1. Relevant texts include Kathleen Foster's comprehensive examination of Eakins's "boating scenes" in terms of his working methods in *Thomas Eakins Rediscovered: Charles Bregler's Thomas Eakins Collection at the Pennsylvania Academy of the Fine Arts* (New Haven and London: Yale University Press, 1997), 131–43. See also W. Douglass Paschall, "The Camera Artist," in *Thomas Eakins: American Realist,* exh. cat. (Philadelphia Museum of Art, 2001), 241–42. Readings of the paintings in psychobiographical terms, specifically regarding the father-son relationship and issues of masculinity, include Henry Adams, *Eakins Revealed: The Secret Life of an American Artist* (New York: Oxford University Press, 2005), 185–91, and Martin Berger, *Man Made: Thomas Eakins and the Construction of Gilded Age Manhood* (Berkeley, Los Angeles, and London: University of California Press, 2000), 27–30. Finally, an ethnographic framework for the hunting series is offered by Alan C. Braddock in "Eakins, Race and Ethnographic Ambivalence," *Winterthur Portfolio* 33 (Summer–Autumn, 1998): 139–40, 148–53.
2. Foster, 131, 134.
3. Ibid., 131.
4. Ibid., 134.
5. Ibid., 135–36, 263n16; *L'Art* 2 (1875): 276, cited in Braddock, 148. See also F. De Laenevais's response in the *Revue des Deux Mondes,* excerpted in Natalie Spassky, *American Paintings in the Metropolitan Museum of Art,* vol. 2, *A Catalogue of Works by Artists Born between 1816 and 1845* (New York: Metropolitan

Museum of Art in association with Princeton University Press, 1985), 595.

6. Paschall, 241–42.

7. Adams, 187. For a different perspective on Eakins's relationship with his father, defined by mutual respect and love, see Amy Werbel, *Thomas Eakins: Art, Medicine, and Sexuality in Nineteenth-Century Philadelphia* (New Haven and London: Yale University Press, 2007), 150–56.

8. Braddock, 152.

68. George Inness (1825–1894)

Stone Pines (Pine Grove, Barberini Villa, Albano, Italy), 1874

Oil on canvas

30 ¼ x 45 ⅜ in. (76.8 x 115.2 cm)

Signed and dated lower left: "G. Inness Paris 1874"

Gift of the Commonwealth of Virginia, 44.16.1

PROVENANCE: Possibly Doll and Richards gallery, Boston, Mass.; possibly sale, "Third Special Sale: George Inness, Paintings," Leonard and Company, Auctioneers, Boston, Mass. (December 13, 1876, lot no. 4); Mrs. William H. Jackson, Long Island, N.Y. (until 1941); M. Knoedler and Company, New York, N.Y. (1941–42); John Levy Galleries, New York, N.Y. (1942); William Macbeth Galleries, New York, N.Y. (1942–44)

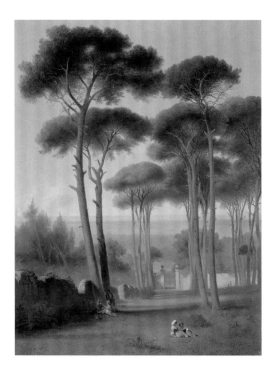

FIG. 110 John Gadsby Chapman (1808–1889), **Pines of the Villa Barberini,** 1856, oil on canvas, 27 x 21 in. (68.58 x 53.34 cm). Museum of Fine Arts, Boston, Gift of Martha C. Karolik for the M. and M. Karolik Collection of American Paintings, 1815–65, 47.1247.

Few landscapists have played such a significant transitional role in American painting as has George Inness. The New York native began his artistic career in the style of the established Hudson River school painters. Indeed, many of the movement's major figures, including Frederic Church and Jasper Cropsey, were his contemporaries (see cat. nos. 56 and 57). Yet, in the second half of the nineteenth century, Inness forged a new direction.[1] Influenced by French artistic currents of the time as well as the development of his own increasingly spiritual view of the world, he turned away from straightforward naturalism and embraced a more expressive, painterly approach in his work. As a result, images such as his powerful *Stone Pines* possess, in the artist's words, "both the subjective sentiment—the poetry of nature—and the objective fact."[2]

During an extended stay in Italy in the early 1870s, Inness sketched and painted the umbrella-shaped stone pines at several locations. This particular stand of trees in the countryside south of Rome offered exceptional visual and historical appeal.[3] The foliage towered above an ancient olive grove and rock wall at the Villa Barberini, adjacent to the lake town of Albano and the papal villa at Castel Gandolfo. Planted in pairs generations earlier, these lofty pines had drawn the attention of other painters—including Virginia-born John Gadsby Chapman, who completed a picturesque composition in 1856 (fig. 110). Inness, for his part, chose to represent the scene in a less conventional manner. His vista includes a glimpse of a ruin at distant left—the so-called Tomb of Pompey—that stands near the Appian Way. But the painter veiled this landmark, as well as the unusual formation of the pines, under the indistinct haze of twilight. Against a luminous golden sky striated with a band of cream and tinted with pale blue, apricot, and lavender gray, Inness defined the dark contours of the grove. He articulated the silhouettes of a few individual trees; the others he painted with flat passages of dark brown and green, merging them into a dense contiguous mass that both entices with its promise of shelter and deters with its mysterious inky shadows. In the foreground—nearly imperceptible in dusk's half-light and diminutive against the giant pines— a shepherd drives his flock homeward. Their diffuse shapes echo the low brambles and occasional fieldstones lit by stray glints of the setting sun.

68

By employing flattened forms, evocative lighting, and softened details—all laid down with the loose brushwork that characterizes Inness's mature style—the artist captured more than the terrain and features of a particular scene. His critical exposure in the early 1850s to the work of Théodore Rousseau and other French artists who painted near the village of Barbizon encouraged Inness to convey his personal response to nature through art.[4] In the following decade, his search for subjective expression gained momentum when he adopted the religious philosophy of eighteenth-century Swedish visionary Emanuel Swedenborg, which held that all material things have a corresponding spiritual essence. Aligning artistic practice with religious conviction, Inness sought to depict the "inner life" of his subjects through a freer use of color and form while cultivating his own spirituality in the process.[5]

In his search for universal correspondences, the painter also increasingly looked for evidence of geometric and mathematical expressions in nature. The exceedingly careful composition of *Stone Pines*—with its rhythmic ordering of trees to form a bold diagonal and the careful bifurcation of heaven and earth—suggests Inness's efforts to evoke natural order and unity.[6] Furthermore, while the artist's landscapes rarely exhibit overtly religious content, his metaphysical views seem manifest in this canvas, with its unusually vivid coloration and sharp contrasts, as well as the presence of a good shepherd who leads his flock through the transitory boundary between light and dark.[7]

Initially, Inness's turn toward a more suggestive interpretation of landscape garnered an unenthusiastic response from his American peers, many of whom were either upholding the midcentury naturalism of the Hudson River school style or embracing the meticulous literalism of the American Pre-Raphaelites, who were inspired by the writings of English art theorist John Ruskin (see cat. no. 86). "Inness, in his best moods," wrote Henry Tuckerman in 1867, "is effective through his freedom and boldness, whereby he often grasps the truth with refreshing power; [but] sometimes this manner overleaps the modesty of nature, and license takes the place of freedom; . . . too much of the French style is often complained of."[8] By the late 1870s, however, Inness gained steady patronage from wealthy Americans who were developing a near-insatiable appetite for French Barbizon paintings. Moreover,

the artist found a new, appreciative audience among the increasing number of European-trained American artists who favored a direct, freer application of paint. In 1878, Inness joined this younger generation as a founding member of the Society of American Artists, a progressive organization that championed new cosmopolitan approaches.[9]

Toward the end of his life in the early 1890s, Inness was heralded as one of the nation's artistic pathfinders.[10] His paintings, which had become even more atmospheric and imbued with mood, inspired others to experiment with subtle color relationships and ambiguous forms. Many of them, including tonalists Dwight Tryon, Alexander Wyant, and Charles Warren Eaton (see fig. 176), would further the stylistic trend toward a more muted, poetic form of painting by the century's end.[11]

ELO

NOTES

1. A teenage Inness first trained with an itinerant painter in Newark, New Jersey, and then relocated to New York City, where he apprenticed as an engraver and studied painting with French-born Régis François Gignoux. He established a professional studio in 1845. For consideration of the artist's early career, see Nicolai Cikovsky Jr., *George Inness* (New York: Abrams in association with the National Museum of American Art, Smithsonian Institution, 1993), 9–15.

2. Letter from Inness to Ripley Hitchcock, March 23, 1884, Montclair Art Museum Archives, reprinted in *George Inness: Writings and Reflections on Art and Philosophy*, ed. Adrienne Baxter Bell (New York: George Braziller, 2006), 128–30.

3. This was Inness's third visit to Europe. Working from his Italian field sketches, he painted this canvas during a stay in Paris before returning to the United States in early 1875. Closely related paintings include *Pines and Olives at Albano (The Monk)* (1873, Phillips Academy, Andover, Massachusetts) and *Pine Grove of the Barberini Villa, Albano* (1876, Metropolitan Museum of Art). See Michael Quick, *George Inness, A Catalogue Raisonné* (New Brunswick, N.J., and London: Rutgers University Press, 2007), cat. nos. 426, 495 (VMFA's painting), and 556.

4. Cikovsky, 29–30.

5. Inness first came to Swedenborgianism during his 1863–64 residency at the Eaglewood art colony in Perth Amboy, New Jersey. For an examination of the influence of this religious philosophy, see Cikovsky, 56–58; Sally M. Promey, "The Ribband of Faith: George Inness, Color Theory, and the Swedenborgian Church," *American Art Journal* 26 (1994): 45–65; and Adrienne Baxter Bell, *George Inness and the Visionary Landscape* (New York: National Academy of Design; New York: George Braziller, 2003), 29–35.

6. Rachael Ziady DeLue, *George Inness and the Science of Landscape* (Chicago and London: University of Chicago Press, 2004), 174–78.

7. Cikovsky, 54, 78, 107–8, 115–17.

8. Henry T. Tuckerman, *Book of the Artists*, (1867; repr., New York: James F. Carr, 1966), 527.

9. Peter Bermingham, *American Art in the Barbizon Mood*, exh. cat. (Washington, D.C.: Smithsonian Institution Press for the National Collection of Fine Arts, 1975), 35–36, 55, 70–73. Inness was in Paris at the time of the first exhibition of the French impressionists, but there is no evidence that he attended or took notice of it. He later rejected comparisons of his work with theirs, dismissing impressionism as a fad. Cikovsky, 64–65.

10. Cikovsky, 89, 91–92. At the turn of the century, Charles Caffin's book about the most influential American artists of the previous fifty years opens with an appreciation of Inness. Charles H. Caffin, *American Masters of Painting* (New York: Doubleday, Page, 1902), 3–15.

11. For the development of tonalism as a stylistic movement, see Wanda M. Corn, *The Color of Mood: American Tonalism, 1880–1910* (San Francisco: M. H. de Young Memorial Museum, 1972) and Marc Simpson et al., *Like Breath on Glass: Whistler, Inness, and the Art of Painting Softly* (New Haven and London: Yale University Press, 2008).

69. Jervis McEntee (1828–1891)

Natural Bridge, 1877

Oil on board
7 ⅛ x 5 in. (18.1 x 12.7 cm)
Signed lower left: "JMcE"
Museum Purchase, The John Barton Payne Fund, 2008.38

PROVENANCE: By descent through the family of the artist

In the summer of 1877, Jervis McEntee spent an afternoon at Natural Bridge in Rockbridge County, Virginia. A disciplined painter and diarist, the prominent New York artist produced two records of his visit to the famous geological site. From the base of the massive limestone arch, he painted this appealing oil study.[1] In days to follow, he also penned an entry in his journal:

> Wednesday, July 5, 1877—Arrived at Richmond after a pleasant passage on Monday morning 9th and took Chesapeake and Ohio R. R. via Gordonsville, Charlottesville & Staunton to White Sulphur Springs. . . . We left 23rd for Goshen and made a trip to the Natural Bridge through Lexington. Staid there over one day and made a sketch of it. Found it very interesting and impressive.[2]

McEntee joined a long, distinguished line of writers and artists who visited the Virginia landmark and attempted to capture its awesome grandeur through words or image. With a span of 90 feet and a height that soars 240 feet above a creek bed, Natural Bridge was carved from rock by water hundreds of millions of years earlier. At the time of the English landfall at Jamestown, the stone arch was sacred to the Monacan Indians. In 1750, a young George Washington surveyed the site, which Thomas Jefferson later purchased on the eve of the

Revolutionary War. In his *Notes on the State of Virginia* (1785), Jefferson described Natural Bridge as "the most sublime of nature's work," frightening when experienced from the top but from below, "delightful in an equal extreme so beautiful an arch, so elevated, so light, and springing as it were up to heaven, the rapture of the spectator is really indescribable!"[3]

By the turn of the nineteenth century, Natural Bridge figured prominently in travel literature and images of America. European artists, including Jefferson's friend the Marquis de Chastellux, were the first to portray the distinctive formation in prints and book illustrations. By the 1830s, depictions by American artists helped secure Natural Bridge's reputation as the southern counterpart to the wondrous Niagara Falls.[4] At midcentury, the site was so well known that Herman Melville, in his 1851 novel *Moby-Dick,* described the "whole marbleized body" of the elusive white whale rising from the water in "a high arch, like Virginia's Natural Bridge."[5] The same year, Frederic Church, one of the foremost Hudson River school painters (see cat. no. 56), journeyed to Virginia to make his own sketches of the landmark. His *Natural Bridge, Virginia* (University of Virginia Art Museum) drew praise at the 1852 Royal Academy exhibition in London.[6] A decade later in the United States, images of the celebrated rock formation were available to middle-class patrons through lithographic prints published by Currier and Ives (fig. 111).

As a student of Church, McEntee would have certainly recalled his mentor's painting when he made his own journey to the site in the 1870s.[7] Working in the open air on a small section of academy board, McEntee pictured Natural Bridge from a similar southern vantage point, just as the afternoon light illuminated its top ridge. Supported by tall, shadowy parapets and topped with a fringe of trees and brush, the sunstruck crest is articulated in warm tones of ocher and peach. It glows brightly against a deep gray-violet sky.

McEntee, born and raised on the banks of the Hudson River, came of age during the zenith of America's nineteenth-century landscape movement. In a romantic era when nature was linked to both nation and God, images of the land took on new associative meanings.[8] As he developed his skills as a landscapist, McEntee became a trusted friend and traveling companion to many of the movement's key practitioners, including Church, Sanford Gifford, Albert Bierstadt, and

69

Worthington Whittredge (see cat. 40). Enjoying a long, productive career at the center of the New York art scene, he maintained a studio at the famed Tenth Street Studio Building and exhibited regularly at the National Academy of Design and the Century Association. Inspired by the truth-to-nature imperative espoused at midcentury by English theorist John Ruskin, McEntee—like his artist colleagues—made annual sketching trips to natural sites in the open air. His oil studies, like this wonderfully fresh depiction of Natural Bridge, are carefully composed while retaining something of the artist's initial spontaneity in their execution. In contrast to the sharp naturalism that characterizes the works of many of his contemporaries, McEntee typically employed softer, more atmospheric effects to introduce an emotional sensibility into his landscapes.[9] The artist no doubt anticipated the heightened aura of drama that his energetic brushstrokes, as well as his placement of the luminous rock formation against a darkening sky, bring to this iconic Virginia scene. ELO

FIG. 111 Currier and Ives (active 1857–1907), publishers, **Natural Bridge,** ca. 1860, hand-colored lithograph, 12 ⅞ x 17 in. (32.7 x 43.2 cm). Virginia Museum of Fine Arts Purchase, Virginiana Fund, 71.15.6.

NOTES
1. On the reverse of the academy board is an unfinished oil sketch, presumably by the artist, of a woman watering flowers.
2. Jervis McEntee, diary entry for July 5, 1877, McEntee Diaries, 1872–90, Archives of American Art, Smithsonian Institution, microfilm roll no. D180, quoted in *A Diary Illuminated: Oil Sketches by Jervis McEntee,* exh. cat. (New York:

Debra Force Fine Art, 2007), 16. McEntee's detailed diaries provide invaluable glimpses into the inner circles of the American art establishment in the late nineteenth century.
3. Thomas Jefferson, *Notes on the State of Virginia* (1785; repr. Chapel Hill: University of North Carolina Press, 1955), 21, 24–25. Jefferson's descendants owned the property until 1833.
4. For a history of representations of the site, see Pamela H. Simpson, *So Beautiful an Arch: Images of the Natural Bridge, 1787–1890,* exh. cat. (Lexington, Va.: Washington and Lee University, 1982).
5. Herman Melville, *Moby-Dick, or, The Whale* (1851; repr. New York: Hendricks House, 1952), 540.
6. Franklin Kelly, *Frederic Edwin Church,* exh. cat. (Washington: National Gallery of Art), 31, 46.
7. McEntee studied with Church in 1851 and 1852. In the next decade, he made his first trip to Virginia while serving briefly as a lieutenant in the Union army in the Civil War. His oil painting, *Virginia in 1862* (now unlocated), was exhibited to acclaim at the 1867 Exposition in Paris. J. Gray Sweeney, *McEntee and Company,* exh. cat. (New York: Beacon Hill Fine Art, 1997), 3–4, 8.
8. Asher B. Durand, Letter II, "Letters on Landscape Painting," originally published 1855, reprinted in *Kindred Spirits: Asher B. Durand and the American Landscape,* ed. Linda S. Ferber, exh. cat. (Brooklyn: Brooklyn Museum in association with D. Giles, London, 2007), 235.
9. Sweeney, 3–4, 7–9. For a consideration of the practice of plein-air painting in nineteenth-century America, see Eleanor Jones Harvey, *The Painted Sketch, American Impressions from Nature, 1830–1880,* exh. cat. (Dallas: Dallas Museum of Art, 1998).

70. Pottier and Stymus Manufacturing Company (active 1859–1919)

Slipper Chair, ca. 1870–75

New York, New York

Rosewood with Thuya burlwood veneer; gilding; bronze doré mounts; original upholstery

28 x 25½ x 20 in. (71.1 x 64.8 x 50.8 cm)

Marked inside back of seat frame under upholstery: "Ingersoll"

Gift of the estate of Ailsa Mellon Bruce with additional support from John Barton Payne, Mrs. M. S. Wightman, Hildreth Scott Davis in memory of George Cole Scott, Mr. and Mrs. Raymond Cox, Mrs. Adelaide C. Riggs, Miss Belle Gurnee, and Mrs. Edwin Darius Graves Jr., by exchange, 93.109

PROVENANCE: Private collection; Margot Johnson, Inc., New York, N.Y.

Two bronze doré sphinx heads stare out calmly from this richly carved, gilded, and upholstered slipper chair, part of an important set of Egyptian Revival furniture created by the New York cabinetmaking and decorating firm of Auguste Pottier and William Stymus.[1] Supported by a gilded frame

detailed with geometric patterns and stylized motifs—including animal paws, palms, and lotus blossoms—each sphinxlike figure wears a *nemes* headdress with a lotus center. Between them, the low-slung seat retains its original upholstery, an Aubusson-style tapestry featuring another sphinx.[2] This is a powerful object, its visual appeal engaging both the casual viewer and the exacting scholar.

The chair evokes multiple aspects of a complex cultural revival that began in ancient Rome. Far older than Greek and Roman antiquity, Egypt's three-thousand-year history was a rich source of inspiration over the two millennia that followed its collapse as a political force. In the imagination of subsequent cultures, Egyptian architecture and artifacts were deeply associated with solemnity, sublimity, and enduring power. This influence was particularly strong within industrializing nations, where links with the past became ever more valuable to citizens who were disturbed by the rapidity of urban change.[3]

During the first half of the nineteenth century, Egypt's antiquities became increasingly accessible to Westerners through new literature and wider travel. Prompted by Napoleon Bonaparte's Egyptian campaign of 1798–1802, greater access meant fresh interest in Egyptology and a higher standard of archeological correctness in the description and imagery of venerable relics.[4] The resulting Egyptian Revival swept France, England, Germany, Italy, and the United States.[5] Towns along the Mississippi River—sometimes called the "American Nile"—adopted names such as Cairo, Karnak, Thebes, and Memphis.[6]

In the wake of these developments, a number of American architects and designers turned to ancient Egypt for fresh inspiration. Between 1830 and 1850, they created synagogues, churches, cemeteries, and prisons in a neo-Egyptian mode.[7] In its frequent association with mathematical and scientific wisdom, the Egyptian style was deemed appropriate for institutions of learning and progress, including libraries, medical institutions, and industrial facilities.[8] Few structures better exemplify the wide-ranging influence of the revival than the colossal obelisk in Washington, D.C., designed in 1833 by Robert Mills as a monument to George Washington, or the templelike Egyptian Building in Richmond, Virginia, (fig. 112) designed in 1844–45 by Scottish-born Thomas S. Stewart to serve as the first permanent home of the medical department of Hampden-Sydney College.[9] Special exhibitions helped perpetuate the American taste for things Egyptian into the second half of the nineteenth century. In 1852, the first major collection of Egyptian art and artifacts was brought to New York, and in 1876 a prominent Egyptian display at the International Centennial Exposition in Philadelphia reminded its visitors that "the oldest people of the world sends its morning greeting to the youngest nation."[10] Pottier and Stymus was not the only American firm to respond with adaptations of Egyptian design. Tiffany and Company, for example, offered a black marble clock with attendant obelisks (fig. 113), lending solemnity and grandeur to a high-style mantelpiece, while Gorham and Company provided well-to-do hosts with fashionable sterling and gilt objects such as fish servers pierced with a lotus pattern. In cabinetmaking, Egyptian-inspired motifs were most often used as surface ornament for weighty Renaissance Revival forms.[11]

Established in 1859, Pottier and Stymus also gained praise for its luxury work in Renaissance and Gothic Revival styles and became known for its splendid interiors.[12] Auguste Pottier, a French émigré who partnered with Gustav Herter (see cat. nos. 63 and 75) in Herter, Pottier and Company, began his training in wood carving and cabinetmaking. By the late 1850s, he and William P. Stymus were employed as foremen

FIG. 112 Thomas S. Stewart (1806–1889), **Egyptian Building,** designed 1844–45. The Medical College of Virginia, Virginia Commonwealth University, Richmond, Virginia. Photograph © Richard Cheek for Historic Richmond Foundation.

FIG. 113 Tiffany and Company (retailer), **Mantel Set: Clock and Two Obelisks,** ca. 1875–85, marble, bronze, gold and silver leaf, clock: 18 x 16 x 7 in. (45.7 x 40.6 x 17.8 cm); each obelisk: 20 x 6¾ x 4⅞ in. (50.8 x 17.1 x 12.4 cm). Museum Purchase, The Mary Morton Parsons Fund for American Decorative Arts, 77.40a–c.

for the decorating company Rochefort and Skarren.[13] The death of Rochefort marked the advent of their partnership.[14] Organized into distinct studios variously engaged in producing furniture, tapestries, paintings, mosaics, trimmings, upholstery, veneers, and cast bronze mounts, the firm's business thrived. In 1875, with employees numbering around 750, sales exceeded a million dollars.[15]

In the absence of a company stamp or label, the credible attribution of various revival furnishings to Pottier and Stymus has been based on a stylistic kinship between objects as well as the company's practice of assigning inventory numbers to works as they passed through the hands of different specialists.[16] A more solid attribution for this chair and extant others from the set derives from the name "Ingersoll" inscribed on interior seat frames. Once thought to refer to the chair's owner, the inscription matches a company roster dated May 1, 1869, which records an employee by the name of "E. Ingersoll."[17]

With its French-style tapestry, American frame, and Egyptian motifs, the VMFA slipper chair testifies to the international tenor of the art world in the second half of the nineteenth century. It also underscores the importance of original upholstery, which, while significant to present-day curators and collectors, rarely survives changing tastes and the ravages of time.[18] According to conservation reports on related objects, the original upholstery was colored a brilliant turquoise detailed with by-then deteriorated metallic threads.[19] One can only imagine the dramatic impact of an entire suite furbished with such resplendent materials. DPC

NOTES

1. The firm's public commissions included work at the White House and the Connecticut state capitol in Hartford. Their private clients were William Rockefeller, Leland Stanford, and Henry M. Flagler. David Hanks, "Pottier and Stymus Manufacturing Company, Artistic Furniture and Decorations," Art and Antiques 7 (September–October 1982): 84–90; Bernadette M. Sigler and Kevin Stayton, The Sphinx and the Lotus: The Egyptian Movement in American Decorative Arts, 1865–1935, exh. cat. (Yonkers, N.Y.: Hudson River Museum, 1990), 37.

2. There is some question as to the origins of the French-style covering. Although Pottier and Stymus produced tapestry in its Lexington Avenue factory and expended large sums on tools and machinery, the sophistication of this hand-woven seat cover, made in the "twining" technique associated with specialty looms and Aubusson-trained artisans, suggests that the firm may have supported a tapestry workshop in France or sent sketches there for bespoke commissions—a practice they undertook in the production of carpets. Hanks, 90; Doreen Bolger Burke et al., In Pursuit of Beauty: Americans and the Aesthetic Movement (New York: Metropolitan Museum of Art, 1986), 116–17.

3. Richard G. Carrott, The Egyptian Revival: Its Sources, Monuments, and Meaning, 1808–1858 (Berkeley: University of California Press, 1978), 47–57, 80.

4. For explorations of period theories and approaches to the Egyptian Revival, see Carrott, 25–37, 61–75; Jean-Marcel Humbert, Egyptomania: Egypt in Western Art, exh. cat. (Ottawa: National Gallery of Canada, 1994), 21, 252–56, 312–17, 450–57; and Charles Brownell and Leslie Haas, "Egyptian Influences on the Architecture and Decorative Arts of Nineteenth-Century Richmond" (lecture, Virginia Commonwealth University's Seventh Annual Symposium on Architectural History, September 25, 1999).

5. A number of important sourcebooks followed Napoleon's military incursion, first among them Vivant Denon's Voyage dans la Basse et la Haute Egypte pendant les campagnes du general Bonaparte, 3 vols. (Paris, 1802), which inspired [Commission des Monuments d'Egypte], Description de l'Egypte, ou, Recueil des observations et des recherches qui ont été faites en Egypte pendant l'expédition de l'armée française, publié par les orders de Sa Majesté l'empereur Napoleon le Grand, 21 vols. (Paris, 1809–28). See also Carrott, 25; Humbert, 257.

6. Carrott, 49–50.

7. Henry Austin's stately Grove Street Cemetery gate in New Haven (1844–48), for example. For a discussion of the style's iconographical influence on funerary structures, see Carrott, 80–101.

8. These ranged from Benjamin Henry Latrobe's unbuilt Congressional library in Washington, D.C. (1808) to John Francis Rague's Dubuque city jail (1857–58) in Iowa. Several of these evocative buildings are of local or regional interest, including the now ruined bridge at Harpers Ferry, Virginia (now West Virginia), designed by Benjamin Henry Latrobe Jr. and Wendel Bollman. For a discussion of the style's iconographical significance for nonfunerary structures, see Carrott, 102–29, and Humbert, 312–17.

9. Charles E. Brownell et al., The Making of Virginia Architecture (Richmond: Virginia Museum of Fine Arts, 1992), 270–71, no. 37. The medical department of Hampden-Sydney College—the main campus of which was in Prince Edward County—was later renamed the Medical College of Virginia and is now a part of Virginia Commonwealth University Medical Center.

10. James D. McCabe, The Illustrated History of the Centennial Exhibition (1876; repr., Philadelphia: National, 1975), 147.

11. Hanks, 84. For a discussion of the Egyptian Revival influence on furniture design, see Carrott, 31–32, and Humbert, 254–56.

12. Hanks, 84.

13. Born in Coulommiers, France, Pottier apprenticed with a Parisian wood sculptor and then immigrated in 1847 to New York, where he worked for E. W. Hutchings and Son before forming a brief alliance with Herter, 1851–53. Kristin S. Herron, "The Modern Gothic Furniture of Pottier and Stymus," The Magazine Antiques 155 (May 1999): 764, 769n8; Hanks, 84–85.

14. Hanks, 84–85. As the firm grew, it occupied workshop and showroom space on Wooster Street (115), Broadway (623), and Mercer Street before opening the Lexington Avenue factory between Forty-first and Forty-second Streets in 1871. In 1888, the company was liquidated and reformed into Pottier, Stymus and Company, a cooperative of twelve men including Pottier and his nephew, Adrian Pottier, and Stymus and his son, William P. Stymus Jr. On March 1, the Lexington Avenue factory caught fire. Although the firm was rebuilt on the same site, many of its records were likely destroyed. Extant papers are now in the collection of the Museum of the City of New York. Herron, 764; Hanks, 85. The 1859–60 New York city directory records: "Pottier and Stymus LATE B. E. Rochefort, upholsterers and cabinetmakers.

15. Hanks, 90; Cynthia V. A. Schaffner and Susan Klein, American Painted Furniture, 1790–1800 (New York: Clarkson Potter, 1997), 98; Herron, 762–69; Reports of the Grand Centennial Exhibition, series 20 of Golden Book of Celebrated Manufacturers and Merchants in the United States (New York, 1875), 12, quoted in Herron, 763.

16. Twenty-three Gothic Revival objects in the collection of Glenmont (Thomas Edison's home in West Orange, New Jersey) are identifiable as Pottier and Stymus pieces

and bear five-digit inventory numbers. Herron, 765.

17. Hanks, 90. The "Ingersoll" inscription appears on similarly upholstered and ornamental objects in the collections of the Art Institute of Chicago and the Metropolitan Museum of Art. Ingersoll may have left Pottier and Stymus by 1875–76, when a listing for "Ingersoll, Watson and Co., chairs, 71 Bowery and 49 Christie" appeared in the New York city directory. Herron, 765. See *Notable Acquisitions, 1983–1984* (New York: Metropolitan Museum of Art, 1984), 90; Judith Barter, *American Arts at the Art Institute of Chicago* (New York: Hudson Hills Press for the Art Institute of Chicago, 1998), 235, no. 111; correspondence, VMFA curatorial files.

18. VMFA is privileged to own additional furnishings with their original textiles: two American side chairs (see fig. 45) and a pair of ca. 1840 New York classical side chairs bearing horse-hair slip seats (77.128.1/2).

19. VMFA curatorial files.

71. George Jakob Hunzinger (1835–1898)

Armchair, after 1876

New York, New York

Walnut; original fabric-covered steel mesh; brass casters

39 ½ x 26 ½ x 23 in. (100.3 x 67.3 x 58.4 cm)

Impressed rear left leg: "Hunzinger, Pat. April 18, 1876"

Museum Purchase, The Floyd D. and Anne C. Gottwald Fund, 2003.6

PROVENANCE: Margot Johnson, Inc., New York, N.Y

71

Metal mesh covered in woven fabric and stretched over a geometric walnut frame with dark-stained turnings sets this chair apart from other examples of innovative nineteenth-century "patent" furniture. Here, the emphasis on abstraction—resonant in the repetitive use of geometric shapes—and interchangeable parts places this chair within a body of important, forward-looking objects.[1] Thought to have been inspired by Assyrian and medieval works reproduced in Jacob von Falke's *Art in the House*—first published in America in 1878—these objects likely date to 1878–79, when their unusual combination of form and detail debuted in *Asher and Adams Commercial Atlas*.[2]

George Hunzinger was one of many furniture manufacturers of German origin living in New York. Having apprenticed in his hometown of Tuttlingen, where his family had been in the cabinetmaking business since 1612, Hunzinger moved to Geneva, Switzerland, and worked as a journeyman before joining the wave of German immigrants who arrived in America in the 1850s.[3] Settling in Brooklyn, the entrepreneur worked with Auguste Pottier (see cat. no. 70) and then opened a shop on Centre Street, Manhattan, in 1860.[4] The following year, he took out his first patent—for a foldable reclining chair with attached footboard-cum-table.[5] By 1866, he was established at 192 Laurens Street, offering "Folding, Reclining, and Extension Chairs." Over the next six years, as its capital base expanded from $10,000 to $60,000, the firm grew in size from four to fifty employees.[6]

Hunzinger's "innovations" were based not as much on aesthetic qualities as on structural ones.[7] For example, the 1876 patent for woven-wire seating evident in the VMFA chair represented an "Improvement in Chair Seats and Backs" that substituted industrial materials for natural ones—in this case, iron bands instead of woven rush or cane (fig. 114). As Hunzinger explained it: "The chair seat or back is made with reference to the use of wire in place of cane, to form an open-work seat, . . . to insure great strength and beauty, and to facilitate the interweaving of the wires."[8] To this end, the patent reads, "finely tempered flat steel ribbons or springs . . . [are] covered with a durable web of silk or worsted, not sewed, but woven around the steel."[9] The result was a fabric-covered grid secured by notched channels to the chair frame. The chair's almost-perfect condition is testament to the designer's achievements in durability.

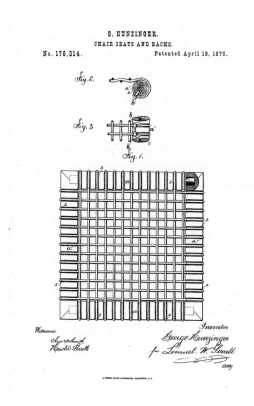

FIG. 114 George Jakob Hunzinger (1835–1898), **Patent drawing for "Improvement in Chair Seats and Backs,"** April 18, 1876. U.S. Patent No. 176,314. United States Patent Office.

Close inspection of the stark wooden chair reveals Hunzinger's commitment to the mechanical arts. The taut grid of metal mesh, the echoing pattern of the crest rail, the regulated turnings of the walnut frame, and the impressed stamp of the designer's patent number all seem to celebrate engine components or pipe fittings fifty years before the machine age swept Europe and America early in the twentieth century.[10] Today considered a significant "protofunctionalist," Hunzinger created designs that belong to no stylistic school. Rather, they anticipate the woven metalwork of late-nineteenth-century Viennese designers as well as furniture by such twentieth-century craftsmen as Harry Bertoia.

In 1877, following a fire that destroyed the five-story workroom on Seventh Avenue—as well as the neighboring factories of cabinetmakers Pierre J. Hardy and Roux and Company—Hunzinger set to work on a new six-story factory at 323–327 West Sixteenth Street. By the 1880s, the self-described maker of singular "fancy" furniture was providing

ornamental accents for eclectic middle- and upper-middle-class American interiors.[11] A clever marketer, Hunzinger maintained a consistent—and cost-efficient—aesthetic vocabulary while offering the consumer a selection of finishes at varying prices.[12] Still, innovation and variation did not come cheaply. A Hunzinger chair could cost $40—this when steak was a nickel.[13]

<div align="right">DPC</div>

NOTES

1. The group includes a rare suite of furniture: a settee in the collection of the Metropolitan Museum of Art (1992.269) and two armchairs, three side chairs, a settee, and a center table in the collection of the Chrysler Museum of Art (71.2292a–g). This suite is distinguished from the VMFA example in three details: stylized palmettes, which stand in place of conical finials; crest rails composed of inset circles rather than squares; and the absence of casters. A related daybed is in the collection of the Brooklyn Museum (86.177). Barry R. Harwood, *The Furniture of George Hunzinger: Invention and Innovation in Nineteenth-Century America* (Brooklyn: Brooklyn Museum of Art, 1997), 94–102.

2. Harwood, 96–97. Hunzinger's design for a cloth-covered mesh, the sixth patent of his career, was indebted to Chester D. Flynt, a "steel-lacer" whose 1867 patent for wire mesh domed over a rubber cushion was reissued in 1878 and assigned to Hunzinger. Harwood, 86–91.

3. The town of Tuttlingen is located in the German State of Württemberg, where John Henry Belter (see cat. nos. 45 and 46) was born in 1804. Hunzinger arrived in Brooklyn about 1855. By 1860, he was listed in the Brooklyn city directory as a cabinetmaker at 117½ Court Street. Richard W. Flint, "George Hunzinger," in *Nineteenth Century Furniture: Innovation, Revival and Reform*, ed. *Art & Antiques* (New York: Roundtable Press, 1982), 124; David A. Hanks, *Innovative Furniture in America from 1800 to the Present* (New York: Horizon Press, 1981), 84; Barry R. Harwood, "Armchair" in *Masterpieces of American Furniture from the Munson-Williams-Proctor Institute*, ed. Anna Tobin D'Ambrosio (Syracuse: Syracuse University Press, 1999), 112, no. 39.

4. Harwood, "Armchair," 112.

5. Flint, 126.

6. Expansion resulted in the company's move to 402 Bleecker Street. Flint, 124; Hanks, 84.

7. Different kinds of patents were available for inventions, designs, and trademarks. Hunzinger emphasized not the novelty of his designs, but their exceptional structural strength. Flint, 126.

8. Quoted in Hanks, 85.

9. Quoted in Flint, 127.

10. Evidence suggests that Hunzinger stamped each object with his name and the date of its related patent. By the end of his career, he could boast twenty-one patents. Flint, 126.

11. Flint, 124.

12. Harwood, "Armchair," 112.

13. Kimball, *Book of Designs*, retailer's catalogue, 1886; cited in Marilyn Johnson et al., *19th-Century America: Furniture and Other Decorative Arts* (New York: Metropolitan Museum of Art and the New York Graphic Society, 1970), no. 186.

72. William Merritt Chase (1849–1916)

The Wounded Poacher (The Veteran), 1878

Oil on canvas

24 x 18 ¾ in.

Signed, inscribed, and dated upper left: "W. M. Chase / München / 1878"

Gift of James W. and Frances G. McGlothlin, 2009.310

PROVENANCE: Herman Simon to Mrs. Elizabeth M. Simon, Easton, Penn.; American Art Association, New York (April 12, 1929, lot no. 65); Charles T. Davies, Wyomissing, Penn. (by 1949); Sotheby's, New York (May 19, 2004, lot no. 25); James W. and Frances G. McGlothlin

The craggy, weather-beaten face of a middle-aged man peers out of the murky background of a painted canvas. Beneath a stark, white head bandage, his gaze is direct and forceful, his manner and pose confrontational. The man's expertly foreshortened hands maintain a tight grip on a highly illusionistic (nearly trompe l'oeil) white clay pipe thrust into the viewer's space like the barrel of a pistol—an impression shaped by the painting's various titles conflating hunter with soldier. *The Wounded Poacher,* later known as *The Veteran,* is a consummate example of William Merritt Chase's Munich period. Characterized by an earthy color scheme and fluid brushwork, it is simultaneously reminiscent of the Old Masters and modern German painting with its emphasis on texture (the man's leathery skin) and tone (the dramatic play of dark and light). This then-progressive Munich style marked the artist's debut in the New York art world of 1878.[1]

Fresh from his studies at the Munich Royal Academy, Chase, who had trained at New York's National Academy of Design from 1869 to 1872 before traveling to Germany, quickly established himself as a rising star. His advanced art contained all the hallmarks of the Munich school in both form—dusky palette and *alla prima* (direct) painting technique—and subject—moody, penetrating character studies. According to one contemporary critic, Munich-trained American artists used rich color and theatrical flourishes to "attempt to fix upon the canvas the instantaneous impression of a scene—to catch a changing mood or feeling; a fleeting touch of color, a vanishing light, a sudden insight or grasp."[2]

The Wounded Poacher was one of four such Munich-style paintings submitted by Chase to the inaugural annual

72

exhibition of the Society of American Artists (SAA), held at New York's Kurtz Gallery in the spring of 1878. Founded in 1877 by an assortment of young European-trained artists weary of the hegemony of the hidebound National Academy of Design, the SAA provided alternative exhibition and sales opportunities for the more progressive camp of the New York art world. Chase's eager alliance with this "new-movement" faction on his return from Germany reveals his ambition to be viewed as an innovative artist of consequence, plying his talents equally as a figure painter and portraitist.[3]

The artist's submissions to the 1878 SAA exhibition reflected these ambitions—from the nearly full-length *Ready for the Ride, 1795* (fig. 115), a historical costume picture that became Chase's first major sale when it was acquired by the prominent New York art dealer Samuel P. Avery, to the three-quarter-length *Wounded Poacher,* which hung alongside the larger work and shared its Rembrandt-like minimal compositional devices of stark light-dark contrasts and an emphasis on head, hand, and a singular accessory (be it riding crop, pipe, or pistol). Comparing the two works, *New York Times* art critic Charles de Kay (brother of Helena de Kay, an SAA founder) described the latter picture as "bolder and less delicate in finish, but in fact no broader," observing that "this truculent knave expresses his character by his defiant glance and the careless gesture in handling his clay pipe." *Ready for the Ride,* which Avery lent to a subsequent exhibition at New York's Union League Club (its present owner), continued to garner critical attention and, with paintings such as *The Wounded Poacher,* helped to secure Chase's early reputation as "an older man and a riper artist . . . destined to produce great works."[4]

As de Kay predicted, Chase rose to critical and popular heights as a fashionable painter, pastelist, and collector—as well as an esteemed teacher and tastemaker—over the course of his highly productive forty-year career. Moving stylistically from the dark naturalism of his Munich period to the subtle artifice of Aestheticism (see fig. 132) and a light and airy impressionism, Chase's artistic evolution ended, in a sense, where it had begun, in the self-consciously art historical realm of Grand Mannerish portraiture (see fig. 183) and seventeenth-century-style still-life painting (see cat. no. 110). In the words of insightful critics Mariana Griswold Van Rensselaer and Henry James, respectively, Chase's "intense, if unbeautiful reality,"

first learned in Munich and later reprised in his poignant *nature morte* compositions, provided an "excellent foundation" for the distinctively modern career of an undisputed American Old Master.[5] SY

FIG. 115 William Merritt Chase (1849–1916), **Ready for the Ride,** 1877, oil on canvas, 54 x 34 in. (137.2 x 86.4 cm). Union League Club, New York, N.Y.

NOTES

1. The later title, *The Veteran,* apparently dates to the 1929 American Art Association sale of the painting. See Ronald G. Pisano, *William Merritt Chase: Portraits in Oil* (New Haven and London: Yale University Press, 2006), 2:24. A humorous account of the picture's appearance in the 1878 Society of American Artists exhibition refers to it as both *The Wounded Poacher* and *Blown to Blazes.* See H. C. Bunner, "The Society of American Artists," *Puck* 3 (March 27, 1878): 16.

2. The Indiana-born Chase was likely drawn to Munich for further study by way of his midwestern roots; numerous other artists from Saint Louis to Cincinnati favored Munich over Paris for European training—for example, John Mulvaney (an early influence on Chase), Frank Duveneck, and John Twachtman. For a discussion of Chase's studies with Wilhelm Leibl and the progressive–Old Master dialogue of his instruction, see Bruce Weber, *Chase Inside and Out: The Aesthetic Interiors of William Merritt Chase,* exh. cat. (New York: Berry-Hill Galleries, 2004), 14–16. The contemporary observation appears in "Impressionism in Art," *Appleton's* 21 (1879): 376, quoted in ibid., 17.

3. See Jennifer A. Bienenstock, "The Formation and Early Years of the Society of American Artists: 1877–1884" (Ph.D. dissertation, City University of New York, 1983). For a discussion of Chase's increasing role in the organization's activities—

he became its president in 1880—and his subsequent transition from the aesthetic ideals of Munich to those of Paris, see Barbara Dayer Gallati, *William Merritt Chase: Modern American Landscapes, 1886–1890,* exh. cat. (Brooklyn Museum of Art in association with Abrams, 2000), 23–25.

4. [Charles de Kay], "Society of American Artists," *New York Times,* March 7, 1878, 4. See also Pisano, 2:19–21.

5. For the first feature-length critical assessment of Chase, see Mariana G. Van Rensselaer, "William Merritt Chase. First Article," *American Art Review* 2 (January 1881): 93. See also Henry James's discussion of Chase's Munich work in "On Some Pictures Lately Exhibited," *Galaxy* (July 1875). Both articles are quoted in Gallati, 23.

73. Attributed to Chester Webster (1799–1882)

Pitcher, 1879

Randolph County, North Carolina

Salt-glazed stoneware with incised decoration

13 x 7 in. (33 x 17.8 cm)

Museum Purchase, The W. Gabe Burton Fund; The Arthur and
 Margaret Glasgow Fund; The Mary Morton Parsons Fund for
 American Decorative Arts; The Adolph D. and Wilkins C. Williams
 Fund; and Various Donors, by exchange, 2008.45

PROVENANCE: Museum of Early Southern Decorative Arts, Winston-Salem, N.C.

Beginning in the eighteenth century, enterprising émigré potters brought their experience to bear on the development of American ceramic manufactures, particularly along the urbanizing coast, where clay deposits were prevalent and transport was easy.[1] By the early nineteenth century, the rising cost of coastal farmlands encouraged potter-farmers to migrate south and west.[2] The Great Wagon Road facilitated this movement, and gradually potteries were established in Hagerstown, Maryland; Shepherdstown, Virginia (now West Virginia); and, eventually, southwestern Virginia, North Carolina, and Tennessee.[3] This salt-glazed pitcher made by Chester Webster is a product of that migration.

In 1819, entrepreneurial merchant and insurance agent Gurdon Robins, a native of Hartford, Connecticut, established a pottery outside Fayetteville, North Carolina, at the head of the Cape Fear River. Fayetteville was the leading commercial gateway to the North Carolina Piedmont and a vibrant center of trade. Encouraged by advancements in steamboat navigation and the development of internal canal systems, Robins intended to compete with the flood of northern and foreign

ceramics imported into the South.[4] To run the operation, he lured Edward Webster from the Goodwin and Webster Pottery of Hartford.[5]

In 1827 Chester Webster joined his brother and began producing the incised salt-glazed stoneware for which he is distinguished.[6] Ultimately, however, the sandy coastal plain provided only limited supplies of good clay, and in the mid-1830s the Websters abandoned the Fayetteville factory. Chester moved to Randolph County, North Carolina, where he began working as a turner for the Craven pottery.[7] There, his incised salt-glazed pots achieved their maturity.

About two dozen objects have been attributed to the "Bird and Fish Potter," as Chester Webster is known; they are representative of the most accomplished stoneware produced in the United States.[8] Rarely stamped by name, nine are dated—from 1842 to 1879—including this pitcher, described by an unidentified early owner as "distinctly Flemish" and "ornamented with childish drawings of birds and flowers, with scalloped bands and [a] handle decorated at its juncture."[9] The observation is astute. The origins of salt-glazed stoneware are in fourteenth- or fifteenth-century Germany, perhaps when salt-tainted wood was accidently added to a kiln (fig. 116).[10] The first patented English examples were made by John Dwight of Fulham (London) in 1671,[11] and not until 1794 did New England become a center of production.[12] Through the work of Chester Webster, German salt-glazed stoneware and New England incised decoration become a southern vernacular tradition. This pitcher combines a European form—the rounded belly and upright neck—with the New England technique. The vessel is enhanced by an attenuated strap handle and unique decorative details: the date contained within an elaborate cartouche; the floral surround of the one and one-half gallon mark; the "quail" bird and toothy, scaled fish; the poinsettia beneath the date; the interlocking triangular and scalloped bands; and the finely detailed handle terminal reminiscent of early Germanic silver.[13]

The clay, too, is distinctly southern. Perhaps taken from Michfield or Auman Pond near Seagrove, North Carolina, it contains an abundance of silica—a colorless crystalline compound like quartz or sand—that made it difficult to manipulate but receptive to salt glazing. Once dug, the clay was left to break down for increased plasticity, soaked in water to soften, ground and churned in a mule-drawn beam mill, and "picked" of alien material like rocks or roots. Finally, it was kneaded until dense to be measured into blocks and stored in a damp pit. Prior to turning and firing, the block was cut into thin slices, cleaned of any additional debris, wedged and thrown multiple times on a board, and finally kneaded into balls to release remaining air pockets. Traditionally, a southern potter stood over the treadle wheel to center the clay and relied upon his upper body strength to bring up its shape. Success also depended on a consistent wheel speed: faster for smaller objects, slower for larger ones.[14]

Once multiple objects were turned and dried, the potter loaded the kiln. The VMFA pitcher was set upright on a sand floor and fired in a cross-draft "groundhog" kiln based on a fifteenth-century German prototype, probably brought south by eighteenth-century Moravians. Low and rectangular, the single-chamber kiln was built into the ground with an entrance and ceiling of locally made bricks. At one end, a firebox held the burning wood, which the potter stoked for a day or more. At the other end, a chimney drew the flames across the pots. The tremendous heat—about 2,350°F—fused a watertight surface. As salt was added and vaporized by the heat, its sodium content served as a flux with the silica. The resulting sodium silicate glaze acquired the orange-peel texture that distinguishes salt-glazed earthenware from lead- or alkaline-glazed wares. In some instances, the ash from the firebox, known as "fly ash," fell on the turned wares, causing decorative drips that fused into glass atop the glaze. A similar effect resulted when the kiln itself began to melt green "potters' tears"—a signal for rebuilding that occurred every year or two.[15]

FIG. 116 German artisan, **Pitcher,** 1577, salt-glazed stoneware, silver-gilt mounts, 9½ x 5 in. (24.1 x 12.7 cm). Virginia Museum of Fine Arts, Gift of Mrs. E. Claiborne Robins, 2001.131.

If potting was an art, it was also a wintertime livelihood for talented farmers. In the cooperative barter system that was typical of agrarian society, Chester Webster worked as an independent contractor (a part-time turner and laborer) for Randolph County storekeeper, pottery owner, and farmer B. Y. Craven. Craven's business accounts from 1854 through 1863 indicate that Webster was paid and provisioned according to the number and size of wares he turned and the number of days he performed agricultural tasks such as gathering corn and binding wheat. In addition to cash, which was scarce, he received foodstuffs and services—the hauling of clay from a local pit or repairs to his furnishings, for example. By 1870, Webster was averaging twelve and one-half cents for a one-gallon jug.[16]

Eighty years old when he made this pitcher, Chester Webster was by all standards a master potter, versed not only in form but in the nuances of material and technique. The vessel's mellow ocher tone, for example, reveals an ability to experiment with color by reducing the oxygen content of the kiln.[17] Ultimately, however, it is the unusual attention to decoration that distinguishes Webster's work. Every design element for which he is known—the bird, the fish, the date, the detailed handle terminal, the pointed-petal flower, the cartouche—was incorporated into this pitcher, the final orchestration of a long career. Shortly after making the vessel, Chester Webster left Randolph County to live with his nephew in Marion County, South Carolina. He died there two years later.[18]

SJR

NOTES

1. For the history of early American ceramics, see Luke Beckerdite and Robert Hunter, "Earth Transformed: Early Southern Pottery at MESDA and Old Salem," *The Magazine Antiques* 171 (Jan. 2007): 161–63; Nancy Sweezy, *Raised in Clay: The Southern Pottery Tradition* (1984; repr., Chapel Hill and London: University of North Carolina Press, 1994), 19, 52; Charles G. Zug III, *Turners and Burners: The Folk Potters of North Carolina* (Chapel Hill and London: University of North Carolina Press, 1986), 26, 28; Mark Hewitt and Nancy Sweezy, *The Potter's Eye: Art & Tradition in North Carolina Pottery* (Chapel Hill: University of North Carolina Press for North Carolina Museum of Art, 2005), 51.

2. Zug, 264; Sweezy, 19. Among other southern stoneware manufactories, Beckerdite and Hunter refer to the Richmond pottery of Benjamin DuVal. See "Earth Transformed," 163–4. See also Bradford L. Rauschenberg, "'B. DuVal & Co./Richmond': A Newly Discovered Pottery," *Journal of Early Southern Decorative Arts* 4, no. 1 (1978): 45–75; Robert Hunter and Marshall Goodman, "The Destruction of the Benjamin DuVal Stoneware Manufactory, Richmond, Virginia," in *Ceramics in America,* ed. Robert Hunter (Hanover, N.H.: University Press of New England for the Chipstone Foundation, 2005): 37–60.

3. Beckerdite and Hunter refer particularly to the northern Shenandoah family potteries of John George Weiss Sr. and Peter Bell Jr. Sweezy notes the Mount Shepard pottery near Asheboro, N.C. Beckerdite and Hunter, 165; Sweezy, 19. For information about the Great Wagon Road, see cat. no. 16.

4. James H. Craig, *The Arts and Crafts in North Carolina 1699-1840* (Winston-Salem, N.C.: Old Salem, 1965), 93, cited in Zug, 32; Hewitt and Sweezy, 59; Beckerdite and Hunter, 165–66; Sweezy, 19; Quincy Scarborough, "Connecticut Influence on North Carolina Stoneware: The Webster School of Potters," *Journal of Early Southern Decorative Arts* 10 (May 1984): 15–19, 25; Zug, 27–28.

5. Possibly the first manufactory of stoneware in Connecticut, where the three Webster brothers—Chester, Edward, and Timothy—likely apprenticed with their uncle McCloud Webster, a partner in the concern. The large numbers of Connecticut artisans and merchants who had moved to the area suggest an already established relationship between Fayetteville and the Lower Connecticut River Valley. Scarborough, 15–6, 28, 40; Hewitt and Sweezy, 59.

6. Scarborough, 27, 35; Beckerdite and Hunter, 165–66; Hewitt and Sweezy, 75.

7. Financial insolvency had forced Robins back to Hartford in 1823, and by the time of Chester's arrival, Edward had assumed ownership of the firm. The pottery's decline was probably due to both the financial panic of 1837 and the ready availability of imported goods. In 1838, Edward moved to Marion County, South Carolina. Chester appears to have journeyed between Fayetteville and Randolph County, North Carolina, ca. 1832–37, before settling in Randolph County. Following Solomon Craven's death in 1833, Chester turned for his son, Bartlet Yancey Craven. He may also have operated as a journeyman potter for other firms. Scarborough, 19, 21–22, 30, 34–36, 42; Zug, 28, 36; Hewitt and Sweezy, 61.

8. Works by Chester Webster can be found in the Brooklyn Museum, Colonial Williamsburg, and the Mint Museum, Charlotte.

9. A jug is also dated 1879. Only one plain jug stamped "C. Webster" has been identified. Six bear both the bird and fish design. The letter, dated 1921, was presumably intended for Jacques and Juliana Busbee, the founders of Jugtown Pottery, near Seagrove, North Carolina. For an illustration of the 1879 jug, see Scarborough, fig. 50, 64. See also Jean Crawford, *Jugtown Pottery: History and Design* (Winston-Salem: John F. Blair, 1964), 7, cited in Zug, 37; Zug, 36–37; Scarborough, 42, 49–50.

10. The "tigerware" surface is caused by a particularly heavy dose of salt in the kiln. Phil Rogers, *Salt Glazing* (London: A. and C. Black, 2002), 11–12, cited in Hewitt and Sweezy, 43. See also Hewitt and Sweezy, 45.

11. Zug suggests a patent date of 1671. Dwight later developed a white salt glaze intended to compete with porcelain. Hewitt and Sweezy, 49; Zug, 26.

12. Jonathan Fenton of New Haven, Connecticut, set up a pottery in Boston using clays from Perth Amboy, New Jersey. With its incised cobalt-colored images of fish and birds, the salt-glazed wares of Fenton pottery reflected and influenced the practice of artisans in New England and the mid-Atlantic. For more information, see Hewitt and Sweezy, 51–59; Rauschenberg, 62.

13. Scarborough, 26–27; Hewitt and Sweezy, 73, illus. 72–73.

14. Sandy stoneware clays, particularly high in silica, take salt best. Sweezy, 22, 30, 35, 48–50, 52.

15. The kilns might measure between six and eight feet wide by sixteen to twenty feet long. Sweezy, 22–23, 52–53, 60, 64; Scarborough, "The Webster School of Potters," 15; Hewitt, "The North Carolina Pottery Tradition," in Hewitt and Sweezy, 41; Hewitt and Sweezy, 25.

16. Zug, 264, 275. Demand for utilitarian wares continued in the rural South until about 1950. Sweezy, 23–29.

17. Although clay color varied according to its content—as determined by the location of its mining, the percentage of iron, and the degree to which the potter refined it—color could be transformed when oxygen was "reduced" and the iron was turned into oxide. Sweezy, 53; Hewitt and Sweezy, 67, 69.

18. Chester died at the home of Edward's son. Scarborough, 39.

Expatriates and the Gilded Age

74

74. Decoration attributed to **Pottier and Stymus Manufacturing Company** (active 1859–1919) Furniture attributed to **Sypher and Company** (active 1869–1908)

Worsham-Rockefeller Bedroom, ca. 1880–81

New York, New York

Mahogany, ebonized with satinwood inlay; textiles; metal; glass; ceramic

Approximately 25 x 28 x 12 ½ feet

Gift of the Museum of the City of New York, 2008.213

PROVENANCE: Arabella Worsham; John D. Rockefeller Sr. (1884); gift of John D. Rockefeller Jr. to The Museum of the City of New York, 1937

The Worsham-Rockefeller Bedroom is a consummate example of the Anglo-American Aesthetic movement, the late-nineteenth-century cultural phenomenon that promoted "beauty" as an artistic, social, and moral force, particularly in the domestic realm. Grounded in English reform ideas, the style was popularized on both sides of the Atlantic by publications like Charles Lock Eastlake's *Hints on Household Taste* (1868) and Clarence Cook's *The House Beautiful* (1878)—described by one reviewer as an effort to "persuade people to . . . pursue the paths of true art and taste in furnishing their house."[1] The movement's free use of historical and foreign sources appealed to fashion-conscious middle- and upper-class Americans.[2] As the Worsham-Rockefeller interior attests, these ideals inspired holistic domestic environments composed of subtle blendings of diverse stylistic and material vocabularies.[3]

This room was originally situated in a mid-1860s Italianate house at 4 West Fifty-fourth Street in New York City (fig. 117) that was enlarged by Arabella Worsham of Richmond, Virginia, in about 1880 (fig. 118).[4] Born Catharine "Bell" Duval Yarrington in 1850, Arabella was the daughter of Richard Milton Yarrington, a carpenter-machinist, and his wife, Catharine, who operated their home as a boarding house.[5] Yarrington died in 1859 on the eve of the Civil War. By age fifteen, Arabella was fatherless in a war-ravaged South, living in Richmond's First Ward in a residential hotel leased by "F. Wingo" and operated by her mother.[6]

Reconstruction came to the South in many guises. Until the reforms of the 1870s, Richmond was peppered with gaming halls and bawdy houses that served a large population

FIG. 117 **View of 4 West Fifty-fourth Street complex,** ca. 1865. Rockefeller Family Archives.

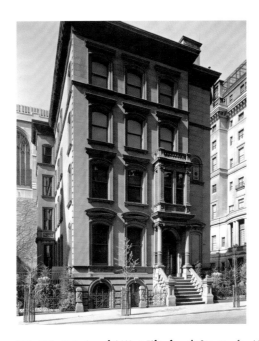

FIG. 118 **Exterior of 4 West Fifty-fourth Street,** after Worsham renovation, photograph by Samuel Gottscho, 1937. Rockefeller Family Archives.

of war-weary soldiers, government officials, and local businessmen.[7] One of the grandest of these establishments, located at Fourteenth and Main Streets about six blocks from Arabella's home, was owned by John Archer Worsham.[8] Arabella and Worsham likely met in Richmond sometime after 1860. However, beginning in 1865, following the burning and temporary evacuation of the city (and a presidential pardon for his Confederate status), Worsham also operated a "faro bank" in

New York. Located at 17 West Twenty-fourth Street at the junction of Fifth and Broadway, the business benefited from close proximity to the fashionable Fifth Avenue Hotel (established in1859) adjacent Madison Square Park.[9] Although growing competition eventually forced Worsham's business to a less desirable location, he retained a downtown residence on Prince Street. This was just blocks away from Bleeker and Bond streets, where the Yarrington family lived, successively, beginning in 1867. The 1870 federal census records John and Bell "de Worsiem" (Worsham) and their three-month-old son as residents of Mrs. Yarrington's Bond Street home. Less than a year later, however, their relationship had ended, and Arabella had begun her own "reconstruction" (fig. 119).[10]

In 1871, accompanied by her mother and son, the "widowed" Bell D. Worsham departed Bond Street to lease a town house at 109 Lexington Avenue.[11] Subsequently purchased by Collis P. Huntington, erroneously described by one Texas

FIG. 119 Alexandre Cabanel (1823–1889), **Mrs. Collis P. Huntington,** 1882, oil on canvas, 85¼ x 50½ in. (216.5 x 128.3 cm). Fine Arts Museums of San Francisco, Gift of Archer M. Huntington, 40.3.11.

newspaper as her "uncle," the residence served the small family for three years until the purchase of a house at 68 East Fifty-fourth Street. The move marked the beginning of Arabella's economic ascension.[12]

Arabella's self-fashioning as an upper-class New Yorker was aided by her maturing relationship with Huntington. This, too, likely began in Richmond. Best known as the mastermind of the Central Pacific Railroad, Huntington was recruited by directors of the Virginia Central to underwrite a new line in the wake of the Civil War. Formed from a group of smaller railways decimated by the conflict, the Chesapeake and Ohio Railroad provided a vital link between the East Coast and the Midwest, affording transcontinental access to valuable resources like coal and lumber. Coincidently, Huntington acquired lands in Warwick County, Virginia, where he and his associates established the Newport News Shipbuilding and Drydock Company. Combined, the ventures permitted the efficient and profitable transport of West Virginia coal to the Northeast.[13]

Huntington's business occasioned his frequent trips to Richmond and his likely introduction to Arabella Yarrington; an unexplained influx of wealth recorded by Mrs. Yarrington shortly after their arrival in New York and Huntington's subsequent purchase of the Lexington Avenue townhouse suggest that he assisted the Yarringtons' move to New York.[14] However, in 1877, Arabella acquired 4 West Fifty-fourth Street and, shortly thereafter, commissioned a major New York architect and decorating firm to expand the structure and remodel the interiors of the four-story brownstone.[15] The Worsham-Rockefeller bedroom was part of that commission.

Measuring approximately twenty-five by twenty-eight feet, the bedroom features approximately seventy objects in a complex architectural framework. The walls are covered in an ocher-toned "Lincrusta"—a brand of stamped composition paper—awash in a rose-colored glaze. Conceived in two parts, the paper's pattern is a marriage of naturalistic and stylized ornament: against a dark-colored ground, a boldly rendered frieze of broadly sweeping acanthus leaves (fig. 120) is edged with bands of contiguous roundels highlighted in gold and silver leaf (possibly precious aluminum); below, vertical panels of more moderate relief (fig. 121) bear bouquets of acanthus leaves intermingling with seedpods and blossoms. In like

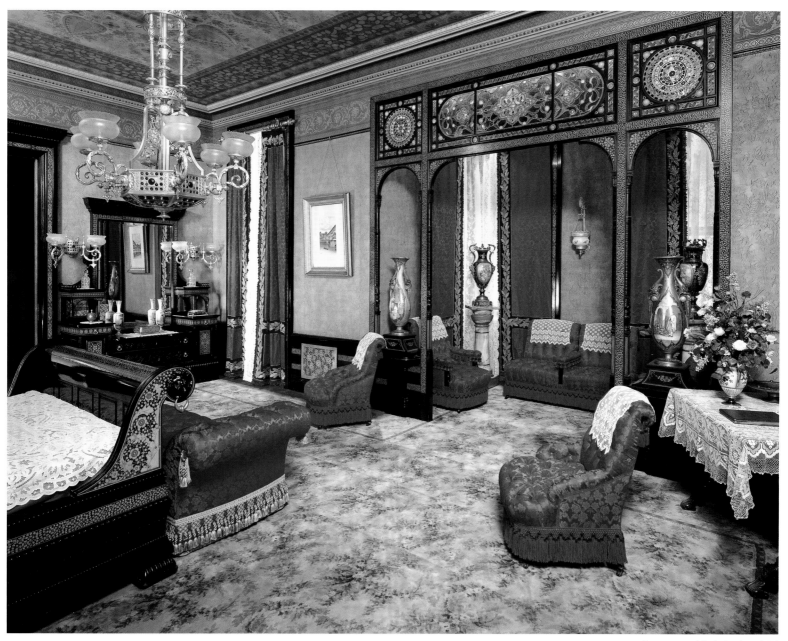

(view toward Turkish alcove) 74

manner, a hand-painted ceiling cloth, also of a naturalistic and stylized design, is conceived in three sections: intermittent arches centered by a fan motif; a darker-toned outside border of oak leaves and acorns edged, to the inside, with a band of stylized rosettes; and a central rectangular panel detailed with stylized gilt-edged spades interwoven with naturalistic swags of pastel-toned flowers.[15]

All of these patterns and tones are reiterated in the textiles, metalwork, glass, and inlay that enrich and enliven the room. The "Smyrna" carpet, reproduced in 1937 from the original, repeats the French-inspired garlands of the ceiling and the sweeping sequence of the acanthus frieze.[16] The window and bed hangings, partially reproduced in a red floral silk-damask, host original bands of "old rose" velvet with gilt-embroidered

arrangement of upholstered seating in corded and trimmed red damask. The "confidante"—or two-seater chair—and two small "lady's" armchairs complement the two easy chairs and "chaise couch" of the larger room. This collection of upholstered objects is supplemented by additional single works, among them a gilded side chair and mahogany table with a Napoleonic cross stretcher.[17]

For all of this, the room's highlight is the remarkable en suite furniture and woodwork of ebonized mahogany with satinwood inlay. Moldings, door surrounds, window cabinets, and mantelpiece (fig. 126) are treated, in Aesthetic fashion, as extensions of the room's furniture—a half-tester Second Empire bed (fig. 127),[18] a jewelry safe, a large-scale bureau with "dressing glass to match," and a large-scale "étagère and

FIG. 120 Detail of **stamped composition frieze.**
FIG. 121 Detail of **stamped composition wallpaper.**

FIG. 122 Detail of **embroidered headboard.**
FIG. 123 Detail of **bat figure on alcove wall sconce.**

chains of oak leaves and acorns (fig. 122) that echo the pattern of the ceiling border. A monumental brass chandelier, four matching two-arm wall lights, and an additional one-arm sconce (fig. 123) unite Renaissance, Gothic, and Asian motifs. With their silver or aluminum highlights, the fixtures pick up the gold-silver interplay of the frieze. At the same time, their stylistically inclusive details reinforce the diverse treatment of the ceiling.

Bearing opalescent and multicolored glass stones (fig. 124), the lighting is also linked to the extraordinary carved, pierced, and glass-inlaid screen (fig. 125) that separates the principal interior from the expanded bay. This fashionable Turkish niche functions as a sitting area (cat. no. 74, view toward Turkish alcove). Accommodating scaled versions of the painted wall and ceiling coverings—the latter a trellis with scattered sprigs and posies reminiscent of the carpet—the alcove includes an

mirror to match"—as described in the mansion's 1884 inventory.[19] Linking these objects with the upholstered pieces is a pair of ebonized and inlaid side chairs with tufted seats and backs. In each of these works, the ebonized ground serves as a foil to the intricate and eclectic satinwood inlay that plays on the room's surfaces, unifying the artistic environment.

Popularized by British displays at Philadelphia's Centennial International Exhibition of 1876, the key vehicle for the introduction of Aestheticism in America, ebonized versions of en suite furnishings were most commonly commissioned for bedrooms.[20] The marquetry of this suite is composed, in part, of plain and pierced leaves along attenuated vines occasionally interlaced with beaded tassels. The pattern recalls the "Indian and Burmese" and "Moorish" designs reproduced by Owen Jones in *The Grammar of Ornament* (1856).[21] But, like the room's wall, ceiling, and floor coverings, it also invokes

French Second-Empire designs—the garlands and ribbons, for example. As Pottier and Stymus reported in 1882, their most well-to-do clients favored the French Louis XIV, Louis XVI, and neo-Renaissance styles.[22] This inclusive blending of Aesthetic and neo-Renaissance sources, perhaps an influence of the patron's taste, extended to all facets of the interior's production: the applied metallic banding on the drapery panels was probably produced in France by European specialists;[23] the Lincrusta wallpaper may have been made in England to a design affiliated with the British architect Bruce Talbert;[24] and the light fixtures may have been designed for in-house production or commissioned from a firm like Mitchell, Vance and Company, which displayed similar examples at the Centennial Exhibition.[25]

claimed that his firm: "furnished the house 4 West 54th St. and can give you all the information you may desire should you contemplate buying;" and, still more forcefully, "that the interior woodwork and decoration of your new residence . . . was designed and executed by us."[29] However, in yet another letter to John D. Rockefeller Jr., dated March 31, 1938, Mitchell Samuels of French and Company, well-known purveyors of antique furniture, wrote:

> I knew Mrs. Huntington . . . and I recalled conversations with her about the interiors of the house. I remember she told me that the old firm of Pottier and Stymus did a good deal of work for her and she also had some pieces of furniture made by the old firm of Sypher &

FIG. 124 Detail of **brass and glass chandelier.**
FIG. 125 Detail of **glass-inlaid screen.**

FIG. 126 Detail of **mantelpiece inlay.**
FIG. 127 Detail of **lion's-head mount on bed.**

The successful orchestration of these various components, previously the sphere of the craftsman-upholsterer, depended on the talents of the newly professional decorator, who was responsible for providing and integrating the full range of interior goods.[26] The ascension of the decorator has complicated the attribution of the bedroom's parts. The large, high-end firms produced, commissioned, and imported furniture, textiles, metalwork, papers, and other items, often attaching their own label or marks to pieces made elsewhere.[27] Although a thorough study of the practice of subcontracting has yet to be conducted, there is evidence to suggest that, while one firm likely had supervisory responsibility for the Worsham commission, it may have hired others for specialized services.[28] In two letters to John D. Rockefeller, dated January 21 and October 29, 1884, George A. Schastey, proprietor of Schastey and Company and one-time employee of Pottier and Stymus,

Company, to whom we are the successors. . . .[30] We had an Empire bed, said to have been presented to the Princess Demidoff, niece of Napoleon I, and this bed I believe was used as a model for your Father's bed. . . . Some years ago, Mrs. Huntington saw the bed in our establishment and remarked that it was used as a model for the bed that was made for her.[31] She mentioned that it was in a house in which she formerly lived. Now that I have seen your Father's bed I can recall this conversation distinctly, and therefore there is no doubt that Sypher and Company made this particular bed. . . . The woodwork of the house was undoubtedly done by Pottier and Stymus.[32]

Considering the scale of the Worsham commission, the practice of appropriating imported goods as one's own, and

the familiarity of Pottier and Stymus with Schastey's work, it seems possible that the larger firm subcontracted portions of the job to its former employee. Not only would Schastey's abilities have been familiar to Pottier and Stymus (see cat. no. 70), but the practice would have allowed for concurrent commissions and prompt deliveries.[33] By 1869, Pottier and Stymus had moved further uptown, a stone's throw from Sypher and Company, to set up showrooms, galleries, and workshops specializing in frescoes, carpets, veneers, textiles, woodwork, ceilings, and bronzes in a model that was readily adopted by other high-end concerns—and captured the attention of Arabella Worsham.[34]

On July 12, 1884, nine months after the death of his first wife, Collis P. Huntington wed Arabella Worsham at her 4 West Fifty-fourth Street home. Shortly thereafter, she sold the furnished residence to John D. Rockefeller. With the sale of the West Fifty-fourth Street mansion, Arabella and Collis Huntington moved to their new home on Fifty-seventh Street. Following Huntington's death in 1900, she was regularly touted the richest woman in America.[35]

In 1913, Arabella married Collis's nephew and associate, Henry E. Huntington.[36] While they worked to assemble the important Huntington Collection in San Marino, California, the Aesthetic interiors of her old home remained largely intact. Following Rockefeller's death in 1937, more than fifty years after their making, three of the rooms were donated by his son to public institutions: a bedroom and dressing room to the Museum of the City of New York; and a Moorish Smoking Room to the Brooklyn Museum.[37] SJR

NOTES

1. "Cook's House Beautiful," *North American Review* 126 (January 1878): 182.
2. For more information about the British Reform and Aesthetic movements, see Andrew Porter, "Introduction: Britain and the Empire in the Nineteenth Century," in Andrew Porter, ed., *The Oxford History of the British Empire,* vol. 3, *The Nineteenth Century* (Oxford: Oxford University Press, 2001), 1–10, 25–27; John M. MacKenzie, "Empire and Metropolitan Cultures," in Porter, 270–93; Chris Cook, *Britain in the Nineteenth Century, 1815–1914* (London and New York: Routledge, 2005), 56–64, 70, 87; Chauncey B. Tinker, ed., *Selections from the Works of John Ruskin* (Boston: Houghton Mifflin, 1908), passim; Charles Eastlake, *Hints on Household Taste* (4th ed., rev., 1878; repr., New York: Dover, 1969), 5, 40; Rosalind Blakesley, *The Arts and Crafts Movement* (New York and London: Phaidon Press, 2006), 10–25; Doreen Bolger Burke et al., *In Pursuit of Beauty: Americans and the Aesthetic Movement* (New York: Metropolitan Museum of Art, 1986); Susan Weber Soros, *The Secular Furniture of E. W. Godwin* (New Haven and London: Yale University Press for the Bard Graduate Center, 1999), 17, 21, 38–39, 51, 56, 64, 73–76; Juliet Kinchin, "E. W. Godwin and Modernism," in Soros, ed.,

E. W. Godwin: Aesthetic Movement Architect and Designer (New Haven and London: Yale University Press for the Bard Graduate Center, 1999), 105–7.
3. British architects like Bruce J. Talbert were first to publish designs of integrated neo-Gothic spaces featuring Anglo-Japanese objects. The Aesthetic movement was contemporaneously celebrated in the American book *Artistic Houses* (1883–84), which sold by subscription to an elite audience of five hundred patrons. Arnold Lewis, James Turner, and Steven McQuillin, *Opulent Interiors of the Gilded Age: All 203 Photographs from "Artistic Houses" with New Text* (New York: Dover, 1987), v–vi; Roger B. Stein, "The Aesthetic Movement in Its American Cultural Context," in Burke et al., 25–30, 36, 39, 45–46, 48; Lynn, "Decorating Surfaces: Aesthetic Delight, Theoretical Dilemma," in Burke et al., 53–62; Catherine Lynn, "Surface Ornament," 65–66, 76; Blakesley, 38, 33–35, 208–9, 237; Marilynn Johnson, "The Artful Interior," in Burke et al., 111–12; Johnson, "Art Furniture: Wedding the Beautiful to the Useful," in Burke et al., 143–61; James D. Kornwolf, "American Architecture and the Aesthetic Movement," in Burke et al., 341–55, 361.
4. The land was purchased by William P. Williams in 1862 and the house and stable erected prior to 1866. The property also included a two-story carriage house and elaborate gardens. Between 1877 and 1880, the first-floor oriel was expanded into a full rise of bay windows and the interior stairway was enlarged into a living hall. The front portico was also amended into a two-story porch structure. See Alterations Index, vol. 1880–81, Bureau of Buildings, Manhattan-Bronx, New York, F. 1881, 4 West Fifty-fourth Street, Alteration no. 598, Mrs. B. D. Worsham, cited in James T. Maher, *Twilight of Splendor: Chronicles of the Age of American Palaces* (Boston: Little, Brown, 1975), 264, 430; Johnson, "Artful Interior," 112–6, 120, 137; Charles Lockwood, *Bricks and Brownstone; The New York Row House, 1783–1929: An Architectural and Social History* (New York: McGraw-Hill, 1972), 228; Kornwolf, 341.
5. The 1850 census lists Arabella simply as "Catharine" aged 5 months on December 3, 1850. The June 26, 1860 record alternately identifies her as the nine-year-old "Carolina B." Letter from Mrs. Stuart Gibson, Librarian, Valentine Museum, Richmond, Virginia, to Robert R. Wark, Curator of Art, Henry E. Huntington Library and Art Gallery, San Marino, California, June 10, 1969, Valentine Richmond History Center; www.Ancestry.com, *1850 United States Federal Census, Virginia, Richmond (Independent City),* (Provo, Utah: The Generations Network, 1999–2008), roll M432_951, p. 421, image 370, and *1860 United States Federal Census, Virginia, Richmond Ward 1, Henrico,* roll M653_1352, p. 61, image 62. For additional biographical information, see Maher, 247–50.
6. www.Ancestry.com. *1860 United States Federal Census, Virginia, Richmond Ward 1, Henrico,* roll M653_1352, p. 61, image 62, and *Virginia Marriages, 1740–1850.*
7. Richmond was nicknamed "Farobankopolis" after the card game "Faro," played in gambling establishments in which the proprietor served as a "banker." Gregg D. Kimball, *American City, Southern Place: A Cultural History of Antebellum Richmond* (Athens: University of Georgia Press, 2000), 43–44; Maher, 248.
8. Worsham died May 26, 1878. www.Ancestry.com, *1850 United States Federal Census, Virginia, Northern District, Dinwiddie,* roll M432_941, p. 467, image 506, and *1860 United States Federal Census, Virginia, Richmond Ward 2, Henrico,* roll M653_1352, p. 303, image 304; Maher, 248–49, 257; Stephen Birmingham, *The Grandes Dames* (New York: Simon and Schuster, 1982), 190.
9. Worsham's application for amnesty was approved on Nov. 10, 1865, at which time his personal wealth was estimated at $20,000. www.Ancestry.com, *Confederate Applications for Presidential Pardons, 1865–1867;* New York city directory, 1867; www. Ancestry.com, *U.S. IRS Tax Assessment Lists, 1862–1918, New York, District 6, 1865,* NARA series M603, roll 67; Maher, 251, 253.
10. The 1870 New York census is dated June 12. For more information see www. Ancestry.com, *1870 United States Federal Census, New York, Ward 15, District 8, New York,* roll M593_994, p. 597, image 135, and 1870 United States Federal Census, Richmond, Virginia, Jefferson Ward, Richmond (independent city), Virginia, roll M593-1653, p. 500, image 364.

11. The 1873 and 1874 New York city directories list her as the widow of John A. Worsham. See also Maher, 246–47.

12. For more information see Maher, 257–58, 260, 263; New York city directories, 1877–79; www.Ancestry.com, *1880 United States Federal Census, New York, New York (Manhattan), New York City-Greater*, roll T9_895, family history film 1254895, p. 355.2000, enumeration district 578, image 0112; Bennett, 1–5.

13. Maher, 244, 261–63; David Lavendar, *A Great Persuader: A Major Biography of the Greatest of all the Railroad Magnates, Collis P. Huntington* (Garden City, N.Y.: Doubleday, 1970), 244–53, 340, 344, 350–51. Congress passed legislation for the development of a transcontinental railroad in 1862.

14. Whereas the prewar federal census of 1860 records Mrs. Yarrington as having personal property equal to $100, the 1870 census records a property value of $15,000. www.Ancestry.com. *1860 United States Federal Census, Virginia, Richmond Ward 1, Henrico*, roll M653_1352, p. 61, image 62, and *1870 United States Federal Census, New York, New York, Ward 15, District 8*, roll M593_994, p. 597, image 135.

15. Lynn, "Surface Ornament," 76–77.

16. "Smyrna" carpets were Axminster types (knotted, without seams) made in England or America, increasingly in French floral designs. Ibid., 76–85; Johnson, "The Artful Interior," 133; "Art Furniture," 153.

17. According to extant records, the carpet was produced by Mohawk Carpet Mills to consultant Bruce Buttfield's specifications. Likewise, the ceiling canvas and cornices were reproduced according to the originals. The fabric was produced by F. Schumacher and Company. The "fringe, borders, and lining with interlining" were retained from the originals. Five pairs of lace panels were also provided. Samuel H. Gottscho took extensive photographs of the house and interiors in 1937, prior to its demolition. See letter from Otto Haumann, F. Schumacher and Company, to H. Sholle, Museum of the City of New York, December 13, 1937, regarding reproduction of material (copy on file); Bruce Buttfield, Inc., New York, receipt for modern lace panels, period lace bedspread, design for carpet woven by Mohawk Mills (copy on file); Cummings and Engbert, Inc., New York, receipt for ceiling cornices (copy on file); Rudolf Guertler, Decorating and Painting, New York, receipt for reproducing the ceiling and for the removal, cleaning, and installation of wallpaper (copy on file). All material from Rockefeller Family Archives, Sleepy Hollow, New York (hereafter RAC), Record Group: III, 2, I, Series: Homes, Subseries: 4 West 54th Street, Box: 145, 146, Folders: 1449, 1451, 1452, 1453, 1454, 1456. For visual documentation, see Record Group 1005, Series: Homes, Subseries: Photographs by Samuel H. Gottscho, Folder 1003–4 W. 54th Street. Additional photographs are contained in Box 39, Photo Album 1005.

18. According to one report, Rockefeller considered the bed a "museum piece" and first offered it to the Museum of the City of New York in 1935. Helen Worden, "Old Rockefeller Bed Offered to Museum," *New York World-Telegram*, October 30, 1935. Rockefeller Family Archives, Record Group: III, 2, I, Series: Homes, Subseries: 4 W. 54th St/Gift to MCNY, Box 145, Folder 1453, RAC.

19. MacRae to Rockefeller, Rockefeller Family Archives, Record Group: III, 2, I, Series: Homes, Subseries: 4 West 54th Street, Box: 145, Folder: 1452, "West 54th St. #4, 1884," RAC. Recent conservation at VMFA revealed additional bands of satinwood inlay on the door frames beneath a layer of black paint. Further examination is pending.

20. Catherine Hoover Voorsanger, "From the Bowery to Broadway: The Herter Brothers and the New York Furniture Trade," in Katherine S. Howe, Alice Cooney Frelinghuysen, and Voorsanger, *Herter Brothers: Furniture and Interiors for a Gilded Age* (New York: Abrams in association with the Museum of Fine Arts, Houston, 1994), 75; Stein, 28; Johnson, "Art Furniture," 146, 152–53, 158–59; Lynn, "Surface Ornament," 76.

21. Johnson, "The Artful Interior," 130–31; Owen Jones, *The Grammar of Ornament* (1856; repr. New York: Dover, 1987), plates 15, 16, 57.

22. Marshall B. Davidson, ed., *American Heritage History of Antiques; From the Civil War to World War I* (New York: American Heritage, 1969), 112, noted by Robert E. P. Hendrick, object files, Brooklyn Museum.

23. The expense for a set of drapery panels with lace inner panels could run upwards of $1000 per pair. Herter Brothers invoice to John Sloane, March 21, 1882, Brooklyn Museum, cited in Johnson, "The Artful Interior," 135; Joseph Beunat, *Empire Style Designs and Ornaments, a Reprint of Recueil des dessins d'ornements d'Architecture* (New York: Dover, 1974), plate 2, no. 409 and plate 53, no. 702; Jones, plate 95.

24. Lynn, "Surface Ornament," 76–77; Johnson, "The Artful Interior," 129.

25. Jonathan Meyer, *Great Exhibitions: London–New York–Paris–Philadelphia* (Woodbridge, Suffolk, U.K.: Antique Collectors' Club, 2006), illus. 220–21, F35, F36.

26. Prior to the 1860s, firms rarely offered fully integrated interiors. Lynn, "Decorating Surfaces," 53–62; "Surface Ornament," 65–77, 87–89, 95; Johnson, "The Artful Interior," 111–12, 116; "Art Furniture," 143–49; Simon Jervis, "England," in Howe et al., 16–21; Howe, "An Introduction to the Herter Brothers," in Howe et al., 40–41, 49–51; Frelinghuysen, "Patronage and the Artistic Interior," in Howe et al., 78–79.

27. Voorsanger, "From the Bowery to Broadway," 67–69; Frelinghuysen, 90.

28. Johnson, "The Artful Interior," 118; Frelinghuysen, 92, 95, 97–98.

29. David A. Hanks, "George A. Schastey and Company," *Art and Antiques*, September–October 1983, 54–57; Letters from George A. Schastey to John D. Rockefeller, Brooklyn Museum of Art object files; Record of Gift from Employees of Pottier and Stymus to Mr. William P. Stymus, New York, May 1, 1869, Brooklyn Museum of Art object files.

30. See "Pottier and Stymus Co.," *Kings Handbook of New York* (New York, 1893), 854; Clarence Cook, "Beds and Tables," *Scribner's Monthly*, April 1876, 813–14, and "Culture and Progress," *Scribner's Monthly*, August 1874, 500, in Johnson, "Art Furniture," 162, 164; Andrew Boyd, *New York State Directory, 1872, 1873, 1874* (Syracuse, New York: Truair, Smith and Company, 1872), 576; *Atlantic Monthly*, June 1893, 25; Cook, "Beds and Tables, Stools and Candlesticks," *Scribner's Monthly*, October 1876, 798, 803, and January, 1877, 320, 322.

31. Mathilde Bonaparte, later Princess Demidoff, was the daughter of Napoleon's youngest brother, Jérôme Bonaparte. Separated from her husband, she became a highly influential figure during the French Second Empire, helping to secure the restoration of her cousin and one-time fiancée, Charles Louis Napoléon Bonaparte, as Napoleon III. Titled "Notre-Dame des Arts," she was famous for her salons. Arabella's fascination with Second Empire France is suggested by her later lease of the Château de Beauregard. David Baguley, *Napoleon III and His Regime: An Extravaganza* (Baton Rouge: Louisiana State University Press, 2000), 98, 129, 227, 231; Maher, 241.

32. Rockefeller thereafter cited Pottier and Stymus as the "firm of decorators" that completed "the woodwork and interior decoration of 4 West 54th Street for Mrs. Worsham." See letter from Mitchell Samuels, French and Company, to John D. Rockefeller Jr., Record Group: III, 2, I, Series: Homes, Subseries: 4 W. 54th St, 1935–53, Gift to MCNY, Box: 145, Folder: 1453, RAC; letter from John D. Rockefeller Jr. to Mr. Charles Nagel, Director, Brooklyn Museum, January 7, 1954, Brooklyn Museum object files.

33. In 1856, Auguste Pottier became general foreman at Rochefort and Skarren cabinetmakers in New York City, where William P. Stymus was the upholstery foreman. After Rochefort's death in 1859, Pottier and Stymus formed a partnership and took over the firm. A fire in 1888 destroyed many of the company's records. Voorsanger, "From the Bowery to Broadway," 70.

34. Johnson, "Art Furniture," 162; Johnson, "The Artful Interior," 116; Voorsanger and John K. Howat, *Art and the Empire City: New York, 1825–1861* (New Haven and London: Yale University Press for the Metropolitan Museum of Art, 2000), 305; Voorsanger, "From the Bowery to Broadway," 70–72.

35. See *Harper's Bazaar*, September 1887.

36. For more information about Henry and Arabella Huntington, see James Thorpe, Robert R. Wark, and Ray Allen Billington, *The Founding of the Henry E. Huntington Library and Art Gallery: Four Essays* (San Marino, Calif.: Huntington Library, 1969).

37. Recent structural revisions to the Museum of the City of New York precluded the bedroom's and dressing room's reinstallation. The museum subsequently donated the Dressing Room to the Metropolitan Museum of Art, New York.

75. Attributed to **Christian Herter** (1839–1883), designer

Herter Brothers (active 1864–1906), manufacturer

Center Table, 1877–78

New York, New York

Ebonized maple with gilding; gilt bronze

30 ¾ x 56 x 35 in. (78.1 x 142.2 x 88.8 cm)

Museum Purchase, The Adolph D. and Wilkins C. Williams Fund, 90.30

PROVENANCE: Mark Hopkins; to wife Mary Frances Sherwood Hopkins (later Mrs. Edward F. Searles); to son Timothy Hopkins; to wife Mrs. Timothy Hopkins; Estate of Mrs. Timothy Hawkins, Sherwood Hall, Menlo Park, Calif.; sold at auction by Butterfield and Butterfield (October 5, 1942, lot no. 683); Private collection; sold at auction by Butterfield and Butterfield (March 14, 1989, lot no. 87); Margot Johnson, Inc., New York, N.Y.

A striking example of nineteenth-century Aesthetiscism, this table represents Herter Brothers' creative blending of neo-Egyptian form with Gothic- and Asian-inspired ornament. The rectangular top above trilateral legs records the enduring influence of Egyptian designs brought to the West by Napoleon's Egyptian Campaign (1798–1801).[1] The post-and-lintel arrangement of the table's overall form is repeated in the horizontal-vertical relationship of its component parts: the elongated H-frame stretcher; the perpendicular screens

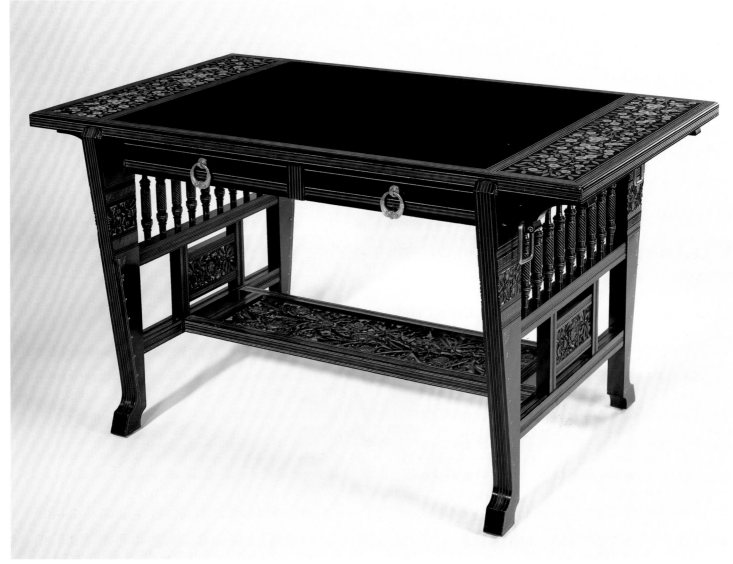

composed of horizontal segments; and the vertical neo-Gothic turnings above three-part horizontal panels. This dialogue is further reiterated in the series of reeded and gilt-incised bands that outline the structure—top, drawers, stretcher, legs, side panels—and is conceptually similar to the "Egyptian Ornament" reproduced in Owen Jones's *The Grammar of Ornament* (1856), the "bible" of Aesthetic design.[2] Reinforcing this Near Eastern sensibility is a group of low-relief friezes framed by fretwork bands commonly called "Greek key" but typical to many parts of the ancient world.

If some aspects of the form of the Herter Brothers table invoke ancient sources, others reflect contemporary Aesthetic taste. Shallow-relief panels of partially gilded sunflowers—a signature motif of English Aestheticism—enliven the vertical screens. Moreover, recalling the example of Asian art and its controlled arrangement of ornament in space, the table displays an ebonized finish and Christian Herter's celebrated marquetry (fig. 128), which is compressed and polarized by mahogany borders to the edges of the table's surface.[3] The decorative pattern of the inlay links this table with other components of the integrated interior that was conceived by the firm's chief designer, Charles Atwood, for railroad magnate Mark Hopkins.[4] Treasurer of the Central Pacific Railroad and partner of Collis P. Huntington (see cat. no. 74), Hopkins purchased a corner lot at California and Mason Streets in San Francisco's Nob Hill in 1875. He subsequently commissioned the architectural firm of Wright and Saunders to design a thirty-four-room home in the French-Gothic château style (fig. 129).[5] Shortly thereafter, Atwood began fashioning a series of thematically orchestrated rooms based on the diverse Aesthetic paradigm.[6] The salon featured doors and dado inlaid with flowering cherry branches, walls hung with floral brocade, and a frieze of relief-carved panels. At the room's center stood this table.[7] Although commissioned by Hopkins, the project proceeded under the guidance of his wife, Mary; Mark Hopkins died before work was completed.[8]

The Hopkins interiors marked the Herter company's recent foray into Aestheticism, which was occasioned by the transition in artistic leadership from Gustave Herter (see cat. no. 63) to his half-brother Christian. Whereas Gustave had advertised "Decorations, Furniture and Upholstery," Christian expanded the firm's fashionable offerings in the 1870s to

FIG. 128 Detail of **marquetry,** cat. no. 75.

FIG. 129 **Mark Hopkins residence,** 1875–1906, San Francisco, California, ca. 1888–90, photograph.

include a full-service inventory of furniture, decorative objects, frames, interior woodwork, decorative painting, upholstery, and textiles.[9] Christian's travels and studies abroad brought a sophisticated knowledge of the English reform movement to the firm's stylistic vocabulary and a unique ability to use it in combination with more conventional designs.[10] The result was a fusion of ebonizing, marquetry, and stylized carving inspired by Near and Far Eastern sources, as well as a variety of specialty details—in metalwork and textile, for example—imported from European suppliers.[11] Such eclecticism was reiterated at world's fairs. Most significantly, Philadelphia's Centennial

Exhibition of 1876 introduced and promoted the lexicon of ancient, Asian, and Gothic motifs resonant in Herter's distinct brand of Anglo-Japanese design.[12]

Typical of Herter clients, Mark Hopkins belonged to a class of patron whose newly acquired wealth served as a catalyst for the development of interior decoration. The Aesthetic movement endorsed key rules for the demonstration of a progressive taste that reflected not only one's social and economic standing but one's degree of refinement. Without training or experience in the interior arts, these patrons turned to professionals.[13] Wide usage of the term "interior decorator" came about in the decade after the Civil War to distinguish those individuals or firms that were self-proclaimed arbiters of taste.[14] The success of Herter Brothers and the expansion of "art" manufactures depended on this mutually beneficial relationship.

<div align="right">SJR</div>

NOTES

1. See, for example, an architectonic slab-form console table illustrated in "Perspective View of the Bedroom of *Citoyen* V. in Paris," by Charles Percier and Pierre-François-Leonard Fontaine, Napoleon's official architect-designers, in *Empire Stylebook of Interior Design: All 72 Plates for the "Recueil de decorations interiors," with New English Text* (1801; repr., New York: Dover, 1991), plate 13.
2. Owen Jones, "Egyptian Ornament," in *The Grammar of Ornament* (1856; repr., New York: Dover, 1987), plates 7–8.
3. Marilynn Johnson, "The Artful Interior," in Doreen Bolger Burke et al., *In Pursuit of Beauty: Americans and the Aesthetic Movement* (New York: Metropolitan Museum of Art, 1986), 128; Katherine S. Howe, Alice Cooney Frelinghuysen, and Catherine Hoover Voorsanger, *Herter Brothers: Furniture and Interiors for a Gilded Age* (New York: Abrams in association with the Museum of Fine Arts, Houston, 1994), 111.
4. Voorsanger, "Center Table," in Howe et al., 184–85.
5. Voorsanger, "The Mark Hopkins Residence," in ibid., 180–81.
6. This "Queen Anne" eclecticism was a departure from the modern Gothic. Marilynn Johnson, "Art Furniture: Wedding the Beautiful to the Useful," in Burke et al., 143–49, 153, 158–61.
7. David Park Curry, "The Painting Over the Table," *Source: Notes in the History of Art* 24 (Winter 2005): 62; Voorsanger, "Center Table," 185.
8. Frelinghuysen, "Patronage and the Artistic Interior," in Howe et al., 86–87; Voorsanger, "The Mark Hopkins Residence," 180–81.
9. Herter Brothers invoice to Mrs. Cobby, 316 East Eighteenth Street, New York, July 17, 1871, collection of Currier Gallery, Manchester, New Hampshire, cited in Frelinghuysen, 79–80.
10. Although listed in the New York City directory as early as 1859, Christian's residency in Paris, in about 1868, gave him immediate access to the wide scope of furniture displayed at the 1869 Paris Univeral Exposition. Howe, "An Introduction to the Herter Brothers," in Howe et al., 45–46.
11. Ibid., 53–55.
12. Many of the company's Anglo-Japanese designs may be attributed to the French-born Alexandre Sandier, who went on to become the director of works at Sèvres. Clarence Cook, *The House Beautiful: Essays on Beds and Tables, Stools and Candlesticks* (1881; repr., Mineola, N.Y.: Dover, 1995), 108, no. 40; Howe,

"Introduction," 49–53; Simon Jervis, "England," in Howe et al., 20; Voorsanger, "From the Bowery to Broadway," in Howe et al., 69–70; Marie-Noëlle Pinot de Villechenon, *Sèvres: Porcelain from the Sevres Museum 1740 to the Present Day*, trans. John Gilbert (1993; London: Lund Humphries, 1997), 105–6; Phillipe Burty, "Les industries, de luxe àl Exposition de l'Union Centrale," *Gazette des Beaux-Arts* 2, no. 2 (1869): 530–31, cited in Marc Bascou, "France," in Howe et al.
13. Johnson, "Artful Interior," 111–12, 116; Voorsanger, "From the Bowery to Broadway," 74.
14. Johnson, "Artful Interior," 116.

76. Edwin Austin Abbey (1852–1911)

Tile Fireplace Surround, 1878

Hand-painted Minton, Hollins, and Company ceramic tiles, inset in ferrous metal surround
38 ¼ x 24 in. (97.2 x 61 cm)
Museum Purchase, The J. Harwood and Louise B. Cochrane Fund for American Art, 2008.39

PROVENANCE: Installed in Floyd Field house, Astoria (Queens), N.Y., ca. 1900–90s; Private dealer, New York, N.Y.; Martin Cohen, New York, N.Y.

This rare surviving example of a popular late-nineteenth-century applied art form epitomizes the cultural spirit and varied production of American Aestheticism, a movement founded on the belief that daily life could be improved by wedding the beautiful to the useful. Inspired by such English reformers as Christopher Dresser and William Morris, Aesthetic producers and consumers in the years after America's centennial embraced domestic design with newfound artistic vigor. In their quest to create "the house beautiful"—that is, an ideal setting for moral and aesthetic development—they cultivated America's first full-fledged lifestyle movement.

This fireplace surround, the work of American painter, illustrator, and muralist Edwin Austin Abbey, was executed under the auspices of the Tile Club, a fraternal association of multitalented New York art professionals. Whereas the name derived from the group's initial organizing activity—the decoration of eight-inch glazed tiles, manufactured by the famous British firm Minton and Company—the weekly meetings were dedicated to artistic experimentation in a variety of media as well as to discussions of market trends. The club was conceived by English artist Walter Paris and English architect Edward Winbridge at Paris's Union Square studio. Abbey and Charles Stanley Reinhart, then best known as house

FIG. 130 Attributed to Arthur Osborne (1855–1942), designer, for J. and J. G. Low Art Tile Works (active 1877–1902), **Tile Andirons,** Chelsea, Massachusetts, 1884, glazed ceramic tiles, inset in ferrous metal, 18 ½ x 10 x 22 in. (47 x 25.4 x 55.9 cm) each. Virginia Museum of Fine Arts Purchase, The J. Harwood and Louise B. Cochrane Fund for American Art, 2009.4.1–4.

An ideal setting for tiled decoration was the hearth, which remained a focal point in late-nineteenth-century domestic interiors—less as a source of heat and light than as an artistic and symbolic centerpiece associated with family values and traditions. In addition to fireplace surrounds, other hearth accessories received lavish tile embellishment. A remarkable example, also in VMFA's collection, is a pair of andirons (fig. 130), likely designed for the Low firm by English-trained sculptor Arthur Osborne.[3]

The artistic and commercial interests that created the tile industry in England and America also influenced the Tile Club's choice of medium. As a miniature canvas, the tile was the most suitable of all ceramic forms for painted design. Moreover, its widespread availability and low cost marked it as a "democratic" art form that embodied the progressive agenda of Anglo-American Aestheticism.[4]

Compared to other club members, Homer and Abbey approached their tile work with great seriousness, producing the only known fully realized fireplace surrounds. The two also created individual painted tiles that related directly to their contemporary "fine" art. Homer, for instance, rendered the same pastoral scenes of shepherds and shepherdesses on tiles, in oil paintings, and in watercolors, and Abbey's tile work treated such Anglo-American subjects as "Puritan" (or "Queen Anne") maidens in a Japanesque style—the fashionable fine-art theme depicted in this fireplace surround. Likely design sources ranged from seventeenth-century Dutch tiles and the Colonial Revival phenomenon popularized at the nation's centennial to the contemporary English work of Walter Crane—all of which can be considered under the Aesthetic rubric. There is some evidence that both artists may have intended to pursue commercial production of their tile designs; Homer copyrighted one of his two fireplace surrounds, produced, like Abbey's, in 1878.[5]

Although not as well known today as Winslow Homer, Abbey, in his time, was internationally acclaimed for his illustration work as well as for his easel and mural paintings of American and English historicized subjects. (As a young painter in his native Holland, Vincent van Gogh came to admire Abbey's art through the publications of the Tile Club.) In addition to his academic bona fides, Abbey maintained a profile in more progressive artistic circles. A cofounder of the

illustrators for Harper and Brothers publishers, attended the second meeting. Eight more men joined the company within the first few months, including painters Winslow Homer and Julian Alden Weir as well as artist-writers William Mackay Laffan and Earl Shinn (who wrote under the name Edward Strahan). Later members included William Merritt Chase, Augustus Saint-Gaudens, Elihu Vedder (see cat. nos. 72, 92, 93, and 87), and Stanford White. Couching their decorative interests in the rhetoric of playful bonhomie, the Tilers sought to capitalize on the public's growing fascination with Aesthetic culture in particular and artistic lifestyles in general.[1]

The display of British tile production at America's first world's fair—the 1876 Centennial International Exhibition held in Philadelphia—sparked a mania for ceramics in this country. The versatility of inexpensive decorative tiles in interior and exterior domestic design accounted for their special appeal. The J. and J. G. Low Art Tile Works was one of numerous tile manufacturers established soon after the fair to meet and encourage the consumer demand for the fashionable household art. Low quickly distinguished itself as one of the most acclaimed tile producers, sharing international honors with such renowned firms as Minton and Company.[2]

THE TILE CLUB AT WORK.

"This is a decorative age," said an artist. "We should do something decorative, if we would not be behind the times."

"Stuff!" said another. "It will all be over soon. It is only a temporary craze, a phase of popular insanity that will wear itself out as soon as a new hobby is presented to take its place. Of course it has interfered with the sale of our pictures. I don't dispute that; but would you have us make old brass fenders and andirons, or paste paper jimcracks on old ginger-jars?"

"Or turn carpenter," added a third, "and make Eastlakey things?"

"Your allusions to brass," said the first speaker, gravely, "are irrelevant, and that remark about ginger-jars is an uncalled-for aspersion upon the crude, incipient struggles of the female of our species to be decorative. The popular interest in all matters that pertain to decoration, domestic and otherwise, is a healthy outgrowth of the artistic tendency of our time, and an encouraging evidence of the growing influence of our methods of art education and of the public disposition to take an active, practical interest in things that are more or less nearly allied to art itself."

"Admirable!" said a person of an iron-

Vol. XVII.—33.

TILES FOR A MANTLEPIECE.

ical turn. "Spoken like a furniture man, keenly alive to a sense of the beautiful in his 'umble profession, but 'opeful of its future helevation to a 'igher plane——"

"Silence!" said the advocate of modern principles, with a becoming glance of reproof. "It is just this disposition to shallow, ignorant, and captious criticism among persons who call themselves artists that misleads people of ordinarily wholesome tendencies. If those who in the nature of things, should be artists by instinct and edu-

FIG. 131 Edwin Austin Abbey (1852–1911), **Tiles for a Mantlepiece,** in W. Mackay Laffan, "The Tile Club at Work," *Scribner's Monthly,* January 1879.

Broadway group in England's Cotswolds—a popular artist community that hosted the likes of John Singer Sargent (see cat. nos. 84 and 91) and writer Henry James—Abbey maintained a career on both sides of the Atlantic. His reputation culminated during the so-called American Renaissance when he became renowned for his ambitious mural-painting cycles executed for public libraries and state capitols from Boston, Massachusetts, to Harrisburg, Pennsylvania.[6]

Little documented information on the early history of Abbey's fireplace surround exists, but it may have once been installed in the artist's former New York studio, which served as the Tile Club's headquarters from 1881 to 1887. A detail of the design appeared as a black-and-white woodcut illustration (fig. 131) in the first in a series of *Scribner's Monthly* articles on the club.[7] The surround later turned up in a large Victorian home owned by the Field family of Astoria (Queens), New York. When the house was slated for demolition in the 1990s,

it was removed by a local antiques dealer and surfaced on the market a decade later.[8] SY

NOTES

1. For more on the history and activities of the Tile Club, see Sylvia Yount, "Give the People What They Want: The American Aesthetic Movement, Art Worlds, and Consumer Culture, 1876–1890" (Ph.D. dissertation, University of Pennsylvania, 1995), 159–70; and Ronald G. Pisano, *The Tile Club and the Aesthetic Movement in America,* exh. cat. (New York: Museums at Stony Brook, 1999).

2. Minton's popular reputation largely derived from its decorative tile production, and its fame in America quickly followed the firm's major showing at the Centennial Exhibition. For an overview of Aesthetic tile production in England and America, see Alice Cooney Frelinghuysen, "Aesthetic Forms in Ceramics and Glass," in Doreen Bolger Burke et al., *In Pursuit of Beauty: Americans and the Aesthetic Movement* (New York: Metropolitan Museum of Art in association with Rizzoli, 1986), 231–35.

3. Anna Tobin D'Ambrosio, "The Rage for Brass," in *A Brass Menagerie: Metalwork of the Aesthetic Movement,* exh. cat. (Utica, N.Y.: Munson-Williams-Proctor Arts Institute, 2005), 22–24. See also "Poems in Clay: Arthur Osborne's 'Plastic Sketches' for the Low Art Tile Works," exh. brochure (Erie, Penn.: Erie Art Museum, 1999).

4. Signficantly, members of the Tile Club (including Abbey) paid a ca. 1882 visit to the Chelsea, Massachusetts, headquarters of the Low Art Tile Works, where they painted and fired tiles. See George William Curtis, "How it Came About," in *Harper's Christmas: Pictures and Papers Done by the Tile Club and Its Literary Friends* (New York: Harper's, 1882), 2.

5. Nicolai Cikovsky Jr., *Winslow Homer,* exh. cat. (Washington, D.C.: National Gallery of Art and Yale University Press, 1995), 101–2. For discussion of the larger cultural context for Homer's pastoral tile designs, see Sarah Burns, "The Pastoral Ideal: Winslow Homer's Bucolic America," in *Frederic Church, Winslow Homer, and Thomas Moran: Tourism and the American Landscape,* exh. cat. (New York: Cooper-Hewitt National Design Museum, Smithsonian Institution, and Bulfinch Press, 2006), 128–31.

6. Yale University Art Gallery, *Edwin Austin Abbey, 1852–1911,* exh. cat. (New Haven: Yale University Art Gallery, 1973). See also Marc Simpson, "Windows on the Past: Edwin Austin Abbey and Francis Davis Millet in England," *American Art Journal* 22 (1990): 64–89. For more on Van Gogh's appreciation of Abbey's work, see Joyce A. Sharpey-Schafer, *Soldier of Fortune: F. D. Millet, 1846–1912* (Utica, N.Y.: privately printed, 1984), 64.

7. W. Mackay Laffan, "The Tile Club at Work," *Scribner's Monthly,* January 1879, 401.

8. Martin Cohen to Sylvia Yount, April 1, 2008. See also Karen Zukowski, "The Artistic Hearth: The Fireplace in the American Aesthetic Movement," *The Magazine Antiques* 173 (March 2008): 92. Zukowski was the first to publish a color image of the full surround, to attempt to document its provenance, and to bring its existence to my attention.

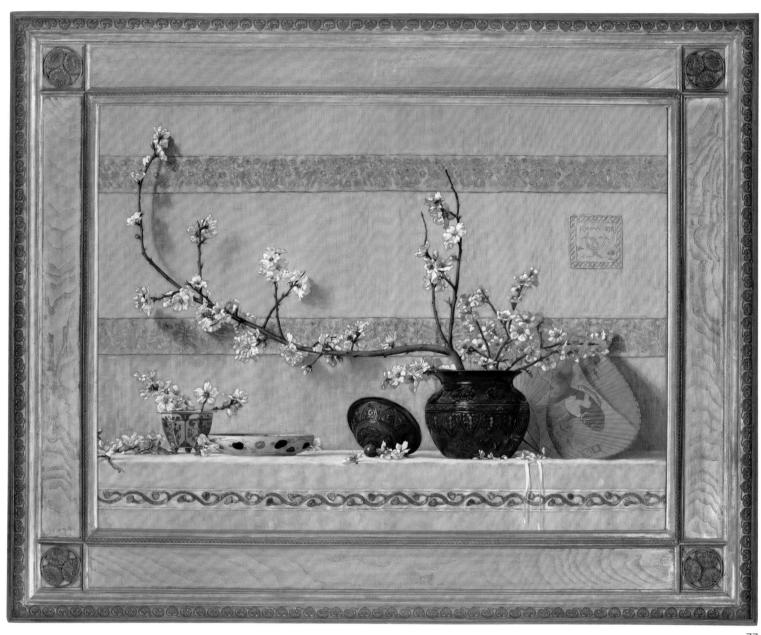

77. Charles Caryl Coleman (1840–1928)

Quince Blossoms, 1878

Oil on canvas

31 ¾ x 43 ⅝ in. (80.7 x 110.7 cm)

Inscribed, dated, and signed with monogram center right: "ROMA
1878 / CCC"

Museum Purchase, The J. Harwood and Louise B. Cochrane Fund for
American Art, 90.29

PROVENANCE: Alexander M. Lindsay, Rochester, N.Y. (after 1883–1920); by descent in the family; Stan Lutomski, Rochester, N.Y. (ca. 1982–84); sold at auction by William Doyle, New York, N.Y. (October 24, 1984); Graham Williford, New York, N.Y. (1984–1987); Private collection, New England (1987); Jordan-Volpe Gallery, New York, N.Y. (1989)

Charles Caryl Coleman was ranked by his late-nineteenth-century contemporaries as the preeminent painter of "decorative" still lifes set in harmonious artist-designed frames. He remains best known for such refined work, exemplified by *Quince Blossoms*. Produced in Italy for an international clientele, the picture belongs to a series of some fourteen paintings featuring precisely arranged flowers and bric-a-brac from the artist's personal collection. Whereas some were commissioned as part of a decorative interior scheme for private residences, VMFA's example is a singular masterwork of the genre. Indicative of his high regard for the painting, Coleman submitted it to the Paris Salon of 1878 as well as to the 1883 annual exhibition of the Pennsylvania Academy of the Fine Arts in Philadelphia.[1]

A native of Buffalo, New York, Coleman entered the progressive Paris atelier of Thomas Couture in 1859 before moving to Florence, Italy, one year later. He returned to the United States in 1862 to join the Union cause during the Civil War. After being wounded the following year on Folly Island, South Carolina, he was honorably discharged. He maintained a New York studio until 1866 when he returned permanently to Italy.[2] Along with his close friend Elihu Vedder (see cat. no. 87), Coleman was at the center of American expatriate circles in Rome. An avid collector and colorful personality known for his sumptuous studio filled with "rich-hued satins, rare old brocades, tapestry, faience and bric-a-brac," Coleman realized his greatest artistic achievement in 1886 when he converted a guest house at a former convent on the

island of Capri into an elaborate home and studio. Suitably named Villa Narcissus (period photographs taken there reveal the self-fashioning artist's taste for costumes and theatrical trappings), the eclectic structure of Roman, Pompeian, and Moorish architectural details was further embellished with Coleman's own inspired handiwork.[3]

This interest in seeking decorative effects through the combination of styles and cultures—represented by various artistic objects and historical artifacts—lay at the heart of the late-nineteenth-century Aesthetic movement as well as Coleman's fashionable decorative panels.[4] In these years, artists sought out bric-a-brac—both unique historical objects and contemporary reproductions—as decoration and props for studio interiors, setting a trend among upper- and middle-class consumers for similar Aesthetic accumulation and display. Coleman's younger colleague William Merritt Chase, also an inveterate collector and aesthete, famously documented his

FIG. 132 William Merritt Chase (1849–1916), **In the Studio,** 1884, pastel on paper, 39 x 22 ½ in. (99.1 x 55.9 cm). Collection of James W. and Frances G. McGlothlin, Promised Gift to Virginia Museum of Fine Arts.

New York studio in a series of figurative oils and pastels throughout the 1880s (fig. 132). As symbols of progressive taste, the studio trappings themselves became legitimate subjects for paintings, still lifes in particular, literally expressing the widespread collecting mania.[5]

The vogue for bric-a-brac and its representation on canvas—that is, art about art—captivated many Aesthetic producers and consumers in the late 1870s.[6] Vedder himself, perhaps inspired by his friend, tried his hand at the genre with *Japanese Still Life* (fig. 133). More static and stylized than Coleman's panels, Vedder's picture, with its characteristic Aesthetic components, reveals a theatrical attention to the placement of inanimate objects, from textiles and screens to prints and ceramics. A pearly pink and white shell sheathed in silk evokes the harmony of organic and manufactured decoration.[7]

By comparison, Coleman's *Quince Blossoms* sparkles with naturalistic and animated life—a quality enhanced by the graceful arabesques of the blossoms (both on and off the branch), the floral motifs of the Chinese export porcelain, and the Near Eastern ornamental embroidery. While the branch's clearly defined shadow suggests a play between naturalism and abstraction, the tangibility of the depicted objects asserts itself. The precariously positioned lid of the glazed earthenware jar, the gently dangling trompe-l'oeil satin ribbon, and even the swimming carp on the painted Japanese paper fan create a lively dynamic in flowing patterns, revealing the hand of an artful arranger.[8]

Compositionally more daring and subtle than Vedder's bright-hued oil, *Quince Blossoms* displays a spare linearity, asymmetry, and flatness—as well as what one critic termed Coleman's "delicate appreciation of values"—that are also more inherently Asian.[9] The harmonious and well-balanced placement of the objects is staged by the artist in a shallow foreground and set against a textile backdrop. The flat horizontal bands of intricately brocaded linen—decorated with fanciful creatures and arabesques stitched in gold, pink, and blue thread—create an ornamental rhythm above and (in a different multicolored pattern) below the draped ledge, denying the spatial recession found in Vedder's depicted studio corner. Coleman's triple-C monogram in a faux-embroidered cartouche at center right further enhances the picture's planar qualities, as does the rectilinear carved and gilded *cassetta*

FIG. 133 Elihu Vedder (1836–1923), **Japanese Still Life,** 1879, oil on canvas, 21 ½ x 34 ¹³⁄₁₆ in. (54.5 x 88.4 cm). Los Angeles County Museum of Art, Gift of the American Art Council.

FIG. 134 Photograph of **Tiffany and Company coffee service,** ca. 1878.

frame with triple lotus-leaf borders and corners that echo the monogram and the painted motifs.

As both a document of Coleman's cherished treasures and a statement of Aesthetic taste and purpose, *Quince Blossoms* also shares pictorial conventions with more commercial practices. Widely circulated prints of the popular Japanese displays at the 1876 Centennial International Exhibition as well as studio photographs of Tiffany and Company wares (fig. 134) parallel Coleman's decorative arrangement and evoke the dialogue between art and commerce that shaped the Anglo-American Aesthetic movement.[10] SY

NOTES

1. Coleman also produced Italian landscapes and figure paintings throughout his career but distinguished himself in the decorative still-life genre. One contemporary critic, while praising such imagery, linked it to the artist's lack of "imagination or strong creative ability." See "Charles C. Coleman," *Art Amateur* (February 1880): 45–46. Adrienne Baxter Bell, who is working on the Coleman catalogue raisonné, has identified fourteen such decorative panels. See her unpublished paper "Charles Caryl Coleman: Framing Eccentricity," *Initiatives in Art and Culture Symposium—The Transformative Power of the Frame*, City University of New York, September 20, 2008, VMFA curatorial files. See also Catherine Hoover Voorsanger, Charles Caryl Coleman entry in "Dictionary of Architects, Artisans, Artists, and Manufacturers," *In Pursuit of Beauty: Americans and the Aesthetic Movement*, exh. cat. (New York: Metropolitan Museum of Art and Rizzoli, 1986), 410. VMFA's painting was exhibited in Paris as *Branches de pommier en fleurs (Branch of Apple Blossoms)* and in Philadelphia as *Almond Blossoms*, suggesting the imprecise identification of the subjects of Coleman's works, which were generically called "decorative panels." It is unknown when the present title, *Quince Blossoms*, was first assigned, but the picture's Asian overtones may have inspired the retitling as the flowering quince was commonly referred to as "japonica" in the nineteenth and early twentieth centuries. A sticker on the verso of the painting confirms the 1883 Pennsylvania Academy of the Fine Arts (PAFA) display; the catalogue for the 1883 annual exhibition documents its appearance with another "decorative panel," *White Azaleas*, as well as its sale price of $600. My thanks to PAFA archivist Cheryl Leibold for sharing the relevant catalogue pages.

2. According to an unidentified biographical entry in the VMFA curatorial files, Coleman joined Company K, 100th Regiment, New York Volunteers as second lieutenant in September 1862. The 1863 war wound in his left jaw resulted from the accidental discharge of a fellow officer's revolver; Coleman received a disability pension and was in poor health for years.

3. "Charles C. Coleman," 45. The English artist Walter Crane, part of the Vedder-Coleman circle, called Coleman's abode on Via Margutta "the most gorgeous studio of bric-a-brac of any" in Rome. See Walter Crane, *An Artist's Reminiscences* (London: Macmillan, 1907), 129. For an extended description of Coleman's object-filled interiors, see "A Roman Studio," *Decorator and Furnisher* (December 1884): 86–87; the article's woodcut illustrations reveal how Coleman incorporated his decorative panels into an elaborate and historically eclectic design scheme. For a description of his later, equally fanciful Capri home, see Charles de Kay, "A Villa in Capri," *Architectural Record* 12 (1902): 71–92. Vedder, also a collector and owner of a treasure-filled Capri villa, may have collaborated with Coleman on frame designs for his own paintings, for example VMFA's *The Cup of Death* (see cat. no. 87). Both artists' interest in frames was likely inspired by their friendship with the architect and frame designer Stanford White. Coleman designed two types of carved frames for his decorative still lifes—a flat, rectilinear style with corner rosettes of lotus leaves and more elaborate panels of gilded Renaissance-style grotesques. Coleman's younger brother, Caryl Coleman, also worked in the Aesthetic design field—namely, as the New York agent for the leading American tile firm, J. and J. G. Low Art Tile Works (see cat. no. 76), and as the founding editor of the short-lived but influential journal *Art and Decoration* (1885–86), in which his writings championed different contemporary art forms. See Voorsanger, 410.

4. For an examination of the many Aesthetic influences on Coleman's work dating from an 1876 visit to London, where he mixed with progressive artists and designers, as well as from the inspiring Japanese displays at Philadelphia's Centennial Exhibition, see Jonathan Stuhlman, "Towards an Integrated Understanding of Charles Caryl Coleman's Decorative Panels" (seminar paper, University of Virginia, 2001), 15–20, VMFA curatorial files. See also Bell for her discussion of the influence of Pre-Raphaelite frames on Coleman's designs (7–8).

5. Annette Blaugrund, "William Merritt Chase's Studio: The Ultimate Marketing Tool," in *The Tenth Street Studio Building: Artist-Entrepreneurs from the Hudson River School to the American Impressionists*, exh. cat. (Southampton, N.Y.: Parrish

Art Museum, 1997), 105–27. See also Sarah Burns, *Inventing the Modern Artist: Art and Culture in Gilded Age America* (New Haven and London: Yale University Press, 1996), 46–76.

6. John La Farge, the first painter to enter the decorative arts field in America, is credited with setting the precedent for Aesthetic still lifes. The genre was also embraced by such progressive painters as Julian Alden Weir as well as the trompe l'oeil specialist William Michael Harnett. For more on the phenomenon, see Sylvia Yount, "Commodified Displays: The Bric-a-Brac Still Lifes," in *William M. Harnett*, exh. cat. (New York: Metropolitan Museum of Art, 1992), 243–51.

7. Vedder's collecting habit may have been fed by his brother, who served as a naval physician in Japan from 1865 until his death in 1870, at which time a large collection of Japanese artifacts came into the artist's possession. See Elihu Vedder, *The Digressions of V. Written for His Own Fun and That of His Friends* (Boston: Houghton Mifflin, 1910), 316–17, and Joshua Taylor, *Perceptions and Evocations: The Art of Elihu Vedder*, exh. cat. (Washington, D.C.: National Collection of Fine Arts, 1979), 106.

8. David Park Curry, VMFA's former curator of American art who acquired the Coleman, identifies the specific objects in "The Painting over the Table," *Source: Notes in the History of Art* 24 (Winter 2005): 60–69.

9. "Charles C. Coleman," 46.

10. Significantly, the first owner of VMFA's painting, Alexander M. Lindsay, was a Scottish-born dry-goods merchant in Rochester, New York—cofounder of Sibley, Lindsay and Curr—suggesting the sympathetic relationships that existed in the Aesthetic age between artistic display in private and public settings, particularly department stores. See Curry, 62, and Yount, 247–49.

78. James McNeill Whistler (1834–1903)

Sotto Portico—San Giacomo, 1879–80

Pastel and charcoal on brown woven paper

12 x 5 in. (30.5 x 12.7 cm)

Signed lower left with artist's butterfly

Museum Purchase, The J. Harwood and Louise B. Cochrane Fund for
 American Art, 2002.524

PROVENANCE: William B. Osgood Field (by 1912); by descent to private collection, New York, N.Y.; sold at auction by Sotheby's, New York, N.Y. (May 24, 2000, sale no. 7480, lot no. 6); Private collection, Vt.

James McNeill Whistler's Venetian pastels of 1879–80 mark a turning point in the career of this innovative, influential, and controversial artist. Following his bankruptcy, wrought by his famous libel case against John Ruskin, Whistler went to Venice on commission from London's Fine Art Society to produce a dozen etchings of the famous Italian city. Asked to return in three months, he remained for fourteen, creating fifty etchings, a hundred pastels, and a few oils—a body of work that has never lost the power to engage the eye.

When Whistler arrived in Venice during the fall of 1879, the beautiful but decaying city had become almost a cliché

78

in artistic circles. However, Whistler saw *La Serinissima*— "the most serene republic"—as no other artist had before him. While the models he chose were not J. M. W. Turner or Richard Parkes Bonington, but Francesco Guardi and Canaletto, Whistler injected a modernist spirit into the work. "I have learned to know a Venice in Venice that the others seem never to have perceived," he wrote.[1] Avoiding tourist routes, Whistler explored the humble backwater canals, the modest courtyards, and the empty salons of impoverished palazzos. The ragged urchins and fluttering laundry in many of these images predate by two decades the much harsher urban Realism of early-twentieth-century American artists. The identification of Whistler's art in general and pastels in particular with early-twentieth-century modernism is eloquently underscored by the use of *Sotto Portico—San Giacomo* as the frontispiece to the 1912 book *Whistler's Pastels and Other Modern Profiles* by avant-garde painter, critic, and collector Albert Gallatin.[2]

In *Sotto Portico* Whistler used a compositional device he came to favor in Venice—a distant view focused through layers of intervening architecture. A *sotto portico* is a pedestrian passageway that cuts under buildings into otherwise-hidden courtyards. The site has recently been identified as a still-extant narrow passageway in the Santa Croce quarter near the Campo San Giacomo da l'Orio.[3] Whistler was looking west into the sunlit *campo,* or large city square.

Layers of gray blue and gray white, punctuated by smaller patches of turquoise and acid green, shimmer and float upon the brown paper, much of which is left bare. Whistler leads the eye down by means of a stick chair in primary yellow at the passageway's near end. Resting before it is a large box made bright by a heap of blue Venetian beads, a theme recalled in his contemporaneous etching of *Bead Stringers* (fig. 135). The artist fixes his coral butterfly signature just above the chair. Rich color pulls the eye farther through the shadowy passageway into the almost blinding white light of the sunny courtyard beyond. There, with a few tiny, deft strokes, Whistler conveys Venetian women leaning on an old wellhead.

Always eager to stretch the artistic envelope, Whistler practiced advanced Aestheticism, creating formal, almost abstract relationships of color and line. Narrative elements are suppressed or hidden beneath glittering surface layers, a practice that became popularly known as "art for art's sake."

FIG. 135 James Abbott McNeill Whistler (1834–1903), **Bead Stringers, from A Set of Twenty-Six Etchings,** 1880, etching, 8 15/16 x 5 7/8 in. (22.7 x 14.9 cm). Virginia Museum of Fine Arts, Bequest of John Barton Payne, 35.1.47.

But Whistler reassured viewers accustomed to story-telling pictures by choosing something familiar—in this case, old Venetian buildings—as a departure point.

Upon Whistler's return, his Venetian images were displayed in a series of controversial exhibitions that took London by storm and presaged contemporary performance art.[4] Properly confounded, a humorist for *Punch* magazine described *Sotto Portico,* the first pastel featured in the 1881 exhibition at the Fine Art Society, as "a sort'o portico. Pretty clear so far." The exhibition was the most elaborate Whistler had designed, and it included special frames, mostly yellow gold, but a few in green gold "dotted about with a view to decoration."[5]

More than a century after Whistler wandered the quiet courtyards and back alleys of Venice, his exquisite pastels remain among the most eloquent testaments to the evanescent beauty of this often-painted city. With its masterful and compelling composition and distinguished history as the lead object in Whistler's groundbreaking exhibition of 1881, *Sotto Portico—San Giacomo* is one of the finest Whistler pastels extant. DPC

NOTES

1. Whistler to Marcus Huish, January 1880, Glasgow University Library archives, GUL LB3/8.

2. Albert Eugene Gallatin, *Whistler's Pastels and Other Modern Profiles* (New York and London: John Lane, 1912), frontispiece. See also David Park Curry, *James McNeill Whistler: Uneasy Pieces* (Richmond: Virginia Museum of Fine Arts in association with the Quantuck Lane Press, New York, 2004), 4, 7, 16, fig. 2 (frontispiece).

3. Alastair Grieve, *Whistler's Venice* (New Haven and London: Yale University Press for the Paul Mellon Centre for Studies in British Art, 2000), 59, 61, figs. 47 and 48.

4. David Park Curry, "Total Control: Whistler at an Exhibition," in *James McNeill Whistler: A Reexamination,* vol. 19, *Studies in the History of Art* (Washington, D.C.: National Gallery of Art, 1987), 76–77.

5. "Venice Pastels," Whistler's Press Clippings, 1881, 4:39, Glasgow University Library, quoted in ibid., 77. *Sotto Portico* is presently housed in a replica frame that copies a surviving original by F. H. Grau. The original is now in the collection of the Freer Gallery of Art.

79. A. and H. Lejambre (active 1865–ca. 1907), manufacturer

Occasional Table, ca. 1880

Philadelphia, Pennsylvania

Mahogany; brass, copper, silver, mother-of-pearl

28 ¼ x 35 ⅝ x 20 in. (71.7 x 90.4 x 50.8 cm)

Gift of John C. and Florence S. Goddin, by exchange, 92.3

PROVENANCE: P. J. Reeves, Ltd., London

Delicacy, restraint, and streamlined elegance merge in this superb example of Aesthetic-movement "art furniture." Six attenuated legs boasting twisted brass-shod feet link parallel

FIG. 136 Detail of insects, cat. no. 79.

FIG. 137 Tiffany and Company (founded 1837), **Coffeepot and Cream Jug,** 1878, hammered silver, 7 x 2 ⅞ x 5 in. (17.8 x 7.3 x 12.7 cm) coffee-pot; 4 x 2 ⅜ x 3 ¼ in. (10.2 x 6 x 8.3 cm) cream jug. Virginia Museum of Fine Arts, Gift of Sydney and Frances Lewis, 85.283–2.

hexagonal surfaces mediated by adjacent square shelves. Opposing corners of turned, brass-mounted cross stretchers reinforce the geometric outline decoratively reiterated in narrow metal bands of tabletop inlay. The resulting linearity is relieved by a proportional relationship between solid and void. It is further tempered by the asymmetrical inlay of semiprecious-stone insects that play across the table's surface

(fig. 136). Similar details grace Tiffany and Company's 1878 *Coffeepot and Cream Jug* (fig. 137).[1] Both owe their inspiration to the "judiciously eclectic" Aesthetic designs of the English architect-designer Edward William Godwin.[2]

Godwin belonged to a group of English reformers who, against the tenets of stricter "Gothics," appropriated historical styles from a broad geographic region and reconceived them as designs born of modern life.[3] Though mindful of contemporary anxieties about industrialization and sympathetic to the aims of more Ruskinian Gothics—"to animate . . . the blacksmith's forge and the sculptor's *atelier,* the painter's studio and the haberdasher's shop"—he sought to restore "art" to the people through the machine-assisted production of Aesthetic goods.[4] Although Godwin's art furniture company had limited financial success, its origins mark the beginnings of commercially manufactured "art" furniture.[5]

The Lejambre table represents Godwin's Anglo-Japanese design, first articulated in the 1860s and resonant in his *Side Chair* of 1877, also in VMFA's collections (fig. 138).[6] The cross stretchers suggest a neo-Napoleonic taste, while spare and asymmetrical inlay attests to Asian inspiration.[7] The results document the Aesthetic triumph of a Philadelphia firm known primarily for its French Second Empire works.[8] Disseminated through publications like William Watt's *Art Furniture, from Designs by E. W. Godwin, F.S.A, with Hints and Suggestions on Domestic Furniture and Decoration* (1877) and the American periodical *Art-Worker,* Godwin's designs were similarly influential in the work of other leading American firms, including Herter Brothers in New York (fig. 139; see also cat. nos. 63 and 75).[9]

Inspired by the display of Japanese wares at the London International Exhibition of 1862, the popularity of the Anglo-Japanese style turned, in part, on its multivalent connotations—both stylistic (exoticism) and political (imperialism)—among industrializing publics like Britain and the United States.[10] The "Orient" was not only a new commercial and cultural frontier; its endemic differences resonated among Britons, Americans, and other Europeans as evidence of their own nationalistic superiority, helping to alleviate unease about the local implications of global interests and modern "progress."[11] At the same time, the spare simplicity of Asian motifs was perceived as distilled, clean, and modern, underscoring Godwin's

FIG. 138 E. W. Godwin (1833–1886), designer, **Side Chair,** 1877, mahogany, caned seat and back, 38 ³⁄₁₆ x 16 ⁵⁄₁₆ x 16 in. (97 x 41.1 x 40.6 cm). Virginia Museum of Fine Arts, Gift of Mr. David K. E. Bruce, 96.99.

FIG. 139 Herter Brothers (active 1864–1906), manufacturer, **Side Chair,** ca. 1880, ebonized cherry with gilding, 34 ¼ x 17 ½ x 19 in. (87.5 x 44.4 x 48.2 cm). Virginia Museum of Fine Arts Purchase, The Mary Morton Parsons Fund for American Decorative Arts, 85.7.

role as a pioneer of modernism and his important contributions to the later Art Nouveau style.[12]

Named for the immigrant French upholsterer and decorator John Peter Alphonse Lejambre, the firm, A. Lejambre, thrived under the direction of his widow, upholsterer Anna Rainier Lejambre, and his son, cabinetmaker Alexis Napoleon Lejambre, from 1853 until 1862. Upon her son's death in 1862, Anna entered into partnership with her cousin and son-in-law Henri Lejambre—an upholsterer with the firm.[13] For the next decade, A. and H. Lejambre manufactured and retailed furniture with documented success. In 1874, it closed its retail shop.[14] The furniture manufactory continued under Henri and his son, Eugène, until 1907.[15] SJR

NOTES

1. David A. Hanks with Jennifer Toher, "Metalwork: An Eclectic Aesthetic," in Doreen Bolger Burke et al., *In Pursuit of Beauty: Americans and the Aesthetic Movement* (New York: Metropolitan Museum of Art, 1986), 255–68.

2. VMFA's table was probably inspired by the multilevel, poly-sided occasional tables produced by London firms, such as William Watt and Collinson and Lock, according to Godwin's designs in the late 1860s and 1870s. The term "judicious eclecticism" was coined by Godwin in "Friends in Council: No. 40, a Retrospect," *British Architect and Northern Engineer* 16 (December 1881): 655, cited in Susan Weber Soros, *The Secular Furniture of E. W. Godwin* (New Haven and London: Yale University Press for The Bard Graduate Center, 1999), 17; Soros, 29, 73; Marilynn Johnson, "Art Furniture: Wedding the Beautiful to the Useful," in Burke et al., 159.

3. Beginning in the early nineteenth century, the "battle of the styles" set successive generations of architects, designers, and theorists of a moralistic and nationalist English "Gothic" tradition—John Ruskin, Augustus Welby Northmore Pugin, William Morris, and Charles Eastlake, for example—against so-called "classicists" criticized for their "capricious" blending of diverse historic styles into eclectic designs infused with modern sensibilities. Charles Eastlake, *Hints on Household Taste* (4th ed., rev., 1878; repr., New York: Dover, 1969), 40; Soros, 17, 64; Juliet Kinchin, "E. W. Godwin and Modernism," in Susan Weber Soros, ed., *E. W. Godwin: Aesthetic Movement Architect and Designer* (New Haven and London: Yale University Press, 1999), 105–7; Roger B. Stein, "The Aesthetic Movement in its American Cultural Context," in Burke et al., 27.

4. Ruskin and other early "Gothic" reformers defied the established "classicist" melding of myriad historical styles—the neo-Renaissance formula (see cat. no. 63)—in the interest of a nationalistic style and ideology. Unlike Ruskin, Pugin accepted the machine as a helpmate to the artisan. Ruskin, "Characteristics of Gothic Architecture," in Chauncey B. Tinker, ed., *Selections from the Works of John Ruskin* (Boston: Houghton Mifflin, 1908), 164–69; Ruskin, "Traffic," in Tinker, 278–82, 287–89; Eastlake, 5; Soros, *Secular Furniture,* 56; Stein, 25–30, 36–7, 39, 48; Catherine Lynn, "Decorating Surfaces: Aesthetic Delight, Theoretical Dilemma," in Burke et al., 53–62; Catherine Lynn, "Surface Ornament: Wallpapers, Carpets, Textiles, and Embroidery," in Burke et al., 65–66.

5. Eastlake, 5, 40; Soros, *Secular Furniture,* 17, 21, 38–39, 51, 56, 64, 73–76; Kinchin, 105–7; Nancy B. Wilkinson, "E. W. Godwin and Japanisme in England," in Soros, *Secular Furniture,* 71, 78; Stein, 25–30, 36–37, 39, 48; Lynn, "Decorating Surfaces," 53–62; Lynn, "Surface Ornament," 65–66; Johnson, 159.

6. Godwin began referring to his "Japanese" designs as "Anglo-Japanese" in 1876. A rosewood chair designed by H. W. Batley was displayed the same year at

the Philadelphia Centennial Exhibition near a lacquer cabinet designed by Godwin. In general, little distinction was made between Japanese and Chinese influences. Soros, *Secular Furniture*, 38–39, 73–76; Wilkinson, 71, 78; Johnson, 159; Jonathan Meyer, *Great Exhibitions: London–New York–Paris–Philadelphia* (Woodbridge, Suffolk, U.K: Antique Collectors' Club, 2006), illus. 210, F8. For additional illustrations of Anglo-Japanese tables designed by Godwin, see Soros, *Secular Furniture*, 143–71.

7. William Chambers published an engraving of "Chinese Furniture" in 1757. Thomas Chippendale, William Halfpenny, and others produced designs in the "Chinese" taste. See Peter L. L. Strickland, "Furniture by the Lejambre family of Philadelphia," *The Magazine Antiques* 113 (March 1978): 600; Peter Ward-Jackson, *English Furniture Designs of the Eighteenth Century* (London: Victoria and Albert Museum, 1984), figs. 81–82, 126–27, 135–36.

8. Other works were inspired by French designers like Pierre La Mésangère. By the 1870s, the firm was also producing furniture in the Louis XVI Revival style. Strickland, 602, 609.

9. Soros, *Secular Furniture*, 39, 51, 76.

10. By 1858, Godwin's friend, the architect William Burges, had amassed a small collection of Japanese prints. In 1862, Sir Rutherford Alcock assembled "The Japanese Court" for the London exhibition, marking the beginning of Japonisme in Britain. After the fair, the objects were retailed at William Hewett's newly established "Chinese Warehouse." In 1868, with the restoration of the country's imperial family, Japanese goods became increasingly accessible and were frequently included at world's fairs. Wilkinson, 73–75.

11. Soros, *Secular Furniture*, 18–19.

12. See Gorham candelabra (cat. no. 96) and Tiffany punch bowl (cat. no. 97). Soros adds: Godwin "and many of his clients marked their very modernity by admiring cultures that were less developed (and therefore inferior, in their view); to be modern was also to be anti-modern" (21).

13. The 1860 federal census lists Alexis as a farmer, Henry Lejambre as an "Upholsterer," and Anna as a furniture manufacturer and head of household with assets of $20,000. See www.Ancestry.com, *1860 United States Federal Census, Philadelphia Ward 8, Pennsylvania* (Provo, Utah: Generations Network, 2009), roll M653_1158, p.334. Strickland, 600–601.

14. The firm first registered as "A. & H. Lajambre" in 1867. Strickland, 602.

15. Henri and Cora became sole proprietors in 1887, following the death of Cora's sister Elizabeth. Strickland, 602; Catherine Hoover Voorsanger, "Dictionary of Architects, Artisans, Artists, and Manufacturers," in Burke et al., 449.

80. Louis C. Tiffany and Company, Associated Artists (active 1881–83), designer and manufacturer

Trifold Screen, ca. 1881

New York, New York

Rosewood; glass; bronze-dust coated copper wire, paint; brass hinges

66 ⅝ x 27 x ⅞ in. (169.2 x 68.6 x 2.2 cm) each panel

Museum Purchase, The J. Harwood and Louise B. Cochrane Fund for American Art, 2000.16

PROVENANCE: William S. Kimball, Rochester, N.Y.; to wife, Laura Mitchell Kimball (1895); Mr. and Mrs. Charles H. Babcock, Rochester, N.Y. (1922); by descent through the family of Mrs. Babcock's caregiver, Syracuse, N.Y. (1947); David Rudd, Syracuse, N.Y. (1990); Margot Johnson, Inc., New York, N.Y.

Louis Comfort Tiffany made this opulent screen to furnish one of the great "artistic houses" of the Gilded Age—the magnificent residence built by architect James G. Cutler for William S. Kimball and his second wife, Laura Mitchell Kimball. Completed in 1882, the thirty-room half-timber mansion stood on the corner of Caledonia Avenue and Troup Street in Rochester, New York.[1] The main feature in its hall was Tiffany's wooden screen, which is composed of pierced panels of East India teak that reached nearly thirteen feet to the ceiling. The adjacent library featured a fireplace surround of glittering glass tiles. The lavish interiors of "Kimball's Castle"—as it was called by locals—reflected the success and prominence of the owner, a civic leader whose tobacco company employed eight hundred workers, the largest force in Rochester. But the rooms and their furnishings also reflected the kind of independent thinking that would allow for the hiring of young Tiffany and his associates.[2]

Son of Charles Louis Tiffany, the founder of Tiffany and Company, Louis launched his career in 1866 as a student of painter George Inness (see cat. no. 68) before traveling to Paris two years later to study with Léon Bailly. Following sojourns to Spain, North Africa, and the Near East, Tiffany returned to the United States in the early 1870s and resumed painting. He helped to found the American Art Association, but his attention began shifting to decorative arts. Writing in 1879 to textile designer Candace Wheeler, Tiffany declared: "I have been thinking a great deal about decorative work, and I am going into it as a profession. I believe there is more in it than in painting pictures."[3] The same year, Tiffany joined with Wheeler, Samuel Colman, and Lockwood de Forest to establish Louis C. Tiffany and Associated Artists.

With this turn in direction, Tiffany soon gained acclaim as a designer of glass and metal objects—a reputation that grew in his lifetime and is how he is best known today (see cat. no. 97). His efforts in painting and furniture making, however, also reveal the artist's fascination with materials and surfaces. In *The Pottery Market at Wurtzburg* (fig. 140), for example, painted about 1892, Tiffany pictures a dark side street in Germany where a vendor and her customers are nearly enveloped by gleaming crockery and metalware.

In a similar vein, this bold screen blurs the distinction between fine and decorative art. Like most of the decorations

at the Kimball house, it reveals an engagement with developing modernist philosophies.[4] While representing one of the most important design forms of the late nineteenth century, the modernity of the Islamic-inspired screen is also suggested—paradoxically perhaps—by Romantic notions of temporal and geographic distance: the purposefully rough-cast glass jewels suggest antiquity (fig. 141), while the design's exoticism implies far-off lands and cultures. Such allusions were beloved among late-nineteenth-century Aesthetic-movement designers and are compelling reminders of the many competing ideals in this new industrial age.[5]

In the manner of a Suzani textile, characteristically patterned by appliquéd designs, the panels of Tiffany's trifold screen display stylized representations of naturalistic forms—scrolling vines, splaying leaves, emergent blossoms—symmetrically arranged and contained within banded borders. The traditional legacy of the Near Eastern motif was well known to Tiffany, who collected Suzani textiles during travels to the central region of Asia.[6] Yet, while the pattern speaks to Tiffany's romance with the East, its purposeful containment within a simple, rectilinear frame and its translation into nontraditional materials are suggestive of more contemporary sensibilities. As wood, glass, metal, and paint supplanted dyed and applied cotton, so the "exotic" tenor of a nonindustrial, non-Western design was highlighted, appropriated, and made modern. Such practice typified the Aesthetic movement in the last quarter of the nineteenth century (see cat. nos. 74, 75, and 77).

Despite the company's success—its commissions included the White House (1883)—the Associated Artists partnership was short-lived, dissolving after only four years when L. C. Tiffany and Company became an independent concern in 1883. By the time he exhibited at the World's Columbian Exposition in Chicago in 1893, Tiffany had established an international reputation. Noted art critic Charles de Kay summed up the designer's impact in 1914: "there is none who has affected the taste of the public more profoundly than Louis Comfort Tiffany . . . he has refused to limit his curiosity as an artist to one or two paths. . . . In some branches he has achieved a world-wide reputation; in others . . . he has been so content to pursue the study for his own enjoyment that hardly a person in his immediate circle knows what he has achieved."[7]

DPC

NOTES

1. The house was razed in 1948. *Rochester Democrat and Chronicle,* August 22, 1948. Information on the house and its owner is held at the Rochester Museum and Science Center and at the Rochester Public Library.
2. "William S. Kimball House," in *The Opulent Interiors of the Gilded Age: All 203 Photographs from Artistic Houses,* rev. ed. (1883–84; repr., New York: Dover, 1987), 80–81.
3. Quoted in Robert Koch, *Louis Comfort Tiffany, Rebel in Glass* (New York: Crown, 1964), 11. During its brief existence, the Associated Artists served prominent clients including Mark Twain, Hamilton Fish, Henry de Forest, and John Taylor Johnson.
4. The blue-green painted panel backs of the folding screen recall James McNeill Whistler's notorious Peacock Room, completed in London only a few years earlier

FIG. 140 Louis Comfort Tiffany (1848–1933), **The Pottery Market at Wurtzburg,** ca. 1892, oil on canvas, 23 x 28 ⅛ in. (58.4 x 71.4 cm). Virginia Museum of Fine Arts Purchase, The Arthur and Margaret Glasgow Fund, 79.118.

FIG. 141 Detail of cat. no. 80.

amid huge publicity. David Park Curry, "Artist and Architect," *James McNeill Whistler at the Freer Gallery of Art* (New York: W. W. Norton, 1984), 52–69. See also Linda Merrill, *The Peacock Room: A Cultural Biography* (New Haven and London: Yale University Press, 1998).

5. Tiffany replayed the technique of suspending glass jewels in wirework to great effect in later projects, including the decoration of the H. O. Havemeyer house in New York around 1891. For illustration, see Alice Cooney et al., *Splendid Legacy: The Havemeyer Collection* (New York: Metropolitan Museum of Art, 1993), plate 167, fig. 34.

6. The panels were inspired by a Suzani textile indigenous to the Turkoman city of Bukhara (in present-day Uzbekistan). Tiffany and his fellow painter Samuel Colman collected such textiles on their travels. Robert Koch, *Louis Comfort Tiffany, Rebel in Glass,* 3rd ed. (New York: Crown, 1982), 7.

7. Charles de Kay, *The Artwork of Louis Comfort Tiffany* (New York: Doubleday, Page, 1914), quoted in *Nineteenth-Century America: Furniture and other Decorative Arts,* exh. cat. (New York: Metropolitan Museum of Art, 1970), no. 262.

81. Matthew Andrew Daly (1859–1937),

designer

Matt Morgan Art Pottery Company

(active 1882–84), manufacturer

Vase, 1884

Cincinnati, Ohio

Glazed ceramic

14 1/2 x 12 3/4 x 4 1/4 in. (36.8 x 32.4 x 10.8 cm)

Initialed lower right: "MAD"

Gift of Karen Brandt Siler and Fritz Brandt in memory of their parents,
 Frederick and Carol Brandt, 2008.106

PROVENANCE: Frederick and Carol Brandt, Richmond, Va.

82. William Hill Fulper II (ca. 1875–1928),

designer

Fulper Pottery Company (active 1860–ca. 1935),

manufacturer

Two-handled Vase, ca. 1912–15

Flemington, New Jersey

Glazed stoneware

11 x 5 1/2 x 5 1/2 in. (27.9 x 14 x 14 cm)

Marked on underside: "FULPER"

Gift of Karen Brandt Siler and Fritz Brandt in memory of their parents,
 Frederick and Carol Brandt, 2008.111

PROVENANCE: Frederick and Carol Brandt, Richmond, Va.

The Matt Morgan Art Pottery Company of Cincinnati, Ohio, has a short and poorly documented history.[1] Founder Matt Morgan returned to America from travels abroad at the urging of Cincinnati inventor George Ligowsky, who sought a manufacturer of clay trapshooting pigeons for the Ligowsky Clay Pigeon Company.[2] To this end, Morgan established a pottery in 1882. But by 1884, the firm's mission had expanded to include the production of "art pottery"—a designation that signaled a maker's creative intent, regardless of the method of manufacture.[3] The pottery's ambitions are recorded in a review of its first public exhibition, held in May of that year. Writing for the *New York Times,* the reviewer describes two types of decorative wares: "one resembling what is called Limoges ware"—characterized by "Moresque and arabesque" shapes, copper and bronze metallic glazes, and rich blue hues—and "the other, quite novel, designated as terra cotta cameo-ware," which included molded terra-cotta bas-reliefs. Commanding particular attention was the "plaque, a dragon, plunging through the sea, blue and gold, . . . [of] striking . . . Japanese feeling." The author further praised the quality of the clay, the affordability of the pots, and the firm's demonstration of a key component of the pottery movement: "what can be done at home."[4]

Produced by Cincinnati artist Matthew Andrew Daly, the Morgan vase in VMFA's collection reflects the marriage of traditional form and modern techniques. Reminiscent of an Asian ginger jar, the flat-sided ovoid shape is adorned with a hand-painted scene of a solitary swan in a wetlands landscape. The image may derive from a Japanese sourcebook like *Manga,* a series that inspired much Aesthetic-movement design during the late 1870s, notably among the Cincinnati potters.[5] The form also demonstrates the overlapping use of mold makers and sourcebooks among local manufacturers; the vase replicates a work of the same dimensions that was produced by Albert R. Valentine in 1883 at the neighboring and better known Rookwood Pottery, where Daly was later employed.[6]

The VMFA vase also denotes the introduction of modern pottery techniques. By the time it was crafted, Matt Morgan Art Pottery Company was using an innovative atomizer for the even distribution of heavy slips on its wares.[7] The technical improvement to traditional postfiring practices allowed

the mellow ocher ground to be applied prior to firing and glazing. By these means, "a particularly soft, delicate background or shading is produced upon the ware, which may be made to gradually fade or vanish in one or more directions, and to blend from one color to another without any perceptible line of demarkation [sic]." The method afforded the decorator greater control over the application of color as well as the opportunity to make graduated variations in multiple tones.[8]

With its subtle glazes and classical amphora shape, VMFA's Fulper vase signals the transition to Arts and Crafts influences.[9] Established in Flemington, New Jersey, as a producer of utilitarian wares, Fulper Pottery began experimenting with glazes shortly after the Paris International Exposition of 1900, introducing its specialty Vasekraft line in 1909.[10] Like Matt Daly, Fulper potters glazed the bisque surface of the molded form prior to firing.[11] The drive for "complete unity"

81

FIG. 142 Tiffany Furnaces (active 1902–20), **Tel el-Amarna Vase,** New York, N.Y., ca. 1909, favrile glass, 9 ⅞ x 4 ⅝ in. (25.1 x 11.7 cm). Virginia Museum of Fine Arts Purchase, The Sydney and Frances Lewis Art Nouveau Fund, 81.199.

FIG. 143 George Prentiss Kendrick (1850–1919), designer; Kiichi Yamada (active 1900–1902), potter; Grueby-Faience Company (active ca. 1897–1909), manufacturer, **Vase,** Boston, Massachusetts, ca. 1900, stoneware, 22 ¼ x 9 in. (55.9 x 22.9 cm). Virginia Museum of Fine Arts Purchase, The Arthur and Margaret Glasgow Fund, 90.118.

of glazing and firing was encouraged by Charles Fergus Binns, director of the nearby Trenton Technical School of Science and Art and a former director of the Royal Worcester Porcelain Works in England.[12] Binns underscored the firing process as the moment in which color and texture were fused into art.[13]

The "Chinese blue flambé" color of this vase was probably inspired by the display of Chinese ceramics at the 1904 Louisiana Purchase Exposition in Saint Louis, where Fulper was awarded a bronze medal.[14] Widely emulated since the eighteenth century by European porcelain manufacturers such as Sèvres and Chelsea, the color had been adapted and updated in the late 1890s by Auguste Delaherche and other French potters. It was in production at Fulper from 1909 until the 1920s.[15] As VMFA's *Tel el-Amarna Vase* (fig. 142) attests, it also inspired the "Mazarin Blue" glass produced by Tiffany Studios in New York in 1909.[16] The classical forms and Near Eastern decoration—the geometric zigzag on the Tiffany piece and the volute handles of the Fulper work—reflect the interest in Egypt that was fueled by contemporary excavations at Amarna and, in particular, Ludwig Borchardt's discovery of the bust of Queen Nefertiti in 1912—the approximate date of the Fulper vase.[17]

In 1915, Fulper Pottery was awarded a gold medal at San Francisco's Panama-Pacific International Exposition for a monumental amphora-form vase of black mirror ground with a green luster and flambé glaze.[18] The firm exhibited in a space shared with Gustav Stickley's Craftsman Workshops and was thereafter affiliated with the "mission" style.[19] The association complemented Fulper's objectives as a "master craftsman": "to counteract . . . the desire for over-ornamentation and specious originality [and to] . . . insist upon the necessity of sobriety and restraint."[20] In this it was aligned with other American potteries, including the Grueby-Faience Company in Boston (fig. 143), where the local Society of Arts and Crafts was particularly influential.

These two examples of art pottery, which bridge the transformative eras of the Aesthetic and the Arts and Crafts movements, represent the unfailing commitment of the late Frederick Brandt to collecting works of consummate quality. As early as 1971, when he organized VMFA's ground-breaking *Art Nouveau* exhibition, Brandt, who later became the museum's curator of twentieth-century art, demonstrated an avid

82

interest in objects of the late nineteenth and early twentieth centuries. Winning the support of instrumental collectors Sydney and Frances Lewis, he spent the next thirty years stewarding the acquisition and exhibition of important works of this period, discerningly cultivating collections of international consequence on behalf of the Lewises and the Virginia Museum of Fine Arts. He also assembled a personal collection of objects, books, primary documents, and ephemera. Following his death on December 12, 2007, selections from this collection were given by his children to VMFA. SJR

NOTES
1. The pottery appears to have failed when it converted to commercial production. Lucile Henzke, *American Art Pottery* (Camden, N.Y.: Thomas Nelson, 1970), 179.
2. Ibid.
3. Alice Cooney Frelinghuysen, "Aesthetic Forms in Ceramics and Glass," in Doreen Bolger Burke et al., *In Pursuit of Beauty: Americans and the Aesthetic Movement* (New York: Metropolitan Museum of Art, 1986), 199–201, 213, 224–29.
4. "Art Pottery," *New York Times*, May 3, 1884; Marilynn Johnson, "The Artful Interior," in Burke et al., 111.
5. Frelinghuysen, 228.
6. It is unclear if Daly worked as a designer for Matt Morgan Pottery during or before his tenure with Rookwood Pottery or if he had access to Rookwood's Shape Book. Valentine (also Valentien) was Rookwood's chief decorator. Henzke, 179; Frelinghuysen, 228. The Rookwood vase is in the collection of the Charles

Hosmer Morse Museum of American Art and illustrated in Frelinghuysen, *American Art Pottery: Selections from the Charles Hosmer Morse Museum of American Art* (Seattle and London: University of Washington Press for the Orlando Museum of Art, 1995), 42.

7. Fry v. Rookwood Pottery Co. et al. (Circuit Court, S.D. Ohio, W.D. December 2, 1898, no. 4,531) *Federal Reporter* 90, www.bulk.resource.org/courts.gov/c/F1/0090/0090.f1.0494.pdf, 499.

8. Ibid., 494–500.

9. Robert W. Blasberg, *Fulper Art Pottery: An Aesthetic Appreciation, 1909–1929,* (New York: Jordan-Volpe Gallery, 1979), 34.

10. The pottery burned down in 1929. The name *Vasekraft* was used by Fulper to distinguish its specialty art wares from ca. 1909 to ca. 1912/14. Henzke, 15–23. Blasberg, 16, 20, 40–42; Frelinghuysen, *American Art Pottery,* 31; Evelyn Marie Stuart, "Vasekraft—An American Art Pottery," *Fine Arts Journal* (1914): 5, cited in Blasberg, 21.

11. Stuart, 5, quoted in Blasberg, 21.

12. Charles Fergus Binns, "In Defense of Fire," in *The Craftsman* (March, 1903), 369–72, quoted in Kirsten Keen, *American Art Pottery, 1875–1930* (Wilmington: Delaware Art Museum, 1978), 66, cited in Blasberg, 21.

13. He later directed the New York State School of Clay Working and Ceramics at Alfred University. Blasberg, 21.

14. Fulper claimed its glazes were an "improvement" on the Chinese originals. Blasberg, 16.

15. Blasberg, 21–22; David Rago et al., *The Fulper Book* (State College, Penn.: Nittany Valley Offset, 1986), 33, 50; Frelinghuysen, *American Art Pottery,* 30.

16. Letter from Tiffany Studios to the Philadelphia Museum, March 13, 1909, Philadelphia Museum of Art, Morris Papers, cited in Martin Eidelberg, *Tiffany Favrile Glass and the Quest of Beauty* (New York: Lillian Nassau, 2007), 78; William Burton, "Oriental Influence on Twentieth Century Pottery," *The American Pottery Gazette,* quoted in Keen, 6, cited in Blasberg, 21.

17. In the 1890s, Sir Flinders Petrie began excavations at Amarna, located in Upper Egypt on the east bank of the Nile, for the Egypt Exploration Society. The "Amarna tablets," discovered in 1887, revealed trade relations with Greece during the reign of Pharoah Akhenaten (1350s–1330s BC) and Nefertiti. In addition to the ancient source, the volute handles of the Fulper vase recall designs by Charles Percier and Pierre-François-Léonard Fontaine derived from Napoleon's Egyptian Campaign (1798–1801). Blasberg, 55–58.

18. Ibid., 35–36.

19. Based on a ca. 1894 chair for the Swedenborgian Church in San Francisco designed by A. Page Brown, Bernard Maybeck, and A. C. Schweinfurth, it was termed "mission" by Joseph McHugh, a New York furniture manufacturer-retailer, who wanted to invoke the romanticism of Spanish mission culture in describing the linear and rustic style of furniture he began producing around 1895. John S. Bowman, *American Furniture* (New York: Bison Books, 1985), 149.

20. This was the model prescribed by the Boston Society of Arts and Crafts. Martin Eidelberg, "The Ceramic Art of William H. Grueby," in *Connoisseur* 184 (Sept. 1973): 49, quoted in Blasberg, 39.

83. George Washington Jack (1855–1952), designer

Morris and Company (active 1861–1940), manufacturer

Secrétaire Cabinet, ca. 1893–1906

London, England

Mahogany with marquetry of sycamore, Spanish mahogany, ebony, holly, tulip, rosewood; tooled leather; velvet

51 ¾ x 55 ⅞ x 27 in. (131.4 x 141.9 x 68.6 cm)

Stamped: "Morris & Co., 449 Oxford S.W.;" "1195"

Museum Purchase, The Arthur and Margaret Glasgow Fund, 2002.528

PROVENANCE: Probably made for William Knox D'Arcy (d. 1920) of Stanmore Hall, Middlesex, England; Private collection, Scotland (ca. 1980); North London antiques dealer (ca. 1993); Private collection, Great Britain; sold at auction by Christie's, London (February 16, 1994, lot no. 44); Frank McDonald, Sydney, Australia; Private collection, Great Britain; Paul Reeves, London (2001)

FIG. 144 Interior view of cat no. 83.

This neo-Georgian *secrétaire cabinet* designed by George Washington Jack is a visual tour de force of artistic cabinetry.[1] Elaborate inlays of astonishing freedom decorate the surface with intertwined branches of ash, enormous oak leaves (fig. 145), bold thistle heads, running bands of small dots and foliage, slender stringing, checked borders, and a crisp trellis pattern. Large chevrons enliven the interior doors, while tooled leather enriches the drop-front desk (fig. 144). The exuberance of these details is held in check by the foursquare proportions

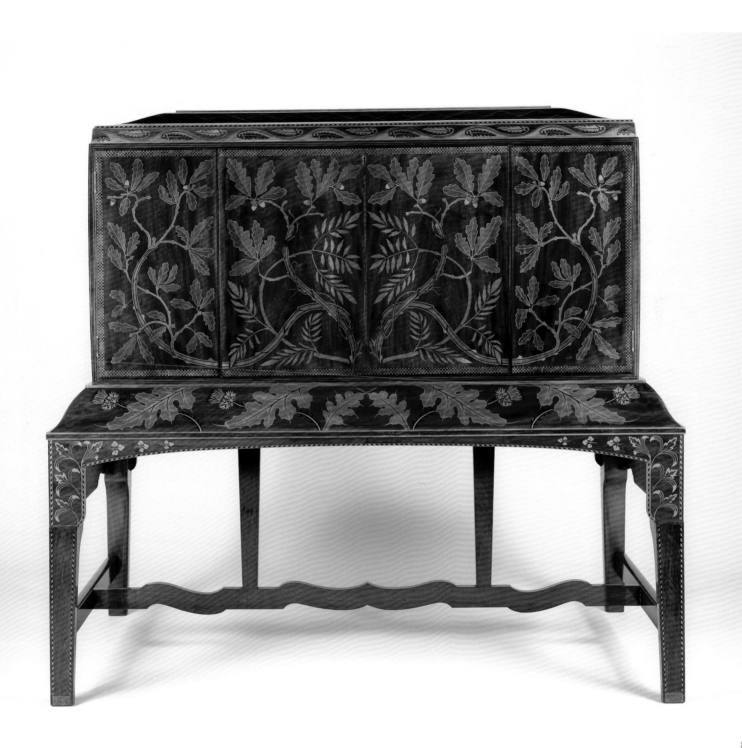

83

EXPATRIATES and the GILDED AGE 239

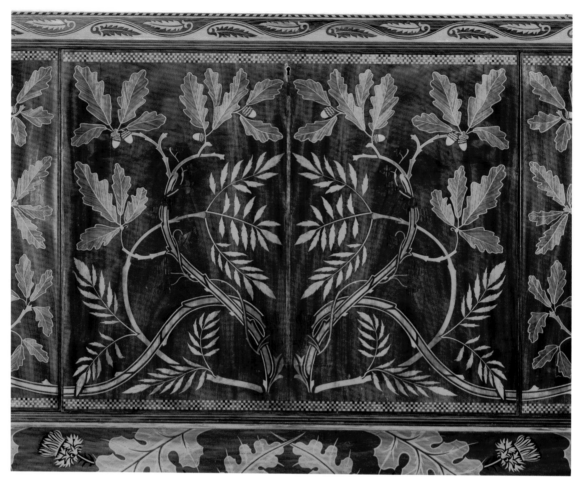

FIG. 145 Detail of cat. no. 83.

of the boxlike cabinet and its four-legged stand, while subtle design decisions—the sloping sides of the lid, the gentle entasis (or swell) of the box sides, the ogival profile of the stand's frieze, and the soft curve of the front apron—keep it from feeling ponderous.

The American-born, Glasgow-trained George Washington Jack began his professional career in 1880 at the architectural office of Philip Webb, located in London and one of the most forward-thinking design firms of the day.[2] Together with design-reformer William Morris, Webb and his colleagues created a cutting-edge, internationally influential Victorian modernism based on notions of handcraft and the richness of the historic past. Webb's studio bore the responsibility for designing most of the furniture that was offered by Morris and Company.[3]

Jack was gifted in woodcarving, clay modeling, and furniture design. By 1890, the multitalented American had replaced Webb as chief furniture designer of Morris and Company, a position he held until after Morris's death. During the course of his tenure, Jack designed some of the most elaborate furniture ever produced by the firm. One of only six known examples, the VMFA *secrétaire* represents Morris and Company at its highest level of excellence, demonstrating the sophisticated cabinetmaking skills that the firm could offer its most affluent clients.[4] First published in 1889, the design for this *secrétaire* made its debut at London's Arts and Crafts Exhibition Society that same year.[5] In 1896, Reginald Blomfield was still praising it as "a very beautiful instance of modern marquetry and indeed one of the finest pieces of furniture executed in England since the last century."[6] And the 1912 Morris and Company catalogue continued to extol it and similar designs as "Cabinet Work of the highest standard, . . . equal to the best productions of Chippendale and Sheraton."[7]

Based on the stamped registration number "1195" and the process of elimination, it can be reasonably stated that the cabinet was originally built for William Knox D'Arcy, who made his millions in Australian gold mining.[8] Morris and Company was commissioned to decorate D'Arcy's Middlesex home, Stanmore Hall, from 1888 to 1896, and the *secrétaire* probably dates to the later part of this period. D'Arcy also ordered a set of twelve tapestries depicting the quest for the Holy Grail, the largest commission ever executed by the firm's Merton Abbey workshop. Like the tapestries, the richly inlaid *secrétaire* clearly ranks as one of the finest artistic achievements of the Arts and Crafts movement, as powerful as the better-known Morris textiles to which the inlay closely relates.[9]

Like all Morris and Company objects, the *secrétaire* was informed by specific design philosophies. Appalled by the tacky eclecticism of commercial Victorian decoration, the reform-minded Morris claimed early on to offer unpretentious "good citizens' furniture . . . [with] nothing about it that is not easily defensible, no monstrosities or extravagances, not even of beauty."[10] But Morris's dedicated socialist stance did not support a viable business plan. The first case pieces—unique medievalizing cabinets painted by the likes of Pre-Raphaelite artists Dante Gabriel Rossetti and Edward Burne-Jones—were attainable only by the well-to-do. Although Jack was influenced by other historic furniture models—the *secrétaire* recalls a stately eighteenth-century English cabinet on stand and harkens further back to the *vargueno*, a Renaissance furniture form with a portable boxlike writing desk held on a wooden stand—his designs were no less costly to execute.[11] By his later years, Morris had come to recognize that "elaborate" furniture, too, merited a place in the arts. Alongside the "necessary workaday furniture" of his youth he placed ornamental "state furniture," including "sideboards, cabinets and the like" made "elegant . . . with carving or inlaying or painting"; these, he wrote, "are the blossoms of the art of furniture."[12]

Within the Morris and Company oeuvre, Jack's *secrétaire* serves as an important reminder of the cyclical nature of design ideas and sensibilities. But this fine piece also speaks to the transmission of ideas and practices among cabinetmakers in general. As is the case with the Herter Brothers' important carved and inlaid center table of 1877–78 (see cat. no. 75),

the *secrétaire* underscores the international fluidity and reciprocity of the late-nineteenth-century art world. As George Washington Jack traveled from America to Europe, honing his design principals, others were traveling from Europe to America intent on a similar purpose. DPC

NOTES

1. George Washington Jack was born on Long Island, New York, to British parents. After his father's death, the family moved to Glasgow, Scotland. By 1870, he was apprenticed to local architect Horatio K. Bromhead. For details, see A. Stuart Gray, *Edwardian Architecture: A Biographical Dictionary* (Chicago: University of Iowa Press, 1986), 219.

2. Jack was appointed Webb's assistant in 1880, at which time Morris reduced his involvement in the furniture side of the business. Linda Parry, ed., *William Morris* (London: Victoria and Albert Museum, 1996), 179.

3. The original partnership of 1861 was dissolved March 31, 1875, leaving Morris as sole proprietor. For background, see Joanna Banham, ed., "Morris & Co.," *Encyclopaedia of Interior Design* (London and Chicago: Fitzroy Dearborn, 1997), 838–42.

4. The only other known example in an American museum is the inlaid *secrétaire* that probably once belonged to Jack himself, now in the Philadelphia Museum of Art. Another, made in 1893 for Thomas Middlemore, is in the Victoria and Albert Museum. Additional cabinets remain in situ at Ickworth, Suffolk; Compton Hall, Wolverhampton; and Tapeley Park, Devon. Parry, 173, 179, 295.

5. J. Williams Benn, ed. *The Cabinet Maker and Art Furnisher* (London: Benn Brothers, 1889), 10:114–15. The illustrated drawing differs slightly from known examples of the cabinet.

6. Reginald Blomfield, "Furniture," *Magazine of Art* (1896): 488–91. This time the drawing illustrating the piece is more accurate.

7. The cabinet is illustrated in the catalogue from both front and rear, allowing potential customers to appreciate its full complement of marquetry patterns. Morris and Company, *Specimens of Furniture, Upholstery, and Interior Decoration* (London, 1912), 2, no. 353.

8. These apparent "batch" numbers are presumed to be chronological—the higher the number the later the batch. The VMFA cabinet, no. 1195, likely dates to about 1894, being close in production to the Victoria and Albert Museum cabinet, no. 1147, made in 1893. Parry, 163.

9. Stanmore Hall had a checkered career following D'Arcy's death in 1920, when it was sold with Morris decorations. It changed hands three times before 1931 and then was used as the Royal National Orthopaedic Hospital. According to Linda Parry, the house was standing empty in 1983, derelict and under a demolition order. Parry, *William Morris Textiles*, (London and New York: Weidenfeld and Nicolson, 1983), 144, 182n400; Parry, *William Morris*, 162.

10. Morris reiterated this stance in a lecture, "The Lesser Arts," January 23, 1882, quoted in part in *William Morris and Kelmscott* (London: Design Council, 1981), 76.

11. A variety of evidence suggests that cabinets and other major pieces were made to order from designs kept in the shop. The *secrétaire* design was still available from Morris and Company in 1912 at the hefty price of 98 guineas, making it one of the most expensive of all known cabinets offered by the firm. Apparently, it was also offered plain, at 60 guineas, though no surviving example is known. Morris and Company, *Specimens of Furniture*, 2, no. 353; Reinier Baarsen, *17th-Century Cabinets*, trans. John Ridge (Amsterdam: Rijksmuseum, 2000); George Washington Jack, *Wood-carving Design and Workmanship with Drawings by the Author and Other Illustrations* (New York: D. Appleton, 1903).

12. William Morris, *The Collected Works*, 22:261, cited in Elizabeth Aslin, *Nineteenth Century English Furniture* (London: Faber and Faber, 1962), 56.

84

84. John Singer Sargent (1856–1925)

Mrs. Albert Vickers (Edith Foster), 1884

Oil on canvas

82 ¾ x 39 ¹³⁄₁₆ in. (208.4 x 101.5 cm)

Signed at lower right: "John S. Sargent"

Museum Purchase, The Adolph D. and Wilkins C. Williams Fund,
 91.152

PROVENANCE: Albert Vickers, husband of sitter, Sussex, England; to son Vincent Cartwright Vickers, Royston, Hertsfordshire, England (1926); to niece the Late Hon. Lady Gibbs, C.B.E., Berkshire, England (until 1989); Hirschl and Adler Galleries, New York, N.Y.

In this striking portrait, an attractive woman pauses in wide-eyed expectancy before a wardrobe in an oak-paneled hall, her monochromatic dress harmonizing with the shadowed background. The artist, a rising star at the time, was destined to become the most acclaimed portraitist of his generation. Produced mere months after the scandalous Paris Salon display of the iconic *Madame X* (fig. 146)—the daring portrayal of a Louisiana-born "professional beauty" of French and Italian ancestry that made his early reputation—*Mrs. Albert Vickers* is John Singer Sargent's first full-length portrait to result from his ultimately restorative English sojourn.

Commissions from brothers Tom and Albert Vickers, who ran a Sheffield engineering and armaments firm, kept the artist busy during the summer and fall of 1884 and laid the groundwork for his successful move to London two years later. Sargent's friend Edmund Gosse linked this "hiatus" in the artist's career to the Vickerses' patronage, which allowed Sargent time to regroup and paint through the "self-doubt" that plagued him after the *Madame X* debacle.[1]

Sargent portrayed thirteen different members of the Vickers family, mostly in 1884, beginning with the Sussex branch—Albert and Edith Foster Vickers and their children. The commissions, received earlier that year (before the *Madame X* scandal broke), may have originated with the wife of Colonel T. E. (Tom) Vickers, Frances Mary Douglas Vickers, who had studied art in Paris. Likely introduced to this family of wealthy industrialists through the Paris-based German sculptor Gustav Natorp, Sargent was invited to spend July through September painting the daughters of Colonel and Mrs. Vickers (*Misses Vickers*, Graves Art Gallery), whom he

uncharitably referred to as "three ugly young women at Sheffield, dingy hole," suggesting the artist's lifelong ambivalence toward commissioned portraiture. In the end, the arrangement turned out to be more favorable than anticipated, and the Vickerses became Sargent's first important English patrons. The relationship was enduring; some thirty years later he painted a portrait of Douglas Vickers (fig. 147), a son of the colonel.[2]

Stopping off in West Sussex en route to Sheffield in the summer of 1884, Sargent settled into life at Beechwood, Albert Vickers's home in Lavington, near Petworth. The novelty of English country life, particularly its social customs and gardens, became the artist's central subject, beginning with this haunting portrait.[3] Like most of his previous sitters, Edith Vickers, the second wife of Albert (he had been

FIG. 146 John Singer Sargent (1856–1925), **Madame X** (Virginie Amélie Avegno Gautreau), 1883–84, oil on canvas, 82 ⅛ x 43 ¼ in. (208.6 x 109.9 cm). The Metropolitan Museum of Art, Arthur Hoppock Hearn Fund, 1916 (16.53).

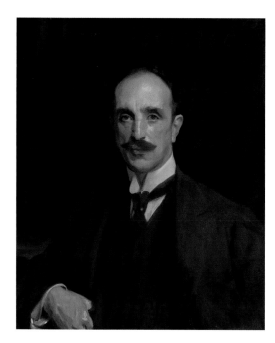

FIG. 147 John Singer Sargent (1856–1925), **Portrait of Douglas Vickers,**
1914, oil on canvas, 30¼ x 25 in. (76.8 x 63.5 cm). Collection of James W.
and Frances G. McGlothlin, Promised Gift to Virginia Museum of Fine Arts.

married previously to a Bostonian), hailed from the newer
wealth of northern England, families whose social position
was based on industrial might rather than aristocratic lineage.
This class distinction may have accounted for the Vickerses'
special interest in a progressive, newly infamous painter like
the young Sargent—just as other northern industrialists such
as Frederick Leyland had earlier favored the talents of James
McNeill Whistler as well as the Pre-Raphaelites Dante Gabriel
Rossetti and Edward Burne-Jones. Aristocratic taste was typi-
cally more conservative.[4]

The portrait of Edith Vickers is one of a number of
Sargent's 1880s depictions of strong, if varied, women from
this social class. That group also includes *Mrs. Henry White*
(Corcoran Gallery of Art), a portrait of the wife of an Ameri-
can diplomat in London. Margaret (Daisy) Stuyvesant White,
along with writer Henry James, had facilitated the artist's
entry into English society. A much-admired hostess, Daisy
White associated with many of the celebrated figures in the
fashionable Aesthetic movement, including Oscar Wilde. She
was also a member of the Souls—a socially mixed group of
well-known male and female aristocrats, industrialists, artists,
and writers who embraced the "art for art's sake" doctrine of

English Aestheticism—many of whom Sargent would later
paint. While the Albert Vickers family was not likely a part
of this London clique, they appear to have shared the group's
aesthetic sensibility and openness to new ideas about painting
and portraiture.[5]

According to Edith Vickers's daughter Izmé, Sargent was
"devoted" to her mother, whom he painted in a gown of her
own invention. The subtle dove-gray fabric and black-laced
Bo Peep–style bodice covering a full-sleeved shift evoke
the "olden time" (or "Queen Anne") fancy dress favored by
another smart Aesthetic set, which was based in the London
suburb of Bedford Park. The garment was an amalgam of
fashions from three previous eras—the seventeenth-century
English Puritan; the eighteenth-century Stuart; and the early-
nineteenth-century Regency (or storybook idiom) reimagined
by illustrators Kate Greenaway and Walter Crane. The dress
reveals Edith Vickers's progressive artistic taste as well as her
willingness to collaborate with Sargent on the conceptualiza-
tion of the portrait.[6]

Edith Vickers's modest accessories—delicate diamonds in
her hair, around her neck, and on her finger—are complemented
by a richly painted magnolia blossom, presumably fresh from
the garden, setting off her "English Rose" complexion and
bearing. While not quite as Aesthetic an icon as a lily—that
flower figured largely in Sargent's subsequent *Garden Study of
the Vickers Children* (Flint Institute of Arts), a precursor to his
most self-consciously Aesthetic painting, *Carnation, Lily, Lily,
Rose* (Tate Gallery) of one year later—the American *Magnolia
grandiflora* had been introduced to English gardens by the
eighteenth century. Thus, its presence may be seen as reinforc-
ing the portrait's artful historicism. Iconographically associ-
ated with sweetness, beauty, nobility, and dignity in the
Victorian language of flowers, the blossom further accentuates
Mrs. Vickers's "Englishness," a quality that in broader terms
might be a rejoinder to what Sargent termed the "beastly
French" style for which certain critics initially assailed his
work in London.[7]

Taken a step further, as David Park Curry has argued, *Mrs.
Albert Vickers* can be interpreted as a deliberate counterpoint to
Madame X, the public reception of which Sargent so seriously
miscalculated—"similar in scale and palette, utterly differ-
ent in purpose. The Gautreau portrait shocked; the Vickers

portrait reassured."[8] The latter, which was titled *Madame V* in the Paris Salon of 1885, is seemingly less contrived and more naturalistic than *Madame X*. The sober English "rural" beauty of Edith Vickers is a marked contrast to Amélie Gautreau's stylized French "urban" artifice, just as the English portrait's quiet, reflective tone responds to *Madame X*'s noisily defiant audacity. While Gautreau turns away from the artist and viewer in haughty disregard, Vickers looks out of the canvas with an inviting, if slightly guarded, openness. Yet both portraits—true collaborations, like the best of Sargent's works—are indicative of his ambitions at the time. The provocative *Madame X* was intended to showcase Sargent's modern (meaning French) bravura talent—in the words of his great-nephew Richard Ormond, "to stand out and to startle." In contrast, the shadowy reticence, elegant austerity, and understated theatricality of *Mrs. Vickers*—utilizing certain Old Master conventions—is a deliberate outcome of the artist's rehabilitative stay in England.[9]

Both paintings reveal how Sargent wedded a progressive visual language derived variously from James McNeill Whistler and Edouard Manet (the subdued tonal harmonies and broad brushwork) to an Old Master syntax associated with the influential Spaniard Diego Velázquez (the somber palette and summarily defined backgrounds) and even the Italian Mannerists Agnolo Bronzino and Parmigianino (the graceful elongation of form). As Ormond has observed, Sargent used this synthetic approach in the three recognized "masterpieces" of his Paris period—*El Jaleo* (1882), *The Daughters of Edward D. Boit* (1882), and *Madame X* (1884)—works that in composition, color, and mood suggest the primary influence of Velázquez on nineteenth-century avant-garde painting.[10]

While Sargent likely began *Mrs. Albert Vickers* in the summer, he did not complete it until fall. As Henry James informed a mutual friend on October 21, 1884: "I dined two days since with the plastic John, who was in town from Petworth where he is painting the portrait of a lady whose merits as a model require all his airy manipulation to be expressed (in speech). I trust it is a happy effort and will bring him fame and shekels here."[11] In fact, Sargent was immensely proud of the resulting work, exhibiting it at the Paris Salon of 1885 and at London's Royal Academy in 1886, where he noted that the portrait, along with *Misses Vickers*, "rather retrieved me."

Though a few American and British critics found the painting "peculiar" and "unsympathetic," most recognized it as a new form of portraiture, grounded in the work of "Velásquez and of kindred masters" and expressed with a "certain eccentricity, yet with fearless sincerity." James, writing in 1887 for American audiences, observed that Sargent's recent Royal Academy showing "reminded the spectator of how much the brilliant effect he produces in an English exhibition arises from a certain appearance that he has of looking down from a height— a height of cleverness, a kind of giddiness of facility—at the artistic problems of the given case."[12]

At the Paris display, one French critic compared *Mrs. Albert Vickers* to Edgar Allan Poe's Ligeia and Morella, the haunted vampiric heroines of the American writer's early short stories of death and resurrection that were enjoying a new wave of appreciation in France. Edith Vickers's eerily distinctive appearance, as rendered by Sargent, may be seen to echo Ligeia's unconventional intelligence and beauty—to Poe, her "strangeness"—just as the theme of death and rebirth would have resonated for the painter one year after the strategic failure of *Madame X* and his attendant crisis of confidence.[13]

Ultimately, the positive reception of *Mrs. Albert Vickers*— Sargent's first English portrait painted in England—finalized the artist's decision to settle permanently in London, where his career eventually flourished. By the time of his first professional visit to America in 1887, during which he was greeted as a celebrity and lavished with portrait commissions, Sargent was well on the way to establishing himself as the towering public figure whom sculptor Auguste Rodin famously called the "Van Dyck of our times"—a recuperative career arc that began with this picture.[14] SY

NOTES

1. See Evan Charteris, *John Sargent* (New York: Charles Scribner's Sons, 1927), 68. As Sargent wrote to his friend Henry James in May 1884, "It will be pleasant getting to London and especially leaving Paris. I am dreadfully tired of the people here and of my present work," quoted in Marc Simpson, *Uncanny Spectacle: The Public Career of the Young John Singer Sargent,* exh. cat. (Williamstown, Mass.: Sterling and Francine Clark Art Institute and Yale University Press, 1997), 122. Sargent also confided to Edmund Gosse that the critical setback made him consider ending his career. See Charteris, 76. Sargent's cousin, Ralph Curtis, who was with him in Paris during the *Madame X* debacle, wrote to his parents that "he [Sargent] has never had such a blow. He says he wants to get out of Paris for a time. He goes to Eng. In 3 weeks." See Sarah Burns and John Davis, *American Art to 1900: A Documentary History* (Berkeley, Los Angeles, and London: University of California Press, 2009), 814.

2. For an overview of the Vickers commissions, see Richard Ormond and Elaine Kilmurray, *John Singer Sargent: The Early Portraits*, vol. 1, *Complete Paintings* (New Haven and London: Yale University Press, 1998), 130–37. Sargent wrote to Vernon Lee from Paris in early 1884: "Will you be in England next summer? If so I shall see you there for I am to paint several portraits in the country [the Albert Vickers in Sussex] and three ugly young women at Sheffield, dingy hole [*The Misses Vickers*]. . . . It will take me probably from the 15th July to 15th September," quoted in ibid., 131.

3. The Lavington Park estate is now owned by Seaford College, a coeducational boarding school. Sargent's three major paintings of the Albert Vickers family—this full-length portrait of Edith, the intimate lamp-lit depiction of the couple at dinner (Fine Arts Museums of San Francisco), and a study of their children Dorothy and "Billy" watering pots of lilies in the garden (Flint Institute of Arts)—reveal the range of styles with which Sargent was experimenting at the time: Old Master by way of Velázquez, French Impressionist by way of Degas, and plein-air English Aesthetic by way of the second-generation Pre-Raphaelites. These different approaches to portraiture are also indicative of a level of comfort and acceptance shared by both artist and sitter. In addition to these three works, Sargent produced a small gestural charcoal study of Mrs. Vickers (Harvard University Art Museums) as well as more conventional portraits of her daughters Dorothy and Izmé and step-son Edward (private collections).

4. Edith Foster, daughter of John Foster of Newhall Grange, Maltby, County York (now Yorkshire) married Albert Vickers in 1875. His first wife was Helen Gage of Boston. See David Park Curry, "John Singer Sargent, *Portrait of Mrs. Albert Vickers*," *American Art Review* 5 (Winter 1993): 167. For an overview of the progressive patronage of Liverpool shipowner Leyland during the 1860s and 1870s, see Linda Merrill, *The Peacock Room: A Cultural Biography* (New Haven and London: Yale University Press, 1998), 77–80, 109–45.

5. For a discussion of Sargent's relation to Aesthetic London, see Albert Boime, "Sargent in Paris and London: A Portrait of the Artist as Dorian Gray," in Patricia Hills, *John Singer Sargent*, exh. cat. (New York: Whitney Museum of American Art in association with Abrams, 1986), 75–109. When Sargent signed a three-year lease for Whistler's former Tite Street studio in 1887, he became even more involved with the Chelsea Aesthetic set.

6. Ormond and Kilmurray, 134. For Bedford Park and other domestic manifestations of the Aesthetic movement—from children's books to garden and fashion design—see Mark Girouard, *Sweetness and Light: The "Queen Anne" Movement, 1860–1900* (New Haven and London: Yale University Press, 1977), 130–76. See also Aileen Ribeiro, *Fashion and Fiction: Dress in Art and Literature in Stuart England* (New Haven and London: Yale University Press, 2006).

7. See Kate Greenaway's contemporary *Language of Flowers* (London: George Routledge and Sons, 1884) and Ernest H. Wilson, *Aristocrats of the Garden* (New York: Garden City, N.Y.: Doubleday, Page, 1917). Sargent discusses the potential "long struggle" for his painting to be accepted in England in an 1885 letter to Edwin Russell, quoted in Ormond and Kilmurray, 130.

8. Curry, 166. For a thoughtful analysis of *Madame X*, see Susan Sidlauskas, "Painting Skin: John Singer Sargent's *Madame X*," *American Art* 15 (Fall 2001): 8–33.

9. Ormond, Introduction in Simpson, 2. For a study of Sargent's use of theatricality and masquerade to explore the relationship between appearance and character in his post-*Madame X* production (excepting *Mrs. Albert Vickers*), see Leigh Culver, "Performing Identities in the Art of John Singer Sargent" (Ph.D. dissertation, University of Pennsylvania, 1999).

10. The influence of Velázquez and Manet on Sargent's work is regularly noted in the scholarship; for example, see Ormond, 2. For an overview of this late-nineteenth-century artistic dialogue, see *Manet/Velázquez: The French Taste for Spanish Painting*, exh. cat. (New York: Metropolitan Museum of Art, 2003). The more unusual Bronzino reference is explored in an idiosyncratic article by Charles Merrill Mount, "The Works of John Singer Sargent in Washington," *Records of the Columbia Historical Society* 73–74 (1973–74): 460–70. I also see the shadow of Parmigianino's mannered *Madonna with a Long Neck* (Uffizi Gallery) in Edith Vickers's gently curving jaw line and slender neck.

11. See Ormond and Kilmurray, 134. James, an old friend, first encouraged Sargent to settle in London after the foundering of his Paris career.

12. Ibid. For these two exhibitions of *Mrs. Albert Vickers* in the artist's lifetime, see Simpson, 180, 183; the portrait was also featured in the Royal Academy's 1926 memorial exhibition of Sargent's work. For selected critical reviews, see ibid., 144–45, and Ormond, *John Singer Sargent: Paintings, Drawings, Watercolors* (New York: Harper and Row, 1970), 39; Henry James, "John S. Sargent," *Harper's New Monthly Magazine*, October 1887, reproduced in Burns and Davis, 818.

13. Charles Ponsonailhe, "Salon de 1885: La Peinture (Suite): III," *L'Artiste* 55 (June 1885): 452, reproduced in Simpson, Appendix, 144. For a translation of the French review, see Malcolm Warner and Robyn Asleson, *Great British Paintings from American Collections*, exh. cat. (New Haven: Yale Center for British Art, 2001), 214.

14. Ormond, Introduction, 3.

85. Charles Sprague Pearce (1851–1914)

Peines de Coeur (Heartbreak), ca. 1884

Oil on canvas

61 ⅝ x 47 ⅜ in. (156.5 x 120.3 cm)

Museum Purchase, The J. Harwood and Louise B. Cochrane Fund for American Art, 2007.17

PROVENANCE: Estate of Mrs. Charles Sprague Pearce (née Antoinette-Louise Bonjean), Auvers-sur-Oise, France; Abbe Henri-Edouart-Prosper Breuil, France (1925); Arnold Fawcus, England (1961); Peter Rudolph, Haverford, Pa.; A.J. Kollar Fine Paintings, L.L.C., Seattle, Wash.; Private collection, Washington, D.C. (1997)

In this narrative of romantic loss and consolation, Charles Sprague Pearce renders a tour-de-force demonstration of his talents as a figure and landscape painter, blending realist and impressionist tendencies. He contrasts the highly finished naturalism of the picture's young women with the more fluidly painted countryside through different viewpoints: the close-up and the panoramic. The placement of the two figures in the foreground draws the viewer into their intimate moment, while the tiered landscape conveys an expansive rural setting. At the 1885 Paris Salon, critics remarked on the striking effect of these combined styles and perspectives, which are harmonized by an encompassing natural light and a luminous color scheme. American writer Alfred Trumble, who featured a small drawing of *Peines de Coeur* in his 1887 study *Representative Works of Contemporary American Artists*, commended Pearce as a painter of peasants—"the first in merit and in power, and among the most poetic in the subtle delicacy with which he brightens his subjects by an airy charm of color and of light."[1]

85

Peines de Coeur also represents a defining period in Pearce's life. The Boston-born artist belonged to the generation of American painters who increasingly settled in France in the postbellum years.[2] He had begun painting in 1872, perhaps under the tutelage of William Morris Hunt, the influential Boston teacher and tastemaker who introduced the French Barbizon style to America in the 1860s. On Hunt's advice, Pearce traveled to Paris and studied with Léon Bonnat, the leading salon painter. Bonnat's independent atelier was founded on the "wholesome purpose of studying nature as closely as possible."[3] The result was immediate and lasting for Pearce, who pursued this "naturalistic" approach throughout his career in a series of wide-ranging portraits and figure paintings, beginning with "orientalist" subjects.[4]

A key figure in American expatriate circles, Pearce exhibited in the Paris Salon nearly every year from 1876 to 1906. He also sent his paintings to important venues in the United States, including the Pennsylvania Academy of the Fine Arts in Philadelphia, where they frequently won awards and were reproduced in catalogues. Pearce regularly served on juries for domestic and international exhibitions and was instrumental in shaping the taste for cosmopolitan painting styles and subjects in America.[5]

In 1884 Pearce purchased a farm in Auvers-sur-Oise in the Picardy region, where he would live for the next thirty years. His property included a specially designed glass-enclosed plein-air (outdoor) studio that allowed him to work in natural light year-round. Such accommodations were crucial, Pearce believed, for his lyrical representations of rural life painted in the manner of French naturalist artists. "I want my peasants to be the real article; I want to see the fields and the trees, the hills, streams and country roads as they are," he explained.[6] A visiting American journalist, who called Pearce "the most natural painter of the day," claimed that the artist moved to Auvers for its "lovely landscapes and pure and undiluted rustic life uncontaminated by too much modernization," emphasizing the underlying appeal of his work to American audiences.[7] *Peines de Coeur,* the title of which Pearce translated as *Heartbreak,* was his first Auvers painting.[8] It features his fellow art student, model, and muse, Antonia Bonjean (perhaps posing for both figures), whom he married in 1889. The painting's air of melancholic reverie may have been a response to the death

FIG. 148 Jules Bastien-Lepage (1848–1884), **Les foins (Haymaking),** 1877, oil on canvas, 63 x 76¾ in. (160 x 195 cm). Musée d'Orsay, Paris.

that year of Jules Bastien-Lepage, whose innovative plein-air peasant pictures had greatly influenced Pearce. The unconventional posture of the figures as well as the tilted picture plane and high horizon of the landscape—a creative reworking of Bastien's infamous 1877 *Les foins* (Haymaking) (fig. 148)— suggest that *Peines de Coeur* was an homage to his French colleague.[9] One reviewer of the 1885 Salon detected the elegiac tenderness in Pearce's painting, which he likened to the romantic works of writer Alfred de Musset. Interestingly, American viewers referred more directly to the shadow of Bastien in *Peines de Coeur,* deemed "the flower of all Franco-American pictures" at the Pennsylvania Academy's 1885 annual exhibition. One year later, a Boston critic concluded: "Technically, the picture is equal to Mr. Pearce's best work, and any comment is unnecessary on painting so eminently pure, refined, and masterly."[10] SY

NOTES

1. Alfred Trumble, *Representative Works of Contemporary American Artists* (ca. 1887; repr., New York and London: Garland Series, *The Art Experience in Late Nineteenth-Century America,* 1978), n.p.

2. For a further discussion of these expatriates, see *Americans in Paris, 1860–1900,* exh. cat. (London: National Gallery, 2006).

3. Barclay Day, "L'Atelier Bonnat," *Magazine of Art* 5 (1882): 138. I am grateful to Marion F. Houstoun for sharing this and other references; see her unpublished 2005 essay, VMFA curatorial files.

4. For an overview of Pearce's life and career, see Mary Lublin, *A Rare Elegance: The Paintings of Charles Sprague Pearce* (New York: Jordan-Volpe Gallery, 1993).

5. In addition to appearing in the 1885 Paris Salon, *Peines de Couer* was featured in the Pennsylvania Academy's annual exhibition of the same year, where it received the Temple Gold Medal for the best figure painting. In addition to exhibiting frequently at the Academy, Pearce served on the Paris jury for the Philadelphia annuals throughout the 1880s. See Peter Hastings Falk, *Annual Exhibition Record of the Pennsylvania Academy of the Fine Arts, 1876–1913* (Madison, Conn.: Sound View Press, 1989), 374.

6. "Art and Artists," *Boston Evening Transcript,* April 25, 1885, 10.

7. "Our Artists at Home: Mr. Charles Sprague Pearce at Auvers-sur-Oise, Why He Went There," *New York Herald,* Paris edition, September 14, 1890, Sunday Supplement, 20.

8. The painting became one of the artist's best known in his lifetime. In fact, its fame led Pearce to paint a second version, *On the Bank of the Brook,* possibly for the production of a Goupil and Company photogravure (distributed by D. Appleton and Company, New York). This wide, horizontal-format picture features the same figural group as found in *Peines de Coeur,* but set in a different Auvers landscape. It was reproduced and discussed in George William Sheldon's *Recent Ideals of American Art* (New York and London: D. Appleton, ca. 1888; repr., *Art Experience in Late Nineteenth-Century America,* 1978), 4, 9.

9. Lublin, 34.

10. Théodore Véron, *Dictionnaire Véron, 11e Annuaire de l'art et des artistes contemporains,* Salon de 1885 (Poitiers, 1885), 361; "The Exhibition at the Pennsylvania Academy," *Art Interchange* 15 (November 19, 1885), 135; "Some of the Academy Pictures," *Philadelphia Call* (November 1885), n.p.; "Art Notes, The Art Club Exhibition," *Boston Evening Transcript,* January 19, 1886, 4.

86. Henry Roderick Newman (1843–1918)

Anemones and Daffodils, 1884

Watercolor on paper

21 5/16 x 11 7/8 in. (54.1 x 31.3 cm)

Signed and dated lower left: "H R Newman / 1884"

Museum Purchase, The J. Harwood and Louise B. Cochrane Fund for

American Art, 91. 59

PROVENANCE: Private collection, Brooklyn, N.Y.; Jordan-Volpe Gallery, New York, N.Y. (1988); Private collection, Calif.; Jordan-Volpe Gallery, New York, N.Y. (1990)

Evoking a fragrant Tuscan breeze, Henry Roderick Newman's *Anemones and Daffodils* brings us close to the ground to view spring flowers blooming in the countryside near Florence, Italy. The steep pitch of the knoll obscures any glimpse of sky and most of the rolling hills beyond, compelling us to inspect the minutely detailed vegetation at hand. We can easily trace the graceful flowers from full-blown petals, down delicate stems, and into thickets of grass and leaves where each joins the warm earth. Looking above through a partial view, we find echoes of the verdant beauty in the distant flowering trees.

In 1884, the year Newman completed this lush watercolor, his friend and biographer H. Buxton Forman published an article about the American expatriate's life and work.[1] By that time, Newman had established what would become a lifelong residency in Florence and had gained some international acclaim for his meticulous watercolors of historic buildings as well as his renderings of flowers growing in their natural settings. Forman praised Newman's ability to create "an individual portrait of every flower he introduces into his picture," and the critic gave particular attention to "the anemone pictures in which Mr. Newman not only attains his best results in flower combinations, but also, I think, surpasses all that has been done elsewhere in that department of modern art." He added, "there are good examples in England in the hands of Mr. Ruskin."[2] Indeed, John Ruskin, prominent English art critic, author, and artist, had recently acquired several watercolors from Newman, including studies of the Tuscan *Anemone coronaro.*[3]

Long before their first meeting in 1877, Newman was already a devoted practitioner of Ruskin's art theories. Through the Englishman's enormously influential books—particularly his five-volume *Modern Painters* (1843–59) and *Elements of Drawing* (1857)—Newman and a small band of young New York artists had embraced Ruskin's exhortation to seek universal truths in the direct study and careful depiction of nature. In 1863, after forming the short-lived Association for the Advancement of Truth in Art (popularly known as the American Pre-Raphaelites), they published the *New Path,* a journal dedicated to Ruskinian philosophy and methods.[4] Their serious and often provocative calls for reform countered the general direction of artistic taste in mid-nineteenth-century America. During an era when other painters were achieving critical and financial triumph with vivid, large-scale landscapes (see cat. no. 57), they sought to "observe and record truth" through small, delicate renderings of natural forms: birds' nests, wildflowers, leaves, tufts of grass, or rock formations. And, as advocated by Ruskin, their chosen medium was typically watercolor.[5]

Newman, a superb draftsman, developed his own disciplined and distinctive technique. It was carefully described by one of his students in 1884—the same year that *Anemones and Daffodils* was completed. After laying down a light

86

pencil sketch on paper, Newman next prepared a palette of only four colors: yellow ocher, lemon yellow, rose madder, and cobalt blue (ultramarine). Following sequential washes of ocher and blue, the preferred method was to "[t]hen take up bit by bit and stipple in the color with an almost dry brush and small strokes, drawing, as it were, with color. Do most of the drawing with the brushpoint. . . . Avoid black or dark spots especially in the distance. Let the papers shine between your strokes of color. In this way you get lightness and transparency."[6] Among the American Pre-Raphaelites, only Newman maintained the slow, meticulous manner of delineation as he approached various subjects throughout his long career.

The cosmopolitan Newman traveled extensively, making painting trips to England, Switzerland, Germany, France, and even Japan. In 1887, he and his wife spent the first of at least twenty-five winters in Egypt. There, he employed the same close attention to picturing ancient ruins at Karnack and Luxor that he brought to his Italian flower studies and medieval church facades. Among Newman's many artistic legacies are his hauntingly beautiful and archeologically significant renderings of the Temple of Isis at Philae, completed in the years just before the Aswan Dam project sent devastating flood waters to the site.[7] ELO

NOTES

1. Newman grew up in New York City. After teaching himself to draw and paint natural scenes, he abandoned his medical studies in 1861. During the next decade he established himself in the American art community, showing almost annually at the National Academy of Design and the Brooklyn Art Association. For biographical information about his formative years, see H. Buxton Forman, "An American Studio in Florence," *The Manhattan* 3 (June 1884): 526–27; and Annette Blaugrund, "Henry Roderick Newman," in *The New Path: Ruskin and the American Pre-Raphaelites*, exh. cat., ed. Linda S. Ferber and William H. Gerdts, (Brooklyn, N.Y.: Brooklyn Museum, 1985), 204. For the most thorough consideration of Newman's life and career to date, see Royal W. Leith, *A Quiet Devotion: The Life and Work of Henry Roderick Newman*, exh. cat. (New York: Jordan-Volpe Gallery, 1996).

2. Forman, 534.

3. Theodore E. Stebbins Jr., with Susan Ricci, "Charles Eliot Norton, Ruskin's Friend, Harvard's Sage," in Theodore E. Stebbins Jr. and Virginia Anderson, *The Last Ruskinians: Charles Eliot Norton, Charles Herbert Moore, and Their Circle* (Cambridge: Harvard University Art Museums, 2007), 19–21; William H. Gerdts, "Through a Glass Brightly: The American Pre-Raphaelites and Their Still Lifes and Nature Studies," in *New Path*, 73. Buxton further notes that Ruskin acquired some of Newman's early drawings as technical examples for his Guild of St. George study collection at Sheffield. Buxton, 528.

4. The association also included like-minded architects, geologists, and art critics. The practicing artists of the group included English émigré Thomas Farrer, former

Ruskin student and the association's leader; John Henry Hill; his son John William Hill; Charles Herbert Moore; William Trost Richards; and Newman; Roger B. Stein, *John Ruskin and Aesthetic Thought in America, 1840–1900* (Cambridge: Harvard University Press, 1967), 145–56, 196–97; Ferber, "'Determined Realists': The American Pre-Raphaelites and the Association for the Advancement of Truth in Art," in *New Path*, 11–37.

5. Gerdts, 39–77; Roger B. Stein, "A Flower's Saving Grace, The American Pre-Raphaelites," *ARTnews* 85 (April 1985): 85–90; Kathleen A. Foster, "The Pre-Raphaelite Medium: Ruskin, Turner, and American Watercolor," in *New Path*, 79–83.

6. Denman W. Ross, diary entries, April 7 and April 9, 1884; cited in Leith, 33–34. Leith notes that Ruskin found fault with Newman's limited palette, believing the restriction to four colors too severe (34).

7. Leith, 44–55.

87. Elihu Vedder (1836–1923)

The Cup of Death, 1885

Oil on canvas

44 ⅜ x 20 ¾ in. (112.7 x 52.7 cm)

Signed lower right: "Copyright 1899 by Elihu Vedder"

Museum Purchase, The Adolph D. and Wilkins C. Williams Fund,
 76.38.3

PROVENANCE: Miss Susan Minns, Boston, Mass. (1900); Mrs. John Booton (neé Vedder), Boston, Mass.; Vose Gallery, Boston, Mass.

> So when the Angel of the darker Drink
> At last shall find you by the river-brink,
> And, offering his Cup, invite your Soul
> Forth to your Lips to quaff—you shall not shrink.
>
> ——— *The Rubáiyát of Omar Khayyám*, verse 49

Two somnambulistic figures—the naturalistically winged Angel of Death, "full of might and mildness," and a pallid young woman—draw near a riverbank in the dead of night, their shroudlike draperies rippling in the roseate light of the half-hidden moon. This haunting image of ultimate acceptance, "imbued with a sense of heavy sorrow," is derived from the forty-ninth quatrain of *Rubáiyát of Omar Khayyám*. Elihu Vedder's visual sources for this languorous conception of death ranged from the eighteenth-century Roman tomb sculpture of Antonio Canova to the contemporary English Pre-Raphaelite painters George Frederick Watts and Edward Burne-Jones. The overall theme, however, had greater personal and cultural resonance for the American artist.[1]

A permanent expatriate best known for his allegorical and literary subjects, Vedder had opened a studio in Rome during the late 1860s and quickly established a reputation as a distinctive painter, sculptor, muralist, illustrator, and author. Although not directly linked with any single artistic style, his work assimilated aspects of different late-nineteenth-century movements, including academicism, Pre-Raphaelitism, and symbolism—leading a contemporary critic to call Vedder "one of the most completely original of modern artists."[2] During the 1870s and 1880s, moving between Rome, London, and New York, the artist was consumed by themes of loss and psychological struggle, a near obsession that peaked in his 1884 masterwork—fifty-six illustrations for a deluxe edition of Edward FitzGerald's *Rubáiyát of Omar Khayyám.* Vedder found his ideal subject in this work that combined meditative poetry and monumental design and considered it to be his major artistic achievement.[3]

Vedder had been introduced to FitzGerald's text in 1871 by English artist Edwin Ellis, and his appreciation for it deepened after the death of his eldest son, Philip, four years later. FitzGerald's 1859 translation of the twelfth-century Persian

text, composed by the astronomer-poet Khayyám, stressed in 101 quatrains the importance of daily meditation and the celebration of life while speculating on the mysteries of existence and death. The translation appeared the same year that Charles Darwin published his controversial *On the Origin of Species,* mirroring the period's spiritual unrest and tension between religion and science. FitzGerald's text was regarded as a masterwork in its own right and exerted a great influence on late-nineteenth-century English poetry.[4]

During an 1881–83 sojourn in New York, Vedder's sensitivity to current cultural trends was on full view. The artist's early introduction to English Aestheticism—a cultural phenomenon that celebrated a nonhierarchical approach to art making—caused him to embrace the American variant through a range of decorative experiments. Within eighteen months of his arrival in New York, the respected expatriate's designs for greeting cards, magazine covers, bookplates, stained glass, tiles, firebacks, and book illustrations assured his standing as one of the leading "progressives." Socializing with other like-minded artists in fraternal organizations such as the Tile Club (see cat. no. 76)—formed in response to the new popular demand for Aesthetic objects—Vedder, with "the cry of money always in my ears," pursued these projects as both artistic and commercial ventures at a time when the market for American painting was faltering.[5]

Vedder's fertile connections with New York's Aesthetic set ultimately led to his most artistically celebrated and financially successful project: the so-called visual accompaniments to FitzGerald's *Rubáiyát.* Joseph Millet, who worked with Houghton Mifflin publishers and was the brother of fellow Tile Club member and former expatriate Francis Davis Millet, apparently encouraged Vedder's idea to produce an artistic book. An agreement was finalized in 1883, and the volume, designed entirely by Vedder, appeared in the fall of the following year. It was an immediate sensation, spawning a new era of fine art publishing in America.[6] The full-page illustrations (fig. 149) were also exhibited to great acclaim in Boston and New York. Executed on gray paper with black and white crayons, the drawings were described by critics as possessing "an infinite tenderness, a grace and loveliness, which mark a close human sympathy as well as the utterances of a stern and inexorable fate."[7]

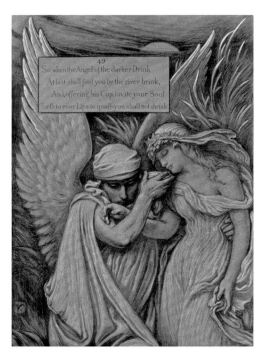

FIG. 149 Elihu Vedder (1836–1923), **The Cup of Death,** in *The Rubáiyát of Omar Khayyám,* verse 49, 1883–84. Virginia Museum of Fine Arts Library.

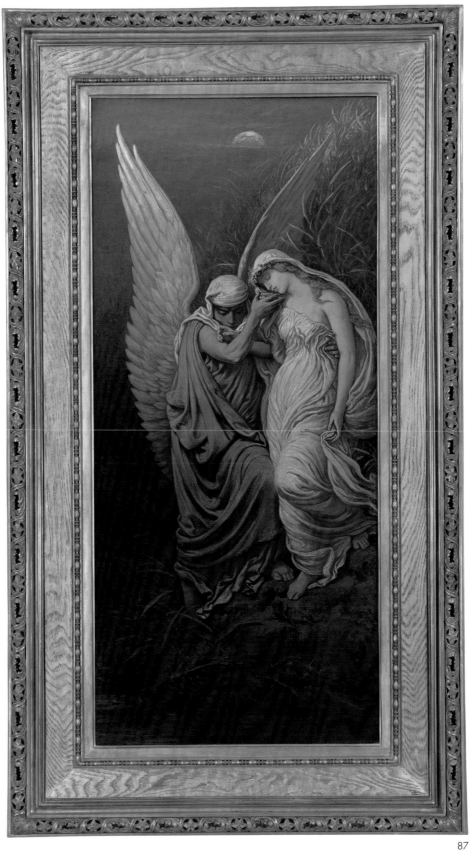

87

The 1884 *Rubáiyát* volume, alternately shaded by tragic and joyous undertones, struck a chord with a broad American public traumatized by the Civil War, shaken by the scientific theories of Darwin, and further challenged by foreign immigration, massive industrialization, and growing social discord. The appeal of Khayyám's poetry was its dominant theme of transience, a perspective offering the fearless acceptance of death and the unknown. Vedder's interpretive approach to the work emphasized the text's grounding in notions of doubt and personal conflict, reflecting the anxieties of his age.[8] The *Rubáiyát* drawings marked a new phase in the artist's career, providing him with thematic material for subsequent large-scale paintings, including two versions of *The Cup of Death*.[9]

According to the artist's daughter, Anita, the original oil (purchased by collector William T. Evans and now at the Smithsonian American Art Museum) was left unfinished by Vedder until 1911. Apparently, he grew dissatisfied with its somber palette—so much so that he decided to repaint the composition "with another coloring more brilliant and rich."[10] This second, warmer version, owned by VMFA, was sold for $2,500 in 1900 to Susan Minns, "whose fad," the artist wrote, "is to have the greatest collection of *dances of death* going. Well, all I can say is 'Viva la faccia of death.'"[11] Comparing the relative merits of both paintings of the subject, Anita Vedder declared of the VMFA picture, "Certainly my father represents [death] in a consoling and fortifying manner so that even a dying person could gaze with pleasure on it." Virginia's painting is further distinguished by its less harshly defined figures, viewed at a greater distance and more harmoniously placed against a greater profusion of fluttering reeds.[12] Vedder copyrighted this version in 1899, presumably for reproduction. The Boston-based Curtis and Cameron marketed different sizes of the hand-colored image for $6.00 and $3.50, attesting to its ongoing popularity with the public.[13] SY

NOTES

1. William Howe Downes, "Elihu Vedder's Pictures," *Atlantic Monthly*, June 1887, 844. William Kloss, *Treasures from the National Museum of American Art* (Washington and London: Smithsonian Institution Press, 1985), 86; Jane Dillenberger, "Between Faith and Doubt: Subjects for Meditation," in *Perceptions and Evocations: The Art of Elihu Vedder* (Washington, D.C.: Smithsonian Institution Press, 1979), 142. Interestingly, Vedder's figurative drawings for the Eastern poem are more suggestive of a classical and Christian Pre-Raphaelitism than the "oriental"

fantasy that characterized his earlier work. It is likely that Vedder was familiar with a 1870s volume of the translation, illuminated by Burne-Jones, William Morris, and Charles Fairfax Murray. See Regina Soria, *Elihu Vedder: American Visionary Artist in Rome, 1836–1923* (Rutherford, N.J.: Fairleigh Dickinson University Press, 1970), 183.

2. Downes, 846.

3. Tragedy haunted the Vedder family throughout their lives with the loss of an infant son, Alexander (called Sandro), to diphtheria in 1872; their eldest, Philip, to the same disease in 1875; and, in 1916, that of a third son, Nico. Their daughter, Anita, remained the artist's sole heir. For an analysis of Vedder as "a cultural migrant," an identity that shaped discussions of him as an artistic outsider or misfit, see Sarah Burns, *Painting the Dark Side: Art and the Gothic Imagination in Nineteenth-Century America* (Berkeley: University of California Press, 2004), 158–87.

4. Vedder claimed to have been one of the first Americans to appreciate the work: "this was so far back that it was in the time when Omar, or FitzGerald, was only known to Tennyson and his friends as 'old Fitz' and to a few besides." See Elihu Vedder, *The Digressions of V. Written for His Own Fun and That of His Friends* (Boston: Houghton Mifflin, 1910), 404.

5. Sylvia Yount, "Give the People What They Want" (Ph.D. dissertation, University of Pennsylvania, 1995), 171–75.

6. Vedder himself was surprised by its immense popularity. See Vedder, 231.

7. The same critic observed, "*Weirdness* is a word which occurs to all who know Mr. Vedder's work, and yet it is but vaguely indicative of the mystic spirituality of its character, allied to which is a striking demonic element." See "Vedder's Drawings for Omar Khayyám's *Rubáiyát*," *Atlantic Monthly*, January 1885, 113.

8. For a thorough and thoughtful interpretation of Vedder's *Rubáiyát* project, see Akela M. Nigrelli [Reason], "Elihu Vedder's Conception of Edward Fitzgerald's *Rubáiyát of Omar Khayyám*" (M.A. thesis, University of Maryland, 1993).

9. In *The Cup of Death* paintings, Vedder visualized a detail from the quatrain that was missing in his published volume by presenting the full-length figures (rather than the half-length composition of the drawing) standing at the "river-brink." See [Reason], 71.

10. See Anita Vedder to R. Rathburn, May 21, 1911, copy in VMFA curatorial files.

11. Quoted in Soria, *Elihu Vedder*, 226. For more on Susan Minns, the first female graduate of the Massachusetts Institute of Technology, see [Reason], 148n13.

12. Both paintings retain their original Aesthetic frames, which may have been designed by Vedder in collaboration with his artist-colleague Charles Caryl Coleman (see cat. no. 77).

13. See [Reason], 148n15.

88. Edwin Lord Weeks (1849–1903)

The Hour of Prayer at Moti Mushid (The Pearl Mosque), Agra, ca. 1888–89

Oil on canvas

81 x 118 in. (205.7 x 299.7 cm)

Museum Purchase, The J. Harwood and Louise B. Cochrane Fund for American Art, 2008.40

PROVENANCE: Estate of the artist to wife Frances Rollins Hale Weeks, Paris (1903); sold at auction by American Art Galleries, New York, N.Y., to George D. Pratt, Brooklyn, N.Y. (1905); Brooklyn Museum, Brooklyn, N.Y. (1915–47); Alexander R. Raydon (1947–2008)

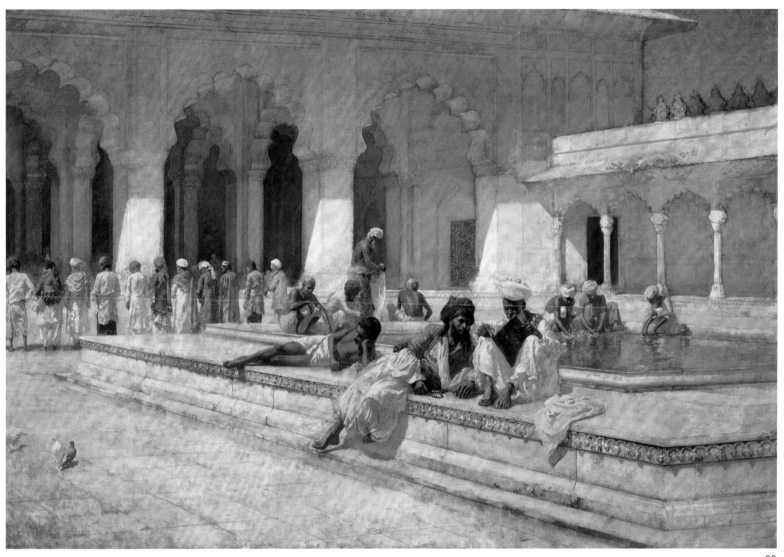

88

This delicate and charming "Pearl Mosque"... most exquisite in its architectural features and the rich and pearly tones, ... all of the purest white, with its shimmering purplish shadow, seems to reveal all the extravagant fancy and lazy luxuriousness of this land of sunshine.

So was this remarkable painting described in the 1905 auction catalogue detailing the studio contents of acclaimed expatriate Edwin Lord Weeks. The artist's similarly multitalented colleague and friend, Francis Davis Millet, defined Weeks's association with the subject at the turn of the last century: "Many a traveler in India during recent years has envied Edwin Lord Weeks his artistic vision. . . . Where the ordinary traveler has observed only squalor and misery, he has seen the enchanting glories of sunlight and shadow and the bewitching contrasts of color in costume, in architecture and in landscape."[1]

A leading "orientalist" painter, illustrator, photographer, writer, explorer, and collector, Weeks was among the first-known American artists to visit India. Boston born and Paris trained, the inveterate traveler was inspired by the "exotic" historical subjects and linear and painterly techniques of the French academic painters Jean-Léon Gérôme and Léon Bonnat, with whom he likely studied in the 1870s. After attracting critical and popular attention on both sides of the Atlantic for his contemporary North African and Middle Eastern scenes, Weeks made the first of three trips to India in 1882. He was particularly drawn to Ahmadabad, the principal city of the western state of Gujarat, famed for its fifteenth- and sixteenth-century mosques and tombs with their intricate teak and sandstone architectural decorations. On his first trip, Weeks encountered the American painter-cum-designer Lockwood de Forest, an avid admirer and promoter of Indian art and craft. An early business colleague of Louis Comfort Tiffany, de Forest had recently established the Ahmedabad [sic] Wood Carving Company in partnership with a prominent local merchant banker, Dalpatbhai Muggunbhai Hutheesing.[2]

The Hour of Prayer at Moti Mushid, housed in its original frame designed by de Forest (fig. 150), dates from Weeks's second Indian excursion. The scene depicts worshippers gathered in the central court of a mosque. In the foreground, a "moolah," or holy man, reads to a companion, while others recline or bathe in the open sunny space. A row of worshippers in the background stand facing Mecca. The painting was awarded a gold medal at the 1889 Paris Salon, where the artist's Indian subjects frequently created public sensations. Late-nineteenth-century viewers were drawn to these technically skilled works picturing foreign locales that were little explored by Westerners. Characterized by a rich pageantry and visual grandeur, such paintings express Weeks's passion for India's ancient architectural settings and local customs, and according to a period critic, they were "full of incident and coloring." Although composed from Weeks's highly detailed on-site sketches and photographs, paintings such as *The Hour of Prayer at Moti Mushid* (measuring nearly six by ten feet) were major productions, completed in the artist's Paris studio (fig. 151) and destined for a large, international audience. Weeks exhibited this particular painting, under the title *Prayer House in the Mosque at Agra,* with four other works "of the Oriental type" at the Paris Salon of 1889. Deemed "the gem of Weeks's showing," it was described by an American critic as "almost a perfect picture, complete in religious sentiment and poetical inspiration."[3]

Both American and European reviewers agreed that Weeks's Indian scenes represented a "cooler" and "drier" (that is, more objective) vein of "orientalism"—more anthropological than emotional in its intent and effect. Unlike his fellow orientalists

FIG. 150 Detail of original frame designed by Lockwood de Forest (1850–1932), cat. no. 88.

FIG. 151 Photograph of **Edwin Lord Weeks in Paris studio painting** *The Hour of Prayer at Moti Mushid.*

By the turn of the twentieth century, Weeks had established himself as an esteemed member of the American expatriate community in Paris (he was designated a knight of the French Legion of Honor in 1896). However, soon after his death in 1903, his work, like that of other academically trained cosmopolites, fell from favor with the advent of modernism.[5] A resurgence of interest in Weeks's art began in the 1970s and continues to this day. SY

NOTES

1. F. D. Millet, "Edwin Lord Weeks," in *Catalogue of Very Important Finished Pictures, Studies, Sketches and Original Drawings by the Late Edwin Lord Weeks* (New York: American Art Association, 1905). See also the artist's extensively illustrated *New York Times* obituary, March 12, 1905.

2. Pratapaditya Pal et al., *Romance of the Taj Mahal,* exh. cat. (Los Angeles County Museum of Art, 1989), 211. For an overview of Weeks's life and career, see D. Dodge Thompson, "Edwin Lord Weeks, American Painter of India," *The Magazine Antiques* 128 (August 1985): 246–58. For Lockwood de Forest, see Amelia Peck and Carol Irish, *Candace Wheeler: The Art and Enterprise of American Design, 1875–1900,* exh. cat. (New York: Metropolitan Museum of Art and Yale University Press, 2001), 108–13.

3. See "Walks in the Salon," *New York Times,* June 2, 1889; "American Artists Honored," *New York Times,* June 29, 1889; and *Salon de 1889, catalogue illustré, peinture & sculpture* (Paris: Librairie d'Art, 1889), 44.

4. Lois Marie Fink, *American Art at the Nineteenth-Century Paris Salons* (Cambridge: National Museum of American Art, Smithsonian Institution, and Cambridge University Press, 1990), 165–67. During the artist's second trip to India, when the *Hour of Prayer* was conceived, Weeks kept a diary that led to a series of illustrated articles for *Harper's Magazine* and later a book. See Edwin Lord Weeks, *From the Black Sea through Persia and India,* (New York: Harper and Brothers, 1896), 325. Benjamin (1881), Sheldon (1890), and Weeks (1896); quoted in Teresa A. Carbone, *American Paintings in the Brooklyn Museum, Artists Born by 1876* (London: Brooklyn Museum and D. Giles, 2006), 1:1059–60.

5. The artist's most iconic picture, *The Last Journey, Souvenir of the Ganges, Benares*—the only painting to be presented by his widow to a museum—was deaccessioned in 1956 by the Metropolitan Museum of Art. *The Hour of Prayer* met the same fate at the Brooklyn Museum in 1947.

and Paris colleagues Frederick Bridgman, who painted primarily interior scenes of daily life, or Henry Ossawa Tanner, whose work featured biblical subjects (see cat. no. 102), Weeks focused on human activity performed outdoors under intense sunlight. In his 1896 collection of travel essays, the artist compared the courtyard of the Moti Mushid to the "blinding dazzle of a snowfield, for nothing meets the eye but marble and the deep blue sky." Years earlier, the art critic S. G. W. Benjamin had emphasized this particular talent of the artist: "The art qualities in which Mr. Weeks excels, are light and color. He has a passion for brilliant effects, but renders them so skillfully that his pictures do not seem either crude or sensational." Other period writers praised Weeks for investing his Indian subject matter with aesthetic interest. According to George William Sheldon, "Mr. Weeks has learned that, to express India, one must paint the hideous and grotesque side by side with the beautiful; but he attaches himself to the purest traditions of classic art by his systematic and conscientious search for beauty in tone and line." Whereas Weeks was fascinated by his human subjects, he knew that most European and American viewers would find "the particulars of the Indian population . . . these bewildering castes and their subdivisions" perplexing, thus he balanced his highly detailed figural treatment with a theatrical flair that emphasized the country's "sensuous outward beauty."[4]

89

89. Robert Frederick Blum (1857–1903)

The Temple Court of Fudo Sama at Meguro, Tokyo, 1891

Oil on canvas

27 x 19 ⅞ in. (68.6 x 55 cm)

Museum Purchase, The J. Harwood and Louise B. Cochrane Fund for
American Art, 91.503

PROVENANCE: Flora de Stephano, Boston, Mass. (ca. 1903); by descent through
Mullins family, Fla. (after 1923); Mr. and Mrs. Richard Manoogian, Grosse Point,
Mich. (1981); Private collection, Boston, Mass. (1990)

This painting of a Buddhist temple on the outskirts of Tokyo resulted from a "wild desire that had grown up" in Robert Frederick Blum over many years. One of the first American artists to visit Japan—a country of long-standing fascination to Westerners—the expatriate had been impressed by the culture's design principles and craftsmanship traditions throughout his artistic career.

Blum attributed this early interest to a number of influences, beginning with a "hawker" of Japanese fans he encountered in his native Cincinnati. As a seventeen-year-old, Blum attended classes at Cincinnati's McMicken School of Design (now the Art Academy of Cincinnati) under the English-born educator and wood-carver Benn Pitman, one of the key figures who shaped Blum's artistic development and taste for all things Japanese. Three years later, Blum moved to Philadelphia to study at the Pennsylvania Academy of the Fine Arts. There he joined the throngs of visitors attending the city's Centennial International Exhibition, America's first world's fair. He especially admired the Japanese showing—the striking displays in the Main Building, a traditional teahouse, and a bazaar where consumers could purchase a range of moderately priced, high-quality goods for the home. These presentations marked the first widespread introduction of Japanese culture in America. Blum later credited the fair's "magnificent Japanese display" for fueling his admiration for the quality of workmanship and the adaptation of natural forms in Japan's objets d'art.[1] Among Blum's other influences were Christopher Dresser (whose own Japanese-inspired design work [fig. 152] was exhibited at the centennial, which Dresser visited en route to Japan) and James McNeill Whistler (see cat. no. 78), whom

Blum first encountered in Venice in 1880 (though Whistler himself never visited Japan).[2]

Blum finally achieved his long-held dream of visiting the Land of the Rising Sun in 1890 by way of a commission from *Scribner's Magazine.* (On arriving in Japan, Blum wrote to his friend William Merritt Chase: "It is simply a new world where life is on another plane—and yet one where with all its strangeness I feel strangely at home.") His assignment was to illustrate a series of articles on Japanese culture by the British poet, journalist, and "orientalist" Sir Edwin Arnold; they were later compiled in book form under the title *Japonica.* Working characteristically in a variety of media—from oil to watercolor and pastel (a particular talent of the artist)—Blum sought to portray the distinctive customs, fashions, architecture, and design of the Japanese, what he termed "artistic devices" that revealed the culture's love of color and form. In the process, Blum celebrated the population's natural beauty and traditional handicraft.[3]

The Temple Court of Fudo Sama at Meguro, Tokyo is the first major oil Blum undertook in Japan. Although the picture did not feature in the Arnold series, it was later reproduced in the artist's personal account of his Asian sojourn, also published in *Scribner's.* Blum described the practical difficulties

FIG. 152 Christopher Dresser (1834–1904), for Minton Hollins and Company (est. 1845), **Ceramic Tea Boxes,** Staffordshire, England, ca. 1870, bone china, 4 x 4 x 3 ⅜ in. (10.2 x 10.2 x 8.6 cm) each. Virginia Museum of Fine Arts, Gift of the Estate of Ailsa Mellon Bruce, and of Mrs. Wayne Chatfield-Taylor, Mr. and Mrs. Dean A. Covey, Mrs. John R. Curtis, Mrs. George R. Frost, and Bequests of Mrs. Arthur Kelly Evans, and John C. and Florence S. Goddin, by exchange, 96.98.1a/b–2a/b.

he encountered representing the temple and its "magnificent" woodwork on canvas—from the long journey by "jurickshaw" to atmospheric challenges such as shifting light and high winds. His commitment to painting the scene on-site—rather than resorting to quick sketches to be developed later in the studio, or to photography, a tool Blum used in figural compositions—reveals his absorption of impressionist plein-air methods. The composition's sharply fragmented angles and flattened space also suggest his ongoing study of Japanese

FIG. 153 Robert Frederick Blum (1857–1903), **Flora de Stephano, The Artist's Model,** 1889, pastel on paper, 20½ x 18¼ in. (52.1 x 46.4 cm). Collection of James W. and Frances G. McGlothlin, Promised Gift to Virginia Museum of Fine Arts.

prints, which greatly informed impressionism in both France and America. Finally, the picture's contrasting light effects and energetic brushwork highlight Blum's lifelong devotion to the work of Spanish artist Mariano J. M. B. Fortuny (at the outset of Blum's career, critics dubbed him "Blumtuny").[4]

Not content merely to document Japan's ritual architecture, Blum here conveys its visual beauty and vitality to Western audiences. Reveling in "the prismatic tints, the glint of sun on gold and bronze, the play of light and shade on opalescent pillars and boldly carved doors and screens,"

the artist captured the particular quality of light in Tokyo— "strong, chilled steel hued, and of permeating keenness, bringing opposing surfaces into exaggerated relief by its intensity—flattening out shadows, making them vapory, sullen toned."[5]

Blum also gives careful, if fluidly painted, attention to detail in the work, and numerous symbolic and utilitarian objects are discernible: bronze wooden gongs, two *shimenawa* (sacred ropes), a brazier for burning ritual incense, ceramic fire buckets, and a stone guardian lion. The figural presence, more understated in this picture than in others Blum produced in Japan, emphasizes Buddhists' seamless integration of religion into their daily existence: while one man bows his head in prayer outside the temple, another kneels on the steps, and a third peers out from the building's dim recesses. The inclusion of a pigeon, perched on the curved roof, and chickens pecking the dirt at right lends telling, quotidian details to this fragmentary glimpse of Japanese life.

The Temple Court passed to Blum's friend and sometime model, Flora de Stephano (fig. 153), upon his early death from pneumonia (an illness he first contracted in Japan). Like other Japanese oils by the artist (for example, *The Ameya,* in the collection of the Metropolitan Museum of Art), the painting retains its original, highly elaborate frame made of fragile wire and plaster, selected by Blum to echo and enhance the decorative patterns he rendered on canvas. SY

NOTES

1. For a comprehensive overview of Blum's life, including his early fascination with Japanese culture, see Bruce Weber, "Robert Frederick Blum (1857–1903) and His Milieu" (Ph.D. dissertation, City University of New York, 1985), 8–9, 45–54. See also Robert Blum, "An Artist in Japan," *Scribner's Magazine* 13 (April 1893): 399. For an overview of the Japanese presence at the 1876 world's fair, see Sylvia L. Yount, "'Give the People What They Want': The American Aesthetic Movement, Art Worlds, and Consumer Culture, 1876–1890" (Ph.D. dissertation, University of Pennsylvania, 1995), 73–80.

2. Blum took night classes in antiques and design at McMicken's during the 1873–74 school year; the future academic painter Kenyon Cox was a fellow classmate and friend. The school's progressive instruction also attracted other student talents such as John Twachtman, Elizabeth Nourse, Joseph DeCamp, and Edward Potthast. For a discussion of Cincinnati and its artistic ferment in the 1870s, see Julie Aronson, ed., *The Cincinnati Wing: The Story of Art in the Queen City* (Athens, Ohio: Cincinnati Art Museum and Ohio University Press, 2003), 58–62, 78–79, 138–39. For Dresser, see Michael Whiteway, ed., *Shock of the Old: Christopher Dresser's Design Revolution,* exh. cat. (London: Victoria and Albert Publications in association with Cooper-Hewitt National Design Museum, 2004); and for Whistler and his (as well as Frank Duveneck's) formative impact on Blum and

his art, see Marc Simpson, "Venice, Whistler, and the American Others," *After Whistler: The Artist and His Influence on American Painting,* exh. cat. (New Haven and London: Yale University Press in association with High Museum of Art, Atlanta, 2003), 32–49.

3. Weber argues that Blum was better known in his lifetime for his illustration work than for his figure paintings; see viii, 65–73, 336. An 1879 commission for *Scribner's* had brought the artist to Yorktown and Alexandria, Virginia, where he executed a series on "colonial" life; see Richard J. Boyle, *Robert F. Blum, 1857–1903: A Retrospective Exhibition,* exh. cat. (Cincinnati: Cincinnati Art Museum, 1966), 3–4.

4. Robert Blum, "An Artist in Japan," *Scribner's Magazine* 13 (April–June 1893): 399–414, 624–36, 729–49. See also Weber, 65, 350, 373–74.

5. Blum, 748; Weber, 336.

90. Cecilia Beaux (1855–1942)

Alexander Harrison, 1888

Oil on canvas

26 x 19 ¾ in. (66 x 50.2 cm)

Inscribed, signed, and dated lower left: "To Alexander Harrison / Cecilia Beaux / Concarneau-1888"

Museum Purchase, The J. Harwood and Louise B. Cochrane Fund for American Art and Partial Gift of Juliana Terian Gilbert in memory of Peter G. Terian, 2009.2

PROVENANCE: Cecilia Beaux to Alexander Harrison (1888); to sister Mrs. Harrison Fulton; to daughter Mrs. Margaret Harrison Fulton Spencer, wife of artist Robert Spencer; Private collection, Penn. (by descent); Richard York Gallery, New York, N.Y.; Peter G. Terian, New York, N.Y. (1994); to wife Juliana Terian, New York, N.Y. (2002–9)

91. John Singer Sargent (1856–1925)

The Sketchers, 1913

Oil on canvas

22 x 28 in. (55.9 x 71.1 cm)

Museum Purchase, The Arthur and Margaret Glasgow Fund, 58.11

PROVENANCE: M. Knoedler and Company, New York, N.Y.; to Mrs. Francis Carolan, Malabar, India (ca. 1914) ; H. P. Carolan, New York, N.Y. (ca. 1927); Mrs. Arthur F. Schermerhorn, New York, N.Y. (ca. 1956) ; M. Knoedler and Company, New York, N.Y. ; Victor D. Spark (in partnership with James Graham and Son and Renaissance Galleries, New York, N.Y.)

Born and raised in Philadelphia, Cecilia Beaux was heralded at the turn of the twentieth century as the "best woman painter" in history and the "Jane Austen of art." Superlatives aside, she was unquestionably at the top of her game—an internationally acclaimed figure painter and portraitist who also happened to be the most successful female artist working in America. Yet Beaux—unlike her better-known contemporaries Mary Cassatt, Thomas Eakins, and John Singer Sargent—has not fared well in modernist-driven art history that finds little merit in the upper-class imagery for which she was celebrated. Avidly commissioned and acquired for major private and public collections throughout her forty-year career, Beaux's work more recently has garnered renewed interest from art historians, collectors, critics, and the general public on both sides of the Atlantic.[1]

Already an accomplished painter by the time she arrived in Paris for further training at age thirty-three, Beaux studied at the Julian and Colarossi academies—private, coeducational art schools frequented by many Americans. She quickly distinguished herself as one of the more advanced students. Like her younger contemporaries, Beaux also attended summer art colonies, traveling to the seaside village of Concarneau in Brittany, a region particularly popular with Philadelphians. There she explored more ambitious figural compositions and embraced the practice of plein-air (outdoor) painting.[2]

Beaux's dynamic portrait of one of her early mentors, Philadelphia-born painter Alexander Harrison, dates from a pivotal stage of her artistic training and conveys what one critic identified as the essence of her art: "its spontaneity, its nervous swing, its self-confidence and quite exhilarating fluency." It is one of two extant, fully realized pictures she produced in Brittany; the other, *Twilight Confidences* (private collection), is a rare genre scene of two Breton women. A fellow Pennsylvania Academy of the Fine Arts alumnus, Harrison had spent nearly a decade in France by the time he met Beaux in Paris in 1888, and was therefore a figure of some influence for many newly arrived American art students. Best known for his naturalistic marines and landscapes, Harrison was a favorite in the Paris Salons from his first appearance in 1880. (Beaux once penned a verse to her expatriate colleague praising his "ocean blue or green or glimmering ocean sheen with pinky throbs between, most mooningly marine.")[3]

Beaux's initial impression of Harrison, only two years her senior, was far from positive; she described him as "very tall, very handsome, and distinguished—dark hair and gray

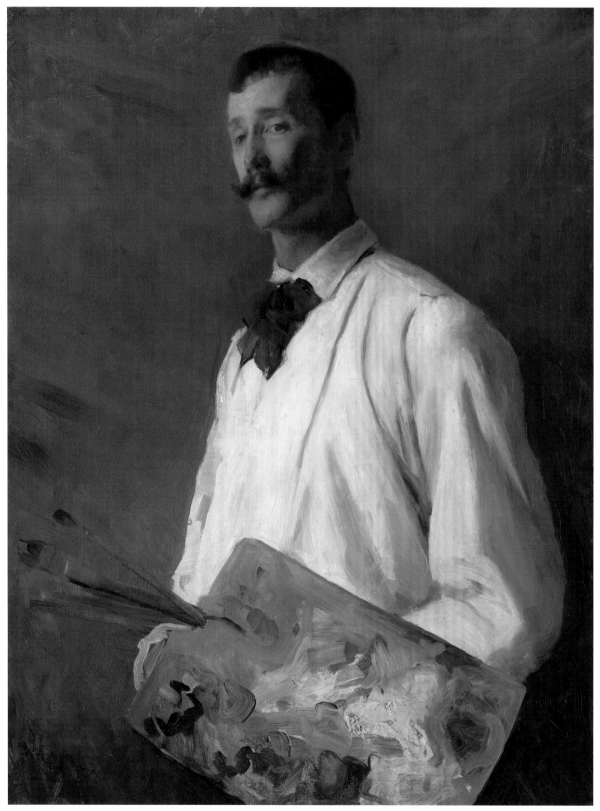

90

eyes, and long, dark moustache—And the worst cold, blasé expression. He looks at one as he would a horse—He has evidently two sides—one for Art into which all the weight and feeling of his nature flows—and the small part that is left amuses itself coldly." But in Concarneau, they established a more collegial relationship, and she was flattered when Harrison asked her to paint his portrait—their greatest collaboration. Throughout the summer, Harrison offered constructive critiques of Beaux's work, encouraging her to lighten her palette and adopt a more fluid brushwork while spending more time in the open air. Harrison's counsel had a profound effect on her working method, beginning with this portrait. In a bravura statement, Beaux captured her subject's debonair swagger and lanky good looks as well as his appraising eye; the color-strewn palette dazzles in its fresh immediacy. The completed picture led Harrison to comment that Beaux had the "right stuff" to become a painter, "the stuff that digs and thinks and will not be satisfied and is never weary of the effort of painting nor counts the cost."[4]

By the end of her nineteen-month stay in Europe, which included travels throughout France, Italy, and England, Beaux was determined to pursue a career as a painter of "heads." "People do seem to me more interesting than anything else in the world and that is the bottom of my success in heads," she wrote home from France. "I don't think that even the charm of color and values could ever put out that which character has for me."[5]

Beaux's single treatment of the time-honored artist-painting-artist theme contrasts with that of her contemporary John Singer Sargent, whose frequent explorations of the subject throughout his career culminated in VMFA's *The Sketchers.* Yet Beaux's character study of Harrison suggestively resonates with Sargent's picture; both depict a subject of the opposite gender, and both focus on the physical practice of painting—from appropriate tools and dress to the give-and-take of pleasure and rapt concentration. Beaux was a great admirer of Sargent, who, although only a year younger, had established his career in Europe while she was still an art student in Philadelphia. Critics frequently compared their work, finding their talents as portraitists all but commensurable.[6]

Sargent's artist-as-subject pictures, completed in the 1880s, derived from summer sojourns spent with friends and family away from city life and his unrelenting wave of portrait commissions. Like Beaux, Sargent frequented artist colonies early in his career; his first major salon sensation, *The Oyster Gatherers at Cancale* (1878, Corcoran Gallery of Art), was painted in his Paris studio from plein-air sketches made at one such community on the north coast of Brittany.[7]

Sargent's series of painter friends at work was produced among smaller, more select company, though in locations that drew large numbers of artists. For example, Sargent's *Claude Monet Painting by the Edge of a Wood* (ca. 1885, Tate Gallery) is thought to have been painted in Giverny, which would become the most popular French colony for Americans later in the century, largely due to Monet's presence. Appropriately, it is the first of the series to reveal Sargent's experimentation with impressionism. Paying homage to the painter whose work gave the avant-garde movement its name (and whom Sargent befriended in Paris in the 1870s), the picture documents the impressionist's central mission—to paint nature in the open air. Sargent's subtle palette and broken brushwork, accentuating the day's flickering sunlight, echo the landscape on Monet's easel.[8]

Sargent incorporated this picture-within-a-picture device in his next two portrayals of artists—*Dennis Miller Bunker Painting at Calcot* (Terra Foundation for American Art) of 1888 and *Paul Helleu Sketching with His Wife* (Brooklyn Museum) of 1889—both produced during summer stays in the English countryside and both depicting the intimate fellowship between the artist and a female companion. Sargent explored the same subject for a third time (in a light-filled, airy interior rather than *en plein air*) in the 1904 *An Artist in His Studio* (Museum of Fine Arts, Boston), which pictures his friend and frequent traveling companion Ambrogio Raffele (fig. 154) painting in a cramped hotel room in the Italian Alps.[9]

Dubbed "painted diaries" by a family member, these images of Sargent's working vacations increased after the turn of the century, at which time the artist had established a fairly regular pattern. Returning to the country of his birth, Italy, nearly every summer and autumn, Sargent invited a number of close friends (some artists, some not) and family members to accompany him on excursions to various sites—from the Veneto to Tuscany to Lombardy and elsewhere. There he captured scenes of pleasurable leisure and fellowship under

sunny skies—experiences that served as creative inspiration and personal and professional respite from what he termed his "paughtraits," which he stopped painting on commission in 1907.[10]

During these years, Sargent produced artist-as-subject pictures more frequently, with his friends Jane and Wilfrid de Glehn given starring roles. Sargent first met Wilfrid in Paris, where the latter was studying with Gustave Moreau. He later assisted Sargent and Edwin Austin Abbey on the Boston Public Library murals, working in Abbey's English studio

FIG. 154 John Singer Sargent (1956–1925), **Portrait of Ambrogio Raffele,** ca. 1904, watercolor over graphite on paper, 20 x 14 in. (50.8 x 35.6 cm). Collection of James W. and Frances G. McGlothlin, Promised Gift to Virginia Museum of Fine Arts.

at Fairford, in Gloucestershire. De Glehn and Sargent became quite close; when Sargent learned of de Glehn's pending marriage to fellow painter Jane Emmet (the younger sister of the better-known artists, and friends of Beaux, Lydia and Rosina Sherwood Emmet), he expressed to Wilfrid a "hope and ambition" of "becoming her friend as well as yours." The countless oils and watercolors Sargent painted of Jane, especially during their travels in Italy, suggest that his desire was duly realized and that friend quickly became muse.[11]

Monet famously said that Sargent was never fully an impressionist, given the lingering influence of his academic training and fondness for black pigment, and this statement is born out by his later artist pictures that join intimate portraits with boldly painted impressionistic landscapes. In most of these works, more so than in Sargent's 1880s treatment of the theme, forms blend harmoniously with sun-dappled settings but never completely dissolve. The carefully composed figures, shaped by the same painterly impulses as his portraits, have led to an interpretive focus on sitter identification, given their status as what Sargent's great nephew Richard Ormond terms "a form of extended autobiography."[12]

The Sketchers, which captures a pair of Sargent's painter friends contentedly at work in a lush olive grove in San Vigilio, near Lake Garda, is seemingly more spontaneous than many of his figurative landscapes. While its subject appears to be the unfettered pleasures of plein-air painting more than a concern with the individual artists depicted, the work has elicited a determination to identify the sitters conclusively. There is no debate that the thickset man viewed from the back is Wilfrid de Glehn. The woman's identity, however, is uncertain; she has been alternatively named as Jane Emmet de Glehn or her friend and fellow painter Mary Foote (who took part in the San Vigilio sojourn), the latter based on primary- and secondary-source correspondence and other visual evidence. Regardless of her identity, she is placed prominently in the foreground of this dynamic work, in contrast to Sargent's 1880s images in which the female figure functions as a minor pictorial element or decorative accessory.[13]

Arguably the most compositionally inventive and abstract of all Sargent's artist pictures, *The Sketchers* reveals the experimental palette and fluid brushwork inspired by his personal travels. The boldly rendered nonfigural elements are suggestive of another oil of a few years earlier—the spatially ambiguous *Gathering Blossoms, Valdemosa* (fig. 155), its radically cropped figures and dense vegetation enlivened by a vigorous surface texture. Both pictures evoke what Patricia Hills has called Sargent's new way of seeing that resulted from his years of impressionist experimentation—"a 'retinal' vision that absorbed the *color* reflected from surfaces in full sunlight." They also suggest his willingness to learn from then-current modernist approaches to picture making.[14]

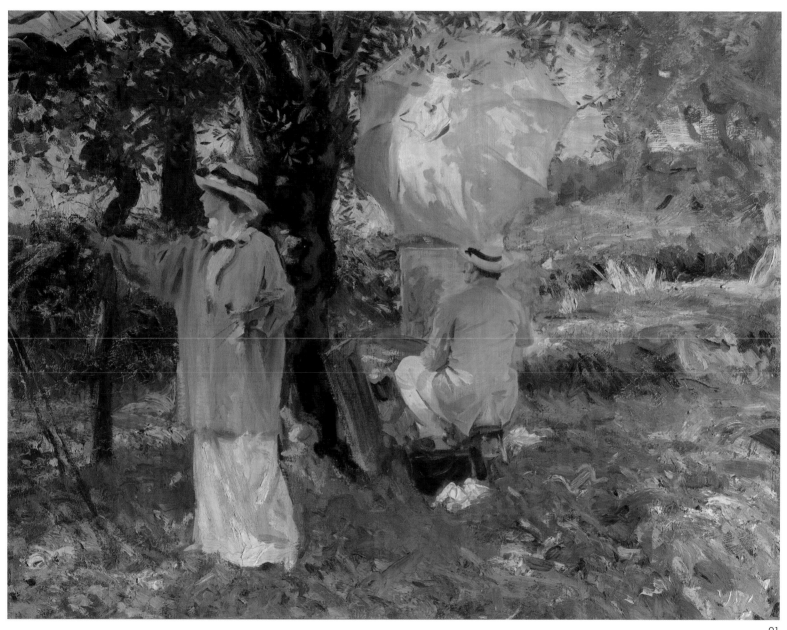

91

FIG. 155 John Singer Sargent (1856–1925), **Gathering Blossoms, Valdemosa,** 1908, oil on canvas, 28 x 22 in. (71.1 x 55.9 cm). Collection of James W. and Frances G. McGlothlin, Promised Gift to Virginia Museum of Fine Arts.

Sargent exhibited *The Sketchers* in the 1914 annual Royal Academy show before sending it to the New York branch of Knoedler and Company, the gallery that successfully sold many of his later landscapes in America. The following year its new owner, Francis Carolan, lent the painting to the Fine Arts display of the Panama Pacific Exposition in San Francisco, for which Sargent chaired the London committee. It was one of thirteen pictures by the artist exhibited there.[15]

The Sketchers represents one of Sargent's last *dolce far niente* (loosely translated as the "sweetness of doing nothing") images that celebrate the sensuous satisfactions of art and friendship. Produced on the eve of World War I and in the year of New York's famous Armory Show, which widely introduced modern art to America, the painting offers a glimpse of a culture about to change irrevocably, marking the end of an era in sociopolitical and aesthetic terms. After accepting a commission as an official war artist on the Western Front, Sargent concentrated almost exclusively on his neotraditional American mural projects and never returned to Italy. By the time of his death in 1925, the figural work for which he was once celebrated (like Beaux's) had come to be viewed as *retardataire* when compared to more modernist tendencies. Sargent's critical reputation underwent reappraisal beginning in the 1950s, and his standing as an undisputed American master has remained firm ever since.[16] SY

NOTES

1. For a comprehensive overview of Beaux's life and work, see Sylvia Yount, *Cecilia Beaux, American Figure Painter,* exh. cat. (Berkeley, Los Angeles, and London: University of California Press and High Museum of Art, 2007).

2. Ibid., 29–30. See also H. Barbara Weinberg, "Summers in the Country," in *Americans in Paris, 1860–1900,* exh. cat. (London: National Gallery, 2006), 115–50.

3. For more on Harrison, see David Sellin, *Americans in Brittany and Normandy, 1860–1910,* exh. cat. (Phoenix: Phoenix Art Museum, 1982), 45–51. Beaux's clever ode is quoted in Alice A. Carter, *Cecilia Beaux: A Modern Painter in the Gilded Age* (New York: Rizzoli, 2005), 91.

4. Carter, 78–81, 87–88. See also Tara Leigh Tappert, *Cecilia Beaux and the Art of Portraiture,* exh. cat. (Washington, D.C.: National Portrait Gallery, Smithsonian Institution, 1995), 22.

5. Quoted in Yount, 30.

6. For a discussion of the gender bias directed at Beaux's work, see Sarah Burns, "The 'Earnest, Untiring Worker' and the 'Magician of the Brush': Gender Politics in the Criticism of Cecilia Beaux and John Singer Sargent," *Oxford Art Journal* 15 (1992): 34–53.

7. Sellin, 8–9, 135–37. See also Sarah Cash, "Testing the Waters: Sargent and Cancale," in *Sargent and the Sea,* exh. cat. (New Haven and London: Yale University Press in association with Corcoran Gallery of Art, 2009), 89–117.

8. Elaine Kilmurray and Richard Ormond, eds., *John Singer Sargent,* exh. cat. (London: Tate Gallery, 1998), 110–11; Warren Adelson, "John Singer Sargent and 'The New Painting,'" in *Sargent at Broadway: The Impressionist Years,* exh. cat. (New York: Coe Kerr Gallery, 1986), 25–61; Katherine M. Bourguignon, ed., *Impressionist Giverny: A Colony of Artists, 1885–1915,* exh. cat. (Giverny: Musée d'Art Américain and Terra Foundation for American Art, 2007).

9. For more on Raffele, see David Park Curry, *Capturing Beauty: American Impressionist and Realist Paintings from the McGlothlin Collection,* exh. cat. (Richmond: Virginia Museum of Fine Arts, 2005), 50–51.

10. Mary Newbold Patterson Hale, Sargent's second cousin, coined the phrase in her article "The Sargent I Knew," *World Today,* November 1927, reprinted in Carter Ratcliff, *John Singer Sargent* (New York: Abbeville, 1982), 235–38. For an overview of the related imagery, see Patricia Hills, "'Painted Diaries': Sargent's Late Subject Pictures," in *John Singer Sargent,* exh. cat. (New York: Whitney Museum of American Art in association with Abrams, 1986), 181–207. See also Ormond, "Sargent's Art," in Kilmurray and Ormond, 38–40; and Erica Hirshler, "John Singer Sargent," in Theodore Stebbins Jr., *The Lure of Italy: American Artists and the Italian Experience, 1760–1914,* exh. cat. (Boston: Museum of Fine Arts in association with Abrams, 1992), 255–56. For Sargent's letter to his cousin Ralph Curtis in which he wrote, "No more paughtraits whether refreshed or not. I abhor and abjure them and hope never to do another especially of the Upper Classes," see Evan Charteris, *John Sargent* (New York: Charles Scribner's Sons, 1927), 155.

11. See Kilmurray, "Traveling Companions," in *Sargent Abroad: Figures and Landscapes* (New York, London, and Paris: Abbeville, 1997), 57. Jane Emmet,

like her older sisters, was a student of William Merritt Chase. For more on the de Glehns' art, see Jane Hamilton, *In Search of a Golden Age: Works from the Studio Estate of Wilfrid and Jane de Glehn,* exh. cat. (London: Studio Publications, 2008). See also Charteris, 230–31. For various images of Jane Emmet de Glehn by Sargent, including the best-known oils *The Fountain, Villa Torlonia, Frascati, Italy* (Art Institute of Chicago) and *In the Garden, Corfu* (Terra Foundation for American Art), see Kilmurray and Ormond, 212–13, 228, 237, 254, 256.

12. See William H. Gerdts, "The Arch-Apostle of the Dab-and-Spot School: John Singer Sargent as an Impressionist," in Hills, 111, and Kilmurray and Ormond, 39.

13. See Charles Merrill Mount, "A Phoenix at Richmond," *Arts in Virginia* 18 (Spring 1978): 2–19. Based on the numerous images of Jane Emmet de Glehn painted by Sargent and her marital relation to Wilfrid, that identification has been most common, but I find the Mary Foote evidence particularly convincing based on both artists' respective correspondence as well as a close study of their physical characteristics. For an extensive overview of the sitter debate—including a ca.1950 letter from Mary Foote to David McKibben confirming the picture's subject and setting as well as its date of execution—see VMFA curatorial files. See also *Mary Foote, 1872–1968,* exh. brochure, John Pence Gallery, San Francisco, 1994.

14. See Hills, 181, and Mount, 15–19. The modernist American painter Manierre Dawson (see cat. no. 112) recounted a 1910 meeting with Sargent—"he is in favor of portrayals of sunlight"—in which the two discussed their fundamentally different approaches of looking. According to Dawson, the ever-polite, thoughtful, and attentive Sargent "never said at any of these meetings that I was on the wrong track." See Henry Adams, "Manierre Dawson, 1887–1969," in *Manierre Dawson: American Pioneer of Abstract Art,* exh. cat. (New York: Hollis Taggart Galleries, 1999), 31–32.

15. According to Elizabeth Oustinoff, *The Sketchers* may have been painted with American sales in mind; see "The Critical Response," in *Sargent Abroad,* 231. For a copy of the painting's "official label" from the Panama Pacific Exposition, which identifies the owner at the time, see VMFA curatorial files.

16 For a brief overview of Sargent's late portrait commissions and murals, see Ormond, "Sargent's Art," 41–42.

92. Augustus Saint-Gaudens (1848–1907)

The Puritan, modeled 1887, cast 1899
Bronze
30 ½ x 20 ½ x 12 in. (77.5 x 52.1 x 30.5 cm)
Inscribed on base front: "THE PURITAN"
Inscribed on base proper right: "AUGUSTUS SAINT GAUDENS / MDCCCLXXXII"
Inscribed on base rear: "COPYRIGHT / BY AUGUSTUS / SAINT-GAUDENS / M / DCCCXC / IX"
Stamped on base rear: "E. GRUET / JEUNE / FONDEUR / 44^BIS AVENUE DE CHATILLON / PARIS"
Museum Purchase, The Charles G. Thalhimer Family Fund, 83.74

PROVENANCE: Victor Spark, New York, N.Y.; Private collection, Providence, R.I. (until 1980); Hirschl and Adler Galleries Inc., New York, N.Y.

93. Augustus Saint-Gaudens (1848–1907)

Diana of the Tower, modeled 1892, cast 1899
Bronze
39 x 13 ¼ x 13 ¼ in. (99.1 x 33.7 x 33.7 cm) (including triangular pedestal and base)
Cast on top of base back: "AUGUSTUS / SAINT GAUDENS / MDCCCXCIX"
Inscribed on base back edge: "© A. SAINT GAUDENS / MDCCCXCV"
Cast on pedestal proper right front: "DIANA OF THE TOWER"
Museum Purchase, Adolph D. and Wilkins C. Williams Fund, 76.40.1

PROVENANCE: Didier, Inc., New Orleans, La.; Childs Gallery, Boston, Mass.

Augustus Saint-Gaudens's *The Puritan* and *Diana of the Tower* exemplify the extraordinary talent and range of America's foremost sculptor of the late nineteenth and early twentieth centuries. These splendid bronzes, reductions of earlier large-scale monuments by the artist, also provide a study in contrasts. The Puritan—somber and solid beneath his high-crown hat and undulating cloak—plods heavily forward, Bible in hand. Unrelenting naturalism defines such details as the creases around his mouth, the straining fabric of his waistcoat, and the rough knots of his cudgel-like walking stick.[1] The classically nude Diana, ancient goddess of the hunt, is no less self-assured and strong, though her lithe figure appears weightless and ethereal. Tiptoe on one foot, she strikes perfect balance as she draws back a slender bow in careful aim. In these figures, Saint-Gaudens—whether employing the academic realism of the first figure or the cool idealism of the second—reveals a sure command over three-dimensional form. He also exhibits a confident facility with French Beaux-Arts sculptural approaches, which he helped introduce to American practice in the late 1870s.

Exceptional ability and fortunate timing propelled Saint-Gaudens's rise to prominence. After moving to the United States as an infant with his French father and Irish mother, he grew up in New York City. Laboring through his teen years as a cameo cutter's apprentice, Saint-Gaudens developed early skills in modeling. With his earnings, he traveled abroad in 1867 and, the following year, was admitted as one of the first Americans to study sculpture at the École des Beaux-Arts in Paris.[2] From leading French practitioners, he not only learned

traditional sculptural methods but also adopted a new manner of surface treatment. In contrast to earlier generations of neoclassical sculptors, who prized smooth, highly polished finishes (see cat. nos. 54 and 58), Paris-trained artists sought to preserve the tactile evidence of human production. Their sculpted and cast figures retain in varying degrees the myriad subtle impressions of hands, fingers, and tools that shaped the clay originals.[3] In 1870, as Saint-Gaudens was mastering his technique, the commencement of the Franco-Prussian War drove him to Italy. Living and working in Rome over the next

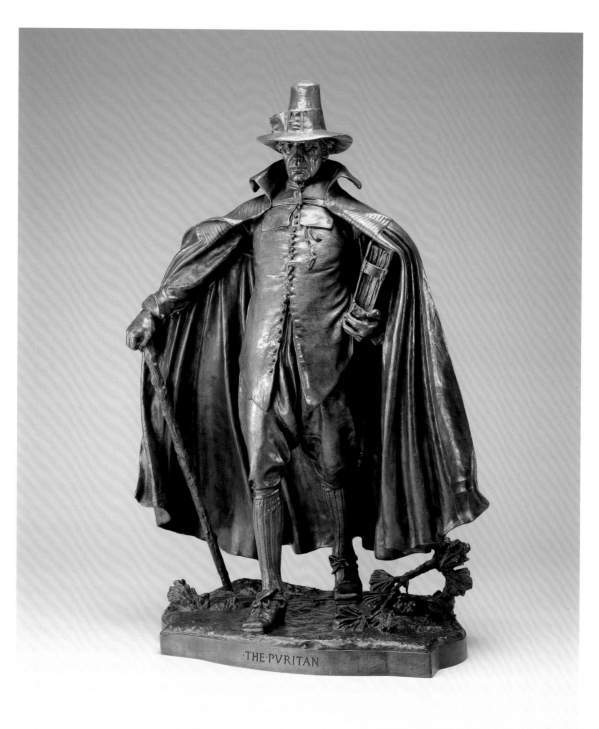

92

five years, he became fascinated with the earlier sculptors of the Italian Renaissance, particularly Luca della Robbia and Donatello.[4] The clarity, elegance, and naturalism in the work of those Quattrocento masters found a lasting resonance in his own.

When Saint-Gaudens returned to the United States in 1875, he found a nation brimming with optimism and prosperity. He also discovered an artistic climate ripe for development. The post–Civil War years brought a growing demand for public monuments to honor America's political, civic, military, and industrial leaders. At the same time, an increasing number of private patrons—many enjoying unprecedented personal wealth—sought to have themselves or loved ones immortalized in portrait busts and reliefs and to adorn their residences, gardens, and grave sites with sculpture. Under such favorable circumstances, Saint-Gaudens gained a steady stream of commissions. He bolstered his reputation by participating in a number of large-scale public and private projects, including the decoration of Boston's Trinity Church and the New York mansion of Cornelius Vanderbilt II. Such endeavors required close collaboration with other sculptors, as well as painters, artisans, and architects—a number of them also Beaux-Arts trained. The talented sculptor very quickly found himself folded into an elite circle of patrons and art associates—including his colleagues in the Tile Club (see cat. no. 76)—that was aesthetically and philosophically attuned to new cosmopolitan (that is, British and French) artistic approaches. In 1877, responding to the increasingly nationalistic policies of the National Academy of Design, he helped establish the Society of American Artists as a supportive exhibition organization for younger, progressive artists.[5]

Over the course of a prolific thirty-year career, Saint-Gaudens produced close to two hundred sculptures ranging from portrait busts and bas-reliefs—which comprise the majority of his work—to designs for medals and coins.[6] He earned his highest acclaim, however, for his twenty public monuments, of which *The Puritan* and *Diana* are among the best known. *The Puritan* was commissioned in 1881 by railroad tycoon and former congressman Chester W. Chapin, who desired a heroic-scale bronze figure of his seventeenth-century ancestor Deacon Samuel Chapin, one of the founders of Springfield, Massachusetts. During the surge of interest

in the colonial period that followed the nation's centennial celebration in 1876 (see cat. no. 65), Saint-Gaudens set about crafting an imaginary portrait of the religious leader that would also embody the austere fortitude of Puritanism.[7] The Chapin family fully participated in the project, helping to research costume details from period woodblock prints, while Congressman Chapin himself posed for the figure's granite-jawed countenance. The result was *The Puritan (Deacon Samuel Chapin),* the imposing caped figure who treads purposefully across New England soil. The nine-foot-high, cast-bronze monument was unveiled on Thanksgiving Day, 1887, in Springfield's Stearns Square. One of Saint-Gaudens's closest friends, architect Stanford White, designed the sculpture's plinth as well as the park environment, which included a fountain, benches, and a spherical pool.[8]

It was for Stanford White, a principal in the famed McKim, Mead, and White architectural firm, that Saint-Gaudens produced his only female nude, *Diana.* After meeting in the mid-1870s, the two men formed a deep friendship that resulted in a series of professional collaborations in which White designed the architectural supports and settings for several of Saint-Gaudens's key monuments.[9] In 1886, as White drew up plans for his new, multimillion-dollar Madison Square Garden building in New York, he asked Saint-Gaudens to create an ideal figure to top its lofty tower. For a structure slated to house sporting events, the two made the apt choice of the Roman goddess of the hunt. Moreover, the mythical figure was in keeping with the era's resurgent interest in classical motifs and subjects—the so-called American Renaissance that, for many, embodied the nation's cultural maturity (see cat. no. 101).[10] On an autumn night in 1891, Saint-Gaudens's colossal *Diana* was unveiled with great fanfare and the illumination of hundreds of incandescent lamps. The figure, fashioned from gilded sheet copper and standing eighteen feet high, functioned as a weather vane, turning as the wind caught a fixed swathe of drapery that billowed out behind her. Finding the proportions of the sculpture too large for the tower, Saint-Gaudens replaced it in 1894 with a modified *Diana* that retained the same delicately balanced tiptoe pose but was five feet shorter and had a more slender profile (fig. 156).[11] For thirty years, the graceful goddess soared over New York City and weathered both climatic and political

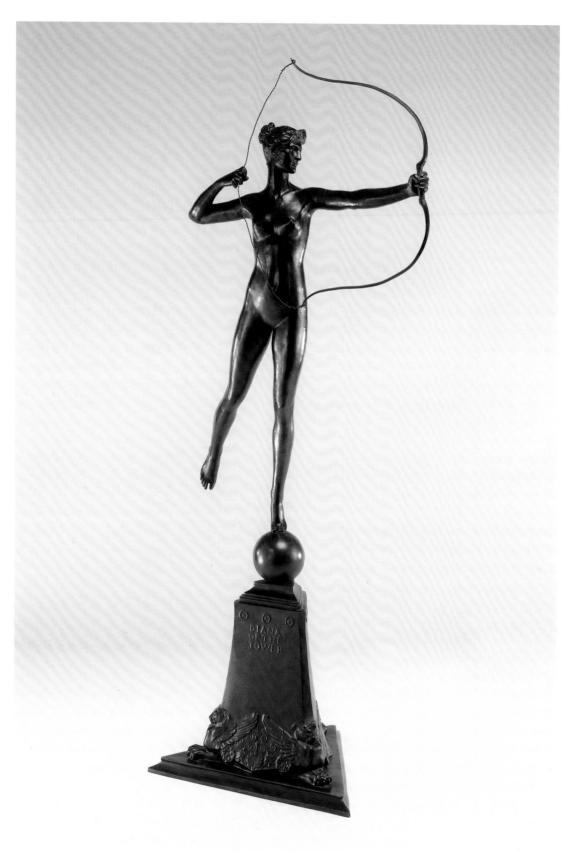

93

storms. After wind gusts snatched Diana's swirl of drapery, she was bolted firmly in place. And when her nudity drew protests from some—including Anthony Comstock, the era's vocal, self-proclaimed defender of decency—the popular press came to her defense.[12]

Between 1897 and 1900, Saint-Gaudens relocated to Paris, where he exhibited sculptures at two Salons and at the 1900 Paris Exposition. He also turned his attention to creating reduced versions of previous monuments, including his well-received *The Puritan* and *Diana*.[13] Earlier, at midcentury, French foundries had perfected the process for making quality reductions of large-scale sculptures to satisfy a growing demand among collectors for *bronze d'art* for the home, a trend that took hold in America in the 1890s.[14] Saint-Gaudens responded by working with foundries on both sides of the Atlantic to commission various editions, which were sold through Doll and Richards in Boston and Tiffany and Company in New York. VMFA's *The Puritan* was cast by the Gruet Foundry in Paris in 1899, a year after the successful showing of the original full-size plaster at the Salon exhibition. The museum's *Diana of the Tower*, also produced in 1899, has no foundry mark but likely was cast by Aubry Brothers Foundry of New York. It is one from a series of twelve that features the goddess atop a Renaissance-style tripod pedestal adorned with griffins.[15]

Myriad projects and honors occupied Saint-Gaudens in the late decades of the century, including his appointment as chief sculpture advisor for the 1893 World's Columbian Exposition—the Chicago world's fair that heralded the triumph of classical Beaux-Arts architecture and art. The sculptor was also universally revered as an influential teacher at the Art Students League in New York and as a mentor to a handful of aspiring young sculptors who served as assistants in his New York, Paris, and Cornish, New Hampshire, studios.[16] Of those select few, Frederick MacMonnies was the master's most responsive and ultimately successful pupil. Following his lengthy apprenticeship and subsequent study abroad at the École des Beaux-Arts, MacMonnies won honorable mention in the 1889 Paris Salon for his own depiction of Diana. But it was his ebullient *Bacchante and Infant Faun*, well received at the Salon exhibition of 1894, that garnered comment and controversy in the United States. Commissioned by architect Charles McKim for the courtyard of his firm's newly constructed Boston Public

FIG. 156 Augustus Saint-Gaudens (1848–1907), The second **Diana** atop Madison Square Garden (presently in the collection of the Philadelphia Museum of Art).

FIG. 157 Frederick MacMonnies (1863–1937), **Bacchante and Infant Faun,** modeled 1893, cast 1895, bronze, 31 x 10 x 12 in. (78.7 x 25.4 x 30.5 cm) without base. Virginia Museum of Fine Arts, Gift of Mr. G. A. Peple, 55.29a/b.

Library, the seven-foot figure of a nude nymph, skipping and twisting as she dangles a cluster of grapes over the head of a baby, was rejected by the library board as inappropriate—more on grounds of her seemingly tipsy demeanor than for her state of undress.[17] Almost immediately after the sculpture was "banned in Boston," it was accepted into the collection of New York's Metropolitan Museum of Art. MacMonnies, who enjoyed a prolific career for decades to come, found a successful market for bronze reductions of the infamous *Bacchante*—including the 1895 casting in the VMFA collection (fig. 157), which retains its original Corinthian-column pedestal.[18]

ELO

NOTES

1. The bronze is marked "MDCCCLXXXII" (1882), a dating error made either by Saint-Gaudens or Gruet Foundry. It was meant to read "MDCCCLXXXVII" (1887), the date of the original Springfield, Massachusetts, monument. *Carved and Modeled: American Sculpture, 1810–1940* (New York: Hirschl and Adler Galleries, 1982), 46.

2. Augustus Saint-Gaudens, *The Reminiscences of Augustus Saint-Gaudens*, ed. Homer Saint-Gaudens (New York: Century, 1913), 1:60–61.

3. Ibid., 1:153. The question of finish, in both painting and sculpture, emerged in American art criticism in the late 1870s. Fueled by a growing taste for the indistinct, evocative imagery of French Barbizon painters, the Paris-trained artists sought to retain the spontaneity and immediacy of the painted or sculpted sketch. Wayne Craven, *Sculpture in America*, rev. ed. (Newark, Del.: University of Delaware Press; New York and London: Cornwall Books, 1984), 377. See also Thayer Tolles, "'Refined Picturesqueness': Augustus Saint-Gaudens and the Concept of 'Finish,'" in *Augustus Saint-Gaudens, 1848–1907: A Master of American Sculpture*, exh. cat. (Toulouse: Musée des Augustins and Musée national de la Coopération franco-américaine, Château de Blérancourt, 1999), 59–64.

4. Before his relocation, Saint-Gaudens may have been predisposed to the influence of Renaissance sculptors through contact with his École classmate, Antonin Mercié, who preceded him to Italy. At the 1872 Paris Salon, Mercié successfully exhibited a figure of David produced in what the critics dubbed the Neo-Florentine style. Édouard Papet, "Saint-Gaudens and France," in *Augustus Saint-Gaudens 1848–1907*, 23.

5. Craven, 378–79. By 1906, the SAA merged into the NAD, which had grown more accepting of European-trained artists and their approaches. Tolles, 63.

6 In 1904, at the request of his friend President Theodore Roosevelt, the sculptor submitted new designs for national coinage. On Saint-Gaudens's death three years later, Roosevelt ordered the U.S. Mint to strike his $10 and $20 gold pieces—today highly treasured by collectors. See Barbara A. Baxter, "Coins and Medals," in *Augustus Saint-Gaudens, 1848–1907*, 77–82. In late 2008, the U.S. Mint restruck the $20 gold piece (also known as the "Double Eagle") for a one-year offering. Mathew Healey, "Century Later, Gold Coin Reflects Sculptor's Vision," *New York Times*, November 25, 2008, C-2.

7. Saint-Gaudens, 354.

8. In 1899, the figure was relocated to Springfield's Merrick Park and White's outdoor furnishings sent to storage. John H. Dryfhout, *The Work of Augustus Saint-Gaudens* (Hanover and London: University Press of New England, 1982), 162.

9. In addition to his contributions for *The Puritan* monument in Springfield, Stanford White also collaborated on Saint-Gaudens's *Admiral David Farragut* (1881, New York); *Adams Memorial* (1891, Washington, D.C.); *Robert Gould Shaw* (1897,

Boston); and *William Tecumseh Sherman* (1903, New York). White also designed frames for some of the sculptor's bas-relief portraits. Saint-Gaudens, in turn, was a frequent consultant for various projects for McKim, Mead, and White. See Joyce K. Schiller, "Saint-Gaudens and Architects: Collaboration and Innovation," in *Augustus Saint-Gaudens, 1848–1907*, 71–76.

10. Richard Guy Wilson, "Expressions of Identity," in *The American Renaissance, 1876–1917*, exh. cat. (Brooklyn: Brooklyn Museum, 1979), 11–25.

11. In 1893, the original *Diana* was moved to top the massive Agriculture Building at the World's Columbian Exhibition in Chicago. It was damaged the following year when fire swept the abandoned fair site. The second *Diana* was removed in 1925 when the first Madison Square Garden was demolished. After some time in storage, it was acquired in 1931 by the Philadelphia Museum of Art, where it is on view today. John H. Dryfhout, "Diana," in *Metamorphoses in Nineteenth-Century Sculpture*, ed. Jeanne L. Wasserman (Cambridge, Mass.: Fogg Art Museum, 1975), 203, 209.

12. Dryfhout, 201–13; Burke Wilkinson, *Uncommon Clay: The Life and Works of Augustus Saint Gaudens* (San Diego, New York, London: Harcourt Brace Jovanovich, 1985), 217.

13. The third reduction was of his bas relief of *Robert Louis Stevenson*. Dryfhout, *Work of Augustus Saint-Gaudens*, 34.

14. Michael Edward Shapiro, *Bronze Casting and American Sculpture 1850–1900* (Newark, Del.: University of Delaware Press; London and Toronto: Associated University Presses, 1985), 102–4.

15. Dryfhout, "Diana," 207–11.

16. E. Adina Gordon, "Augustus Saint-Gaudens: The Lure of Paris," in *Augustus Saint-Gaudens, 1848–1907*, 92–95. The artist's studio and home in Cornish, New Hampshire—once the center of a thriving summer artists' colony—is now maintained by the National Park Service as an historic site.

17. See Julia Rosenbaum, "Displaying Civic Culture: The Controversy over Frederick MacMonnies' *Bacchante*," *American Art* 14 (Fall 2000): 41–57.

18. MacMonnies led the way in the production of bronze reductions. Saint-Gaudens, making note of the successful marketing of his former student's multiples of *Bacchante*, followed suit. Gordon, 95.

94. Moses Ezekiel (1844–1917)

Thomas Jefferson, modeled 1897; cast ca. 1900–1910

Bronze, with brown patina

23 ¾ x 8 ⅜ x 7 ⅜ in. (60.3 x 21.3 x 18.7 cm)

Inscribed at rear vertical edge of base: "GLADENBECK'S
BRONCEGIESSEREI / G. m. b. H FRIEDRICHSCHAGEN"

Museum Purchase, The Floyd D. and Anne C. Gottwald Fund, 2008.44

PROVENANCE: Private collection, central Virginia; James Graham and Sons, New York, N.Y.

Among the many allegorical, historical, and portrait figures of Moses Ezekiel's long career, this elegant bronze sculpture of Thomas Jefferson embodies the talent, ambitions, and ideals of a Virginia artist who rose to international prominence in the late nineteenth century. He was the last in a line of major American neoclassical sculptors who established a home and

94

studio in Italy—Hiram Powers and William Wetmore Story led previous generations (see cat. nos. 54 and 58). Ezekiel had reached the pinnacle of his career when he conceived this figure in 1897. A recipient of many honors, including decorations from the rulers of both Germany and Italy, the expatriate embraced the opportunity to turn his thoughts back to his native state and to depict one of his lifelong heroes.[1] As a subject, Jefferson appealed to him not only for his role in drafting the key American document supporting civil liberties but also for his staunch advocacy of religious freedom.[2]

As he recounted in his memoirs, Ezekiel chose to portray Thomas Jefferson at full length, dressed in formal colonial costume, and "holding the Declaration of Independence in his hand at the moment he was about to read it to our first congress." The artist continued: "Everybody else had always represented Jefferson as an old man, but, as he was only about thirty-three years of age at the time, I decided to give him the benefit of his youth."[3] The impetus for representing Jefferson came from a private commission for a bronze monument to the third president for the city of Louisville, Kentucky. Unveiled in front of the Jefferson County courthouse in 1901, the figure—which alone measures close to nine feet—stands atop an equally scaled Liberty Bell that is adorned with four allegorical figures of Liberty, Equality, Justice, and Brotherhood (also described as Religious Freedom). In 1910, a nearly identical replica of the multifigure monument was dedicated on the esplanade before the University of Virginia's Rotunda in Charlottesville (fig. 158)—a counterpart to Ezekiel's earlier sculpture of Homer, placed on the university's Lawn three years earlier.[4]

In the decade between dedications of these outdoor monuments, the artist produced four reduced versions, all cast at the same German foundry as the large-scale prototypes: two that include the Liberty Bell and attendants[5] and two one-quarter scale figures of Jefferson alone.[6] This handsome bronze, made with the traditional lost-wax method, is believed to be the only surviving example of the latter pair.

Moses Ezekiel was born in Richmond, Virginia, to Sephardic Jewish parents and came of age during the Civil War. Enrolled as a cadet at Virginia Military Institute—the first Jewish student admitted to the academy—he participated in the famous battle of New Market in 1864, during which

FIG. 158 Moses Ezekiel (1844–1917), **Thomas Jefferson,** conception 1897, cast 1898, bronze, 84 in. high (213.4 cm) without base. University of Virginia, Charlottesville.

FIG. 159 Moses Ezekiel (1844–1917), **Thomas Crawford,** 1878, marble, 84 in. high (213.4 cm) with base. Virginia Museum of Fine Arts, Gift of Mr. and Mrs. Bruce Dunstan, 52.15.

cadets were mustered to help Confederate forces counter a Union advance in the Shenandoah Valley. Several cadets were killed in the intense fighting, including Ezekiel's roommate, Thomas Garland Jefferson—the former president's young cousin, who died in Ezekiel's arms. Following the end of the war and graduation from VMI, Ezekiel returned to Richmond in 1866 to work in his family's struggling mercantile business. Two years later, he relocated with his parents to Cincinnati, Ohio, where he took his first formal art lessons. In 1869, he found resources to travel abroad and was admitted to the Royal Academy in Berlin. Four years later, Ezekiel's advanced skills earned him that institution's prestigious fellowship to study in Rome—the first granted to a foreigner. Except for occasional visits to the United States, he remained there for the rest of his life.[7]

Working from his cavernous studio in the ancient ruins of the Baths of Diocletian, the artist gained acclaim with a series of major commissions on both sides of the Atlantic, including a monumental figure, *Religious Liberty,* that was displayed at the 1876 Centennial International Exhibition, America's first world's fair. The following year, Ezekiel commenced a multi-year project to produce eleven, larger-than-life marble statues of famous artists to adorn the exterior niches of the Corcoran Gallery of Art in Washington, D.C. (In 1952 one of those sculptures, the figure of American sculptor Thomas Crawford [fig. 159], was presented to VMFA; for nearly three decades it has been on long-term loan to the Norfolk Botanical Gardens, where it is exhibited alongside the other sculptures from the Corcoran series.)[8] Among Ezekiel's final and best-known works is his 1914 *Confederate Monument,* also known as *New South,* at Arlington National Cemetery.[9] In its shadow, the celebrated sculptor was laid to rest with a small headstone identifying him simply as a VMI cadet. In later years, the *Dictionary of American Biography* cogently summed up Ezekiel's artistic career: "America bore him, Germany trained him, Italy inspired him: all three countries had his love and possess his works."[10]

<div align="right">ELO</div>

NOTES
1. Ezekiel had portrayed Jefferson previously with an 1888 commission from the federal government to produce a marble bust for exhibition in the U.S. Capitol; that likeness differs in appearance from this later representation.
2. David Philipson, "Moses Jacob Ezekiel," *Publications of the American Jewish Historical Society* (1922): 39.

3. Moses Jacob Ezekiel, *Memoirs from the Baths of Diocletian,* ed. Joseph Gutmann and Stanley F. Chyet (Detroit: Wayne State University, 1975), 377; Philipson, 39–41.
4. I am grateful to Roger B. Stein for sharing his research notes and insights on Ezekiel and to Ellen Daugherty for providing VMFA a copy of her unpublished manuscript and bibliography, "A New Focus for the Lawn: Outdoor Sculpture at the University of Virginia, 1895–1915" (distinguished majors thesis, University of Virginia, 1997).
5. At some time before 1910, the artist presented the first multifigure reduction (one-quarter scale) to author and U.S. Ambassador to Italy Thomas Nelson Page. Following Page's death, it was given by his brother to the Commonwealth in 1924 and is presently on view at the Library of Virginia. In 1914, the artist gave the second multifigure reduction (one-third scale) to VMI; it is currently exhibited at the Hall of Valor Museum, New Market Battlefield State Park. For their generous sharing of images and information, I thank David Voelkel, former curator of state collections, Commonwealth of Virginia; and Keith Gibson, director of museum operations, Virginia Military Institute.
6. Responding to an inquiry from Edwin Anderson Alderman, president of the University of Virginia, Ezekiel wrote that he had cast in bronze two individual Jefferson figures, one having been purchased by a Miss Faith Moore of New York for $1,000. Letter from Ezekiel to Alderman, March 11, 1910, President's Papers, Office Administrative Files, Folder 1908, Jan.–Mar., Box 10, acc. no. RG-2/1/2.472, subseries I, Special Collections, University of Virginia Library, Charlottesville.
7. Ezekiel's autobiography, cited in note 3 above, is wonderfully detailed and insightful—as is the introduction by its editors, Gutmann and Chyet. See also Judith S. Lucas, "Moses Jacob Ezekiel: Prix de Rome Sculptor," *Queen City Heritage* 44 (Winter 1986): 3–16; Roberta Tarbell et al., *Ezekiel's Vision: Moses Jacob Ezekiel and the Classical Tradition,* exh. cat. (Philadelphia: National Museum of American Jewish History, 1985); and Stan B. Cohen and Keith Gibson, *Moses Ezekiel: Civil War Soldier and Renowned Sculptor* (Missoula, Mont.: Pictorial Histories Publishing, 2008).
8. In 1967 VMFA also acquired, as a gift, a pair of idealized marble busts of Demosthenes and Sophocles by Ezekiel (1904; acc. nos. 67.44.1 and 67.44.2).
9. Other major Ezekiel sculptures on public display include the *Edgar Allan Poe Monument* (Baltimore), *Stonewall Jackson Monument* (Charleston, W. Va.), and *Virginia Mourning Her Dead* (VMI, Lexington, Va.).
10. Adeline Adams, "Moses Jacob Ezekiel," *Dictionary of American Biography,* rev. ed. (New York: Charles Scribner's Sons, 1958), 3:241.

95. Claude Raguet Hirst (1855–1942)

Books and Pottery Vase, early 1900s

Oil on canvas
7 ⅛ x 10 in. (18.1 x 25.4 cm)
Museum Purchase, The Collector's Circle Fund, 71.23

PROVENANCE: Bernard Danenberg Galleries, New York, N.Y.

In the early twentieth century, when modernist approaches had supplanted the kind of highly naturalistic, detailed imagery that artist Claude Hirst favored, paintings like her *Books and Pottery Vase* still held enormous appeal. "Her pictures," noted a fellow artist, "are of an intimate kind that people like

95

to get near. . . . In fact, at exhibitions they are apt to be hanging crooked, as, it is said, people take them down so many times to hold them and look at them."[1]

While touching art in the gallery was as likely to be discouraged then as it is now, close examination was precisely the result that Hirst sought with her meticulous still lifes. In *Books and Pottery Vase,* painted sometime in the early 1900s, she presents a tabletop display that includes a jumble of old books and a ceramic pot with Chinese-dragon motifs.[2] The painter invites us to look at a brightly lit open book rendered with such precision that one can read words from the pages. Positioned so closely to the picture plane that it appears to be within our grasp, the book's aged covers are splitting and its pages are tattered to the extent that an owner was compelled to stitch an engraved illustration back into place. Hirst's worn volume is an English translation of Bernardin de Saint-Pierre's *Paul et Virginie.*[3] The internationally popular novel, first published in 1787, relates the story of a boy and girl raised by single mothers on Mauritius, a tropical island in the Indian Ocean. Devoted to each other from infancy, the two become nearly inseparable as they mature—a point underscored by the pages displayed in the painting.[4] The illustration depicts Paul and Virginia laughing as they run for shelter during a sudden rain shower, their heads covered by the girl's outer skirt. On the page opposite, the story's narrator explains: "Those two charming faces, placed within the petticoat swelled by the wind, recalled to my mind the children of Leda, enclosed in the same shell." The viewer, however, cannot know from the cheerful passage and image that the saga takes a tragic turn: Virginia perishes in a shipwreck after a cruel relative forces her to move to France, and a grieving Paul dies of a broken heart.

Well-worn books, which Hirst acquired from secondhand shops, became something of a leitmotif in her work at the turn of the century.[5] Initially, the Cincinnati-born painter featured tidy arrangements of fruit or flowers in her oils and watercolors.[6] Her studio props changed dramatically after 1890 when she exhibited the first of her "bachelor" still lifes at the National Academy of Design in New York City. More haphazard—and decidedly more masculine—her new tabletop arrangements featured old leather-bound books, pipes, tobacco pouches, and spectacles. After 1915 the smoking paraphernalia gave way to decorative pots and vases, yet all the

while her beloved books remained. Hirst rendered her subjects with trompe-l'oeil fidelity, literally "fooling the eye" with sharply delineated objects in a shallow space and against a dark background. Pointing out another important characteristic of the visual trickery, she noted: "I always paint small things that I can paint the actual size."[7]

In signing her artworks, Hirst exercised yet another sleight of hand. As early as age seventeen, she truncated her given name, Claudine, to the more masculine Claude. The deception helped her garner more objective responses to her paintings as her career advanced.[8] Nevertheless, many informed critics felt compelled to comment on her gender, including one reviewer who praised her work and then added that Hirst was "a woman, despite the name."[9]

Hirst became one of a handful of American artists—the others all male—to gain recognition for illusionary still lifes. While there were earlier practitioners, including John Orr (see cat. no. 43), a resurgence of interest brought a new generation of trompe-l'oeil painters to prominence in the final decades of the nineteenth century. Each featured commonplace objects that appear readily at hand. A smoldering match and the glimmer of an ember, for instance, lend a certain smoky ambiance to John Frederick Peto's *Still Life with Pipe* (fig. 160), painted ca. 1885. And at first glance, De Scott Evans's *Free Sample, Take One* (fig. 161), created about 1890, offers a cache of peanuts so precariously balanced that they might tumble

FIG. 160 John F. Peto (1854–1907), **Still Life with Pipe,** ca. 1885–1900, oil on composition board, 6 ½ x 9 ½ in. (16.5 x 9.5 cm). Virginia Museum of Fine Arts Purchase, The Adolph D. and Wilkins C. Williams Fund, 79.63.

out at the least disturbance—though any observant taker would be dissuaded by the jagged edges of broken glass.

Most successful of the era's trompe-l'oeil artists was William Michael Harnett, who occupied a studio near Hirst's

FIG. 161 De Scott Evans (1847–1898), **Free Sample, Take One,** ca. 1890, oil on canvas, 12 x 10 in. (30.5 x 25.4 cm). Virginia Museum of Fine Arts Purchase, The J. Harwood and Louise B. Cochrane Fund for American Art and Partial Gift, Mr. and Mrs. Alexander G. Reeves Jr. and H. Marshall Goodman, 2000.106.

FIG. 162 Detail of frame, cat. no. 95.

in the late 1880s. After adopting a style and approach similar to his, Hirst gained the moniker "the female Harnett" in her own era, as well as later scholarly speculation about the influence of this better-known contemporary upon her work.[10] The painter herself attributed her stylistic shift toward "bachelor" still lifes to the day she contemplated the "attractive" jumble of smoking accessories left on a table by her future husband, landscape painter William Fitler.[11] Whatever the various sources of inspiration, Claude Hirst remained a dedicated and talented still-life artist through the remainder of her long career.

The period frame for *Books and Pottery Vase* (fig. 162) merits mention as well. Contemporary with the canvas—though not original—the burl wood molding offers its own illusionary surprise. Close inspection reveals that the beautiful curling grain is, in fact, painted in. One trompe-l'oeil triumph supports the other. ELO

NOTES

1. "A Pipe That Brought Fame," *New York Times,* June 4, 1922, sec. 7, 5.

2. From style and objects pictured, Hirst scholars have dated *Books and Pottery Vase* between 1900 and 1920. While Christine Crafts Neal has suggested that it may also be the canvas titled *An Edition of 1796,* which was exhibited in 1917 at the Society of Independent Artists, there are no extant images or records to confirm that they are one and the same. Martha M. Evans, *Claude Raguet Hirst, Transforming the American Still Life,* exh. cat. (New York and Columbus: Hudson Hills Press in association with Columbus Museum of Art, 2004), 117; Correspondence from Christine C. Neal, December 21, 1998, VMFA curatorial files.

3. In 1795, Saint-Pierre's novel was translated into English by Helen Maria Williams and published in London by Verner and Hood.

4. It appears that Hirst used the same volume of *Paul et Virginie* as a studio prop for at least eight paintings. In an interview, she described this favorite book as having been published on May 24, 1796. The date does appear in captions beneath the novel's engraved illustrations. However, as revealed in her 1905 painting *The Title Page* (Mount Holyoke College Art Museum), she was working from Verner and Hood's fourth edition of 1799. "Pipe That Brought Fame," 5; Evans, 74–75, figs. 49, 50, and 51.

5. "An Artist's Book Models," *New York Times,* August 11, 1910, sec. SM, 5.

6. Hirst studied at the University of Cincinnati School of Drawing and Design before relocating to New York City in 1879. For biographical details and discussion of her training, see Evans, 16–36; Christine Crafts Neal, "Claude Raguet Hirst: Her [Still] Life Story," *Woman's Art Journal* 23 (Spring–Summer 2002): 11–16.

7. Neal, 14; "Pipe That Brought Fame," 5.

8. Eleanor Tufts, *American Women Artists, 1830–1930* (Washington, D.C.: International Exhibitions Foundation for the National Museum of Women in the Arts, 1987), n.p.; Evans, 23.

9. "The Spring Academy: Second Article," *New York Times,* April 3, 1896, 4.

10. At least one of Hirst's paintings also gained the ignoble distinction of acquiring a forged Harnett signature. Alfred Frankenstein, *After the Hunt: William Harnett and Other American Still Life Painters, 1870–1900* (Berkley and Los Angeles: University of California Press, 1953), 153–54.

11. "A Pipe That Brought Fame," 5.

96. Gorham Manufacturing Company

(founded 1831)

Pair of Candelabra, 1899

Providence, Rhode Island

Silver

19 ½ x 18 ¾ x 18 ¾ in. (49.5 x 47.6 x 47.6 cm) each

Marked on underside: "[lion passant facing right], [anchor surmounted
by eagle with spread wings], G / 950–1000 Fine / + / 2387
[in cartouche]"; 65.3.2: lion, anchor, and "G" intentionally rubbed
out; marked on underside: "950–1000 Fine / + / 2387"; 65.3.1,2:
inside base marked "Shreve, Crump & Low 00" candle cups
marked "950–1000 Fine"

Bequest of Florence H. Lawler, 65.3.1a–i–.2a–i

PROVENANCE: Florence H. and John N. Lawler, Richmond, Va.

Bold arcs and brazen curves serve as effective foils to the ethe-
real decoration of this striking pair of seven-light candelabra.
Convex waves intermittently terminating in gadrooned feet
support delicate dragonflies and coursing owls. Nymphlike
figures personifying day and night float weightlessly across
the surface (fig. 163). Ivy-entwined arms of sweeping S curves
terminate in tulip-shaped candleholders, their petal-like details
topping undulating water-lily bobeches. Meticulously articu-
lated, the effect is a characteristically American expression
of the Art Nouveau style.[1]

Art Nouveau embraced a distinctive visual vocabulary
that included an innovative blending of historical elements
with naturalistic motifs that were rendered flat or in shallow
relief. Frequently drawing on neorococo models, its forms
were embellished with Japanesque details (see cat. no. 79),

yet it was distinguished from earlier styles by its emphasis on the "modern." As these candelabra attest, this could be achieved through the "contort[ion and] attenuation" of form and the inclusion of ethereal female figures, which were commonly conflated with the "whiplash" curve.[2]

As the signature motif of the Art Nouveau style, the curve—simultaneously natural and feminine—functioned as both a decorative element and a consolidated symbol of the "exotic" East.[3] In its latter guise, it referenced the "different" and "primordial" sensibilities associated with non-Western civilizations.[4] At the same time, particularly among European artists, its distortion expressed a tension resonant in contemporary disillusions with modern life—nature morphing into the feminine, for example, as seen here and, even more dramatically, in the ormolu lamp (fig. 164) modeled on American dancer Loie Fuller, whose diaphanous veils conjured images of a sensual and ethereal East.[5] This permitted the style's manipulation to subversive ends, a radical tendency that sat uneasily with American makers and patrons; as the contemporary French journalist André Hallays noted, "The Modern Style [wa]s European."[6] By extension, Art Nouveau's most potent vehicle was the world's fair.[7]

Beginning with the 1851 Great Exhibition held at London's Crystal Palace, these expositions provided an important venue for the display and promotion of international arts and manufactures.[8] They also provided a medium for the dissemination of nationalist propaganda. As early as the 1830s, largely in reaction to industrialization, British—and eventually American—reformists set out to improve the standards and conditions of domestic craftsmanship.[9] The decorative art displays at the 1851 show accelerated this movement, prompting the 1857 foundation of a British design program—the South Kensington Museum and Schools of Art—and a systematic study of the nature and meaning of ornament.[10]

In the United States, similar concerns over the perceived dissolution of artistry in manufactures had led Gorham Company to institute an in-house training program for cultivating artist-craftsmen.[11] By 1896 Edward Holbrook, the company's chief executive officer, and William C. Codman, its English-born chief designer, led the firm in producing a select body of silver objects hammered up and chased from a single sheet of near-pure silver.[12] With the artisan's handprint—signified by

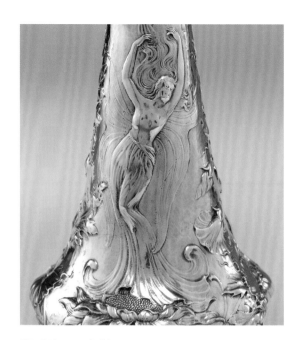

FIG. 163 Detail of figure, cat. no. 96.

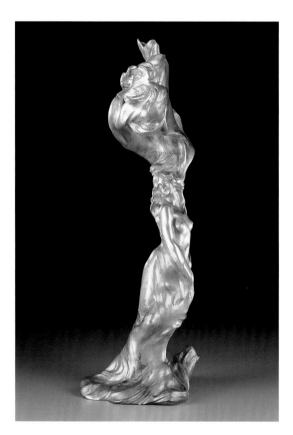

FIG. 164 Raoul-François Larche (French, 1860–1912), **"Loie Fuller" Lamp,** ca. 1896, gilt bronze, 17½ x 6½ x 5¼ in. (44.5 x 16.5 x 13.3 cm). Virginia Museum of Fine Arts Purchase, The Sydney and Frances Lewis Art Nouveau Fund, 79.72.

the hammer marks—left intact, Martelé (from the French *marteler,* meaning "to hammer") was born.[13] A year later, the product was unveiled to an elite audience at New York City's Waldorf-Astoria hotel. By 1900, Gorham boasted few rivals.

The Paris Exposition of 1900 was particularly important to the American contingent. At the 1889 fair, American painting and sculpture, produced in large part by Americans living abroad, had been designated "but a brilliant annex to the French section."[14] Thereafter, American officials looked upon the international trade show as a venue for advertising the country's status as a preeminent economic and military power.[15] In this context, the candelabra's figures of "Night" and "Day" assume a nationalistic dimension. In Art Nouveau's complicated iconography, the two forms could personify the cyclical movement of time—specifically, the transition from one century to another. But within the exposition's thematic context of civilization and savagery, they could also invoke the metaphorical darkness that accompanied the cycle of progress from East to West in what one contemporary British critic described as the "Americanisation of the world."[16]

Although the advisory committee's emphasis on the fine arts reduced decorative arts to a secondary "shop show," the so-called minor arts were widely regarded as the source of American excellence.[17] The fair provided over fifty million attendees the opportunity to ogle, critique, and sometimes purchase the latest, best, rarest, or most "exotic."[18] By the exposition's end, VMFA's "Artistic Candelabra in Hammered Silver" had secured for Gorham five gold medals and the grand prix.[19]

The marks on the candelabra accord with Gorham Company's registered trademark of December 1, 1899, and its practice of denoting important speculative works with an assigned number in an oval cartouche. Factory records suggest that the pair was completed on December 12 and intended for both the installation *Martelé—Paris* as well as a showing by "Mr. Sweetser . . . in Boston."[20] Those records also document the highly specialized, limited, and expensive nature of Martelé silver production: nine hundred hours of labor at an approximate cost of eight hundred dollars were required to complete the candelabra.[21] This extravagant figure was more than half the annual income of the highly skilled specialist chaser who brought up the candelabra's intricate decoration.[22]

If the expense of hand production precluded ownership by the broader public, such works as these—demonstrating innovative techniques, novel materials, a rich appearance, or specialized labors—assumed the stature of art among wealthy American advocates of Art Nouveau.[23] SJR

NOTES

1. The term derived from Siegfried Bing's Parisian gallery of the same name, L'Art Nouveau, established in 1895. Discomfort with the style's subversive influences generally resulted in more restrained interpretations by American designers. Helen Clifford and Eric Turner, "Modern Metal," in Paul Greenhalgh, ed., *Art Nouveau: 1890–1914* (New York: Abrams, 2000), 225, 234; Alice Cooney Frelinghuysen, "Louis Comfort Tiffany and New York," in Greenhalgh, ed., *Art Nouveau,* 401.

2. See *Lejambre Table* (cat. no. 79). Doreen Bolger Burke, Preface in Burke et al., *In Pursuit of Beauty: Americans and the Aesthetic Movement* (New York: Metropolitan Museum of Art, 1986), 20.

3. In the manner of a vine or figure such as Loïe Fuller, the Art Nouveau "femme fatale" dancer with the "diaphanous veils." Francesca Vanke, "Arabesque: North Africa, Arabia and Europe," in Greenhalgh, 115–16, 120–23; Greenhalgh, "The Cult of Nature," in Greenhalgh, 55, 65–68.

4. Siegfried Bing, *Le Japon Artistique* 1 (May 1886): 6, quoted in Anna Jackson, "Orient and Occident," in Greenhalgh, 109–10.

5. Jackson, 101, 111; Ghislaine Wood and Paul Greenhalgh, "Symbols of the Sacred and Profane," in Greenhalgh, 84.

6. Greenhalgh, "The Style and the Age," in Greenhalgh, 18–31; Greenhalgh, "*Le Style Anglais:* English Roots of the New Art," in Greenhalgh, 127; Vanke, 120–21; Hallays quoted in Philippe Jullian, *The Triumph of Art Nouveau at the Paris Exhibition, 1900* (New York: Phaidon, 1974), chapter 5, cited in Jonathan Meyer, *Great Exhibitions: London–New York–Paris–Philadelphia, 1851–1900* (Woodbridge, Suffolk, U.K.: Antique Collectors' Club, 2006), 292.

7. Greenhalgh, "Style and the Age," 31; Greenhalgh, "Alternative Histories," in Greenhalgh, 52–53.

8. For a general overview of the advent of the international trade fair, see John M. MacKenzie, "Empire and Metropolitan Cultures," in Andrew Porter, ed., *The Oxford History of the British Empire,* vol. 3, *The Nineteenth Century* (Oxford: Oxford University Press, 2001), 280–82; Martin Lynn, "British Policy, Trade, and Informal Empire in the Mid-Nineteenth Century," in Porter, 102; Meyer, 11–17; Gabriel P. Weisberg, "The French Reception of American Art at the Universal Exposition of 1900," in Diane P. Fischer, ed., *Paris, 1900: The "American School" at the Universal Exposition* (New Brunswick and London: Rutgers University Press, 1999), 145–46, 148, 151, 163.

9. Benn Pittman, *A Plea for American Decorative Art* (Cincinnati, 1895), quoted in Marilynn Johnson, "Art Furniture: Wedding the Beautiful to the Useful," in Burke et al., 143–44; Roger Stein, "The Aesthetic Movement in Its American Cultural Context," in Burke et al., 25–30, 36, 48; Johnson, 143–44.

10. Including Owen Jones, *The Grammar of Ornament* (1856) and John Ruskin, *The Two Paths, Being Lectures on Art and its Application to Decoration and Manufacture* (1859). Burke et al., 19–20; Simon Jarvis, "England," in Katherine S. Howe, Alice Cooney Frelinghuysen, and Catherine Hoover Voorsanger, *Herter Brothers: Furniture and Interiors for a Gilded Age* (New York: Abrams in association with the Museum of Fine Arts, Houston, 1994), 17–18; Sarah Fayen, "Introduction: Everything in My Life Seemed to Point toward this Work," in Joseph Cunningham, *The Artistic Furniture of Charles Rohlfs* (New Haven and London: Yale University Press for the American Decorative Art 1900 Foundation, 2008), 3; Catherine Lynn, "Decorating Surfaces: Aesthetic Delight, Theoretical Dilemma," in Burke et al., 53–62.

11. *Art Interchange* 44 (April 1900): 79.

12. Martelé required a purer, .950 silver content rather than the standard .925 sterling. Although a more costly material, its greater plasticity made it easier for craftsmen to bring up a form, ultimately resulting in lower labor costs. A 1900 French catalogue illustrating Gorham's Martelé work described these candelabra as "Candelabre martelé, 'Nuit et Matin.'" See Dorothy T. Rainwater, ed., *Sterling Silver Holloware* (Princeton: Pyne Press for the American Historical Catalogue Collection, 1973), n.p.

13. Gorham's official use of the term *Martelé* appears to correspond with its preparations for the 1900 Exposition Universelle in Paris. It is not mentioned in the 1899 registry of trademarks. See Charles H. Carpenter Jr., *Gorham Silver, 1831–1981* (New York: Dodd, Mead, 1982), 290.

14. Ministère du Commerce, de l'industrie et des Colonies, *Rapport général administrative et technique*, vol. 4 (Paris: Imprimerie nationàle, 1891–92), III, translated in *Official Illustrated Catalogue, Fine Arts Exhibit, United States of America, Paris Exposition of 1900* (Boston: Noyes, Platt), xv, quoted in Diane P. Fischer, "Constructing the 'American School' of 1900," in Fischer, 1.

15. Fischer, 1–2; Linda Docherty, "Why Not a National Art?: Affirmative Responses in the 1890" in Fischer, 109, 117.

16. William Thomas Stead, *The Americanization of the World; or, The Trend of the Twentieth Century* (London: Review of Reviews, 1902), quoted in Robert W. Rydell, "Gateway to the 'American Century': The American Representation at the Paris Universal Exposition," in Fischer, 123.

17. The decorative arts were represented not only in individual objects but in the integrated wall, ceiling, and carpet installations that distinguished the American fine-art galleries from their European counterparts. Fischer, 5, 11, 17.

18. Meyer, 285–87; Rydell, 120.

19. In addition, Edward Holbrook, the company's chief executive officer, was made a chevalier of the Legion of Honor, and William C. Codman, its English-born chief designer was awarded a gold medal. *Art Interchange*, 81; Stephen Harrison, "Artistic Luxury in the Belle Epoque," in Harrison et al., *Artistic Luxury: Fabergé, Tiffany, Lalique*, exh. cat. (New Haven and London: Yale University Press for the Cleveland Museum of Art, 2008), 33–35.

20. See cost slip for "2387 Candelabrum 7-Lt.," Gorham Archives, copy in VMFA curatorial files. A "pp" annotation adjacent the "Making" column suggests that both candelabrum were completed by this time. Sweetser was probably an agent for the retailer Shreve, Crump, and Low, which over-stamped the Gorham marks with its own.

21. Four and one-half hours to draw at $.40 per hour, 225 hours to bring up the shape at $.45 per hour, and 216 hours to chase the decoration at a cost of $.60 per hour. An additional $2.50 was spent oxidizing the works to highlight the chasing. Records suggest that each candelabrum was valued at $800, about twice its cost. Additional annotations suggest a retail price of $1,350 each. See cost slip for "2387 Candelabrum 7-Lt.," Gorham Archives, copy in VMFA curatorial files. A preliminary XRF analysis indicates that the silver content of the two candelabra are unequal: 65.3.2 has a higher content of sivler (96.1) than 65.3.2 (91.6).

22. The highly skilled chaser responsible for these candelabra earned approximately $30 per week or $1500 per year—four times that of the average public school-teacher. For more statistics, see http://usa.usembassy.de/etexts/his/eprices1.htm.

23. Harrison, 1–35; Johnson, 170; Clifford and Turner, 235.

97. Tiffany Glass and Decorating Company (1892–1900)

Punch Bowl with Three Ladles, 1900

New York, New York

Favrile glass; silver, gilding, copper

14 ¼ x 24 in. (36.2 x 61 cm)

Stamped on underside of base: APRIL 1900 / TIFFANY G. & D. CO. / NEW YORK / 1282

Museum Purchase, The Sydney and Frances Lewis Art Nouveau Fund, 74.16 a–d

PROVENANCE: Henry O. Havemeyer (1847–1907); Stranahan family, Toledo, Ohio; Arnold King, dealer (1965–66); Robert and Gladys Koch, Stamford, Conn. (1966–74)

Supporting wrought-metal ladles with iridescent basins above a silver pool of chased and gilded ripples, this shell-encrusted bowl of golden glass marks the zenith of the Art Nouveau Style. Eliciting popular attention for its "strange tonalities" upon display at the 1900 Paris Exposition (fig. 165), this extraordinary punch bowl was intended by the fair's promoters as the "chef d'oeuvre" of the United States exhibits.[1] Previewed in New York prior to Paris, it was promoted as evidence of American ingenuity and a source of national pride. Contemporary critics exclaimed over the vessel's "breaking waves," "foaming crests," and "arms of peacock-hued Favrile glass," which echoed the "changing lights and pulsing waves of color" on display at the Palais de l'Electricité.[2] Signaling the technical triumph of Favrile glass, the punch bowl won for Tiffany Glass and Decorating Company five gold medals and a grand prix.[3]

Initially titled "Fabrile" (from the Latin *fabrilis,* meaning hand wrought), the glass was renamed "Favrile" in 1894 to evoke desirability.[4] Waterlike in effect, the polychrome patterns derive from the repetitive application of iridescent color to the glass as it was heated and formed into a ball. As the molten orb was shaped into a vessel by the skilled blower, the applied colors were integrated into the body itself according to Louis Comfort Tiffany's prescribed design.

Tiffany's success with Favrile glass was due in large part to the technical talents of Arthur John Nash, who, while employed at Webb and Sons in Stourbridge, England, had

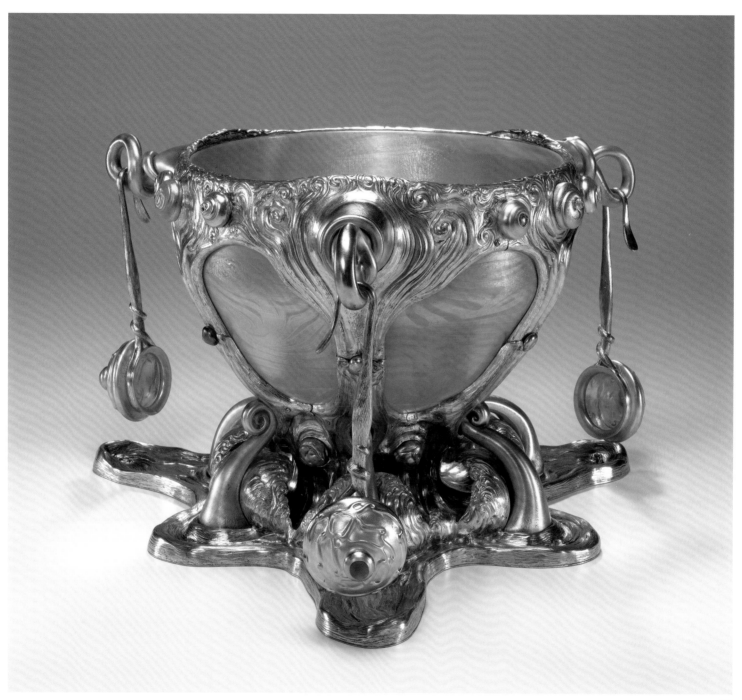

97

EXPATRIATES and the GILDED AGE 283

created the formula for "bronze glass" exhibited by the British firm at the 1878 Paris fair.[5] Three years later, Tiffany purchased a patent for its production and began experimenting with mosaics, plate glass, and oxides.[6] In 1885 he established the Tiffany Glass Company in New York and, six years later, he founded Tiffany Furnaces at Corona, Queens, under Nash's supervision.[7] Formally incorporated as the Tiffany Glass and Decorating Company in 1892, the firm was initially responsible for producing both flat and blown glass. In 1893, however, the blown-glass function was spun off as the Stourbridge Glass

Company and, a year later, Tiffany's first glass "curiosit[ies]" were being shipped to Siegfried Bing's gallery, L'Art Nouveau, in Paris.[8] Shortly thereafter, they began appearing in noted public and private collections, including that of Henry O. and Louisine Havemeyer.[9] By 1898, the firm was rendering golden Favrile glass into an extraordinary peacock decoration, also represented in VMFA's collection (fig. 166).[10]

As evanescent swirls of color transform the punch bowl's modest material into an illustrious substance, so the artisan's skilled treatment elevates the simple shape into sculpture.

FIG. 165 **Tiffany display at the Universal Exposition in Paris,** 1900, photograph. The punch bowl is exhibited in the glass case at center.

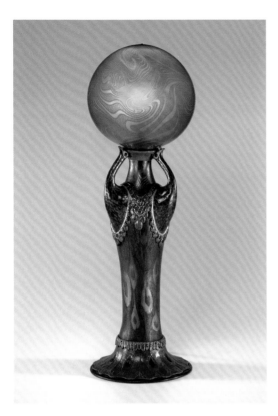

FIG. 166 Louis C. Tiffany (1848–1933), **Peacock Lamp,** commissioned by Charles Winthrop Gould, ca. 1898–1900, New York, N.Y., Favrile glass, enamel, brass, gilding, 40½ x 13 in. (102.9 x 33 cm) dia. at base. Virginia Museum of Fine Arts, Gift of the Sydney and Frances Lewis Foundation, 85.152a–b.

Formally, the punch bowl may have been inspired by talented period designers with whom Louis Tiffany was connected. Edward C. Moore, chief decorator for Charles Tiffany's Tiffany and Company, was probably responsible for a related punch bowl dated 1889 featuring a silver basin atop a school of mermaids also resting above cresting waves.[11] The same was true of the German-born artist Édouard Colonna. Colonna produced metal mounts for Tiffany works exhibited by Bing in 1899. He also designed an undulating whiplash pattern similar to the punch bowl's rippling silver base.[12] Together the two men provided Tiffany with formal precedents for his striking bowl. The fair provided a context.

Tiffany's punch bowl heralded an America poised on the cusp of a golden age, as suited the artist's promodern commercial interests. But visitors strolling through the grounds of the exposition might also have noticed an intermittent series of sculptural groups reminding them of the fragile balance of power between virtue and corruption that informed a fin-de-siècle tension with modern life.[13] Based on the classical labors of Heracles, the collection included works like *Harmony Destroying Discord.*[14] Such designations suggest that the Paris theme was both a celebration of human progress and—somewhat paradoxically—a cautionary reminder of the corruptive influence of commercial excess.[15] Only a few years later, Gustav Stickley would call Art Nouveau "undemocratic," correlating the "chaos of lines" characteristic of the style with "volcanoes and earthquakes in the world of matter. They are creators of disorder and destruction."[16] Recalling the "course of empire" premise first iterated by Bishop Berkeley in 1723, American historian Henry Adams observed of the fair: "There are things in it, which run close to the day of judgement. . . . It is a new century. . . . [Yet,] the curious mustiness of decay is already over our youth."[17] SJR

NOTES

1. As described by the unknown author of "A Tiffany Masterpiece: The Havemeyer Punch Bowl of Favrile Glass on Exhibition at Paris—Grandest Known Example of the Art," *Buffalo Express,* May 1900, n.p. See also "Glass Working as a High Art," *Jeweler's Circular and Horological Review, And the Jewelers' Weekly,* Consolidated 40 (May 9, 1900): 6–7; David Park Curry, "Tiffany's Golden Bowl," *The Magazine Antiques* 151 (January 1997): 245.

2. Florence N. Levy, "Applied Arts at the Paris Exposition," American Art Annual (1900): 21, cited in Robert Koch, "The Tiffany Exhibition Punch Bowl," *Arts in Virginia,* 16 (Winter–Spring 1976): 34; Curry, 246. Also cited in Jeannine Falino, "America: A Tale of Two Tiffanys," in Stephen Harrison, Emmanuel Ducamp, and Jeannine Falino, *Artistic Luxury: Faberge, Tiffany, Lalique* (New Haven and London: Cleveland Museum of Art in association with Yale University Press, 2008), 288.

3. The punchbowl was also exhibited at the Pan-American Exposition held in Buffalo, New York, in 1901. For a review of Tiffany's "de tonalités estranges," see Ministère du Commerce, de l'industrie des Postes et des Télégraphes, "États-Unis," in *Exposition Universelle Internationale de 1900 à Paris, Rapports du jury internationale, Groupe XV, Industries diverses* (Paris: Imprimerie Nationale, 1902), 506, quoted in Gabriel P. Weisberg, "The French Reception of American Art at the Universal Exposition of 1900," in Diane P. Fischer, ed., *Paris 1900: The "American School" at the Universal Exposition* (New Brunswick and London: Rutgers University Press, 1999), 165; Koch, 34.

4. According to an advertisement in *Decorator and Furnisher* (October 1894) reproduced in Martin Eidelberg, "Tiffany's Early Glass Vessels," *The Magazine Antiques* 137 (February 1990): 507. See also Martin Eidelberg, *Tiffany Favrile Glass and the Quest of Beauty* (New York: Lillian Nassau, 2007), 16, 21.

5. Eidelberg, *Tiffany Favrile Glass,* 26–27.

6. Until he established his own glass company, Tiffany contracted from other commercial firms, including Louis Heidt and Company of Brooklyn, which likewise supplied his rival, John La Farge. Falino, 276; Eidelberg, *Tiffany Favrile Glass,* 13–14; Jennifer Hawkins Opie, "The New Glass: A Synthesis of Technology and Dreams," in Paul Greenhalgh, ed., *Art Nouveau: 1890–1914* (New York: Abrams, 2000), 217–18; Alice Cooney Frelinghuysen, "A New Renaissance: Stained Glass in the Aesthetic Period," in Doreen Bolger Burke, et al., *In Pursuit of Beauty:*

Americans and the Aesthetic Movement (New York: Metropolitan Museum of Art, 1986), 185, 188–9, 193.

7. Falino, 276, 280.

8. Ibid., 280, 284.

9. First mention of Havemeyer patronage appears in the *Buffalo Express* article of May 1900, cited above. Further research has not confirmed this commission. According to oral tradition, the bowl was purchased in 1966 by Gladys Koch from dealer Arnold King who purchased it from the Stranahan family in Toledo, Ohio, where it was thought to have resided for sixty years. Dr. Frank Duane Stranahan (born in Saint Louis, Missouri, in 1876) died in Perrysburg, Ohio, in November 1965 and may have been the owner. When the Havemeyer Collection was sold in 1930, this punchbowl was not among the objects. Moreover, according to Havemeyer scholar Frances Weitzenhoffer, family members living in 1987 were unfamiliar with the bowl. See VMFA curatorial files. Ibid., 280.

10. Alice Cooney Frelinghuysen, "Louis Comfort Tiffany and New York," in Greenhalgh, 402; Eidelberg, *Tiffany Favrile Glass,* 15–16, 36, 46.

11. The silver punchbowl was called the "Goelet Prize for Sloops." John T. Curran, an admirer of Colonna, succeeded Edward Moore at Tiffany and Company in 1891. Koch, 37, 39. For another discussion of the punchbowl, see Curry, 244–47.

12. Frelinghuysen, "Louis Comfort Tiffany and New York," 405; Frelinghuysen, "A New Renaissance," 193.

13. For a discussion of this theme, see Paul Greenhalgh, "The Style and the Age," in Greenhalgh, 15, 18 - 22.

14. Jonathan Meyer, *Great Exhibitions: London–New York–Paris–Philadelphia 1851–1900* (Woodbridge, Suffolk, U.K.: Antique Collectors' Club, 2006), 285.

15. John Ruskin uses the Heraclean theme to interpret the influence of industrialization and commerce on moral order. The theme inspired works by various artists, including John Mallord William Turner, *The Goddess of Discord choosing the Apple of Contention in the Garden of the Hesperides,* exh. 1806, Coll. Turner Bequest 1856, transferred to the Tate Gallery 1910 (N00477), and Albert Herter, *The Garden of the Hesperides,* ca. 1900, Spanierman Gallery. See Ruskin, *Modern Painters,* vol. 5, *Of Leaf Beauty. Of Cloud Beauty. Of Ideas of Relation* (1860; repr. London: George Allen, 1906), 330–44. Coincidentally, the story of Heracles' tenth labor includes a golden bowl, which carries the youthful Olympian from East to West to rescue the apples of immortality on the island of the Hesperides. In the process, his golden bowl is tossed upon waves by the jealous half-serpent Okeanos, an Old World Titan. Ruskin describes the metaphor of the changing sea in *Of the Pathetic Fallacy.* See Chauncey B. Tinker, ed., *Selections from the Works of John Ruskin* (Boston: Houghton Mifflin, 1908), 66.

16. Stickley, "Thoughts Occasioned by an Anniversary: A Plea for a Democratic Art," *The Craftsman* 7 (Oct 1904): 54, cited in Curry, 247.

17. See Berkeley, "On the Prospect of Planting Arts and Learning in America," which highlights the five stages of development he uses to explain the natural rise and fall of cultures and, in particular, the moral decay of England against the fresh promise of America. The most famous visual example of Berkeley's idea is Thomas Cole's series of the five stages of empire completed 1833 - 36. Henry Adams cited in Richard D. Mandell, *Paris 1900–The Great World's Fair* (Toronto: University of Toronto Press, 1967), quoted in Meyer, 285; Diane P. Fischer, "American School," in Fischer, 47–56; Robert W. Rydell, "Gateway to the 'American Century': The American Representation at the Paris Universal Exposition," in Fischer, 128, 136.

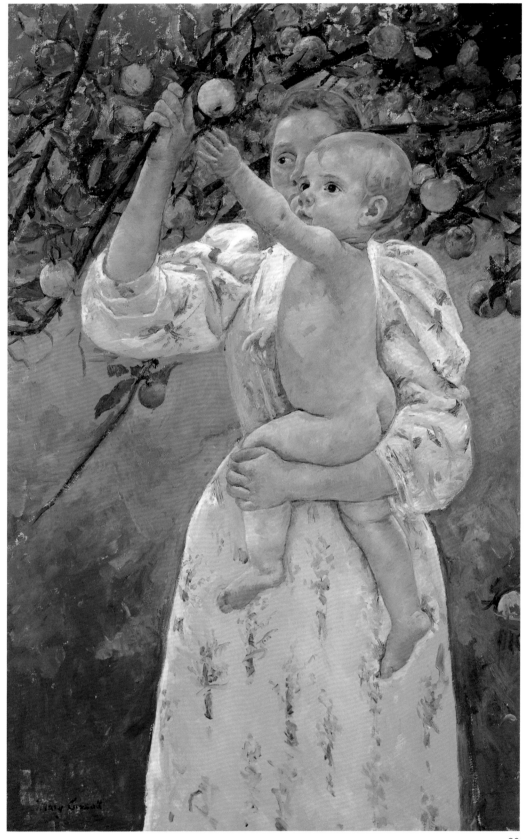

98

98. Mary Cassatt (1844–1926)

Child Picking a Fruit, 1893

Oil on canvas

39 ½ x 25 ¾ in. (100.3 x 65.4 cm)

Signed lower left: "Mary Cassatt"

Gift of Ivor and Anne Massey, 75.18

PROVENANCE: From the artist to Durand-Ruel gallery, Paris (1893); James Stillman, Paris (1910); E. G. Stillman, New York, N.Y.; Mrs. Blaine Durham, Hume, Va.

99. Mary Cassatt (1844–1926))

The Banjo Lesson, 1894

Pastel over oiled pastel on tan wove paper

28 x 22 ½ in. (71.1 x 57.2 cm)

Signed lower right: "Mary Cassatt"

Museum Purchase, The Adolph D. and Wilkins C. Williams Fund, 58.43

PROVENANCE: From the artist to Ambroise Vollard, Paris (1904); Durand-Ruel gallery, Paris; Durand-Ruel gallery, New York, N.Y.; Mrs. Montgomery Sears (neé Sarah Choate), Boston, Mass.; Mrs. J. Cameron Bradley (neé Helen Sears), Boston, Mass.; M. Knoedler and Company, New York, N.Y.

A talented painter, pastelist, and printmaker, the Pennsylvania-born Mary Cassatt, whose career flourished abroad, occupies a unique place in the history of American art. Her early alliance with the French impressionists (she was the only American to exhibit with the avant-garde group in Paris) led to her early-twentieth-century reputation as one of the country's most important artists.

Child Picking a Fruit, or *Enfant cueillant un fruit*, merges a more ambitious examination of "modern woman" with the subject that had made Cassatt famous: a young woman—possibly a mother—and child painted with characteristic "sturdy wholesomeness and naturalness."[1] And it is the former subject that connects this oil with *The Banjo Lesson*, Cassatt's striking pastel from one year later, also in the VMFA collection. Both works derive from the artist's now-lost *Modern Woman* mural, produced for the Woman's Building of the 1893 World's Columbian Exposition in Chicago. For this prestigious world's fair, Cassatt presented her allegorical subject in a three-panel lunette. The large central panel, *Young Women Plucking the Fruits of Knowledge*, featured women of different ages clad in contemporary dress

harvesting fruit from an orchard. The left panel was titled *Young Girls Pursuing Fame* and the right, *The Arts, Music, and Dancing*, which included a vignette of banjo playing.[2]

The rigorous design of Cassatt's so-called orchard imagery, including *Child Picking a Fruit*, links it to her allegorical cycle, in which the fruit of knowledge bears no taint of biblical downfall. There was "no serpent in this nineteenth century Eden," critic Marianna Griswold van Rensselaer wrote of Cassatt's mural, "For today the forbidden fruit is no longer forbidden."[3] Yet while the eager child, splendid in a naked innocence, gazes at the golden fruit with curiosity and wonder, the roaming eye of the young woman, as well as her sturdy grip on the child's knee, seems to betray an uncertainty and wariness. Perhaps it is this quality that has led some writers to view the image as "hard and unsympathetic,"[4] complicating its overall warmth—from the rosy hues of the child's skin and woman's floral dress to the lush greenery of the outdoor setting.

The association of women and children with the natural world—long a popular cultural trope—became an even more prevalent theme at the turn of the twentieth century. In both impressionist oils and pictorialist photographs, with their

FIG. 167 Gertrude Käsebier (1852–1934), **Mrs. Vitale and Child,** ca. 1900–1905, platinum print, 8 x 5 ½ in. (20.3 x 14 cm). Virginia Museum of Fine Arts, Gift of Hermine M. Käsebier Turner, 74.11.2.

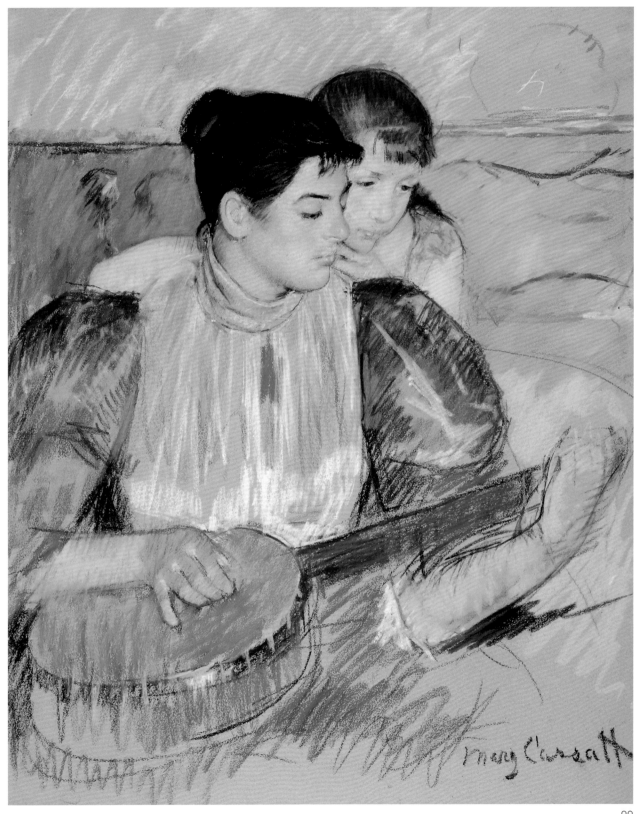

99

imported painterly conventions, mothers and babies peacefully commune in outdoor settings. The leading photographer of the period, Gertrude Käsebier (fig. 167), taking her cue from Cassatt, specialized in this genre, which presents women as a crucial moral force in the care and education of their offspring.[5]

This theme of intimate exchange also shapes the form and content of Cassatt's *The Banjo Lesson.* Likening "plucking the fruits of knowledge" to plucking the strings of a musical instrument, Cassatt explored the subject in a series of pastels and color prints shortly after completing her *Modern Woman* mural.[6] The popularity of the banjo, a distinctively American instrument (with African roots) spread across race, gender, and class lines in the 1880s. Cassatt first employed the motif in her mural as a symbol of contemporary femininity.[7] In VMFA's vibrant pastel—one of the artist's most accomplished—the fashionably dressed models sit cheek to cheek, lost in their music. Around the same time, Cassatt used her considerable printmaking skills to render this compelling image in drypoint and aquatint (fig. 168).[8] Be it a pastel or print, *The Banjo Lesson* resonates with notions of sisterly affection and instruction, perhaps emphasizing the transition from childhood to

young womanhood. This critical rite of passage was explored through contemporary allegories of music by other women artists, such as Lilla Cabot Perry and Cecilia Beaux (cat. no. 90), in the 1890s. SY

NOTES

1. "Mary Cassatt Dies; An American Artist," *New York Times,* June 16, 1926, 25.
2. Sally Webster, *Eve's Daughter/Modern Woman: A Mural by Mary Cassatt* (Urbana: University of Illinois Press, 2004).
3. Mariana van Rensselaer, "Current Questions of Art," *New York World,* December 18, 1892, 24.
4. *Cassatt: A Retrospective,* ed. Nancy Mowll Mathews (New York: Hugh Lauter Levin, 1996), 216.
5. For a discussion of how Käsebier "internalized Cassatt's repertoire of poses," see Kathleen Pyne, *Modernism and the Feminine Voice: O'Keeffe and the Women of the Stieglitz Circle* (Berkeley: University of California Press, 2007), 21–31.
6. *The Banjo Lesson* relates to a slightly earlier pastel, *The Two Sisters* (Museum of Fine Arts, Boston), which presumably depicts the same models, but in a more abbreviated, sketchlike composition absent any activity, banjo-playing or otherwise. See Adelyn Dohme Breeskin, *Mary Cassatt: A Catalogue Raisonné of the Oils, Pastels, Watercolors, and Drawings* (Washington, D.C.: Smithsonian Institution Press, 1970), 115. For a discussion of Cassatt's pastel technique in the mid-1890s, see Harriet K. Stratis, "Innovation and Tradition in Mary Cassatt's Pastels: A Study of Her Methods and Materials," in Judith A. Barter, *Mary Cassatt: Modern Woman* (New York: Art Institute of Chicago in association with Abrams, 1998), 217–22.
7. Webster, 91–98; Sarah Burns, "Whiteface: Art, Women, and the Banjo in Late-Nineteenth-Century America," in *Picturing the Banjo,* ed. Leo G. Mazow (University Park: Palmer Museum of Art and the Pennsylvania State University Press, 2005), 80–81.
8. For consideration of Cassatt as printmaker, see Mathews and Barbara Stern Shapiro, *Mary Cassatt: The Color Prints,* exh. cat. (New York: Abrams in association with Williams College Museum of Art, 1989), 164–66.

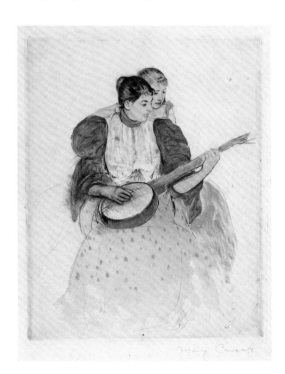

FIG. 168 Mary Cassatt (1844–1926), **The Banjo Lesson,** ca. 1893, drypoint and aquatint on blue laid paper, 11 ⅝ x 9 ⅜ in. (29.5 x 23.8 cm). Virginia Museum of Fine Arts, Gift of M. Knoedler and Company, 58.50.

100. John Leslie Breck (1860–1899)

Grey Day on the Charles, 1894

Oil on canvas

18 x 22 in. (45.7 x 55.9 cm)

Signed and dated lower right: "John Leslie Breck–1894–"

Museum Purchase, The J. Harwood and Louise B. Cochrane Fund for American Art, 90.151

PROVENANCE: Mrs. Ellen Frances Newell Breck Rice, the artist's mother (by 1900); Camp Huntington, Bartlesville, Okla.; Brown Corbin Fine Art, Milton, Mass.; Richard Manoogian, Detroit, Mich. (1986); Jordan-Volpe Gallery, New York, N.Y.

Lily pads float delicately on gently ruffled waters in Breck's *Grey Day on the Charles,* painted near Auburndale, Massachusetts, in 1894. Sunlight ripples over the surface, punctuated by vertical water reeds, while deep within the pictorial space

a silvery mist hovers at the edge of a densely wooded bank. A full palette of rich greens and acid yellows, complemented by scattered hints of rusty red, pink, and plum, shimmers against cool mauves and blue grays. Breck chose to picture the still, natural beauty of this waterway near Boston rather than its typical bustle of shipping and industry. The title records the artist's interest in atmospheric effects, while his nonnarrative subject and soft, broken brushwork reveal him as an American exponent of impressionism.[1]

Although Breck's formal training included stints in Leipzig, at the Royal Academy of Fine Arts in Munich, in Antwerp, and at the Académie Julian in Paris, the impact of Claude Monet is clearly evident in this elegant canvas. During the summer of 1877, Breck was among the first young American artists to paint in Giverny, where Monet had planted his elaborate garden. Eventually Monet befriended Breck, and the two were working together by 1890.[2] When Breck returned to his native Boston to exhibit recent pictures, he caused excitement with his finely rendered compositions overlaid with seemingly transient atmospheric effects.[3] A reviewer commented that Breck

has been saddled, whether he likes it or not, with the title "Head of the American Impressionists." It is stating it mildly to say that artistic Boston was nearly pushed off its critical equilibrium, and a fierce controversy at once arose between the champions of the old, or black, and the new, or light, landscape schools, of which latter Mr. Breck was at once recognized by friend and foe, to be the American head.[4]

While Breck was first committing himself to impressionism, his contemporary and former Académie Julian classmate Arthur Wesley Dow was embarking upon another stylistic path. Instead of making summer sojourns to Giverny, Dow—also from Massachusetts—chose to visit the Pont Aven art colony in Brittany, where he became familiar with the post-impressionist followers of Paul Gauguin and their love of rhythmic patterning and broad passages of color. On his return to Boston, Dow also began to study Japanese woodblock prints under Ernest Fenollosa, curator of Japanese art at the city's Museum of Fine Arts. The synthesis of these dual

influences are manifest in the lithographic poster he created to advertise the quarterly publication *Modern Art* (fig. 169) in 1895—produced a year after Breck completed his canvas. Like Breck, Dow pictures a calm ribbon of water that meanders along lush banks; but its highly abstracted, simplified, and decorative forms anticipate the modernist impulses that would eclipse American impressionism in the early decades of the next century.[5]

FIG. 169 Arthur Wesley Dow (1857–1922), **Modern Art,** 1895, lithograph, 21 ¼ x 15 ¼ in. (54 x 38.7 cm). Virginia Museum of Fine Arts Purchase, The Adolph D. and Wilkins C. Williams Fund, 89.66.

Breck would not live to see the movement's decline; he died in 1899 at the age of thirty-nine. His work is less frequently exhibited or published than are paintings by his longer-lived friends and colleagues such as Childe Hassam (see cat. no. 103), Willard Metcalf, John Twachtman, and J. Alden Weir. These American impressionists promoted memorial exhibitions of Breck's sensitive paintings. When a selection, which included *Grey Day on the Charles,* was exhibited in Boston in May of 1899, a critic for the *Boston Herald* observed, "[Breck's] happiest efforts have been in rendering some transient effect. A stream half shrouded in mist . . . ring[s] through the memory like minor music."[6] DPC

101

1. Carol L. Shelby, "John Leslie Breck, 1860–1899," in William H. Gerdts, *Lasting Impressions: American Painters in France, 1865–1915*, exh. cat. (Evanston, Ill.: Terra Foundation for the Arts, 1992), 146–47; H. Barbara Weinberg, "Summers in the Country," in Kathleen Adler et al., *Americans in Paris, 1860–1900*, exh. cat. (London: National Gallery, 2006), 142, 164.

2. While scores of American artists flocked to Giverny from 1885 until the early decades of the twentieth century, only a handful had a personal relationship with the famous but reclusive French painter. Breck was among the lucky few. Their friendship appears to have cooled rather abruptly, however, when Monet disapproved of Breck's courtship of Blanche Hoschede, daughter of his longtime mistress. Weinberg, 142; Shelby, 147.

3. "Mr. John L. Breck's Landscapes," *Boston Daily Globe*, January 25, 1893, 10. Breck may have exhibited the picture as *On the Charles River* the following year at the Society of American Artists, New York, March 24–April 27, 1895, cat. no. 189.

4. "Breck's Landscapes," 10, quoted in Kathryn Corbin, "John Leslie Breck, American Impressionist," *The Magazine Antiques* 134 (November 1988): 1146.

5. Frederick C. Moffatt, *Arthur Wesley Dow (1857–1922)*, exh. cat. (Washington, D.C.: National Collection of Fine Arts, 1977), 24–39, 49–50, 63–67, 76.

6. *Boston Herald*, May 17, 1899, quoted in Corbin.

101. Henry Prellwitz (1865–1940)

Lotus and Laurel, 1904

Oil on canvas

30 x 60 in. (76.2 x 152.4 cm)

Inscribed, dated, and signed lower left: "Copyright 1904 by Henry Prellwitz"

Gift of Joseph T. and Jane Joel Knox, 2008.42

PROVENANCE: Estate of the artist; Spanierman Gallery, New York, N.Y.; Joseph T. and Jane Joel Knox, Richmond, Va.

In subject and style, Henry Prellwitz's *Lotus and Laurel* exemplifies the American Renaissance—a pervasive classicizing trend embraced by numerous artists and architects in the late nineteenth and early twentieth centuries. With its

layered allusions to ancient Greece and Rome, as well as to Quattrocento Italy, this large canvas depicts a procession of languorous figures.[1] As carefully and rhythmically staged as the bas-reliefs on Phidias's Parthenon frieze or the sylvan gathering in Sandro Botticelli's *Primavera*—reproductions of which embellished most nineteenth-century academic studios—the classically draped subjects gather in a verdant grove. They greet a man who emerges from a shaded thicket at right. Dressed in a cap and velvet tunic more suggestive of the European Renaissance than of antiquity, the traveler pauses to contemplate the group's gifts of an austere laurel wreath and the more heady enticements of wine, music, and the fragrant lotus plant.[2] Both animate and inanimate forms dissolve beneath Prellwitz's painterly brushstrokes, tonalist palette, and shifting gradations of light.[3]

Lotus and Laurel made its debut at the Louisiana Purchase Exposition—the 1904 world's fair held in Saint Louis, Missouri.[4] For the fair's official two-volume history, Prellwitz provided an explication of his allegory: "The youth, clad like a pilgrim on the stony road to Fortune, encounters the maidens of pleasure, whose symbol is the enticing lotos bloom. As he seems about to turn to the life of music, wine and love, Ambition, holding aloft the laurel wreath, recalls him."[5] The artist likely anticipated that his image—with its chiton-clad nymphs, their amphora-bearing attendant, and the mysteriously veiled Ambition—would show to great advantage within the exposition's Greek-inspired Art Palace (the present-day Saint Louis Art Museum). Moreover, as the fair hosted the third Olympiad alongside competing exhibitions of international achievements in art and industry, Prellwitz's narrative of personal choice, discipline, and ultimate reward promised a certain resonance with the momentous presentation of wreaths and prizes to victorious athletes and exhibitors alike.

While the intriguing canvas garnered its own reward—it earned a silver medal at the fair—such calculated classicism was not unique to Prellwitz or this venue. The painter came to artistic maturity during a resurgence of interest in ancient myth, literature, and history. In the post–Civil War decades, increasing numbers of American artists and architects traveled abroad to enroll in European academies—the most influential being the École des Beaux-Arts in Paris—while others sought

placement in a handful of private teaching ateliers. As part of their academic training, students were encouraged to look to antiquity and the High Renaissance for examples of timeless beauty, unity, and refined technique. In painting and sculpture, this endeavor involved mastering the depiction of the human figure. By the late 1870s, the Beaux-Arts aesthetic had been transplanted across the Atlantic and nurtured by a growing number of French-trained Americans in New York City. Finding themselves out of step with the conservative and increasingly chauvinistic National Academy of Design, they gravitated toward the more progressive and newly formed Society of American Artists. They also established the Art Students League, a self-supporting academy that offered "classes for study from the nude and draped model" conducted "on the principles of the Parisian ateliers."[6]

This increasingly cosmopolitan outlook and conscious reverence for the classical past coincided with an emerging ideology that identified the United States as rightful heir to the legacy of Western culture—a notion that found full expression in a series of world's fairs in Chicago (1893), Buffalo (1901), Saint Louis (1904), and San Francisco (1915). In the full flush of the so-called American Renaissance, classical figures abounded across the nation, enacting mythological scenes or serving as allegorical personifications in painting, sculpture (see cat. no. 93), illustration, architectural ornamentation, and decorative arts. Such poetic visions of an Arcadian golden era—like Prellwitz's *Lotus and Laurel* or Lucia K. Mathews's 1906 covered jar with its encircling polychrome frieze (fig. 170)—provided Gilded Age audiences momentary escape from the modern trials of rapid industrialization, imperial expansion, labor conflict, race and gender unrest, and a burgeoning immigrant population.[7]

As a precocious teenager, Prellwitz studied art and classical literature in his native New York City. After enrolling at the Art Students League, he worked as an apprentice to instructor Thomas Wilmer Dewing, a painter who was composing his own monumental canvas, *The Days* (1886, Wadsworth Atheneum). Dewing's painting depicts a gathering of classically garbed figures who arrange themselves friezelike across a flower-strewn field—an image that likely inspired his student's later allegory.[8] Following a three-year course of study at the Académie Julian in Paris, Prellwitz settled permanently

in New York in 1890 and continued his close association with Dewing and other painters who upheld the classical banner, including Kenyon Cox, Francis Davis Millet, and George de Forest Brush. Within that circle was the artist's wife, Edith Mitchill Prellwitz, another award-winning painter. While maintaining their New York studios, the couple retreated annually to the summer art colonies of Cornish, New Hampshire, and Peconic on New York's Long Island Sound. Henry Prellwitz maintained an active and distinguished career until his death in 1940, exhibiting his figure studies and tonalist landscapes frequently at the Society of American Artists and at the National Academy of Design. He taught art at the Pratt Institute in Brooklyn and served for three years as director of the Art Students League.[9] ELO

FIG. 170 Lucia K. Mathews (1870–1955) Furniture Shop, **Covered Jar,** ca. 1906, painted and gilded wood, 12 ½ x 10 in. (31.8 x 25.4 cm) dia. Virginia Museum of Fine Arts, Gift of the Sydney and Frances Lewis Foundation, 85.299a–b.

NOTES

1. Descended through the artist's family are photographs of models—perhaps friends and family members—wearing Grecian gowns and striking poses for the various figures in *Lotus and Laurel.* Many Gilded-Age artists and their upper-class patrons enjoyed such costumed entertainments in which they created tableaux vivants. Among the best known is "A Masque of 'Ours,' the Gods and the Golden Bowl," given in 1905 to honor sculptor Augustus Saint-Gaudens (see cat. no. 93),

Prellwitz's friend and former Cornish, New Hampshire, neighbor. John H. Dryfout, *A Circle of Friends: Art Colonies of Cornish and Dublin* (Durham, N.H.: University Art Galleries, University of New Hampshire, 1985), 52.

2. Prellwitz alludes to the *Odyssey,* Homer's eighth-century BC epic poem based on Greek mythology, in which the ingestion of the plant's fruit causes a stupor of indolence and forgetfulness. This legendary snack of the Lotus-Eaters is most often identified as the *Zizyphus lotus,* a shrub found in the southern Mediterranean region. Not an aquatic plant like the *Nelumbo* lotus that resembles the water lily, the *Zizyphus* grows directly from the soil—as does Prellwitz's hearty specimen.

3. In the early twentieth century, Prellwitz's style softened under the influence of tonalism, a Barbizon-inspired approach in which painted contours became more indistinct and palettes were limited to slight gradations of similar hues. The resulting images were introspective, evocative, and often mysterious. See William H. Gerdts, "American Tonalism: An Artistic Overview" in *The Poetic Vision: American Tonalism,* ed. Ralph Sessions (New York: Spanierman Gallery, 2005), 22–28; and Lisa N. Peters, "Henry Prellwitz," in ibid., 160.

4. Prellwitz's copyright inscription may indicate his intent to publish the image as a chomolithograph—a common practice among artists who sent their work to the world's fairs at the turn of the twentieth century. To date, however, no related print has been located. See Peter C. Marzio, *The Democratic Art: Pictures for a 19th-Century America: Chromolithography, 1840–1900* (Boston: David R. Godine; Fort Worth, Texas: Amon Carter Museum of Western Art, 1979), 201–5, 313, 343.

5. Mark Bennitt, *History of the Louisiana Purchase Exposition: Comprising the History of the Louisiana Territory, the Story of the Louisiana Purchase and a Full Account of the Great Exposition, Embracing the Participation of the States and Nations of the World, and Other Events of the St. Louis World's Fair of 1904* (Saint Louis: Universal Exposition Publishing, 1905), 491, illus. 495. A separate guide to works on view in the fair's Art Palace provides a similar narrative in which the young pilgrim hesitates between maidens "offering the lotos, symbolizing ease, music, wine, etc.," and a "somber, hooded figure" who "shows the forgotten laurel wreath to recall to the youth his ambitious dreams." Halsey C. Ives, Charles M. Kurz, and George Julian Zolnay, *Illustrations of Selected Works in the Various National Sections of the Department of Art, with Complete List of Awards by the International Jury, Universal Exposition, St. Louis, 1904* (Saint Louis: Louisiana Purchase Exposition, 1904), 239–41.

6. Richard N. Murray, "Painting and Sculpture" in *The American Renaissance, 1876–1917,* exh. cat. (Brooklyn: Brooklyn Museum, 1979), 153–56; *American Masters: Art Students League,* exh. cat. (New York: Art Students League of New York, 1967), 9. This generation found further inspiration in the work of contemporary European painters who adopted styles and themes of classical antiquity and the Renaissance, including Pierre Puvis de Chavannes, Lawrence Alma-Tadema, Frederic Leighton, and Edward Burne-Jones. See Robert Rosenblum and H. W. Janson, *19th-Century Art,* revised (Upper Saddle River, N.J.: Pearson Prentice Hall, 2005) 274–77, 404, 452–54.

7. For a contextual overview of the cultural movement in the United States, see Richard Guy Wilson, "The Great Civilization," in *American Renaissance, 1876–1917,* 11–70. See also the discussion of "Painting as Rest Cure" in Sarah Burns, *Inventing the Modern Artist: Art and Culture in Gilded Age America* (New Haven and London: Yale University Press, 1996), 145–56; and Evie Savidou-Terrono, "Greek Classicism: Aesthetic Ideal and Ideological Reference within the American Renaissance," in *Anglo-American Perceptions of Hellenism,* ed. Tatiani G. Raparitzikou (Newcastle, U.K.: Cambridge Scholars Press, 2007), 144–57.

8. Susan Hobbs, *The Art of Thomas Wilmer Dewing: Beauty Reconfigured,* exh. cat. (Washington, D.C.: Smithsonian Institution Press, 1996), 106–9.

9. Ronald G. Pisano, *Henry and Edith Mitchill Prellwitz and the Peconic Art Colony,* exh. cat. (Washington, D.C.: Board of Governors of the Federal Reserve System, 1996), 4–15.

102. Henry Ossawa Tanner (1858–1937)

Christ and His Disciples on the Sea of Galilee,

ca. 1910

Oil on artist's canvas board

10 x 14 in. (25.4 x 35.6 cm)

Signed lower left: "H. O. Tanner"

Inscribed in pencil, verso: "To Mr Hodge-/3746 Elles [Ellis] Ave./
 Chicago Ill"

Museum Purchase, The J. Harwood and Louise B. Cochrane Fund for
 American Art, 2002.514

PROVENANCE: J. W. Young Gallery, Chicago, Ill., sold to Mr. Hodge, Chicago,
Ill.; A. W. Schmidt (1950s); Schmidt family, by descent; Richard C. Edgeworth,
Chicago, Ill.; Owen Gallery, New York, N.Y.

To capture the mystery and drama of the story of Christ's miraculous calming of the waters, Henry Ossawa Tanner created a small but powerful image.[1] At center, a fishing boat plows diagonally through a roiling sea rendered in thick bands of aqua, jade, and slate blue pigment. The craft bends back at a near forty-five-degree angle toward the high horizon, with its straining mast and swelling sail signaling the power of wind and wave. The frightened passengers, braced in the bottom of the boat, struggle against nature with their oars. Ethereal, almost transparent, the figure of Jesus stands before them—arms outstretched in a gesture that prefigures his fate. As the clouds break in the distance, the skies lighten and sunlight streams from the left, leaving a glimmer of warm orange upon the bow of the beleaguered vessel.

By the time Tanner produced *Christ and His Disciples on the Sea of Galilee,* he had built an admirable exhibition record and garnered international acclaim. The Pittsburgh-born artist—a former student of Thomas Eakins in Philadelphia and the Académie Julian in Paris—had exhibited at the French Salon almost every year since 1894. His large biblical scene, *The Resurrection of Lazarus,* was purchased in 1897 for the French national collection, housed in the Musée du Luxembourg, a rare accolade that few Americans could claim. At the time, a writer in the *Quartier Latin* announced that the painting had placed the American "among the envied ranks of the arrived."[2]

For Tanner, an African American, the question of professional arrival was inexorably linked to social and political

acceptance in his homeland. Increasing racial tensions and Jim Crow restrictions in the United States drove the painter abroad. "I cannot fight prejudice and paint," he announced before departing for Europe in 1891. Although he returned to America for extended visits with friends and family, France remained Tanner's primary residence until his death at age seventy-nine.[3]

As is often the case with successful expatriates, Tanner received acclaim in America only after he had gained critical notice overseas. The artist's work was featured in such magazines as *Outlook, Fine Arts Journal,* and *Brush and Pencil.* By the turn of the century, Tanner's paintings found their way back across the Atlantic and into important exhibitions as well as private and public collections—including those of the Philadelphia Museum of Art and the Art Institute of Chicago.[4] In 1909, the year before he created *Christ and His Disciples,* he was elected an associate member of the National Academy of Design alongside fellow nominees Mary Cassatt and George Bellows (see cat. nos. 98, 99, and 113). He was the first African American artist to be so honored.[5]

A survey of Tanner's career reveals his careful consideration and synthesis of the artistic influences of his era. From Thomas Eakins (see cat. no. 67) he reaped the benefits of a rigorous academic training—evident in the naturalism and attention to anatomy exhibited in his well-known canvas *The Banjo Lesson* (1893, Hampton University Museum). His relocation to Europe opened other avenues of expression, including the adaptation of a Whistlerian tonalism in landscapes such as *The Seine* (1902, National Gallery of Art). Summers in the Pont-Aven colony in Brittany gave him proximity to the Nabis, a circle of Paul Gauguin's followers whose own brand of postimpressionism explored the symbolic expressiveness of saturated color in order to convey emotion and spirituality.[6]

Between 1908 and 1914 Tanner employed an evocative, modernist style to create a series of paintings—which includes *Christ and His Disciples*—depicting the miracles on the Sea of Galilee. Underlying his modernity was a thorough knowledge of the art that preceded him. A link between this canvas and the emotive *Christ on the Lake of Gennesaret* by Eugène Delacroix (1853, Metropolitan Museum of Art) has been proposed, for example.[7] When Tanner exhibited his *Daniel*

102

in the Lion's Den (1895, location unknown) at the 1900 Paris Universal Exposition, he would have undoubtedly been drawn to Robert Loftin Newman's enigmatic *Christ Stilling the Tempest* (fig. 171), also on view in the fair's American section.[8] But personal history played an equally significant role in his choice of subject. Tanner, who chose religious themes as a leitmotif for his mature career, was well versed in Bible stories. His father, Benjamin Tanner, a bishop in the African Methodist Episcopal Church, encouraged his son to apply his talents toward spiritual subjects. Moreover, both the senior Tanner and his artist son were well aware that biblical narratives could illuminate the struggles and hopes of black Americans.[9]

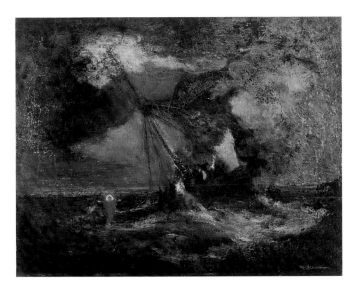

FIG. 171 Robert Loftin Newman (1827–1912), **Christ Stilling the Tempest,** ca. 1880–1900, oil on canvas, 14 x 18 in. (35.5 x 45.7 cm). Virginia Museum of Fine Arts Purchase, The Katherine Rhoads Memorial Fund, 42.8.1.

The artist's preoccupation with religious painting was bolstered by two trips to the Holy Land in the late 1890s. He returned with enduring impressions of Palestine, Jerusalem, the Jordan River—and the Sea of Galilee. In 1912, he wrote: "I have no doubt an inheritance of religious feeling, and for this I am glad, but I have also a decided and I hope an intelligent religious faith not due to inheritance but to my own convictions. I have chosen the character of my art because it conveys my message and tells what I want to tell to my own generation and leave to the future."[10]

More than half a century later, the artist's son, Jesse Ossawa Tanner, described the enduring legacy of that message and the timeless appeal of his father's paintings:

> If you study them you keep discovering new things about them—a new form is revealed, a new star seems to shine, a new shadow stretches out—in a word, his pictures are very much alive. A Tanner can do more than give you enjoyment, it can come to your rescue, it can reaffirm your confidence . . . , it can help you to surmount your difficulties. . . . A picture by Tanner is really a part of the artist himself, a mystic whose visions are deeply personal yet universal in significance.[11]

ELO

NOTES

1. Tanner illustrates Matthew 8:24–26, which reads in the King James Version: "And, behold, there arose a great tempest in the sea, insomuch that the ship was covered with the waves: but [Jesus] was asleep. And his disciples came to him, and awoke him, saying, Lord, save us: we perish. And he saith unto them, Why are ye fearful, O ye of little faith? Then he arose, and rebuked the winds and the sea; and there was a great calm."

2. "Tanner's Salon Painting," *Quartier Latin* 3 (1897): 449, quoted in Lois M. Fink, *American Art at the Nineteenth-Century Paris Salons* (Washington, D.C.: National Museum of American Art, Smithsonian Institution; Cambridge: Cambridge University Press, 1990), 174.

3. Daniel Garrett, "Behind a Veil: Henry Ossawa Tanner's Triumph—and the Price of His Exile," *Art and Antiques* (February 1991): 78. See also William R. Lester, "Henry O. Tanner, Exile for Art's Sake," *Alexander's Magazine* 7 (December 15, 1908): 69–73.

4. The Philadelphia Museum and School of Art bought *The Annunciation* in 1899. The following year, the Pennsylvania Academy of the Fine Arts purchased *Nicodemus Visiting Jesus*. In 1906, the Art Institute of Chicago awarded *Two Disciples at the Tomb* the Harris Prize for "the most impressive and distinguished work of art of the season" and acquired it for the permanent collection.

5. At present the most comprehensive biography and consideration of Tanner's work is Dewey F. Mosby, Darrel Sewell, and Rae Alexander-Minter, *Henry Ossawa Tanner*, exh. cat. (Philadelphia: Philadelphia Museum of Art, 1991).

6. Lynda Roscoe Hartigan, *Sharing Traditions: Five Black Artists in Nineteenth-Century America* (Washington, D.C.: Smithsonian Institution Press, 1985), 110–11.

7. Hartigan, 106; Mosby et al., 218.

8. Diane P. Fischer, ed., *Paris 1900: The "American School" at the Universal Exposition*, exh. cat. (New Brunswick: Rutgers University Press in association with Montclair Art Museum, 1999), 28–30; Marcia M. Mathews, *Henry Ossawa Tanner* (Chicago and London: University of Chicago Press, 1994), 101–2.

9. Mosby et al., 24–28.

10. Henry O. Tanner, "An Artist's Autobiography," *The Advance* (March, 20, 1913): 2012, quoted in Dewey F. Mosby, *Across Continents and Cultures: The Art and Life of Henry Ossawa Tanner*, exh. cat. (Kansas City, Mo.: Nelson-Atkins Museum of Art, 1995), 44.

11. Jesse Ossawa Tanner, 1969, Introduction in Mathews, xii–xiii.

103. Childe Hassam (1859–1935)

Isles of Shoals (Girl and the Sea, Isles of Shoals), 1912

Oil on canvas

22 x 18 in. (55.9 x 45.7 cm)

Signed and dated right edge center: "Childe Hassam / 19[12]"

Signed and dated on back of canvas: "CH / 1912"

Museum Purchase, The Adolph D. and Wilkins C. Williams Fund, 70.17

PROVENANCE: Mr. and Mrs. Henry Lipfield, Whitestone, N.Y.; Wiener Gallery, New York, N.Y.; Auslew Gallery, Norfolk, Va.

Fluid and vibrant, Childe Hassam's *Isles of Shoals* exudes an aura of spontaneity in both subject and style. Painted by one of America's foremost impressionists at the turn of the twentieth century, the canvas depicts a seated nude who suns herself at the edge of an oceanfront gorge. Pictured from the back, the woman seems transfixed as she stares out at the shimmering sea. The curves of her diminutive form are echoed by the narrow, hourglass-shaped cove that opens before her. In a sharply tilted setting that obscures distance and conceals the horizon, she is visually enveloped by the water, laid down in countless horizontal brushstrokes of azure, turquoise, and gray violet that shift to near black beneath the sharply rising cliffs on either side. The same flesh-tone hues that articulate the contours of the bather reappear as patches of glinting sunlight along the edges of the jagged precipices.

The oil is one of a series of coastal views that Hassam completed in 1912 during his regular summer visit to the Isles of Shoals, a cluster of rocky islands ten miles off the New Hampshire coast. For thirty years the painter sojourned to the islands' small resort community of Appledore in search of inspiration and rejuvenation from the ongoing pressures of the art market. He first came to the Shoals about 1886, attracted not only by the promise of fresh air and scenic views, but by the invigorating company of Celia Laighton Thaxter. Poet, writer, gardener, and proprietress of her family-owned inn, Appledore House, this vivacious woman—many years Hassam's senior—presided over an exclusive salon that attracted literary, musical, and artistic personalities of the day. Having formed a deep friendship with the painter and his wife, she welcomed their almost-annual visits and recruited Hassam to illustrate

An Island Garden, her book of practical gardening advice. Just after its publication in 1894, Thaxter died peacefully but unexpectedly—a loss that drove Hassam away from the Shoals for several years.

Upon resuming his visits, he shifted the focus of his imagery. Whereas his earlier watercolors, pastels, and oils had captured the floral splendor of Thaxter's cottage and gardens—with an occasional glimpse of his hostess—Hassam turned an eye to the natural features of the islands.[1] He seemed especially fascinated by the elemental boundaries of water, air, and earth, typically captured in brilliant sunshine but sometimes rendered at night (fig. 172).[2] "The rocks and the sea are the few things that do not change," Hassam wrote from Appledore in 1911, "and they are wonderfully beautiful—more so than ever!"[3]

Beauty was an ongoing quest in Hassam's artistic endeavors. Raised in the suburbs of Boston by art-loving parents, he began his career as an illustrator but made the transition to painting through watercolor. Encouraged by a successful exhibition of tonal, Barbizon-inspired city scenes, Hassam relocated to Paris, where he studied at the Académie Julian for nearly two years. By the time he returned to the United States in late 1889, he had mastered oil painting—his canvases had been accepted at the Paris Salon and the Paris Universal Exposition—and he had developed a new approach to painting that revealed an unmistakable exposure to French impressionism.

FIG. 172 Childe Hassam (1859–1935), **Moonlight,** 1907, oil on canvas, 25 ¾ x 36 ¼ in. (65.4 x 92.1 cm). Collection of James W. and Frances G. McGlothlin, Promised Gift to Virginia Museum of Fine Arts.

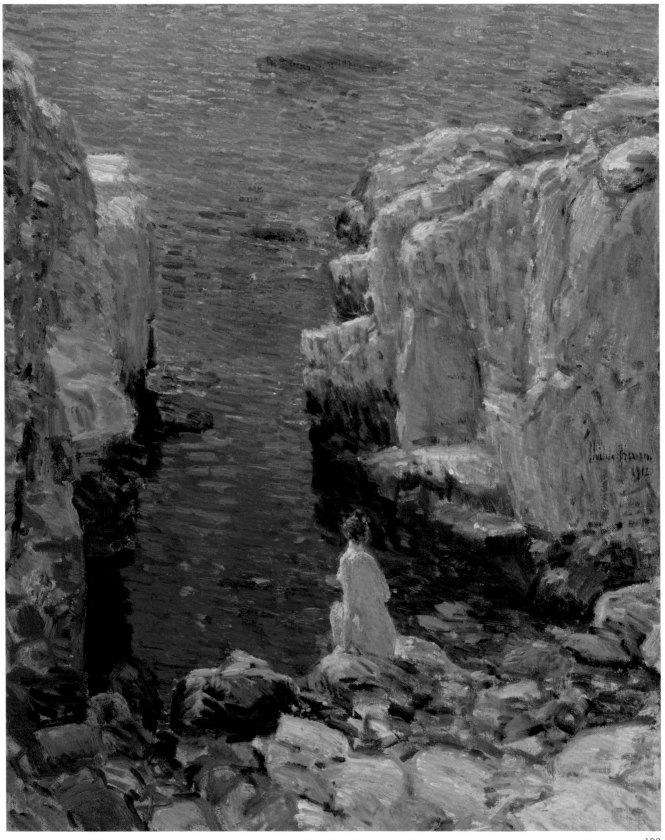

103

While he did not gain acquaintance with or instruction from Claude Monet or other participants in the movement—as did Mary Cassatt, John Singer Sargent, Frederic Frieseke, and fellow Bostonian John Leslie Breck, among others (see cat. nos. 98, 99, 84, 91, 104, and 100)—Hassam did have the opportunity to study their paintings. Setting up residency in New York, where he would maintain a studio for the remainder of his life, he debuted a hybrid style that wed academic compositional solidity with an "impressionized" bright palette and broken brushwork.[4]

Like the progressive French artists, Hassam favored scenes of modern life; cityscapes were a mainstay of his oeuvre. However, his paintings rarely give evidence of the period's rapid industrialization or the cities' teeming working-class populations with growing segments of poor immigrants. Instead, the painter preferred to depict affluent members of society, largely Anglo-American, engaged in genteel activities (fig. 173).

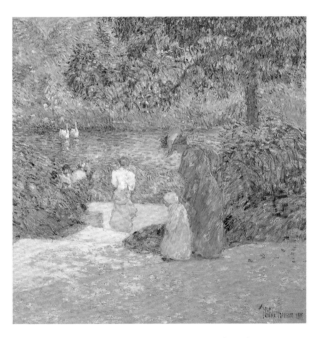

FIG. 173 Childe Hassam (1859–1935), **Descending the Steps, Central Park,** 1895, oil on canvas, 22 ⅜ x 22 ¼ in. (57 x 56.5 cm). Virginia Museum of Fine Arts, Gift of the Estate of Hildegarde G. van Roijen, 93.112.

Like his French counterparts, Hassam had an interest in sketching and painting *en plein air* (outdoors), though he did not share their concern with the scientific effects of light nor their compulsion to finish a painting in one session. Hassam

frequently completed his compositions in the studio. Indeed, *Isles of Shoals* may be less spontaneous than its seemingly rapid strokes suggest. Hassam could have produced it in indoors, referring to his many watercolor studies to craft its artful composition and relying on his imagination for its lyrical but anatomically awkward nude.[5]

Even as Hassam steadfastly disavowed any French influence on his painting—he grew increasingly nativist over time—his national reputation and fortunes skyrocketed as the impressionist style gained favor in the United States. The artist exhibited an impressive number of landscapes, figure studies, and still lifes at world's fairs and in shows sponsored by the several academies and societies to which he belonged. In 1898, Hassam and a small circle of painters who worked in both tonalist and impressionist modes organized the Ten American Painters—an exclusive group that mounted shows without the constraint of a jury. By the time they held their last exhibition in 1919, their once-progressive styles seemed antiquated. Six years earlier Hassam had been one of the oldest exhibitors at the *International Exhibition of Modern Art*—otherwise known as the Armory Show—where he ridiculed entries submitted by the European avant-garde. He was destined to spend the final two decades of his life railing against the successive waves of modernism that crashed on the shores of America in its wake.[6] ELO

NOTES

1. Thaxter, having befriended Hassam in Boston in 1883, encouraged him to drop the use of his first name, Frederick, in favor of his more distinctive and marketable middle name, Childe. Susan G. Larkin, "Hassam in New England, 1889–1918," in *Childe Hassam, American Impressionist* (New York: Metropolitan Museum of Art; New Haven: Yale University Press, 2004), 121. For a consideration of Hassam's experiences and work on the Isles of Shoals, see David Park Curry, *Childe Hassam: An Island Garden Revisited,* exh. cat. (New York and London: W. W. Norton in association with Denver Art Museum, 1990).

2. Hassam greatly admired the Aesthetic paintings and theories of James McNeill Whistler (see cat. no. 78), an influence clearly evident in *Moonlight,* a rather Whistlerian nocturne. Curry, 164.

3. Hassam to J. Alden Weir, July 20, 1911, Hassam Papers, American Academy and Institute of Arts and Letters, New York (microfilm, Archives of American Art, reel NAA-1, frame 66).

4. H. Barbara Weinberg, "Hassam in Paris, 1886–1889," in *Childe Hassam, American Impressionist,* 56–60. Elsewhere, Weinberg comments: "In painting both figures and landscapes the Americans often appear to be 'impressionizers,' rather than 'Impressionists,' applying chromatic veneers of broken strokes to solid forms that depend on preliminary studies and some studio retouching." H. Barbara Weinberg, "'When to-day we look for 'American art' we find it mainly in Paris,'" in *America, The New World in 19th-Century Painting,* ed. Stephan Koja (Munich, London, and New York: Prestel, 1999), 225.

5. A selection of Hassam's 1912 watercolor studies of various coves and gorges in the Shoals are pictured in Curry, 139, 154, 184, 187–88.

6. H. Barbara Weinberg, Introduction in *Childe Hassam, American Impressionist*, 16–19. See also *Ten American Painters*, exh. cat. (New York: Spanierman Gallery, 1990), 102–7.

104. Frederick Carl Frieseke (1874–1939)

Blue Interior: Giverny (The Red Ribbon),

ca. 1912–13

Oil on canvas

32 x 32 in. (81.3 x 81.3 cm)

Signed and inscribed lower left: "To my friends / the Whitmans / F. C. Frieseke"

Museum Purchase, The J. Harwood and Louise B. Cochrane Fund for American Art, 99.44

PROVENANCE: Family of Mrs. George Whitman, by descent; Hollis Taggart Galleries, New York, N.Y.

Frederick Carl Frieseke's *Blue Interior: Giverny* shows a statuesque and comely young model standing before a mirror adjusting a red ribbon in her hair. The expatriate painter's silvery palette captures a feminine interior scene with complex overtones that reach both forward and backward in the history of art. While domestic scenes were common in Western art, Frieseke, like most American impressionists, overlaid a clear volumetric understructure—the legacy of his academic training—with shimmering surfaces born of modern ideas and techniques.[1] The result underscores the artist's stated intent to "make a mirror of the canvas."[2]

First admired by Europeans, Frieseke's canvases were eagerly sought by American collectors and museums following his first single-artist exhibition at a New York gallery in 1912 and his grand-prizewinning display at the Panama-Pacific International Exposition in San Francisco in 1915, which helped to confirm American impressionism as a preeminent style in American collecting circles. In 1932, a journalist for *Art Digest* suggested that Frieseke was "America's best known contemporary painter."[3] Yet, prevailing winds of abstraction were already sweeping domesticated Aestheticism aside, and Frieseke's work and reputation were soon to be obscured by nonrealist trends until the last quarter of the twentieth century.

In *Blue Interior*, a cool luminosity tempers the vibrant surface that Frieseke created by juxtaposing divergent patterns. Passages of the painting reveal a "dry brush" technique, in which a clean brush is lightly dragged over a painted canvas causing areas of light ground to show through. In a rare instance of preservation, the chalky, pastel-like appearance of the original painting remains untouched by the heavy varnish applied in later periods.

Frieseke's use of a square format adds a modernist element to the picture.[4] But it also presented the painter with compositional challenges. He responded by angling the space, placing the subject just off center, and animating the figure with a subtle bodily twist. "I avoid being conventional as much as possible, for picture-making is conventional," the artist commented.[5] The highly decorative nature of Frieseke's work often distracts the viewer from another aspect of his painting: the quiet eroticism inherent in many of his subjects.

Blue Interior was painted in Giverny, the French hamlet made famous by that country's leading impressionist, Claude Monet. Frieseke, who visited Giverny at the turn of the century, moved into the house next door to Monet's in 1906. Although he continued to maintain an apartment in Paris, he was attracted by Giverny's beautiful gardens and its regular influx of visiting artists. The town remained his principal residence until 1919.[6] Executed at the height of Frieseke's career—probably shortly after the New York show—the painting was given to local friends and remained hidden from public view until the 1990s, when it was brought to market by the owners' descendants.[7]

Frieseke's light-filled palette and assertive brushwork immediately call to mind Monet's impact on the large group of American expatriate painters that flocked to Europe in the early twentieth century. The elegant composition and subtle color harmonies work to fuse the figure with her flatly modeled surroundings. The combination attests to Frieseke's interest in the Aestheticism of James Abbott McNeill Whistler (see cat. no. 78), with whom he associated when he first arrived in Paris in 1898. Certainly, the picture should be seen in part as homage to Whistler's *Little White Girl* (1864, Tate Gallery). The painting was owned by Arthur Studd and kept at a villa in le Pouldu, a small town where Frieseke visited in 1901.

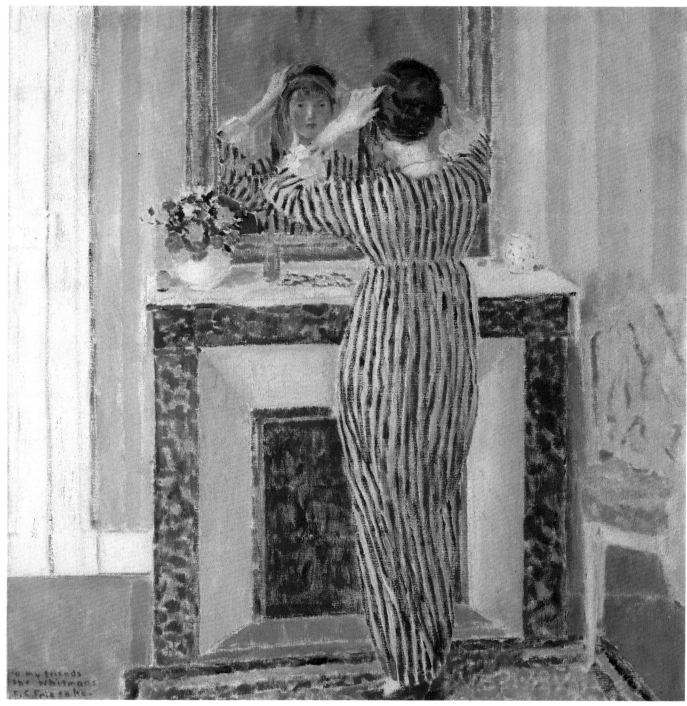

At the same time, Frieseke's abstract geometric patterning and flattened forms resonate with the influence of the French Nabi painters, including Edouard Vuillard and Pierre Bonnard, the latter of whom was painting near Giverny. Like the Nabi painters, Frieseke was concerned with patterns—in furniture, clothing and accessories, fabrics, wall coverings, flowers, even light and shade—and the way they play off one another.[8]

In 1914, would-be visitors to Frieseke's Giverny house were treated to an armchair tour via the *New York Times:*

> The walls of the Frieseke living room are tinted a lemon-yellow; the doors opening into the garden an emerald green. The furniture is covered with flowered cretonne and the window curtains are made of the same material. The kitchen is painted a deep, rich blue, forming a wonderful background for the highly-polished copper pots and kettles. It was easy to infer that all this scheme of color and decoration was intended as a setting for future pictures.[9]

Other houses—including those of Monet and numerous American expatriate painters—relied upon similar interior color schemes, making the exact site of *Blue Interior* uncertain. Still, it may well have been set in Frieseke's own home, for the picture relates closely to *The Yellow Room* (ca. 1910, Museum of Fine Arts, Boston), which matches the description in the *New York Times.* Both paintings measure thirty-two inches square and exhibit a similar dry, broken surface.

In *Blue Interior,* Frieseke achieved his twin goals for painting: using formal compositions to explore abstract issues of design, color harmony, and luminosity; and maintaining a focus on intimate, essentially domestic moments. Like many artists of his day, Frieseke was occupied with variations on themes, and several of his canvases unite his practiced color harmonies with differing scales, formats, and details. The striped dress depicted here was among the artist's favorite motifs—it often appears in works of this period. DPC

NOTES

1. Born in Michigan and first trained in Chicago, Frieseke went to Paris in 1898 and studied at the Académie Julian. Among the Old Masters Frieseke admired in the Louvre were Sandro Botticelli, Jean-Antoine Watteau, Jean-Honoré Fragonard, and Nicolas Lancret.

2. Clara T. MacChesney, "Frieseke Tells Some of the Secrets of His Art," *New York Times,* June 7, 1914, 7.

3. See *Art Digest* 6 (March 15, 1932): 12. Frieseke exhibited twenty-six works in Berlin in 1907 and seventeen works at the Venice Biennale of 1909. In 1912, William Macbeth of Macbeth Galleries, New York, the leading American art dealer, hosted his first one-artist exhibition in America. The same year, Frieseke's patron, department store magnate Rodman Wanamaker, gave his painting *La Toilette* to the Metropolitan Museum of Art. By that time, Frieseke was represented in numerous museums in Europe and America. See Macbeth brochure (New York, 1912), Library, Museum of Fine Arts, Boston.

4. William Gerdts, "Square Format and Proto-Modernism in American Painting," *Arts* 50 (June 1976): 70–75.

5. MacChesney, 7.

6. See Arleen Pancza, "Frederick Carl Frieseke (1874–1939)," in *Artists of Michigan from the Nineteenth Century,* exh. cat. (Muskegon, Mich.: Muskegon Museum of Art, 1987), 170. The house was previously occupied by Theodore Robinson, who was among the first generation of American expatriates active in Giverny.

7. Marion Johnston Whitman was part of the American expatriate art colony at Giverny, where she lived in the Buehr house with her brother, William B. Johnston, and his wife. The latticed garden walls, trellises, luxuriant flowerbeds, and circular pond of the Buehr house often appear in paintings by Frieseke. And Frieseke's daughter, Frances, recalled playing on the property as a child during a period of residency when the Friesekes were renovating their own home. Although the painting was given to "the Whitmans," the gift seems to have been made to the Whitman-Johnston family.

8. For a discussion of this link, see William Gerdts, *Monet's Giverny: An Impressionist Colony* (New York: Abbeville Press, 1993), 172.

9. MacChesney, 7.

105. Frederic Remington (1861–1909)

The Pursuit, ca. 1896–98

Oil on canvas

27 1/4 x 40 in. (69.2 x 101.6 cm)

Signed lower right center: "Frederic Remington"

Inscribed below signature lower right: "Copyright 1898 by Harpers Weekly"

Gift of the Estate of Sally D. Eddy, 76.20.1

PROVENANCE: F. W. Von Schrader, San Francisco, Calif.; sold at auction by M. Knoedler and Company, New York, N.Y. (lot no. 14447); Joseph D. Eddy, New York, N.Y.; to daughter Sally Dunlop Eddy, Williamsburg, Va.

"A man on a horse is a vigorous, forceful thing to look at," wrote Frederic Remington in 1898. "It embodies the liveliness of nature in its most attractive form, especially when a gun and saber are attached." The artist published his observations in "The Essentials at Fort Adobe," a *Harper's New Monthly Magazine* article chronicling his visit to a remote Army post in Nebraska. Two years earlier, he had spent several days there

observing and sketching soldiers attached to the 9th U.S. Cavalry, one of the African American regiments known as "Buffalo Soldiers."[1] Among the images resulting from this campaign is *The Pursuit,* which the magazine reproduced as a full-page halftone illustration.

Few artists are as closely associated with the American West as is Remington. In the late nineteenth and early twentieth centuries, his prodigious output of illustrations, paintings, sculptures, and literature helped shape the popular perception of rough-and-tumble frontier life. Like William Ranney (see cat. no. 48), who painted images of outdoorsmen a generation earlier, Remington produced field sketches during regular sojourns to western states and territories and returned to his New York studio to complete his work.[2] For more than twenty-five years, his vivid figures of cowboys, Native Americans, Mexican vaqueros, and cavalry troops—pictured individually or together, sometimes in conflict, and often mounted on powerful horses—fueled the imagination of an enthusiastic eastern audience. Remington's narrative and naturalistic images were widely celebrated as authentic glimpses of the untamed West. Nevertheless, as he constructed or embellished his scenes, he was aware that the way of life he was portraying in images like *The Pursuit* was rapidly disappearing.[3]

Here, Remington presents a cavalcade galloping across the arid plains. The regiment's dark forms stand out against a tawny landscape, vast and barren except for a ridge of buttes on the horizon. In the foreground a robust sergeant, with gun and saber in evidence, maintains a firm seat on a horse that leaves the ground in a full-out charge.[4] The metal edges of the scabbard, ammunition belt, and horseshoes glint in the harsh sunlight. Other members of the command dash forward in a diagonal line.[5]

If *The Pursuit* leaves the object of the chase to the viewer's imagination, the *Harper's* article provides details. Participating in the unit's field maneuvers, Remington joined a handful of soldiers as they pursued comrades posing as the enemy. By that time, the Indian wars were over; "[t]he buffalo, the war-path, all are gone," noted the artist. A decade earlier, while visiting the more sizeable encampments of the 9th and 10th cavalries in the Southwest, Remington had written admiringly of the skills and discipline of the Buffalo Soldiers.[6] His appreciation had not diminished in the late 1890s.

"The crowning peculiarity of cavalry is the rapidity of its movement," he explained, and the 9th maintained its readiness. Still, in describing the reduced peacetime exercises, he pondered, "what is one man beside two troops . . . with horses snorting and sending the dry landscape in a dusty pall for a quarter of a mile in the rear? . . . [B]ut stop and think, what if we could magnify that?" On canvas, the painter played out his fantasy, transforming the small unit into countless riders whose distant flank vanishes behind a cloud of dust.[7]

Remington made his first western trip in 1881 following a brief stint studying art at Yale University. After selling drawings to *Harper's* a few years later, he quickly rose to become the leading illustrator of western scenes for the magazine as well as for other publications.[8] In addition to his own books and articles, he also illustrated the writings of Owen Wister, celebrated as the first western novelist, and Theodore Roosevelt, who published his youthful adventures as a Dakota cattle rancher just as he embarked on a highly successful political career. The three easterners, lifelong friends, encouraged and inspired each other. Their collective vision of the self-reliant, hard-riding westerner helped develop the era's potent Wild West mythology and bolstered an individualistic, vital, and decidedly masculine American identity that resonated well into the twentieth century.[9]

Beyond his achievements as an illustrator, Remington also gained recognition as a painter, exhibiting canvases regularly at the National Academy of Design and at world's fairs in Paris, Chicago, and Saint Louis.[10] In late 1894 he turned to a new medium—sculpture. Excited by this foray into three dimensions, he predicted in a letter to Wister: "My oils will all get old mastery—that is, they will look like *s[t]ale molasses* in time—my watercolors will fade—but I am to endure in bronze."[11] Indeed, the artist is best known today for his iconic statuettes of mounted cowboys, familiar to many as Oval Office fixtures for presidents ranging from Harry Truman to Barack Obama. Like his graphics and paintings, Remington's sculptures depict skilled horsemen commanding energetic steeds. But he heightened the naturalism by adding such fine details as reins, stirrups, and canteens—cast separately and pinned to the sculpture.

Of his twenty-one separate bronze images, *The Outlaw* (fig. 174) is among the most daring. Cast in 1906, it exploits

105

the tensile strength of the medium by depicting a horse that bucks so violently that it seems to have leapt into the air. Its confident rider leans far back in the saddle, shifting his weight vertically over his mount's forelegs as they plummet back to earth—in truth already grounded through a convenient patch of sagebrush. For a Christmas card (fig. 175), Remington rendered a sketch of himself presenting a similarly bold model to foundry owner Riccardo Bertelli. "Can you cast him [?]" the artist asked. Bertelli, who operated the New York–based Roman Bronze Works, responded: "Do you think I am one of the Wright brothers?" In the half century since Clark Mills's equestrian *Andrew Jackson* had literally broken ground (see cat. no. 55), such a dynamic composition was made possible by new technological innovations—particularly the revival and improvement of the ancient lost-wax casting method, brought from Europe to America by Bertelli.[12]

In 1909 at the height of a prolific and financially successful career, Remington died suddenly at age forty-eight from a burst appendix. Two years earlier, President Theodore Roosevelt had written an appreciation of his friend's art: "The soldier, the cow-boy and rancher, the Indian, the horses and battles of the plains, will live in Remington's pictures and bronzes, I verily believe, for all time."[13] ELO

FIG. 174 Frederic Remington (1861–1909), **The Outlaw,** 1906, bronze, 23 ¼ x 15 ¼ x 9 in. (59.1 x 38.7 x 22.9 cm). Roman Bronze Works, cast no. 7(A). Virginia Museum of Fine Arts, Gift of Kenneth Ellis, 76.33.7.

NOTES

1. Frederic Remington, "The Essentials at Fort Adobe," *Harper's New Monthly Magazine* (April 1898): 727–35; quote, 731. "Fort Adobe" is Remington's pseudonym for Fort Robinson, which he visited on the exposed plains of northwest Nebraska. The C, F, and K Troops of the 9th Cavalry occupied the post's adobe barracks. Terry L. Steinacher and Gayle F. Carlson, *1887 Adobe Barracks, Fort Robinson, Nebraska* (Lincoln: Nebraska State Historical Society, 2002). For more about the era's African American regiments, see William H. Leckie and Shirley A. Leckie, *The Buffalo Soldiers: A Narrative of the Black Cavalry in the West,* rev. ed. (Norman: University of Oklahoma Press, 2007). In addition to the *The Pursuit,* the 1976 Eddy bequest to VMFA also included three of Remington's sketches on paper; two bronzes—*Bronco Buster* (cast #233) and *The Rattlesnake* (cast #78); and six books written and illustrated by the artist.

2. Remington, a native of upstate New York, resided most of his life at his estate, Endion, in New Rochelle, New York, where he maintained a studio filled with western artifacts, weapons, and costumes. David McCullough, "Remington, the Man," in Michael Edward Shapiro and Peter H. Hassrick et al., *Frederic Remington: The Masterworks,* exh. cat. (New York: Abrams in association with the Saint Louis Art Museum, 1988), 26; Chronology in Hassrick and Melissa J. Webster, *Frederick Remington: A Catalogue Raisonné of Paintings, Watercolors and Drawings* (Cody, Wyo.: Buffalo Bill Historical Center; Seattle, Wash. and London: University of Washington Press, 1996), 2:861–64.

3. In 1890 the government's long war against Native Americans came to an end at Wounded Knee, South Dakota. Within months, Remington visited the site to re-create scenes of the massacre for the January 24, 1891, issue of *Harper's.*

FIG. 175 Frederic Remington (1861–1909), **Sketch for a Christmas Card** sent to Riccardo Bertelli, ca. 1906, pen and ink. The R. W. Norton Art Gallery, Shreveport, Louisiana.

Also during these years, the Federal Census Bureau documented the rapid population growth in the West and announced that a discernible frontier no longer existed in the continental United States—a phenomenon that figured largely in Frederick Jackson Turner's now-famous paper delivered at the 1893 World's Columbian Exposition in Chicago. Howard R. Lama, "An Overview of Westward Expansion," in The West as America: Reinterpreting Images of the Frontier, 1820–1920, ed. William H. Truettner (Washington, D.C., and London: Smithsonian Institution Press for the National Museum of American Art, 1991), 18–22.

4. The naturalism reveals Remington's study of stop-action images by photographers such as Eadweard Muybridge. Peter H. Hassrick, "Remington, the Painter," in Frederic Remington: The Masterworks, 96–108.

5. Remington was especially fond of portraying the U.S. Cavalry, the military branch in which his father served during the Civil War. Alex Nemerov examines the lingering overtones of that war in Frederic Remington and the American Civil War: A Ghost Story, exh. cat. (Stockbridge, Mass.: Norman Rockwell Museum, 2006).

6. Remington, 727. Over the past two decades, art historians have noted the artist's racist, xenophobic, and anti-Semitic sentiments. At the same time, Remington scholars Peter Hassrick and James K. Ballinger have pointed out some of his positive comments about and imagery of the Buffalo Soldiers. Hassrick, "Frederic Remington, The Painter: A Historiographical Sketch," in Hassrick and Webster, 1:1, 47, 54–59; James K. Ballinger, Frederic Remington's Southwest, exh. cat. (Phoenix, Ariz.: Phoenix Art Museum, 1992), 7–8, 21–24. See also Frederic Remington, "A Scout with the Buffalo-Soldiers," Century Magazine, April 1889, 899–911.

7. Remington, "Essentials at Fort Adobe," 728, 731. The 9th, which had taken part in dozens of Indian conflicts since the late 1860s, put its battle readiness to the test again in 1898 when it deployed to Cuba during the Spanish-American War. There, Remington's Fort Robinson host, Lt. Col. John M. Hamilton, suffered a fatal wound as he and several of his troops participated in the famed charge at San Juan Hill. B. Byron Price, "Remembering a Soldier," Persimmon Hill (Spring 1995): 61–65. However, no black soldiers appear in Remington's romanticized paintings of the battle. For more on the artist's Cuba experiences, see Hassrick, 106–23.

8. Hassrick, "Remington in the West," Arts in Virginia 17 (Winter 1977): 19–20. For a stylistic and contextual exploration of the artist's work, see Doreen Bolger Burke, "Remington In the Context of His Artistic Generation," in Shapiro and Hassrick et al., 39–67.

9. Lamar, 20. Director John Ford relied heavily on Remington images for his 1939 film Stagecoach. Richard Slotkin, "Visual Narrative and American Myth from Thomas Cole to John Ford," in American Victorians and Virgin Nature, ed. T. J. Jackson Lears (Boston: Isabella Stewart Gardner Museum, 2002), 91–112.

10. Hassrick, "Remington the Painter," in Frederic Remington: The Masterworks, 69–167. For more about the artist's endeavors as a painter, particularly his turn to impressionistic nocturnes, see Nancy K. Anderson et al., Frederick Remington: The Color of Night (Princeton, N.J., and Washington, D.C.: Princeton University Press in association with the National Gallery of Art), 2003.

11. For a thorough consideration of the artist's work in bronze, see Michael Edward Shapiro, Cast and Recast: The Sculpture of Frederic Remington (Washington, D.C.: Smithsonian Institution Press for the National Museum of American Art, 1981). Letter from Remington to Owen Wister, January 1895, reproduced in Shapiro, 40.

12. Shapiro, 26–35, 54.

13. Theodore Roosevelt, "An Appreciation of the Art of Frederic Remington," Pearson's Magazine, October 1904, 394, quoted in Alex Nemerov, "'Doing the "Old America,"' The Image of the American West, 1880–1920," in The West as America, 287.

106. Thomas Moran (1837–1926)

Bridalveil Fall, Yosemite Valley, 1904

Oil on canvas

30¼ x 20 in. (76.8 x 50.8 cm)

Signed lower left: "TMORAN. 1904"

Gift from Mr. and Mrs. Huntington Harris, 65.45.1

PROVENANCE: Hayden and Lina Harris, Chicago, Ill.; by descent to Huntington and Mary Harris, Leesburg, Va.

In his majestic *Bridalveil Fall, Yosemite Valley,* Thomas Moran pictures a boulder-filled gorge in California's Sierra Nevada mountain range where an impressive waterfall thunders down the face of a sheer granite cliff.[1] High above, the waterworn contours of the precipice dip to reveal blue sky—a glimpse bracketed by craggy formations with pinnacles soaring beyond view. The cascade, radiant in late-afternoon sunlight, strikes the valley floor behind a screen of mist. This bright bowl of iridescent, rainbow-tinged vapor dominates the scene.[2] For turn-of-the-century viewers, the image not only provided a faithful rendering of a remote western site, but, with a glowing prospect brimming with near-biblical promise, it offered a triumphant celebration of one of the nation's natural wonders.[3]

Months before completing *Bridalveil Fall* in 1904, the sixty-seven-year-old Moran traveled to sketch the site and other geological features in the famed Yosemite Valley. Heralded at the time as the foremost painter of the American West, the artist had built and sustained a highly successful career with similar journeys and painted scenes. Beginning in the early 1870s, Moran ventured into the wilds of Wyoming, Montana, Colorado, Utah, Arizona, New Mexico, and California to capture the compelling natural elements and vistas still inaccessible to all but the most intrepid explorers. Returning to his studio in the East, he transformed his plein-air sketches into some of the most celebrated and influential landscape paintings of the late nineteenth century.[4]

Born in England and raised in Philadelphia, Moran learned basic art skills as a wood engraver's apprentice and as a studio assistant to his brother Edward, a painter of marine and historical images.[5] By the mid-1850s, young Thomas had established himself as both an engraver and painter of fairly

106

conventional landscapes in the Hudson River school style (see cat. no. 64). Nevertheless, his early paintings reveal the influence of the eminent English landscapist J. M. W. Turner, whose canvases he studied firsthand during an 1862 trip abroad. Suggestions of Turner's expressive coloration and painterly brushwork remained present throughout Moran's oeuvre. In these formative years, the young American also absorbed the writings of English art critic and theorist John Ruskin, whose truth-to-nature aesthetics shaped Moran's meticulous fieldwork.[6]

In the post–Civil War years, Moran grew aware of the public's increasing desire for images of America's western territories, a fascination fueled by the completion of the first transcontinental railroad in 1869. Expansionist rhetoric of Manifest Destiny—the notion of a divinely ordained imperative that the United States take possession of the entire continent—reached new levels of intensity, as did military campaigns to displace native populations. The pace of western settlement and development quickened as public and private expeditions mapped the frontier lands and documented their vast resources.[7] Artists and photographers who accompanied the surveys produced official images. On their return east, they also offered paintings, photographs, prints, and illustrations to an enthusiastic audience.

Making his first western sojourn in 1871, Moran accompanied the United States Geological and Geographical Survey, led by Ferdinand V. Hayden, to Wyoming's Yellowstone region. The following year, Moran's skilled drawings and watercolors, along with Hayden's scientific report and the evocative photographs of William Henry Jackson, helped convince Congress to pass legislation setting aside Yellowstone as the country's first national park. The artist also completed his epic canvas *Grand Canyon of the Yellowstone* in 1872, which the federal government promptly purchased and mounted in the Senate lobby of the U.S. Capitol. Following an 1873 journey to Arizona's Grand Canyon with John Wesley Powell's expedition, Moran produced a second, equally impressive landscape, *Grand Chasm of the Colorado,* which Congress acquired to hang as a pendant to the earlier painting.[8]

Between completion of these significant canvases, Moran made his first sketches of Yosemite Valley landmarks during an 1872 trip to California with his wife, Mary. Several of these studies were transformed into prints and illustrations for magazines and travel books; nevertheless, Moran would not record the site on canvas for years to come. Although a rising star in the depiction of western landscape, he was likely avoiding comparison with painter Albert Bierstadt, already famous for his grand-scale Yosemite views from the 1860s.[9]

In subsequent decades, Moran continued his far-ranging journeys, including sketching trips to Great Britain, Venice, Cuba, and Mexico. He also pictured the more familiar eastern views of New York and New Jersey. However, the artist's fame and fortune remained linked with his western travels, which were regularly funded with commissions from various publishing, printmaking, and railroad companies that marketed his images and his name (by the 1880s, he had assumed the popular moniker Thomas "Yellowstone" Moran). For many of these rugged sojourns he was reunited with photographer William Henry Jackson, with whom he had forged a deep friendship during the Hayden expedition. Their joint travels included an 1881 trek through Colorado's Garden of the Gods, where the two painted and photographed the otherworldly Cathedral Spires (fig. 176).[10]

When Moran returned to Yosemite in 1904, he was a widower traveling with his grown daughter, Ruth. He created

FIG. 176 William Henry Jackson (1843–1942), **Cathedral Spires, Garden of the Gods,** ca. 1879–81, albumen print photograph, 17 ⅛ x 21 in. (43.5 x 53.3 cm). Virginia Museum of Fine Arts, Gift of William Henry Anderson Jr., 2001.26.

Bridalveil Fall following that trip. Moran later painted at least two other versions of the scene, one of which was his last oil, completed in 1924, two years before his death.[11]

In the late nineteenth and early twentieth centuries, younger artists began to explore new aesthetic approaches in their representations of the American West. In 1921, Charles Warren Eaton traveled to one of the country's newest national parks, where he painted *Glacier Park (Montana)* (fig. 177).[12]

FIG. 177 Charles Warren Eaton (1857–1937), **Glacier Park (Montana),** ca. 1921, oil on canvas, 24 1/16 x 19 in. (61.1 x 48.3 cm). Virginia Museum of Fine Arts, Gift of Mr. and Mrs. E. Bryson Powell in memory of Elizabeth Bryson Powell, first president of The Council of the Virginia Museum of Fine Arts (1955–57), 2007.12.

Working on-site, Eaton pictured a serene, evergreen-framed view of a mountain lake situated at the foot of towering peaks. He cast the entire scene in the airy blues and purples of dusk. Influenced by the subtle aesthetic harmonies of James McNeill Whistler and the Barbizon-inflected landscapes of George Inness (see cat. nos. 78 and 68), Eaton and other practitioners of American tonalism turned away from traditional landscape conventions to craft visions that were muted in color and more subjective and introspective in mood.[13]

ELO

NOTES

1. The painting's title—including the singular use of "Fall"—corresponds with the site's historical and still-current name.

2. Moran depicts the 620-foot waterfall as it appears on a still day. Brisk winds often set the cascade at a veil-like angle—hence its name. Examination of contemporary site photographs, including Edith Irvine's *Bridal Veil Falls* (ca. 1900–1920, Harold B. Lee Library, Brigham Young University), reveals Moran's topographical accuracy.

3. Floramae McCarron-Cates, "The Best Possible View: Pictorial Representation in the American West," in Gail S. Davidson et al., *Frederic Church, Winslow Homer, and Thomas Moran: Tourism and the American Landscape* (New York and Boston: Bullfinch Press in association with Cooper-Hewitt, National Design Museum, Smithsonian Institution, 2006), 75. For a discussion of the role of waterfall imagery in shaping American national identity, see Sue Rainey, *Creating Picturesque America: Monument to the Natural and Cultural Landscape* (Nashville: Vanderbilt University Press, 1994), 206–14. The prismatic mist is a natural effect, but landscapists, including Moran, also understood the religious association of rainbows with the biblical covenant between God and the people. Andrew Wilton, "The Sublime in the Old World and the New," in *American Sublime: Landscape Painting in the United States, 1820–1880* (London: Tate Publishing in association with the Tate Britain, 2002), 54–57.

4. Thurman Wilkins and Caroline Lawson Hinkley, *Thomas Moran: Artist of the Mountains,* 2nd rev. ed. (Norman: University of Oklahoma Press, 1998), 112–13, 297. The location of Moran's studio varied over time: Philadelphia; Newark, New Jersey; New York City; East Hampton, Long Island; and Santa Barbara, California. See a detailed chronology in Nancy K. Anderson et al., *Thomas Moran* (Washington, D.C.: National Gallery of Art; New Haven and London: Yale University Press, 1997).

5. Moran was a member of a large extended family of artists that included older brother Edward; younger brothers John, a photographer, and Peter, an animal and landscape painter; as well as nephews Percy and Leon, genre and figure painters respectively. Many of them, like Moran's former student and wife, Mary Nimmo Moran, also distinguished themselves as etchers.

6. Anderson et al., *Thomas Moran,* 22–28; William H. Truettner, "'Scenes of Majesty and Enduring Interest': Thomas Moran Goes West," *Art Bulletin* 58 (June 1976): 251–59.

7. Howard R. Lamar, "An Overview of Westward Expansion" in *The West as America: Reinterpreting Images of the Frontier, 1820–1920,* exh. cat., ed. William H. Truettner (Washington and London: Smithsonian Institution Press for the National Museum of American Art, 1991), 1–26.

8. These paintings, each measuring seven by twelve feet, are presently in the collection of the U.S. Department of the Interior.

9. Amy Scott, *Yosemite: Art of an American Icon* (Berkeley: University of California Press, 2006), 46. Bierstadt, a serious rival, painted his version of the site, *Bridal Veil Falls,* ca. 1871–73 (North Carolina Museum of Art).

10. Mary Panzer, "Great Pictures from the 1871 Expedition: Thomas Moran, William Henry Jackson, and The Grand Canyon of the Yellowstone" in Anne Morand et al., *Splendors of the American West: Thomas Moran's Art of the Grand Canyon and Yellowstone—Paintings, Watercolors, Drawings, and Photographs from the Thomas Gilcrease Institute of American History and Arts* (Birmingham, Ala.: Birmingham Museum of Art, 1990).

11. Thomas Moran, Anne Morand, and Joan Carpenter Toccoli, *Thomas Moran: The Field Sketches, 1856–1923* (Norman: University of Oklahoma Press, 1966), 39–41. Moran painted Bridalveil Fall again following a return trip to Yosemite with Ruth in 1922 (location unknown; owned by Hirschl and Adler, New York, in 1978). Following the artist's death, his daughter presented his final canvas to the National Park Service; it is on view in the Yosemite Museum.

12. This is one of several canvases Eaton painted at Glacier Park in the summer of 1921 on commission from James J. Hill, president of the Great Northern

Railroad. By year's end Eaton's series toured to several New York state galleries as part of the railroad's "See American First" campaign. "Art; The December Exhibitions," *New York Times*, December 25, 1921, S6, 69. See also William Wyckoff and Lary M. Dilsaver, "Promotional Imagery of Glacier National Park," *The Geographical Review* 87 (January 1997): 1–26.

13. McCarron-Cates, 79; Wanda M. Corn, *The Color of Mood: American Tonalism 1880–1910*, exh. cat. (San Francisco: M. H. de Young Memorial Museum and the California Palace of the Legion of Honor, 1972), 1–7; *Charles Warren Eaton (1857–1937): An American Tonalist Rediscovered*, exh. cat. (New York: Spanierman Gallery, 2004).

107. Attributed to Charles Rohlfs (1853–1936), designer
Attributed to Charles Rohlfs Workshop (active 1898–1928), manufacturer

Desk, after 1898
Buffalo, New York
White oak; iron; brass
56 x 25 ½ x 23 ¾ in. (142.2 x 64.8 x 60.3 cm)
Gift of Sydney and Frances Lewis, 85.66

PROVENANCE: Jordan-Volpe Gallery, New York, N.Y. (1982); Sydney and Frances Lewis, Richmond, Va.

Constructed of oak, stained dark to evoke age and history, this fall-front desk is a simple, rectilinear form relieved by swells to the side panels and base. Boasting two interior drawers, upper and lower storage areas, and a writing surface, the case incorporates four exterior drawers backed by four shallow shelves (fig. 178). A revolving element in the structure's base permits horizontal rotation while flanking flame-shaped finials add visual lift. This sense of movement is amplified by three pierced details in the cabinet's front panel, which recall the stylized sinuousness of secessionist or Celtic ornament. The whole is supported atop curvilinear feet.

Charles Rohlfs's training began in 1867 when, following the death of his German-born father, he enrolled in night courses at the Cooper Union in New York City.[1] Founded in 1859 by Peter Cooper, the school was premised on the example of London's South Kensington program and invoked the power of art for social improvement.[2] There, Rohlfs excelled in ornamental drawing, which paved the way for his later employment as a pattern maker.[3] This skill likely nourished his fascination with the work of architect Louis Sullivan, whose "distinctively American" Guaranty Building was praised by

the young designer as bearing "more art in one of its panels than in any other building in the city."[4]

Rohlfs's move to Buffalo in 1887 allowed him to study firsthand Sullivan's unique talents. That year, the earliest known date of his documented furniture, Rohlfs took up a position as "inventor, designer and general superintendent" for the Sherman S. Jewett Company, a firm that likened its "art" stoves to sculpture.[5] Three years later, he retired to

FIG. 178 Interior view of cat. no. 107.

travel abroad with his family and visit the sites of Shakespearean England.[6] By that time, the influence of his wife, Anna Katherine Greene, a successful author of detective fiction, appears to have been considerable. After their marriage in 1884, she served alternately as designer and advisor to her husband, who by 1897 was concentrating on the manufacture of "art furniture."[7]

Promoting the Ruskinian idea of the artist in his studio, Rohlfs espoused "workmanship that was a pleasure rather than a toil" and encouraged in "the workingman a desire for artistic labor, that expresses his own individuality . . . [and] keeps alive the artistic sense."[8] In 1898, Rohlfs opened his first workshop and began production on "A Graceful Writing Set," a

two-piece unit that included a compact "Swinging Writing-Desk" and "baronial" chair.[9] A year later, he began signing his works.[10]

While many period designers in various media employed themes of nature to decorative effect, Rohlfs uniquely interpreted his solid oak forms with curved, arced, spiraled, and whipped details as symptomatic of his personal spiritualism.[11] For him, abstract motifs freely applied to rectilinear planes were "embellishment[s]" inspired by "the guiding spirit of the manifestations of nature."[12] Likewise, furniture making, which required the craftsman to engage with nature in an act of creation, was symptomatic of a "great plan" supportive of a "grand purpose"—the transcendentalist's "from Nature up to Nature's God."[13] Bearing the spiritual imprint of their makers, objects were thus deemed by Rohlfs to be mediums of self-improvement and progressive self-realization.[14] Ultimately, Rohlfs concluded, "My aim is to develop myself."[15]

Rohlfs's work drew on both Arts and Crafts and Art Nouveau principles. But his shared views on the relationship between maker and object and the importance of art as a means of improving taste and advancing the human spiritual condition were qualified by a fundamental difference.[16] For Rohlfs, art was not social or communal but individual, and the sensibilities that awakened knowledge in one person would not of necessity rouse self-awareness in others.[17] Hence, truth in art required the artist to create only that which was compelled by his own nature, unimpeded by considerations of popular taste.[18] Rohlfs's metaphysical correlation between the work of the hand and the substance of the spirit reiterates the ideals of John Ruskin, likewise embraced by Louis Sullivan.[19] Ultimately, it is Ruskin's precepts on ornament, virtue, truth, and self-discovery that echo in Rohlfs's work, specifically that "no architecture is so haughty as that which is simple; which refuses to address the eye" and a work of art is a reflection of "the whole spirit" of its maker.[20] While inspiring superficial similarities in designs by Gustav Stickley, the Roycrofters, and others (fig. 179), Rohlfs's oak forms and naturalistic details are better understood as the distinctive by-products of an exceptional introspection filtered through screens of autobiographical resonance—a Germanic upbringing, a love of Shakespeare and medieval England, and a transcendental spiritualism.[21] A folio of "the Rohlfs style" was published at the end of his cabinetmaking career in 1907.[22] SJR

FIG. 179 Gustav Stickley (1858–1942), designer; George H. Jones, manufacturer of inlay; United Crafts (1901–3) or Craftsman Workshops (1903–16), manufacturer, **Fall-Front Desk,** ca. 1903–4, oak, 46 x 42 x 11 ½ in. (116.8 x 106.7 x 29.2 cm). Virginia Museum of Fine Arts, Gift of Sydney and Frances Lewis, 85.70.

NOTES
1. Joseph Cunningham, *The Artistic Furniture of Charles Rohlfs* (New Haven and London: Yale University Press for the American Decorative Art 1900 Foundation, 2008), 22.
2. Sarah Fayen, "Introduction: Everything in My Life Seemed to Point toward This Work," in Cunningham, 2–3, 5.
3. He is listed as a pattern maker in the 1871 Brooklyn city directory. Fayen, 3; Cunningham, 20.
4. Rohlfs also admired the work of George Grant Elmslie, Sullivan's chief designer. Rohlfs, "Address to Arts and Crafts Conference," cited in Cunningham, 95. Cunningham, 84, 95; Fayen, 1–2; Bruce Barnes, Foreword in Cunningham, xii–xiii; Lauren S. Weingarden, "Louis Sullivan and the Spirit of Nature," in Paul Greenhalgh, ed., *Art Nouveau: 1890–1914* (New York: Abrams, 2000), 323–33.
5. Sherman S. Jewett and Company, *Semi-Centennial* (Buffalo, N.Y.: Matthews, Northrup, 1886), 51, cited in Fayen, 8; Cunningham, 19, 24.
6. Cunningham, 48–55.
7. Works included *The Leavenworth Case* (1878) and *A Strange Disappearance* (1879). Diary of Charles Rohlfs, August 1, 1887, Zetterholm Collection, cited in Michael L. James, *Drama in Design: The Life and Craft of Charles Rohlfs* (Buffalo, N.Y.: Burchfield Art Center/Buffalo State College Foundation, 1994), 23; Cunningham, "Anna Katharine Green and Charles Rohlfs: Artistic Collaborators," *The Magazine Antiques* 174 (December 2008): 70–75; Fayen, 8–10.
8. Grace Adele Pierce, "Mr. Charles Rohlfs on the Art Principle in Furniture," *Chataqua Assembly Herald,* July 15, 1902, in James, Appendix C, 96.

107

9. Rohlfs, quoted in Will M. Clemens, "A New Art and a New Artist," in *Puritan*, August 1900, 592, and Charlotte Moffitt, "The Rohlfs Furniture," *House Beautiful*, January 1900, 83, 85, cited in Cunningham, "Anna Katharine Green and Charles Rohlfs," 73n4; Cunningham, *Artistic Furniture*, 65–69, 72–73, 79.

10. Cunningham, *Artistic Furniture*, 70.

11. Ibid., 81, 114–15, 117–18.

12. Rohlfs, "My Adventures in Wood-Carving," *Buffalo Arts Journal*, September 1925, in James, Appendix E, 99.

13. Rohlfs wrote: "the false and the true are almost in exact relation" in the things we create or covet as they are "to the false and true in the individual." He compared the relationship between a craftsman and his object with the Tabernacle designed by God and undertaken by Moses. See Charles Rohlfs, "The True and False in Furniture," address delivered to the Arts and Crafts Conference, Buffalo, April 19, 1900, reprinted in *Buffalo Morning Express*, April 20, 1900, in James, Appendix A, 93–94; Cunningham, *Artistic Furniture*, 105, 109.

14. Rohlfs, "True and False," 93; "The Grain of Wood," *House Beautiful*, February 1901, 147–48, in James, Appendix B, 95. See also Cunningham, *Artistic Furniture*, 109; James, 34–35.

15. Grace Adele Pierce, "Mr. Charles Rohlfs on the Art Principle in Furniture," in James, 96.

16. Ibid.

17. Roger Stein, "The Aesthetic Movement in its American Cultural Context," in Doreen Bolger Burke et al., *In Pursuit of Beauty: Americans and the Aesthetic Movement* (New York: Metropolitan Museum of Art, 1986), 48.

18. Rohlfs, "Address to Arts and Crafts Conference, Chataqua," *Chataqua Assembly Herald*, July 15, 1902, in James, Appendix D, 97; Rohlfs, "My Adventures in Wood-Carving," 99.

19. Weingarden, 325–26; James D. Kornwolf, "American Architecture and the Aesthetic Movement," in Burke et al., 367; Stein, 26.

20. John Ruskin, "Characteristics of Gothic Architecture," in *The Stones of Venice*, vol. 2 (1853); "The Relation of Art to Use," in *Lectures on Art* (1870); and "Art and History," in *The Queen of the Air* (1869), in Chauncey B. Tinker, ed., *Selections from the Works of John Ruskin* (Boston: Houghton Mifflin Company, 1908), 183–85, 197, 258–59, 270–72.

21. See also Stickley's "Bellworth Tabourette," listed as no. 1 in its "New Furniture" catalogue of 1900. "The New Things in Design," *Furniture Journal*, August 25, 1900, cited in Cunningham, *Artistic Furniture*, 42; Fayen, 10–3; James, 13, 17–20; Cunningham, *Artistic Furniture*, 38–42, 83, 123–140.

22. Fayen, 1, 6.

108. Frank Lloyd Wright (1867–1959), designer
Linden Glass Company (1890–1934), manufacturer,

Chicago, Illinois
Matthews Brothers Furniture Company

(1857–1937), woodworkers, Milwaukee, Wisconsin

Tree-of-Life Window, ca. 1904

Stained and leaded glass, zinc, copper, wood

47 5/8 x 32 in. (121 x 81.3 cm) window frame; 41 1/4 x 26 1/4 in. (104.8 x 66.7 cm) glass

Gift of the Sydney and Frances Lewis Foundation, 85.347

PROVENANCE: Darwin D. Martin House, Buffalo, N.Y.; sold at auction by Christie's, New York, N.Y. (May 26, 1983, lot no. 98); Sydney and Frances Lewis

Born in the farming community of Richland Center, Wisconsin, Frank Lloyd Wright lived a rural midwestern childhood before moving with his family to Madison in 1878. In 1885, after two semesters in the University of Wisconsin's engineering program, Wright followed his uncle, radical Unitarian minister Jenkin Lloyd Jones, to Chicago. After a brief tenure with suburban residential architect Joseph Lyman Silsbee, Wright joined the Chicago firm of Dankmar Adler and Louis H. Sullivan as a draftsman.[1] In the wake of the Great Chicago Fire of 1871, the Chicago school partnership best known for its skyscrapers advocated a contemporary urban antihistoricist philosophy based on a credo of "form follows function" and Sullivan's vision of "organic architecture"—a model of simplified masses with naturalistic ornament.[2] Wright imbibed Sullivan's Ruskinian doctrine from 1888 until 1893, when he left to open his own office.[3]

Wright's departure heralded a new kind of organic architecture based on a modified principle of "form and function are one."[4] The revision marked an important intellectual shift from the primacy of exterior form and ornament to that of interior space and light—what Wright described as "an architecture that *develops* from within outward in harmony with the conditions of its being, as distinguished from one that is *applied* from without."[5] The resulting "prairie style," as it was later known, marked the first phase in a domestic architectural movement that informed the six-structure Martin complex from which this "light screen" originated.[6] The commission was part of a larger body of work that Wright undertook for the Martin brothers beginning in 1903.[7]

Darwin Martin, a soap company executive and one of "the American men of business" whom Wright admiringly described as bearing "unspoiled instincts and untainted ideals," was typical of Wright's patrons—largely self-made men who, rather than following the conventions of a conservative elite, preferred functionally comprehensive modernist environments purposefully designed on principles of simplicity and efficiency.[8] Wright's design for the Martin window includes a linear triptych bearing three arrowlike abstractions formed of repetitive chevrons vertically linked with a square base.[9] Although conventionally known as the tree of life, the design resembles both an arrow—a key tool and symbol for the Illiniwek people of the region—and the upwardly

108

FIG. 180 Karl Kappes (1861–1943), decorator; S. A. Weller Pottery Company (active 1872–1948), manufacturer, **Vase,** ca. 1895–1918, Cincinnati, Ohio, glazed ceramic, 11 ½ x 5 ¼ in. dia. (29.2 x 13.3 cm). Virginia Museum of Fine Arts, Gift of William B. O'Neal, 87.131.

angled, golden-flowering stems of Indian grass (*Sorghastrum nutans*) native to the Illinois prairie. The Native American theme—likewise resonant in Karl Kappes's nostalgic "Indian Portrait" vase (fig. 180) produced for the Louwelsa line of Weller Pottery—suited Wright's broad interest in nonderivative nationalist design and his specific affinity for the American Midwest.[10]

Drawing on the sensibility of a childhood spent in the Wisconsin River valley, Sullivan taught Wright to equate the simple, horizontal lines of the prairie with a native and national aesthetic. This emphasis on horizontalism was articulated by British architect Charles F. A. Voysey, a contemporary of Sullivan.[11] Although the term "Prairie School" did not arise until 1935, or enter public parlance until the midcentury publication of the *Prairie School Review,* the style's most salient characteristics—an overall horizontality composed of simple, low, rectilinear spaces; shallow-pitched rooflines; broad eaves; and bands of contiguous casement windows—were introduced in February 1901 when the *Ladies' Home Journal* published " A House in Prairie Town" featuring Wright's work.[12] As

Robert Twombly has observed, the term is somewhat paradoxical, the prairie being but the impressionable venue for an idiom that heralded its proportional destruction.[13] Yet, consciously modern and suburban, the style implicitly confronted the tacit dualities of urban and rural, steel and grass, reflecting the Midwest's acceptance of—rather than resistance to—industrialization and technology; as Janet Ashbee recalled while on tour with her husband, Arts and Crafts architect and designer Charles Robert Ashbee, "when a man is finished with Hell . . . he is sent to Chicago."[14]

In addition to the influences of mentor and place, Wright's vision of "integrated design"—the coordination of structure, environment, and materials into a unified schema governing all aspects of an "architecture [that] is life"—owed homage to both Japanese design and the international Arts and Crafts movement.[15] Aptly represented in his European-inspired windows for the Avery Coonley Playhouse (fig. 181), a progressive home-school serving Coonley's daughter and other neighborhood children, Wright's approach complemented

FIG. 181 Frank Lloyd Wright (1867–1959), designer, **Windows,** 1912, stained and leaded glass, zinc, copper, wood, 30 ½ x 12 ¼ in. (77.5 x 31.1 cm). Virginia Museum of Fine Arts, Gift of Sydney and Frances Lewis, 85.348.1–2.

the *gesamtkunstwerk* (total art work) articulated by Austrian architect Otto Wagner, as well as the holistic and democratic doctrine of Charles Ashbee.[16] Ashbee, who described Wright as "far and away the ablest man in our line of work that I have come across in Chicago, perhaps in America," complained that "a great [British] social movement" had become "a narrow and tiresome little aristocracy working with great skill for the very rich."[17]

The Arts and Crafts movement was, most importantly, a theory of socioeconomic and aesthetic reform that allowed for multiple—and sometimes conflicting—stylistic interpretations.[18] Resonant in Wright's work is the movement's undergirding principles of honesty and simplicity and its goal of making good design accessible to a broader public.[19] That philosophy inspired the 1898 establishment of the Chicago Arts and Crafts Society, of which Wright was a founding member.[20] Yet the essentially industrial context of the urban Midwest also informed key departures from the movement's romantic ideal of the craftsman in his studio, aligning Wright with colleagues from other recently industrialized European centers.[21]

Wright's doctrine signaled his support of what Oscar Lovell Triggs, founder of Chicago's Industrial Art League (established 1899), termed a "new industrialism," which advocated machines as helpmates in the human creative process.[22] Wright favored this progressive approach not only as a time- and cost-saving measure, but because it supported the zeitgeist of contemporary urban life.[23] Consequently, whereas other designers disguised innovative techniques with allusions to medieval craftsmanship, Wright did away with the illusion, outsourcing his light screens to a commercial manufacturer.[24] Moreover, dispensing with more traditional lead and copper cames (dividers), Linden Glass Company, which produced the majority of Wright's windows, employed a newly patented technique in which copper-plated zinc cames were electro-glazed into "grilles" to frame the individual units of iridized glass.[25]

Wright's so-called New School of the Middle West thus embraced key principles that derived from the Arts and Crafts movement—holistic design, natural materials, useful forms— but also departed from them with elements such as standardized "units" conducive to manufacturing.[26] Ultimately, however, his ability to resolve a key tension in Arts and Crafts ideology—the hand versus the machine—depended on a fundamentally modern modification to the movement's prescribed wisdom: in a reversal of Ruskinian doctrine, Wright located the source of human pleasure not in the physical activity of the craftsman's hand, but in the intellectual activity of the designer's mind.[27] SJR

NOTES

1. David A. Hanks, *The Decorative Designs of Frank Lloyd Wright*, exh. cat. (Washington, D.C.: U.S. Government Printing Office, 1977), 1; Richard Guy Wilson, "Prairie School Works in the Department of Architecture at the Art Institute of Chicago," in *The Art Institute of Chicago Museum Studies 21*, vol. 2 *The Prairie School: Design Vision for the Midwest* (1995; 2nd printing, Chicago: Art Institute of Chicago, 1996): 105.

2. Hanks, 3; Thomas E. Tallmadge, "The Chicago School," *Architectural Review* (1908): 4, cited in Rosalind P. Blakesley, *The Arts and Crafts Movement* (New York and London: Phaidon, 2006), 218; Wendy Kaplan, "America: The Quest for Democratic Design," in Kaplan, *The Arts and Crafts Movement in Europe and America: Design for the Modern World*, exh. cat. (London, Thames and Hudson for Los Angeles County Museum of Art, 2004), 259–62.

3. See Charles Rohlfs's *Desk* (cat. no. 107); James D. Kornwolf, "American Architecture and the Aesthetic Movement," in Doreen Bolger Burke et al., *In Pursuit of Beauty: Americans and the Aesthetic Movement* (New York: Metropolitan Museum of Art, 1986), 367, 378.

4. Hanks, 5; Frank Lloyd Wright, *An Organic Architecture: The Architecture of Democracy* (1939; reprinted in facsimile, Cambridge, Mass.: MIT Press, 1970), 4, cited in Blakesley, 218; Kaplan, "America," 262–64.

5. Frank Lloyd Wright, "In the Cause of Architecture: Second Paper," in *Architectural Record 35* (1914), reprinted in Frederick Gutheim, ed., *In the Cause of Architecture, Frank Lloyd Wright* (New York: McGraw-Hill, 1975), 122, cited in Judith Barter, "The Prairie School and Decorative Arts at the Art Institute of Chicago," in *The Prairie School*, 113.

6. Wright, "In the Cause of Architecture," *Architectural Record 23* (March 1908): 155–221, cited in Barter, 113.

7. Between 1903 and 1905, Wright designed the Darwin H. Martin House, the George Barton house for his sister and brother-in-law, a pergola, conservatory, stable-garage, and gardener's cottage. Wright also designed an administrative building in Buffalo and a factory in Chicago for the Larkin Company. See Ada Louise Huxtable, *Frank Lloyd Wright* (New York: Lipper/Viking, 2004), 97; William Allin Storrer, *The Architecture of Frank Lloyd Wright: A Complete Catalogue* (Cambridge: MIT Press, 1978), 93, 114.

8. Martin worked his way up from bookkeeper to executive in the Larkin Soap Company. Blakesley, 9; Leonard K. Eaton, *Two Chicago Architects and Their Clients: Frank Lloyd Wright and Howard Van Doren Shaw* (London and Cambridge, Mass.: MIT Press, 1969), 31, quoted in Blakesley, 222; Robert Twombly, "New Forms, Old Functions: Social Aspects of Prairie School Design," in *The Prairie School*, 88–89.

9. Julie Sloan's typology of Wright's window designs from his pre-Prairie to post-Prairie aesthetic includes ten motifs of which the chevron is one. Sloan, *Light Screens: The Complete Leaded-Glass Windows of Frank Lloyd Wright* (New York: Rizzoli International Publications, 2001), 106–7, 257.

10. The S. A. Weller Pottery Company began producing the Louwelsa line of "art pottery" in 1895, following the purchase of Lonhuda Pottery. The popular use of Native American motifs was inspired by the dissolution of the frontier that came in the wake of westward expansion. See Stephen Harrison, "Artistic Luxury in the Belle Epoque," in Stephen Harrison, Emmanuel Ducamp, and Jeannine Falino, *Artistic Luxury: Fabergé, Tiffany, Lalique* (New Haven and London: Yale University

Press for the Cleveland Museum of Art, 2008), 28–29; Alice Cooney Freling-huysen, *American Art Pottery: Selections from the Charles Hosmer Morse Museum of American Art* (Seattle and London: University of Washington Press for the Orlando Museum of Art, 1995), 18.

11. Charles R. Ashbee compared the Asian-inspired horizontalism of Wright with Greene and Greene (see cat. no. 109) in "Pasadena, Jan.," Journal Entry, 1909, Ashbee Papers (doc. nos. 72–74), cited in Edward R. Bosley, *Greene and Greene* (London: Phaidon, 2000), 140; Charles F. A. Voysey, *Individuality* (London: Chapman and Hall, 1915): 111, quoted in Anne E. Mallek, "The Beauty of a House: Charles Greene, the Morris Movement, and James Culbertson," in Edward R. Bosley and Anne E. Mallek, *A New and Native Beauty: The Art and Craft of Greene and Greene* (London and New York: Merrell Publishers for the Gamble House/University of Southern California, 2008), 26.

12. *Ladies Home Journal*, February 1901, 17, cited in Blakesley, 220; Wilson, 94; Mary Woolever, "Prairie School Works in the Ryerson and Burnham Libraries at the Art Institute of Chicago," in *The Prairie School*, 151.

13. Twombly, 85–87.

14. Felicity Ashbee, *Janet Ashbee: Love, Marriage, and the Arts and Crafts Movement* (Syracuse, N.Y.: Syracuse University Press, 2002), 56, quoted in Blakesley, 217; Blakesley, 105, 130–1; Allan Crawford, "United Kingdom: Origins and First Flowerings," in Kaplan, 22; Kaplan, Introduction and "America," in Kaplan, 12–13, 247.

15. Although Wright did not travel to Japan until 1905, he no doubt visited the Japanese pavilion at Chicago's Columbian Exposition in 1893, and his own collection of Japanese prints included similar stylized designs. Edgar Kaufmann, Jr., *Frank Lloyd Wright at the Metropolitan Museum of Art* (1982; 3rd printing, New York: Metropolitan Museum of Art, 1998), 6; Twombly, 87–88; Cheryl Robertson, "Progressive Chicago: Frank Lloyd Wright and the Prairie School," in *International Arts and Crafts*, ed. Karen Livingstone and Linda Parry, exh. cat. (New York: Abrams for the Victoria and Albert Museum, 2005), 178; Wilson, 93–94.

16. The Coonley school agenda was based on the pragmatic prescriptions of educational reformer, John Dewey. According to Wilson, the window's colorful, geometric abstraction may have been inspired by a parade. Blakesley, 11–13, 29–35, 113, 218–20, 224; Hanks, *Frank Lloyd Wright, Preserving an Architectural Heritage: Decorative Designs from the Domino's Pizza Collection* (New York: E. P. Dutton, 1989), 74–81, cited in Donald C. Pierce, *Art and Enterprise: American Decorative Art, 1825–1917: The Virginia Carroll Crawford Collection* (Atlanta: High Museum of Art, 1999), 382; Kaplan, "America," 248; Kaufmann, 24; Robert McCarter, "The Fabric of Experience: Frank Lloyd Wright's Darwin Martin House," in *Frank Lloyd Wright: Windows of the Darwin D. Martin House*, ed. Jack Quinan (Buffalo, N.Y.: Buffalo State College Foundation, 1999), 21–22; Twombly, 88–89; Wilson, 93–94, 104–5; Kaplan, Introduction, 18.

17. C. R. Ashbee, December 1900, Ashbee Journals, King's College, Cambridge, cited in Robertson, 166; Blakesley, 29–35; Gillian Naylor, *The Arts and Crafts Movement: a Study of Its Sources, Ideals, and Influence on Design Theory* (1971; London: Trefoil Publications, Ltd., 1990), 9, quoted in Blakesley, 51; Robertson, 164.

18. Hampered by three sets of competing dualities—economic needs versus social concerns; handcraft versus machine work; integrated labor versus divided labor—the stylistic movements included the Gothic Revival, British Arts and Crafts, "Old English," American Craftsman, the Romantic Nationalism of developing European countries, and the Secessionists, Reitveld, de Stijl, and Art Nouveau movements. Blakesley, 8–9, 13–16, 22–23, 28, 45–51, 136–205, 209; Crawford, 20–66; Kaplan, Introduction, 11, 17–19; Twombly, 90.

19. T. J. Cobden-Sanderson, "Art and Life," *The Artist* 18 (December 1896): 542–43, cited in Robertson, 166; Kaplan, "America," 258–59; William Morris, "The Art of the People," delivered to the Birmingham Society of Arts and the Birmingham School of Design, February 19, 1879; reprinted in Norman Kelvin, ed., *William Morris on Art and Socialism* (Mineola, N.Y.: Dover, 1999), 32–33; John Ruskin, "Lamp of Memory," *Seven Lamps of Architecture* (1849), cited in Blakesley, 22–3.

20. Blakesley, 211–17; Robertson, 166.

21. Crawford, 22, 27–38; Kaplan, "America," 247–78.

22. Blakesley, 52–75; Kaplan, "America," 273–74, 278; Robertson, 166–67, 181.

23. Blakesley, 223–24; Robertson, 166.

24. Tiffany Studios used copper foil strips that were soldered together to effect a fine line on the edge of the glass, permitting the glass to appear more of a piece. More than two hundred light screens were produced for the Martin complex. See Julie Sloan, "'A Glimmer of Vivid Light': The Stained Glass of Greene and Greene," in Bosley and Mallek, 164–66; Jane Shadel Spillman and Susanne K. Frantz, *Masterpieces of American Glass* (New York: Crown for the Corning Museum of Glass, 1990), 51–53; Julie Sloan with David G. De Long, *Light Screens: The Leaded Glass of Frank Lloyd Wright*, exh. cat. (New York: Exhibitions International in association with Rizzoli International, 2001), 25. Correspondence between Wright and Martin is in the University of Buffalo Archives at Buffalo, New York.

25. Kaufmann, 34; Jack Quinan, "Documentation of the Martin House Art Glass," in Quinan, 31–33; Robertson, 170; Sloan, 339–40.

26. Robertson, 168–70; Wright, "In the Cause of Architecture," 113.

27. Ruskin argued against the separation of the two processes in "Characteristics of Gothic Architecture," vol. 2, *The Stones of Venice*, in Chauncey B. Tinker, ed., *Selections from the Works of John Ruskin* (Cambridge: Cambridge University Press, 1908) 182–83; Barter, 113.

109. Charles Sumner Greene (1868–1957) and Henry Mather Greene (1870–1954), designers
Peter Hall Manufacturing Company

(active ca. 1906–22), manufacturer

Sideboard, ca. 1907–9

Pasadena, California

Mahogany; ebony, copper, pewter, mother-of-pearl

38 1/8 x 95 1/4 x 22 1/4 in. (96.8 x 241.9 x 56.5 cm)

Museum Purchase, Sydney and Frances Lewis Endowment Fund, 93.16

PROVENANCE: Robert R. Blacker House, Pasadena, Calif.; Richard Anderson, Bristol, R.I.; Hirschl and Adler Galleries, New York, N.Y.

This sideboard was intended as an anchor piece in the thirty-five-foot-long dining room of the "ultimate bungalow"[1] designed by brothers Charles and Henry Greene for lumber merchant Robert R. Blacker. It marks the extraordinary convergence of multiple stylistic influences at the hands of visionary architects in partnership with supremely skilled craftsmen.[2] Boasting climate-friendly, Scandinavian-style joinery masked by ebony plugs meticulously rendered 1/64 inch above the structure's surface, this mahogany piece with its butterlike finish reflects the Arts and Crafts emphasis on "handwork."[3] At the same time, its simple rectilinear form and spare

naturalistic ornamentation bespeak an Asian inspiration: graduated waves of low-relief carving enliven the recessed door panels, while silver vines with petals of semiprecious gems detail the door frames and meander along the edge of the upper surface. Together with the side chairs (fig. 182) and wall lights (fig. 183) also from the Blacker House (now in the VMFA collection), the sideboard confirms the description offered by famed British architect-designer Charles Robert Ashbee: "without exception the best and most characteristic furniture I have seen in this country."[4]

Born in Cincinnati, Ohio, on the cusp of the city's important artistic development, the Greene brothers were students of a progressive liberal and mechanical arts program offered by Saint Louis's Manual Training School. They later graduated from the Massachusetts Institute of Technology's two-year architectural certificate program and then apprenticed

in important Boston firms: Henry with Shepley, Rutan, and Coolidge, the successor to architect Henry Hobson Richardson's firm; and Charles with the English-born H. Langford Warren as well as Winslow and Wetherell, among others.[5] Thus primed, they followed their parents to California in 1893, stopping en route to tour Chicago's Columbian Exposition, where they likely observed the aesthetically and structurally unique Bungalow Village exhibited by Malaysia and the Ho-o-den Pavilion of Japan.[6]

Arriving amid a population boom of well-to-do patrons who had fled the harsh winters of the Northeast and Midwest, the Greenes established their company in Pasadena in January 1894.[7] There, the brothers found an architectural tabula rasa upon which to draft a California aesthetic inspired by the visceral impact of a vast and arid landscape and the structural and intellectual remnants of disappearing—and increasingly

109

FIG. 182 Charles Sumner Greene (1868–1957) and Henry Mather Greene (1870–1954), designers; Peter Hall Manufacturing Company (active ca. 1906–22), manufacturer, **One of a Pair of Side Chairs,** ca. 1907–9, mahogany, ebony, copper, pewter, mother-of-pearl, leather; original spring seating, 42 ¼ x 20 x 20 ¼ in. (106.7 x 50.8 x 51.4 cm). Virginia Museum of Fine Arts Purchase, Sydney and Frances Lewis Foundation by exchange, 97.122.1/2.

FIG. 183 Charles Sumner Greene (1868–1957) and Henry Mather Greene (1870–1954), designers; Peter Hall Manufacturing Company (active ca. 1906–22), manufacturer, **One of a Pair of Sconces,** ca. 1907–9, mahogany, ebony, glass, silk, electrical fittings, 19 x 12 x 9 in. (48.3 x 30.5 x 22.9 cm). Virginia Museum of Fine Arts Purchase, Sydney and Frances Lewis Endowment Fund by exchange, 93.17.1/2.

romanticized and reinvented—Native American and Spanish missionary civilizations.[8] For Charles, the missions conjured a potent narrative. Constructed, he wrote, by "old monks" according to their "knowledge of climate and habits of life," they symbolized an "old art of California," where ghostly influence ran "in every line, turns in every arch and hangs like incense in the cathedral light." "Study it," he advised, "and you will find a deeper meaning."[9] In this romanticized "elsewhere," where historical values were ascribed to invented realities and monuments erected to mythical characters, the Greenes were free to develop their singular aesthetic.[10]

Based on a floor plan designed by the architectural firm of Myron Hunt and Elmer Grey, the Robert R. Blacker House was built between 1907 and 1909. The site was Pasadena's

Oak Knoll subdivision, a neighborhood developed from Oak Knoll Park by its adjacent landowner, Henry E. Huntington (see cat. no. 74), and William R. Staats.[11] As the first and most impressive of the Greenes's California-style houses, the Blacker commission came to represent the characteristic patrons—educated, self-made, and progressive—and features—airy and openly circulating floor plans and integrated interior-exterior arrangements—of the firm's bungalow aesthetic.[12]

Robert Roe Blacker and his wife, Nellie Canfield, were midwestern transplants who purchased a five and one-half acre tract in Pasadena in 1905.[13] At the time of their marriage, Nellie's father, John Canfield, was the wealthiest citizen of Manistee, Michigan, with entrepreneurial investments in lumber mills, a tugboat line, real estate, and retail establishments.[14] Robert Blacker, son of a brick manufacturer from Ontario, Canada, was similarly successful, working himself up the socioeconomic ladder through the acquisition of lumber mills, saltworks, banks, and railroads, ultimately becoming Michigan's secretary of state.[15]

The Blackers' patronage of the Greene firm coincided with the beginning of the brothers' expanded architectural

vocabulary. As apprentices, they had been introduced to the Anglo-centric Queen Anne and shingle styles.[16] Langford Warren, Charles's one-time mentor, was a contemporary of the famed English Arts and Crafts architect C. F. A. Voysey, an early practitioner of the half-timbered English style. Voysey also favored the horizontal emphasis characteristic of Greene work: "When the sun sets horizontalism prevails. . . . What, then, is obviously necessary for the effect of repose in our houses, [is] to . . . make our dominating lines horizontal rather than vertical."[17]

Although there is little documentation to suggest the brothers' conscientious study of British Arts and Crafts structures, they were certainly exposed to its principles and designs. Calvin Milton Woodward, founder of the manual-arts training school that the Greenes attended in Saint Louis, studied with William Morris in London."[18] Moreover, Charles made several visits to England following his 1901 marriage to English-born Alice Gordon White, becoming, as he wrote, "in through [sic] sympathy with the Wm Morris movement."[19] This commitment to Arts and Crafts principles is suggested by the emphasis on function and beauty characteristic of the Greenes' furniture designs.[20] It is further evidenced by the interior-exterior relationship of the Blacker complex; like Voysey and Morris, Charles conceived of his architecture as an extension of the landscape, mediating the relationship between man and nature.[21]

The brothers also absorbed the period's influence of Asian art. Styles from Japan and China, in particular, were made familiar by international fairs in London (1862), Chicago (1893), San Francisco (1894), Buffalo (1901), and Saint Louis (1904); made relevant by California's geographic proximity to the East; and made aesthetically accessible through publications like Edward S. Morse's 1886 *Japanese Homes and Their Surroundings* (purchased by Charles in 1903). Such influences undergird the rectilinear shape, rounded corners, and delicate inlay of the Greene sideboard.[22] They also reinforced the integrated interior and interior-to-exterior environments and bold rectilinear framework—including the extended rafter "tails"—of the Greenes' architecture.[23] "The spell of Japan is on him," C. R. Ashbee wrote in 1909, "he feels the beauty."[24]

In fact, while the Greenes' sensitive use of tactile, earthy materials like wood and stone respond to Arts and Crafts concerns with "honest" construction and "truth to materials," the implied globalism of such imported and unusual materials sat at odds with the movement's nationalism. Earlier proponents of Japanese design had tried to reconcile this tension by presenting Asian objects as somehow Gothic in their nature and execution.[25] As German architect and historian Hermann Muthesius explained at the time, "We must see in this mixture of Japanese and Gothic one of the influences that has helped to shape the new art of the interior in England."[26] In the Greenes' work, this tension is diffused by the democratic absorption of multiple stylistic and intellectual influences. As a result, subtle details rendered in diverse materials within exacting teak and mahogany fittings effect New World spaces both complete in themselves and complementary to the whole.[27]

Ultimately, the various sources and philosophies imbibed by the Greenes, before and after their move to California, informed their progression from designers of architectural spaces for furnishings by manufacturers like Gustav Stickley (see fig. 179) to producers of the *gesamtkunstwerk*—total art work—of the Blacker House environment and its furnishings. If VMFA's sideboard resonates with the romantic and "exotic" implications of the "freedom of life" Charles ascribed to California, it also evokes the period's broader dualities of old and new, nationalism and internationalism, conservative and progressive, and the tamed and the natural.[28] SJR

NOTES

1. Term coined by Randell L. Makinson to describe the seven estates designed by the Greenes, 1907–11. See Makinson, *Greene and Greene: Architecture as Fine Art* (Salt Lake City: Peregrine Smith, 1977), 150.

2. John Hall was a skilled cabinetmaker likely responsible for producing and mediating interpretations of Charles's furniture designs. See Edward R. Bosley, *Greene and Greene* (London: Phaidon, 2000), 106.

3. The joinery is atypical among Arts and Crafts adherents for being disguised. It is also unlike other American work in its technique: screws were set into oversized holes that allowed for the wood's natural expansion and contraction; ebony plugs were then set over the screws to hide them from view. Edward S. Cooke, "An International Studio: The Furniture Collaborations of the Greenes and the Halls," in Edward R. Bosley and Anne E. Mallek, eds., *A New and Native Beauty: The Art and Craft of Greene and Greene* (London and New York: Merrell; Pasadena: Merrell in association with the Gamble House, 2008), 115, 124–25; Margaretta M. Lovell, "The Forest, the Copper Mine, and the Sea: The Alchemical and Social Materiality of Greene and Greene," in Bosley and Mallek, 85; Letter from Mrs. J. W. Purchas to William R. Thorsen, 1909, cited in Randell J. Makinson and Thomas A. Heinz, *Greene and Greene: The Blacker House* (Salt Lake City: Gibbs-Smith, 2000), 46.

4. Ashbee Papers, Modern Archive Centre, King's College Library, Cambridge University, doc. nos. 72–74, quoted in Bosley, 140; Mallek, "The Beauty of a House: Charles Greene, the Morris Movement, and James Culbertson," in Bosley and Mallek, 15n3.

5. For more biographical and educational information about the Greenes, see Bosley, 8–21; Virginia Greene Gates and Bruce Smith, "Charles and Henry Greene," in Bosley and Mallek, 42–43.

6. There is no evidence that the Greenes immediately absorbed this influence from the Chicago fair. Bosley, 24–25; Makinson and Heinz, 42.

7. The population of Southern California grew twentyfold between 1870 and 1880. Bruce Smith, "Sunlight and Elsewhere: Finding California in the Work of Greene and Greene," in Bosley and Mallek, 59.

8. For an elaboration on this theme, see ibid., 59–60.

9. Charles Greene, "California Home Making," Pasadena Daily News, January 2, 1905, 26–27, quoted in Smith, 69.

10. An example is Ramona, the illegitimate Scots-Indian orphan character in Helen Hunt Jackson's novel Ramona: A Story (1884). Once she was absorbed into California lore, tourist sites were erected to mark events in her life. In a letter to her sons dated January 29, 1893, Lelia Mather Greene wrote of visiting "the old mission the other day, where 'Ramona' [was] born." Smith, 71–75; Marilynn Johnson, "Art Furniture: Wedding the Beautiful to the Useful," in Doreen Bolger Burke et al., In Pursuit of Beauty: Americans and the Aesthetic Movement (New York: Metropolitan Museum of Art, 1986), 162.

11. Myron Hunt and Elmer Grey were dismissed from the job in 1906 shortly after the interior floor plan was published in Architectural Record (October 1906). A slightly modified plan, relocated by the Greenes to a new site with corresponding terracing, was published in Craftsman in 1907. Working drawings for the Blacker House are dated March 7, 1907, and labeled "Greene and Greene Job No. 209." The project broke ground mid-February 1907 and rough construction was completed mid-December 1907 at an estimated $30,000. Peter Hall was contracted to begin the interiors on April 20, 1908; they were completed on September 9, 2008. Permit No. 6287 estimated interior woodwork at $20,000. The furniture was conceived as part of the larger project and sketched along with the house. According to Greene and Greene records, total costs for the "Main house, furniture, fixtures, and grounds" came in at $70,925.00. Makinson and Heinz, 15, 18–19, 21, 25, 27, 59; Bosley, 101, 106.

12. For more information on the Blacker House restoration, see Makinson and Heinz, ix; Makinson, Greene and Greene: Architecture as a Fine Art/ Furniture and Related Designs (Layton, Utah: Gibbs Smith, 2001), 150.

13. Makinson and Heinz, 13.

14. Ann Scheid, "Independent Women, Widows, and Heiresses: Greene and Greene's Women Clients," in Bosley and Mallek, 186–87.

15. For more information on the history of the Blacker and Canfield families, see Makinson and Heinz, 1–11.

16. Herbert Langford Warren was founder of the Harvard School of Architecture (now the Graduate School of Design) and a cofounder of the Boston Society of Arts and Crafts. Clinker brick is the irregular brick that the Greenes later incorporated into their stonework. Charles also apprenticed with Alfred F. Rosenheim in Saint Louis in 1887–88 and in Boston with Andres, Jaques, and Rantoul as well as Richard Clipston Sturgis. Henry held additional apprenticeships with Chamberlin and Austin, Stickney and Austin, and Edward Raymond Benton. H. Langford Warren, "Recent Domestic Architecture in England," Architectural Review 2 (1904): 5, quoted in Mallek, 16; Gates and Smith, 43; Johnson, 158–59.

17. Charles F. A. Voysey, Individuality (London: Chapman and Hall, 1915), 111, quoted in Mallek, 26.

18. James D. Kornwolf, "American Architecture and the Aesthetic Movement," in Burke et al., 378.

19. He continued, "in fact the whole inside of the house is influenced by it in design." Letter from Charles Sumner Greene to James Culbertson, October 7, 1902, Greene and Greene Archives, the Gamble House, University of Southern California. See Mallek, 20, 32.

20. Alan Crawford, "Charles Greene and Englishness," in Bosley and Mallek, 202.

21. Crawford, 197–200, 209; David C. Streatfield, "Divergent Threads in the Garden Art of Greene and Greene," in Bosley and Mallek, 214, 216; Kornwolf, 350–51.

22. Mallek, 24; Smith, 75–76; Nina Gray, "'The Spell of Japan': Japonism and the Metalwork of Greene and Greene," in Bosley and Mallek, 134; Kornwolf, 347.

23. Los Angeles Times, May 10, 1908, cited in Makinson and Heinz, 41; Letter from Charles Greene to Lucretia R. Garfield, June 5, 1903, cited in Bosley, 66; ibid., 76, 94–95; Smith, 75–79; Kornwolf, 347.

24. Ashbee, "Pasadena, Jan." journal entry, Ashbee Papers, doc. nos. 72–74, cited in Bosley, 140; Robert Judson Clark, ed., The Arts and Crafts Movement in America, 1876–1916, exh. cat. (Princeton: Princeton University Art Museum, 1972), 83, cited in Gray, 133.

25. Early practitioners of the Gothic style who integrated Asian elements into an "Anglo-Japanese" style were E. W. Godwin, Richard Norman Shaw, and W. E. Nesfield. Simon Jervis, "England," in Katherine S. Howe, Alice Cooney Frelinghuysen, and Catherine Hoover Voorsanger, Herter Brothers: Furniture and Interiors for a Gilded Age (New York: Abrams in association with the Museum of Fine Arts, Houston, 1994), 18–19; Lovell, 89; Cooke, 112–13.

26. Adam Gottlieb Hermann Muthesius, Das englische Haus (Berlin: Wasmuth, 1904–5), translation, The English House (London: Crosby Lockwood Staples, 1979), 157, quoted in Mallek, 24.

27. Cooke, 116.

28. Charles S. Greene, "Impressions of Some Bungalows and Gardens," Architect 10 (December 1915): 3, quoted in Smith, 79. Lewis Mumford later described their work as a "native and humane form of modernism" in "The Architecture of the Bay Region," New Yorker (October 1947), quoted in Bosley, "Out of the Woods," 242.

110. William Merritt Chase (1849–1916)

Still Life with Fish, ca. 1910

Oil on canvas

28 ½ x 41 ½ in. (72.4 x 105.4 cm)

Signed lower left: "Wm. M. Chase"

Gift of Mr. and Mrs. John McGuigan and Museum Purchase,
 The J. Harwood and Louise B. Cochrane Fund for American Art,
 2000.84

PROVENANCE: Milch Galleries, New York, N.Y.; William H. Dicks, Chicago, Ill. (until 1920); Detroit Institute of Arts, Detroit, Mich. (1920); sold at auction by Sotheby's, New York, N.Y. (May 22–26, 1993, lot no. 27); Private collection, Tex. (1993–2000)

By the early twentieth century, William Merritt Chase had achieved international recognition as a master of American painting. At the 1915 Panama-Pacific International Exposition in San Francisco, he was one of only ten American artists honored with an entire gallery at the Palace of Fine Arts. Among the thirty-one oils included in the Chase gallery were two large still lifes with fish.[1] An exhibition guide stressed the significance of these pictures: "His still lifes have for years been famous for their fidelity to interpretation of a variety of contrasting things, like fishes [and] copper bowls. . . . He has

110

never been afraid of painting anything . . . with great breadth, fine pictorial feeling, and charm of colour."[2]

Even as various modes of modernist abstraction were gaining ground, Chase returned to a subject that had interested him at the outset of his long career, one that formed part of a tradition reaching back to seventeenth-century Dutch "Golden Age" paintings and works by French artist Jean-Simeon Chardin.[3] Closer to home, paintings by Raphaelle Peale suggested an American tradition of dead fish as subject matter. Always aware of art history, Chase created a series of large-scale, simply composed still lifes of fish, often combined with metal pots and old ceramics. These works were acquired as contemporary art by many public museums and private collectors, commanding the highest sums paid for Chase's work during his lifetime.[4] Chase told a journalist in 1915: "It may be that I am remembered as a painter of fish."[5]

Chase's choice of subject demonstrated his preference for a "commonplace" motif, which he painted "in such a way as to make it distinguished." He also assigned himself a technically challenging subject. Working *au premier coup*—directly in oil on the canvas without benefit of previous sketches—Chase created fish of a briny beauty that rivaled his paintings of elegant women. He once compared iridescent fish scales to sequins on an evening gown, the latter effect well captured in his portrait of Hilda Spong (fig. 184), whose dress shimmers with reflected light. Chase explained: "I enjoy painting fishes: in the infinite variety of these creatures, the subtle and exquisitely colored tones of the flesh, fresh from the water, the way their surfaces reflect the light, I take the greatest pleasure."[6]

In *Still Life with Fish*, the artist's pleasure is evident. The sinuous bodies of various fish are highlighted with touches of frosty white, lustrous black, silvery blue, cool turquoise, and rich coral. A large bucket and a piece of antique ceramic—probably a Chinese *famille rose* plate—complement the curves of the fish. To add further interest to the image, Chase slicked the plate with water, using slight changes in perspective to effect the illusion of refraction.

Around the time Chase was executing his fish still lifes, an important change was taking place in American attitudes toward painting. The aesthetics of previous decades were being overshadowed by the self-conscious, assertively masculine approach to art championed by the American realists—the

FIG. 184 William Merritt Chase (1849–1916), **Hilda Spong,** 1904, oil on canvas, 84⅛ x 39½ in. (213.6 x 100.3 cm). Virginia Museum of Fine Arts, Gift of Ehrich-Newhouse Galleries in memory of Walter L. Ehrich, 36.7.1.

so-called Ashcan school.[7] Chase's ability to segue from the refinement of his impressionist pictures—for which he is best known today—to large, dark, muscular works such as *Still Life with Fish* is a testament to his flexible technique as well as his canny knowledge of both audience and market.

Chase was a versatile stylist, and his facility with the brush made him a painter's painter.[8] But he was also an inspiring teacher. As a 1909 critic for *International Studio* noted: "It really seems incredible that such verisimilitude can be reached with paint on canvas. Yet Mr. Chase dashes in with enthusiastic energy and apparently, *premier coup*, evolves the brilliant pictures of dead fish, pots and brasses in a really masterful manner."[9] These still lifes were recognized not only as "the best of the *nature morte* performances of modern men," but also as highly effective teaching tools.[10]

In the flash and brio of his surfaces, covered with readily apparent brushstrokes, and in the performance aspect of these images, Chase's fish still lifes represent a significant yet accessible aspect of modernity. On both a national and international level, the VMFA picture is a fine exemplar from a key— if now largely forgotten—aesthetic campaign waged by a major American painter, one who also ranks among history's four most influential American teachers of art.[11] DPC

NOTES
1. Chase exhibited no. 3764, *Big Copper Kettle and Fish,* and no. 3767, *Still Life: Fish. Catalogue de Luxe of the Department of Fine Arts Panama-Pacific International Exposition,* ed. John E. D. Trask and J. Nilsen Laurvik (San Francisco: Paul Elder, 1915), 1:221–22.
2. Eugen Neuhaus, *The Galleries of the Exposition; a Critical Review of the Paintings, Statuary and the Graphic Arts in the Palace of Fine Arts at the Panama-Pacific International Exposition* (San Francisco: Paul Elder, 1915), 68.
3. Chase launched his career with *Still Life with Watermelon* (1869, private collection, Birmingham), a "display piece" that showcased his skills and attracted funds for his studies abroad. His first recorded fish painting, *A Fish Market in Venice* (1878–90, Detroit Institute of Arts), was originally a shop-front scene of freshly caught wares. He repainted it as a traditional still life twelve years after it was begun. Roland G. Pisano, *A Leading Spirit in American Art: William Merritt Chase* (Seattle: University of Washington, 1983), 24.
4. Museums holding these pictures include the Art Institute of Chicago, Corcoran Gallery of Art, Metropolitan Museum of Art, Pennsylvania Academy of the Fine Arts, Seattle Art Museum, and Museum of Fine Arts, Boston.
5. W. H. Fox, "Chase on Still Life," *Brooklyn Museum Quarterly* (January 1915): 197–98.
6. Chase quoted in Barbara Dayer Gallati, *William Merritt Chase* (New York: Abrams, 1995), 116.
7. Doreen Bolger, David Park Curry, and H. Barbara Weinberg, *American Impressionism and Realism: The Painting of Modern Life,* exh. cat. (New York: Metropolitan Museum of Art, 1994).
8. For a brief biography, see Carolyn Kinder Carr, "Chase," *Dictionary of Art,* ed. Jane Turner (London: Macmillan, 1996), 6:499–500.
9. Arthur Hoeber, "Winter Exhibition of the National Academy of Design," *International Studio* 36 (February 1909): 137–38.
10. Ibid.
11. The others are: in the eighteenth century, Benjamin West, second president of the Royal Academy; in the nineteenth and early twentieth centuries, Charles Hawthorne with his art colony at Provincetown (similar to Chase's at Shinnecock); and Robert Henri as the leader of the American realists in New York.

111. Robert Henri (1865–1929)

Spanish Girl of Madrid (Una Chula), 1908

Oil on canvas

60 x 40 in. (152.3 x 101.6 cm)

Inscribed on verso of canvas: "E186"

Inscribed on back of stretcher, bottom center: "Una Chula"

Museum Purchase, The J. Harwood and Louise B. Cochrane Fund for
 American Art, 90.138

PROVENANCE: Estate of the artist; Chapellier Gallery, New York, N.Y.; Mr. and Mrs. Howard Weingrow, New York, N.Y. (1977); Joan Michelman, New York, N.Y.

A dynamic painter, teacher, and art theorist, Robert Henri was one of the pivotal figures in American art at the beginning of the twentieth century.[1] Pushing against the prevailing trends of academicism and impressionism, he turned to the slice-of-life realism associated with earlier French artists such as Gustav Courbet and Edouard Manet. Henri grew impatient with the late nineteenth century's favored genteel subjects composed in decorative styles. With direct, quick strokes and a dark palette, he strove to make paintings that "express the undercurrent, the real life" of contemporary existence, which included gritty urban scenes and images of common, everyday people. These, Henri believed, provided an accessible, vital art better suited for a democratic society.[2] Finding resistance from an art establishment that would dub him and his followers "Apostles of Ugliness" and, much later, the "Ashcan school," he made an enduring mark as the leader of a successful campaign to liberalize exhibition practices in the United States.[3]

Henri produced his *Spanish Girl of Madrid* in 1908 during an extended visit to Spain with his students from the New York School of Art.[4] For the image of *una chula*—a soubriquet denoting one of Madrid's working-class women—he decided to strike a bold note.[5] Henri positioned his attractive model in a confrontational stance. Engaging us with a direct, playful glance and slight smile, she tilts her head in an inquiring manner. Her hands-on-hips gesture suggests that a quick retort may come our way.[6] Henri was interested in capturing not only intimations of personality but also the woman's traditional costume. To add vibrancy to the bright white of her ruffled blouse and deep red of her skirt, he placed the figure

111

against a black background; at intervals, her brunette hair and black, fringed shawl disappear into inky darkness. An entry in Henri's painting journal reveals that the model was a local *modiste* (dressmaker), which may account for a perceptible aura of pride from one whose beautifully fashioned garments are likely of her own making. The artist, however, may have suggested the smattering of accessories—gold medallion, folded fan, and pink scarf—to bring additional sparkle to the composition.[7] The painting's strong contrasts of light and dark, laid down in broad, assured strokes, give evidence of Henri's admiration for earlier figure paintings by the European masters Frans Hals, Diego Velásquez, and Manet.[8]

In 1908, four months before embarking for Spain, Henri and seven other painters known as "The Eight" staged a highly publicized exhibition at Macbeth Galleries in New York City. The previous year, Henri—a respected member and jurist of the National Academy of Design—had withdrawn his paintings from the annual exhibition in an act of protest after the selection committee systematically rejected some of his friends' pictures, deeming them either unfinished or inappropriate. In response, Henri and his colleague John Sloan organized the independent exhibition to bring their work, unjuried, directly to the public. The challenge to the long-entrenched authority of the academy, which played out openly in the New York press, attracted thousands to the two-week show.[9]

In the aggressive push for publicity for the exhibition, Henri was aided by the core group of The Eight—Sloan, William Glackens, Everett Shinn, and George Luks—men he befriended in the 1890s while living and teaching in Philadelphia.[10] These artist-reporters, who produced quick sketches of current events for newspapers, made the transition to painting with Henri's encouragement. They gathered in his studio for weekly art discussions encompassing criticism, theory, and Whitmanesque assertions of nationalism and self-reliance.[11] Henri moved to New York in 1900, and his colleagues soon followed. For the 1908 Macbeth exhibition, the urban realists drew upon their journalist backgrounds to promote their self-described revolt. The effort was joined by Maurice Prendergast, Ernest Lawson, and Arthur B. Davies (see fig. 188), painters unrelated stylistically (they worked in variations of post-impressionism and symbolism) but philosophically aligned through their commitment to artistic freedom.[12]

The Macbeth show marked the only time that The Eight exhibited together as a unit. With diverging outlooks and interests, the artists pursued independent careers as painters, illustrators, and teachers. Of the original circle, John Sloan remained closest to Henri in outlook and approach. The two also shared models on occasion—including Efzenka Stein, a favorite whom Sloan described as "a great girl, so ingenuous, so paintable."[13] His *Stein at Window, Sixth Avenue* (fig. 185) might easily be viewed as a realist response to the refined, highly decorative images that had come to dominate the market, such as Frederick Frieseke's pastel-hued *Blue Interior* (see cat. no. 104). Sloan pictures Stein, a sturdy émigré from Bohemia, against the dark walls of his Greenwich Village studio. Sunlight streaming through the window defines the contours of her profile and sets her orange tunic aglow.[14] Perching on the arm of a well-worn "Morris" chair, she seems oblivious to an assemblage of art objects at her feet—including a bit of blue-and-white china, the clichéd icon of late-nineteenth-century Aestheticism. Instead, Sloan sets her gaze out the oversize window to take in a sector of New York's bustling metropolis. Amid the jumble of buildings, an American flag waves and a commuter train passes on the elevated railway.[15]

FIG. 185 John Sloan (1871–1951), **Stein at Window, Sixth Avenue,** 1918, oil on canvas, 23¼ x 27 in. (59.0 x 68.6 cm). Virginia Museum of Fine Arts Purchase, The Adolph D. and Wilkins C. Williams Fund, 77.97.

FIG. 186 Robert Henri (1865–1929), **Her Sunday Shawl,** 1924, oil on canvas, 24 x 20¼ in. (60.9 x 51.4 cm). Virginia Museum of Fine Arts, Gift of Charles G. Thalhimer in memory of his wife, Rhoda, 2003.125.

FIG. 187 Robert Henri (1865–1929), **Listening Boy,** 1924, oil on canvas, 24 x 20 in. Collection of James W. and Frances G. McGlothlin, Promised Gift to Virginia Museum of Fine Arts.

Bolstered by the triumph of the Macbeth exhibit, Henri and Sloan—with the help of Arthur B. Davies and Walt Kuhn (see cat. no. 123)—set up an even larger unjuried show, the *Exhibition of Independent Artists,* in 1910. Featuring over one hundred artists and attracting enthusiastic crowds, it solidified Henri's place as the key American champion for artistic individualism. But his position at the head of the progressive front was short lived. Three years later, the *International Exhibition of Modern Art*—better known as the Armory Show—introduced some of the more radical strains of avant-garde European modernism to the United States. Stylistic currents such as cubism, fauvism, and futurism opened new avenues of expression for a younger generation of American artists, including Kuhn and Henri's student Stuart Davis (see cat. no. 136). Nevertheless, the realist impulse was not fully eclipsed. Henri remained an active and respected teacher, and his influence proved vital over the next two decades to the art of such painters as George Bellows, Rockwell Kent, and Edward Hopper (see cat. nos. 113 and 124). It also had an impact on the figurative American scene, social realist, and regionalist movements of the 1930s (see cat. no. 125).

Until his death in 1929, Henri continued to travel extensively and, ever the humanist, enjoyed depicting individuals of diverse ages, races, and nationalities. "The people I like to paint are 'my people,'" he noted in 1915, "whoever they may be, wherever they may exist . . . old or young, rich or poor . . . my interest is awakened and my impulse immediately is to tell about them through my own language—drawing and painting in color."[16] Visits to Achill Island, Ireland, in the 1910s and 1920s brought him the opportunity to paint some of his favorite subjects—small children. "Feel the dignity of a child. Do not feel superior to him, for you are not," Henri advised students in his influential book, *The Art Spirit,* published in 1923.[17] The following year, he captured the quick intelligence of a pair of Irish youngsters in *Her Sunday Shawl* and *Listening Boy* (figs. 186 and 187). These late portraits, in which his sitters' bright faces emerge from dark backgrounds, recall the manner in which Henri earlier animated his vivacious *Spanish Girl of Madrid.* ELO

NOTES

1. Robert Henry Cozad assumed the name Robert Henri (pronounced "Hen-rye") as a teenager in 1882 after his gambler father shot a man in Cozad, Nebraska.

The family fled east to establish new lives under various pseudonyms. William Innes Homer, *Robert Henri and His Circle* (New York: Hacker Art Books, 1988), 17.

2. Henri trained at the Pennsylvania Academy of the Fine Arts before studying abroad in Paris at the Académie Julian. Homer, 1–6, 20–39; Robert Henri, *The Art Spirit,* ed. Margery Ryerson (1923; repr., Philadelphia: J. B. Lippincott, 1960), 92.

3. Elizabeth Milroy, *Painters of a New Century: The Eight and American Art,* exh. cat. (Milwaukee, Wis.: Milwaukee Art Museum, 1991), 15–17. The term "Ashcan school" did not appear in print until 1934. Bennard B. Perlman, *The Immoral Eight: American Painting from Eakins to the Armory Show* (New York: Exposition Press, 1962), 202.

4. Like John Singer Sargent, Mary Cassatt, and Thomas Eakins before him, Henri fell in love with Spain during his first visit in 1900. He returned frequently in subsequent decades—often with students—to study art in the Prado Museum and to paint. Homer, 122–25. For an exploration of Spanish influence on nineteenth-century European and American painting, see *Manet/Velázquez: The French Taste for Spanish Painting,* exh. cat. (New York: Metropolitan Museum of Art, 2003) and Nicolai Cikovsky Jr., Introduction in Mary Crawford Volk et al., *John Singer Sargent's El Jaleo,* exh. cat. (Washington, D.C.: National Gallery of Art, 1992), 14–19.

5. The artist inscribed "Una Chula" on the painting's stretcher. At the time, the term generally indicated a female descendant of the *monolos* and *majas* of the earlier period, proud of her *castizo*—meaning Castillian—heritage and notorious for equally snappy clothing and banter. The male counterpart is *un chulo.* I am indebted to Suzanne Freeman, Spanish literature scholar and VMFA head fine arts librarian, for her guidance in interpreting the term in period context.

6. The figure's flirtatious posture prompted John Sloan to describe the image as a "laughing Spanish girl of low dancing type I imagine—a very good thing." Sloan diary entry, October 29, 1908, published in John Sloan, *John Sloan's New York Scene,* ed. Bruce St. John (New York: Harper and Row, 1965), 257.

7. The painting is listed as no. E186 in the artist's Record Book (Henri Estate, LeClair Family Collection) in which Henri described it as: "Una Chula, Modiste. Spanish Girl of Madrid, 1908. Red skirt with white dots showing. Arms akimbo. Blue grey eyes, white waist, black shawl, gold medal. Black hair with brown touch." Also in 1908, Henri produced two head-and-shoulders portraits of the same model: *Spanish Girl—Modiste,* (Record Book, no. E185), private collection, illus. cat. no. 17 in *Robert Henri (1865–1929), Selected Paintings* (New York: Berry-Hill Galleries, 1986), 31; and *Modestilla de Madrid,* (Record Book, no. E188), former collection of Mathilda Goldman, illus. lot no. 30 in "Important American Paintings, Drawings and Sculpture," Christie's, New York, sale, November 29, 2001, 55.

8. Rebecca Zurier, *Picturing the City: Urban Vision and the Ashcan School* (Berkeley: University of California Press, 2006), 107–34.

9. Homer, 126–46.

10. Milroy, 17–18, 46–51. See also Virginia M. Mecklenburg, "Manufacturing Rebellion, The Ashcan Artists and the Press" in Rebecca Zurier, Robert W. Snyder and Virginia M. Mecklenburg, *Metropolitan Lives, The Ashcan Artists and Their New York,* exh. cat. (Washington, D.C.: National Museum of American Art and New York: Norton, 1995), 191–212.

11. Homer, 68–78.

12. Ibid., 126–36.

13. Sloan diary entry, January 18, 1908, in Sloan, 185. Rowland Elzea, *John Sloan's Oil Paintings, A Catalogue Raisonné* (Newark, Del.: University of Delaware Press and London: Associated University Presses, 1991), 65, 71, 228.

14. The painting's bright colors give evidence of the artist's new interest in the high-keyed color system developed by Hardesty Maratta, introduced to Sloan by Henri. See Heather Campbell Coyle and Joyce K. Schiller, *John Sloan's New York,* exh. cat. (Wilmington: Delaware Art Museum; New Haven and London: Yale University Press, 2007), 60–66.

15. The view is of Jefferson Market at Sixth Avenue, where Sloan made occasional late-night forays to the police court to sketch "[p]oor little women, habitual drunkards" awaiting sentencing. Sloan diary entry, May 29, 1909, in Sloan, 313–14. The same view also appears in *Jefferson Market, Sixth Avenue* (Pennsylvania Academy of the Fine Arts). Sloan, whose Socialist leanings fueled his interest in picturing common people, habitually roamed the city in search of subject matter. Zurier, 249–303

16. "My People," *Craftsman* 97 (February 1915): 459, quoted in Homer, 252.

17. Homer, 152–70, 249, 252; Henri, 271; Valerie Ann Leeds, *My People: The Portraits of Robert Henri,* exh. cat. (Orlando, Fla.: Orlando Museum of Art, 1994), 39–42.

112. Manierre Dawson (1887–1969)

The Struggle, 1912

Oil on canvas

58 ¼ x 48 ¼ in. (148 x 122.5 cm)

Signed lower left: "Dawson"

Dated center: "12"

Museum Purchase, The Adolph D. and Wilkins C. Williams Fund, 88.51

PROVENANCE: Estate of the artist; Tilden Foley Gallery, New Orleans, La.

Two geometrically faceted bodies engaged in physical combat slowly emerge from the fractured and compressed space of this canvas. The jagged forms of figure and ground, viscerally highlighted by blood-red splashes in the picture's upper section, accentuate the violent action, only slightly muted by the overall subdued palette of earth tones. Aptly titled, this dynamic, nearly nonobjective painting by the Chicagoan Manierre Dawson crystallizes the struggle of many young American artists to reconcile traditional and revolutionary modes of seeing in the early twentieth century.

Dawson, despite his status as one of this country's earliest pioneers of abstraction, is less known than his New York–based modernist contemporaries—particularly those associated with photographer and tastemaker Alfred Stieglitz. An abbreviated professional career and the art world's regional bias may explain this subsequent neglect, yet Dawson's distinctive contributions were recognized at the time by important avant-garde collectors and fellow artists who featured his paintings in groundbreaking efforts, such as the 1913 Armory Show, America's first large-scale introduction to modernism.

Artistically, Dawson was self-taught, save for a year in high school when he was exposed to the abstract design philosophy

of influential artist and educator Arthur Wesley Dow. After graduation, Dawson trained formally as a civil engineer while continuing to paint on weekends. He completed his studies in 1909 and then worked for five years in the drafting department of Holabird and Roche, Chicago's largest architectural firm. Within a year of his employment, however, he took a five-month leave of absence to tour Europe, presumably to study Old World architecture.[1]

While abroad, Dawson immersed himself in academic and avant-garde painting, lunching with the likes of John Singer Sargent in Italy one day and making his first picture sale to the inimitable Gertrude Stein in France the next. The expatriate Stein was celebrated for her weekly salons, which drew both established and emerging American and European modernists (including Henri Matisse and Pablo Picasso) to her Paris apartment. It was among Stein's collection that Dawson first encountered the work of Paul Cézanne, widely considered the father of modern art. Cézanne exerted a tremendous influence on a generation of American and European artists, Dawson included, largely due to his use of color as structural form.[2]

Dawson's architectural training would have predisposed him to conceptualize visual compositions in three dimensions and, based on a 1908 journal entry, he had already begun his pictorial experiments in pure abstraction before departing for Europe: "This winter I am very hard at work . . . on several arbitrarily constructed paintings of arrayed figures, blocking things out without rhyme or reason other than to make the picture look right." These nonobjective paintings, which Dawson called "equations," likely derived from mathematical aspects of his architectural drafting (as arrangements of line, form, and color) and slightly anticipated the 1910 appearance of more celebrated abstract works by Arthur Dove (see cat. no. 121) in Connecticut and Wassily Kandinsky in Munich.[3]

Dawson's visual sophistication deepened after his return to America in 1910, a year that proved to be a critical turning point for the artist. Stopping in New York en route to Chicago, he made the acquaintance of Arthur B. Davies, a complex and well-connected painter and art-world figure who helped lay the groundwork for modernism in America. Two years earlier Davies had participated in the landmark exhibition of The Eight, a group of urban realists and postimpressionists at New York's Macbeth Galleries (see cat. no. 111). At the time of his meeting with Dawson, Davies served as president of the progressive Association of American Painters and Sculptors, in which capacity he played a key role in planning the Armory Show. Yet Davies's own painting largely resisted both realist and modernist impulses. In mythical and allegorical fantasies, his lithe figures languidly cavort in pastoral settings (fig. 188). The poetic "innocence" of these painted idylls has more in common with the work of nineteenth-century artists like Pierre Puvis de Chavannes and Albert Pinkham Ryder than with modernists like Dawson.[4]

FIG. 188 Arthur B. Davies (1862–1928), **Line of Mountains,** ca. 1913, oil on canvas, 18 x 40⅛ in. (45.7 x 101.9 cm). Virginia Museum of Fine Arts, Gift of a Friend, 44.20.1.

Despite their different approaches to painting, Dawson's contact with Davies (much like that he had established earlier with John Singer Sargent) made an impact. Indeed, Davies's advice to the younger artist to concentrate on figural abstractions led Dawson to produce a series he termed "museum" paintings. Inspired by his European discoveries, and echoing Cézanne's famous wish to make pictures "like those found in the museums," Dawson sought to integrate more tradition-laden Old Master subjects (drawn from antiquity and the Renaissance) with avant-garde compositional strategies. *The Struggle* is one such work. Although its figural group is suggestive of Old Master images like Antonio del Pollaiulo's *Battle of Ten Naked Men* (fig. 189), an influential mid-fifteenth-century engraving Dawson may have seen through reproduction, the actual source is unknown.[5]

Two years after their initial meeting, Davies invited Dawson to submit one of his paintings to the Armory Show, but the younger artist declined, feeling he had nothing appropriate

112

FIG. 189 Antonio del Pollaiuolo (1432–1498), **Battle of Ten Naked Men,** ca. 1465, engraving, 15 ⅛ x 23 ³/₁₆ in. (38.4 x 58.9 cm). The Metropolitan Museum of Art, Purchase, Joseph Pulitzer Bequest, 1917 (17.50.99).

to send. A year later, however, when Davies's colleague Walter Pach was in Chicago for the show's national tour at the Art Institute of Chicago, he visited Dawson and selected for him; *Wharf Under Mountain* (Norton Museum of Art) was installed at the venue a few weeks after the official opening. Dawson recorded in his journal that "it was the only non-objective abstraction in the American room." Returning to the Art Institute again and again, Dawson was exhilarated by the discovery of work that resonated with his own: "These are without question the most exciting days of my life. . . . I am feeling elated. I had thought of myself as an anomaly and had to defend myself, many times, as not crazy. . . . I wish the show could stay longer."[6]

The Armory Show's display of a stylistically diverse group of European and American modernists galvanized Dawson, and he continued to pursue the cubistic idiom he had instinctively adopted after his return from Europe. The experience also turned him into a tentative collector. After failing to convince his wealthy father to lend him funds to purchase a cubist portrait by Picasso, Dawson used his own savings to acquire a less expensive figure painting by Marcel Duchamp, whose iconic *Nude Descending a Staircase* was the exhibition's cause célèbre, as well as a smaller work by Portuguese artist Amadéo de Souza Cardoso.[7]

This heady period of inspiration and exploration encouraged Dawson to leave his architectural drafting job in order to

paint full time. Within a few months he was again displaying his work at the invitation of Davies and Pach—in *The Fourteen* exhibition of American abstract painting sponsored by New York's Montross Gallery that traveled to Detroit, Cincinnati, and Baltimore, and in Milwaukee's *Paintings and Sculptures in "The Modern Spirit,"* an exhibition of European and American modern art from Midwest collections that Dawson helped to organize. The latter occasioned the only lifetime mention of his innovative art in print.[8]

By the end of 1914, the twenty-seven-year-old Dawson had become frustrated by his inability to make a living as a painter, despite having sold a few works to private collectors, including Chicagoan Arthur Jerome Eddy, famous for his Kandinsky holdings. In a surprising turn of events, Dawson purchased a cherry orchard in the small town of Ludington, Michigan (where his parents owned a farm), married, and started a family, ultimately trading his experimental art for farming. Though Dawson painted and sculpted sporadically until the end of his life, his effective disappearance from the art world set the stage for his lapsed legacy. He exhibited his work only three more times before being "rediscovered" by a curator at the Ringling Museum of Art, in Sarasota, Florida, where the engineer-artist-farmer had retired in the early 1960s.[9] SY

NOTES
1. As befitting a "rediscovered" artist, much of the recent Dawson scholarship has been initiated by commercial galleries; for example, see the art historian Henry Adams's essays in *Manierre Dawson: New Revelations,* exh. cat. (Chicago: Hollis Taggart Galleries, 2003) and the more comprehensive *Manierre Dawson: American Pioneer of Abstract Art,* exh. cat. (New York: Hollis Taggart Galleries, 1999). The latter publication includes a transcription of Dawson's revealing journal entries from 1908 to 1940.
2. For Cézanne's influence on American painters in particular, see Gail Stavitsky, ed., *Cézanne and American Modernism,* exh. cat. (New Haven and London: Montclair Art Museum and Baltimore Museum of Art in association with Yale University Press, 2009). Dawson encountered Cézanne's work again at Ambroise Vollard's gallery, where he was struck by the "invariable success of Cézanne's color." Quoted in Adams, "Manierre Dawson, 1887–1969," in *American Pioneer,* 34.
3. See Dawson's December 26, 1908, journal entry transcription in ibid., 160.
4. Dawson secured the introduction to Davies through a Chicago acquaintance. That Davies himself had begun his artistic training in Chicago, and later worked as a draftsman for a civil engineering firm, may have accounted for the special interest he took in Dawson—inviting him to his studio, critiquing his work, and introducing him to other New York artists, including the aging Albert Pinkham Ryder, who, according to Dawson's journal, made the strongest impact. By this time, Ryder had become something of a patron saint to younger antiestablishment artists; Davies would feature ten of his paintings in the 1913 Armory Show. For a

brief overview of Davies's career, see Paul D. Schweizer, "Arthur B. Davies (1862–1928)," in *Avant-Garde Painting and Sculpture in America, 1910–25*, exh. cat. (Wilmington: Delaware Art Museum, 1975), 52–53.

5. For Dawson's fortuitous 1910 exchanges with Sargent, whom he unexpectedly encountered at a pensione in Siena, see Adams, "Manierre Dawson," 31–32. For the possible sources of Dawson's "'museum' paintings," see Mary Matthews Gedo, "Modernizing the Masters: Manierre Dawson's Cubist Transliterations," *Arts Magazine* 55 (April 1981): 135–45. See also Randy J. Ploog, "The First American Abstractionist: Manierre Dawson and His Sources," in *American Pioneer*, 70–71. Other related 1912 works include *Attack, Birth of Venus, Blue Boy, Meeting (The Three Graces)*, and *Venus and Adonis*. Ibid., 158.

6. See Dawson's journal entries for his exhilarating descriptions of his visits to the Armory Show in *American Pioneer*, 172; see also his transcribed correspondence with Pach, ibid., 184.

7. Dawson had initially expressed interest in the most expensive work in the exhibition, a $50,000 landscape by Cézanne; the $324 Picasso he hoped to buy was *Woman with a Mustard Jar* (Gemeentemuseum, the Hague); the Duchamp he ultimately purchased for $162 was *Nu(esquisee)*, now known as *Sad Young Man on a Train*; the price of Cardoso's *Return from the Chase* is unknown. See Adams, "Manierre Dawson," 37–40.

8. Ibid., 42–43.

9. After a long silence, Dawson and Pach reconnected in 1921, leading to Dawson's participation in the 1922 and 1923 annual exhibitions of the Society of Independent Artists in New York. In 1923, the first solo exhibition of Dawson's career was held at the Milwaukee Art Society; see Ploog, 77–79. See also Karl Nickel, Introduction in *Manierre Dawson: Paintings, 1909–1913*, exh. cat. (Sarasota, Fla.: Ringling Museum of Art, 1967), 3–7.

113. George Bellows (1882–1925)

Shipyard Society, 1916

Oil on panel

30 x 38 in. (76.2 x 96.5 cm)

Signed lower right: "Geo Bellows"

Museum Purchase, The Adolph D. and Wilkins C. Williams Fund, 62.34

PROVENANCE: Estate of the artist (1925); Estate of Emma S. Bellows, his wife; H. V. Allison and Company, New York, N.Y. (1959)

A diverse community of laborers and spectators gather in a Maine shipyard, intent on a shared creative undertaking— the construction of a wooden sailing ship. The vessel's immense scale is emphasized by the diminutive figures poised on its arcing ribs and by the stacked white houses on the neighboring hills. Beneath the majestic open hull, lively human interchange occurs in a series of eye-catching incidents. The warmth of the sun and bite of the sea air are palpable. Such is the vivid scene George Bellows renders in *Shipyard Society* with his robust and whimsical realist style.

Originally from Columbus, Ohio, Bellows moved to New York for artistic training. There, he quickly became a friend, protégé, and associate of Robert Henri (see cat. no. 111), the leader of the "independent movement." Although not a formal member of Henri's "Ashcan group" or "The Eight," Bellows was often linked with those artists through his personal association and realist aesthetic. While best known for his forceful depictions of urban life—from street and park scenes to the gritty world of boxing—Bellows, like many of his New York colleagues, spent summers in cooler climes, usually by the sea. Maine was a favorite destination for Henri's group, particularly Bellows, Rockwell Kent, and Edward Hopper (see cat. no. 124). Informal artist colonies on Monhegan Island and in Ogunquit offered these realists fruitful opportunities to paint dramatic marines in slashing strokes of sensuous pigment. Whether figural compositions or pure landscapes, all of these pictures were deeply informed by the art of Winslow Homer, whose iconic Maine seascapes were drawing renewed acclaim for their "virile" Americanness at the turn of the twentieth century.[1]

From his early years in New York, Bellows was attracted to what art historian Franklin Kelly has called the "assertive presence of water." The "waterward" urban views, painted on the upper banks of the Hudson River—for example, *Summer City* (fig. 190)—seem to have led naturally to his affection for

FIG. 190 George Bellows (1882–1925), **Summer City**, 1909, oil on canvas, 38 x 48 in. (96.5 x 121.9 cm). Collection of James W. and Frances G. McGlothlin, Promised Gift to Virginia Museum of Fine Arts.

113

coastal communities that depended on the mighty Atlantic for their livelihood. Whether depicting a city- or townscape, however, the artist was most passionate about painting the modern scene as defined by energetic fellowship, exploring a visual dialogue between different classes of people and their environments, at work and play, in all seasons. For example, the overall composition of *Shipyard Society,* with its careful balance of narrative and natural elements, recalls Bellows's 1913 *Cliff Dwellers* (Los Angeles County Museum of Art), a busy, vertiginous view of Lower East Side life, as well as his concurrent images of upper-class leisure like *A Day in June* (Detroit Institute of Art). Heeding Henri's "art spirit" dictum that found "beauty in everything if it looks beautiful in your eyes," Bellows broadened his subject matter to include a full range of what he termed "real" life. "I am always very amused with people who talk about lack of subjects for painting," he remarked in a 1917 interview. "Wherever you go, they are waiting for you. The men of the docks, the children at the river edge, polo crowds, prizefights, summer evening and romance, village folk, young people, old people, the beautiful, the ugly."[2]

Shipyard Society dates from a summer Bellows spent in Camden, Maine, which was less of a resort community than Ogunquit but more active with harbor life than Monhegan. It is one of five works he painted on the theme of shipbuilding— a new subject for the artist. The "colossal" skeleton of the wooden craft, the first one built in a Camden shipyard in seven years, greeted Bellows on his arrival in June 1916. The outbreak of World War I in Europe a few years earlier had been a boon to Maine shipbuilding, and the industry's physical and social dimensions proved to be an irresistible draw for the artist. According to Bellows biographer Charles H. Morgan, the local newspapers were "full of news of the campaigns in Europe, and the local gossip rippled with rumors of submarines sighted off the coast. George [Bellows] cursed the war and its futility and began to paint diligently." The *Camden Herald* reported in late May 1916 that Robert L. Bean had leased a former shipyard to build six four-masted vessels on contract over a five-year period. The project necessitated a new launching ramp, which was constructed from the old one by three men, a team of horses, and a chain to remove the "huge bed of logs" from the ground—a considerable undertaking that became a mere detail in Bellows's composition.[3]

The influence of Homer is once again apparent in Bellows's work; the former's modest 1871 oil *Shipyard at Gloucester* (Smith College Museum of Art) served as a basis for his subsequent *Harper's Weekly* illustration, *Ship-Building, Gloucester Harbor,* which added a figural presence to the picture's foreground. As it did for Homer, the shipyard subject took on epic proportions in Bellows's eyes. In the rhetoric of World War I patriotism, the self-described "patriot for beauty" observed: "When I paint the great beginning of a ship . . . I feel the reverence the ship-builder has for his handiwork. He is creating something splendid, to master wind and wave, something as fine and powerful as Nature's own forces. . . I am filled with awe, and I am trying to paint as well as he builds, to paint my emotion about him."[4]

Despite Bellows's earnest statement about the builder's noble craft and its impact on the artist's imagination (in a letter to Henri, he compared the series' powerful rhythms to the work of his favorite Old Masters, El Greco and Rembrandt), VMFA's painting is as concerned with the *spectacle* of the construction effort as with the physical work itself. The cast of multigenerational characters—conversing, flirting, scratching—introduces a greater warmth and humor to the scene than if the pictorial emphasis were on the labor alone. It is the scene's invigorating combination of effort and incident that distinguishes *Shipyard Society* from Homer's work, while it links the picture to Bellows's other modern imagery through its focus on community.[5]

Homer's compelling interest in the lives of seafaring people and the pleasures and dangers of their pact with nature, which he shared as a Maine resident, led him to craft narratives of quieter gravitas than those pursued by "summer folk" like Bellows. A more direct connection to Homer's legacy can be found in Bellows's exact contemporary and fellow disciple of Henri, Rockwell Kent, who shunned urban themes for travel throughout the remote north seas, seeking new subjects for his "visionary" realism. As he later wrote, "If minds can become magnetized, mine was: its compass pointed north."[6]

The "man and the sea" theme reached a high point for the peripatetic Kent in his mature Greenland paintings of the 1930s, such as VMFA's *Greenland Summer* (fig. 191). This work is somewhat unusual in its focus on an intimate human exchange set against the epic summer landscape of Igdlorssuit,

a small island settlement north of the Arctic Circle. The subject is Kent's housekeeper and mistress, Salamina, a Greenlander widow who lived with her young children (one of whom is pictured in the work). Striking in its monumental yet reductive formal simplicity and electric-hued palette of unmodulated color, *Greenland Summer* goes further than Bellows's work in its emphasis on archetypal "fisherfolk" recast in a modern visual language. Kent, who identified Greenland as "geographically, part of the North American continent," also embraced the theory that Greenlanders shared ancestry with North American Indians, revering their premodern culture in a manner that evoked the practice of nineteenth-century artist-explorers. As the *New York Times* observed at

FIG. 191 Rockwell Kent (1882–1971), **Greenland Summer,** 1932, oil on canvas mounted on plywood, 34 x 44 in. (86.4 x 111.8 cm). Virginia Museum of Fine Arts Purchase, The Adolph D. and Wilkins C. Williams Fund, 90.189.

the time of his death, Kent's "people were portrayed with the subtle compassion of one who knew their secrets."[7]

What Bellows and Kent shared in their work was a fascination with the centrality of family, community, industry, and bravery in the lives of North Atlantic coastal inhabitants. Both artists also conveyed a fervent desire to celebrate this maritime culture with varying levels of engagement as spectator and participant. "It seems to me that an artist must be a spectator of life; a reverential, enthusiastic, emotional spectator," Bellows famously proclaimed, "and then the great dramas of human

nature will surge through his mind." Kent, instead, put life before art, arguing that "to bring more people to appreciate the beauty of their world and fellow beings is the one supremely worthy purpose of the arts."[8] SY

NOTES

1. The definitive text regarding Homer's impact on the next generation of realists and modernists remains Bruce Robertson, *Reckoning with Winslow Homer: His Late Paintings and Their Influence,* exh. cat. (Cleveland: Cleveland Museum of Art and Indiana University Press, 1990).

2. For an overview of Bellows's related water images, see Franklin Kelly, "'So Clean and Cold': Bellows and the Sea," in *The Paintings of George Bellows,* exh. cat. (Fort Worth, Tex.: Amon Carter Museum and Abrams, 1992), 135–69. See also "The Big Idea: George Bellows Talks about Patriotism for Beauty," *Touchstone* 1 (July 1917): 274–75.

3. The other works in the 1916 Camden series are: *The Rope (Builders of Ships)* (Yale University Art Gallery); *Shipyard* (Art Complex Museum, Duxbury); *The Skeleton* (Wichita Art Museum); and *The Teamster* (Farnsworth Art Museum). Bellows missed the December launch of the ship, which was unceremoniously claimed by Germans as a commerce raider—an unsettling irony given Bellows's patriotic stance. See Susan C. Larsen, "Bellows and Benson in Maine: Reality and Dream," exh. brochure (Rockland, Maine: Farnsworth Art Museum, 1998). See also Charles W. Morgan, *George Bellows: Painter of America* (New York: Reynal and Company, 1965), 200.

4. For Homer's shipbuilding imagery, see Linda Muehlig, ed., *Masterworks of American Painting and Sculpture from the Smith College Museum of Art* (New York: Hudson Hills Press in association with Smith College Museum of Art, 1999), 81–83. The wartime context for Bellows's shipbuilding series has received less attention from art historians than his more literal "Great War" subjects, but the imagery was viewed in such terms in 1917, the year America entered the conflict. See "The Big Idea," 269–75. Interestingly, in this article the artist misidentifies the shipyard location as being in Gloucester, Massachusetts, the site of Homer's painting. *Shipyard Society* had an active exhibition history in 1917, first appearing at the Chicago Art Club, then moving to New York, where it was seen at the Milch Gallery and the Red Cross exhibition, and to the New Jersey Art Association annual show, in Montclair. See VMFA curatorial files.

5. September 1916 letter to Henri, cited in Kelly, 169. For an examination of Bellows's modernist sensibility, see Marianne Doezema, *George Bellows and Urban America* (New Haven and London: Yale University Press, 1992) and Rebecca Zurier, *Picturing the City: Urban Vision and the Ashcan School* (Berkeley, Los Angeles, and London: University of California Press, 2006), 213–45.

6. Robertson, 101–6. See also Rockwell Kent, *It's Me O Lord: The Autobiography of Rockwell Kent* (New York: Dodd, Mead, 1955), 204.

7. Jake Milgram Wien, *Rockwell Kent: The Mythic and the Modern,* exh. cat. (New York: Hudson Hills Press in association with Portland Museum of Art, 2005), 70–79. See also Alden Whitman, "Rockwell Kent, Controversial Artist, is Dead," *New York Times,* March 14, 1971.

8. "The Big Idea," 275. Rockwell Kent, Introduction in *Rockwell Kent: The Early Years,* exh. cat. (Bowdoin, Me.; Bowdoin College Museum of Art, 1969), n.p.

114. Maxfield Parrish (1870–1966)

Little Sugar River at Noon, ca. 1922–24

Oil on panel

15 ½ x 19 ¾ in. (39.3 x 50.2 cm)

Signed lower left: "Maxfield Parrish"

Gift of Langbourne M. Williams, 62.5.2

PROVENANCE: Langbourne M. Williams, New York, N.Y.

The scene: an achingly perfect early summer day in the verdant Connecticut River Valley. The sun looms high in the sky, a gentle breeze rustles the trees, and an artist known for his luminous blue hue captures the limpid light of his own corner of paradise in western New Hampshire.

Little Sugar River at Noon is one of a handful of works that Maxfield Parrish produced for his own pleasure.[1] After studying architecture at Haverford College in Pennsylvania and painting at the Pennsylvania Academy of the Fine Arts, he dedicated himself to sharing his art with a mass audience, applying his talents to the popular mode of illustration. Even though the beauty of nature inspired Parrish throughout his long life, his noncommissioned landscapes were few, especially during the 1920s. Extraordinarily successful works such as his 1922 *Daybreak* (fig. 192)—the first image he painted expressly for reproduction as an "art print"—firmly established the artist as America's favorite fantasist and influenced his commissions for more than a decade.[2]

The specificity of the painting's title, *Little Sugar River,* as well as the naturalistic treatment of an identifiable New England setting at an essential moment, differentiates this image from Parrish's other landscapes, particularly those he later produced for Brown and Bigelow, a calendar and greeting card company. Having famously sworn off figurative work in favor of landscapes in 1932, Parrish painted nearly one hundred idyllic representations of sunny New England days and wintry nights over the next quarter of a century. Imbued with cheerful sentiment, these commissioned images were eagerly consumed by Americans longing for domestic stability and serenity during the World War II years.[3] While *Little Sugar River* also resonates with themes of Americanness in its sense of place (New Hampshire as Yankee heartland), it conveys a greater sense of realism in its plein-air exactness. As one

contemporary wrote of Parrish's remarkable verisimilitude, achieved through a painstaking technique of drawing and glazing, "The overall impression when you view a Parrish picture is that you're looking into and through the painting, not just at it."[4]

Parrish and his wife, Lydia Austin, relocated from Philadelphia to Plainfield, New Hampshire, in 1898. His father, landscape artist Stephen Parrish, and mother, Elizabeth Bancroft, had recently become year-round residents of the neighboring village and progressive artists' colony of Cornish. The younger Parrishes purchased a plot of land on a secluded hillside pasture about a mile away. They called their new home (designed and built by the artist) The Oaks, for the property's central

FIG. 192 Maxfield Parrish (1870–1966), **Daybreak,** 1922, oil on panel, 26 ½ x 45 in. (67.3 x 114.3 cm). Private collection.

feature, and proceeded to carve out a distinctive place for themselves in the colony. Parrish's Haverford College roommate, art critic Christian Brinton, described Parrish's profound influence on his new community:

> While it is possible, both historically and geographically, that Cornish may have existed before his advent, there are grounds for doubting this. . . . In short, [Parrish] remade Cornish. . . . After his coming, folk began remarking that the hills seemed to shape and group themselves more effectively, that certain trees stood forth more picturesquely against the horizon, and that those swift-scudding cloud-forms marshaled themselves almost as majestically across the sky as

114

they did in the backgrounds of his canvases. . . . He appeared to have a secret understanding with, as well as of, Nature.[5]

One of twentieth-century America's most beloved artists, Parrish remained committed to disseminating his art through vehicles such as magazines and books, murals and stage sets, advertisements, posters (fig. 193), and calendars over a successful career of nearly seventy years. Although his work was dismissed by the critical establishment in the middle of the twentieth century, a resurgence of interest coincided with the vogue for Pop Art in the early 1960s. More recently, contemporary artists and viewers have evinced a renewed appreciation for the so-called master of make believe.[6] SY

FIG. 193 Maxfield Parrish (1870–1966), **The Century Midsummer Holiday Number,** August 1896, lithograph on paper, 19 ⅞ x 13 ⅜ in. (50.5 x 34 cm) sheet. Virginia Museum of Fine Arts Purchase, The Adolph D. and Wilkins C. Williams Fund, 89.67.

NOTES

1. See Catalog of Selected Works in Coy Ludwig, *Maxfield Parrish* (New York: Watson-Guptill Publications, 1973). See also Coy Ludwig, "Maxfield Parrish: Sharp-Focus Visionary," *American Art Review* 3 (March–April 1976): 87–88.

2. By 1925 the House of Art, the publishing firm based in New York and London that commissioned *Daybreak,* estimated that both high- and low-end reproductions of the painting could be found in one out of every four American households. See Alma Gilbert, *Maxfield Parrish: The Masterworks,* 2nd ed. (Berkeley, Calif.: Ten Speed Press, 1995), 164. From 1918 to 1934, Parrish submitted annual calendar images featuring "girls on rocks" for the Edison Mazda Lamp Division of General Electric—another highly lucrative venture. See Ludwig, *Maxfield Parrish,* 122–29.

3. Sylvia Yount, *Maxfield Parrish, 1870–1966* (New York: Abrams in association with the Pennsylvania Academy of the Fine Arts, 1999), 113–17.

4. Quoted in "Maxfield Parrish, Painter and Illustrator, Dies at 95," *New York Times,* March 31, 1966. For a discussion of Parrish's unusual technique, see Mark F. Bockrath, "'Frank Imagination, within a Beautiful Form': The Painting Methods of Maxfield Parrish," in Yount, 127. Coy Ludwig has argued that a number of the artist's "photo-realist" landscapes were painted from four-by-five-inch black-and-white glass-plate negatives and that Parrish anticipated the glowing luminosity of color photography long before it was perfected. Ludwig, "Maxfield Parrish: Sharp-Focus Visionary," 88–89.

5. Christian Brinton, "A Master of Make-Believe," *Century Illustrated Monthly Magazine,* July 1912, 345.

6. For an analysis of Parrish's lifetime and posthumous reputations, see Yount.

115. Max Weber (1881–1961)

Black Chair, 1922

Oil on canvas

46 x 31 ¼ in. (116.8 x 79.4 cm)

Signed and dated lower right: "MAX WEBER 1922"

Museum Purchase, The Floyd D. and Anne C. Gottwald Fund, 2008.2

PROVENANCE: Estate of the artist; Gerald Peters Gallery, New York, N.Y.

Hailed at his death as the dean of American moderns, Max Weber is widely regarded today as an influential figure in America's first-generation avant-garde, having left a mark as a painter, printmaker, sculptor, poet, essayist, and teacher. Yet throughout most of his highly productive career, Weber struggled to find a distinctive voice with which to express his modernist aesthetic. *Black Chair* dates from a more settled and mature period in the artist's life, when he was beginning to attract greater critical acclaim and popular attention. Having experimented since his early years with different modernist styles, Weber returned in the 1920s to the artist whose work remained his touchstone—Paul Cézanne.

115

Weber first encountered the art of the French recluse, whom Henri Matisse called "the father of us all," at the Paris home of the adventurous American collectors Gertrude Stein and her brother Leo. Weber considered the exhibition of Cézanne's paintings in the 1906 Salon d'Automne a turning point in his career, writing that the works gripped him "at once and forever." Cézanne's "plasticity" and his distinctive approach to painting—that is, the definition of form with color—inspired a generation of American modernists in the 1920s, a decade when interest in Cézanne's work resurged.[1]

The Russian-born Weber was raised in New York and began his progressive art education under the tutelage of Arthur Wesley Dow at the Pratt Institute in Brooklyn. He spent a few years teaching art in Virginia public schools—as did the later Dow pupil Georgia O'Keeffe (see cat. no. 120)—and summer classes at the University of Virginia. In 1905 Weber moved to Paris, where he trained in the private Julian and Colarossi academic ateliers before organizing a class with Matisse, with whom he studied for one year, alongside Virginian Patrick Henry Bruce.[2]

By the time Weber returned to New York in 1909, he had abandoned a vivid postimpressionist and fauvist painterly approach in favor of the more radical protocubism that baffled most American critics. Weber was one of five modernists included in Alfred Stieglitz's landmark *Young American Moderns* exhibition, held in 1910 at the recently opened 291 gallery; Alfred Maurer, Arthur Dove, Marsden Hartley, and John Marin were the other four. Weber's formal distortions received the harshest criticism, spotlighting his early reputation as one of the most advanced of the American "moderns." (A critic for the *New York Times* remarked that Weber's "impressions of humanity, as in the grip of epileptic seizures, if taken seriously, as they must be, are eloquent of horror and nightmare."[3]) Within two years, Weber had moved on to futurist views of New York that captured the dynamic rhythm of the modern metropolis. By 1919, he had all but eliminated abstraction in his canvases and begun to work self-consciously through his debt to and understanding of Cézanne with a series of monumental female nudes and experimental, if classicizing, still lifes.[4]

Black Chair, although deeply informed by Cézanne (as well as by Pablo Picasso and Georges Braque, both of whom Weber knew in Paris), is far less derivative of the French masters than

are other contemporary American pictures. The inventive and sophisticated composition—with its thrusting, tilted picture plane—fuses Weber's bold painting style with a geometric simplicity and graphic exuberance (particularly in the expressive tabletop still life) to a degree not seen in subsequent Cézannian works by the artist. Weber's naturalistic approach to his subject departs from Cézanne's more systematic pictorial strategies and highlights the purely sensuous quality of paint and its manipulation. Yet the work is not merely a formal exercise; it may also be read as a subtly veiled self-portrait.

The studio setting and classic French still life recall Weber's bohemian experiences in Paris, while the black Hitchcock chair—of the painting's title—and the Arts and Crafts–style table confirm his American identity with a vocabulary of iconic forms.[5] This interest in a collective American past defined through early American furnishings (loosely termed Colonial Revival) pervaded 1920s culture and is also apparent in the work of Weber's fellow modernist Charles Sheeler (fig. 194; see cat. no. 137). Both artists used the subject of

FIG. 194 Charles Sheeler (1883–1965), **Interior,** 1926, oil on canvas, 33 x 22 in. (83.82 x 55.88 cm). Whitney Museum of American Art, New York; Gift of Gertrude Vanderbilt Whitney, 31.344.

interiors to experiment with a kind of domesticated cubism—grounded in Cézanne—that proved more palatable to an American public.[6]

Dynamic and commanding in scale and composition, Weber's *Black Chair* is a hallmark work from a decade during which the artist established an international reputation with solo shows in Europe and America. In both form and content, it suggests Weber's fundamental approach to art making—what his friend and colleague William Zorach identified as "a power of expression . . . a rare and personal flavor. . . . Spirit and form and color are welded into life, a complement of intellectual power and emotion."[7] SY

NOTES

1. Alfred Werner, *Max Weber* (New York: Abrams, 1975), 40. Cézanne's art was prominently featured in a series of modernist exhibitions held in galleries and museums in Philadelphia and New York throughout the early 1920s. See John Rewald, *Cézanne and America: Dealers, Collectors, Artists and Critics, 1891–1921* (Princeton, N.J.: Princeton University Press, 1989), 311–36, 341. See also Gail Stavitsky, ed., *Cézanne and American Modernism*, exh. cat. (New Haven and London: Montclair Art Museum and Baltimore Museum of Art in association with Yale University Press, 2009.)

2. For a detailed discussion of Weber's life, including his close relationship with Dow, see Lloyd Goodrich, *Max Weber* (New York: Macmillan, 1949). After graduating from Pratt, Weber taught construction drawing and manual art from 1901 to 1903 in Lynchburg's school system; its superintendent recommended him for the University of Virginia position teaching summer classes. During the summer of 1912, while living with her parents in Charlottesville, O'Keeffe came under the sway of Dow's teachings in a University of Virginia drawing class run by his student Alon Bement. Over the next six years, Dow's philosophy influenced her own approach to teaching art at public schools and colleges in Virginia, South Carolina, and Texas. O'Keeffe later studied with Dow at Columbia University's Teachers' College. See Charles C. Eldredge, *Georgia O'Keeffe: American and Modern* (New Haven and London: Yale University Press, 1993), 20, 160–61.

3. Elizabeth L. Carey's comments from the *New York Times* were referenced in an article in Stieglitz's house organ; see "'The Younger American Painters' and the Press," *Camera Work* 31 (July 1910): 45.

4. For an overview of this period, see *Max Weber: The Cubist Decade, 1910–1920*, exh. cat. (Atlanta: High Museum of Art, 1991).

5. Named after the Connecticut master woodworker Lambert Hitchcock, who pioneered the mass-produced design in 1818, the Hitchcock chair revived many of the characteristics of the colonial Windsor chair; an 1825–35 version is in VMFA's collection. The small table depicted in *Black Chair* resembles a Craftsman design by Gustav Stickley, an example of which is also owned by the museum. Weber's chair remains in the artist's family.

6. See Carol Troyen and Erica E. Hirshler, *Charles Sheeler: Paintings and Drawings*, exh. cat. (Boston: Museum of Fine Arts, Boston, 1987), 110.

7. Quoted in Werner, 70.

116. Maria Martinez (1887–1980) and Julian Martinez (ca. 1885–1943)

Platter, ca. 1925
New Mexico clay, fired black on black
14 ⅜ in. (36.5 cm) dia.
Signed on bottom: "Marie + Julian"
Museum Purchase, The Floyd D. and Anne C. Gottwald Fund, 2003.45

PROVENANCE: Private collection, N.M.; Adobe Gallery, Santa Fe, N.M.

Maria and Julian Martinez, Tewa Indians of San Ildefonso Pueblo, are among the most widely recognized twentieth-century American potters. Together they developed a distinctive black-on-black pottery that has long been heralded as one of the signature styles of the American Southwest. For this bold platter, Julian used one of their favorite motifs—the *puname,* an eagle-feather design adapted from pottery motifs of the nearly thousand-year-old Mimbres Pueblo culture.[1] Flickering with movement of light, a highly polished circle of feathers seems to float above a dark, flat field.

At an early age, Maria Antonia Montoya learned to make clay vessels from her aunts in their small village near Santa Fe, New Mexico. By 1904, the same year that she married Julian Martinez, she had become a well-respected potter who was invited to exhibit at the Saint Louis World's Fair. Four years later, archeological excavations at ancient sites on the Pajarito Plateau near her home inspired her to study and emulate prehistoric forms and motifs. In a collaborative partnership that would last four decades—she shaped the pots and Julian painted the designs—Maria and her husband created their earliest revival pieces in polychrome.[2]

Through experimentation, the couple developed a specialized technique that resulted in a mirrorlike luster on solid black or solid red pottery. In 1918, they also perfected the process for creating their magnificent black-on-black ware. Maria hand-formed the pots, bowls, and platters from a mixture of clay and volcanic ash collected from hills on the San Ildefonso Reservation. Following a sequence of drying, scraping, sanding, and polishing, she applied a slip into which Julian painted motifs. The pottery was then baked outdoors in an iron grill banked with smoldering wood and dried cow

dung. The firing process carbonized the iron-red clay to a deep black and resulted in a surface that has both matte and glossy areas.³

With few opportunities to earn revenue in the early twentieth century, pueblo peoples—alongside other Native American cultures—came to rely heavily on the barter and sale of traditional crafts. At the same time, collectors and tourists, with increasingly easier access to remote reservations, began to differentiate the products and styles of particular cultures and artisans. Maria and Julian's unusual blackware became a favorite among visitors who came to the markets in Santa Fe and Albuquerque. In subsequent decades, the Martinezes gained an international reputation through exhibition at several world's fairs and sales to both private collectors and museums.

A guest to the White House more than once, Maria received encouragement from Eleanor Roosevelt. According to the artist, the First Lady urged, "Keep on the Indian way. Send your children to school, but keep your own way!"[4]

In the early years of her career, Maria left her work unsigned. In 1920, the director of the Santa Fe Indian School urged her to mark her pieces with her name—not a traditional practice among pueblo potters. He also encouraged her to use "Marie" to appeal to an Anglo market. Five years later Maria added Julian's name; their combined signature appears on the bottom of this platter.[5] In the late nineteenth and early twentieth centuries, other Native American potters, weavers, leather makers, silversmiths, and basket makers found varying degrees of success in the growing tourist market. Without their signatures, however, the majority of these skilled artists and artisans—like those of the Western Apache maker of the handsome coiled basket in the VMFA collection (fig. 195)—are lost to obscurity.[6]

In the decades of Maria's and Julian's active production, several painters from the eastern establishment—including Robert Henri, John Sloan, Marsden Hartley, Milton Avery, Max Weber, and Georgia O'Keeffe (cat. nos. 111, 115, and 120)—found inspiration in the indigenous artwork of the Southwest.[7] "Here in the pueblos of New Mexico," Henri noted, "the Indians still make beautiful pottery and rugs, works which are mysterious and at the same time revealing of some of the great life principle which the old race had . . . a spark of a spiritual life. . . . The whole pueblo manifests itself in a piece of pottery."[8]

Building upon their cultural heritage, Maria and Julian produced a legacy of their own. Following Julian's death in 1943, Maria made pottery with other family members, including her daughter-in-law Santana and her son Popovi Da. Working well into her nineties, she remained active until her death in 1980. Today, a renowned fifth generation of descendants carries on the tradition of creating polished, black-fired pottery at San Ildefonso.[9] ELO

FIG. 195 Unknown artisan (American Indian), **Western Apache Coiled Basket,** ca. 1890–1905, willow and devil's-claw pod splits, cedar root, 9 x 7 ⅝ in. (22.9 x 19.4 cm). Virginia Museum of Fine Arts, Gift of Mr. John D. Archbold, 83.109.

NOTES

1. An example of the ancient motif can be seen on a Style III, Mimbres Classic black-on-white bowl in the collection of the Department of Anthropology, University of Minnesota, illustrated as fig. 83 in J. J. Brody et al., *Mimbres Pottery: Ancient Art of the American Southwest,* exh. cat. (New York: Hudson Hills Press in association with American Federation of the Arts, 1983), 82.

2. Susan Peterson, *The Living Tradition of Maria Martinez* (Tokyo, New York, and San Francisco: Kodansha International, 1977), 109. Maria's early period is covered effectively in Alice Marriott, *Maria: The Potter of San Ildefonso* (Norman: University of Oklahoma Press, 1948).

3. Maria credited her husband for the discovery of this process. Peterson, 91–100, 197–99. The artist's obituary noted that in 1910, John D. Rockefeller purchased her first nine black pots. "Maria Povera Martinez, Potter, 94," *New York Times,* July 22, 1980, B-8.

4. Peterson, 109–10. Maria and Julian also exhibited at the San Diego World's Fair in 1915, the Chicago World's Fair in 1933, and the San Francisco World's Fair in 1943. Continuing the legacy of White House appreciation, President Barack Obama and First Lady Michelle Obama selected a sizable Martinez jar for display in the West Wing offices.

5. She would begin signing "Maria" after 1954. Peterson, 98–99; Marriott, 234–35.

6. The olla form made its appearance among Western Apache cultures in the 1880s. Not an indigenous shape, it emulates the pottery ollas of Mexico and other Native American cultures that were then gaining popularity among Anglo collectors. Correspondence with author and Bruce Bernstein, Assistant Director of Cultural Resources, National Museum of the American Indian, VMFA curatorial files. See also Lydia L. Wyckoff, ed., *Woven Worlds: Basketry from the Clark Field Collection* (Tulsa, Okla.: Philbrook Museum of Art, 2001), 42–44.

7. For a broad discussion of the sojourns of eastern artists, see Charles C. Eldredge, Julie Schimmel, and William H. Truettner, *Art in New Mexico, 1900–1945,* exh. cat. (New York: Abbeville Press for the National Museum of American Art, 1986).

8. Robert Henri, *The Art Spirit,* ed. Margery Ryerson (1923; repr., Philadelphia: J. B. Lippincott, 1960), 187–88.

9. For more about the Martinez family, see Peterson, *Maria Martinez: Five Generations of Potters,* exh. cat. (Washington, D.C.: Renwick Gallery of the National Collection of Fine Arts, Smithsonian, 1978). Also in the VMFA collection is a polished black bowl (2008.3) signed by Maria and her daughter-in-law and then-collaborator, Santana Roybal Martinez. Donor Irma Goldstein commissioned it directly from the makers at San Ildefonso Pueblo in 1945.

117. Paul Manship (1885–1966)

Flight of Europa, 1925

Bronze, gilded; original onyx base

20½ x 31 x 9 in. (52.1 x 78.7 x 22.9 cm) overall, without base

Signed on rear dolphin's fin: "© P. Manship"

Museum Purchase, The J. Harwood and Louise B. Cochrane Fund for American Art, 2005.74

PROVENANCE: Private collection; Spanierman Gallery, New York, N.Y.

Beautifully balanced, both technically and aesthetically, *Flight of Europa* exemplifies Paul Manship's mature style. By 1925, when this figural grouping was completed, the artist had already gained international acclaim. The Minnesota-born Manship had trained at the Pennsylvania Academy of the Fine Arts in Philadelphia and in 1909 won a prestigious three-year fellowship to the American Academy in Rome. There he immersed himself in the study of antiquity and traveled extensively throughout the eastern Mediterranean region, developing a taste for the abstract characteristics of ancient Etruscan, Greek, and Egyptian art. He also studied early artworks of the Near East and South Asia. From these diverse influences, Manship devised a synthesized approach—reworking classical subjects with formalized, streamlined modeling. Upon his return to the United States, his transitional style earned praise from old-guard academicians and avant-garde modernists alike.[1]

Exhibiting Manship's distinctive stylization, *Flight of Europa* depicts the story of the abduction of a Phoenician princess. According to the Greek myth, Europa became intrigued with the docility of a magnificent bull and climbed onto its back. Taking advantage of her trust, the bull—actually a love-lorn Zeus in disguise—kidnapped her and carried her across the sea. On their arrival in Crete, Zeus revealed himself in human form and took her as a lover. In time, Europa bore him three sons, including Minos, the king of Crete.[2]

Crafted in bronze and supported by an onyx base, Manship's sculptural interpretation of the tale is both lively and playful.[3] Resembling Minoan frescoes the artist studied at the Cretan Palace of Knossos, the muscular bull stretches his legs to fly above a school of swimming dolphins. The undulating bulk of the beast contrasts dramatically with his slender, upright passenger. Europa, sitting primly and looking backward, seems unconcerned about her journey. As a winged Eros whispers in her ear, a tiny smile plays across her lips—suggestive of the archaic Greek sculpture that Manship deeply admired.

Flight of Europa is one of Manship's principal works. Balancing his time between Paris and Rome, he produced twenty versions of the sculpture.[4] Meticulous and technically proficient, Manship explored varied surface effects for each casting, ranging from a dark, greenish brown patina to full gilding. He also took care in designing appropriate bases; the onyx platforms for the series feature wavelike striations.[5] This particular bronze retains its original gilded patina—intentionally distressed to suggest age. Such effects evoke "shades of ancient bronzes, buried for centuries," as a reviewer observed after visiting a Manship exhibition presented at the Virginia Museum of Fine Arts in 1936.[6]

In press coverage for the third exhibition of its inaugural year, VMFA touted the Manship show as the "first large sculpture exhibit ever staged in Richmond."[7] The New York–based sculptor arrived early to help supervise the placement of seventy-five works of all subjects, sizes, and media—including *Flight of Europa*.[8] The *Richmond Times-Dispatch* reported that the show offered something for everyone, "whether he likes his art nice, charming, powerful, lecherous, noble or conventional," and wryly added, "Perhaps most people were more interested in the two equestrian figures of Lee and Jackson in bronze, forceful and conventional, than in the sensuous and exciting Eurpdices [sic], Europas, and Salome."[9]

Months before the exhibition, the VMFA board had already expressed its confidence in Manship's skills by commissioning him to create a profile portrait of founding patron John Barton Payne. The eight and one-half inch plaster bas-relief plaque was completed in 1937 (see fig. 4).[10] Fifty years later, VMFA purchased Manship's *Head of a Girl* (fig. 196).

This dark bronze head, produced in 1916, is a study for Manship's well-known sculpture of the same year, *Dancer and Gazelles,* and suggests a similar Greek archaic influence as his later *Flight of Europa.*

After successful solo shows and key commissions, Manship became the nation's leading sculptor between the world wars. His major works of the 1920s and 1930s—the most prominent of which is the 1934 gilded *Prometheus* commissioned for New York City's Rockefeller Center—are considered icons of the American art deco movement. Relinquishing the strict naturalism required of previous generations of sculptors, Manship inspired younger artists—among them Gaston Lachaise, who worked as the artist's studio assistant. Exploring new modernist directions in figural representation, Lachaise went on to produce a series of powerful female nudes, including his monumental *Standing Woman (Elevation)* (fig. 197). ELO

FIG. 196 Paul Manship (1885–1966), **Head of a Girl,** ca. 1916, bronze, marble base, 9½ x 6¾ x 7 in. (24.1 x 17.1 x 17.8 cm) head. Virginia Museum of Fine Arts Purchase, The Charles G. Thalhimer Family Fund, 86.199.

NOTES

1. Wayne Craven, *Sculpture in America* (Newark, Del.: University of Delaware Press, 1984), 565–68. For considerations of Manship's life and career, see Harry Rand, *Paul Manship,* exh. cat. (Washington, D.C.: Smithsonian Institution Press for the National Museum of American Art, 1989) and Susan Rather, *Archaism, Modernism, and the Art of Paul Manship* (Austin: University of Texas Press, 1993). The artist's son offers an informative and affectionate account in John Manship, *Paul Manship* (New York: Abbeville, 1980).

2. G. M. Kirkwood, *A Short Guide to Classical Mythology* (New York: Holt, Rinehart and Winston, 1959), 32.

3. Manship explored the theme in 1924, creating a smaller bronze showing a seated *Europa and the Bull* in a triangular embrace. It is illustrated in Rand, 65, fig. 56.

4. Testifying to Manship's celebrity, the production of *Flight of Europa* was announced with fanfare in "New Manship Sculpture; Recently Completed in Paris," *Vanity Fair,* April 1926, 68.

5. Rand, 67–69. Castings of this version appear in other public collections including Brookgreen Gardens, Murrells Inlet, South Carolina; Indianapolis Museum of Art; Los Angeles County Museum of Art; and Reynolda House Museum of American Art, Winston-Salem, North Carolina. The series also includes a heavily gilded version in the collection of the Smithsonian American Art Museum. A larger version, cast in 1931, sits at the corner of Sunset and Vine in Hollywood, California.

6. Julia Sully, "Manship's Sculpture Show Termed Finest Exhibit of Fine Arts Museum," *Richmond News Leader,* November 18, 1936.

7. Katherine Warren, "Museum to Show Manship's Animals in Sculpture Hall," *Richmond News Leader,* November 9, 1936.

8. *Flight of Europa* is listed in *The Sculpture of Paul Manship,* exh. cat. (Richmond: Virginia Museum of Fine Arts, 1936) 7, no. 59. For this show, held November 15– December 14, 1936, there are no extant documents or photos to identify the specific casting.

9. Margaret Leonard, "Manship Present at Opening Here of His Exhibit," *Richmond Times-Dispatch,* Nov. 15, 1936, 3. At the time of the VMFA show, Manship was at the height of his career; the previous year featured a major retrospective of his work at the Tate Gallery in London.

10. The circular bas-relief (VMFA, acc. no. 37.23.1/a), created for casting as a bronze award medallion, depicts the profile bust of Payne (see fig. 1); the reverse features the seal of the Commonwealth of Virginia.

FIG. 197 Gaston Lachaise (1882–1935), **Standing Woman (Elevation),** modeled 1912–15, cast 1930, bronze, 68 x 28 x 16 in. (172.7 x 71.1 x 40.6 cm). Virginia Museum of Fine Arts Purchase, The Adolph D. and Wilkins C. Williams Fund, 78.9.

118. Thomas Hart Benton (1889–1975)

Brideship (Colonial Brides), ca. 1927–28

Oil and egg tempera on canvas, mounted on composite board

60 3/16 x 42 1/8 in. (152.9 x 107 cm)

Gift of R. Crosby Kemper and Museum Purchase, The J. Harwood and
Louise B. Cochrane Fund for American Art, 98.28

PROVENANCE: Thomas Piacenza Benton, the artist's son, Kansas City, Mo.;
Crosby Kemper, Kansas City, Mo.

Brideship—also known as *Colonial Brides*—is one of two final canvases that Thomas Hart Benton painted for his first mural cycle, *The American Historical Epic*.[1] Designed initially as a series of seventy-five pictures grouped into "chapters," the *Epic* was intended to convey "a people's history"—an alternative to the "Great Men" narrative of academic painting. As Benton explained it, he "wanted to show that the people's behaviors, their action on the opening land, was the primary reality of American life."[2] Inspired by Marxist theory, the series explored themes of racial conflict and economic exploitation.[3] In the section about commerce, *Brideship* served to narrate one kind of colonial negotiation—that between a prospective bridegroom and a would-be bride requiring payment for passage to the New World.[4]

With his characteristic tangle of expressive figures, Benton stages an episode from the early years of the Jamestown settlement.[5] Between 1620 and 1621, the Virginia Company dispatched five ships carrying 147 "younge, handsome, and honestly educated Maides" from England to serve as brides for the settlers, all males. The potential suitors subscribed to the endeavor beforehand by contributing 150 pounds of tobacco each. Newly arrived, Benton's tall and languorous red-haired maiden confronts her fate on the bustling wharf as she examines the small coin in her hand. Did she sell herself short? The game of chance that brought her to the New World—a metaphorical flip of the coin—appears to have cast her lot with the coarsely featured man at bottom left. Her future husband beckons to her with talonlike fingers.[6]

Still, *Brideship* is far less grim than other pictures from Benton's *Epic* series. Indeed, the picture is not without humor or charm. The lively men who populate the canvas wear anachronistic costumes from the eighteenth century, transforming them into characters from central casting for a Colonial Revival "Yankee-Doodle" review. And the model for the bride-to-be was Benton's own wife, Rita, who added to the family income by making hats. Rita Benton's fashionable 1920s chapeau is shown to advantage in the image. This present-day touch signals a change in Benton's thinking about the series: the last picture in the group, *Bootleggers* (fig. 198), deals with completely contemporary subject matter.[7]

Benton's ambitious *Epic* sets out the essential elements of his mature work, in both its American subject and its manner of organizing forms. At the same time that he was composing *Brideship*, Benton was defining and defending his formal principles in a series of articles published in the *Arts*.[8] These tenets proved valuable not only for Benton's development but for their influence on his pupils at the Art Students League in New York. Although Jackson Pollock, for one, eventually rejected recognizable subject matter, he absorbed Benton's ideas about composition (see cat. no. 135).[9]

Key to Benton's compositional organization was the notion of a visual "pole"—real or implied—around which rotating forms were arranged.[10] In *Brideship*, a central vertical pole runs through the middle of the composition, surrounded by repeating passages of white: from the sweeping sails at upper left to the foolscap proclamation unfurling on the wall;

FIG. 198 Thomas Hart Benton (1889–1975), **Study for *Bootleggers*,** ca. 1927, oil on composition board, 17 7/8 x 15 3/4 in. (40 x 30.2 cm). Virginia Museum of Fine Arts Purchase, The Arthur and Margaret Glasgow Fund, 79.64.

from the white feather and pleated linen of the woman's cap and sleeve to the white cuff of the yeoman's shirt. The figures' arms—outstretched, akimbo, and crooked upward—help spin them out around the pole, while hats, which are scattered along a horizontal S curve, carry the eye into deep space. The pole line is underscored by a pronounced vertical crease in the blue coat of the central figure.

Benton's theoretical and technical choices reflected years of thoughtful study. Elongated forms, exaggerated features, and actively engaged limbs; broad, bold outlines filled with jewel-toned hues; a strong chiaroscuro and foreshortened space: the combination speaks to the varied influences under which Benton labored—Renaissance classicism, mannerism, and French cubism.[11] But the artist was also concerned about producing art that was compatible with a modern socialist narrative.

Son of a congressman, Benton left Washington, D.C., in 1907 to enroll at the Art Institute of Chicago. The following summer he traveled to Paris and remained to study at the Académie Julian. But the experience was short lived. He soon rejected the academic model and by 1912 was settled in New York among fellow modernists. Yet, in the radical trend toward greater abstraction, an allegiance to social narrative left Benton increasingly isolated. His response was a unique sculptural realism informed by the "inevitable condition of [human] experience," a sort of everyman style rooted in the democratic ideals he associated with regional—primarily midwestern and southern—American life. This regionalist style, with its "asymmetrical but equilibrated masses, expressed by firmly cut planes of an essentially dynamic nature," was particularly suited to large-scale mural works.[12] Whereas early-twentieth-century American muralists had traditionally embraced the legacy of Puvis de Chavannes, a nineteenth-century French mural painter whose cool, tranquil subject matter and friezelike figures occupied flat planes rendered in pale colors harmonious with the actual walls, Benton forged an alternative model, creating highly structured and aggressively three-dimensional imagery populated by numerous robust figures.

In 1928, Benton abandoned the *American Historical Epic* to pursue more lucrative commissions. But the significance of the seventeen-canvas series is notable. As Benton's first important cycle, the *Epic* marks his transition from experimental modernist to assured muralist of the American scene style— a mode of painting that would dominate artistic production during the 1930s (see cat. no. 125). DPC

NOTES

1. Benton conceived the *American Historical Epic* in 1918 while serving in the navy in Portsmouth, Virginia. He worked on it from 1919 until 1928. Of the sixteen other paintings completed, ten are now in the Nelson-Atkins Museum, Kansas City, Missouri; five are in the Benton Trust, also in Kansas City; and one is in the Reynolda House Museum of American Art, Winston-Salem, North Carolina.
2. This was "in contrast to the conventional histories which generally spotlighted great men, political and military events, and successions of ideas." Benton, quoted in Henry Adams, *Thomas Hart Benton, An American Original* (New York: Knopf, 1989), 129.
3. Benton later illustrated a Marxist history of the United States, titled *We the People,* written by his friend Leo Huberman and published in 1933.
4. The other two parts of the three-part chapter were titled *Smugglers, 1760* and a never-completed *Fisherman's Wharf* (sketch title). Polly Burroughs, *Thomas Hart Benton: A Portrait* (Garden City, N.Y.: Doubleday , 1981), 90–91.
5. Benton likely learned of the colonial brides when he "read and reread" a history book by J. A. Spencer, which he discovered in his rented rooms during his tour of duty at Norfolk Navy Yard. Adams, 87–88, 128. The rather idealized passage appears in J. A. Spencer, *History of the United States* (New York: Johnson, Fry, and Company, 1858), 1:41.
6. While little is known of the first ninety women to arrive in 1620, surviving records document the circumstances of the fifty-seven who followed in 1621. The brides, primarily in their late teens and early twenties, came from the artisan and gentry classes with written recommendations. As widows, orphans, or youngest daughters of large families, few had economic resources or protectors at home. Virginia proved a grim choice; those who survived the Indian attack in March 1622, likely perished in the starving winter of 1622–23. See David R. Ransome, "Wives for Virginia, 1621," *William and Mary Quarterly,* 3rd series, 48 (January 1991): 3–18.
7. *Brideship* was the second-to-last picture executed in the series. *Bootleggers* incorporates gangsters, gun molls, fast cars, trains, and planes. The VMFA version is an oil sketch for the larger painting in the Reynolda House Museum of American Art.
8. Benton's theory on art was published in five parts between 1926 and 1927. Thomas Hart Benton, "Mechanics of Form Organization in Painting," *The Arts,* Part 1 (November 1926): 285–89; Part 2 (December 1926): 340–42; Part 3 (January 1927): 43–44; Part 4 (February 1927): 95–96; and Part 5 (March 1927): 145–48. Roger Fry, a contemporary author on cubism, expressed his admiration for Benton's articles, noting that the American regionalist "was really without equal" in his sophisticated comprehension of cubist ideas, cited in Adams, 114.
9. Henry Adams argues that Pollock's compositions related directly to Benton's teaching. He links pictures such as Pollock's trenchantly titled *Blue Poles* (1953, National Gallery of Australia) to structural diagrams from Benton's articles. Adams, 116–17.
10. Benton, Part 1, 286–89.
11. Benton's achievements reflected his respect for Old Master artists such as Michelangelo, Peter Paul Rubens, Tintoretto, and El Greco and for the sophisticated modernist principles of arrangement absorbed during Parisian encounters with postimpressionism and cubism.
12. Benton, Part 1, 285–89.

119. Sidney Waugh (1904–1963), designer
Steuben Glass Works (founded 1903), manufacturer

Mariner's Bowl, 1935

Corning, New York

Glass

2 ¾ x 16 in. (7 x 40.6 cm) dia.

Bequest of Lelia Blair Northrop, 78.74

PROVENANCE: Lelia Blair Northrop, Richmond, Va.

In 1947 Sidney Waugh, the designer of this bowl, wrote a brief essay describing the difference between late-nineteenth- and mid-twentieth-century glassmaking. According to Waugh, the weakness of domestic glassmaking was attributable, in large measure, to the absence of an American glass tradition. By the same token, he allowed that this lack had positively encouraged the free exploration of "the many sources of inspiration" by which young artisans might "strive towards what is new in a constructive . . . spirit." By this means, Waugh argued, the "highly 'personalized' creations of Early Steuben glass, often depending for their particular beauty on chance effects, and not infrequently degenerating into mere feats of technical virtuosity," were replaced by "more orthodox methods of production, giving greater attention to perfection of metal and soundness of design than to those half-fortuitous effects which, to the modern eye, often seem more bizarre than beautiful."[1] Waugh's analysis helps place the *Mariner's Bowl* in the context of Steuben's production. But it also highlights the broader changes that affected the production of American art glass.

Founded in 1903 by Frederick Carder, an English-born designer trained in the Stourbridge firms of J. and J. Norwood and Stevens and Williams, the company of Steuben Glass was largely funded by Thomas G. Hawkes, owner of the cut-glass business T. G. Hawkes and Company. The partnership was mutually beneficial: Carder provided Hawkes with his much-needed glass "blanks" and Hawkes afforded Carder the independence to pursue inventive colors and techniques.[2] The first and most celebrated of these innovations was a gold luster glass that competed with Tiffany Favrile Glass and was produced by spraying metallic salts in the firing process.[3]

In 1918, Carder's factory was sold to Corning Glass Works, and Carder stayed on as artistic director of Steuben.[4] But the firm began to lose money. In 1933, on the heels of new discoveries in crystal optical glass, financial losses forced the firm's restructuring, and Arthur Amory Houghton Jr., a great-grandson of Corning's founder, was made president of the company.[5] Convinced by famed industrial designer Walter D. Teague that there was a market for luxury objects in a progressively modern taste, Houghton adopted the example of European firms like Orrefors in Sweden and set about designing and marketing a new Steuben crystal. The formula, based on the research into optical glass, boasted a crystalline purity that complemented the asceticism of modernist environments.[6] In addition to hiring a new staff of architects and designers, Houghton began commissioning designs from contemporary artists.[7] Under the direction of architect John M. Gates, award-winning sculptor Sidney Waugh became Steuben's chief associate designer.

In the 1930s, clarity, transparency, brilliance, flawlessness, and perfection were the watchwords of the Steuben glassmaker. These standards were deemed a measure of the firm's "high scientific achievement" and its "unusual facilities for research." The results were considered a "laboratory triumph," complementary to the material and appealing to the eye.[8] Polished to a translucent brilliance, the *Mariner's Bowl* represents the flawless quality of the new wares.[9] A blown object converted into a shallow bowl, its central engraving of a nautical compass is surrounded by four images: a male figure, North, who bears a two-handled cup; a female figure, South, who reclines beneath a palm tree; and two hybrid horse-fish forms, East and West, which complete the quartet.[10] This intricate engraving bears the illusion of bas-relief. Achieved by the scoring of the crystal surface with fine abrasives as it is turned on a copper wheel, it is a mark of the engraver's immense skill. But it further signals Steuben's conscientious drive toward modernism.[11] The works of the 1930s to 1950s were heralded as Steuben's best, and in 1937 the firm was rewarded with a gold medal at the Paris Universal Exposition.[12]

In adopting and celebrating this industrial aesthetic, the firm assumed the ideals of art moderne, and its products acquired the sculptural qualities of weight, balance, and proportion complementary to Steuben's new credo of "material,

119

workmanship, and design."[13] Steuben proactively distanced itself from the achievements of the previous century's Aesthetic, Arts and Crafts, and Art Nouveau artisans. According to the company's catalogue, modern Steuben glass was "not the florid outpouring of uncontrolled imagination, not the sterile imitations produced by pedantic research, not the dull commonplaces of 'craft' production," but rather the first "true" expression of an extraordinary material.[14]

As the *Mariner's Bowl* represents the changes in philosophy, technique, and taste that undergird the firm's progress described by Waugh, so it also records the evolving influence of new retail and marketing trends on craft production at large. The wares were sold at elite boutiques in New York, Chicago, and Palm Beach as well as through luxury retailers like Neiman-Marcus.[15] High-end marketing in fashion magazines and profile-boosting charity events at Steuben's Fifth Avenue shop helped fuel the firm's subsequent success.[16] Although the arrival of World War II forced modifications to Steuben's operations, as employees like Waugh were called into service and the military took control of domestic lead sources, the postwar era witnessed the company's revival. A series of new exhibitions excited popular interest in its wares.[17] Those displays coincided with a building boom and the consequent demand for home furnishings. To meet these needs, Steuben returned to its prewar designs, reinventing them for a growing audience. VMFA's *Tiger Bowl* (fig. 199), designed by sculptor Bruce Moore, highlights the adaptability of the prewar form.[18] Moore subsequently served as the firm's second associate designer.[19] SJR

FIG. 199 Bruce Moore (1905–1980), designer; Steuben Glass Works (founded 1903), manufacturer, **Tiger Bowl,** 1950, Corning, New York, glass, 1 ½ x 14 in. (3.8 x 35.6 cm) dia. Virginia Museum of Fine Arts, Bequest of Lelia Blair Northrup, 78.76.

NOTES

1. Sidney Waugh, Introduction in *Steuben Glass* (New York: Steuben Glass, 1947), 5–7.
2. Paul N. Perrot, Introduction in *Steuben: Seventy Years of American Glassmaking* (New York and Washington, D.C.: Praeger, 1974), 14–15; Paul V. Gardner, "Steuben Glass: The Carder Years, 1903–32," in *Steuben: Seventy Years,* 8–19.
3. Gold "Aurene" was followed by a blue version and other refined and engraved wares, many in the Art Nouveau style. Jane Shadel Spillman and Susanne K. Frantz, *Masterpieces of American Glass* (New York: Crown for the Corning Museum of Glass, 1990), 56; Gardner, 19–23.
4. Carder moved to Corning, N.Y., in 1903. The first piece of Steuben glass was produced in 1904. Carder's designs competed with those of Tiffany Furnaces and, in 1913, Tiffany took him to court; the suit was dropped. Spillman and Frantz, 56; Mary Jean Madigan, *Steuben Design: A Legacy of Light and Form* (New York: Abrams, 2004), 29; Isobel Lee Beers, *Stark Museum of Art: The Steuben Glass Collection* (Orange, Tex.: Nelda C. and H. J. Lutcher Stark Foundation for the Stark Museum of Art, 1978), 7.
5. James S. Plaut, "Steuben Glass: The Houghton Years, 1933–73," in *Steuben: Seventy Years,* 64–65.
6. The origins of lead crystal are in "flint" glass, first developed by the Englishman George Ravenscroft between 1674 and 1675. Once fired to a molten state, its viscous quality allowed it to be worked into more complicated shapes. The process required a highly skilled team to man the furnace, blow the glass, and oversee the design. Many of Steuben's employees were skilled European immigrants. Plaut, 65–66; Perrot, 15–16.
7. Plaut, 67–68.
8. *Steuben Glass,* 8.
9. Madigan, 55–63, 75.
10. These figures were introduced by Waugh to the company's design vocabulary. *Steuben Glass,* 30–31; Plaut, 76.
11. The process, which can take hundreds of hours, derived from Bohemian gem-cutting. A number of gem cutters immigrated to Corning during the late nineteenth century, setting up benches in their homes to meet the demands of a developing glass industry. Plaut, 76.
12. It was exhibited at VMFA in 1938 and again in 1974. *Steuben Glass,* 10–11.
13. Beers, 7; Donald Albrecht, "Glass and Glamour: Steuben's Modern Moment, 1930–1960," *The Magazine Antiques* 165 (January 2004): 170–77; Plaut, 65.
14. *Steuben Glass,* 9–10.
15. Beers, 8; Plaut, 65.
16. By 1937, Steuben occupied the lower floors of the pyrex-faced Corning Glass building at 718 Fifth Avenue, designed by the firm of Platt and Platt. Madigan, 36–37, 89.16
17. In 1951, the firm participated in *L'Art du Verre* at the Louvre. Madigan, 40–41.
18. Beers, 7.

120. Georgia O'Keeffe (1887–1986)

White Iris, 1930

Oil on canvas

40 x 30 in. (101.6 x 76.2 cm)

Gift of Mr. and Mrs. Bruce C. Gottwald, 85.1534

PROVENANCE: Doris Bry, New York; N.Y.; Andrew Crispo Gallery, New York, N.Y.; Baron Henry Thyssen-Bornemesza, Lugano, Switzerland (1974); Kennedy Galleries, New York, N.Y.; Mr. and Mrs. Bruce C. Gottwald, Richmond, Va. (1977)

121. Arthur Dove (1880–1946)

Mars Orange and Green, 1935

Oil on canvas

16 ½ x 25 ¾ in. (41.9 x 65.4 cm)

Signed lower center: "Dove"

Gift of Mr. and Mrs. Arthur S. Brinkley Jr., 79.137

PROVENANCE: Downtown Gallery, New York, N.Y.; Mrs. Lynne Thompson, Blue Hill, Maine (1948); Mr. and Mrs. Arthur S. Brinkley Jr. (1952)

A pair of paintings in VMFA's collection by two leading American modernists—Georgia O'Keeffe and Arthur Dove—provides an opportunity to reconsider the artists' personal and professional relationship, creative talent, and critical profile. The expressive imagery of *White Iris* and *Mars Orange and Green* represent subjects that are fundamentally rooted in nature, a shared interest of O'Keeffe and Dove that reflects their similar backgrounds. Both were raised in farming communities—O'Keeffe in Wisconsin and Dove in upstate New York—and found their calling in painting distinctive "sensations" of the "American earth." Contemporaries often ascribed a Whitman-esque association—an earthy, sexual, peripatetic impulse—to both artists (if in a rhetoric of gendered dichotomies), which points to a broader cultural context for understanding their reputations. The leading modernist critic Paul Rosenfeld famously argued in a 1924 collection of essays, *Port of New York*, that the two shared a "direct sensuous feeling of the earth," viewing Dove as "very directly the man in painting, precisely as Georgia O'Keeffe is the female; neither type has been known in quite the degree of purity before."[1]

White Iris may be interpreted as a transitional work for O'Keeffe, echoing the voluptuous florals of the 1920s that first established her as a painter of consequence while anticipating her more muscular southwestern imagery that flourished after she began spending more time in New Mexico.[2] The flower's elegantly sensuous curves and subtle pastel hues distinguish it from O'Keeffe's series of black irises painted in the late 1920s, works that flirted with a greater degree of abstraction and employed what art historian Kathleen Pyne has called "floral anatomy as the structure of feminine mystery." Such images were championed by O'Keeffe's husband, avant-garde photographer, dealer, and tastemaker Alfred Stieglitz. With the help of other contemporary writers such as Rosenfeld and Marsden Hartley, Stieglitz promoted them as pictures that revealed a new "natural feminine essence." Although O'Keeffe did not welcome this tenaciously sexualized reading of her signature flowers as abstract equivalents of women's bodies and experiences, she "surely exploited the floral composition as a sign of her femininity," as Pyne argues.[3]

Yet O'Keeffe's pictures do not evoke the conventional cultural associations of women and flowers—unlike the delicately wry and intimate conversation pieces by her modernist contemporary Florine Stettheimer (fig. 200), or even the more naturalistic renderings of her one-time Art Students League

FIG. 200 Florine Stettheimer (1871–1944), **Russian Bank,** 1921, oil on canvas, 40 x 36 in. (101.6 x 91.4 cm). Virginia Museum of Fine Arts, Gift of Ettie Stettheimer, 51.17.

120

FIG. 201 Frank Vincent DuMond (1865–1951), **Iris,** ca. 1895–1902, oil on canvas mounted on board, 40 x 36 in. (101.6 x 91.4 cm). Virginia Museum of Fine Arts, Gift of Jerome and Rita Gans, 97.116.

teacher Frank Vincent DuMond (fig. 201).[4] O'Keeffe's defiantly organic florals are entirely a thing apart, imbued with a disorienting tension between the quiet interiority of her private vision—what she called her "little world"—and a boldly extroverted frontality. As Pyne observes, through a process of magnification, O'Keeffe revealed the life source at the flower's center.[5] There is no question that O'Keeffe embraced her private visions; as she admitted in a public interview, conducted the year *White Iris* was painted, "Before I put brush to canvas, I question, 'Is this mine? Is it all intrinsically of myself? Is it influenced by some idea or some photograph of an idea which I have acquired from some man?'"[6]

O'Keeffe's emphasis on an authentic, personal, artistic expression conveyed with brash immediacy earned her Stieglitz's lifelong professional devotion. From the time of their 1916 meeting in his experimental Manhattan gallery at 291 Fifth Avenue, Stieglitz dubbed her "the spirit of 291." Dove concurred, praising O'Keeffe for "doing without effort what all we moderns have been trying to do."[7] Like O'Keeffe, Dove was viewed by Stieglitz and other contemporaries as

a sui generis painter, "hewn out of nature." According to his major patron, Washington, D.C., collector Duncan Phillips, Dove was "strictly yet sensuously visual. . . . One could not analyze him."[8]

In spite of their largely urban viewing audiences, O'Keeffe and Dove required remoteness and seclusion for their art making. While she increasingly sought out the stark desert settings of the Southwest, Dove spent his northeastern residency on farms and houseboats, gaining an intimate knowledge of nature's procreative processes of growth and change. His biomorphic landscapes of the Finger Lakes region of Geneva, New York, where he lived from 1933 to 1938 and where he painted *Mars Orange and Green,* are suffused with an abundance and inclusiveness not unlike that of O'Keeffe's floral imagery. Indeed, Dove's stylized nature scapes, which became increasingly animistic and abstract during the 1930s, are characterized by a noisy and animated fecundity—verdant and alive with pungent smells and sounds.[9]

While not entirely nonobjective, *Mars Orange and Green* is representative of Dove's mature work in its visceral fusion of abstract design and natural forms.[10] During his time in Geneva, Dove devoted himself to a systematic process with a focus on medium and technique. The title of VMFA's picture refers to specific paint colors favored by Dove in the mid-1930s and underlines his emphasis on artistic process over basic landscape elements of trees, hills, bird, and cottage,

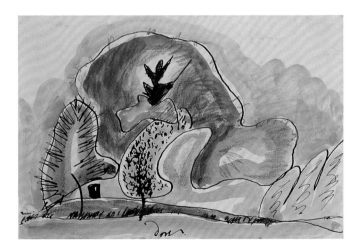

FIG. 202 Arthur Dove (1880–1946), **Mars Orange and Green,** 1935, watercolor on paper, 5 x 7 in. (12.7 x 17.8 cm). Collection of John and Dolores Beck.

121

which he reduced to schematic, if vivid, motifs.[11] (A related sketching his pictorial ideas outdoors while in Geneva.)[12] Despite its descriptive formalist title, *Mars Orange and Green* reveals a specificity of place that resonated with many of the decade's painters. O'Keeffe once explained that Dove was among her favorite artists because "he would get the feel of a particular place so completely that you'd know you'd been there."[13]

The notion of place—an art rooted in a complex nativism that evoked a locale physically and spiritually—supplied the name for Stieglitz's last gallery venture, *An American Place*, which opened at 509 Madison Avenue in late 1929. Throughout its twenty-one-year existence, the gallery-cum-modernist sanctuary would continue to showcase the forceful, life-affirming work of O'Keeffe and Dove, including *White Iris* and *Mars Orange and Green*.[14] SY

NOTES

1. Elizabeth Hutton Turner, *In the American Grain: Dove, Hartley, Marin, O'Keeffe, and Stieglitz: The Stieglitz Circle at the Phillips Collection,* exh. cat. (Washington, D.C.: Counterpoint in association with the Phillips Collection, 1995), 25. See also Marcia Brennan, *Painting Gender, Constructing Theory: The Alfred Stieglitz Circle and American Formalist Aesthetics* (Cambridge and London: MIT Press, 2001), 98–100.

2. There has been some debate regarding the precise title and date of VMFA's work. Once known as *Light Iris* and dated to 1924, it was reattributed by O'Keeffe scholar Barbara Buhler Lynes based on archival evidence, which includes a photograph recording its inclusion in a 1931–32 exhibition of recent New Mexico paintings at Stieglitz's American Place gallery. See *Georgia O'Keeffe, Catalogue Raisonné* (New Haven and London: Yale University Press for the National Gallery of Art and the Georgia O'Keeffe Foundation, 1999), 1:438, 2:Appendix III, fig. 47. The museum accepts this reattribution; see VMFA curatorial files.

3. Kathleen Pyne, *Modernism and the Feminine Voice: O'Keeffe and the Women of the Stieglitz Circle* (Berkeley, Los Angeles, and London: University of California Press, 2007), 260–61. For O'Keeffe's 1939 rebuke of the eroticized view of her flowers, see Brennan, 127. Despite Stieglitz's essentialist analysis of his wife's "feminine" art, he referred to O'Keeffe, along with artists Dove and John Marin, as his "A-1 men." See Abraham A. Davidson, *Early American Modernist Painting, 1910–1935* (New York: Da Capo Press, 1981), 20.

4. Stieglitz first visited Stettheimer's New York studio in 1921, the year she painted VMFA's *Russian Bank;* admiringly, he arranged another studio visit for O'Keeffe the following year. See Elisabeth Sussman and Barbara J. Bloemink, *Florine Stettheimer: Manhattan Fantastica,* exh. cat. (New York: Whitney Museum of American Art, 1995), 125. See also David Tatham, "Florine Stettheimer at Lake Placid, 1919: Modernism in the Adirondacks," *American Art Journal* 31 (2000): 25–26. For DuMond, see *The Harmony of Nature: The Art and Life of Frank Vincent DuMond 1865-1951,* exh. cat. (Old Lyme, Conn.: Florence Griswold Museum, 1990). For more on O'Keeffe's early artistic training—in Virginia and New York—see Charles C. Eldredge, *Georgia O'Keeffe: American and Modern* (New Haven and London: Yale University Press in association with InterCultura, Fort Worth; and the Georgia O'Keeffe Foundation, Abiquiu, 1993), 9–21. See also Marjorie P. Balge-Crozier, "Still Life Redefined," in *Georgia O'Keeffe:*

The Poetry of Things, exh. cat. (Washington, D.C.: Phillips Collection and Yale University Press, 1999), 41–53.

5. Pyne, 255–56, 261.

6. In the same interview—a public debate with Michael Gold, editor of the *New Masses*—O'Keeffe defended the "social content" of her art: "I have no difficulty in contending that my paintings of a flower may be just as much a product of this age as a cartoon about the freedom of women—or the working class— or anything else." See Elsa Mezvinsky Smithgall, "Georgia O'Keeffe's Life and Influences: An Illustrated Chronology," in *Georgia O'Keeffe: The Poetry of Things,* 110. The dialogue was later published. See Gladys Oak, "Radical Writer and Woman Artist Clash on Propaganda and Its Uses," *The World,* March 16, 1930, quoted in Turner, 40.

7. Turner, 38.

8. Ibid., 25.

9. See Elizabeth McCausland, "Dove: Man and Painter," *Parnassus* 9 (December 1937): 3–6; Ann L. Morgan, *Arthur Dove: Life and Work, with a Catalogue Raisonné* (Newark, Del.: University of Delaware Press, 1984), 54, 232; and Brennan, 99, 111–15 for period critics' conflation of Dove's "male vitality," that is, sexual energy—with his landscapes. As Barbara Haskell has argued, "Dove's sexual images are not so much specific biological representations as they are metaphors for an ecstatic vision of life." See Haskell, *Arthur Dove,* exh. cat. (San Francisco: Museum of Art, 1974), 77.

10. Dove has been viewed as a pioneer of abstraction since his production of six small nonobjective pastels in 1910, the year of Wassily Kandinsky's first purely abstract work; both artists were preceded in their experiments by the less known American modernist Manierre Dawson (see cat. 112). Davidson, *Early American Modernist Painting,* 53–54.

11. In the fall of 1935, Dove devoured the newly translated technical handbook *The Materials of the Artist and Their Use in Painting* (1921) by German artist Max Doerner; he noted that O'Keeffe called it her "Bible." Dove was particularly inspired by Doerner's description of painting in "resin oil tempera and resin oil colors with wax," noting it "has the most beautiful in itself quality that I have found." See Turner, "Going Home: Geneva, 1933–1938," in Debra Bricker Balk, *Arthur Dove: A Retrospective,* exh. cat. (Andover, Mass.: Addison Gallery of American Art, Phillips Academy, and the MIT Press in association with the Phillips Collection, 1997), 103–5. For an overview of the mid-1930s craze for wax-emulsion painting, possibly influenced by the Mexican muralist movement, see Gail Stavitsky, *Waxing Poetic: Encaustic Art in American during the Twentieth Century,* exh. cat. (Montclair, N.J.: Montclair Art Museum, 1999). Based on a handwritten label on the verso of the painting—now lost, but recorded in VMFA's curatorial files—a date of 1935 is accepted for *Mars Orange and Green.* For the proposed 1936 dating, see Morgan, 55–57, 232, and Turner, 27–28.

12. For Dove's working procedure, which involved enlarging the basic design of his watercolors with a magic lantern in order to translate them into oil, see Haskell, 77.

13. O'Keeffe's quotation appears in Calvin Tomkins, "The Rose in the Eye Looked Pretty Fine," *New Yorker,* March 4, 1974, 62.

14. Wanda M. Corn, *The Great American Thing: Modern Art and National Identity, 1915–1935* (Berkeley, Los Angeles, and London: University of California Press, 1999), 250. The American Place exhibitions that featured the respective works were *Georgia O'Keeffe: 33 New Paintings* (December 27, 1931–February 11, 1932) and *New Paintings by Arthur G. Dove* (April 20–May 20, 1936). See Sarah Greenough, *Modern Art and America: Alfred Stieglitz and His New York Galleries,* exh. cat. (Washington, D.C.: National Gallery of Art and Bulfinch Press, 2000), 550–51, and Morgan, 232.

122

122. Charles E. Burchfield (1893–1967)

Old House and Elm Trees, 1933–1940

Watercolor on paper

27 x 40 in. (68.6 x 101.6 cm)

Signed with monogram and dated lower right corner:

"CEB / 1933–40"

Museum Purchase, John Barton Payne Fund, 42.9.4

PROVENANCE: Purchased from the artist through *Third Biennial Exhibition of Contemporary American Paintings*, Virginia Museum of Fine Arts, Richmond, Va. (March 4–April 14, 1942)

Throughout his long career as a painter, Charles Burchfield looked closely at houses and depicted them frequently. And, to his imaginative eye, the houses looked back. "A house is often more moody than nature," a young Burchfield mused in his journal in 1916. "In the daytime they have an astonished look; at dusk they are evil; seem to brood. . . . Each one is individual." A few years later, he observed: "As we walk down a street . . . we have the feeling that the houses are looking at us; they glance up the street long before we come to them, and follow us brazenly as we go along, trying to stare us out of countenance."[1]

Burchfield was especially drawn to weathered clapboard houses. "You have the feeling that a lot of living has gone into [them]," he explained in later life.[2] The painter found the two-story dwelling featured in *Old House and Elm Trees* on the outskirts of southern Buffalo, New York, a couple of miles from his suburban home.[3] Picturing the structure and its smaller outbuilding behind a protective screen of sturdy elms, Burchfield instilled notes of ambiguity into his portrayal.[4] The house fronts a paved street, but the open farmland beyond reveals its location at the perimeter of development. No people are shown, but partially drawn window shades hint at habitation. Ornamental wooden trim at the windows and beneath the eaves testify to an owner's earlier bid for elegance; however, unpainted frame siding and jagged boards beneath the porch suggest a more prosaic present. Burchfield set the scene just after a soaking spring rain.[5] The dominant gray hues and stark contours convey a dreary, damp cold. Still, a gentle light breaks through thinning clouds and a soft canopy of new leaves, offering hope of fairer days to come.

The subtle lyrical note that boosts this otherwise somber picture stems from Burchfield's acute sensitivities to nature. As an introspective boy growing up in rural Salem, Ohio, he spent untold hours in the nearby woods, studying plants, insects, animals, and weather patterns. In 1916, following formal training at the Cleveland School (now Institute) of Art, Burchfield returned to Salem, where he developed a flat decorative watercolor style to capture the sights, smells, and sounds of the natural world. Over the next few years, he combined close observation with pantheistic stirrings to produce vibrant biomorphic images. With calligraphic lines and a personal system of symbols to express emotions, he also sought to imbue his images with mood, ranging from sunny exuberance to chilling terror.[6]

In 1921 Burchfield moved to Buffalo, where he worked as a designer for M. H. Birge and Sons, one of the nation's foremost wallpaper companies. For the next eight years, he continued painting, though time at the easel was limited as work responsibilities and the needs of his growing family mounted.[7] Nevertheless Burchfield managed to communicate his romantic visions in imaginative wallpaper patterns like "The Birches" (fig. 203), with its mysterious tangle of trees and vines.[8] His tendency to anthropomorphize subjects may account for the stray eyes, mouths, and nostrils that seem to sprout from the silvery boughs. During this period, the artist

FIG. 203 Charles Burchfield (1893–1967), designer; M. H. Birge and Sons, Buffalo, New York, manufacturer, **The Birches,** silk-screened wallpaper, designed 1921; in production 1923–26, 17½ x 19⅝ in. (44.5 x 49.8 cm) sheet. Virginia Museum of Fine Arts, Gift of Mr. J. B. Lankes, 90.196.

renewed his interest in small-town life, inspired by his own vivid childhood memories and fondness for the realist novels of American writers such as Sherwood Anderson, Willa Cather, and Sinclair Lewis. On weekend rambles, Burchfield sketched and painted residences, stores, and factories in Buffalo and surrounding towns, including his own community of Gardenville. After submitting watercolors to group exhibitions and selling through dealers in New York, he attracted attention in the mainstream press. In 1928 Edward Hopper, another artist drawn to America's vernacular architecture (see cat. no. 124), penned an appreciation of Burchfield in *Arts* magazine, praising the painter's "intensely emotional and personal vision of the American scene." The following year, increasing sales and recognition gave him the confidence to leave Birge and Sons and take up painting full time.[9]

When he painted *Old House and Elm Trees* in 1933, Burchfield had already gained national acclaim for his gritty townscapes and industrial scenes. This "wet, somber, and poetic watercolor"—as described by *Art News*—exemplifies the painter's shift in direction toward the more serious, solid style that he would maintain over the following decade.[10] Subordinating an earlier penchant for fantasy, these "middle years"—as Burchfield scholar John I. H. Baur identified the painter's realist phase—produced tough, unvarnished glimpses of small-town life in Depression-stricken middle America. His images of false-front stores, tumbledown shacks, crumbling factories, and abandoned freight cars were singled out in *Time* magazine's major 1934 art review celebrating the "U.S. Scene." The article grouped Burchfield with other "earthy" midwestern painters—including Thomas Hart Benton (see cat. no. 118), Grant Wood, and John Steuart Curry, who were praised for their dedication to representing their native land and people rather than succumbing to the insidious abstraction of European modernism. In a climate shaped by interwar isolationism and the Great Depression, Burchfield found himself riding the powerful wave of American scene realism.[11] Throughout the 1930s, he won numerous prizes, juried exhibitions at prominent institutions and at the New York world's fair, and enjoyed a solo exhibition at the Museum of Modern Art. Pleased at his growing fame, Burchfield nevertheless chafed at the American scene label, resisting categorization as a regional artist and downplaying

nationalistic readings of what he insisted were straightforward renderings.[12]

In 1944, two years after VMFA purchased *Old House and Elm Trees* from its *Third Biennial Exhibition of Contemporary American Paintings,* Burchfield contacted the museum to request several photographs of the painting. He wrote that he wanted the images not only for his own files but for the house's owner, who wished send the pictures to her five sons fighting overseas. Pleased at having the well-known artist represented in its collection, the museum provided the photos promptly.[13] Even as he wrote, however, Burchfield was in the middle of dramatic break with American scene representation. "I am in danger of painting too realistically," he explained to his puzzled dealer, "and must try to recapture the first imaginative and romantic outlook."[14] Believing he had lost the depth of feeling that he enjoyed in his earlier years, he consciously changed to a more abstract, expressive style in 1943. Reworking and replicating the paintings of his youth, he began a new phase of rhapsodic nature-themed images that occupied him through the end of his life. Once again employing bright colors, stylized forms, and flat decorative lines to express his response to the world around him (fig. 204), he nevertheless held on to representation. Watching the emergence of pure abstraction and formalism in the late 1940s—

FIG. 204 Charles Burchfield (1893–1967), **Gateway to September,** 1946–56, watercolor on paper, 42 x 56 in. (106.7 x 142.2 cm). Hunter Museum of American Art, Chattanooga, Tenn., Gift of the Benwood Foundation, 1976.3.6.

culminating in the primacy of abstract expressionism in the 1950s—Burchfield conceded at the end that abstraction had "won its battle."[15] ELO

NOTES

1. Burchfield journal entry, September 16, 1916, and Sketchbook II, 1919, both quoted in John I. H. Baur, *The Inlander: Life and Work of Charles Burchfield, 1893–1967* (Newark, Del.: University of Delaware Press; New York: Cornwall Books, 1982), 41, 99–100.

2. Sharing his perception that older houses were ruined by fresh paint, Burchfield declared a fascination with the "beautiful tobacco brown that unpainted lumber gets." Charles Burchfield, oral history interview, conducted by John D. Morse, August 19, 1959, tape 1, Archives of American Art, Washington, D.C.

3. In his catalogue raisonné of the artist's work, Joseph Trovato lists the water-color as no. 934 and notes the house's location as "Abbott Road, South Buffalo," a spot just over two miles from Burchfield's studio-residence in Gardenville, New York. Trovato, *Charles Burchfield: Catalogue of Paintings in Public and Private Collections* (Utica, N.Y.: Munson-Williams-Proctor Institute, 1970), 190.

4. Michael Kammen asserts that in American literature and imagery, the combination of an aged house and elm tree (this species in particular) is especially potent in its evocation of time and memory. He singles out Burchfield's *Old House and Elm Trees* as an "ultimate (because most direct) assertion" of these associations. Kammen, *Meadows of Memory: Images of Time and Tradition in American Art and Culture* (Austin: University of Texas Press, 1992), 134–62.

5. According to the artist, he painted the watercolor in May 1933. Letter, Burchfield to Virginia LaSalle, Boston, October 8, 1962, copy in VMFA curatorial files. His signed date "1933–40" indicates that he made additional touches to the composition at some point during the next seven years.

6. Baur, 17–124.

7. Unlike traditional watercolor technique in which the water-soaked paper is laid flat, Burchfield's method was to mount dry paper upright on an easel and lay down strokes with brushes holding a minimum amount of water. Burchfield, oral history interview, 1959.

8. Baur, 126–50. According to the artist, "The Birches" (Birge No. 1186) was the first design made for Birge and was based on his 1917 watercolor, *Bluebird and Cottonwoods*. Printed between 1923 and 1926, it appears in eight color schemes, of which VMFA has three examples. Edna M. Lindemann, *Wallpapers by Charles E. Burchfield*, exh. cat. (Buffalo, N.Y.: Charles E. Burchfield Center, 1973), 13.

9. Baur, 103–5; Edward Hopper, "Charles Burchfield: American," *Arts* 14 (July 1928): 5–12.

10. Baur, 150–66. "Richmond Prizes Quality not Publicity," *Art News* 41 (March 15, 1942): 14.

11. "U.S. Scene," *Time*, December 24, 1934, 25. Although Burchfield seldom painted people, most of the American scene artists, including Thomas Hart Benton and Paul Sample (see cat. nos. 118 and 125), were figurative painters. For an examination of the movement, see Matthew Baigell, *The American Scene: American Painting of the 1930s* (New York: Praeger, 1974).

12. Milton W. Brown, "The Early Realism of Hopper and Burchfield," *College Art Journal* 7 (Autumn, 1947): 3–11. Baur argues that despite his protestations, Burchfield's art was nonetheless a celebration of place—"of Buffalo region and the Ohio River valley—a region quintessentially American." Baur, 168–69.

13. Letter, Burchfield to Virginia Museum of Fine Arts, December 4, 1944, VMFA curatorial files.

14. Letter, Burchfield to Frank K. M. Rehn, September 21, 1944, quoted in Baur, 196.

15. Burchfield, oral history interview, 1959.

123. Walt Kuhn (1877–1949)

Salute, 1934

Oil on canvas
72 x 31 ⅞ in. (182.9 x 80.9 cm)
Signed and dated lower left: "Walt Kuhn 1934"
Museum Purchase, The Adolph D. and Wilkins C. Williams Fund, 79.12

PROVENANCE: Estate of the artist; Kennedy Galleries, New York, N.Y.

In 1932, two years before completing his powerful *Salute*, Walt Kuhn invited viewers to explore his latest canvases as "a number of new and specific adventures in design, color, and human psychology."[1] On all counts, this monumental image of a showgirl provides ample opportunity for such adventurous investigation.

In *Salute*, Kuhn depicts a young woman dressed for the stage in a brightly colored costume, white gloves, and plumed shako cap. Standing against an austere blue-gray background and squared with the picture plane, she acknowledges us with a direct look and crisp salute.[2] The carefully proportioned canvas, recalling the vertical format of earlier grand-manner portraiture, lends formality to the composition.[3] The figure's red, white, and blue ensemble—with festoons of gold braid, epaulets, and an eagle emblazoned on the cap—inserts a note of patriotism. And her steadfast military stance, rigid and firmly anchored by jet-black boots, suggests tradition and stability. Nevertheless, Kuhn undermines such conventions with his audacious subject—a heavily made-up, scantily clothed performer, who meets our eyes with a bold, disquieting gaze. In a 1930 catalogue, critic Alan Burroughs offered his assessment of similar theatrical figures by the artist:

> [Walt Kuhn] wants to paint strongly the things he feels are subtle and general at the same time. . . . He wants you to see . . . a magnificent set of shoulders, formally posed to show off their massive grace. He wants you to believe in his admiration for these shapes and his restraint in presenting them as objects of admiration. But . . . he calls upon you to relish cheap color and a garish model. . . . [The canvas] is delicately painted, nevertheless. And if Walt Kuhn is stimulated by the necessity of combining lavender and veridian,

123

one should not object—provided he concocts enough of each to make a stunning combination and keeps them simple.[4]

Kuhn developed his keen sense of color, form, and composition as an early proponent of European modernism. The Brooklyn-born artist studied abroad at the Académie Colarossi in Paris and the Royal Academy in Munich at the turn of the twentieth century. On his return to New York City, he worked as a magazine illustrator and a painter and taught art at the New York School of Art, where he was befriended by Robert Henri and John Sloan (see cat. no. 111). Aligning himself with these leading realists (more philosophically than stylistically), Kuhn helped them stage the unjuried *Exhibition of Independent Artists* in 1910. Three years later, he played a principal role in organizing the landmark *International Exhibition of Modern Art*—better known as the Armory Show. Guided by Arthur B. Davies (see fig. 188), who headed the endeavor, Kuhn traveled to Holland, Germany, and Paris to select examples of the latest artistic currents for the exhibit. By the time the Armory Show concluded its sensational New York run in 1913, he had established himself as one of America's foremost authorities on postimpressionism, cubism, futurism, and expressionism. Meeting and studying the work of fauve painters— notably André Derain, whose controlled lines instill monumentality in even his smaller renderings (fig. 205)—had a profound and lasting effect on Kuhn's personal style.[5]

While gaining notice and exhibition opportunities for his landscapes and still-life subjects in the late 1910s, Kuhn began supplementing his income by designing sets for musical revues and directing pantomime acts. He developed an enduring fascination with the world of show business and, by the late 1920s, found critical acclaim for his portrayals of circus, theater, and vaudeville performers. These would form the mainstay of his oeuvre through the remainder of his career. In the tradition of Jean-Antoine Watteau, Edgar Degas, and Pablo Picasso, many of Kuhn's stage figures—including the sturdy blonde pictured in *Salute*—often belie the gaiety of their costumes and makeup with expressions that hint of detachment, fatigue, or despair.

At the time of Kuhn's death in 1949, *Salute*—one of a small number of the artist's full-length showgirls—remained in his possession. Furthermore, the painting had been signed and dated, but never exhibited.[6] Kuhn scholar Philip Rhys Adams finds significance in this history. The artist, plagued by extreme self-criticism, systematically reviewed each year's output and destroyed or painted over any canvas that displeased him. Kuhn, Adams suggests, may have held onto *Salute* as a personal monument, knowing that the impressive painting might someday serve as a posthumous curtain call. "And," Adams concludes, "with his innate sense of theater he was not mistaken."[7] ELO

FIG. 205 André Derain (1880–1954), **Portrait of a Woman's Head,** n.d., oil on panel, 12 ⅔ x 12 ½ in. (32.2 x 31.8 cm). Virginia Museum of Fine Arts, Gift of Stephen C. Clark, Esq., New York, 1945, 45.24.1.

NOTES

1. Artist's statement in *Exhibition of Paintings by Walt Kuhn*, exh. cat. (New York: Marie Harriman Gallery, 1932), quoted in Philip Rhys Adams, *Walt Kuhn, Painter: His Life and Work* (Columbus: Ohio State University Press, 1978), 128.

2. In his 1978 catalogue raisonné of Kuhn's work, Philip Rhys Adams identified Elsie Ricardo as the model for *Salute*, but offered no additional information about the sitter. He also notes the existence of a preliminary ink sketch for the painting. Adams, 262, cat. no. 327. This sketch, inscribed "Walt Kuhn / 1934 / Study for 'Salute,'" is reproduced as fig. 64 in *Walt Kuhn*, exh. cat. (New York: Kennedy Galleries, 1968), n.p.

3. Kuhn was meticulous about positioning his figures in relation to the physical edges of the painting, sometimes restretching the canvas to achieve desired proportions. Adams, 118.

4. Alan Burroughs, Foreword in *Exhibition of Paintings by Walt Kuhn*, exh. cat. (New York: Marie Harriman Gallery, 1930), quoted in Adams, 128. Marie and her diplomat husband, Averell Harriman, were longtime patrons of the artist.

5. In 1871, Kuhn's Bavarian father and Spanish mother emigrated from Munich to Brooklyn, where they owned and operated the International Hotel. After a short stint selling and racing bicycles, young Kuhn journeyed to California in 1899 and began his artistic career as a newspaper cartoonist and sign painter. A year later he returned to Brooklyn before commencing his three years of art study abroad.

Adams, 3–16; 25–30, 44–60, 150. For an examination of the Armory Show and its aftermath, see Milton W. Brown, *American Painting from the Armory Show to the Depression,* 2nd ed. (Princeton, N.J.: Princeton University Press, 1972), 47–67.

6. Kuhn would delay signing a work until it was critiqued and approved by his wife and daughter. The calligraphy of his signature and date were then affixed to the canvas as an integral part of the composition. Adams, 118. The artist was also sensitive to the visual impact of frames on his work. While contemporary but not original to the VMFA canvas, the handsome hand-carved and gilded frame on *Salute* is of Kuhn's own design.

7. Adams, "Walt Kuhn's *Salute,*" *Arts in Virginia* 25 (1985): 3, 11n25.

124. Edward Hopper (1882–1967)

House at Dusk, 1935

Oil on canvas

36 ¼ x 50 in. (92.1 x 127 cm)

Signed lower left: "E. HOPPER"

PROVENANCE: Frank K. M. Rehn Gallery, Inc., New York, N.Y.

There is something mysterious to me about the effects Hopper gets in his painting. It carries more meaning than one can account for: the whole always seems to be more than the sum of its parts. His pictures, cool in color, reticent in design, almost determinedly humdrum and undramatic in subject matter, at first glance appear to be only a step away from the purely illustrative. Yet in the space of that step a mood is created that, in his best pieces, lifts the subject instantly out of its ordinariness . . . gives it poetry and momentousness, and sets up strange overtones of suggestion, which continue for as long as one looks at the picture, or even for as long as one remembers it.[1]

The undeniable truth about clichés is that they are sometimes apt and warranted. Robert Coates's 1950 assessment of the compelling imagery of Edward Hopper, like many such descriptions, is a case in point. From Hopper's first belated successes in the New York art world of the mid-1920s to his enduring iconic status as America's most celebrated "painter of loneliness," the artist's evocative pictures of modern America continue to haunt viewers, so firmly are they embedded in the cultural imagination.

House at Dusk, imbued with Hopper's characteristic themes of temporality and ambiguity, is one of the strongest and most lyrical oils of his mature production. The scene is set at the "exquisite hour" of dusk, as one of the artist's favorite French poets, Paul Verlaine, termed this most atmospheric time of day. Hopper's biographer Gail Levin has linked his preference for painting such temporal transitions—specifically, the attendant light effects and shifting moods—to French symbolist literature, which he had discovered as an art student and continued to read all his life. Whatever the source of his interest, Hopper was fascinated with the concept of time, and it remained, in literal and metaphoric terms, a critical leitmotif in his art.[2]

America's architectural past and its relationship to a changing environment also occasioned many of Hopper's most redolent images, particularly those, such as *House at Dusk,* that were painted during the Great Depression. The flat-roofed, ornately corniced Victorian apartment building, nestled on the compressed edge of an exaggeratedly lush urban park, is the main character in this drama—its expressive rhythm of half-drawn shades and illuminated windows echoing the play of outdoor light from the street lamp with the darkening sky. As in many of his works, Hopper introduced a suspenseful narrative element; here, a woman silhouetted by artificial light, is seemingly unaware of the subtle afterglow occuring behind the building. Seated in a red upholstered armchair, she conveys a sense of expectancy with her tense posture—leaning forward, right arm on window sill— as if anxiously awaiting someone's return. The gentle left-to-right sweep of twilight in the evening sky modulates from yellow to green to blue, as if directed by a slight breeze that moves across the band of cloud-streaked trees with discernible purpose. The geometric slabs of light and shadow that define the building, stairs, and natural backdrop create a hermetic stillness—no birds sing nor sirens wail. This is Hopper's New York, subdued, even suspended, yet pregnant with possibility.

The sense of quiet unease that some viewers have found in this meditative scene—one connecting its melancholic mood to the impending death of the artist's mother—may derive from the encroaching darkness as well as from the tension between private lives and public settings that shapes so much of Hopper's art.[3] Realistic yet disorienting in its detail,

124

FIG. 206 Samuel Woolf (1880–1948), **The Under World,** ca. 1909–10, oil on canvas, 22½ x 30½ in. (57.1 x 77.5 cm). Virginia Museum of Fine Arts Purchase, funds provided by a private Richmond foundation, 95.101.

FIG. 207 Edward Hopper (1882–1967), **House Tops,** 1921, etching on paper, 6 x 8 in. (15.2. x 20.3 cm). Harvard University Art Museums, Cambridge, Mass. Philadelphia Museum of Art, Purchased with the Thomas Skelton Harrison Fund, 1962.

the picture suggests both a specificity of place—one writer has offered Upper Manhattan's Morningside Park—as well as a liminal dreamscape, evoking memories of settling twilights everywhere.[4] Although Hopper developed his aesthetic under the tutelage of Robert Henri (see cat. no. 111), the de facto leader of the so-called Ashcan group of urban realists, his city images share little with the noisy, picturesque scenes of other Henri followers or contemporaries equally fascinated

by the private and public dimensions of the metropolis—for example, *The Under World* (fig. 206) by Samuel Woolf. Better known for his later portraits of presidents and celebrities as well as his World War I illustration work, Woolf, like the Ashcan painters, began his career as an artist-journalist—"with a strong sense of drama, of realism." His vivid depiction of urban characters in *The Under World*—the "showgirl" and her "protector," a messenger boy, an immigrant family—reveals the mixing of class, gender, and ethnicity that occurs on the New York subway (specifically, the Interborough Rapid Transit, or IRT), which opened its first line in 1904, between city hall and West 145th Street.[5]

Whereas the rendering of the figures in both *House at Dusk* and *The Under World* suggests a focus that has been called (in relation to Hopper) "a respect for their right to inner privacy in the face of mass living," the artists approached their theme in different ways. Woolf's types may be practicing "civil inattention"—averting eyes and maintaining separate stances in a situation of forced intimacy—but are far from alienated. Instead, they form a makeshift community quite unlike the silent, solitary figures populating Hopper's desolate urban stage.[6]

More Baudelarian flâneur than Whitmanesque omnibus rider, Hopper trains an intense voyeuristic eye on the anonymity of urban life, allowing viewers "to witness his act of seeing."[7] For example, the pervasive air of longing and isolation in his 1921 etching of a commuter in *House Tops* (fig. 207), which anticipates *House at Dusk* in its rhythmic sequence of windows and introspective woman, provides a sharp contrast with Woolf's lively emphasis on subterranean urban fellowship that also suggests an all-seeing, if more viscerally engaged, presence.

Whether glimpsed through his studio window or discovered on his legendary rambles through New York, Hopper's (like Woolf's) earliest urban scenes were informed by those of John Sloan (see fig. 185), a Henri disciple who particularly impressed Hopper with his ability to capture the "quality of a brooding and silent interior in this vast city of ours."[8] By the late 1920s, however, Hopper had discovered his own subject in an emotional response to modern living, capturing a "proud melancholy in the everyday."[9] Moving away from the Ashcan realist aesthetic, he, along with his friend Charles Burchfield

(see cat. no. 122), adopted a "romantic realism," informed by a "poet's sense of mood." Or, as Pamela Koob sums up Hopper's practice: "Expressing emotion by transforming the scene that triggered it, he merged inner realm with exterior fact." Insisting that his "aim in painting has always been the most exact transcription possible of my most intimate impressions of nature," Hopper distinguished himself from other urban realists with work of "severe and ungarnished power," becoming widely recognized as one of the leading interpreters of the so-called American scene.[10]

This was the artist's reputation at the time VMFA purchased *House at Dusk* for $4,000 in 1953. The museum's relationship with Hopper likely began with an introduction from his longtime dealer Frank Rehn, who served as a juror for VMFA's 1937 annual *Virginia Artists* exhibition. The following year Hopper himself helped select works for the museum's *First Biennial Exhibition of Contemporary American Paintings;* he returned in 1953 as a member of a three-person jury (along with sculptor Jacques Lipchitz and arts administrator Gordon B. Washington) for the *Virginia Artists* effort. *House at Dusk* appeared in Richmond that year as a feature of the concurrent *Judge the Jury* display; it had earlier been seen in exhibitions at New York's 1939 World's Fair as well as in Chicago and Venice, where Hopper was one of four American representatives in Italy's international Biennale of 1952. No less an authority on contemporary painting than Alfred Barr, director of New York's Museum of Modern Art, recommended *House at Dusk* as first on a list of definitive, available Hoppers to VMFA's director, Leslie Cheek Jr., who predicted "prompt action" from the accessions committee. He was not mistaken in his assumption.[11] SY

NOTES

1. Robert M. Coates, "The Art Galleries: Edward Hopper and Jackson Pollock," *New Yorker,* February 25, 1950, 73.

2. Gail Levin, *Edward Hopper: The Art and the Artist,* exh. cat. (New York: Whitney Museum of American Art in association with W. W. Norton, 1980), 61–63. Levin also cites Hopper's interest in Robert Frost's poem about dusk entitled "Come In." For more on Hopper's fascination with symbolist writings, see Pamela N. Koob, "States of Being: Edward Hopper and Symbolist Aesthetics," *American Art* 18 (2004): 53–77.

3. Susan Goldman Rubin makes the connection between Hopper's feelings for his ill mother and a poem about evening by Goethe, which the artist knew in both German and English: "All the birds are quiet in the woods/Soon you will rest too." See *Edward Hopper: Painter of Light and Shadow* (New York: Abrams Books for Young Readers, 2007), 38.

4. See Lawrence Campbell, "Edward Hopper," *Arts in Virginia* 13 (Winter 1973): 28. I am grateful to architectural historian Matthew Postal at the New York City Landmarks Preservation Commission for suggesting the specific Morningside Park reference. Wooded bluffs in Hopper's art may also evoke his native Hudson River Valley town of Nyack, New York. See Levin, "Edward Hopper's Nyack," *New York Times,* September 8, 1995. Artist Josephine Verstille Nivison, Hopper's wife, muse, and manager, described *House at Dusk* in detail in the artist's record book. Noting the alternate title "House by an Evening Park," she continued: "Light in lamp post has just been lit—it is a summer evening, early; sky still light—sun gone down back of the trees. It is a park." The lack of a specific location indicates the synthetic nature of most of Hopper's depicted scenes, culled from his memory and imagination. See Levin, *Edward Hopper: A Catalogue Raisonné,* vol. 3, *Oils* (New York: Whitney Museum of American Art in association with W. W. Norton), 238. The painting's particular appeal to European audiences (*House at Dusk* is frequently requested for loan to overseas exhibitions, especially in Germany) suggests further evidence of its universality and/or its symbolist overtones. One writer compares it to the Belgian surrealist René Magritte's 1954 *Realm of Lights.* See Wieland Schmied, *Edward Hopper: Portraits of America* (Munich and New York: Prestel, 1995), 52.

5. Despite his more progressive artistic beginnings, Woolf ended his career an avowed antimodernist, linking abstract painting of the mid-1940s to fakery, incompetence, and insanity. See "S. J. Woolf Dead; Artist-Writer, 68," *New York Times,* December 4, 1948. For a discussion of *The Under World,* see David Park Curry, "Shopping, Collecting, Remembering: Some Turn-of-the-Century American Pictures," *International Fine Art Fair Directory* (1996): 12–13, and Jan Seidler Ramirez, "New Century Cityscapes or, Painting the 'New Metropolis,'" *Culturefront* 6 (Winter 1997–98): 141–42.

6. "Edward Hopper, Painter of the American Scene, Dies Here at 84," *New York Times,* May 17, 1967; see also Ramirez, 141.

7. The distinction between the French and American writers' responses to the urban spectacle may be characterized in terms of distance versus engagement. See Charles Baudelaire's influential essay "The Painter of Modern Life," in *The Painter of Modern Life and Other Essays,* trans. and ed. Jonathan Mayne (New York: Da Capo Press, 1964), 1–40. For Walt Whitman's passion for the "living, endless panorama" of city life, see his *Calamus* (Boston: Laurens Maynard, 1897), 41–42. See also Koob, 68, on Hopper's "state of being" as his primary subject.

8. Edward Hopper, "John Sloan and the Philadelphians," *The Arts* 11 (April 1927): 158–78. As Koob notes, Henri's emphasis on the "idea" over the "object" suggests that the influential teacher's lectures were informed by symbolist ideas. See Koob, 60–63.

9. Celia McGee, "Hopper, Hopper, Everywhere," *New York Times,* July 24, 1994. See also Koob, 66, 72.

10. According to critic John Canaday, Hopper's city pictures remind us that "nature in an urbanized century is only a relative concept," quoted in "Edward Hopper, Painter of the American Scene, Dies Here at 84." See also Koob, 72, and "Edward Hopper: Famous American Realist Has Retrospective Show," *Life,* April 17, 1950, 103.

11. See exhibition records, VMFA Library and "Voting Device Streamlines Judging of Paintings Here," *Richmond News Leader,* March 21, 1953. The other American artists featured in the Venice Biennale of 1952 were Alexander Calder, Stuart Davis (with VMFA's *Little Giant Still Life*—see cat. no. 136), and Yasuo Kuniyoshi. For memoranda to Cheek regarding the availability of Hopper works for exhibition and sale, Barr's list of subsequent recommendations, and correspondence between the artist and Cheek regarding the picture's original frame, see VMFA curatorial files.

125

125. Paul Sample (1896–1974)

Spring Song, 1938

Oil on canvas

40¼ x 45⅝ in. (102.2 x 123.5 cm)

Signed and dated lower left: "PAUL SAMPLE '38"

Museum Purchase, The John Barton Payne Fund and the Arthur and

The Margaret Glasgow Fund, 2003.64

PROVENANCE: Ferargil Galleries, New York, N.Y. (1934–41); Associated American Artists, New York, N.Y. (1941); 21 Club, New York, N.Y. (1948 to 2003)

With his 1938 painting *Spring Song,* Paul Sample created an allegory of the senses. In varying shades of soft brown—suggestive of the haze of cigar smoke—he depicts two figures in the corner of a small bar. Wearing a soft fedora tilted to one side, a man plays an upright piano. The musician needs no sheet music for his impromptu performance; a frothy beer stands ready to supply inspiration. The austere setting is intensely masculine, adorned with only a worn chair, a sliver of mirror, liquor bottles, a boxing picture, and a men's-room door. Nevertheless, the tune apparently strikes a sentimental chord with the barkeep, who leans on his elbow, lost in thought.

The model for the pianist was Sample's friend Bill Cunningham, a *Boston Herald* columnist whom the artist first rendered in a series of pencil sketches (fig. 208).[1] When later describing the studio sessions, Cunningham noted that he imagined himself portrayed soulfully playing "Rachmaninoff or some such at a great concert grand." To his surprise, the completed canvas cast him as a "tough guy . . . pouring forth his not altogether cast iron inside in tin-panny melody oblivious to the world."[2]

The imaginative scene evokes the isolationist mind-set of 1938 America. While Hitler's invasion of Austria culminated in Kristallnacht abroad, Americans turned inward. Long burdened by the Great Depression and years of high unemployment rates, Congress enacted the first minimum-wage law. Meanwhile, a winning streak by the misfit thoroughbred Seabiscuit offered an exciting popular diversion for those who rooted for the underdog. An article in the July issue of the prominent *Magazine of Art* singled out Paul Sample as an artist who sought to picture "the plain unvarnished facts of American life." The writer explained, "The American scene

thus depicted is basically the human scene. . . . It is an art of people and what they do and the places they live in."[3]

During the 1930s, there was a groundswell of interest in creating "works of art that, avoiding foreign influences, actually expressed the spirit of the land."[4] Sample and others of the American scene movement—among them Thomas Hart Benton (see cat. no. 118), Grant Wood, Reginald Marsh, and John Steuart Curry—consciously separated themselves from European movements, notably modernist trends such as cubism, synchronism, and surrealism. They were nonetheless informed by the realist traditions of Edouard Manet and Edgar Degas. Their American influences were more direct: the gritty visual reportage of Robert Henri (see cat. no. 111) and members of his Ashcan group as well as their realist followers, such as Edward Hopper and George Bellows (see cat. nos. 124 and 113). However, the American scene artists of the interwar years tended to redirect their glimpses of everyday life through the more constraining filters of nativism and regionalism.[5]

FIG. 208 Paul Sample (1896–1974), **Sketch for *Spring Song,*** ca. 1938, pencil on paper, from Paul Sample sketchbook. Hood Museum of Art, Dartmouth College, Hanover, N.H.

Paul Sample, a native of Kentucky, attended Dartmouth College, in New Hampshire, and served with the merchant marines during World War I. An extraordinary athlete (intercollegiate heavyweight boxing champion), he was stricken with tuberculosis in 1921. During his recuperation, he began painting lessons. After studying at the Otis Art Institute in

Los Angeles, he commenced a lifelong career as an art teacher, taking a position at the University of Southern California, in Los Angeles. The year he painted *Spring Song,* he was named artist-in-residence at his alma mater Dartmouth, where he remained for an additional thirty years.[6]

In his own day, Sample ranked high among American realists. In 1934 *Time* magazine identified him alongside Thomas Hart Benton as a leader of the regionalist school.[7] Five years later, his *Spring Song* was chosen for the *American Art Today* exhibition at the New York City World's Fair. Sample's landscapes and figurative works—*Spring Song* was among the best and most often exhibited—were celebrated as fine examples of "progressive American art" by contemporary critics.[8] With ironic appropriateness, the painting was acquired by and exhibited at the 21 Club—the acclaimed New York restaurant that began as a speakeasy during Prohibition. It remained in the club's well-known art collection from 1948 to 2003.[9]

Paul Sample also has ties to the early history of the Virginia Museum of Fine Arts. In 1938, the year he painted *Spring Song,* he was selected by a jury headed by Edward Hopper to participate in the new museum's *First Biennial Exhibition of Contemporary American Paintings.* He exhibited in this nationally recognized biennial three more times, including the 1940 show, for which he himself served as an esteemed, well-known juror.[10]

After World War II, during which Sample toured the front lines as an artist-correspondent for Time-Life, the nation's artistic climate shifted. Realist painting fell into disfavor with more widespread acceptance of international modernism and the rise of nonobjective art.[11] In American art history, Sample was eventually eclipsed by his better-known regionalist contemporaries such as Benton and Wood. Nevertheless, the late twentieth century brought renewed interest in and reconsideration of the significant efforts of Sample and other realist painters of the interwar era. DPC, ELO

NOTES
1. The drawing pictured is one of three preparatory studies for the painting in the artist's sketchbooks. Our thanks to Barbara J. McAdam, Cohen Curator of American Art, Hood Museum of Art, Dartmouth College, Hanover, New Hampshire, for bringing them to our attention.
2. Bill Cunningham, "Sample's Brush Does War Epics," *Boston Herald,* November 12, 1943, 28. The broad, large-scale treatment of the figure is unusual in Sample's imagery. One scholar suggests that the monumental formulation may have come
from his recent work on a series of post-office murals at Redondo Beach, California. John Haletsky, *Paul Sample, Ivy League Regionalist* (Miami, Fla.: Lowe Art Museum, University of Miami, 1984), 39.
3. Alfred Frankenstein, "Paul Sample," *Magazine of Art* 31 (July 1938): 387.
4 Peyton Boswell Sr., *Americana Annual,* 1932, cited in Matthew Baigell, *The American Scene: American Painting of the 1930s* (New York: Praeger, 1974), 18.
5. Rebecca Zurier et al., *Metropolitan Lives: The Ashcan Artists and Their New York* (Washington, D.C.: National Museum of American Art; New York: W. W. Norton, 1995), 212–13; Zurier, *Picturing the City* (Berkeley: University of Californmia Press, 2006), 12–16; Matthew Baigell, "American Art and National Identity: The 1920s," in Mary Ann Calo, ed., *Critical Issues in American Art: A Book of Readings* (Boulder, Colo.: Westview Press, 1988), 280–82.
6. For an examination of Sample's life and career, see Robert L. McGrath and Paula F. Glick, *Paul Sample: Painter of the American Scene* (Hanover, N.H.: Hood Museum of Art, Dartmouth College, 1988).
7. "U.S. Scene," *Time,* December 24, 1934, 24.
8. "Paul Sample, Who Worships Peter Breughel," *Art Digest* 8 (May 1, 1934): 8; Peyton Boswell, "The Ivy League in Art," *Art Digest* 12 (February 15, 1938): 3; "Chicago Views State of American Art in its Annual," *Art News* 39 (November 16, 1940): 9; "Paul Sample," *American Artist* 6 (April 1942): 16–21.
9. H. Peter Kriendler, brother of one of the club's cofounders, mentions the painting in his memoir, *"21": Every Day was New Year's Eve,* written with H. Paul Jeffers (Dallas, Tex.: Taylor, 1999), 107.
10. At VMFA, Sample exhibited in the 1938, 1940, 1942, and 1948 juried showings of the *Biennial Exhibition of Contemporary American Paintings.* Exhibition archives, VMFA Library.
11. McGrath and Glick, 43–45.

126. Yasuo Kuniyoshi (1889–1953)

Nevadaville, 1942

Oil on canvas
24 ⅜ x 40 ⅛ in. (61.2 x 102 cm)
Signed lower right: "Y. Kuniyoshi"
Museum Purchase, John Barton Payne Fund, 44.8.1

PROVENANCE: Purchased from the artist through the *Fourth Biennial Exhibition of Contemporary American Paintings,* Virginia Museum of Fine Arts, Richmond, Va. (March 19–April 16, 1944)

127. Bumpei Usui (1898–1994)

14th Street, 1924

Oil on canvas
30 ⅛ x 24 in. (76.52 x 60.96 cm)
Signed and dated, in Japanese, lower right: "Usui 5.1924"
Museum Purchase, The J. Harwood and Louise B. Cochrane Fund for American Art, 2006.245

PROVENANCE: Salander Galleries, New York, N.Y. (1979); Arthur Imperatore Jr., New York, N.Y. (ca. 1992); Stevens Institute of Technology, Hoboken, N.J. (2002); 511 Gallery, New York, N.Y. (2003)

126

A first-generation Japanese American artist, Yasuo Kuniyoshi established his reputation as a leading modernist in the 1920s New York art world with images of popular amusements. *Nevadaville* dates from the mature period of his career, when his imagery took on a markedly somber and symbolic tone indicative of greater emotional, psychological, and sociopolitical intent. Painted soon after the start of World War II, it depicts a western ghost town—the kind of "deserted place" the artist found himself increasingly drawn to in those turbulent years. Whereas the subject may have been specifically inspired by Kuniyoshi's 1941 travels through California, Nevada, and Colorado, its bleak and desolate quality reverberates more generally with wartime tensions.[1]

Born in Okayama, Japan, Kuniyoshi set off for America just before his seventeenth birthday seeking better economic opportunities. With little money and knowledge of the English language, he spent several years laboring as a railroad and field worker in the West and Northwest (an experience that may have informed *Nevadaville*). Apparently, like many Japanese immigrants in 1906 who hoped to find material success in the United States, Kuniyoshi intended to remain only long enough to return prosperous to his native country. Instead, he visited Japan only one more time, in 1931. Moreover, he never planned to become an artist, crediting a high-school teacher for urging him in that direction. From 1907 to 1910, Kuniyoshi studied at the Los Angeles School of Art and Design and, later, with Robert Henri (see cat. no. 111) in New York. By 1916, he had discovered his ideal atelier environment at the Art Students League, working with Kenneth Hayes Miller; he would later teach there himself from 1933 until his death.[2]

Ensconced in the popular artists' neighborhood of Union Square, Kuniyoshi became an active member of the city's modernist scene, spending summers in artist colonies such as Ogunquit, Maine, and Woodstock, New York. His work of the 1920s and 1930s ranged from scenes of daily life in such rural locales to portrayals of children and circus performers. Like his fellow modernists, Kuniyoshi was also inspired by the potent form and emotional content of American folk art and developed an idiosyncratic style that blended aspects of abstraction and representation in a muted, though shimmering, palette of earth tones.[3]

Such works, inflected with both humor and melancholy, comprised his early showings at the Daniel gallery, one of the few commercial venues for modernism in New York. Critics were generally appreciative, but tended to "explain his art's strangeness" in terms of Kuniyoshi's ethnicity. As a writer for the *New York World* observed: "With true Asiatic subtlety, and at the same time in perfect frank and guileless sincerity, he has applied the dynamics of 'cubism' to the flat perspective and synthetic abstractions of Oriental drawing." Henry McBride, the always-perceptive critic with pronounced modernist sympathies, located the distinctiveness of Kuniyoshi's art in the unique marriage of a Japanese sensibility to American subjects— a "joint product of the two nations." This dual cultural focus deepened in his 1940s landscapes, underlining the artist's precarious status and darker visions of isolation in a charged wartime climate.[4]

Although America had barred the naturalization of Japanese citizens since 1922, Japan's infamous December 7, 1941, attack on Pearl Harbor immediately changed Kuniyoshi's immigrant status from "resident alien" to "enemy alien." Perhaps as a result of this reclassification, Kuniyoshi (already aligned with progressive politics in New York) became particularly active in the war effort, designing propaganda posters, delivering radio addresses, and donating proceeds from exhibition sales to various antifascist causes.[5]

From Kuniyoshi's initial arrival in the United States, the western landscape remained a source of inspiration, and he believed American art originated in its echoing vastness and visual grandeur. Whereas *Nevadaville* is arguably informed by this early encounter with the American West (as well as his 1941 sojourn in a remote gold-mining town), the picture moves beyond the specificity of place in its pervasive mood of transience and desolation. This combination of the real and the imaginary would continue to define the artist's work throughout the postwar years.[6]

Nevadaville reveals Kuniyoshi's primary artistic aim— "to combine the rich traditions of the East with my accumulative experiences and viewpoint of the West."[7] A town marked by both progress (signified by the billboard) and its constructed past (represented by the Victorian architecture), *Nevadaville* evokes both the melancholic air of Edward Hopper's regional townscapes (see cat. no. 124) and the formal

jumble of buildings and advertisements associated with the French-inspired art of Kuniyoshi's close friend Stuart Davis (see cat. no 136). Yet, ultimately, the painting's desolate look and mood bespeak a greater symbolism than that found in the work of either contemporary.

In 1947 Kuniyoshi described World War II as "the backdrop for a great number of works—not necessarily the battlefield, but the war's implications: destruction, lifelessness, hovering between life and death, loneliness." *Nevadaville,* which was purchased by VMFA from its 1944 annual exhibition of contemporary art, manifests these "implications of very sad things" as it suggests the artist's particular anxieties of displacement as a Japanese American with no country officially to call his own. On May 14, 1953, while waiting for his naturalization application to be processed (the immigration law had been changed a year earlier to allow Japanese residents to become U.S. citizens), Kuniyoshi passed away in New York of cancer. After a prolonged illness, he died as he had lived—both "expatriate" and "alien."[8]

The art historical attention to Kuniyoshi's significance in American modernism has obscured his arguably greater influence in a smaller subsection of the movement—as mentor and supporter of a large circle of progressive Japanese American artists active in New York between the two world wars. The painter and frame designer Bumpei Usui, whose work is also represented in VMFA's collection, was one such figure. The original period frame on Kuniyoshi's *Nevadaville* may have been designed by Usui.[9]

Born in Nagano, Japan, Usui was raised on a silkworm farm before moving in 1917 to London, where he joined a brother who collected and sold Western art. There, Usui learned English as well as "the secrets of Queen Anne lacquering." Settling in New York in 1921, he opened a professional studio on Fourteenth Street and soon made his living designing furniture and frames for a wide range of clients, from designers and decorators (like Donald Deskey) to artists and collectors (like Kuniyoshi and Abby Aldrich Rockefeller, wife of John D. Rockefeller Jr.). Usui's frame work gained him entry into the art world, and he began painting in earnest.[10]

Usui claimed to be self-taught, but he likely pursued informal training with Kuniyoshi after meeting the painter in 1926 at an exhibition of the Society of Independent Artists,

an organization of American modernists. Friendships with fellow foreign-born artists like Kuniyoshi, whom he portrayed in a 1930 painting (fig. 209), and Jules Pascin, as well as Fourteenth Street neighbors such as Reginald Marsh, Kenneth Hayes Miller, and John Sloan, proved particularly influential on Usui's art as well as on his professional career. It was Kuniyoshi who first approached Usui about framing some of his work, while also encouraging an interest in painting. The two became close friends and spent many summers together in Woodstock.[11]

FIG. 209 Bumpei Usui (1898–1994), **Portrait of Yasuo Kuniyoshi in His Studio,** 1930, oil on canvas, 36 x 48 in. (91.4 x 121.9 cm). Smithsonian American Art Museum, Gift of Regis Corporation.

The glowing palette, matte finish, and expressive line of *14th Street* are representative of Usui's most admired work. Featured in a 1928 Independent Artists exhibition as *Skyline of New York,* it was described as having been painted "decidedly in the new manner . . . with much distinction." The subject and style of the painting suggest a precisionist approach—a term first applied in the 1920s to a diverse group of artists (including Charles Demuth, Georgia O'Keeffe [see cat. no. 120], and Charles Sheeler [see cat. no. 136]) who favored precisely delineated line, composition, and subject matter that expressed the new industrial aesthetic of modernism. Informed by cubism, futurism, and dadism, the precisionists took as their primary subject the simple geometric and architectonic forms of machines and urban settings—including skyscrapers.

Having exhibited with many of the leading practitioners at the Daniel gallery and later at the Downtown Gallery—both precisionist strongholds—Usui not surprisingly experimented with the style. Moreover, the Woodstock art colony, which Usui frequented, was another locus for precisionism during the 1930s.[12]

In addition to his affiliation with the independents, Usui participated in group shows at the Daniel gallery in the late 1920s with Kuniyoshi, Pascin, Thomas Hart Benton (see cat. no. 118), Demuth, Marsden Hartley, John Marin, and Man Ray, including a 1928 exhibition that played a pivotal role in defining precisionism. In the 1930s, while employed in the easel division of the Works Progress Administration's Federal Art Project, Usui continued to take part in different group exhibitions in New York—from a regional effort held at John Wanamaker's department store (where he sold his first painting for $200) to the less commercial venue of the New School for Social Research.[13]

Critics generally discussed Usui's paintings in the same context of ethnicity that characterized the reception of Kuniyoshi's work. For example, reviewing a 1935 exhibition of Japanese American artists at New York's progressive A.C.A. Galleries, Ruth Benjamin identified Usui as a painter "who understands the precious quality of the expressive line of his ancestors," calling him "an able colorist . . . [with] a charming feeling for textures."[14]

Usui never spent any significant time in Japan following his immigration and considered himself more American than Asian. Thus, he did not experience the same kind of identity crisis that Kuniyoshi did, though during World War II, he stopped painting for a time due to anti-Japanese discrimination. When Usui returned to his easel, he embraced more decorative subjects, especially still lifes and interiors featuring Siamese cats that he had bred for decades.[15] SY

NOTES

1. For general biographical information, see Tom Wolf, "Kuniyoshi in the Early 1920s," in *The Shores of a Dream: Yasuo Kuniyoshi's Early Work in America,* exh. cat. (Fort Worth, Tex.: Amon Carter Museum, 1996): 21–42. See also Alexandra Munroe, "The War Years and Their Aftermath, 1940–1953," in *Yasuo Kuniyoshi,* exh. cat. (Tokyo: Tokyo Metropolitan Teien Art Museum, 1989), 40.

2. See Wolf, vi–vii, 21–23.

3. Ibid., 23–31. Kuniyoshi's *New York Times* obituary cited "an iridescent shimmer of color" and "mother-of-pearl luminosity" that characterized his painting, achieved by "piling darker colors on top of lighter ones." See "Kuniyoshi Is Dead: Prominent Artist," *New York Times,* May 15, 1953, 23.

4. Quoted in Wolf, 28, 33.

5. For Kuniyoshi's wartime activities, see ShiPu Wang, "Japan Against Japan: U.S. Propaganda and Yasuo Kuniyoshi's Identity Crisis," *American Art* 22 (Spring 2008): 28–51. I am grateful to Alexandra Davis for sharing a copy of her unpublished conference paper on a particular wartime painting by the artist, "*Rotting on the Shore* and the Inefficacy of Art-making," delivered at the Fifth Annual American Art History Symposium, Yale University, April 26, 2008.

6. See *Yasuo Kuniyoshi (1889–1953),* exh. cat. (Tokyo: National Museum of Modern Art, 2004), 190, 195; and Munroe, 40.

7. Yasuo Kuniyoshi, *Yasuo Kuniyoshi* (New York: American Artists Group, 1945), n.p., quoted in Wolf, 33.

8. Quoted in Lloyd Goodrich, *Kuniyoshi: Catalogue of Kuniyoshi's Posthumous Exhibition,* exh. cat. (Tokyo, National Museum of Modern Art, 1954), n.p.

9. See Ruth L. Benjamin, "Japanese Painters in America," *Parnassus* 8 (October 1935): 13–15; Mitsutoshi Oba, "Japanese Artists in New York between the World Wars: A New Chapter in American Art," www.brickhaus.com/amoore/magazine/oba.html; and *Japanese and Japanese American Painters in the United States,* exh. cat. (Tokyo: Tokyo Metropolitan Teien Art Museum, 1995). Usui collector Joel Rosenkranz has suggested the frame attribution; see VMFA curatorial files.

10. See "Japanese Handy Man," *New Yorker,* January 5, 1935, 16. The most accurate and comprehensive information on Usui, whose biography has frequently and erroneously been conflated with Kuniyoshi's, is published in Japanese. I am grateful to Kazue Soma Jensen for so generously translating the following texts (and to Susan Jensen Rawles and Karl Jensen for facilitating): Seiichiro Kuboshima, "Usui Bumpei no ganmeina e (Stubborn Pictures by Bumpei Usui: A Painter in 1930s New York)," *Mizue* 926 (Spring 1983): 104–11, and Miyuki Shimoda, ed., "Bumpei Usui (1898–1994): A Recollection," in *Exhibition of Bumpei Usui, American Scene, 1920s–40s,* exh. cat. (Tokyo: Fuji Television Gallery, 1983). I am also grateful to VMFA docent Kathryn Gasperini for sharing her research on the artist; see VMFA curatorial files.

11. Shimoda.

12. *14th Street* was among a group of works by Japanese American painters circulated by the Daniel gallery to the second annual exhibition of Independent Artists in Washington, D.C. See "Independent Show Held Significance," *Washington Post,* April 1, 1928, 12. For a general overview of precisionism, see Gail Stavitsky, "Reordering Reality: Precisionist Directions in American Art, 1915–1941," in *Precisionism in America, 1915–1941: Reordering Reality,* exh. cat. (New York: Montclair Art Museum and Abrams, 1995), 12–39.

13. Usui later credited Kuniyoshi for getting his work accepted into key group exhibitions and, presumably, for introducing him to influential dealers such as Charles Daniel and Edith Halpert. See Shimoda. See also Stavitsky, 22. On the 1930s exhibitions, see "Art Instructors Show Their Work," *New York Times,* October 20, 1936; "Japanese Handy Man" and "Regional Show Pipes a Lovely Tune," unidentified clipping [October 1934].

14. See Benjamin, 15, and "Our Japanese Artists," *New York Times,* February 12, 1935, 19. The exhibition also featured work by the better known Kuniyoshi and the sculptor Isamu Noguchi. See Andrew Hemingway, *Artists on the Left: American Artists and the Communist Movement, 1926–1956* (New Haven and London: Yale University Press, 2002), 62–63, 295.

15. Shimoda. Usui received his first solo exhibition in 1946 at New York's Laurel Gallery. The next major showing of his work was in 1979. See *Bumpei Usui Paintings, 1925–1949,* exh. cat. (New York: Salander Galleries, 1979). In the years before his "rediscovery," Usui was better known as an international authority on Japanese antiquities and a leading collector of *katana* (Japanese swords). See "Robbers Posing as Policemen Take $300,000 in Antiques in 'Village,'" *New York Times,* March 6, 1978, and Kuboshima.

128. Jacob Lawrence (1917–2000)

Subway–Home from Work (In the Evening the Mother and Father Come Home from Work), 1943

Gouache on paper

14 ⅜ x 21 ¾ in. (36.7 x 55.2 cm) image; 15 ⅜ x 22 ½ in. (38.7 x 57.2 cm) sheet

Signed lower center right: "J. Lawrence"

Signed and dated lower right center of mat: "J. Lawrence 1943"

Inscribed lower right margin: "Home From Work"

Gift of the Alexander Shilling Fund, 44.18.1

PROVENANCE: Downtown Gallery, New York, N.Y.

By the time Jacob Lawrence painted *Subway–Home from Work* in 1943, he was on his way to becoming one of the most celebrated painters in twentieth-century America. The twenty-six-year-old's reputation had recently experienced a meteoric rise. Employing a cubist-inflected style to chronicle key figures and events in African American history, Lawrence first drew critical attention in the late 1930s with successive narrative series that portrayed the lives of Toussaint L'Ouverture, Harriet Tubman, and Frederick Douglass. He followed with his 1941 landmark *The Migration of the American Negro,* a sixty-painting cycle that told the story of the post–World War I mass migration of southern blacks to the urban North. When the series was exhibited at Edith Halpert's renowned Downtown Gallery, Lawrence became the first black artist to be represented by a major New York dealer. The paintings were immediately acquired by the city's Museum of Modern Art and the Phillips Collection, in Washington, D.C., and selections were published in *Fortune* magazine.[1] Such heady events and associated acclaim validated the young painter's interest in depicting the African American experience—a desire that became a lifelong commitment.

In the immediate wake of these events, Lawrence shifted focus from the historical past to scenes of present-day Harlem, the predominantly black New York district where he resided. His *Subway–Home from Work* captures the community's dynamic visual patterns that fascinated him even as a boy. "I was overwhelmed by my urban experience," Lawrence later recalled, "arriving in New York at thirteen, in 1930, and seeing for

the first time the rhythm and geometry of the fire escapes, the windows, the tenements."[2] In a horizontal composition of primarily blue-gray tones, the artist laid down a simple grid containing buildings, a street, and a pair of rectangular subway entryways with wide triangular roofs. Lawrence populated the scene with near-abstract figures rendered in flat, unmodulated passages of black, brown, and brightly colored pigment—a distinctive schematic style that he developed by synthesizing such disparate influences as early Italian Renaissance paintings, contemporary posters and cartoons, and modernist compositions by painters such as Aaron Douglas and Stuart Davis (see cat. no. 136). Lawrence also looked beyond formal concerns to record the day-to-day patterns of Harlem's working-class residents, an interest that aligned him with currents of social realism that he admired in the work of artists such as Ben Shahn and Mexican muralists José Clemente Orozco and Diego Rivera.[3] In this scene, Lawrence pictures dozens of men and women filing out of the subway stairwells at the end of the day. Making their way home with bowed heads and slumping shoulders, many carry parcels and lunch boxes. A solitary man stands apart from the weary laborers; unoccupied—perhaps unemployed—he leans against the subway entrance and smokes a cigarette. The shelter sits oddly askew. Its foundation tilts away from level ground—a visual instability suggestive of the broader insecurities of the day.

Lawrence knew the sights and rhythms of Harlem intimately. He came of age there just as the financial hardships of the Great Depression began to ravage the once-flourishing neighborhood. The artist missed the heyday of the New Negro Movement, also known as the Harlem Renaissance, by a decade. Nevertheless, he was a beneficiary of its progressive race-affirming philosophies, which had fueled the region's earlier economic, political, and cultural boom. In the mid-1920s, Harlem, which had become the nation's largest African American community, was transformed into a business capital that nurtured a burgeoning black middle class. The district's prolific photographer, James VanDerZee, captured the confident and optimistic population in such striking images as his 1934 *Portrait of Mother and Two Children* (fig. 210). Harlem also became a magnet for other leading African American intellectuals, writers, musicians, performers, and artists—several of whom touched the life of the young Lawrence.[4]

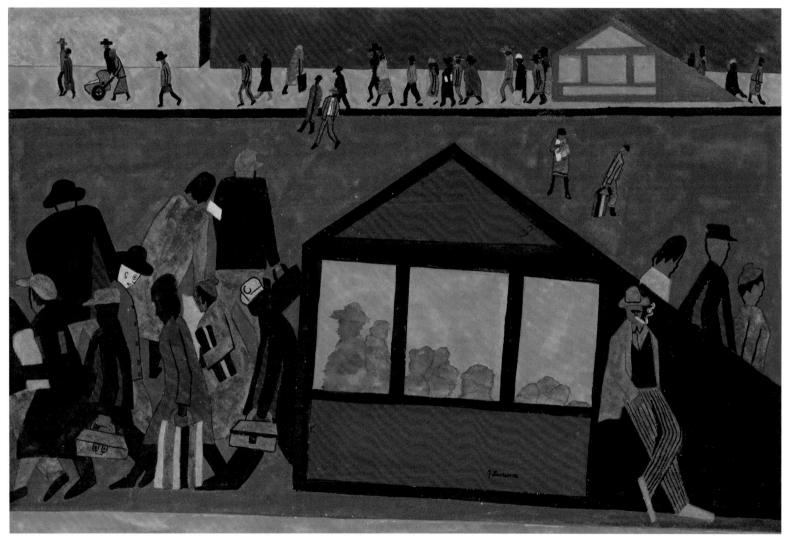

128

FIG. 210 James VanDerZee (1886–1983), **Portrait of a Mother and Two Children,** 1934, gelatin-silver print photograph, 6½ x 4½ in. (16.5 x 11.4 cm). Virginia Museum of Fine Arts Purchase, NEA Fund for American Art, 2001.22.

While he studied art in the mid-1930s at the Harlem Studio Workshop, which offered free classes funded by the Works Progress Administration's Federal Art Project,[5] Lawrence also learned about African American history at the Schomburg Center, housed in the 135th Street branch of the New York Public Library. During these formative years, he met and became friends with some of Harlem's cultural luminaries: artists Augusta Savage, Romare Bearden, and Aaron Douglas; and writers Langston Hughes, Claude McKay, and Countee Cullen. Particularly influential was social and cultural critic Alain Locke, whom Lawrence considered a mentor.[6] Locke, a Harvard- and Oxford-educated professor at Howard University, was a leading force in shaping the New Negro Movement and a proponent of "racial emphasis" in literature and art.[7] In 1940, the year that Locke wrote a letter supporting funding for Lawrence's *Migration* series, he published *The Negro in Art,* a book that surveyed imagery of and by black Americans.[8] Locke espoused themes that addressed the growing crises in labor, housing, and unemployment, calling for art that went beyond "surface show and jazzy tone and rhythm of Negro folk-life" to offer visions that were "solid and instructive with an enlightening truth."[9]

Lawrence met Locke's challenge with his "composite study of the Negro in Harlem," as the artist described the thirty gouache-on-paper paintings—including *Subway–Home from Work*—that he exhibited at the Downtown Gallery in May 1943.[10] Unlike his earlier projects, the genre scenes were not produced as a strictly ordered, multipart narrative. Nevertheless, viewed together, the works provide a cohesive, unvarnished exploration of contemporary life in Harlem. In solid, flat forms, Lawrence pictured the "jazzy" aspects of the district's famed music halls and bars, but he countered with images of overcrowded tenements, grinding poverty, disease, and death. He also portrayed a resilient people who transcended such grim circumstances with determination and dignity. Threaded into the story line are images of Harlem churches, schools, and libraries; there are also scenes of home life: families gathered at meals, children at play, and watchful parents. One painting in the show, *The Mother and Father Go to Work* (Albright-Knox Art Gallery), depicts a couple standing tightly together in a subway car during their morning commute. VMFA's *Subway–Home from Work* was exhibited nearby with an alternative title, *In the Evening the Mother and Father Come Home from Work,* which suggests a linked narrative.[11] Close inspection, however, reveals no evidence of the original couple. Instead, individual figures—most of them faceless—merge to form an anonymous streaming crowd.

Over the subsequent half century, Lawrence continued to produce his highly stylized genre scenes, many exploring universal themes such as the struggle against social injustice. In 1974 the artist was asked to provide a visual answer to the question, What does independence mean to me? Crafting his response less than a decade after the historic Voting Rights Act and on the eve of the American bicentennial, Lawrence produced a vibrant seven-color screen print, *The 1920s . . . The Migrants Arrive and Cast their Ballots* (fig. 211).[12] Returning once again to the epic narrative of the Great Migration and working in his inimitable style, he portrayed southern migrants who, having relocated to the more permissive urban North, could at last realize the right to vote. When Lawrence reflected on his long productive career as a painter, illustrator, and educator, he credited his success to such

enduring subject matter, "that black experience which is our heritage—an experience which gives inspiration, motivation, and stimulation."[13] ELO

FIG. 211 Jacob Lawrence (1917–2000), **The 1920s . . . The Migrants Arrive and Cast their Ballots,** from *Kent Bicentennial Portfolio: Spirit of Independence,* 1974, published 1975, seven-color screen print on Domestic Etching Paper, 34 ⅜ x 25 ⅞ (87.5 x 65.8 cm) sheet, 32 x 25 in. (81.3 x 63.5 cm) image. Virginia Museum of Fine Arts, Gift of Lorillard Co., A Division of Loews Theatres, Inc.

NOTES

1. Ellen Harkins Wheat, *Jacob Lawrence, American Painter* (Seattle and London: University of Washington Press in association with the Seattle Art Museum, 1986), 61–64; Leslie King-Hammond, "Inside–Outside, Uptown–Downtown: Jacob Lawrence and the Aesthetic Ethos of the Harlem Working-Class Community," in *Over the Line: The Art and Life of Jacob Lawrence,* ed. Peter T. Nesbett and Michelle DuBois (Seattle and London: University of Washington Press in association with Jacob Lawrence Catalogue Raisonné Project, 2000), 77–79.

2. Michael Kimmelman, "An Invigorating Homecoming: At the Met and the Modern with Jacob Lawrence," *New York Times,* April 12, 1996, C-4. Before relocating to Harlem, the Lawrence family resided in New Jersey, where Jacob was born, and Pennsylvania. For details of Lawrence's childhood years and early art training in Harlem, see Wheat, 25–30, and King-Hammond, 67–85.

3. Wheat, 37–42.

4. For a detailed examination of the Harlem Renaissance, see David Levering Lewis, *When Harlem Was in Vogue* (New York: Knopf, 1981).

5 The Federal Art Project (1935–43) employed artists to teach free community classes across the nation. The relief program also hired thousands of artists to produce sculptures, posters, illustrations, easel paintings, and murals. Lawrence worked as a WPA easel painter in 1938 and 1939. Wheat, 39–40, 44–45.

6. Ibid., 42.

7. Alain Locke, "The American Negro as Artist," *American Magazine of Art* 23 (September 1931): 210–20.

8. Lizzetta LeFalle-Collins, "The Critical Context of Jacob Lawrence's Early Works, 1938–1952," in *Over the Line,* 123.

9. Alain Locke, *The Negro in Art: A Pictorial Record of the Negro Artist and of the Negro Theme in Art* (Washington, D.C.: Associates in Negro Folk Education, 1940), 10.

10. Quote from Lawrence's 1941 letter of intent to seek funding for the Harlem series from the Rosenwald Foundation, which provided the grant in 1942. Lawrence benefited from the patronage of both the Rosenwald Foundation and the Harmon Foundation, white philanthropic organizations that provided crucial support to black artists and writers in the 1920s through the 1940s. Peter T. Nesbett and Michelle DuBois, *Jacob Lawrence: Paintings, Drawings, and Murals (1935–1999): A Catalogue Raisonné* (Seattle and London: University of Washington Press in association with Jacob Lawrence Catalogue Raisonné Project, 2000), 30; Wheat 66–68.

11. *Harlem by Jacob Lawrence: Exhibition of Paintings in Gouache,* May 11–29, 1943, exh. cat., VMFA curatorial files. The VMFA painting is listed as catalogue no. 10. In contrast to his earlier narrative cycles, Lawrence later clarified that the Harlem gouaches were "not a series, but a theme." Nesbett and DuBois, 70. For images of other paintings shown in this exhibit, see ibid., 71–79.

12. The screen print is one of twelve in the *Kent Bicentennial Portfolio,* commissioned in 1974 by Lorillard Company from leading American artists to interpret the meaning of American independence.

13. Comment by Lawrence during his acceptance of the 1970 Spingarn Medal, the highest award granted by the NAACP and the first presented to an artist, quoted in Wheat, 142.

129. Leslie Garland Bolling (1898–1955)

Cousin-on-Friday, 1935

Maple

6 ¾ x 5 ¾ x 9 ¼ in. (17.1 x 14.6 x 23.5 cm)

Inscribed on base beneath bucket: "Cousin-on-Friday"

Inscribed on base beneath figure's feet: "L. G. Bolling 11–7–35"

Gift of the Honorable and Mrs. Alexander W. Weddell, 44.2.1

PROVENANCE: The Honorable and Mrs. Alexander W. Weddell, Richmond, Va.

130. Leslie Garland Bolling (1898–1955)

Saver of Soles, 1941

Tulip poplar

11 ½ x 7 ½ x 6 ¼ in. (29.2 x 19.1 x 15.9 cm)

Inscribed on base front: "Saver of Soles"

Inscribed on base back: "1–31–41 / L. G. Bolling"

Museum Purchase, The Adolph D. and Wilkins C. Williams Fund,
 2006.246

PROVENANCE: Elizabeth Toobert Hoffman, Richmond, Va. (after 1941); by descent to Carol Hoffman, Huntington Beach, Calif.

When the Richmond Academy of Arts—a forerunner of the Virginia Museum of Fine Arts—sponsored a solo exhibition of the work of Leslie Garland Bolling in 1935, the show was heralded in the national magazine *Art Digest.* Beneath a photo of two of Bolling's genre sculptures, a reviewer recognized the thirty-seven-year-old Richmonder's achievement as the "first Negro artist to be accorded an exhibition in Virginia" and that his "successful debut" was attended by more than 2,500 visitors.[1] Among them was renowned painter Thomas Hart Benton (see cat. no. 118), who made the daring pronouncement that he found Bolling's sculptures more to his liking than the Civil War murals in nearby Battle Abbey.[2] This was high praise indeed for the modest self-taught artist who carved his highly detailed figures with a penknife from single blocks of wood.

Bolling, a native of Dendron, Virginia, earned his living as a porter at the Everett Waddey stationery company in Richmond while creating his sculptures at night. For most of his subjects, he found inspiration in the commonplace activities of the working people around him. In 1928, he came to the attention of New York writer and photographer Carl Van Vechten. A leading white advocate of the artists and writers of the New Negro Movement (also known as the Harlem Renaissance), Van Vechten helped launch Bolling's national reputation.[3] With additional support from the Harmon Foundation—the first major organization dedicated to the promotion of African American art—Bolling's carved figures were featured in twenty-three exhibitions between 1928 and 1943. During those years, his work also appeared in several national magazines and books.[4]

The unique sculptures by Bolling in the VMFA collection—each diligently carved over the course of one to four months—easily represent his best efforts.[5] The poignant figure of *Cousin-on-Friday* depicts an African American woman cleaning a floor, its checkerboard pattern lightly scored and painted.[6] As she scrubs on hands and knees, her mouth is open in song. The carving is one of seven sculptures from the artist's *The Days of the Week* series, which pays tribute to the labors of an extended family of African American women. Most of these sculptures link a domestic chore—laundry, ironing, mending, baking, and floor scrubbing—to the day it was customarily performed.[7]

For his genre imagery, Bolling also turned an eye toward Richmond's working men, rendering such figures as a baggage porter, an iceman, a street vendor selling fish, and a construction worker muscling a jackhammer. The industrious cobbler portrayed in *Saver of Soles* exemplifies the artist's keen powers of observation. His carving shows the older man leaning forward to concentrate on repairing a shoe. Bolling articulated small details like the folds of the worker's leather apron, the laces of his wingtips, and the staves of the bucket. The surface of the sculpture, with its myriad small planes, retains evidence of the artist's knife. While images of working people were already part of the repertoire of American realist painters and sculptors in the early twentieth century, Bolling's renderings capture not only the particulars of the occupation but also the quiet dignity of the laborers. They also evoke a determined entrepreneurship among individuals who kept shop in Jackson Ward, Richmond's African American business community.

Bolling gave his imagination free rein when he also produced close to a dozen nude female figures over the course of

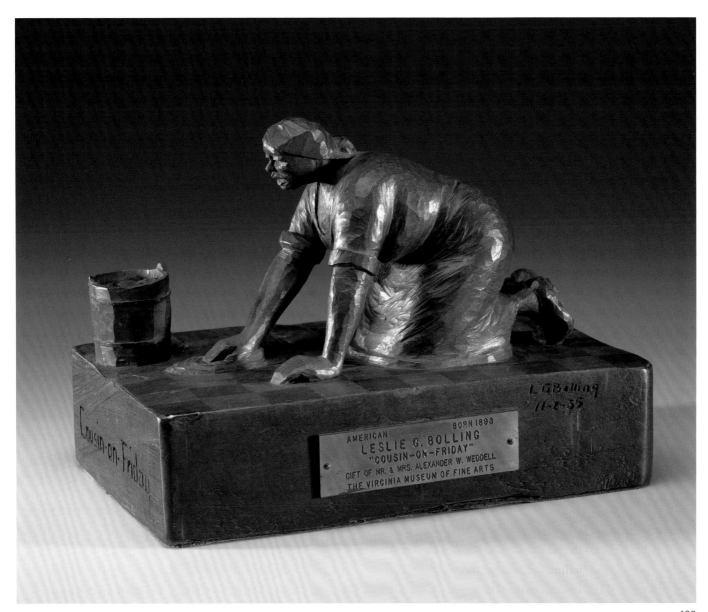

129

130

his career. These stylized and curvaceous carvings, including his 1937 *Queen of Dreams* in the VMFA collection, take the viewer from the prosaic realities of labor to the sensual realms of fantasy and desire. In contrast to his genre sculptures, he finished these figures with smooth, highly polished surfaces. In the late 1920s, Van Vechten noted that Bolling's nudes recalled sculptor Gaston Lachaise's fleshy, powerful female figures (see fig. 197). Upon examining one of the Virginia sculptor's nudes in 1931, Lachaise responded that the figure was "no weak copy of any statue . . . but a genuinely original work."[8]

Despite having gained national interest and many patrons—both white and black—Bolling was unable to realize much financial gain from art sales. In a challenging era marked by a depressed economy and strict segregation, he made his way by working variously as a porter, postal carrier, and handyman until his death in 1955. Although he retired from art making and slipped into obscurity in the last decade of his life, his name and reputation were recovered by American art historians in the 1970s and 1980s. By the end of the century, Bolling was listed in most encyclopedias and surveys of African American art. In 2006, the sculptor was celebrated with a retrospective exhibition at the Library of Virginia, the official library and archives of the Commonwealth.[9]

ELO

NOTES

1. "Richmond Academy Accords Show to Negro," *Art Digest* (February 15, 1935): 23.

2. *Richmond Times-Dispatch,* January 4, 1935, 1, 2; January 10, 1935, 3. Built in 1913 by the Confederate Memorial Association, Battle Abbey was a repository for Confederate records and a shrine to the war dead. In 1946, the neoclassical building was acquired by the Virginia Historical Society. Today it remains at the core of that institution's expanded library and museum complex.

3. Barbara C. Batson, *Freeing Art from Wood: The Sculpture of Leslie Garland Bolling,* exh. cat. (Richmond: Library of Virginia, 2006), 4–5.

4. These included venues in New York, Washington, D.C., Dallas, Los Angeles, Chicago, and—of course—Richmond, where his sculptures were featured in nine Virginia artist exhibitions, four of which were mounted at the newly opened VMFA. Among published mentions, Bolling appears in periodicals: *American Magazine of Art* 26 (January 1933): 45–46; *Opportunity* 15 (August 1937): 240; *Art News* 40 (May 1–14, 1941): 16ff.; and books: Alain Locke, *Negro in Art* (1940), 68, and James A. Porter, *Modern Negro Art* (1942), 152–54. In 1937 the Harmon Foundation dispatched photographer and filmmaker Kenneth F. Space to the South to gather images of various musicians, artists, and artisans for its project "Negro Notables; Negro Education and Art in the U.S., 1937." Unedited footage shot in Richmond records Bolling performing tasks at Everett Waddey Company and in his home studio carving *Queen of Dreams.* (It also includes similar footage of Richmond painter George H. Ben Johnson [see cat. no. 131].) Harmon Foundation, Collection H, 1922–67, National Archives and Records Administration,

Special Media Archives Services Division. I thank Barbara Batson, exhibitions coordinator at the Library of Virginia, for bringing this rare footage to my attention.

5. Just as the manuscript neared completion for this publication, VMFA acquired two more Bolling sculptures made in the mid-1930s, both gifts of John M. Camp Jr.: *Brunswick Stew* and *Quilt Making.*

6. Alexander Weddell, former U.S. ambassador and then-president of the Virginia Historical Society, purchased *Cousin* from the artist in 1943 and presented it to VMFA the following year. The canceled check and correspondence from Bolling are in the Weddell Papers, 1858–1955, Mss1W4126 bFA2, Virginia Historical Society, Richmond. When accepted by the museum trustees in February 1944, *Cousin-on-Friday* became the first work by an African American artist to enter the VMFA permanent collection.

7. The laborers seem to get a break in *On Thursday—Gossip,* in which Bolling depicts two women chatting over a fence (Thursday being Richmond's traditional "maid's day off"). He represents Sunday with a parson in his pulpit preaching to unseen workers and families assembled on their day of rest. All seven sculptures are pictured in E. J. Tangerman, *Design and Figure Carving* (New York: Whittlesey House, 1940), 242. At present, *Aunt Monday* is in a private collection and *Sister Tuesday* is in the Art Institute of Chicago; the location of the other *Days of the Week* figures is unknown.

8. Quoted in Batson, 5, 17n6.

9. Until 2002, the whereabouts of fewer than a dozen of Bolling's sculptures were known. In preparation for *Freeing Art from Wood: The Sculpture of Leslie Garland Bolling,* the 2006 retrospective at the Library of Virginia, Barbara Batson created a catalogue raisonné listing of over eighty works from archival materials and, through research and networking, eventually located over thirty figures. Her exhibition catalogue of the same name provides the most comprehensive consideration of Bolling's life and work to date. Images, including additional works located after the exhibit, are posted at www.lva.virginia.gov/exhibits/bolling/list_lva.asp.

131. George H. Ben Johnson (1888–1970)

Idyll of Virginia Mountains, 1945

Oil on canvas

16 3/16 x 20 in. (41.1 x 50.8 cm)

Signed bottom right: "Geo. H. Ben / Johnson"

Museum Purchase, Katherine Rhoads Memorial Fund, 45.10.3

PROVENANCE: Purchased from the artist through *Tenth Exhibition of Work of Virginia Artists,* Virginia Museum of Fine Arts, Richmond, Va. (April 8–29, 1945)

132. Robert Gwathmey (1903–1988)

Family Portrait, 1944

Oil on canvas

30 x 28 in. (76.2 x 71.1 cm)

Signed upper left: "gwathmey"

Museum Purchase, Katherine Rhoads Memorial Fund, 45.10.1

PROVENANCE: Purchased from the artist through *Tenth Exhibition of Work of Virginia Artists,* Virginia Museum of Fine Arts, Richmond, Va. (April 8–29, 1945)

In the spring of 1945, Robert Gwathmey and George H. Ben Johnson each received notice that his painting would be purchased by the Virginia Museum of Fine Arts for its permanent collection. During the preceding weeks, a panel of visiting jurists for the museum's *Tenth Exhibition of Work of Virginia Artists* had surveyed close to five hundred entries—a surprisingly large number considering the period's wartime constraints. From these they chose eighty-five to exhibit and a handful to recommend to the trustees for acquisition.[1] Two of the prizewinners, Gwathmey's powerful *Family Portrait* and Johnson's poetic *Idyll of Virginia Mountains,* are strikingly different in subject and style. And, besides the fact that both men were born in Richmond, the artists appear equally dissimilar. The self-trained Johnson, a retired mail carrier who gave art lessons in his home, found few opportunities to excel as a black artist living in the strictly segregated Old Dominion. Yet he persevered, enjoying occasional notice of his still lifes, landscapes, and history paintings—the VMFA award among the most prestigious recognitions. Gwathmey, the younger of the two by fifteen years, was a white, academically trained painter based in New York City. He had recently gained national attention with his images of black southerners rendered in a bold modernist style. Still, for all their differences, Johnson and Gwathmey—who likely never met—shared a common vision. Both were passionate advocates for African American civil rights.

With the announcement of the museum's purchase prizes, the older man's life story led in the Richmond press.[2] George H. Ben Johnson grew up in Jackson Ward, the city's black cultural and business center. As a teenager operating an elevator in a downtown dry goods store, he impressed the company's owners with his hand-decorated postcards. With their support, Johnson enrolled at Hampton Normal and Agricultural Institute (now Hampton University) in 1905. Disappointed to discover that a studio art program had yet to be established, he trained there instead as a tailor. In the years following his graduation, Johnson traveled north to Philadelphia and New York, working variously as a tailor and a singing entertainer on boats operated by the Hudson River Line. In 1914, concern for his aging mother and the prospect of steady work with the U.S. Postal Service brought him back to Richmond, where he resided for the rest of his life. In his leisure time, Johnson

became proficient as an illustrator and painter through a series of correspondence courses. Between 1917 and 1920, he provided the African American newspaper the *Richmond Planet* dozens of editorial cartoons, nearly all of which addressed the ongoing suppression and unrealized potential of the nation's black citizens.[3] Especially stinging are his images denouncing state-mandated segregation, such as his 1919 depiction of an African American soldier, recently returned from active duty in World War I (fig. 212). With a salute, he addresses a personification of Virginia: "Your Honor Miss—Cut out the flags and the hurrahs. Abolish the Jim Crow laws in your house. Do something of consequence for us."[4]

In his paintings, Johnson focused primarily on biblical and historical scenes in which ancient Ethiopian figures perform heroic acts. In 1929, the Harmon Foundation selected one of these—a depiction of the poet Atheotes—for a national traveling exhibition of work by black artists.[5] A few years later, Johnson's *Zerah, Ethiopian Warrior* was chosen for a show at the British Empire Society of Arts in London. In the late 1940s, the artist printed these images alongside four more from his Ethiopian series as greeting cards, which he distributed

FIG. 212 George H. Ben Johnson (1888–1970), **Don't Camouflage with Drills. No, No!!,** editorial cartoon, *Richmond Planet,* June 21, 1919.

131

132

"in order to spread information about the Negro race."[6] Far less didactic are Johnson's still lifes and landscapes; *Idyll of Virginia Mountains* is one of the more lyrical of these. In this hushed, tranquil scene, he locates the viewer high up on a craggy promontory overlooking a series of mountaintops. Evoking the atmospheric haze of the state's famous Blue Ridge range, Johnson defined it with soft painterly strokes of turquoise, violet, gray, and brown. In places, he added touches of peach, suggesting the final rays of sunlight as dusk falls.

Johnson continued to paint and submit entries for Virginia artists' exhibitions at VMFA through the mid-1950s; afterward, however, he slipped into obscurity until his death in 1970. In a handwritten "Statement of Objectives" provided to the museum in 1954, he summed up his primary goal: "To render creations in all mediums on and in things which touch Humanity."[7]

An abiding interest in the human figure and the human condition also shaped Robert Gwathmey's artistic career. Raised in a middle-class family by his schoolteacher mother, Gwathmey left Richmond in the mid-1920s. After completing a four-year academic program at the Pennsylvania Academy of the Fine Arts, he taught at Beaver College (now Arcadia University) outside Philadelphia and later held faculty positions at the Carnegie Institute of Technology (now Carnegie-Mellon) in Pittsburgh and at the Cooper Union School of Art in New York City, where he taught for twenty-six years. In 1938 after destroying his earlier paintings—thinking them too traditional and derivative—Gwathmey developed a distinctive modernist style in which he pictured objects and people with flat passages of color edged with strong black lines. By that time, he had also shifted his attention to capturing the experiences of America's laboring poor.[8]

During the Depression-stricken decade of the 1930s, Gwathmey became sensitive to the nation's class and race disparities. Influenced by the era's surging leftist politics, he began addressing social concerns in his paintings. His work found new focus in 1938 and 1939 during travels to the South to complete a Work Projects Administration post-office mural commission in Alabama and to visit family in Richmond and in Charlotte, North Carolina—the hometown of his wife, photographer Rosalie Hook Gwathmey. Viewing the Jim Crow regime of his native South with new, critical eyes,

he employed his semiabstract style to render images of rural blacks at work and at leisure. In 1944 Gwathmey won a Rosenwald Fund grant,[9] which allowed him to spend the summer in Rocky Mount, North Carolina, where he and Rosalie observed, sketched, and photographed sharecroppers as they primed and picked tobacco. To fully experience the workers' rhythms and challenges, Robert toiled alongside them in the fields—a transformative experience that brought him a deeper appreciation of southern African American culture. On his return to his New York studio, and with added inspiration from Rosalie's North Carolina photographs (fig. 213), he painted *Family Portrait,* which won VMFA's purchase prize the following year.[10]

Using the architectural geometry of a "shotgun" cabin as a compositional frame for the painting, Gwathmey carefully arranged eight members of a family across the dwelling's front

FIG. 213 Rosalie Gwathmey (1908 – 2001), **Family Portrait, Charlotte, North Carolina,** ca. 1944, gelatin-silver print photograph, 9 ⅜ x 7 ¾ in. (23.8 x 19.7 cm). Romona Javitz Collection, Miriam and Ira D. Wallach Division of Art, Prints, and Photographs, New York Public Library. Astor, Lenox, and Tilden Foundations.

porch. The figures all gaze directly at the viewer in disconcerting unison. The parents are seated at center, with an infant balanced on the father's knee. Their other children of various ages—four daughters and a teenage son—stand on either side. Although the youngsters' thin legs and bare feet suggest privation, each appears in tidy clothing, which stands out against the painting's predominating dark earth tones as colorful islands of pigment. One girl's lively, diamond-patterned dress draws the eye, as does the significant red-and-white rectangle of a military service banner at center punctuating the entire composition like an exclamation point.[11] By adding the banner, with its two blue stars signifying the couple's oldest sons' active military service, Gwathmey evokes universal home-front sentiments—pride, concern, sacrifice—that transcended race.

Striking similar notes in her 1943 *Return from Boot Camp* (fig. 214), Hampton Institute art student (and later prominent art historian) Samella Sanders Lewis chose to bring the viewer into the poignant intimacy of a family meal served lovingly to a son preparing to embark to the front. It is more subtle than George H. Ben Johnson's imagery from the previous world war; yet it also called to mind the ongoing injustices that denied African Americans full citizenship in a nation for which they were willing to fight and die. Gwathmey addressed the issue directly and graphically in his 1941 painting, *Unfinished Business,* which pictures a wizened plantation owner welcoming a uniformed black soldier back to the home place; in the foreground a Ku Klux Klan robe is draped ominously on a fencepost. Commenting about the image, Gwathmey explained: "The Negro soldier goes to war. . . . Prejudices are alleviated for the moment. But there is still unfinished business . . . the Klan, the poll-taxer, the 'Posted' areas."[12]

Gwathmey's progressive politics brought personal hardships upon him and his family through the 1950s. Though he endured accusations on the floor of Congress of un-American activities and ongoing FBI surveillance, he nevertheless continued painting his hard-hitting images. Gwathmey also faced stiff challenges when the mainstream art world suddenly shifted in favor of abstract expressionism. Resolutely defending representational art, Gwathmey became an outspoken opponent of a style that he claimed was a denial of humanism.[13] Politically recharged during the 1960s and 1970s with the

FIG. 214 Samella Sanders Lewis (b. 1924), **Return from Boot Camp,** 1943, oil on canvas, 48 x 84 in. (121.9 x 213.4 cm). Collection of Dr. and Mrs. William R. Harvey, Hampton, Va.

civil rights and antiwar movements (at age sixty-seven, the painter was arrested at a Vietnam War protest), Gwathmey nevertheless made a gradual shift away from his earlier social realist themes. In his final two decades, he focused on a series of intricate floral still lifes and autobiographical imagery that referenced his long, productive life.[14] ELO

NOTES

1. Also from this exhibition, which ran April 8–29, 1945, the trustees awarded a third purchase prize to *Judy,* a figure study of a little girl by Norfolk painter Greta Matson. Guest jurists were Blake-More Godwin, director of the Toledo Museum of Art, and practicing artists Kurt Roesch and Philip Evergood (who would become one of Gwathmey's closest friends). *Tenth Exhibition of the Work of Virginia Artists,* exh. cat. (Richmond: Virginia Museum of Fine Arts, 1945), 5; *Museum Bulletin, Virginia Museum of Fine Arts* 5 (April 1945): 1.

2. "Former Postman's Canvas Selected for Purchase Prize at Virginia Artist Exhibition," *Richmond Times-Dispatch,* April 8, 1945, II, 1, 4. Though unacknowledged in the board minutes and in the press, the acquisition of Johnson's painting also represented VMFA's first purchase of a work produced by an African American artist. The year before, the board accepted the first two *donations* of works by black artists: Leslie Garland Bolling's *Cousin-on-Friday* (cat. no. 129) and Jacob Lawrence's *Subway–Home from Work* (cat. no. 128). Quietly breaking the racial barrier, these significant acquisitions, along with the 1944 purchase of Yasuo Kuniyoshi's *Nevadaville* (see cat. no. 126), took place under the leadership of interim director Beatrice von Keller, an art professor from Randolph-Macon Woman's College who served while director Thomas Colt was away on active military duty during the war.

3. Ibid.; Larry Hall, "Black Artist Quietly Left a Strong Impression," *Richmond Times-Dispatch,* August 11, 2007, H-7. A few of his images were picked up and reprinted in other publications, including the *Literary Digest* and *New York Tribune* and, in one instance, *La Revue Moderne* in Paris. "Richmonder's Art in Paris Journal. Two Cartoons and Sketch of George H. Ben Johnson, Negro, Printed," *Richmond News Leader,* November 19, 1929, 26. See also Benjamin R. Bates et al., "Redrawing Afrocentrism: Visual *Nommo* in George H. Ben Johnson's Editorial Cartoons," *Howard Journal of Communications* 19 (October 2008): 277–96.

4. "Don't Camouflage with Drills. No, No!!," *Richmond Planet,* June 21, 1919, 1. The cartoon was placed above a news story about thousands of black Richmonders turning out to cheer returning doughboys in the "Colored Soldiers Parade" held

the previous Saturday along Jackson Ward's Leigh Street. The procession took place days after a separate parade for white troops on Broad Street.

5. The first major organization dedicated to the promotion of African American art, the Harmon Foundation (active 1922–67) awarded stipends and also sponsored traveling exhibitions. Gary A. Reynolds and Beryl J. Wright et al., *Against the Odds: African-American Artists and the Harmon Foundation* (Newark, N.J.: Newark Museum, 1989), 64–65, 286.

6. G. Watson James Jr., "Postman's Hobbies Are Art Laurels," *Richmond Times-Dispatch*, January 19, 1936, Sunday Magazine Section, 7; "Richmonder's Art in Paris Journal," *Richmond News Leader*, November 19, 1929; "His Painting in London Show: Negro Artist and Mail Carrier Sends Work on Ethiopia," *Richmond News Leader*, June 26, 1936, 2; "Artist to Use Lithograph Cards to Teach History of Negro Race," *Richmond Times-Dispatch*, October 6, 1948, 5. In 1937, the Harmon Foundation sent photographer and filmmaker Kenneth F. Space south to collect images of various musicians, artists, and artisans for its project "Negro Notables; Negro Education and Art in the U.S., 1937." Unedited footage shot in Richmond records Johnson at work as a mail carrier and in his home studio painting a still life. (It also includes similar footage of Richmond sculptor Leslie Garland Bolling [see cat. nos. 129 and 130]). Harmon Foundation, Collection H, 1922–67, National Archives and Records Administration, Special Media Archives Services Division. I thank Barbara Batson, exhibitions coordinator at the Library of Virginia, for bringing this and other bibliographic information about Johnson to my attention.

7. "George H. Ben Johnson," artist vertical file, VMFA Library.

8. Michael Kammen, *Robert Gwathmey: The Life and Art of a Passionate Observer* (Chapel Hill and London: University of North Carolina Press, 1999), 3, 13–21; Charles K. Piehl, "Robert Gwathmey: The Social and Historical Context of a Southerner's Art in the Mid Twentieth Century," *Arts in Virginia* 29 (1989): 3–5.

9. The New York–based Julius Rosewald Fund, perhaps best known for its building initiative for African American schools across the South, also awarded stipends to artists, writers, teachers, and scholars (both white and black) interested in improving race relations. See Daniel Schulman et al., *A Force for Change: African American Art and the Julius Rosenwald Fund* (Chicago: Spertus Institute of Jewish Studies and Northwestern University Press, 2009), 22–23.

10. Kammen, 25–38, 80–83; Piehl, 3–6. See also *Rosalie Gwathmey: Photographs from the Forties East Hampton* (New York: Glenn Horowitz Bookseller, 1994). A year after VMFA awarded Gwathmey a purchase prize, the museum mounted a one-man exhibition for this native son and rising star. As if to mitigate any unease on the part of members and visitors pondering the "social concept" of the artist's images of "the downtrodden segments of the South's population," the museum held an evening panel discussion that included insights from sociologist William Shands Meacham. "Art Museum Plans Showing By Gwathmey," *Richmond Times-Dispatch*, October 20, 1946, 20.

11. Michael Kammen suggests that with this figure, Gwathmey may be referencing the diamond-pattern harlequin costumes of Picasso's famous *Family of Saltimbanques* (1905, National Gallery of Art, Washington, D.C.). He also points out Gwathmey's own sartorial tendencies toward colorful patterns, including his ubiquitous gingham shirts and argyle socks. Kammen, 6, 82–83.

12. The present location of *Unfinished Business* is unknown. Quote and reproduction of painting are found in Elizabeth McCausland, "Robert Gwathmey," *American Magazine of Art* 39 (April 1946): 148. Fifteen months after Gwathmey's comments were published, President Harry Truman issued Executive Order 9981, desegregating the military. The order was implemented in full in 1954, the same year that the U.S. Supreme Court ruled in *Brown v. Board of Education*, setting the stage for civil rights legislation in the 1960s.

13. Kammen, 108–117; Piehl, 9; Representative Georget A. Dondero of Michigan, "UNESCO—Communism and Modern Art," HR, 84th Cong., 2nd sess., *Congressional Record* (July 20, 1956), 1–2; Robert Gwathmey, "Art for Art's Sake?," address delivered at the International Design Conference, Aspen, Colorado, 1958; transcript printed in *American Art* 7 (Winter 1993): 99–103.

14. Piehl, 13–14; Kammen, 166–68.

133. Philip Guston (1913–1980)

The Sculptor, 1943

Oil on canvas

46 x 30 in. (116.8 x 76.2 cm)

Signed and dated lower left: "Philip Guston / 1943"

Museum Purchase, John Barton Payne Fund, 46.9.1

PROVENANCE: Midtown Galleries, New York, N.Y.

134. John B. Flannagan (1895–1942)

Jonah and the Whale: Rebirth Motif, 1937

Cast stone

30 ¼ x 11 ¼ x 4 in. (76.8 x 28.6 x 10.2 cm)

Gift of Curt Valentin, 46.15.1

PROVENANCE: Buchholz Gallery, New York, N.Y.

Best known for his 1950s experiments with gestural abstraction and his 1970s cartoonish figuration, Philip Guston, like many postwar modernists, began his career as a mural painter. Coming of age during the 1930s, he drew early inspiration from the work of leading Mexican masters Diego Rivera, José Clemente Orozco, and David Alfaro Siqueiros, with whom he briefly worked in Mexico in 1934. Two years later, at the urging of friend and former classmate Jackson Pollock (see cat. no. 135), Guston moved from his childhood home of Los Angeles to New York. There, he promptly joined the mural division of the Works Progress Administration's Federal Art Project and its ranks of other young painters such as Stuart Davis (see cat. no. 136) and Willem de Kooning. Through his mural production, Guston developed a taste and talent for monumentality and structural order that owed as much to Renaissance painters Andrea Mantegna and Piero della Francesca as to the modern cubist approaches of Pablo Picasso and Fernand Léger and the surrealism of Giorgio de Chirico ("about whom he was mad!")[1]

In 1941 Guston accepted the offer of a teaching position at the State University of Iowa, where he would spend the next four years honing his painterly craft and personal vision. In a transitional series of easel pictures, of which VMFA's *The Sculptor* is among the most acclaimed, Guston moved from a

133

preoccupation with fresco technique to an exploration of the oil medium. Along the way, he established a national reputation as an individualistic painter.[2]

The domestically scaled pictures that came out of Guston's Iowa sojourn depict primarily friends and family. Their matte surfaces are suggestive of the one-time muralist's fondness for fresco, but are infused with a neoromantic, moody sentiment echoed in the dusky palette and stoic figures. *The Sculptor* portrays Humbert Albrizio, a direct carver of wood and stone who, like Guston, moved to Iowa from New York to join the university's art department. Direct carving, equated with a greater sense of immediacy and artistic "truth" than earlier traditions of modeling or casting allowed, was the most popular mode of modern sculptural production. Albrizio's New York studies with Spanish-born José de Creeft, who had trained with a French stonecutter in his youth, would have predisposed him to direct carving, an approach that went beyond mere technique to embody an aesthetic principle and spiritual harmony between artist and material.[3]

Less a portrait of an individual than an almost archetypal image of the artist as worker, *The Sculptor* presents Albrizio in his studio (various armatures appear in the background) as a grave Pygmalion. Mallet and chisel in hand, he is intently focused on his sculptural Galatea, whose gridded, ovoid head suggests de Chirico's haunting figures. The paper hat that Albrizio wears to keep his hair free of wood, stone, or plaster chips appears in Guston's dreamlike series of children at play, such as *If This Be Not I* (1945, Mildred Lane Kemper Art Museum, Washington University)—a recurring motif that anticipates his later inventory of books, cigarettes, and shoes, as seen in VMFA's *The Desert* (fig. 215).[4]

The Sculptor was likely included in Guston's initial solo exhibition, held at the university's Iowa Memorial Union in the spring of 1944. The following year it appeared in the artist's first New York exhibition, at Midtown Galleries, where it attracted positive critical notice. Rosamund Frost described the single figure's "overweening importance," its readiness to "outgrow its frame," identifying Guston as the "man who can make us see the symbols behind the commonplaces." Soon after this successful New York debut, Guston moved from Iowa to Missouri, where he served as visiting artist at the Saint Louis School of Fine Arts at Washington University and then

went on to head the painting department. That fall he won the prestigious first prize of $1,000 in the Carnegie Institute's *Painting in the United States* exhibition, an honor that landed him a prominent feature in *Life* magazine, the first such press coverage that would trace his increasing move toward abstraction during the 1950s.[5]

Guston's reputation was also fueled by his prizewinning presence in group exhibitions across the country, including VMFA's *Fifth Biennial Exhibition of Contemporary American Paintings*—"the South's most heralded competition"—which opened March 30, 1946, and closed April 25, just a month before the publication of the *Life* article. The exhibition jury, headed by Guston's New York acquaintance Henry Varnum Poor—who apparently found the work of his New York colleagues to be lacking compared to other submissions—saw fit to award Guston the institution's John Barton Payne Medal. Moreover, *The Sculptor,* which graced the cover of the accompanying catalogue, was one of seven paintings acquired by the

FIG. 215 Philip Guston (1913–1980), **The Desert,** 1974, oil on canvas, 72 ½ x 115 in. (184.2 x 292.1 cm). Virginia Museum of Fine Arts, Gift of Sydney and Frances Lewis, 85.400.

museum from that year's biennial. A few months later it was featured, along with other recent VMFA purchases, in another regional round-up—the *New Accessions USA* exhibition at the Colorado Springs Fine Arts Center.[6]

The Sculptor's Pygmalion-like theme of creation or rebirth echoed in another VMFA acquisition that year—John Flannagan's *Jonah and the Whale: Rebirth Motif,* a cast-stone replica made from the original bluestone design (Brooklyn Museum

134

of Art). It was donated to the museum by the deceased sculptor's longtime dealer Curt Valentin. Flannagan, an acclaimed direct carver whose national profile was higher than that of Guston's friend and model Albrizio, had committed suicide in early 1942, just months before his first solo exhibition was to open at Valentin's Buchholz Gallery. This tragedy was marked by a flurry of critical and public attention, from the gallery show and a larger exhibition at the Museum of Modern Art, which was organized later by respected curators Dorothy Miller and Carl Zigrosser, to Valentin's publication of Flannagan's selected letters. *Jonah and the Whale* figured prominently in all of these efforts (fig. 216), underlining its critical importance to the sculptor (who considered it "profound") and his supporters.[7]

One of Flannagan's more ambitious works, *Jonah* exemplifies his shift away from naturalist to more allegorical concerns. During a difficult period, its redemptive implications resonated with the sculptor as a metaphor for birth and rebirth (made explicit by its subtitle). A favored primal theme of Flannagan and other influential direct carvers such as William Zorach (fig. 217), it was often symbolized by the mother-child relationship (Flannagan was separated from his mother at an early age). The graceful and whimsical repose of the bearded Old Testament prophet, his body folded womblike in the whale's belly, suggests a positive outcome for this well-known tale of spiritual resurrection—what the sculptor called "the wishful rebirth fantasy." Making the connection between the fish and the ancient "female principle," Flannagan connected the subject to his recurrent themes of birth, captivity, and escape, which, as Michael Lewis has argued, were "restated in his own physical struggle to liberate the figure from its stone mantel."[8]

In its powerful abstract simplicity, *Jonah and the Whale* exemplifies the sculptor's belief in the existence of an "image in the rock." Flannagan had an empathetic talent for recognizing forms in stones that he discovered on his rambles around his home in Woodstock, New York, particularly the distinctive bluestone of the area, which provided the raw material for many of his works. The "provocative silhouette" of the specimen used for the original *Jonah and the Whale* sculpture initially drew his attention; though it was two years later before he realized that it was "fitted for the Whale."[9]

FIG. 216 John B. Flannagan (1895–1942), **Note for Jonah,** sketch included in letter from Flannagan to Carl Zigrosser, June 1937.

FIG. 217 William Zorach (1887–1966), **Awakening,** 1942, Colorado alabaster, 17 x 34 x 6 in. (43.2 x 86.4 x 15.2 cm). Virginia Museum of Fine Arts Purchase, The General Endowment Fund, 55.14.

In keeping with his "scrupulous regard for his material," Flannagan added only minor, shallow incisions to the heavy stone slab to delineate the whale—from the few lines at top suggesting its flukes to the fishing line and eye below the more elaborately carved Jonah—then placed its rounded curve upright on a simple wood base, emphasizing its organic nature. "I have taken considerable liberties with the literal," he confessed in a June 1937 letter to Carl Zigrosser, "but I think that in that deeper verity of the symbolic it is right." He added, "P.S. Again Jonah, like all fish stories, of course, it feels infinitely longer and bigger than I can stretch or reach or even than it looks"—an apt summation of Flannagan's vital, enduring art.[10] SY

NOTES

1. For Guston's early biography, see Dore Ashton, *A Critical Study of Philip Guston* (Berkeley, Los Angeles, and Oxford: University of California Press, 1976), 11–41, 53.

2. One of Guston's influential colleagues on the Iowa faculty was the young art historian Horst W. Janson—later immortalized in academic circles for his canonic 1962 survey of art history. The two worked together again at Washington University and New York University. As curator of the Washington University Gallery of Art in 1945, Janson acquired Guston's first major work, *If This Be Not I*; he also authored one of the earliest critical appreciations of the artist. See H. W. Janson, "Philip Guston," *Magazine of Art* 40 (February 1947): 55–58. For the most comprehensive examination of Guston's preabstract period, see Michael E. Shapiro, *Philip Guston: Working Through the Forties*, exh. cat. (Iowa City: University of Iowa Museum of Art, 1997).

3. For more on the direct-carving tradition, see Wayne Craven, *American Art: History and Culture* (Madison, Wis.: WCB Brown and Benchmark, 1994), 494–97, and Judith Zilcer, "The Theory of Direct Carving in Modern Sculpture," *Oxford Art Journal* 4 (November 1981): 44–49.

4. For Albrizio, see John C. Gerber et al., *A Pictorial History of the University of Iowa* (Iowa City: University of Iowa Press, 2005), 201; "Albrizio Moods," *Art Digest* (November 15, 1950); "Traditional and Modern," *New York Times,* November 19, 1950; and Thomas S. Tibbs, *Humbert Albrizio: Retrospective Exhibition of Sculpture and Recent Drawings*, exh. brochure (Des Moines: Des Moines Art Center, 1961). For mention of Guston's early experience as a Hollywood extra, appropriately playing an artist at work in an atelier in the 1931 movie version of the 1899 George Du Maurier novel *Trilby*, see Ross Feld, *Philip Guston*, exh. cat. (New York: George Braziller in association with San Francisco Museum of Modern Art, 1980), 12. Guston continued to sketch portraits of his artist friends throughout his life. See Ashton, 113–14, for his pen-and-ink caricatures of Willem de Kooning and Franz Kline.

5. Rosamund Frost, "Guston: Meaning out of Monumentality," *Art News* 43 (February 1–14, 1945): 24, and "Critic's Choice at the Armory Show," *Art News* 44 (October 1–14, 1945): 25. See also "Philip Guston: Carnegie Winner's Art Is Abstract and Symbolic," *Life,* May 27, 1946, 90–92. As Robert Storr notes, the feature appeared three years before the magazine's famous article on Guston's old friend, "Pollock: Is He the Greatest Living Painter in the United States?" See Storr, *Guston* (New York: Abbeville, 1986), 18.

6. "Virginia Biennial Opens in Richmond," *Art Digest* 20 (March 15, 1946): 8; *The Fifth Biennial Exhibition of Contemporary American Paintings*, exh. cat. (Richmond: Virginia Museum of Fine Arts, 1946). For a list of other "recommended" acquisitions from the exhibition, including Stuart Davis's *Ultramarine* (now at the Pennsylvania Academy of the Fine Arts) as well as paintings by Joe Jones and George L. K. Morris, none of which were purchased, see VMFA curatorial files. For an overview of Guston's active exhibition presence, including the *New Accessions USA* effort, see Celia Stahr, Chronology in Shapiro, 15–19.

7. While it is not known if Albrizio and Flannagan shared New York connections, descriptions of the former's "poetic" intentions and emphasis on texture in his work echo Flannagan's statement on judging a "real sculptor by the sensitivity of tactile surface, like texture, etc., because to get it one *must love stone.*" See Gerber et al., 201, and *Letters of John B. Flannagan* (New York: Curt Valentin, 1942), 92. See also "Sculptor, Long Ill, Commits Suicide," *New York Times,* January 8, 1942, and *The Sculpture of John B. Flannagan,* exh. cat. (New York: Museum of Modern Art, 1942). Flannagan identified *Jonah* as "profound" in a June 5, 1941, letter to Valentin, recommending the work's inclusion in his upcoming gallery show; and on August 7 he wrote again to Valentin: "and then I learn there is to be a bronze Jonah," suggesting the work's ongoing popularity. See *Letters,* 85, 90. While it is unclear if a bronze version was ever made, VMFA's sculpture appears to have been cast from the original bluestone purchased in 1944 from the Weyhe Gallery by Edith and Milton Lowenthal; it entered the collection of the Brooklyn Museum, as part of the Lowenthal bequest, in 1992. See *Modernist Art from the Edith and Milton Lowenthal Collection,* exh. cat. (New York: Brooklyn Museum, 1981), 24, and Lisa Mintz Messinger, *American Art: The Edith and Milton Lowenthal Collection,* exh. cat. (New York: Metropolitan Museum of Art, 1996), 24.

8. In 1934, exhausted and overworked, Flannagan entered a sanatorium where he remained for several months. In July 1937, he wrote to Carl Zigrosser, "The Jonah, so appropriate this luckless year, is still further appropriate in being BLUESTONE." See *Letters,* 59. Flannagan's health declined further after a car accident in 1940, which seriously affected his ability to work. For a June 1941 discussion of his "great longing and hope" for the "rebirth fantasy," see Flannagan, "The Image in the Rock," in *The Sculpture of John B. Flannagan,* 8. He expounded on the "very ancient symbol of the Female Principle" in a June 15, 1941, letter to Curt Valentin. See *Letters,* 87. See also Michael J. Lewis, *American Art and Architecture* (London: Thames and Hudson, 2006), 240.

9. See W. R. Valentiner, "John B. Flannagan," in *Letters,* 14. In a May 26, 1937, letter to Carl Zigrosser, the sculptor wrote of his "indulging a dubious sense of humor lately. I've just completed for example, a rocky version of 'Jonah and the Whale' greatest of all fish stories." See *Letters,* 56.

10. William Schack, "Four Vital Sculptors," *Parnassus* 9 (February 1937): 40. Flannagan's initial compositional sketch for *Jonah* appears in the June 1937 letter to Zigrosser. See *Letters,* 58–59.

135. Jackson Pollock (1912–1956)

Number 15, 1948 (Red, Grey, Yellow, White), 1948

Enamel on paper, mounted on Masonite

22 ¼ x 30 ½ in.

Signed and dated lower left: "Jackson Pollock 48"

Gift of Mr. and Mrs. Arthur S. Brinkley Jr., 78.2

PROVENANCE: Betty Parsons Gallery, New York, N.Y. (1949); Lynne Thompson, Blue Hill, Maine; Arthur S. Brinkley Jr., Richmond, Va. (1952–78)

"Jackson Pollock: Is he the greatest living painter in the United States?" asked an unsigned feature article in the August 8, 1949, issue of *Life* magazine. Referencing a recent assertion by art critic Clement Greenberg that Pollock had emerged as a major figure in the contemporary art scene, the popular weekly dedicated a three-page feature to "the shining new phenomenon of American art." Alongside images of his shockingly new "drip" paintings, the thirty-seven-year-old Pollock was pictured standing, facing the viewer, with arms and legs crossed, head cocked, and the ubiquitous cigarette hanging from his mouth. Another photograph captured him at work, squatting at the edge of a canvas laid flat on the floor and drizzling paint from a stick to create his distinctive interweavings of line.[1]

It is easy to imagine Pollock employing the same approach while producing his bold *Number 15, 1948* the previous year.[2] Working in industrial Duco enamel on a large sheet of rectangular paper, he first laid down a solid black background. With a stick or brush saturated with thin white pigment and held some inches above the surface, he then trickled lively, calligraphic lines across the surface—a few leaving the paper's edge during exuberant loops, some becoming thick columns or puddles as the artist slowed his application and others turning transparent and feathering against the still-wet ground. Pollock then added numerous spots and thin lines of blue, red, and yellow pigment, a few resulting in larger round pools. He interrupted some of these with apparent swipes with a dry brush or palette knife.

Pollock arrived at his unconventional mode of painting after nearly two decades of experimentation. The Wyoming native began formal art training in 1930 at the Art Students League in New York City, where he initially adopted the regionalist themes and methods of his teacher Thomas Hart Benton (see cat. no. 118). His work became more stylized in subsequent years. As a painter with the Works Progress Administration's Federal Art Project, he came to admire the murals of David Alfaro Siqueiros and worked in his Union Square workshop in 1936. Two years later, following hospitalization for acute alcoholism, Pollock entered an extensive period of Jungian psychoanalysis, which inspired him to seek more introspective means of expression. By 1940, he had adopted aspects of European modernism, particularly the shallow pictorial space and biomorphic forms of Pablo Picasso and Joan Miró. By studying their paintings and methods, he also developed an intense interest in surrealism, with its intuitive, automatist approach to representing myths, dreams, and the unconscious. Over the next five years, Pollock's work—while still retaining some figuration—became more abstract, gestural, and rhythmic. His dramatic break with traditional painting occurred in the winter of 1946–47 when he relinquished the easel and laid his canvases and papers on the floor. With new freedom of movement, he poured or dripped pigment directly onto the surface to create abstract, all-over compositions that circumvented recognizable imagery and illusionistic depth.[3] Shortly after this transition, Pollock explained his new approach in the art journal *Possibilities:*

> On the floor I am more at ease. I feel nearer, more part of the painting, since this way I can walk around it, work from the four sides and literally be *in* the painting. This is akin to the method of the Indian sand painters of the West.
>
> When I am *in* my painting, I'm not aware of what I'm doing. It is only after a sort of "get acquainted" period that I see what I have been about. I have no fears about making changes destroying the image, etc., because the painting has a life of its own. I try to let it come through.[4]

While Pollock was singled out in the 1949 *Life* feature, he was not alone in his search for "new ways and new means of making [a] statement."[5] During the previous decade, numerous other New York–based artists found inspiration in the latest currents of European cubism, expressionism, and

135

surrealism, examples of which were on view in the Museum of Modern Art (MoMA), founded in 1929, and progressive independent galleries. Interest in experimentation increased with the commencement of World War II in 1939 and the immigration of avant-garde artists to the United States, including surrealist leaders André Breton, Salvador Dali, Max Ernst, André Masson, and Roberto Matta. Amid the turbulence of global war, its astounding culmination with the dropping of atomic bombs, and growing postwar anxiety over the threat of communism, various painters and sculptors turned inward. With increasingly nonrepresentational imagery, they pushed their works to new formalist extremes while trying to express subjective and even subconscious experiences. Many looked for purity and truth in the "primitive" art of African, Oceanic, and Native American cultures. Pollock's acknowledged interest in Native American sand painting corresponded with that of a small cadre of painters led by Steve Wheeler (fig. 218) who sought to represent "Indian space" with determined flatness, meandering lines, and all-over compositions.[6]

By 1945 Clement Greenberg noted the bold endeavors of a core group of young artists whose work was featured at Peggy Guggenheim's Art of This Century gallery: Pollock, Willem de Kooning, Robert Motherwell, Barnett Newman, Mark Rothko, David Smith, and Clyfford Still. In a short time, this loose association of men—never formally affiliated and each developing a highly individualized style—came to be known as "abstract expressionists" or their preferred "New York school." The terms eventually encompassed a wider circle of like-minded artists, including Helen Frankenthaler, Adolph Gottlieb, Franz Kline, Lee Krasner (Pollock's wife), Norman Lewis, and Hedda Sterne. In various essays and reviews, Greenberg championed the new art as the inevitable progression, evident through formal analysis, of the modernist impulse begun a century earlier by Edouard Manet. Harold Rosenberg, a rival and equally influential art critic, brought additional acclaim to Pollock and his cohorts, whom he dubbed "action painters," but he conversely celebrated their break with tradition and underscored their fresh, raw creative process.[7] Pollock, in particular, became the face of the new directional shift. In addition to the acquisition of his work by MoMA and a series of successful solo shows, he also contributed widely to progressive group showings—including

VMFA's controversial biennial *American Art 1950* in Richmond (see cat. no. 136). Six years later, having again succumbed to alcoholism, he died after accidentally crashing his car near his Long Island home.[8]

As abstract expressionism gained critical notice, the mainstream press and popular opinion proved less enthusiastic about the radical reorientation of postwar art. If there was a hint of incredulity in the *Life* article, *Time* magazine was blatantly hostile—a stance echoed in conservative newspapers and publications across the country. Fueled by Cold War anxiety, a few politicians condemned "unintelligible" art as subversive and "communistic." In March 1950, three museums—MoMA, the Whitney Museum of American Art in New York, and the Institute of Contemporary Art in Boston—responded with

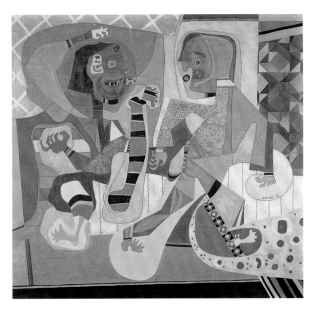

FIG. 218 Steve Wheeler (1912–1992), **The Halogens,** 1942, oil on canvas, 25 x 27 ¾ in. (63.5 x 72.4 cm). Virginia Museum of Fine Arts Purchase, The Arthur and Margaret Glasgow Fund, 2000.83.

a joint manifesto stating that freedom of creative expression, fully evident in the flourishing of modern art, was only possible in a democratic society. The argument held and gained momentum. By the late 1950s, abstract expressionism—with its highly individualistic, dynamic, and much-touted masculine qualities—was widely understood as "American" art; and with its ascendancy, New York became the artistic center of the Western world.[9] ELO

NOTES

1. [Dorothy Seiberling], "Jackson Pollock: Is he the greatest living painter in the United States?," *Life*, August 8, 1949, 42–43, 45; photographs by Hans Namuth. The article's title refers to the statement that Pollock was the "most powerful painter in contemporary American art" in Clement Greenberg, "The Present Prospects of American Painting and Sculpture," *Horizon*, October 1947, 25–28.

2. *Number 15, 1948* was one of twenty-six paintings featured in Pollock's solo exhibition at the Betty Parsons Gallery in New York City in January 1949. It was reproduced five years later with an alternative title, *Red, Grey, Yellow, White*, in B. H. Friedman, "The New Baroque," *Arts Digest* (September 15, 1954): 12. In 1948 the artist chose random numerical titles to obscure meaning. After assigning duplicate numbers to other paintings made in the same year, Pollock later added an "A" designation for the second grouping and sometimes color-reference subtitles. Francis Valentine O'Connor and Eugene Victor Thaw, eds., *Jackson Pollock: A Catalogue Raisonné of Paintings, Drawings and Other Works* (New Haven and London: Yale University Press, 1978), 2:1, 17, no. 196. O'Connor and Thaw list it as *Number 15, 1948: Red, Gray, White, Yellow*, which reverses the last two colors.

3. Kirk Varnedoe, "Comet: Jackson Pollock's Life and Work" in *Jackson Pollock*, exh. cat. (New York: Museum of Modern Art, 1998), 20–41. On the impact of Pollock's psychoanalysis see Michael Leja, "Jackson Pollock: Representing the Unconscious," in *Reading American Art*, ed. Marianne Doezema and Elizabeth Milroy (New Haven and London: Yale University Press, 1998): 440–64.

4. Jackson Pollock, "My Painting," *Possibilities* I (Winter 1947–48), quoted in *American Artists on Art from 1940 to 1980*, ed. Ellen H. Johnson (New York: Harper and Row, 1982), 4.

5. Jackson Pollock, interviewed by William Wright, 1950, quoted in *Jackson Pollock, Interviews, Articles, and Reviews*, ed. Pepe Karmel (New York: Museum of Modern Art 1999), 20. Pollock's statement continues: "It seems to me that the modern painter cannot express this age, the airplane, the atom bomb, the radio, in the old forms of the Renaissance or of any other past culture. Each age finds it own technique."

6. Ann Eden Gibson, *Abstract Expressionism, Other Politics* (New Haven and London: Yale University Press, 1997), 1–45, 188; Sandra Kraskin et al., *The Indian Space Painters, Native American Sources for American Abstract Art*, exh. cat. (New York: Sidney Miskin Gallery, 1991), 7–9.

7. For a contextual examination of rivals Greenberg and Rosenberg and the influential role they played in the critical reception of the New York school artists, see Norman L. Kleeblatt et al., *Action/Abstraction: Pollock, de Kooning, and American Art, 1940–1976*, exh. cat. (New York: Jewish Museum; New Haven and London: Yale University Press, 2008).

8. Varnedoe, 64–67. For the VMFA contemporary art exhibition—organized by James Johnson Sweeney, former director of MoMA's department of painting and sculpture—Pollock contributed a 1948 oil on canvas, *Number 17A*. *American Painting 1950*, exh. cat. (Richmond: Virginia Museum of Fine Arts, 1950).

9. Serge Guilbaut, "Postwar Painting Games: The Rough and the Slick," in *Reconstructing Modernism: Art in New York, Paris, and Montreal, 1945–1964* (Cambridge, Mass.: MIT Press, 1990), 30–41, 60–74; "Museums Demand Freedom for Arts," *New York Times*, March 28, 1950, 33.

136. Stuart Davis (1894–1964)

Little Giant Still Life (The Champion), 1950

Oil on canvas

33 x 43 in. (83.8 x 109.1 cm)

Signed lower center right: "Stuart Davis"

Museum Purchase, The John Barton Payne Fund, 50.8

PROVENANCE: Downtown Gallery, New York, N.Y.; purchased from *American Painting 1950*, Seventh Biennial Exhibition of Contemporary American Paintings, Virginia Museum of Fine Arts, Richmond, Va. (April 22–June 4, 1950)

> RICHMOND: Bloody but unbowed from the controversy which has raged over the current exhibition of American art (chosen by one-man juror James Johnson Sweeney), the trustees of the Virginia Museum have announced the purchase of Stuart Davis' "Little Giant Still-Life."

This single-sentence notice in the May 28, 1950, edition of the *New York Times* communicated not only the salient facts about the purchase of a major contemporary painting by the Virginia Museum of Fine Arts but also the intensity of the public debate surrounding the young institution's seemingly deliberate turn toward abstract art in the mid-twentieth century.[1] Over the next two years, the small announcement would number among dozens of published reactions—both local and national—that pondered the museum's acquisition of Stuart Davis's *Little Giant Still Life* and a possible modernist foothold in the Old Dominion.

Throughout its six-week venue, *American Painting 1950*—VMFA's seventh biennial exhibition of contemporary painting, from which *Little Giant Still Life* was chosen—prompted a flurry of editorials, columns, articles, and letters. Unlike previous biennials, for which works were vetted by a small jury of artists, the 1950 exhibition was single-handedly selected and organized by James Johnson Sweeney, prominent New York art critic and former head of the painting and sculpture department at the Museum of Modern Art (MoMA). He also agreed to promote the show through a series of statewide lectures.[2] After the April opening, Sweeney and VMFA director Leslie Cheek Jr. launched discursive articles about the endeavor in Richmond papers and national art magazines, while art

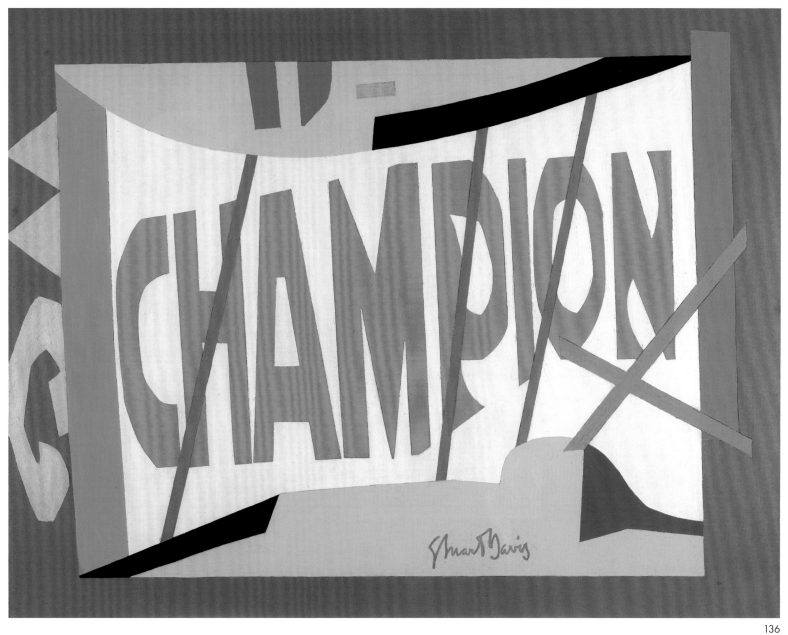

136

critics from the *New York Herald Tribune* and *New York Times* penned supportive reviews.[3] At the same time, however, negative responses to *American Painting 1950* flourished in the local press. Leading the opposition was *Richmond Times-Dispatch* columnist Ross Valentine, whose dislike of the exhibition's offerings extended to a condemnation of modern art as a whole.[4] With growing frequency and vehemence, his articles denounced modernism as a malicious hoax carried out variously by the northern elite, European degenerates, homosexuals, and communists.[5]

In the middle of this "smoldering battle between modernists and traditionalists" at the "Virginia Museum of Modern Art," the museum's acquisition committee chose Davis's *Little Giant Still Life* for its meritorious John Barton Payne Medal and subsequent purchase.[6] During several called meetings, the trustees were guided in their decision by Cheek, the museum's fairly new director who devised the unusual one-juror format.[7] In early May, they asked Sweeney to announce the awards to the public. Having organized and written the catalogue for a major Davis retrospective at MoMA in 1945, the critic confidently praised the selected canvas as "puckish in the manner of Huck Finn; strident, yet soft; rough cast, but gentle; apparently casual, but pictorially subtle." He continued, "It takes a poet of our industrial world to turn sign board materials into a lyric."[8] As for the New York–based artist, Davis sent a telegram expressing pleasure in receiving the honors and pronouncing the painting his best.[9]

In fact, *Little Giant Still Life* marked a significant stylistic change in the painter's oeuvre. By midcentury, Davis had built a reputation as one of the nation's leading practitioners and advocates of abstract art.[10] Through his almost forty-year career, he had championed freedom of artistic expression. A young protégé of Robert Henri (see cat. no. 111) and John Sloan, he turned from urban realism to a modernist idiom after the momentous 1913 Armory Show. In the following decade, which included a year's study in Paris, Davis developed his own loose version of synthetic cubism, which he honed in a series of still lifes featuring common household items and commercial products. He arrived at his distinctive mature style in the 1930s, producing images that expressed particular aspects of the American experience—jazz, modern technology, advertising, and urban living—with solid,

FIG. 219 Stuart Davis (1894–1964), **Studies for *Little Giant Still Life*,** 1950, ink on paper, 11 x 8 ½ in. (28.0 x 21.6 cm). Fogg Art Museum, Harvard University, Cambridge, Mass., Gift of Mrs. Stuart Davis.

sharp-edged planes. In subsequent years, as Davis developed formal theories about color and space, his "configurations," as he called them, became crowded with small, vividly colored, overlapping forms, sometimes punctuated with words and symbols. In the early months of 1950, however, the artist made a deliberate shift toward sparer yet more vibrant compositions.[11]

In *Little Giant Still Life,* Davis allowed a single word to dominate his image. In bright red-orange letters, "CHAMPION" floats at center across a curving white field, surrounded by planes of yellow, blue, green, and black and a wide red border. Slender lines—a green X and three blue diagonal slashes—visually anchor the word in place. Davis's signature drifts below, curling against light blue like a thin red confetti streamer. A concern with balancing horizontal, vertical, and diagonal patterns is evident in the artist's preliminary sketch for the painting. Such formal qualities appear to outweigh subject matter; in his written notes on the sketch, he sequences the "Emergence of Meaning" last (fig. 219). Davis, who found

his subjects in the world around him, stated that the idea for the picture came from "an insignificant inspiration"— a matchbook cover that advertised Champion spark plugs. More interested in exploring shape and color than referencing matches or spark plugs, he emphasized the word but also neutralized associations by crossing through some of the letters. "I've used insignificant words and drawn insignificant objects because [they] were at hand," he explained. "By giving them value . . . and by equating great with little, I discovered the act of believing was what gave meaning to the smallest idea." In other words, as the painting's title suggests, little is rendered giant.[12]

In the eighteen months following the debut of *Little Giant Still Life* at VMFA, the painting was lent to MoMA and the Art Institute of Chicago and then selected for the 1952 Venice Biennale in Italy, where Davis was one of four American representatives.[13] As national and international acclaim mounted, *Little Giant Still Life* continued to draw local interest and, as before, derision. Printed debate over its merits rose and fell, primarily with Ross Valentine heatedly sparring with such notables as the editors of *Art News, Art Digest, Magazine of Art,* and MoMA directors René d'Harnoncourt and Alfred H. Barr.[14] Valentine peppered his columns with terms more suitable for a boxing match than an art museum—or polite Richmond society. He offered up headlines such as "Modern Art on Its Last Legs" and "Up Off the Canvas and Into the Ropes," as well as the boast that he verbally "pulverized Monsieur d'Harnoncourt." Valentine brazenly hit below the belt with the mendacious claim that the artist embedded a four-letter epithet in the painting's maze of abstract shapes.[15]

Throughout the controversy, Davis remained above the fray.[16] If the VMFA director and trustees emerged from the bout "bloody but unbowed"—as the *New York Times* declared after the earliest rounds—the artist came through not only unscathed but energized. Finding a new direction in his work and still intrigued with the concept developed in *Little Giant Still Life,* he began producing variations of the composition— including *Visa,* acquired by MoMA in 1953.[17] Nevertheless, Davis faced other, more pressing battles in the era's broader culture wars. In 1956 he was named alongside several other American modernists in the *Congressional Record* as a communist subversive. The report, made from a speech by a Michigan

legislator, also indicted Jackson Pollock, William Baziotes, and Robert Motherwell—younger painters whose abstract expressionist canvases were also featured in VMFA's *American Painting 1950* exhibit—as artists practicing an even more radical "ism." Having moved away from leftist politics in the previous decade, Davis ultimately sidestepped a summons to appear before the infamous Congressional hearings on un-American activities.[18] Abstract expressionism, on the other hand, proved a formidable stylistic adversary. As Davis continued working over the next decade in his hard-edge, semirepresentational mode, he witnessed the ascendancy of this powerful new vanguard that championed a more subjective approach to abstraction.[19]

ELO

NOTES

1. Local opposition was already primed. Previously, VMFA attracted controversy with its 1948 exhibition of the T. Catesby Jones collection—a recent bequest that included works by European modernists such as Pablo Picasso, Georges Braque, Juan Gris, Paul Klee, André Masson, and Jaques Lipchitz—and its 1949 exhibition, *Alexander Calder and Sculpture Today.* Exhibition files, VMFA Library.

2. The seventy-seven canvases in *American Painting 1950* represented a range of subjects and styles, including nonrepresentational paintings by Jackson Pollock and Mark Tobey; surrealist visions by Yves Tanguy and Salvador Dali; precisionist views by Ralston Crawford and Charles Sheeler; semiabstract works by John Marin, Georgia O'Keeffe, Jacob Lawrence, and Max Weber; and realist images by Andrew Wyeth and Edward Hopper. Leslie Cheek Jr., *American Painting 1950,* exh. cat. (Richmond: Virginia Museum of Fine Arts, 1950).

3. James Johnson Sweeney, "Art Must Speak a Living Language, Says Critic Who Chose Museum Show," *Richmond Times-Dispatch,* April 30, 1950, 4–4, and "Sweeney Setting His American Scene," *Art News* 49 (May 1950): 18–20, 56–57; Leslie Cheek, *Art Digest* 24 (May 1 1950): 7, 31; Emily Genauer, "Controversy Over Sweeney-Directed Art Show Held a Peril to Progress," *New York Herald-Tribune,* May 21, 1950; Aline B. Louchheim, "One Man Picks and Defends Biennial," *New York Times,* April 30, 1950, B–8.

4. "Ross Valentine" was the penname of Kurt Valentine Hoffman, who immigrated as a child from Germany to the United States in 1907. After graduating from Yale, he established a career in journalism working for various newspapers in Connecticut, New York, Alaska, Washington state, and New Jersey. In 1948, he assumed an associate editor position at the *Richmond Times-Dispatch* covering economic and international affairs. He was recruited by the paper's publisher and president, D. Tennant Bryan, who also served as a VMFA trustee during the 1950 controversy. "K. V. Hoffman dies; ex-editor," *Richmond Times-Dispatch,* November 6, 1989, B–2. Valentine's ideological stance against modernism echoed similar Cold War invectives in conservative newspapers across the country. A month before the VMFA show opened, three prominent museums, including MoMA, published a joint manifesto defending modern art as a product of a free, democratic society. "Museums Demand Freedom for Arts," *New York Times,* March 28, 1950, 33.

5. Initially the columnist's primary target was Hyman Bloom's *Female Corpse, Back View* (presently Museum of Fine Arts, Boston), but he focused on Davis's *Little Giant Still Life* after the purchase announcement. Representative of his several commentaries are "Apollinaire's Famous Warning," *Richmond Times-Dispatch,* April 25, 1950, 12; "'Modern Art' on Its Last Legs," ibid., April 30, 1950, 4–4; and "The Case of the Little Giant," ibid., May 28, 1950, 4–2.

6. "An Art Expert States His Credo," *Richmond Times-Dispatch,* April 30, 1950, 4.

7. VMFA Board of Trustees Minute Book, 1:161–65, 183, 204–5. Cheek had arrived less than two years earlier from a directorship at the Baltimore Museum of Art. Previously, the Tennessee native—who earned a fine arts degree from Harvard and an architectural degree from Yale—founded the fine arts department at William and Mary.

8. "Sweeney Picks Payne Medal Winners," *Richmond Times-Dispatch,* May 4, 1950, 2.

9. Western Union Telegram, Stuart Davis to Leslie Cheek Jr., May 4, 1950 copy in VMFA curatorial files.

10. "Why Artists Are Going Abstract: The Case of Stuart Davis," *Life,* February 17, 1947, 78, 83. In a February 1948 issue of *Look* magazine, a poll of museum directors and art critics named Davis as one of America's ten leading artists. "Are These Men the Best Painters in America Today?," *Look,* February 3, 1948, 44.

11. Lowery Stokes Sims et al., *Stuart Davis, American Painter,* exh. cat. (New York: Abrams in association with the Metropolitan Museum of Art, 1991), 272.

12. John R. Lane, *Stuart Davis: Art and Art Theory,* exh. cat. (Brooklyn: Brooklyn Museum, 1978), 62, 68, 71; audio recording of Stuart Davis interview by Sidney Simon, Walker Art Center, Minneapolis, Minn., 1957, Part 3, Track 3, www.walkerart.org/archive/2/A2830576F73CD2C16176.htm; transcript of Stuart Davis interview, Katherine Kuh, *The Artist's Voice: Talks with Seventeen Modern Artists* (1962; repr., New York: De Capo Press, 2000), 52. The original matchbook with Davis's marks crossing out three letters descended in the artist's family. It is pictured as fig. 116 in Sims et al., 270.

13. Edward Hopper was also one of four featured American artists at the 1952 Biennale, which exhibited his *House of Dusk* a year before it entered the VMFA collection (see cat. no. 124).

14. Alfred Frankfurter, editorial, *Art News* 49 (May 1950): 17; Robert Goldwater, "Richmond Revisited," *Magazine of Art* (October 1950): 230–31; Belle Krasne, "Very Free Association," editorial, *Art Digest* 26 (March 15, 1952): 5; "'Unpulverized' d'Harnoncourt Answers Critic," *Richmond Times-Dispatch,* February 20, 1952, 14.

15. Valentine, "Last Legs" and "Up Off the Canvas and Into the Ropes," ibid., November 9, 1950, 16; "One Golden Speck of Truth," ibid., January 10, 1952, 10; "A Question for Mr. d'Harnoncourt," ibid., February 21, 1952, 16; "Well, They Asked for It," ibid., March 21, 1952, 14. Valentine's boxing metaphors may be linked with the painting's prominent word, "Champion"—a term that gained even more currency the year before with the release of a popular film of the same name, starring Kirk Douglas in the role of a ruthless prizefighter. See Maria Caudill Dennison, "Stuart Davis's 'Little Giant Still Life' (1950) and the 'Champion' Series," *Burlington Magazine* 149 (September 2007): 629–30.

16. In 1951, Davis traveled to Richmond to serve as a juror for VMFA's Virginia Artists Exhibition, but he made no public statement about the lingering controversy. In a 1957 interview given in conjunction with his one-man show at the Walker Art Center in Minneapolis, he revealed that he considered a libel suit against Valentine over the allegation of a hidden dirty word. "But people of experience told me not to bother with it because it was too much trouble," he noted. "And I should spend my time painting more pictures instead of following this fellow's lead." Audio recording by Sidney Simon, Part 3, Track 3,

17. Lane, 71–72; Sims, et al., 103–4, 269–75.

18. Representative George A. Dondero of Michigan, "UNESCO—Communism and Modern Art," HR, 84th Cong., 2nd sess., *Congressional Record* (July 20, 1956): 2–3; Patricia Hills, *Stuart Davis* (New York: Abrams in association with the National Museum of American Art, Smithsonian Institution, 1996), 138.

19. Lane, 68, 71–72. Dennison suggests that the "Champion" series may have been Davis's defiant response to abstract expressionism, a style that the artist described as a "belch from the unconscious." Dennison, 629–30.

137. Charles Sheeler (1883–1965)

Steel-Croton, 1953

Oil on canvas

16 x 24 in. (40.6 x 61 cm)

Signed and dated lower right: "Sheeler—1953"

Museum Purchase, John Barton Payne Fund, 54.3.3

PROVENANCE: Downtown Gallery, New York, N.Y.

138. Ralston Crawford (1906–1978)

Construction #5, 1958

Oil on canvas

36 ⅛ x 26 ⅛ in. (91.8 x 66.4 cm)

Museum Purchase, The Floyd D. and Anne C. Gottwald Fund; Partial Gift of Neelon Crawford, 2008.41

PROVENANCE: Downtown Gallery, New York, N.Y.; Estate of the artist

Charles Sheeler was widely heralded as the premier exponent of early-twentieth-century precisionism—an artistic style that synthesized realism and abstraction in the rendering of precise geometric forms. As such, he inspired younger artists, Ralston Crawford among them, to cultivate an industrial aesthetic that matched form with content. Focusing their straightforward descriptive approach on America's machine-age monuments—factories, skyscrapers, steel bridges—as well as its vernacular past—rural architecture, artifacts, and folk art—precisionists crafted a visual iconography that linked America's native tradition of realism with more avant-garde European tendencies, such as cubism, in the larger post–World War I cultural context of the "call to order." The resulting mode of vision, shaped by mechanization, rationalization, and romanticism, was interpreted by critics as an expression of a distinctively American reordering of experience.[1]

Both Sheeler and Crawford were products of the venerable Pennsylvania Academy of the Fine Arts and its French-inspired modernism, which shaped two generations of progressive painting in Philadelphia and beyond.[2] In addition, both men embraced commercial ventures at different points in their careers and later shared the same New York dealer, Edith Halpert, who in 1926 opened the Downtown Gallery,

137

the flagship modernist space in Greenwich Village. Given their common ties and similar precisionist imagery, the two artists are frequently considered together in analyses of twentieth-century modernism. A comparative examination of their later work, such as *Steel-Croton* and *Construction #5,* however, is less common.

Sheeler began his artistic training at Philadelphia's School of Industrial Art, which opened his eyes to the beauty of applied design and engineering. He then moved on to classes with William Merritt Chase (see cat. no. 110) at the Pennsylvania Academy, wedding his methodical approach to the more fluid techniques of Old Master painting. A 1908–9 sojourn in Italy and France with classmate Morton Schamberg introduced Sheeler to the architectonic force of Italian Renaissance frescoes as well as to the work of avant-garde painters such as Paul Cézanne, Henri Matisse, and Pablo Picasso—encounters that proved critical to his future direction. Finding similarities in old and new approaches, Sheeler pursued an inventive art based on structural form, expressive color, and pictorial design throughout his long and versatile career.[3]

In the years after New York's 1913 Armory Show, the exhibition that introduced the country to modern European and American art, Sheeler quickly established himself as a key player in the avant-garde circle surrounding the progressive collectors Walter and Louise Arensberg. Bringing his skills as a painter and photographer to bear on such subjects as New York skyscrapers, Shaker barns, Bucks County farmhouses, and industrial factories (including his celebrated images of the Ford Motor Company's River Rouge plant), Sheeler captured the sharp-edged, rigorous beauty of America's traditional architecture as well as its changing landscape.[4]

During the 1930s, Sheeler produced his most realistic works, perhaps in response to the conservative cultural climate and his growing interest in photography. Precise studies of the built environment offered a means to explore the possibilities of abstract shapes and patterns while simultaneously infusing his work with an identifiably "American" character. (Modernist critic Henry McBride once observed of a Sheeler painting: "It shows how a cute Yankee can get away with cubism in a country that says cubism is against the law."[5]) During this period Sheeler exhibited regularly at the Downtown Gallery, becoming one of Halpert's most successful artists. A 1939 solo

exhibition at New York's Museum of Modern Art solidified his reputation as a major establishment figure.[6] Throughout the next two decades—before a stroke in 1959 brought an end to his art making—Sheeler continued to utilize his acclaimed photography as a tool for painting as well as an independent form of creative expression. This systematic approach is apparent in his postwar geometric semi-abstractions, such as VMFA's *Steel-Croton.*

In 1942, Sheeler and his second wife moved from Ridgefield, Connecticut, to Irvington-on-the-Hudson, in New York's Westchester County. Just a few miles north stood the striking steel bridge at Croton-on-Hudson. Built in 1931, the graceful feat of engineering seemed to Sheeler's artistic eye a "beautiful combination of delicacy and strength." Given the local appeal of the structure, *Steel-Croton* may be viewed as a more personal work of Sheeler's later career—at least when compared to the imagery that resulted from such corporate commissions as the 1948 series of New Hampshire textile mills and the 1952 scenes of the U.S. Steel Company in Pittsburgh.[7]

As was his habit at the time, Sheeler likely first explored *Steel-Croton's* compositional design with his camera, then transposed it into a small tempera painting on Plexiglas (fig. 220), before rendering the final large-scale version in oil. This technical rendering allowed the artist to perfect an "unyielding precise" design of spare abstraction that was still identifiable—for example, in the steel spans of the bridge.[8]

FIG. 220 Charles Sheeler (1883–1965), **Steel-Croton,** 1953, tempera on Plexiglas, 6½ x 9¼ in. (16.5 x 23.5 cm). Frances Lehman Loeb Art Center, Vassar College, Poughkeepsie, N.Y.

The oil was featured in VMFA's biennial of contemporary art, *American Painting 1954,* as one of nine paintings recommended for purchase by the exhibition's juror, Dwight Kirsch, director of the Des Moines Art Center. In a letter to VMFA's director, Leslie Cheek Jr.—whom the artist had met in the mid-1930s while in residence at Colonial Williamsburg—Sheeler expressed his pleasure in the museum's acquisition and applauded the single-juror approach to the biennial. Likening his interest in bridges to his fascination with "spider-webs," Sheeler declared such structures the "best examples of the fact that when they are efficiently designed for their function, they are invariably beautiful without the necessity of a separate consideration of beauty being imposed upon them."[9]

One year after VMFA's purchase of *Steel-Croton,* the Metropolitan Museum of Art acquired its first Sheeler oil, *Golden Gate* (1955), which the *New York Times* described as further proof that "he did not have to depend on the formula of his earlier works." And yet, Sheeler's artistic evolution over his long career can be characterized by a certain consistency of vision—a "classical spirit, formal elegance and technical mastery," as the American Academy of Arts and Letters noted in 1962 when bestowing upon the artist their prestigious Award of Merit.[10]

Like the elder Sheeler, Ralston Crawford established his reputation in the 1930s New York art world with crisply defined precisionist paintings of the American industrial landscape. However, his most inventive work followed the emergence in the late 1940s of abstract expressionism, a movement that all but sidelined the artist's subjective geometric idiom. Crawford's sustained exploration of a hard-edged abstraction over the next three decades resulted in a powerfully versatile oeuvre. *Construction #5* dates from a pivotal moment in Crawford's career when he was perfecting a bold abstract style grounded in both expressivity and rationality.[11]

Crawford's diverse artistic periods parallel his peripatetic biography. Born in Ontario, he attended high school in Buffalo, New York, before working on tramp steamers in the Caribbean. In 1927 he moved to Los Angeles and enrolled in the Otis Art Institute; he also briefly worked at Walt Disney Studios. Within a year Crawford relocated to Philadelphia and, along with Richmond-born Robert Gwathmey (see cat. no. 132), who became a close friend, studied at the Pennsylvania Academy of the Fine Arts with modernist painter Hugh

Breckenridge. An active member of Philadelphia's vanguard circles, Crawford also attended weekly lectures by Dr. Albert Barnes at his newly established foundation, where he was deeply affected by the work of Cézanne and Matisse. By 1931, Crawford had moved to New York (following Gwathmey) and aligned himself with a group of politically minded artists, such as Stuart Davis (see cat. no. 136), who embraced abstraction as a universal language in opposition to the dominance of representational American scene painting.[12]

Like his colleague Davis, Crawford in these years favored a simplified cubism inflected by a restricted color scheme, an approach that revealed the lingering presence of French-inspired modernism in the New York art world. He also became increasingly drawn to architectural and industrial subjects. Not content to recycle his earlier and more commercially viable precisionist imagery, Crawford continued to explore new pictorial territory in the 1950s. "I am not interested, and never have been, in playing it safe," he observed.[13] Newly inspired by the use of photography in his image making, Crawford adopted a flat, geometric treatment of architectural themes, as evident in *Construction #5.*

The painting came about through a commission from the Diesel Construction Company (one of America's largest general contracting firms) given to ten New York artists to interpret one of its skyscraper projects then rising in Lower Manhattan. Designed by the local architectural firm of Emery Roth and Sons, 100 Church Street was a twenty-story office building containing ten thousand tons of steel girders ranging from two to twenty-five feet in length. Such a mammoth undertaking elicited the attention of the local press; a special advertising feature in the *New York Times* called it "a masterpiece of construction art and a block-square center of commerce and industry." The art world also took note. The ever-entrepreneurial Edith Halpert orchestrated the linking of "art and business" in this "partnership of progress," selecting the participating artists and featuring their interpretive work in a special one-week exhibition, *Portrait of a Building,* held at the Downtown Gallery in June 1958 before touring it throughout the country.[14]

According to the artist's son Neelon Crawford, he and his father visited the Church Street construction site on various occasions, "climbing to the highest point possible during the

138

erection of the steel structure." This experience resulted in a series of abstract paintings (as well as drawings and photographs), of which *Construction #5* was the most dynamic and pictorially complex. The challenge of translating the building's intricate three-dimensional architectural framework into two-dimensional alternating and interpenetrating planes—harmonized by a muted palette of steely hues and rhythmic hatching lines—led to a maturation of the formal concerns that had shaped the artist's work from the start of his career.[15]

Whereas Crawford may have drawn inspiration for the skyscraper series from Sheeler's earlier example—whose 1921 collaboration with Paul Strand on the six-minute experimental film *Manhatta,* rediscovered in 1950, as well as countless still photographs and paintings of cityscapes were likely known to the younger artist—the end result is quite different.[16] Crawford, like Sheeler, had incorporated photography early on in his artistic practice—a related image (fig. 221) can be linked to *Construction #5*—but he utilized the medium less for preliminary study than as a form of "nourishment" and "visual stimulation" that contributed to an overall understanding of form and experience.[17] One could argue that it was Sheeler who began to approach his later work, such as *Steel-Croton,* in these broader terms, perhaps inspired by Crawford's example. Certainly, Sheeler's interlocking planes and thrusting diagonals of bridge, light, and sky reverberate with Crawford's densely complex building composition in its internal structure and pictorial tension, suggesting a visual dialogue between two equally inventive and mature artists working along a postwar modernist continuum. SY

FIG. 221 Ralston Crawford (1906–1978), **Construction,** 1958, gelatin-silver print photograph, 10 x 8 in. (25.4 x 20.3 cm). Virginia Museum of Fine Arts, Gift of Neelon Crawford, 2009.352.

NOTES

1. For an overview of the precisionist movement, see *Precisionism in America, 1915–1941: Reordering Reality,* exh. cat. (Montclair, N.J.: Montclair Art Museum in association with Abrams, 1994). Crawford has been called the "most tenacious Precisionist after 1935." See Abraham A. Davidson, *Early American Modernist Painting, 1910–1935* (New York: Da Capo Press, 1981), 226.

2. Sheeler studied at the Pennsylvania Academy from 1903 to 1906, Crawford from 1927 to 1930, spanning the breadth of late-nineteenth-century progressive painting styles associated with William Merritt Chase, Sheeler's first mentor, to the early-twentieth-century modernism of Hugh Breckenridge, who most influenced Crawford. Breckenridge taught both life and antique classes in Sheeler's day. I thank Cheryl Leibold, archivist of the Pennsylvania Academy, for this information. See also Sylvia Yount, "Rocking the Cradle of Liberty: Philadelphia's Adventures in Modernism," in *To Be Modern: American Encounters with Cézanne and Company,* exh. cat. (Philadelphia: Pennsylvania Academy of the Fine Arts, 1996), 9–12.

3. For a biographical overview, see Carol Troyen and Erica E. Hirshler, *Charles Sheeler: Paintings and Drawings,* exh. cat. (Boston: Museum of Fine Arts, Boston, 1987).

4. For an examination of Sheeler's versatility and artistic evolution, see Charles Brock, *Charles Sheeler: Across Media,* exh. cat. (Washington, D.C.: National Gallery of Art in association with University of California Press, 2006).

5. Quoted in Edith Halpert script for NBC Television's "Time Capsule" program on Sheeler (October 6, 1939): 1–9; VMFA curatorial files.

6. See "Charles Sheeler, Painter, 81, Dead," *New York Times,* May 8, 1965.

7. Known today as the AMVETS Memorial Bridge, or the New Croton Reservoir Bridge, the 960-foot-long structure spans the New Croton Reservoir on the Taconic State Parkway. See "Historic Bridges of the United States," www.bridgehunter.com. As Sheeler noted of the bridge in a formal statement about *Steel-Croton* that he produced at the request of VMFA director Leslie Cheek Jr. at the time of the work's acquisition: "It had interested me for some time before I decided to organize a picture based upon it." See VMFA curatorial files. For an overview of Sheeler's later corporate commissions, see Abigail Booth, "Catalogue of the Exhibition and Biographical Notes," in *Charles Sheeler,* exh. cat. (Washington, D.C.: National Collection of Fine Arts, 1968), 24–26; and Brock, 127–29.

8. See Booth, "Catalogue," 26–27; "Painter, 81, Dead," *New York Times;* "The Old Precisionist," *Time,* January 29, 1965, and "For the Machine's Sake," *Newsweek,* October 25, 1954, clippings, VMFA artist's file.

9. See correspondence between Cheek and Kirsch as well as Cheek and Sheeler, including the artist's April 4, 1954, letter and statement, VMFA curatorial files. The museum's 1950 biennial, from which it acquired its controversial Stuart Davis (see cat. no. 136), featured 1949 works by Sheeler (*Buildings at Lebanon*) and Crawford (*Grain Elevators, Minneapolis*), submitted by the Downtown Gallery. Davis and Crawford were close friends and colleagues. Edith Halpert invited

Crawford to join her gallery in 1943, while he was serving in the Air Force, on the recommendation of Davis, who deemed Crawford's "very American style and subject-matter" a good fit for her stable. See Lindsay Pollock, *The Girl with the Gallery: Edith Gregor Halpert and the Making of the Modern Art Market* (New York: Public Affairs, 2006), 263. Sheeler's Williamsburg residency also came about through Halpert, whose major folk art patron Abby Aldrich Rockefeller commissioned the artist to paint "portraits" of the newly reconstructed Governor's Palace and Bassett Hall in 1935. See Halpert, NBC script, 7.

10. "Charles Sheeler, Painter, 81, Dead."

11. See William Agee, *Ralston Crawford* (Pasadena, Calif.: Twelve Tree Press, 1983), 16.

12. Barbara Haskell, *Ralston Crawford,* exh. cat. (New York: Whitney Museum of American Art, 1985), 9–36.

13. Quoted in ibid., 87.

14. I am indebted to special intern Felicia Herzog for uncovering a variety of primary-source materials related to the 100 Church Street group commission, particularly the advertising supplement "Ten Distinguished American Artists Interpret a Masterpiece of Construction Art . . . 100 Church Street," *New York Times,* June 8, 1958, 1–16. The supplement features a related abstraction (*Steel*) by Crawford, not *Construction #5* (6). See Herzog, "Modern Art at the Virginia Museum of Fine Arts: Critical Controversies in the 1950s" (seminar report, Randolph Macon College, 2008), VMFA curatorial files. In addition to being one of the most successful New York builders of the postwar years, Erwin Wolfson, chairman of Diesel Construction, was also one of the most progressive, with avant-garde tastes in architecture and other cultural pursuits. Soon after beginning the Church Street project, Wolfson hired modernist architect William Lescaze to design a building directly across West Broadway from the property. Within a year, he had secured the talents of Pietro Belluschi and Walter Gropius to design the world's largest commercial office building, the so-called Grand Central City tower, later known as the Pan Am Building, above Grand Central Terminal. See "Builder of Skylines," *Time,* February 22, 1960, 35, and "Erwin S. Wolfson Is Dead at 60," *New York Times,* June 27, 1962.

15. Neelon Crawford to author, February 15, 2008, VMFA curatorial files. A related drawing and photograph recently entered VMFA's collection.

16. See Brock, 42–52.

17. Agee, 8.

Index

Page numbers in italics refer to illustrations.

Photography Credits

All photographs of Virginia Museum of Fine Arts works are by Katherine Wetzel, except the following by Travis Fullerton: cat. nos. 2, 19, 26, 69, 84, 101, and 128, and figs. 36, 82, 109, 111, 135, 149, 179, 180, 183, 195, and 216.

Fig. 2 VMFA Photo Archives
Fig. 9 VMFA Photo Archives
Fig. 11 VMFA Photo Archives
Fig. 14 VMFA Photo Archives
Fig. 15 VMFA Photo Archives
Fig. 16 VMFA Photo Archives
Fig. 23 Photograph © 2010 Museum of Fine Arts, Boston
Fig. 24 Wadsworth Atheneum Museum of Art/Art Resource, N.Y. Image Reference: ART385983
Fig. 28 Courtesy of the Ryerson and Burnham Libraries at the Art Institute of Chicago
Fig. 29 Courtesy of the Ryerson and Burnham Libraries at the Art Institute of Chicago
Fig. 32 Photograph by Graydon Wood
Fig. 43 I. N. Phelps Stokes Collection, Miriam and Ira D. Wallach Division of Art, Prints and Photographs, Astor, Lenox and Tilden Foundations
Fig. 51 Image © The Metropolitan Museum of Art
Fig. 52 Image © The Metropolitan Museum of Art
Fig. 54 Photograph courtesy of Smithsonian Institution Libraries, Washington, D.C.
Fig. 55 Photograph by Bruce White © White House Historical Association
Fig. 56 © White House Historical Association
Fig. 60 Image © The Metropolitan Museum of Art
Fig. 68 Photograph courtesy of University of Virginia Libraries
Fig. 80 Library of Congress, LC-USZ62-62554
Fig. 84 Courtesy of North Carolina State Archives
Fig. 85 Photograph courtesy of the Library of Virginia
Fig. 88 Photograph by Carl Clifford
Fig. 89 Photograph: Munson-Williams-Proctor Arts Institute/Art Resource, N.Y. Image Reference: ART369181
Fig. 100 Photograph © 2010 Museum of Fine Arts, Boston
Fig. 110 Photograph © 2010 Museum of Fine Arts, Boston
Cat. no. 74 Worsham-Rockefeller bedroom, originally located at 4 West 54th Street, Manhattan, shown as installed at the Museum of the City of New York. Photograph courtesy of the Museum of the City of New York.
Fig. 117 Photos/Homes/1003–NYC, Courtesy of the Rockefeller Archive Center
Fig. 118 Photos 1005/Homes/4 & 10 W. 54th Street Album/Box 39/Folder 1937 Album/Image #29465, Courtesy of the Rockefeller Archive Center
Figs. 120–127 Photograph courtesy of the Museum of the City of New York
Fig. 129 Courtesy of the Bancroft Library, University of California, Berkeley

Fig. 131 Photograph courtesy of University of Virginia Libraries
Fig. 133 Photograph © 2009 Museum Associates/LACMA, M.74.11
Fig. 134 Tiffany & Co. Archives, New York
Fig. 146 Image © The Metropolitan Museum of Art.
Fig. 148 Photograph: Erich Lessing/Art Resource, N.Y.
Fig. 151 From A. Hustin, Salon de 1892 (Paris, 1892)
Fig. 156 Courtesy of Dartmouth College Library, Hanover, New Hampshire
Fig. 158 Photograph by Dan Addison/University of Virginia Public Affairs
Fig. 165 Photograph from Burton Holmes, The Burton Holmes Lectures, with Illustrations from Photographs by the Author (Battle Creek: Michigan, 1904), courtesy of Fishburn Library, Hollins College, Roanoke, Virginia
Fig. 175 Photograph courtesy of the R.W. Norton Art Gallery, Shreveport, Louisiana
Fig. 192 Photograph courtesy of Christie's, New York
Fig. 194 Photograph by Geoffrey Clements
Cat. no. 118 Art © T. H. Benton and R. P. Benton Testamentary Trusts/UMB Bank Trustee/Licensed by VAGA, New York, N.Y.
Fig. 198 Art © T. H. Benton and R. P. Benton Testamentary Trusts/UMB Bank Trustee/Licensed by VAGA, New York, N.Y.
Cat. no. 121 © Copyright The Estate of Arthur G. Dove
Fig. 202 Collection of John and Dolores Beck. Copyright, © The Estate of Arthur G. Dove
Cat. no. 122 Reproduced with permission of the Charles E. Burchfield Foundation
Fig. 204 Reproduced with permission of the Charles E. Burchfield Foundation
Fig. 205 © 2009 Artists Rights Society (ARS), New York/ADAGP, Paris
Fig. 208 Gift of the artist, Class of 1920
Cat. no. 126 Art © Estate of Yasuo Kuniyoshi/Licensed by VAGA, New York, N.Y.
Cat. no. 128 © 2009 Jacob Lawrence/Artists Rights Society (ARS), New York, 75.21.8
Fig. 211 © 2009 Jacob Lawrence/Artists Rights Society (ARS), New York
Cat. no. 131 Art © Estate of Robert Gwathmey/Licensed by VAGA, New York, N.Y.
Fig. 212 Courtesy of the Library of Virginia
Fig. 213 Art © Estate of Rosalie Gwathmey/Licensed by VAGA, New York, N.Y.
Fig. 214 Art © Samella Lewis / Licensed by VAGA, New York, N.Y.
Fig. 216 Letters of John B. Flannagan (New York: Curt Valentin, 1942), 58, Virginia Museum of Fine Arts Library
Cat. no. 136 Art © Estate of Stuart Davis/Licensed by VAGA, New York, N.Y.
Fig. 219 © President and Fellows of Harvard College. Photograph: Imaging Department © President and Fellows of Harvard College. Art © Estate of Stuart Davis / Licensed by VAGA, New York, N.Y.